SMALL-FORMAT AERIAL PHOTOGRAPHY AND UAS IMAGERY

SECOND EDITION

SMALL-FORMAT AERIAL PHOTOGRAPHY AND UAS IMAGERY

Principles, Techniques, and Geoscience Applications

SECOND EDITION

James S. Aber
Emporia State University, Emporia, Kansas, United States

Irene Marzolff
Goethe University, Frankfurt am Main, Germany

Johannes B. Ries
University of Trier, Trier, Germany

Susan E.W. Aber
San José State University, San Jose, California, United States

ELSEVIER

Elsevier
Radarweg 29, PO Box 211, 1000 AE Amsterdam, Netherlands
The Boulevard, Langford Lane, Kidlington, Oxford OX5 1GB, United Kingdom
50 Hampshire Street, 5th Floor, Cambridge, MA 02139, United States

Notices
Knowledge and best practice in this field are constantly changing. As new research and experience broaden our understanding, changes in research methods, professional practices, or medical treatment may become necessary.

Practitioners and researchers must always rely on their own experience and knowledge in evaluating and using any information, methods, compounds, or experiments described herein. In using such information or methods they should be mindful of their own safety and the safety of others, including parties for whom they have a professional responsibility.

To the fullest extent of the law, neither the Publisher nor the authors, contributors, or editors, assume any liability for any injury and/or damage to persons or property as a matter of products liability, negligence or otherwise, or from any use or operation of any methods, products, instructions, or ideas contained in the material herein.

Library of Congress Cataloging-in-Publication Data
A catalog record for this book is available from the Library of Congress

British Library Cataloguing-in-Publication Data
A catalogue record for this book is available from the British Library

ISBN: 978-0-12-812942-5

For information on all Elsevier publications
visit our website at https://www.elsevier.com/books-and-journals

Publisher: Candice Janco
Acquisition Editor: Laura S Kelleher
Editorial Project Manager: Emily Thomson
Production Project Manager: Vignesh Tamil
Cover Designer: Mark Rogers

Typeset by SPi Global, India

Contents

Preface to the Second Edition

During the late twentieth century, small-format aerial photography (SFAP) was a niche remote-sensing technique, pursued only by selected enthusiasts such as us. When we wrote the first edition of this book a decade ago, SFAP had already started a revival based on kites, balloons, and model aircraft. Since then, the proliferation of unmanned aerial systems (UAS), both professional and consumer-grade, together with new photogrammetric image-processing techniques have revolutionized image-based geodata acquisition beyond even our expectations.

Ultra-high-resolution airphotos have become ubiquitous in spatial applications of all kinds, and the scientific literature on the use of UAS imagery in the geosciences and related environmental disciplines has literally exploded. SFAP and UAS surveys have grown into a remote-sensing method in their own right. The merits and attraction of the bird's-eye view from low heights have become obvious to the general public, too, as drone images and videos are now part of everyday life from *Instagram* to TV dramas.

We have always believed strongly in the potential of large-scale, custom-acquired airphotos for our research, and we have followed this development with great satisfaction. We did not start our SFAP careers, several decades back, as dedicated kite flyers, hot-air blimp developers, UAS pilots, or do-it-yourself gadget builders. We have become aerial photographers out of necessity, because we needed to assess landscapes, forms, processes, and distribution patterns in detail and document their changes through time. We required feasible, cost-effective methods that would adapt to the sizes of the features, the transitory nature of their occurrence, and the speed of their development. We needed ultra-high-spatial resolution and repeated imagery for long-term study sites. Furthermore, our research projects often took us to distant and relatively inaccessible locations in various countries, so logistical and legal issues also became important.

Self-made aerial photographs offer the researcher a maximum of flexibility in field work. Within the technical limits of the camera and platform, the photographer may determine not only place and time but also viewing angle, image coverage, and exposure settings. While imagery acquired from external sources may or may not show the study site at the required scale, time, and angle, such tailor-made photos show exactly those sites and features we seek. Thus, SFAP is a way to bridge the gap in scale and resolution between ground observations and imagery acquired from conventional manned aircraft and satellite sensors.

SFAP enables researchers as well as other professionals and the interested public to get their own pictures of the world. Large-scale aerial photographs in many cases help to state more precisely the scientific question, to improve the understanding of processes, and to deepen the knowledge of our study sites. This enables us to monitor local changes at the spatial and temporal scales at which they occur and to assess their roles and importance in a constantly changing world. In many cases, we might even learn something altogether new.

We began our SFAP efforts in the age of film cameras using mainly kites and blimps prior to the advent of UAS. Since then, digital photography has revolutionized both field and laboratory methods. New photogrammetric approaches such as Structure from Motion (SfM) make fast and efficient reconstruction of surface topography as 3D point clouds accessible to the non-specialist. The rapid growth of UAS in recent years likewise opens new opportunities for SFAP, which is now a mainstream activity involving thousands of people, commercial enterprises, and countless applications. This second edition reflects the swift development and widespread use of small-format aerial photography and UAS imagery.

We hope that this book may continue to take its part in the success story of SFAP and UAS imagery. This second edition has seen minor to major changes throughout all chapters. In particular, the sections on platforms were restructured and revised in order to reflect the considerable development in the field of UAS. The sections on photogrammetry and image processing have been updated with new methodologies. Numerous figures were exchanged or added, with many examples from our latest fieldwork. We have also extended the title of this book to include UAS imagery as a specific form of SFAP. Although the term UAS (or UAV) imagery is more often used now in the literature, we prefer to speak of SFAP throughout this book. It is the image, not the aircraft used for SFAP, that is our main concern, and the principles and techniques we present are common to all large-scale photographs taken with consumer-grade cameras from low flying heights, notwithstanding the type of platform.

Next to drones of all varieties, kites and balloons still retain their virtues as non-autonomous, non-motored platforms. They are less affected by legal constraints—currently an element of uncertainty for planning UAS surveys, as aviation laws are being adapted for drones in many countries. And they have their advantages in sensitive environments where wildlife might be disturbed by the noise of motors and rotor blades and rapid UAV movement.

This book is divided into three major portions. Chapters 1–5 cover introductory material, including history, basic principles, photogrammetry, lighting and atmospheric conditions, and photographic composition. SFAP techniques are elaborated for cameras, manned and tethered platforms, unmanned aerial systems (UAS), field methods, visual interpretation, image analysis, and legal issues in Chapters 6–12. Case studies are presented in Chapters 13–20 with an emphasis on geoscience and environmental applications. Most of these applied examples are drawn from the authors' own field work in North America, Europe, and Africa. A final summary Chapter 21 reviews the emergence of small-format aerial photography and looks forward to the future.

Acknowledgments

This book represents contributions from many individuals and organizations that have encouraged and supported the authors and helped us to pursue small-format aerial photography. Among those who have played significant roles since the first edition, we thank our colleagues and collaborators: Ali Aït Hssaine, Alivia Allison, Peter Blišt'an, Cornelius Claussen, Gayla Corley, Sebastian d'Oleire-Oltmanns, Igor Duriška, Jack Estes, Hassan Ghafrani, Maria Górska-Zabielska, Abdellatif Hanna, Stanislav Jacko, Juraj Janočko, Mario Kirchhoff, David Leiker, Holger Lykke-Andersen, Toshiro Nagasako, Daniel Peter, Firooza Pavri, Robert Penner II, Alan Peterson, Christopher Pettit, Jan Piotrowski, Marta Prekopová, Gilles Rock, David and Mary Sauchyn, Steve and Glenda Schmidt, Jim Schubert, Manuel Seeger, Deon Van der Merwe, Dennis Wiley, and Brenda Zabriskie. Colleagues who assisted with SFAP are named in figure captions.

Many undergraduate and graduate students from Emporia State University, Goethe University, University of Trier, and the Technical University of Košice have provided ample assistance with field projects since the first edition. Students who helped with SFAP are identified in figure captions. JBR gratefully acknowledges the help of Miriam Marzen and Mario Kirchhoff with translations and proofreading.

Financial and logistical support for this second edition were provided by Emporia State University (US), Kansas Academy of Science, Nature Conservancy of Kansas, San José State University (US), Erasmus+ Programme (EU), Technical University of Košice (SK), University of Aarhus (DK), Adam Mickiewicz University (PL), the US Department of Agriculture, Deutsche Forschungsgemeinschaft, Vereinigung der Freunde und Förderer der Johann Wolfgang Goethe-Universität Frankfurt am Main, Stiftung zur Förderung der Internationalen Wissenschaftlichen Beziehungen der Johann Wolfgang Goethe-Universität Frankfurt am Main, and Forschungsfonds der Universität Trier.

James S. Aber
Irene Marzolff
Johannes B. Ries
Susan E.W. Aber

Introduction to Small-Format Aerial Photography

Small is beautiful. E. Schumacher 1973, quoted by Mack (2007)

1-1 OVERVIEW

People have acquired aerial photographs ever since the means have existed to lift cameras above the Earth's surface, beginning in the mid-nineteenth century. Human desire to see the Earth "as the birds do" is strong for many practical and aesthetic reasons. From rather limited use in the nineteenth century, the scope and technical means of aerial photography expanded throughout the twentieth century. Now well into the 21st century, the technique is utilized for all manners of earth-resources applications from small and simple to large and sophisticated.

Aerial photographs are taken normally from manned airplanes or helicopters, but many other platforms may be used, including tethered balloons and blimps, drones, gliders, rockets, model airplanes, kites, and even birds (Tielkes 2003). Recent innovations for cameras and platforms have led to new scientific, commercial, and artistic possibilities for acquiring dramatic aerial photographs (Fig. 1-1).

The emphasis of this book is small-format aerial photography (SFAP) utilizing consumer-grade and small professional digital cameras as well as analog 35-mm film cameras in the visual and near-infrared spectral range. Such cameras may be employed from manned or unmanned platforms ranging in height from just 10s of meters above the ground to 100s of kilometers into space. Platforms may be as simple as a fiberglass rod to lift up a point-and-shoot camera, as technical as unmanned aerial systems (UAS) for GPS-controlled photomosaic imagery, or as complex as the International Space Station.

SFAP became a distinct niche within remote sensing during the 1990s (Warner et al. 1996; Bauer et al. 1997),

and it has been employed in recent years for documenting all manner of natural and human resources. The field is ripe with experimentation and innovation of equipment and techniques applied to diverse situations. Recent development and popularity of UAS demonstrate the human desire for low-height, large-scale aerial imagery for hobby, artistic, and professional applications.

In the past, most aerial photography was conducted from manned platforms, as the presence of a human photographer looking through the camera viewfinder was thought to be essential for acquiring useful imagery. For example, Henrard developed an aerial camera in the 1930s, and he photographed Paris from small aircrafts for the next four decades compiling a remarkable aerial survey of the city (Cohen 2006).

Fig. 1-1 Vertical view of abandoned agricultural land dissected by erosion channels near Freila, Province of Granada (Spain) during a photographic survey taken with a hot-air blimp (left of center) at low flying heights. The blimp is navigated by tether lines from the ground, camera functions are remotely controlled. Its picture was taken from a fixed-wing UAV following GoogleEarth-digitized flightlines at ~200 m height. The blimp takeoff pad at right is 12×8 m in size. *Photo by JBR with C. Claussen and M. Niesen.*

This is still true for many missions and applications today. Perhaps the most famous modern aerial artist-photographer, Y. Arthus-Bertrand, produced his *Earth from above* masterpiece by simply flying in a helicopter using handheld cameras (Arthus-Bertrand 2017). Likewise, G. Gerster has spent a lifetime acquiring superb photographs of archaeological ruins and natural landscapes throughout the world from the open door of a small airplane or helicopter (Gerster 2004).

The most widely available and commonly utilized manned platform nowadays is the conventional fixed-wing small airplane, employed by many SFAPs (Caulfield 1987). Among recent examples, archaeological sites were documented for many years by O. Braasch in Germany (Braasch and Planck 2005), and by Eriksen and Olesen in northwestern Denmark (2002). In central Europe, Markowski and Markowski (2001) adopted this approach for aerial views of Polish castles. Bárta and Barta (2007), a father and son team, produced stunning pictures of landscapes, villages, and urban scenes in Slovakia.

In the United States, Evans and Worster (1998) were among the first to explore the aesthetic aspects of prairie aerial photography from a small manned airplane, and Wark (2004) published hundreds of dramatic landscape pictures taken from a small plane across the country. Hamblin (2004) focused on panoramic images of geologic scenery in Utah, and Morton (2017) displayed spectacular geologic features throughout North America.

D. Maisel has sought out provocative images of strip mines, dry lake beds, and other unusual landscape patterns in the western United States (Gambino 2008). In one of the most unusual manned vehicles, C. Feil pilots a small autogyro for landscape photography in New York and New England (Feil et al. 2005). An ultralight aircraft is utilized for archaeological and landscape scenes in the Southwest by A. Heisey (Heisey and Kawano 2001; Heisey 2007).

Unmanned, tethered, or remotely flown platforms have come into increasingly widespread use during the last two decades. This book highlights such unmanned systems for low-height SFAP, including kites, blimps, and UAS (drones). While the focus of the book is on the use and potential of SFAP for geoscientific research and applications, the merits and attraction of the bird's-eye view from low heights have become of general interest for a far greater range of topics and motifs. Representative recent kite aerial photography, for example, includes Wilson's (2006) beautiful views of Wisconsin in the United States, Tielkes's (2003) work in Africa, and N. Chorier's magnificent pictures of India (Chorier 2016).

Drone photography has already become a subdiscipline of photography, and photo-sharing communities such as *Dronestagram* testify to the fascination of SFAP

Fig. 1-2 Close-up vertical view of the elephant seal rookery on the beach at Piedras Blancas, California, United States. These juvenile seals are ~2–2½ m long, and most are sleeping on a bank of seaweed. People are not allowed to approach the seals on the ground, but the seals were not aware of the silent kite and camera overhead. The spatial detail depicted in such images is extraordinary; individual pebbles are clearly visible on the beach. Special permission was necessary to conduct kite aerial photography at this site; image acquired with a compact digital camera.

felt by photographers around the world. Many professional photographers, with or without previous experience in aerial photography from manned aircraft, are now utilizing drones for their art (Gear 2016). Such imagery has large-scale and exceptionally high spatial resolution that depict ground features in surprising detail from unique vantage points difficult to achieve by other means (Fig. 1-2). These photographic views bridge the gap between ground observations and conventional airphotos and satellite images.

1-2 BRIEF HISTORY

Since ancient times, people have yearned to see the landscape as the birds do, and artists have depicted scenes of the Earth as they imagined from above. Early maps of major cities often were presented as aerial views, showing streets, buildings, and indeed people from a perspective which only could be visualized by the artist. Good examples may be found in Frans Hogenberg's *Civitates Orbis Terrarum* (Cologne, 1572–1617). Seventeenth-century artists such as Wenceslaus Hollar engraved remarkable urban panoramas that showed cities from an oblique bird's-eye view.

George Catlin was another leading practitioner of aerial vantages in the early 1800s (Fig. 1-3). It was not until the mid-1800s, however, that two innovations combined, namely manned flight and photochemical imagery, to make true aerial photography possible. Since then, photography and flight have developed in myriad ways

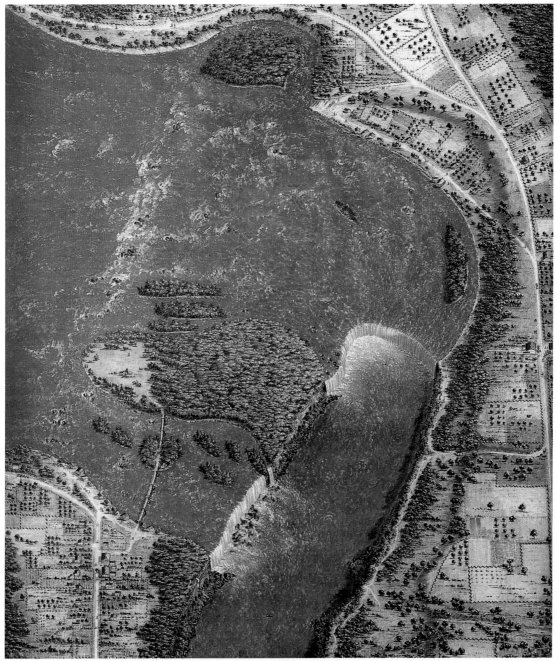

Fig. 1-3 Bird's-eye view of Niagara Falls, Canada and the United States. George Catlin, 1827, gouache, ~45×39 cm. *Adapted from Dippie et al. (2002, p. 36).*

leading to many manned and unmanned methods for documenting the Earth from above.

1-2.1 Nineteenth Century

Louis-Jacques-Mandé Daguerre invented photography based on silver-coated copper plates in the 1830s, and this process was published by the French government in 1839 (Romer 2007). The earliest known attempt to take aerial photographs was made by Colonel Aimé Laussedat of the French Army Corps of Engineers (Wolf et al. 2014). In 1849, he experimented with kites and balloons, but was unsuccessful. The first documented aerial photograph was taken from a balloon in 1858 by Gaspard Félix Tournachon, later known as "Nadar" (Colwell 1997). He ascended in a tethered balloon to a height of several hundred meters and photographed the village of Petit Bicêtre, France. Later that same year,

Laussedat again tried to use a glass-plate camera lifted by several kites (Colwell 1997), but it is uncertain if he was successful. The oldest surviving airphoto was taken by S.A. King and J.W. Black from a balloon in 1860 over Boston, Massachusetts (Jensen 2007).

Hydrogen-filled balloons were utilized for observations of enemy positions during the American Civil War (1861–65); photographs reputedly were taken, although none have survived (Jensen 2007). Meanwhile, Tournachon continued his experiments with balloons and aerial photography in France with limited success. In 1887, a German forester obtained airphotos from a balloon for the purpose of identifying and measuring stands of forest trees (Colwell 1997).

Already in the 1850s, stereophotography was practiced, and new types of glass led to modern anastigmatic camera lenses by 1890 (Zahorcak 2007). Three-color photography was first practiced by Louis Ducos du Hauron, who obtained a French patent for the method in 1868 (Šechtl and Voseček Museum of Photography 2006), and experimental color photography was conducted by F.E. Ives in the 1890s (Romer 2007).

Considerable debate and uncertainty surround the question of who was first to take aerial photographs from a kite. By some accounts, the first person was the British meteorologist E.D. Archibald, as early as 1882 (Colwell 1997). He is credited with taking kite aerial photographs in 1887 by using a small explosive charge to release the camera shutter (Hart 1982). At about the same time, the Tissandier brothers, Gaston and Albert, also conducted kite and balloon aerial photography in France (Cohen 2006). Others maintain that kite aerial photography was invented in France in 1888 by A. Batut, who built a lightweight camera using a 9 × 12-cm glass plate for the photographic emulsion (Beauffort and Dusariez 1995). Later he built a panoramic system that included six cameras in a hexagonal arrangement for 360° views (Tielkes 2003).

In 1890, Batut published the first book on kite aerial photography entitled *La photographie aérienne par cerf-volant*—Aerial photography by kite (Batut 1890; translated and reprinted in Beauffort and Dusariez 1995). In that same year, another Frenchman, Emile Wenz, began practicing kite aerial photography. Batut and Wenz developed a close working relationship that lasted many years. They quickly gave up the technique of attaching the camera directly to the kite frame in favor of suspension from the tether line some 10s of meters below the kite. The activities of Batut and Wenz gained considerable attention in the press, and the method moved across the Atlantic. The first kite aerial photographs were taken in the United States in 1895 (Beauffort and Dusariez 1995). Thereafter the practice of taking photographs from kites advanced rapidly with many technological innovations.

1-2.2 Twentieth Century

The early twentieth century may be considered the golden age of kite aerial photography. At the beginning of the century, kites were the most widely available means for lifting a camera into the sky. Aerial photographs had been acquired from balloons since the mid-1800s, but this was a costly and highly dangerous undertaking and, so, was not widely practiced. Meanwhile powered flight in airplanes had just begun, but it also was a risky way to take aerial photographs. Kites were the "democratic means" for obtaining pictures from above the ground. In the first decade of the twentieth century, kite aerial photography was a utilitarian method for scientific surveys, military applications, and general viewing of the Earth's surface. Its reliability and superiority over other methods were well known (Beauffort and Dusariez 1995).

In the United States, G.R. Lawrence (1869–1938) became a photographic innovator in the 1890s. He built his own large, panoramic cameras that he mounted on towers or ladders. He tried ascending in balloons, but had a near fatal accident when he fell >60 m. Thereafter, he took remarkable aerial photographs with kites. His best-known photograph was the panoramic view of *San Francisco in Ruins* taken in May 1906 a few weeks after a devastating earthquake and fire had destroyed much of the city (Fig. 1-4).

Some controversy has surrounded Lawrence's camera rig, which he called a *captive airship*. Some have interpreted this to mean he used a balloon (Beauffort and Dusariez 1995). However, strong historical documentation exists for kites as the lifting means (Baker 1989, 1997). Lawrence utilized a train with up to 17 delta-conyne kites that flew up to 2000 ft (~600 m) above the ground (Rizzo 2014). For his most famous picture, the kite train and camera were lifted from a naval ship in San Francisco Bay. The panoramic camera took photographs with a wide field of view around 160°. The remarkable quality of this photograph was due to a series of mishaps that delayed the picture until late in the day, when the combination of clouds and low sun position provided dramatic lighting of the scene.

On the same trip to California, Lawrence photographed many other locations in a similar manner, including Pacific Grove (Fig. 1-5). On the centennial of this event, we attempted to recreate Lawrence's panoramic view using modern kite aerial photography techniques. With a single, large rokkaku kite, we lifted a small digital camera rig from a position near Point Pinos, and we achieved a similar height, direction, and field of view (Fig. 1-6). At the top of his fame and fortune in kite aerial photography, Lawrence left the field in 1910 and pursued a career in aviation design.

The most daring method of this era was manned kite aerial photography undertaken by S.F. Cody and his sons

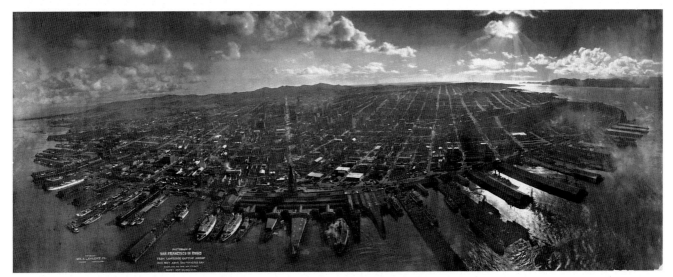

Fig. 1-4 Panoramic kite aerial photograph of San Francisco by George R. Lawrence (1906). Caption on the image reads: Photograph of San Francisco in ruins from Lawrence "captive airship" 2000 ft above San Francisco Bay overlooking waterfront. Sunset over Golden Gate. *Image adapted from the collection of panoramic photographs, U.S. Library of Congress, Digital ID: pan 6a34514.*

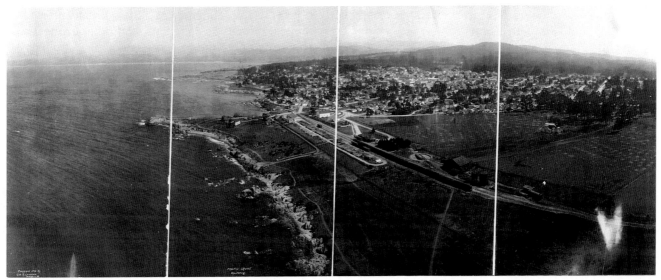

Fig. 1-5 Panoramic kite aerial photograph of Pacific Grove and Monterey Bay, California by G.R. Lawrence (1906). View from near Point Pinos looking toward the southeast at scene center. *Image adapted from the collection of panoramic photographs, U.S. Library of Congress, Digital ID: pan 6a34645.*

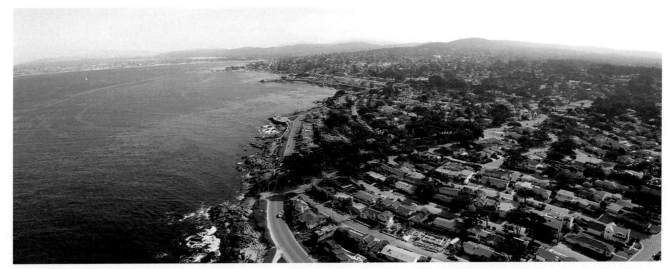

Fig. 1-6 Panoramic kite aerial photograph of Pacific Grove and Monterey Bay, California. Two wide-angle photos were stitched together to create this picture. Award-winning image by JSA and SWA, Oct. 2006.

in the early 1900s (Robinson 2003b). Cody experimented with kites and patented his "Cody kite" in 1901. He eventually succeeded in interesting the British military in man-lifting kites, and a demonstration was conducted at Whale Island, Portsmouth, England in 1903. Further trials were undertaken in 1904–05, and Cody achieved a record height of 800 m for manned kite flight. However, few others followed Cody, because of the cost and enormous risk involved.

During the period 1910–39, René Desclée became the preeminent European kite aerial photographer of his day (Beauffort and Dusariez 1995). His main subjects were the city of Tournai (Belgium) and its cathedral. Over a period of three decades he produced >100 superb aerial photographs, among the best kite aerial photography portfolios prior to World War II. Desclée's career marked the end of kite aerial photography's golden age. Rapid progress in military and commercial photography from airplanes reduced kites to a marginal role (Hart 1982), and kite aerial photography nearly became a lost art during the mid-twentieth century.

The first photograph from a powered flight was taken by L.P. Bonvillain in an airplane piloted by W. Wright in 1908 (Jensen 2007). They shot motion picture film over Camp d'Auvours near Le Mans, France. The original film is lost, but one still frame was published that same year in a French magazine. Aerial photography from manned airplanes gained prominence for military reconnaissance during World War I. Aerial cameras and photographic methods were developed rapidly, and stereo imagery came into common usage. A typical mission consisted of a pilot and photographer who flew behind enemy lines at low height and relatively slow speed. Tens of 1000s of aerial photographs were acquired by Allied and German forces, and the intelligence gained from these images had decisive importance for military operations (Colwell 1997).

At the beginning of the twentieth century, German professors H.W. Vogel and A. Miethe made improvements for three-color photography, and the Russian S.M. Prokudin-Gorsky perfected the technique for *Dreifarbenphotographie* based on triple-color gray-tone negatives (Šechtl and Voseček Museum of Photography 2006). The first near-infrared and near-ultraviolet photographs were published by R.W. Wood in 1910 (Finney 2007). Practical black-and-white infrared film was perfected and made available commercially in the late 1930s, and early types of color film were developed then.

Following World War I, civilian and commercial use of aerial photography expanded for cartography, engineering, forestry, soil studies, and other applications. Many branches of the U.S. federal government employed aerial photography beginning in the 1920s (Weems 2015) and routinely during the 1930s, including the Agricultural Adjustment Administration, Forest Service, Geological Survey, and Navy, as well as regional and local agencies such as the Tennessee Valley Authority and Chicago Planning Commission (Colwell 1997). In his landmark paper on the potential of aerial photography for such applications, and especially for studies of what he termed landscape ecology, the German geographer Carl Troll (1939) highlighted the potential of aerial photographs for viewing the landscape as a spatial and visual entity and strongly advocated their use in scientific studies.

The advent of World War II once again spurred rapid research, testing, and development of improved capabilities for aerial photography. Cameras, lenses, films, film handling, and camera mounting systems developed quickly for acquiring higher and faster aerial photography. Large-format aerial mapping cameras were built for 9-in. (23 cm) format film (Malin and Light 2007). A most important innovation was color-infrared photography designed for camouflage detection.

The global extent of this war led to ever-increasing types of terrain, climate, vegetation, urban and rural settlement, military installations, and other exotic features to confuse photointerpreters. From Finland to the South Pacific, all major combatants utilized aerial photography extensively to prosecute their military campaigns on the ground and at sea. In the end, the forces with the best airphoto reconnaissance and photointerpretation proved victorious in the war, a lesson that was taken quite seriously during the subsequent Cold War (Colwell 1997).

The art and science of aerial photography benefited substantially immediately after World War II in the United States and other countries involved in the war, as military photographers and photointerpreters returned to civilian life (Colwell 1997), and surplus photographic equipment was sold off. Many of these individuals had been drawn from professions in which aerial photography held great promise for further development, and it is not surprising that aerial photography expanded significantly in the post-war years for non-military commercial, governmental, and scientific applications.

Meanwhile, as the Cold War heated up, military aerial photography moved to yet higher and faster platforms, such as the manned U-2 and SR-71 US aircrafts. Unmanned, rocket-launched satellite photographic systems, such as *Corona* (US) and *Zenit* (Soviet), were operated from orbital altitudes during the 1960s and 1970s (Jensen 2007).

Closer to ground, renewed interest in kites began in the United States following World War II. Aeronautical engineering was applied to kites, parachutes, hang gliders, and other flying devices. For example, the *Flexi-Kite* designed and built by F. and G. Rogallo in the late 1940s was the inspiration for many modern kites as well as hang gliders and ultralight aircraft (Robinson 2003a). At the hobby level, Roy (1954) used a home-made camera mounted directly to the frame

of a delta-conyne kite. The *Sutton Flowform*, a soft airfoil kite, was invented as a byproduct of experiments to create a better parachute during the 1970s (Sutton 1999). This kite has become a popular choice for lifting camera rigs.

Non-military uses of aerial photography continued to expand apace. As an example, the US *Skylab* missions in the early 1970s demonstrated the potential for manned, space-based, small-format photography of the Earth (Fig. 1-7). *Skylab* 4 was most successful; about 2000 photographs were collected of >850 features and phenomena (Wilmarth 1977). The lessons learned during *Skylab* missions formed the basis for the program of US space-shuttle photography in the 1980s and '90s. These trends culminated early in the 21st century with astronaut photography of the Earth from the *International Space Station* for scientific and environmental purposes.

SFAP began to make a slow but definite comeback during the 1970s and 80s, particularly in the United States, Japan, and western Europe. Unmanned purpose-built platforms for off-the-shelf cameras in particular were taken up again for archaeology and cultural heritage studies, and also in forestry, agriculture, vegetation studies, and geo-ecology. Since the 1990s, SFAP has become quite widely utilized for diverse applications around the world, from Novaya Zemlya (arctic Russia) to Antarctica. The late twentieth century saw rapid development in methods and popularity for unconventional manned flight, including unpowered hot-air balloons, gliders, and sailplanes, as well as powered ultralight aircraft of various types. All these platforms have been utilized for SFAP (Fig. 1-8).

Developments in computer hardware and software have encouraged the use of small-format, non-metric photography for applications hitherto reserved to large-format metric cameras, particularly photogrammetric and GIS techniques, and SFAP has expanded from mostly scientific studies into the service sector. UAS, also known commonly as drones, have become quite popular in recent years for hobby and professional uses. Both fixed-wing and multirotor platforms have undergone rapid development (Fig. 1-9). SFAP applications range from inspecting bridge structures to evaluating agricultural crop conditions.

1-3 PHOTOGRAPHY AND IMAGERY

The word *photograph* means literally "something written by light," in other words an image created from light. For the first century of its existence, photography referred exclusively to images made using the light-sensitive reaction of silver halide crystals, which undergo a chemical change when exposed to near-ultraviolet, visible, or near-infrared radiation. This photochemical change may be "developed" into a visible picture. All types of film are based on this phenomenon.

Beginning in the mid-twentieth century, however, new electronic means of creating aerial images came into existence. As electronic imagery became more common, many restricted use of the term *photograph* to those pictures exposed originally in film and developed via photochemical

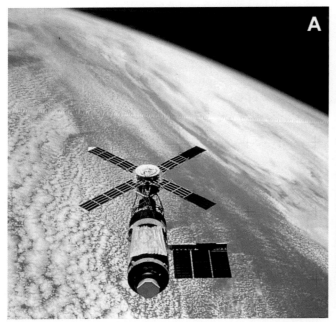

Fig. 1-7 (A) Photograph of *Skylab* in orbit around the Earth taken from the manned rendezvous module. NASA photo SL4-143-4706, January 1974. (B) Near-vertical view of New York City and surroundings. Color-infrared, 70-mm film, Hasselblad camera; active vegetation appears in red and pink colors. NASA photo SL3-87-299, August 1973. *Both images courtesy of K. Lulla, NASA Johnson Space Center.*

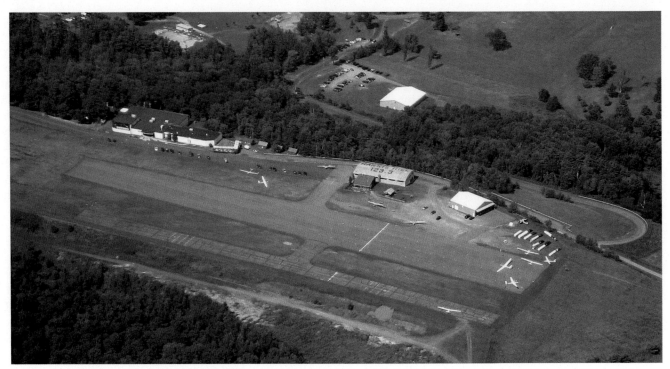

Fig. 1-8 Airport at the National Soaring Museum at Harris Hill, near Elmira, New York, United States. Several gliders are visible on and next to the runway. Photo taken with a compact digital camera through the open window of the copilot's seat in an unpowered, two-person glider several 100 m above the ground, an example of an unconventional platform utilized for SFAP.

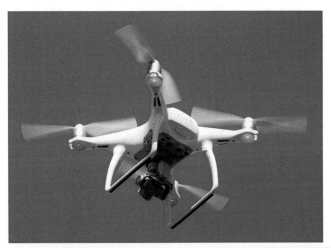

Fig. 1-9 Small UAV, *DJI Phantom*, a quadcopter that has become quite popular. Note the red and green signal lights that aid the pilot in flying the drone. Flown by D. Van der Merwe.

processing. Thus, aerial imagery was classed as photographic or non-photographic; the latter included all other types of pictures made through electronic means.

Traditional film-based photographs are referred to as *analog* images, because each silver halide crystal in the film emulsion records a light level within a continuous range from pure white to pure black. The spatial resolution of a photograph is determined by the size of minute silver halide crystals. In contrast, electronic

imagery is typically recorded as *digital* values, for example 0–255 (2^8) from minimum to maximum levels, for each picture element (cell or pixel) in the scene. Spatial resolution is given by pixel size (linear dimension).

In the late twentieth century, a basic distinction grew up between analog photographs exposed in film and digital images recorded electronically. Analog photographs generally had superior spatial resolution but limited spectral range—panchromatic, color visible, color infrared, etc. Digital imagery lacked the fine spatial resolution of photographs, but had a much broader spectral range and enhanced multispectral capability.

The dichotomy between analog and digital imagery faded quickly in the first decade of the 21st century for several reasons. The advantages of digital image storage, processing, enhancement, analysis, and reproduction are major factors promoting adoption by users at all levels—amateur to professional. Analog airphotos are routinely scanned and converted into digital images nowadays. Digital cameras have achieved equality with film cameras in terms of spatial resolution and geometric fidelity (Malin and Light 2007).

Film photography is rapidly becoming obsolete, in fact, except for certain artistic and technical uses, and where the lower cost of film remains attractive. For most people today, nonetheless, the word *photograph* is applied equally to images produced from film or electronic sensors. We follow this practice, in which we place

primary emphasis on digital photography regardless of how the original image was recorded.

1-4 CONVENTIONAL AERIAL PHOTOGRAPHY

Since World War I, aerial photography has evolved in two directions: larger formats for accurate mapping and cartographic purposes, and smaller formats for reconnaissance usage (Warner et al. 1996). The former became standardized with large, geometrically precise cameras designed for resource mapping and military use. The science of photogrammetry developed for transforming airphotos into accurate cartographic measurements and maps (Wolf et al. 2014). Standard, analog aerial photography today is based on the following:

- Large-format film—panchromatic, color-visible, infrared, or color-infrared film that is 9 in. (23 cm) wide. This format is the largest film in production and common use nowadays.
- Large cameras—bulky cameras weighing 100s of kg with large film magazines. Film rolls contain several hundred frames. Standard lenses are 6- or 12-in. (152- or 304-mm) focal length.
- Substantial aircraft—twin-engine airplanes are utilized to carry the large camera and heavy support equipment necessary for aerial photography. Moderate (3000 m) to high (12,000 m) altitudes are typical for airphoto missions.
- Taking photographs is usually controlled by computer programming in combination with a global navigation satellite system (GNSS) such as GPS to acquire nadir (vertical) shots in a predetermined grid pattern that provides complete stereoscopic coverage of the mapping area.

Large-format aerial photography is expensive—$10s to $100s of thousands to acquire airphoto coverage. This cost may be justified for major engineering projects and extensive regional mapping of the type often undertaken by provincial or national governments—soil survey, environmental monitoring, resource evaluation, property assessment and taxation, topographic mapping, and basic cartography.

Analog aerial photography is mature with many cameras, films, airplanes, and other equipment readily available worldwide. Large-format digital cameras are relatively new, and several types of optical and sensor systems are in use. For example, the *Leica ADS100* airborne digital sensor is a linear array with a swath width of 20,000 pixels in red, green, blue, and near-infrared (RGBN) with forward, nadir, and backward capability (Ribeiro 2013). The *Z/I DMC II 250* camera is another example, which is based on a RGBN 250 MB detector array

(GISCafé 2011). Large-format digital cameras, thus, have achieved technical parity with analog cameras, and large-format digital cameras now dominate the market for conventional aerial photography.

1-5 SMALL-FORMAT AERIAL PHOTOGRAPHY

SFAP, in contrast, employs much smaller lightweight cameras—previously with 35- or 70-mm film, and now predominantly with digital sensors. For the most part, these are popular cameras designed for handheld or tripod use by amateur and professional photographers. Such cameras lack the geometric fidelity and exceptional spatial resolution of aerial mapping cameras. However, the case for SFAP depends on cost and accessibility.

- Low cost—SFAP cameras are relatively inexpensive, few $100 to several $1000, compared with large-format aerial cameras at several $100,000. The cost of SFAP platforms ranges from only a few $100 for kites to tens of $1000 for larger and more sophisticated aircraft. These costs put SFAP within the financial means for many individuals and organizations that could otherwise not afford to acquire conventional aerial photography suitable for their needs.
- Feasibility—low-height, large-scale imagery is possible with various manned or unmanned platforms in diverse circumstances. SFAP may be acquired in situations that would be impractical, illegal, risky, or impossible for operating larger aircraft.
- SFAP has high portability, rapid field setup and use, and limited need for highly trained personnel, all of which makes this means for aerial photography logistically possible for many applications.

Low-cost availability of cameras and lifting platforms is a combination that renders SFAP desirable for many people and organizations (Malin and Light 2007). SFAP is self-made remote sensing system design, technical implementation, and image analysis may be in the hands of a single person, granting utmost flexibility and specialization.

Manned platforms include single-engine airplanes, helicopters, autogyros, ultralight aircraft, hot-air balloons, large blimps, and sailplanes. These are necessarily more expensive and require specialized pilot training in contrast to most unmanned platforms, such as balloons, blimps, kites, model airplanes, and unmanned aerial vehicles (UAVs). Within the field of aerial photography, much innovation is taking place nowadays with all types of platforms and imaging equipment.

As a specialty within remote sensing, SFAP fills a niche of observational scale, resolution, and height between

the ground and conventional aerial photography or satellite imagery—a range that is particularly valuable for detailed site investigations of environmental conditions at the Earth's surface. SFAP is employed in various applications ranging from geoscience, to wildlife habitat monitoring, to archaeology, to crime-scene investigation, to real-estate development.

Within the past decade, commercial satellite imagery of the Earth has achieved sub-half-meter, panchromatic, spatial resolution, for example *WorldView* and *GeoEye* (Satellite Imaging 2017). Such resolution may be possible in principle; however, satellite systems must look through atmospheric haze 100s of km thick, which degrades image quality. Operating close to the surface, SFAP provides cm-scale, multispectral imagery with insignificant atmospheric effects.

As an example, consider mapping vegetation at Kushiro wetland on Hokkaido, northern Japan. Aerial photography and expensive satellite imagery are hampered at Kushiro by persistent sea fog derived from cold offshore currents during the summer growing season when vegetation is active. Miyamoto et al. (2004) utilized two tethered helium balloons to acquire vertical airphotos of a study site in Akanuma marsh. A photomosaic was produced and used to create a detailed map of vegetation. The balloon system allowed the investigators to take quick advantage of brief fog-free conditions to acquire useful imagery. This example demonstrates the spatial, temporal, and cost advantages of SFAP to succeed in a situation where other remote-sensing techniques did not prove capable.

1-6 SUMMARY

For >150 years, aerial photography has provided the means to see the Earth from a bird's-eye perspective. During its first half-century of development, aerial photography was little used because of high cost and risk. Perhaps the most impressive early pictures were the panoramic photographs taken from kites by G.R. Lawrence in the first decade of the twentieth century. With the introduction of powered flight, aerial photography expanded tremendously throughout the 1900s based on many technological inventions for various imaging devices plus the airborne and space-based platforms to carry those devices. These innovations were accelerated by military needs, particularly during World Wars I and II as well as the Cold War.

Since World War I, aerial photography evolved in two directions—larger formats for accurate mapping and smaller formats for reconnaissance usage. During the last 30 years, technical advances in electronic devices and desktop computing have encouraged the use of SFAP with increasingly sophisticated analytical methods. Various types of electronic sensors and digital imagery progressively have taken the place of analog film photography in recent decades.

This book emphasizes SFAP based on light-weight and inexpensive digital and 35- or 70-mm film format cameras operated from platforms at relatively low height (<300 m). Photographs acquired by such means possess large scale and exceptionally high spatial resolution that portray ground features in surprising detail with minimal atmospheric effects. Within the field of remote sensing, SFAP has established a niche that bridges the scale and resolution gap between ground observations and conventional large-format airphotos or satellite images.

Both manned and unmanned platforms are utilized for SFAP. The former includes fixed-wing airplanes, helicopters, autogyros, ultralights, gliders and sailplanes, hot-air balloons, and large blimps. Unmanned platforms are balloons, blimps, kites, and UASs (drones) of various kinds. The advantages of SFAP are based primarily on lower cost and greater accessibility compared with conventional large-format aerial photography or other means of remote sensing. The combination of inexpensive cameras and lifting platforms renders SFAP desirable and feasible for many people and organizations and is particularly valuable for detailed site investigations of environmental conditions and human influence at the Earth's surface.

2

Basic Principles of SFAP

The sky is where I work, and the land and people are what I see … my aerial vantage point is a privileged one. A. Heisey (Heisey and Kawano 2001).

2-1 REMOTE SENSING

Small-format aerial photography (SFAP) is a type of remote sensing, which is the science and art of gathering information about an object from a distance. In other words, measurements or observations are taken without making direct physical contact with the object in question. The electromagnetic spectrum is the energy that carries information through the atmosphere from the Earth's surface to the small-format camera.

Most digital cameras—as well as analog film cameras—are capable of operating in the spectral range that includes near-ultraviolet, visible, and near-infrared radiation, which is the spectrum emphasized in this book. For the most part, this electromagnetic radiation represents reflected solar energy—in other words, natural sunlight that illuminates the scene, reflects from surface objects, and strikes the electronic detector or film of the camera. There are several aspects in which actual SFAP deviates from ideal remote sensing (adapted from Lillesand et al. 2015).

2-1.1 Ideal Remote Sensing

- Sunlight—constant solar energy over all wavelengths at known output, irrespective of time and place.
- Neutral atmosphere—totally transparent atmosphere that would neither absorb nor scatter solar radiation.
- Unique spectral signatures—each object would have a distinctive and known spectral response everywhere and at all times.
- Super sensor—camera that would be highly sensitive through all wavelengths of interest and would be economical and practical to operate.
- Real-time data handling—system that would allow instant downloading, processing, and presentation of images.

- Multiple data users—images would be useful to scientists, engineers, managers, and others from all disciplines and applications.

2-1.2 Actual SFAP

- Sunlight—varies with time and place in ways that cannot be fully predicted. Calibration is sometimes possible, but the exact nature of available solar energy is usually not known.
- Atmosphere—varies according to latitude, season, time of day, local weather, etc. Selective absorption and scattering are the rule at most times and places.
- Spectral signatures—all objects have theoretically unique signatures, but in practice these may change and cannot always be distinguished; many objects appear the same.
- Real cameras—no existing small-format camera system may operate practically in all wavelengths of interest. Each camera is limited by its optics, electronic or film characteristics to certain wavelengths. Likewise certain cameras are limited by their high cost.
- Data handling—digital cameras now generate imagery that may be handled quickly by either visual inspection or computer analysis.
- Multiple users—no single combination of imagery and analysis satisfies all users. Many users are not familiar with subjects outside their immediate disciplines and thus cannot appreciate the full potential or limitations of SFAP.

SFAP, like other types of remote sensing, is a compromise between the ideal and what is logistically feasible and financially affordable for a given project. In this regard, the relatively low cost, high spatial resolution, and field portability of SFAP offer some advantages not possible with other means of aerial remote sensing.

SFAP normally exploits the so-called visible atmospheric window consisting of wavelengths from ~0.3 to 1.5 μm long (Fig. 2-1). On a cloud-free day, this range of wavelengths passes through the atmosphere with little scattering or absorption by gas molecules, aerosols, or

11

Near ultraviolet

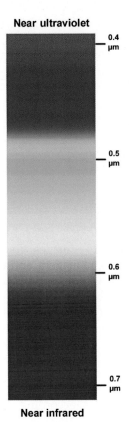

Near infrared

Fig. 2-1 Spectrum of visible light in micrometers (μm) wavelength. All visible colors are made up of three primary colors: blue (0.4–0.5 μm), green (0.5–0.6 μm), and red (0.6–0.7 μm). Near ultraviolet is ~0.3–0.4 μm, and near infrared is ~0.7–1.5 μm wavelengths.

fine dust. Given the low-height operation for most SFAP below 300 m, images are acquired in which the reflected radiation has suffered minimal degradation from atmospheric scattering or absorption. This is an important consideration in terms of clarity and spectral signatures of objects depicted in SFAP images.

2-2 COMMON ASPECTS OF SFAP

Among different types of remote sensing, SFAP undoubtedly has the greatest variety in terms of aerial platforms and camera systems. Some basic aspects are common to all approaches, nonetheless, regardless of the type of platform, camera, or purpose for SFAP. These common aspects are introduced here and elaborated in more detail in subsequent chapters.

2-2.1 Image Vantage

Aerial photographs may be taken in three vantages relative to the Earth's surface, as determined by the tilt of the camera lens relative to the horizon (Fig. 2-2). The amount of tilt is called depression angle.

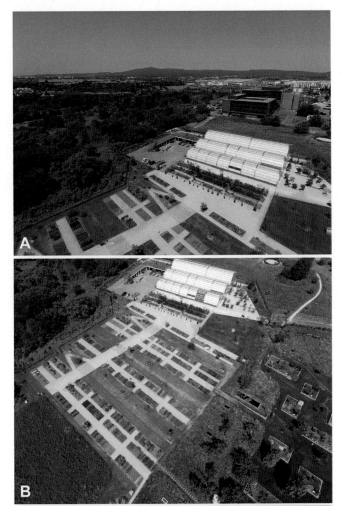

Fig. 2-2 Three views of the Science Garden at Frankfurt University's Campus Riedberg, Germany. (A) High-oblique view showing the horizon with the Taunus mountain range in the background. (B) Low-oblique view in which the horizon is not visible. (C) Vertical view of the central part of the garden. The flowerbeds, used as nursery and for teaching purposes, are arranged according to plant taxonomy. Taken with on-board camera of quadcopter UAV.

- High-oblique vantage—side view, horizon and sky are visible, depression angle typically <20°.
- Low-oblique vantage—side view, horizon is not visible, depression angle typically 20° to 87°.
- Vertical vantage—view straight down, also called nadir, depression angle >87° to 90°.

Vertical images are generally preferred for mapping and measurement purposes, as explained below, because the geometry of vertical images may be calculated. However, such vertical views often are difficult for many people to interpret unless they are quite familiar with the site and objects shown in the image. Oblique shots, on the other hand, provide overviews of sites and their surroundings that are easier for most people to recognize visually and understand readily (e.g. Ham and Curtis 1960). Yet, oblique photographs have substantial distortions in scene geometry that render accurate measurements difficult or impossible.

2-2.2 Photographic Scale and Resolution

The scale of a vertical aerial photograph over flat terrain may be calculated simply in two ways (see Chap. 3). The scale (S) depends on the average height above the ground (H_g) and the lens focal length (f) of the camera. In either case, the units of measurement must be the same.

$$S = f / H_g \qquad \text{(Eq. 2-1)}$$

or

$$S = \text{photo distance}(d) / \text{ground distance}(D) \quad \text{(Eq. 2-2)}$$

In cases where objects of known size appear in the vertical photograph, the second method may be utilized for scale calculation (Fig. 2-3). If no objects of known size are visible in the photograph and the flying height above ground is known, the first method is employed. Scale is usually expressed as a fraction or ratio, such as 1/1000 or 1:1000, meaning one linear unit of measurement on the photograph equals 1000 units on the ground. In rugged terrain, however, photo scale varies because of large height differences within the photograph. Likewise oblique photos also display large scale variations.

Scale is a fundamental property of routine aerial photographs, and is especially important for vertical airphotos used for measurements and photogrammetric purposes. Interpretability of aerial photographs is often determined by photo scale. For analog aerial photographs, the original film scale is the most commonly used characteristic for describing the amount of detail identifiable in the image. The actual photographic resolution is determined by the size of the smallest identifiable feature within an image.

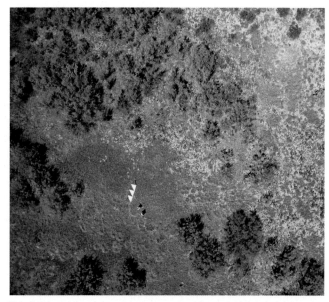

Fig. 2-3 Biological study site near Pueblo, Colorado, United States. The north arrow is 4 m long by 1 m wide; it provides both a scale bar and a directional indicator for this vertical kite aerial photograph. Note two people standing next to the survey arrow. Photo taken with a compact digital camera.

For digital images, the original scale on the image sensor is not of much interest, as the scale of a digital image is easily changed when viewing it on a display device and becomes a property of that device. However, the original image resolution does not change with varying display scale, and the size of the smallest visible object depends directly on the size of the sensor cells or pixels in the electronic detector. In the case of digital imagery, ground sample distance (GSD) is, therefore, more appropriate as a measure for image scale (Comer et al. 1998).

Consider a digital camera with a charge-coupled device (CCD); collection GSD is related to the size of each pixel element within the detector array. Using the scale calculations noted above, GSD may be determined as follows:

$$\text{GSD} = (\text{pixel element size}) \times H_g / f \quad \text{(Eq. 2-3)}$$

However, a single pixel usually cannot be identified as a unique object by itself. For visual identification of distinct objects, generally a group of 4–9 pixels is the minimum necessary (Comer et al. 1998). This leads to a general rule of thumb (Hall 1997):

- *Positive recognition of objects in aerial photographs requires a GSD three to five times smaller than the object size.*

Digital images as well as small-format analog photographs are rarely, if ever, displayed at the original camera scale, which would be much too small for normal visual examination. Most usually, digital images are enlarged substantially for display on a computer monitor, in which the dot pitch (size) controls the image size and

scale, assuming one image pixel is displayed for each monitor dot. In this case, the display scale is a ratio of the collection GSD to the monitor dot pitch.

$$\text{Display scale} = (\text{monitor dot pitch}) / \text{GSD} \quad (\text{Eq. 2-4})$$

As an example, take a digital vertical photograph acquired at a height of 100 m using a camera with a 35-mm lens focal length and CCD pixel element size of 0.009 mm. Converting all units into meters, collection GSD would be $(0.000009 \times 100)/0.035 = 0.026$ m (~2½ cm or 1 in.). Now, displaying this image at full size on a monitor with dot pitch of 0.26 mm, the display scale would be $0.00026/0.026 = 0.01$ (or 1:100). A similar calculation could be done for printed digital images. The nominal pixel size for standard printing at 300 dpi (dots per inch) is about 0.085 mm. In this case, printed scale would be $0.000085/0.026 = 0.00327$ (or about 1:300). Displaying or printing the image at smaller scales would mean losing some of its information content when viewing it on the screen or printout.

This example demonstrates that display and printed scales are usually many times greater than is the original digital image scale, because the display/print pixels are many times larger than are the electronic detector pixel elements. The larger scales employed for display and printing of digital images do not imply more information or better interpretability, however, compared to the raw image data (Fig. 2-4). A digital number is simply a color value for a single pixel, regardless of the size at which the pixel is displayed.

So far, we have used the term resolution, which is employed in different ways in remote sensing, for describing the spatial dimensions of SFAP. Other aspects of resolution include spectral, temporal, and radiometric properties (Jensen 2007). Suitable spectral resolution of the image may be equally or even more important than is spatial resolution for identification of certain objects. For example, color-infrared photography was developed originally for camouflage detection and is widely employed now for vegetation, soil, and water studies (Finney 2007). The combination of visible and near-infrared radiation reveals objects that may appear similar in visible light only (Fig. 2-5).

Temporal resolution refers to how often a remote-sensing system may record an image of the same area. For satellite systems, this is dependent on their fixed orbital periods, image swath width, and off-nadir tilting capacity. SFAP, in contrast, offers much greater flexibility in adapting acquisition

Fig. 2-4 Enlargement of the arrow and people in the previous figure. This image contains no more spatial or spectral information than the previous image; each pixel represents exactly the same ground area and color as before. All the details visible in the enlarged image are present in the original image.

Fig. 2-5 Color-visible (A) and color-infrared (B) kite aerial photographs of the campus of Emporia State University, Kansas, United States. A portion of the football field, dormitory buildings, parking lots, automobiles, grass, and deciduous trees. Photosynthetically active vegetation is depicted in red and pink colors in the infrared image. Note variations in tree appearance in the color-infrared version. Photos taken with a pair of analog SLR cameras.

Fig. 2-6 Time series of three vertical views of a small tributary to Oued Ouaar at La Glalcha near Taroudant (Morocco), taken before and after a heavy rainfall event in autumn 2010. Flow direction is bottom to top in the image; field of view ~50 m across. Between September 29 (A) and December 2 (B), stream channel erosion has resulted in substantial changes at and below the cut bank (CB) at the left side of the channel and at the point bar (PB) at the entry into the main wadi. As the ephemeral stream channel was still partly filled with water during the post-event survey, the survey was repeated 1 day later (December 3; C) to reveal the erosion and deposition changes in the channel bed. All images were taken between 4 and 5 pm; note the similarity of shadows in B and C and the discrepancy with image A, taken 9 weeks earlier, due to differences in seasonal sun position. Fixed-wing UAV photographs taken with digital MILC by IM, S. d'Oleire-Oltmanns and D. Peter.

time and repeat rate to the objectives of a survey. Images may be taken in intervals of minutes, days, or years depending on the requirements of a project. This allows the SFAP photographer to react timely when monitoring changes in a landscape (Fig. 2-6; see also Fig. 16-2). Even if time series are not required, the high temporal flexibility of SFAP in choosing a precise acquisition time is a great advantage over other remote-sensing systems. Deciduous vegetation, as an example, is strongly seasonal in character, and this situation may be exploited for identification of plant types (Fig. 2-7).

Finally, the term radiometric resolution refers to the number of digital levels, also called precision or image depth, that the sensor uses for recording different intensities of radiation. For display devices and most standard image file format, 0–255 or 2^8 (8-bit) digital levels per image band are usual. Most SFAP camera sensors, however, record 12–16 bits for the raw image (see Chap. 6).

2-2.3 Relief Displacement

The camera lens operates much like the human eye, both of which produce single-point perspective views of the scene. This perspective causes increasing relief displacement of objects nearing the edge of view (see Chap. 3) and is most noticeable in vertical airphotos, because tall objects appear to lean away from the photo center. Conversely low objects are displaced toward the center. Relief displacement is minimal near the photo center and becomes extreme at the edge. This allows for a side view

of tall objects near the edge of a vertical photograph, particularly for wide-angle fields of view (Fig. 2-8). The height of a tall vertical object may be calculated from its relief displacement, and the height of tall objects also may be determined from measurements of shadows.

Fig. 2-7 Vertical kite photograph in visible light showing water pools and vegetated hummocks in the central portion of Männikjärve Bog, Estonia. Moss species display distinctive green, gold, and red early autumn colors along with pale green dwarf pine trees on hummocks. These dramatic colors are not so distinct at other times of the year; precise timing of image acquisition is therefore highly valuable. Field of view ~60 m across. Taken with a compact digital camera; based on Aber et al. (2002).

Fig. 2-8 Wide-angle, vertical view over conifer forest at Kojšovská hol'a in southeastern Slovakia. Note how trees appear to lean away from photo center toward outer edges of the scene. Kite photo taken with a compact digital camera.

2-2.4 Stereoscopic Images

Humans see in three dimensions, in other words depth perception, because our eyes provide overlapping fields of view from slightly different vantage points. The amount of depth perception in humans is limited to about 400 m distance, however, because of the relatively close spacing of our eyes only 6–7 cm apart (Drury 2001). Stereoscopic photography has been practiced since the middle nineteenth century to provide 3D imagery (Osterman 2007). Aerial stereo photographs may be taken from widely separated positions (Fig. 2-9); the greater distance in image spacing produces exaggerated depth perception. Such overlapping pictures typically are viewed through a stereoscope (Fig. 2-10) or on-screen with anaglyph glasses or special stereoviewing hardware. Vertical stereophotos are important for visual photointerpretation and are the basis for many photogrammetric techniques (Ogleby 2007; see also Chaps. 3-3 and 11-4).

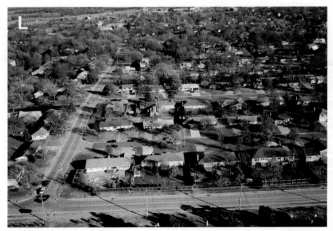
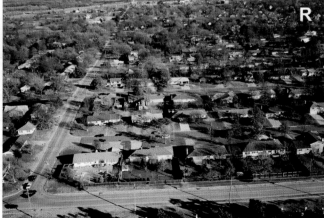

Fig. 2-9 Pair of oblique stereophotos showing a residential scene in Emporia, Kansas, United States. The pictures were taken simultaneously with two cameras spaced ~1 m apart. Note slight left-right offset in views; compare vehicle in lower left corner and house in lower right corner of each photograph. Kite photos taken with a pair of compact analog cameras.

Fig. 2-10 *Sokkia* mirror stereoscope (MS16). This model is the ideal size for viewing 4×6-in. (10×15-cm) prints made from 35-mm film or digital images.

2-3 PHOTOGRAPHIC STORAGE

SFAP is more than just snapshots; usually the images are intended for long-term storage and reproduction years and even decades after they were acquired. However, neither film nor digital photography is everlasting; all photographic media are subject to long-term decay (Rosenthaler 2007). Thus, proper storage of the images becomes a significant issue for most SFAP projects. Geographic information typically consists of two kinds of data. First is the primary dataset comprised of location information and attribute data about individual features. Second is so-called metadata, which includes such information about the geographic dataset as its grid system, map projection, units of measurement, date of creation, camera model, lens focal length, and history of processing.

Aerial photographs are one type of geographic information. The original image itself is the primary dataset. Metadata should contain information about location, date of image acquisition, type of camera and lens, exposure settings, altitude, and other relevant facts. For analog (film, print) photographs, such information could be written directly on the image, so there is no chance the image could be separated from its metadata (see Figs. 1-4 and 1-5). A more common approach is to place metadata on the margins, back, or frame of the photographic medium (Fig. 2-11). Still this approach is often omitted or incomplete for SFAP, and years later nobody would remember the where, when, or what aspects for a photograph.

Some camera-related metadata (EXIF header) is built into image files collected with most modern digital cameras. The image file contains metadata, under file properties, such as image dimensions, file size in bytes, date and time the image was taken, type of data compression, and camera model as well as shutter speed, *f*-stop, and ISO setting. Some camera models also may include GPS data and look direction (Fig. 2-12).

Fig. 2-11 Example of 35-mm color film mounted in a plastic frame (slide). Metadata written on the frame include location, date of acquisition, and picture number. Kite photo taken with a compact analog camera, Estonia.

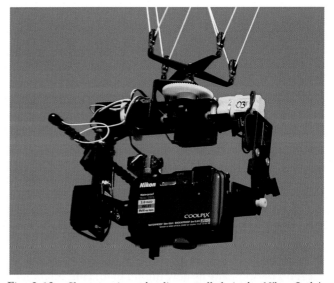

Fig. 2-12 Close-up view of radio-controlled rig for *Nikon Coolpix* 16-megapixel digital camera. The AW110 model is waterproof, dustproof, and shockproof. It has built-in GPS, world map, and compass functions, which are recorded in metadata for each image. This setup is designed for use with a tethered and relatively stationary platform, such as kite, blimp, or balloon.

Image file sizes have increased substantially in the first decades of digital photography, resulting in increased storage requirements. Consider a typical 15-min UAS survey with a rather modest 12-megapixel camera. An exposure interval of 5 s, excluding starting and landing phase, would result in about 150 images of ~5½ MB

jpg file-format size—a total storage space exceeding that of a 700 MB CD, which was a substantial format only 10 years ago. Although the capacity of contemporary storage media continues to increase as well as their miniaturization, their perpetuity remains an important issue.

Both digital images and analog photographs are stored in some type of physical medium, the properties of which determine how long the image is likely to survive. The potential longevity of panchromatic (b/w) film and prints is on the order of one century or more; color film and prints have only about half these lifetimes or less (Jensen 2015; Rosenthaler 2007). In contrast, magnetic media, such as disks, tapes, and solid-state devices, last only one or two decades at most, before they degrade under the Earth's magnetic field. Optical disks (CD, DVD) are thought to survive for a century or more, although they have not been in service long enough to really know their lifespan in practice.

Another, perhaps more serious, long-term issue for digital preservation concerns the computer hardware and software necessary to read, transfer, and display digital files stored in a particular medium. Medium types, file storage formats, and computer operating systems have changed rapidly since digital data became commonplace. So, although the magnetic tape, optical disk, external hard drive, or hardware behind the cloud storage service may survive intact, an operational reading device and software to interpret the file format may no longer exist in many cases.

High-capacity external hard drives and removable solid-state memory have become commonplace; however, like all electronic media they are subject to failure. Serial failures of computers and memory devices, in fact, have cost more than one researcher substantial datasets representing months or years of work. The option to store data "in the cloud" is also subject to the same potential failures as well as security risks. Large technology companies encourage users to link their devices and sync their personal data via wireless connections. While this may be quite convenient, it means that commercial enterprise now controls much of a person's private information, which is *a scary and dangerous development* (Pogue 2014).

Burge (2007) emphasized the importance of data migration periodically as new digital media are established and old media become obsolete; such migration is necessary about every 5 years (Rosenthaler 2007). Large companies and governmental agencies may have the capability to transfer and reformat digital files from one medium to another periodically. In one geospatial analysis laboratory, for example, digital image files were updated from original 9-track tapes, to compact cartridge tapes, to zip disks, and finally to optical disks as well as external hard drives. Nearly all people who work with digital imagery and data have experienced at least one hard-drive crash or data loss due to mechanical failure, viruses, or simple human error. Multiple backup files stored on different devices in separate locations provide

some insurance that critical datasets would not be lost. The investment in time and labor to accomplish this is certainly significant, yet necessary.

Lawrence's photograph of *San Francisco in Ruins* (see Fig. 1-4) has survived for more than a century. One could ask what the chances are for modern digital photographs to survive with their metadata intact for so long (Burge 2007). Recent history suggests that technical innovation and obsolescence will continue to happen rapidly for digital storage devices and file formats. Means of long-term storage for digital imagery is an issue yet to be fully resolved.

2-4 SUMMARY

SFAP is based primarily on solar radiation reflected from the Earth's surface in the visible and near-infrared portions of the spectrum. SFAP is a compromise between ideal photographic conditions and the reality of what is possible to accomplish under natural conditions within logistical constraints and financial limitations. SFAP may be taken in a range of viewing angles from high-oblique to vertical vantages. This facilitates depicting a study area in its broader landscape context as well as in map-like views best suited for accurate measurements. Photographic scale (S) and GSD are closely related, but distinct, concepts dealing with spatial aspects of photographs. Resolution relates to spatial, spectral, temporal, and radiometric aspects of images. Compared to other remote-sensing systems, SFAP offers particularly great advantages with regard to the degree and flexibility of spatial and temporal resolutions.

A single photograph has geometric characteristics similar to the image sensed through a human eye, which creates a single-point perspective view. Two overlapping views of the same area result in stereoscopic imagery in which depth perception is apparent. This is the basis for much photointerpretation as well as photogrammetry. Photographic information consists of both the primary image data and metadata about the image. Metadata should include date of image acquisition, location, type of camera and lens, and other relevant information. These metadata should be saved in a manner that is physically difficult to separate from the image data.

Various media and file formats have been used over the years for storing photographic images and digital datasets. Among the most long-lived are panchromatic film negatives and optical disks; the least stable are magnetic media. Storage of digital datasets is subject to rapid changes in media types and related computer hardware and software necessary for reading the digital files. Continued technical changes and obsolescence are likely to happen in the near future, which raises questions for long-term archival storage of photographs. Periodic data migration and multiple backup files stored on different devices in separate locations may provide some insurance that critical datasets would not be lost.

3

Principles of Photogrammetry

Despite all the exciting possibilities for 3D imaging techniques, users of this technology must keep in mind [that] light will continue to travel in straight lines and an understanding of geometry will be just as valid tomorrow as it is today. John G. Fryer (Fryer et al. 2007).

3-1 INTRODUCTION

Photogrammetry is *the art, science, and technology of obtaining reliable information about physical objects and the environment through processes of recording, measuring, and interpreting photographic images and patterns of recorded radiant electromagnetic energy and other phenomena* (Wolf et al. 2014; McGlone and Lee 2013). Photogrammetry is primarily concerned with making precise measurements of three-dimensional (3D) objects and terrain features from two-dimensional (2D) photographs. Applications include the measuring of coordinates, the quantification of distances, heights, areas, and volumes, the preparation of topographic maps, and the generation of 3D point clouds for surface reconstructions, digital elevation models (DEMs), and orthophotographs.

Photogrammetry is nearly as old as photography itself. Since its development approximately 160 years ago, photogrammetry has moved from a purely analog, optical-mechanical technique to analytical methods based on computer-aided solutions of mathematical algorithms and finally to digital or softcopy photogrammetry based on digital imagery and computer vision, which is devoid of any opto-mechanical hardware. In recent years, the development of technologies coupling photogrammetric principles with computer-vision concepts and algorithms—specifically Structure from Motion–Multi-View Stereo (SfM-MVS)—has led to significant advances in 3D surface modeling from digital images. Especially the increasing automation and integration of all steps of the photogrammetric workflow in easy-to-use software packages have made photogrammetric analysis accessible to the non-specialist. Together with the developments in unmanned aerial systems (UAS) and computing power, this has revolutionized high-resolution 3D geodata acquisition in terms of speed, ease, and cost-effectiveness, offering exciting new opportunities in the geosciences.

Two general types of photogrammetry exist—aerial (with the camera in the air) and terrestrial (with the camera handheld or on a tripod). Terrestrial photogrammetry dealing with object distances up to ca. 200 m is also termed close-range photogrammetry. Small-format aerial photogrammetry in a way takes place between these two types, combining the aerial vantage point with close object distances and high image detail.

This book is not a photogrammetry textbook and only scratches the surface of a continuously developing technology that comprises plentiful principles and techniques from quite simple to highly mathematical. In this chapter, an introduction to those concepts and techniques is given that are most likely to be of interest to the reader who plans to use small-format aerial photography, but has little or no previous knowledge of the subject. For a deeper understanding, the reader is referred to the technical literature on photogrammetry and photogrammetric computer vision, for example, the textbooks by Kraus et al. (2007), Kraus (2012), Luhmann et al. (2013), McGlone and Lee (2013), Konecny (2014), Wolf et al. (2014), Carrivick et al. (2016), Förstner and Wrobel (2016), and Luhmann (2018).

The basic principle behind all photogrammetric measurements is the geometrical-mathematical reconstruction of the paths of light rays from the object to the sensor at the moment of image acquisition. The most fundamental element therefore is the knowledge of the geometric characteristics of a single photograph.

3-2 GEOMETRY OF SINGLE PHOTOGRAPHS

3-2.1 Vertical Photography

Other than a map and similar to the images we perceive with our eyes, a photograph—either analog or digital—is the result of a central projection, also known

19

as single-point perspective. The distances of the central point of convergence—the optical center of the camera lens, or exposure station—to the sensor on one side and the object on the other side determine the most basic property of an image, namely its scale.

Fig. 3-1 shows the ideal case of a vertical photograph taken with perfect central perspective over completely flat, horizontal terrain. The optical axis through the exposure station L intersects the image plane at the principal point (o), which coincides with the image center, and meets the ground in a right angle at the ground principal point P. In this case, the so-called nadir line, which is the vertical line through the exposure station L (see Section 3-2.2), is identical with the optical axis of the camera, and accordingly, the photographic and ground nadir points n and N coincide with the principal points. The triangles established by a ground distance D—e.g. the distance D_2 between points A and P—and the flying height above ground H_g on the terrain side and by the corresponding photo distance d_2 and the focal length f on the camera side are geometrically similar for any given D and d; the scale S or $1/s$ of the photograph is the same at any point.

$$S = 1/s = f / H_g = d / D \qquad \text{(Eq. 3-1)}$$

Once the image scale S is known, this equation may be resolved for D in order to calculate the width or length of the ground area covered by the image by using the image width or length on the sensor chip (or film) as d.

Several other important characteristics of the photograph may be derived from the basic relationships described in Fig. 3-1. By transforming Eq. 3-1, the commonly used equation for H_g may be obtained (compare with Eq. 2-1):

$$H_g = f \times s \qquad \text{(Eq. 3-2)}$$

If the image format is square, the ground area A covered by the photograph may be derived from squaring Eq. 3-1. For SFAP cameras, this usually would not be the case, so the rectangular image format (with d_L as the image length and d_W as the image width) must be taken into account:

$$1/s^2 = (d_L \times d_W)/(D_L \times D_W) = a / A$$

or

$$A = (d_L \times d_W) \times s^2 \qquad \text{(Eq. 3-3)}$$

In the days of analog aerial photography, image scale was the most important descriptive property, as it allowed the user to estimate the degree of detail that is detectable in a scene. For digital images, which may easily be zoomed on the screen, the original scale on the sensor is less important. Here, the ground sample distance GSD (see Chap. 2-2.2 and Eq. 2-3) determines the spatial resolution or smallest visible detail in the photograph. The exact size of the picture element (sensor cell), which is needed for GSD calculation, may be determined from the manufacturer's information on the sensor size in millimeters and pixels.

$$GSD = (\text{pixel element size}) \times H_g / f$$

or

$$GSD = (\text{sensor width} / \text{image width in pixels}) \times H_g / f$$

$$\text{(Eq. 3-4)}$$

Because the relationship is a direct linear one, any change in H_g or f would change the scale and the image distances by the same factor. For example, doubling the flying height results in an image with half the scale S and halved image distances d; tripling the focal length would enlarge the scale and image distances by a factor of three.

In reality, most aerial photographs—especially by far the most SFAP—deviate from the situation in Fig. 3-1 for three reasons:

- The ground is not completely flat, i.e., the distance between image plane and ground varies within the image.
- The photograph is not completely vertical, i.e., the optical axis is not perpendicular to the ground.
- The central projection is imperfect due to lens distortions, i.e., the paths of rays are bent when passing through the lens.

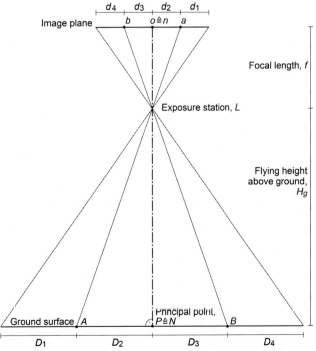

Fig. 3-1 Vertical photograph taken over completely flat terrain. The optical axis, which intersects the image plane center at the photographic principal point o, meets the ground in a right angle at the ground principal point P. Note that the horizontal distances d_1–d_4 are the same in the image, just as D_1–D_4 are the same on the ground.

All three situations spoil the similarity of the triangles and result in scale variations and hence geometric distortions of the objects within the image. The last two problems may be minimized with modern survey and manufacturing techniques for professional high-tech survey cameras and mounts, but may be quite severe for the platforms and cameras often used in small-format aerial photography. The first problem, scale variations and geometric distortions caused by varied terrain, does not depend on camera specifications and occurs with any remote sensing images. However, it also normally would be more severe for SFAP than for conventional aerial photography because of the lower flying heights and thus relatively higher relief variations.

Fig. 3-2 illustrates the effects of different elevations on the geometry of a vertical photograph. All points lying on the same elevation as the nadir point (here again coinciding with the principal point) have the same scale. Points above this horizontal plane are closer to the camera and therefore have a larger scale; points below this horizontal plane are farther away and have a smaller scale. At the same time, the positions of the points in the image are shifted radially away from (for higher points) or toward (for lower points) the image center—compare the different positions of a and a', and b and b', respectively, in Fig. 3-2. This happens because they appear under another angle than they would if they were in the same horizontal plane as the nadir point, seemingly increasing or reducing their distance to the point at the image center.

This so-called relief displacement or radial distortion is clearly recognizable to the image interpreter for objects that are known to rise vertically from the ground—such as trees or buildings—and are now being viewed from an oblique perspective toward the image edges (see for example Fig. 2-8). It is much less obvious for variable terrain (e.g. Figs. 4-30 and 4-31). Relief displacement increases with distance from the image center. It is inversely proportional to the flying height and the focal length; the displacement is less severe with larger heights and longer focal lengths because in both cases the rays of light are comparatively less inclined.

This effect of varying relief displacement may be exploited according to the requirements of image analysis. Images for monoscopic mapping or image mosaicking—demanding minimum distortion by relief displacement—are best taken using a telephoto lens from a greater flying height. However, images utilized for stereoscopic viewing and analysis should have higher relief displacement and stereo-parallaxes and are best attained with wide-angle lenses and lower heights (see section on base-height ratio and Fig. 3-10).

3-2.2 Tilted Photography

None of the equations given above is valid for oblique photographs with non-vertical optical axes, because the scale varies with the magnitude and angular orientation of the tilt (Fig. 3-3). The magnitude of the tilt is expressed by the nadir angle ν, which is the angle between the optical axis and the vertical line through the perspective center (nadir line) and is the complement of depression angle. Topographic relief introduces additional scale variations and radial distortions relative to the nadir point n—much the same as for true vertical photographs (see Fig. 3-2), where n is identical with the principal point or image center o.

Oblique images are useful for providing overviews of an area, and they are easier to understand and interpret for most people (see Chap. 2). As obliqueness undermines the validity of many principles and algorithms used in traditional photogrammetry, oblique photographs are usually avoided for measurement purposes. However, they have their merits in recording the geometries of complex terrain and three-dimensional objects, and photogrammetric workflows based on computer-vision approaches such as SfM-MVS may highly benefit from combining vertical and oblique imagery (see Section 3-3.5 and Fig. 11-22).

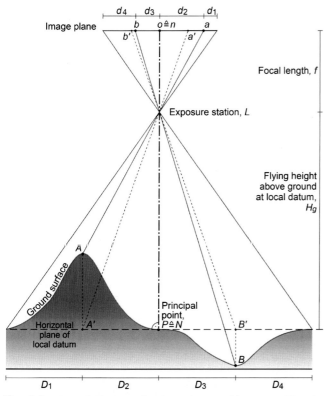

Fig. 3-2 Vertical photograph taken over variable terrain. The elevation of the ground principal point P determines the horizontal plane of local datum. Points lying on this plane remain undistorted, whereas points above or below are shifted radially with respect to the image center. Note: the horizontal distances D_1–D_4 are the same on the ground but not in the image.

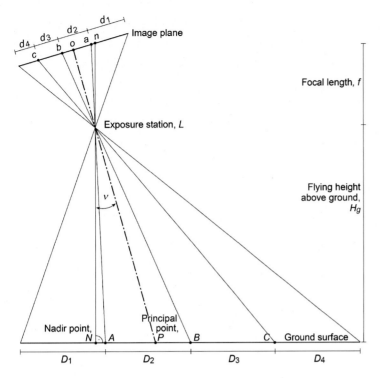

Fig. 3-3 Low-oblique photograph taken over completely flat terrain. The vertical line through the perspective center L intersects the image plane at the photographic nadir point n and meets the ground in a right angle at the ground nadir point N. The angle between the nadir line and the optical axis is the nadir angle ν. Note: the distances D_1–D_4 on the ground are the same, but the corresponding distances d_1–d_4 on the image vary continually.

For photogrammetric purposes, images are classified according to their degree of tilt from vertical (see Fig. 2-2). For many practical applications, the errors resulting in simple measurements from slightly tilted images ($\nu < 3°$) may be considered negligible, but this is not the case with oblique images.

3-2.3 Interior Orientation

The geometrical principles and equations mentioned above are sufficient for simple measurements from analog or digital photographs. For the precise calculation of 3D coordinates, however, the paths of rays both within and outside the camera need to be reconstructed mathematically with high precision (see also further below, Fig. 3-11). The necessary parameters for describing the geometry of the optical paths are given by the interior and exterior orientations of the camera.

The interior orientation of an aerial camera comprises the focal length (measured at infinity), the parameters of radial lens distortion, and the position of the principal point in the image coordinate system. The principal point is defined as the intersection of the optical axis with the image plane and ideally coincides with the origin of the image coordinate system at the image center (o). In real life, a small offset separates the two points, because a camera is constructed from individual parts that cannot be assembled to higher precision than a few micrometers. For measurements within the image, this coordinate system has to be permanently established and rigid with respect to the optical axis. For metric analog cameras this is realized with built-in fiducial marks that protrude from the image frame and are exposed onto each photograph (Fig. 3-4). Digital cameras do not need fiducials because a Cartesian image coordinate system is already given by the pixel cell array of the image sensor.

Various camera calibration methods exist for the determination of interior orientation values (Fraser 1997; Wolf et al. 2014). Metric cameras are usually calibrated with laboratory methods by the manufacturer, but off-the-shelf small-format cameras as used in SFAP do not come with calibration reports. However, they may be calibrated by dedicated companies, or institutions, or even by the user with test-field calibration or self-calibration methods (see also Chap. 6-6.5). Self-calibration processes include the interior orientation parameters as unknowns in the photogrammetric restitution of object coordinates from image coordinates, and have become an integral part of photogrammetric workflows for non-metric imagery. In particular, they constitute a basic principle of the SfM-MVS approach, which was originally designed to work with randomly acquired images from unknown cameras.

3-2.4 Exterior Orientation

The exterior orientation includes the positions X, Y, Z of the camera's exposure station L in the ground coordinate system and the three rotations of the camera, ω, ϕ, κ, relative to this system. The elements of exterior

Fig. 3-4 Top right corner of an aerial photograph taken with a conventional analog (film) metric camera, showing one of four fiducial marks (see enlarged insert) composed of a dot, a cross, and a circle. The text block on the left indicates lens type, number, and calibrated focal length in mm; the mechanical counter records the sequential image number.

orientation may be determined with high-precision global navigation satellite systems (GNSS), for example real-time kinematic or post-processing kinematic global positioning systems (RTK/PPK GPS), simultaneous to image acquisition (direct georeferencing). Many (rather costly) professional-grade UAS with RTK/PPK capability (see Chap. 8) are now available on the market following recent decreases in size and weight of such systems.

The standard GPS receivers built into consumer-grade UAS, in contrast, only allow inferior precisions of georeferencing in the meter range. This could, however, be useful as initial exterior orientation values and suffice for some applications where positional and heighting accuracy is not of primary importance (e.g. d'Oleire-Oltmanns et al. 2012; Carbonneau and Dietrich 2017).

The commonly used method of determining exterior orientation is the post-survey reconstruction using ground control points (GCPs) with known X, Y, and Z coordinates. A theoretical minimum of three GCPs is required for the orientation of a single photograph—in practice, multiple photographs are usually oriented together using least-squares adjustment algorithms (see Section 3-3.4) which allows the use of less than three points per image.

The precision and abundance of GCPs are crucial for the precision of the exterior orientation. Standard GPS measurements or control points collected from maps are useful enough for working with small-scale traditional airphotos and satellite images, but SFAP imagery with centimeter resolution and quite large scale requires accordingly precise ground control (e.g. Chandler 1999). Usually this has to be accomplished by premarking control points in the coverage area and determining their coordinates using a total station or RTK-GPS survey (see Chap. 9-5).

3-3 GEOMETRY OF STEREOPHOTOGRAPHS

3-3.1 Principle of Stereoscopic Viewing

Distorting effects of the central perspective are usually undesirable for the analysis of single photographs, but they also have their virtues. Because the magnitude of radial distortion is directly dependent on the terrain's elevation differences or the heights of objects, the latter can be determined if the former may be measured. We make use of this fact in daily life with our own two eyes and our capability of stereoscopic viewing. People with normal sight have binocular vision, that is, they perceive two images simultaneously, but from slightly different positions that are separated by the eye base (B, Fig. 3-5).

When the eyes focus on an object, their optical axes converge on that point at an angle (the parallactic angle γ). Objects at different distances appear under different parallactic angles. Because the eye's central perspective causes radial distortion for objects at different distances, quite similar to the effects of mountainous terrain in airphotos, the two images on the retinae are distorted. The amount of displacement parallel to our eye base, however, is not equal in the two images because of the different positions of the eyes relative to the object. This difference between the two displacement measures is the stereoscopic parallax p. The stereoscopic parallax and thus 3D perception increase with increasing parallactic angle γ, making it easier to judge differences in distances for closer objects.

Stereoscopic vision also may be created by viewing not the objects themselves but images of the objects, provided they appear under different angles in the images (Fig. 3-6). By viewing the image taken from the left with the left eye and the image taken from the right with the

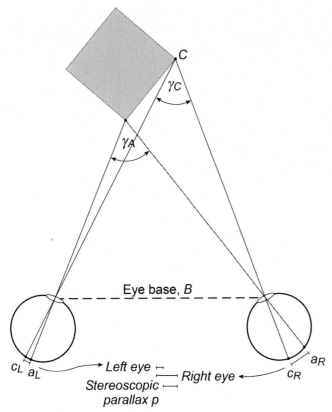

Fig. 3-5 Stereoscopic parallax for points at different distances in binocular vision. The differences of the angles of convergence γ result in different distances of A and C projected onto each retina. Their disparity, the differential or stereoscopic parallax, is used by the brain for depth perception. *After Albertz (2007, Fig. 111, adapted).*

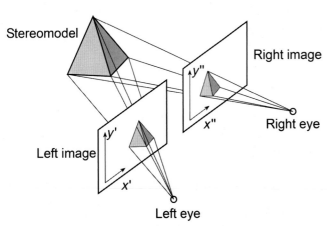

Fig. 3-6 Stereoscopic viewing of overlapping images showing the same object under different angles. A three-dimensional impression of the object—a stereomodel—appearing in the space behind the images is perceived by the brain. *After Albertz (2007, Fig. 112, adapted).*

right eye, a virtual stereoscopic model of the image motif appears where the lines of sight from the eyes to the images intersect in the space behind. Although it is possible to achieve this without the aid of optical devices, just by forcing each eye to perceive only one of the images and adjusting the lines of sight accordingly, it is difficult

especially for larger photographs and may cause eye strain. Devices such as lens or mirror stereoscopes (for analog images), anaglyph lenses (for both analog and digital anaglyphs, i.e., red/blue images), or electronic shutter lenses (for stereographic cards and computer screens) make stereoviewing much easier and also provide facilities for zooming in and moving within the stereoview (see Chap. 10-4).

For any stereoscopic analysis, the images need to be orientated so they reflect their relative position at the moment of exposure. The direction of spacing between the images needs to be parallel to our eye base, because only the *x*-component of the radial distortion vector is different in the two images, effectuating stereoscopic (or *x*-) parallax. The amount of distortion in *y*-direction is the same in both images and needs to be aligned perpendicular to our eye base. This alignment procedure may be as simple as wiggling two photo positives under a lens stereoscope until they merge into a stereomodel. Or it may be as computation-intensive as detecting hundreds of tie points in a series of digital images in order to compute the exact relative orientation of a large number of neighboring stereopairs prior to establishing their precise position in space as a prerequisite for the automatic extraction of digital terrain models (DTMs) (see the following Sections 3-3.4 and 3-3.5).

A typical SFAP problem with regard to the stereo-capability of photographs taken from kites and balloons is the variability of scales and tilting angles that is often unavoidable. From the authors' experience, difficulties with stereoscopic viewing and photogrammetric analysis (see below) may arise if the image scales differ by >10% or so. This problem likewise applies to joining overlapping oblique images to create panoramas.

Stereoviewing is also hampered by image obliqueness. For unfavorable constellations of nadir angles, tilting may even have the additional effect of extinguishing the stereo-parallaxes regardless of good base-height ratios. This would be the case, for example, when the camera is rotated around its perspective center, which may happen with a pendulum suspension on a kite (Chap. 7-4.2) or a hovering multirotor UAV (Chap. 8-5). A good solution for difficult-to-navigate platforms is to take as many photographs as possible during a survey and carefully choose the best of them for analysis, e.g. by a quick appraisal of the stereoscopic quality.

3-3.2 Base-Height Ratio and Stereoscopic Coverage of Survey Area

From Fig. 3-5 it is also evident that the stereoscopic parallax *p* and, thus, depth impression may be increased when the eye base *B* is increased, an option we do not have in real-life viewing, but which is possible and desirable in artificial stereoscopic viewing. If the base between

the exposure stations in relation to their height (the photographic base-height ratio) is larger than the base of our eyes in relation to the viewing distance (the stereoviewing base-height ratio), the stereomodel appears exaggerated in height by the same factor (Wolf et al. 2014). The exaggeration factor varies with image overlap and focal length and is typically between two and six times for conventional aerial photographs.

Stereoscopic photographs from professional aerial surveys are acquired in blocks of multiple flightlines in such a way that full stereoscopic coverage of the area is ensured with multiple vertical stereopairs (Fig. 3-7). Each photograph overlaps the next photograph in a line by approximately 60% (forward overlap or endlap), while adjacent lines overlap by 20%–30% (sidelap). In mountainous terrain, the overlap may be increased in order to avoid gaps of stereoscopic coverage by relief displacement and sight shadowing.

Photogrammetric approaches based on multiview stereo (SfM-MVS), however, depend on high image redundancies with preferably more variable image geometries. An increase of the overlaps as well as the inclusion of low-oblique convergent images is therefore advisable (Fig. 3-8). Regardless of a traditional or SfM-based photogrammetric approach, the addition of oblique imagery is also known to mitigate the so-called doming effect associated with the inaccurate interior orientation of non-metric cameras (see also Section 3-3.7).

The required air base or distance between exposure stations B is dependent on the dimensions of the image footprint and the desired endlap. If D is the image coverage in direction of the flightline and PE the percent endlap, B calculates as:

$$B = D \times (1 - PE / 100) \qquad \text{(Eq. 3-5)}$$

The same equation may be used for calculating the required distance between adjacent flightlines for a desired sidelap PS; keep in mind, however, that SFAP cameras most probably feature a rectangular image format ($d_L \times d_W$), and a decision has to be made as to its longitudinal or transversal orientation along the flightline (substituting D in Eq. 3-5 by D_L or D_W, respectively).

For platforms with approximately constant ground velocity V_g, the time interval ΔT between exposures is:

$$\Delta T = B / V_g \qquad \text{(Eq. 3-6)}$$

The more precisely a platform is navigable, the easier it is to follow a prearranged flightplan with systematic design. For fully automated UAS surveys, the actual flightpath may come quite close to the conventional blocks of aerial photography (see Fig. 9-19). However, with manually navigated UAVs or tethered SFAP platforms, it is usually difficult if not impossible to achieve such a regular flightline pattern, and it is indeed not a prerequisite for stereoscopic analysis. Stereomodels also may be created from images which overlap in a much more irregular pattern as long as all parts of the area are covered by at least two photos each with sufficient base-height ratio (Fig. 3-9).

It should be pointed out, however, that some traditional photogrammetry systems designed for analyzing standard aerial imagery may have difficulties in dealing with irregular image blocks. SfM-MVS photogrammetry, in contrast, benefits from varying scales and angles in an image network, but is highly reliant on multiple overlaps.

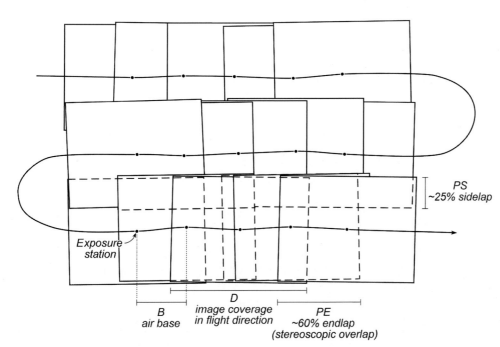

Fig. 3-7 Typical aerial survey design for use in classical photogrammetry. This block of vertical airphotos has 60% endlap in three flightlines with 25% sidelap. This survey design is ideal for ensuring gapless stereoscopic coverage while minimizing image number and redundancy.

Fig. 3-8 Survey design with vertical and low-oblique images, optimized for use in SfM-MVS photogrammetry. Higher overlaps are achieved by repeating the first flightplan (green) with slightly different azimuth angle (purple), and convergent oblique imagery (blue) is added for greater geometric stabilization of the image network.

Fig. 3-9 Block of aerial photographs taken by a tethered hot-air blimp from ~120 m flying height. Although the image alignment and overlaps are irregular and the photographs even have slightly different scales, full stereoscopic coverage of the desired ground area was given.

The vertical exaggeration of relief in the stereomodel plays an important role in 3D analysis. However, which base-height ratio is "sufficient" for stereoscopic analysis depends on the desired degree of depth impression and (if applicable) measurement accuracy for the particular relief type. Small height variations of gently undulating terrain are better viewed and measured with an extra-large base-height ratio, while the analysis of high-relief terrain, which already exhibits larger stereo-parallaxes due to radial distortion, tolerates lower base-height ratios. In general, errors in planimetry and height decrease with increasing base-height ratio and increasing stereo-parallaxes (Kraus et al. 2007; Kraus 2012; Wolf et al. 2014).

For a stereo survey with a given image scale S, wide-angle lenses may be used at lower flying heights than smaller angle lenses, thus increasing the base-height ratio (Fig. 3-10). In addition, wide-angle lenses cause larger relief displacement and thus larger stereoscopic parallaxes than smaller angle lenses, even if both are taken with the same base-height ratio. For stereoscopic purposes, images taken with wide-angle lenses from lower flying heights are therefore preferable to images taken with smaller-angle lenses from larger flying heights—quite contrary to the case of monoscopic mapping or mosaicking (see below) where distortion-minimized images are desired.

3-3.3 Reconstructing 3D Coordinates From Stereomodels

Beyond the simple viewing and interpreting of stereopairs, stereomodels also enable various kinds of 3D measurements using photogrammetric techniques. The 3D ground coordinate of any given object point may be determined if the corresponding 2D image coordinates in a stereopair and the position of the camera within the

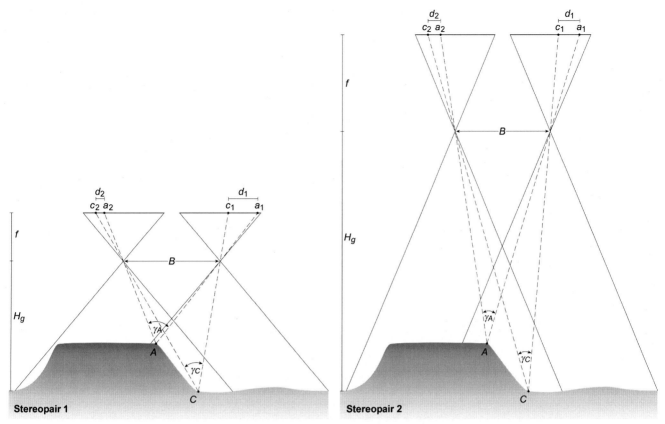

Fig. 3-10 Two stereopairs with equal image scale and air base B taken over the same terrain. Focal length and flying height of stereopair 2 (normal-angle lens) are twice those of stereopair 1 (wide-angle lens), resulting in a halved base-height ratio. Note how the parallactic angles γ and the stereo-parallax—the difference between d_1 and d_2—decrease from stereopair 1 to stereopair 2.

ground coordinate system are known. This is illustrated in Fig. 3-11, where the position of an object point A in the landscape is reconstructed by tracing the rays from the homologous image points a_1 and a_2 back through the lens. With a single image (the left photo in the figure), no unique solution may be found for the position of A along the reconstructed ray. By adding a second (stereo) image on which A also appears, a second ray intersecting the first may be reconstructed and the position of A can be determined. This method is called a space-forward intersection; it is based on the formulation of collinearity equations describing the straight-line relationship between object point, corresponding image point, and exposure station.

Deviating from the schematic situation in Fig. 3-11, the differences between the focal length and the flying height for aerial surveys are in reality much greater. For SFAP surveys, the focal length is usually well below 10 cm and the flying height is somewhere between 30 and 300 m; for conventional aerial surveys, the focal length is normally between 9 and 16 cm and the flying height is somewhere between 2000 and 5000 m. Therefore, the accuracy of the reconstructed 3D coordinate of A is highly dependent on the precision with which a_1, a_2, and the focal lengths are measured. This is why photogrammetry is a science with

many decimal places. To make the extrapolation from the (known) interior of the camera into the (unknown) space beyond as exact as possible, both the values of the interior orientation and the exterior orientation need to be known precisely.

As outlined in the previous section, the required exterior orientation for SFAP images is usually not known a priori. Platforms such as kites and balloons are not equipped with GPS sensors, although their cameras may have built-in GPS, and consumer-grade UAS provide only coarse GPS coordinates for the images in the accuracy range of several meters. However, the exterior orientation may be determined using the same reconstruction method backward in a space resection. With the known 3D coordinates of three ground control points and their corresponding 2D image coordinates, the positions X, Y, and Z of the exposure center at the intersection of the three rays and the three rotations of the camera, ω, ϕ, κ, relative to the ground coordinate system may be calculated. Afterward, these exterior orientation parameters may be used in the space-forward intersection in order to calculate any other object point coordinate in the area covered by the stereomodel.

This establishment of the geometric relationship between the images (relative orientation) and the

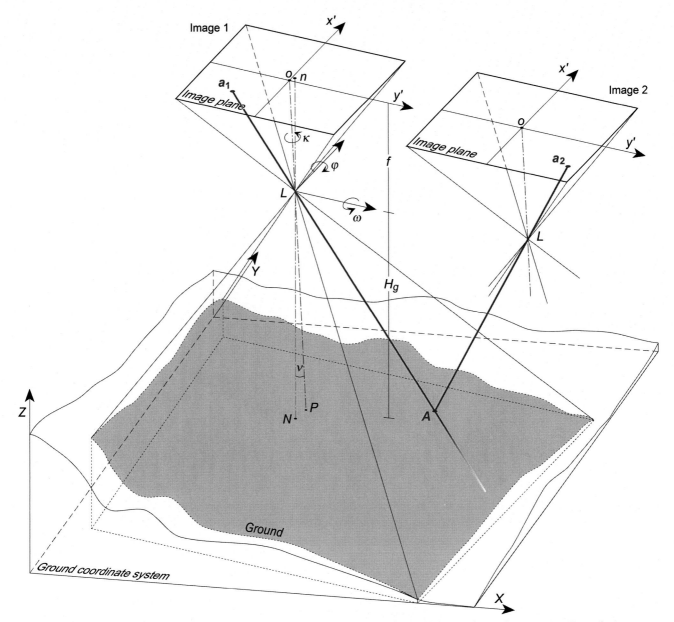

Fig. 3-11 Reconstruction of the 3D ground coordinates of an object point in a stereomodel by space-forward intersection. From the image coordinates x', y' of the homologous points a_1 and a_2, the rays of light are traced back through the exposure center L to the object point A. The interior orientation—the geometric relation of L to the image plane—and the exterior orientation—the positions X, Y, Z of L and the rotations ω, ϕ, κ of the image plane with respect to the ground coordinate system—must be known for this reconstruction.

image coordinate system and object-space coordinate system (absolute orientation) is the basis of all stereo-photogrammetric methods for coordinate restitution—in classical photogrammetry as well as in Structure-from-Motion (SfM) approaches, and for aerial as well as terrestrial viewpoints. The way in which these stereomodels are established and analyzed, however, differs with the photogrammetric approaches and software packages. The following sections briefly outline typical workflows in classical photogrammetry and in SfM-MVS photogrammetry.

3-3.4 Creating and Analyzing Stereomodels in Classical Photogrammetry

The main objective of classical photogrammetric approaches is the reconstruction of 3D object space coordinates with high accuracy for measuring and mapping purposes. In praxis, photogrammetric analysis is mostly done using not one, but several or even many stereopairs for covering larger areas. In order to avoid the individual orientation of each stereomodel with accordingly large numbers of ground control

points, multiple overlapping images forming a so-called block (see Fig. 3-7) may be oriented simultaneously with fewer ground control points using aerial triangulation techniques. One of the most commonly used and most rigorous methods is the bundle adjustment or bundle-block adjustment.

In theory, bundle-block adjustment allows the absolute orientation of an entire block of an unlimited number of photographs using only three GCPs. This requires that the relative orientation of the individual images within the block first be established by additional tie points—image points with unknown ground coordinates which appear on two or more images and serve as connections between them (Fig. 3-12). These tie points may be identified either manually or (in digital photogrammetry) with automatic image matching procedures (see below). The term bundle refers to the bundle of light rays passing from the image points through the perspective center L to the object points. The bundles from all photos are adjusted simultaneously so that the remaining errors at the image points, GCPs, and perspective centers are distributed and minimized.

The distribution of the errors may be controlled by predefined precisions for image-point identification, GCP measurement, and (if applicable) camera positions. Thus, the ground coordinates of the tie points as well as the six exterior orientation parameters of each image may be calculated in a single solution for the entire block. As an alternative or addition to GCPs, the exterior orientation parameters of the cameras may be used in the bundle adjustment, providing their accuracy is high enough. This is, however, rarely the case for SFAP.

The stereomodels are now absolutely oriented in object space and may serve for further quantitative analysis, i.e., manual or automated measuring and mapping of unknown object point coordinates, heights, distances,

areas, or volumes. The manual-visual approach requires a human operator to view the two images of a stereomodel stereoscopically and measure the homologous image points a_1 and a_2 (Fig. 3-11) with the help of a floating mark or cursor (see Chap. 11-6.1). The automatic extraction of point coordinates from stereomodels is realized by stereo-correlation or image-matching techniques, which are briefly outlined in the following.

Based on the two main categories of image-matching techniques, namely area-based matching and feature-based matching, various hybrid methods have been developed. All are concerned with statistically determining the correspondence between two or multiple image areas or features in order to identify homologous image points—a still-challenging task for a computer, which a human operator is able to perform with little conscious effort (Grün 2012; Wolf et al. 2014). A variety of parameters constrains and controls the process of searching and correlating image points. The quality and amount of height points may be affected both by the ground-cover type and by image characteristics such as noise and local contrast. Dark and shadowed regions often show low correlation coefficients owing to increased noise, and homogeneous smooth surfaces may have too little texture for successful image matching (see Section 3-3.8).

Once a set of corresponding points in the overlapping images has been identified, their 3D coordinates are computed by space-forward intersection using the block triangulation results. The primary result is a dataset of more-or-less irregularly spaced points, often called a 3D point cloud, which is usually directly processed by interpolation techniques into a 2.5D raster DEM file or TIN. A next step in the photogrammetric workflow is often the production of orthophotos or orthophoto mosaics from the stereomodel imagery (see Section 3-3.6).

Until the advent of more advanced image matching procedures, the resolution of the DEM extracted with classical digital photogrammetry used to be about one magnitude lower than the image GSD, because not every pixel could be matched (this applies also to some examples given in this book, e.g. Chap. 14). As photogrammetry has moved to higher resolutions—with satellite sensors as well as UAS—image-matching algorithms have seen considerable development in recent years, both for initial tie-point matching and for dense point cloud generation (e.g. Hartmann et al. 2016). The initial sparse point clouds now may be densified with pixel-wise matching algorithms such as the widely used semi-global matching (SGM) (Hirschmüller 2008). The current trend in many photogrammetry packages is going toward multi-image approaches (see also Grün 2012; Bethmann and Luhmann 2017).

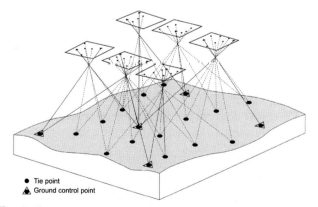

● Tie point
▲ Ground control point

Fig. 3-12 Principle of bundle-block adjustment; example of a possible SFAP survey. The relative orientation of the images in the block is established by both tie points and GCPs, the absolute orientation of the block within the ground coordinate system is realized using the GCP coordinates. *After Kraus (2012, Fig. 5.3.1, adapted).*

3-3.5 Creating and Analyzing Stereomodels in SfM-MVS Photogrammetry

Generally, the main objective of the SfM approach is the reconstruction of the structure and form of a 3D object with high detail for realistic visualization. It is typically based on a set of multiscale images capturing a scene with high overlaps from random positions—as if taken while moving around the object (hence "from motion"). Neither the camera geometry nor its position need to be known a priori. Due to its origins in computer-vision science, this approach is less concerned with accuracies in scale and position than classical photogrammetry. It was not originally intended for aerial photography—and definitely not for the highly ordered, minimal-redundancy image networks with single viewing direction that are so fundamental in classical aerial photogrammetry.

The proliferation of the digital camera in the early 2000s, the "drone boom" of the 2010s, and the increasing popularity of SFAP for the creation of high-resolution topographic data have led to a rapid uptake of SfM by the geoscientific community. Consequently, software packages based on SfM approaches increasingly incorporate concepts, tools, and statistical outputs commonly used in classical aerial photogrammetry. It should be noted, however, that geoscientific studies also are successfully employing SfM for terrestrial photography (see for example Eltner et al. 2016).

The term "Structure from Motion" was originally coined by Ullman (1979) and made more widely known through the work of Snavely et al. (2008), who applied the concept to unordered, random internet photos. But SfM is, in fact, just one constituent of what is now commonly called a SfM workflow in the geoscientific literature. As Smith et al. (2016) pointed out, the majority of studies and software packages use a combined workflow that should more correctly be referred to as SfM-MVS.

Typical SfM-MVS workflows have been described widely in the geoscientific literature (e.g. Westoby et al. 2012; Fonstad et al. 2013; Carrivick et al. 2016; Smith et al. 2016). The first step is the extraction of key points for matching features in multiple photographs. These key points are identified by sets of pixels invariant to the scale and rotation of the images, most commonly with the Scale-Invariant Feature Transform (SIFT) object-recognition system by Lowe (2004), and unique feature descriptors are assigned. The feature key points are then matched across multiple images and filtered for erroneous and insufficient matches.

The actual SfM process then uses bundle-adjustment algorithms (e.g. BUNDLER; Snavely et al. 2008) to reconstruct the 3D scene structure and interior and exterior orientations of the camera simultaneously. The large number of key points and high overdetermination

of the collinearity equations allow for self-calibration of the camera(s) in the process even when no initial interior orientation values are known. The result is a sparse point cloud of tie points in an arbitrarily scaled coordinate system, and estimated camera calibration parameters as well as positions (Fig. 3-13A).

For a more detailed representation of the surface structure, the sparse point cloud is refined subsequently into a dense cloud with multiview stereo (MVS) matching (Fig. 3-13B and C). The images are split into smaller subsets to reduce the computational burden with Clustering View for MVS (CMVS; Furukawa et al. 2010), and 3D points are extracted from these individual clusters, for example with patch-based MVS (PMVS) algorithms (Furukawa and Ponce 2010). This dense point cloud may then be filtered manually or automatically to remove errors and outliers, and classified by point color and elevation to extract 3D points meeting specific constraints (e.g. bare earth points, similar to the processing of LIDAR point clouds).

As most geoscientific applications require known scale and absolute orientation in space, the arbitrary coordinate system is usually transformed into a real-world ground coordinate system using GCPs. The original SfM approaches accomplish this in a separate seven-parameter linear similarity transformation, after creation of the point clouds. Thus, errors in the GCPs may propagate to this solution, with non-linear effects for unfavorable GCP distribution (Fonstad et al. 2013). However, with the increasing adaptation of SfM-based software to classical photogrammetric workflows, many applications now allow to include ground control measurements in the bundle-adjustment process and camera-parameter refinement (James and Robson 2014; Smith et al. 2016), i.e., before the creation of the point clouds. As with classical photogrammetry, the exterior orientation parameters of the cameras may be used as an alternative or addition to GCPs in the bundle adjustment.

The dense point cloud as primary output of the SfM-MVS process needs to be interpolated for a gapless surface representation, e.g. into a 2.5D raster DEM or a 3D mesh (see also Chap. 11-6.2). The final step is usually the creation of orthophotos or orthophoto mosaics from the input images.

The great advantages compared to traditional digital photogrammetry—as well as to terrestrial laser scanning (TLS) for 3D point-data acquisition—and probably the main reasons for the success of SfM-MVS in the geosciences, are its comparative ease of use, high degree of automation, and low cost. Open-source codes are available for all steps of the workflow outlined above, although the most widely used SfM-MVS software package is currently a commercial one (*Agisoft PhotoScan/Metashape*; see also Chap. 11-8). Further advantages include the possibility to produce full 3D data by using images with up

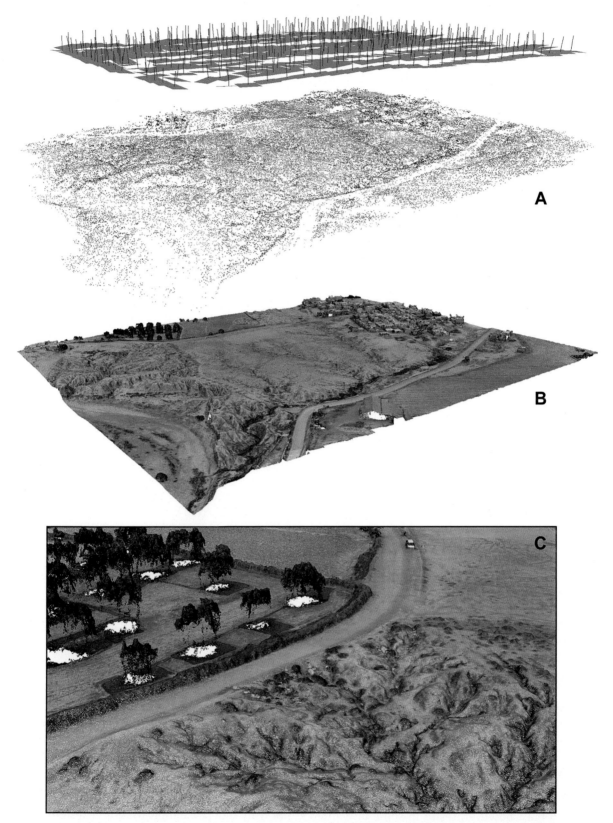

Fig. 3-13 3D model created with SfM-MVS photogrammetry from 370 vertical to near-vertical airphotos, taken from 130 m flying height with a fixed-wing UAV and mirrorless interchangeable-lens camera at El Houmer near Taroudant, Morocco. (A) Sparse point cloud with images, oriented in object space by bundle adjustment in the SfM process (cf. Fig. 3-11). (B) Dense point cloud extracted with MVS matching procedure. (C) Subset of the dense point cloud (~300 points/m^2). Note the reconstruction of the olive trees' top canopy and gaps beneath: The full 3D shape of the trees and the ground surface below the tree crowns could not be reconstructed as they are hidden from view in the vertical imagery.

to 360° coverage of a scene and the correspondingly less rigorous constraints on image-network geometry.

Some of these advantages are, however, based on the higher level of overdetermination and tolerances in the least-squares adjustment and image-matching algorithms, whose specific parameters and quality estimates are often not fully transparent to the user. This less rigorous photogrammetric approach also carries higher risks for error propagation and raises questions of repeatability (e.g. Carrivick et al. 2016; James et al. 2017a, b).

3-3.6 Orthorectification or Orthophoto Correction

Due to their low flying heights, SFAP of variable terrain typically exhibits large distortions caused by relief displacement. These cannot be removed sufficiently with polynomial rectifications by GCPs (see Chap. 11-2), because the surface is too complex to be described by simple mathematical algorithms. A complete and differential rectification of the distorted photograph into a planimetrically correct image with orthographic (= map) projection may be achieved only if the exact amount and direction of displacement for each pixel could be calculated and removed. Following the principles shown in Figs. 3-2 and 3-11, this is possible if the interior and exterior orientations of the camera as well as the terrain heights are known. Orthorectification procedures make use of DEMs in relation to which the photographs are oriented in space so that the relief displacement (with the added effect of image obliqueness and lens distortion) of each single pixel may be determined. In the new, orthorectified image file, each pixel is then placed in its correct planimetric position.

Depending on the type and source of the DEM, the elevation values either describe the ground surface (DTM) or the true surface including all objects rising above the terrain (e.g. woodland, buildings; digital surface model or DSM). Thus, it may be differentiated between conventional orthophotos and true orthophotos, where the latter present an image truly geocorrected for all terrain and object elevations. For orthorectifying SFAP images, a DEM with appropriately high resolution is normally not available from external sources; thus, the common procedure is to generate a DEM from the SFAP images themselves first, with the processes described in the previous sections, and subsequently use this for orthophoto correction. If the DEM is generated by automatic elevation extraction procedures, it would necessarily be a DSM, resulting in a true orthophoto, which may, however, result in some unwanted artifacts (see Fig. 11-3).

For a single rectified photograph or orthophoto that does not fully cover the study area, an aerial mosaic may be constructed by manually or automatically stitching the georeferenced images together (see also Chap. 11-2.3 and Fig. 11-5). Color-balancing techniques are used to minimize a jigsaw-puzzle appearance of the resulting mosaic. The seamlines between the individual mosaic pieces may be manually or automatically placed in order to be most inconspicuous. The most nadir, that is, the least distorted sections of each photograph are normally utilized in automatic mosaicking, sometimes with slightly jagged and winding seamlines, to make the transition between the patches as inconspicuous as possible. Many classical and SfM-MVS software packages have now integrated orthophoto mosaic creation as the final step of the photogrammetric 3D-modeling workflow.

3-3.7 Errors and Accuracies of Small-Format Aerial Photogrammetry

The accuracy of 3D coordinate measurements from SFAP-based photogrammetric models and the uncertainties of the derived high-resolution topographic data depend on a number of factors and have been subject to numerous studies in recent years. Among them are the quality and distribution of GCPs (e.g. Clapuyt et al. 2016; James et al. 2017a, b; Martínez-Carricondo et al. 2018), the accuracy of camera exterior orientation in direct georeferencing (Turner et al. 2014; Fazeli et al. 2016; Carbonneau and Dietrich 2017), the image-network characteristics such as flying height, scale, orientation, base-height ratio, and their variabilities (James and Robson 2014; Smith and Vericat 2015; Mosbrucker et al. 2017), and the stability of interior orientation and the role of the lens model used in camera self-calibration (Harwin et al. 2015; Carbonneau and Dietrich 2017).

Regarding the automatic DEM extraction by image matching and the uncertainty of topographic data derived from the point clouds, additional factors may play a role, e.g. the quality of the images, the nature of the terrain (above all, vegetation cover), the degree of shadowing, parameters of the image-matching algorithms, etc. (e.g. Ahmadabadian et al. 2013; Ouédraogo et al. 2014; Gindraux et al. 2017).

The validation of the ultra-high resolution DEMs or TINs derived from SFAP is difficult due to the lack of comparable reference data. Chandler (1999) as well as Lane (2000) emphasized the need for distinguishing the precision in reconstructing the stereomodel geometry, the accuracy of the model with reference to an independent dataset, and its reliability in terms of sensitivity to different parameterization of the photogrammetric process. The most common method of accuracy assessment, although not truly independent, is to reserve a number of ground control points as check points and compare their Z values with those indicated by the DEM for the same location. This requires that sufficient control points have been installed during the survey preparation (see Chap. 9-5).

The best option for evaluating overall model accuracy is the comparison of the photogrammetric 3D point clouds with terrestrial LIDAR or laser-scanning data (TLS), which also produces non-selective 3D point samples of the surveyed surface (e.g. Niethammer et al. 2012; Mancini et al. 2013; Eltner et al. 2015; Smith and Vericat 2015; Cook 2017). A full appraisal of the current state of literature in the topic is, however, beyond the scope of this book. Useful overviews of error sources, error assessment, and validation methods may be found in Carrivick et al. (2016) and Eltner et al. (2016).

Analyzing the surface-reconstruction accuracies of 50 terrestrial and aerial SfM surveys reported in the literature, Smith and Vericat (2015) have found a degradation of root mean square error (RMSE) with increasing survey range that may be described by a power-law relationship. A mean ratio of RMSE:survey range of 1:639 was observed for the overall accuracies of these 3D models. As the georeferencing precision at the control points, which is typically reported as a result of bundle-block adjustments, is only a part of the overall surface-reconstruction quality, the ratio of GCP RMSE:survey range is usually better. James and Robson (2012) have found ratios of approx. 1:1000 for survey ranges of 20 and 1000 m.

Tables 3-1 and 3-2 summarize typical accuracies for traditional and SfM-based bundle-block adjustments carried out with the type of SFAP appearing throughout this book, using a total of 51 GCPs. The nine images with high overlaps and near-vertical to low-oblique ($\nu < 5°$) angles were taken with an 8 megapixel DSLR camera (*Canon EOS 350D*) and 20-mm lens at flying heights between 60 and 82 m above ground. They were processed in *Imagine Photogrammetry* (formerly *Leica Photogrammetry Suite*; Table 3-1) and for comparison also in *Agisoft PhotoScan* (Table 3-2). The settings controlling the fluctuations in the adjustment process (GCP precision, image point precision, lens distortion parameters) were kept as similar as possible for the classical and SfM processing. The main difference between the two is the number of tie points, i.e., size of the sparse point cloud that was extracted by the applications and used in the bundle alignment. 900 tie points were used in the Imagine Photogrammetry project, whereas the SfM sparse point cloud in the *Agisoft PhotoScan* project comprised 25,000 tie points.

The study site was an agricultural area with an erosion gully, in parts densely vegetated, cutting between two fallow fields (see Fig. 11-1). Of the GCPs, six, 12 or 26 were used as control points, the rest as independent check points for error assessment. The interior orientation of the camera was not defined (fixed to nominal focal length of lens only; "no calibration"), determined by the software in a self-calibrating approach (correction of focal length and principal-point position, lens-distortion model applied; "self-calibration"), or (for

Table 3-1 Summary of bundle-block adjustment results for 9 near-vertical airphotos; classical photogrammetric approach with *Imagine Photogrammetry*. Images taken at Gully Bardenas 1, Province of Navarra, Spain; image GSDs 1.9–2.6 cm. Triangulation performed without camera calibration, with self-calibration and with precedent test-field calibration, using varying numbers of control and check points. Ratio of RMSE:survey range was calculated with a mean flying height of 75.6 m. Photogrammetric processing by IM.

GCP number (control/check)		No calibration			Self-calibration			Test-field calibration		
		6/45	12/39	26/25	6/45	12/39	26/25	6/45	12/39	26/25
Total RMSE (pixels)		0.907	1.154	1.227	0.458	0.453	0.462	0.480	0.482	0.480
Control point	Ground X (cm)	4.10	6.36	4.83	0.21	0.51	0.61	0.22	0.54	0.50
RMSE	Ground Y (cm)	2.90	5.09	3.73	0.45	0.41	0.62	0.45	0.55	0.57
	Ground Z (cm)	11.70	14.94	11.65	0.84	0.55	0.92	0.67	0.70	0.63
	Ground total (cm)	12.73	17.02	13.15	0.98	0.85	1.27	0.84	1.04	0.99
	Image (pixels)	5.34	5.91	4.16	0.69	0.67	0.62	0.62	0.67	0.58
	Ratio	1:594	1:444	1:575	1:7747	1:8844	1:5971	1:9037	1:7261	1:7669
Check points	Ground X (cm)	8.68	11.00	14.95	2.05	1.64	2.44	1.55	1.23	1.66
RMSE	Ground Y (cm)	14.61	10.65	21.51	3.04	2.33	2.01	2.88	2.36	1.80
	Ground Z (cm)	91.87	46.19	76.74	7.11	5.14	6.66	7.18	5.25	5.05
	Ground total (cm)	93.43	48.66	81.09	8.00	5.88	7.37	7.89	5.89	5.61
	Image (pixels)	3.72	2.01	1.05	0.45	0.44	0.40	0.45	0.44	0.41
	Ratio	1:81	1:155	1:93	1:945	1:1286	1:1025	1:958	1:1284	1:1347
Mean exterior	Position (cm)	6.21	5.61	4.78	4.73	6.24	3.48	3.45	2.44	1.94
orientation error	Angle (°)	0.04	0.04	0.03	0.03	0.02	0.01	0.02	0.02	0.01

Table 3-2 Summary of bundle-block adjustment results for the same airphotos as in Table 3-1; structure from motion-based approach with *Agisoft PhotoScan*. Triangulation performed without camera calibration and with self-calibration, using the same variations of control and check points as in Table 3-1. Photogrammetric processing by IM.

		No calibration			Self-calibration		
GCP number (control/check)		6/45	12/39	26/25	6/45	12/39	26/25
Total RMSE (pixels)		0.816	0.831	0.840	0.427	0.427	0.427
Control point	Ground X (cm)	12.10	20.85	12.62	3.00	2.64	2.08
RMSE	Ground Y (cm)	7.89	29.89	9.81	2.86	2.62	1.58
	Ground Z (cm)	55.22	102.24	56.67	8.20	6.33	4.00
	Ground total (cm)	57.08	108.54	58.88	9.19	7.34	4.78
	Image (pixels)	1.21	1.03	1.03	0.40	0.43	0.42
	Ratio	1:132	1:70	1:128	1:823	1:1030	1:1583
Check points	Ground X (cm)	11.26	12.22	13.58	1.53	1.57	1.76
RMSE	Ground Y (cm)	13.76	12.65	18.89	2.80	2.32	1.66
	Ground Z (cm)	77.62	48.77	77.10	4.52	4.72	4.72
	Ground total (cm)	79.63	51.84	80.53	5.53	5.48	5.30
	Image (pixels)	1.03	1.07	1.11	0.43	0.43	0.44
	Ratio	1:95	1:14	1:94	1:1367	1:1379	1:1426

Imagine Photogrammetry only) determined by previous test-field calibration (see Chap. 6-6.5).

Results in Table 3-1 show that bundle adjustment without any camera calibration performs by far the poorest. The non-linear fluctuation of error values with increasing control point number (12 control points are worse than 6 or 26) indicates that no satisfactory solution may be found for the adjustment. As the precision of the camera-position estimation (exterior orientation error) is rather low, too, the errors at the independent check points are higher than the GCP errors. With around 10–20 cm for horizontal and up to 92 cm for vertical position and quite low RMSE:survey range ratios, they must be considered intolerable.

Both the self-calibration and the precedent test-field calibration show much better results, with the latter only slightly superior to the former. All residuals at the control points are well below 1 cm, but the accuracy of the model is somewhat limited by the lower exterior orientation precision. Still, the horizontal errors at the independent checkpoints are within the range of image GSDs (1.9–2.6 cm). Z errors are, as to be expected with aerial triangulations, somewhat poorer but decrease just as horizontal errors with the number of control points employed. The check-point accuracy ratios are between ~1:950 and 1:1350, which compares favorably with results from other studies (see above).

In comparison, the accuracies for the SfM model orientation (Table 3-2) reveal only slightly superior check-point RMSEs, but a different distribution of errors in the least-squares adjustment process: The GCP errors in object space are much higher in both scenarios, but their image-point residuals are lower, indicating a different weighting in the bundle-adjustment algorithms. This makes the GCP errors more representative for the measurement accuracies achievable from this model, as they deviate less from the check-point errors. Interestingly, the self-calibration output from the SfM process is similar to the test-field calibration result from the classical photogrammetric process, and its accuracy as judged from the check-point errors is only slightly sensitive to the number of GCPs used, indicating a high quality of interior orientation. This confirms that camera self-calibration is a viable alternative to test-field precalibration, when a large number of tie points and high-quality ground control exist (e.g. Harwin et al. 2015).

Several studies have shown that the spatial distribution of errors may be non-random and deserves attention, as well. Regardless of a traditional or SfM-based photogrammetric approach, the comparatively poor knowledge of interior orientation common with non-metric SFAP cameras is the main cause of a systematic model deformation commonly observed in the DEMs—the so-called doming effect, where the reconstructed surface shows a circular arching effect (Fig. 3-14). It is particularly pronounced for classical photogrammetric image schemes with regularly spaced, single-scale vertical airphotos, and may be mitigated considerably either by highly precise precalibration of the camera or by improved conditions for accurate self-calibration (inclusion of convergent oblique images, multiscale images, and numerous, well-distributed

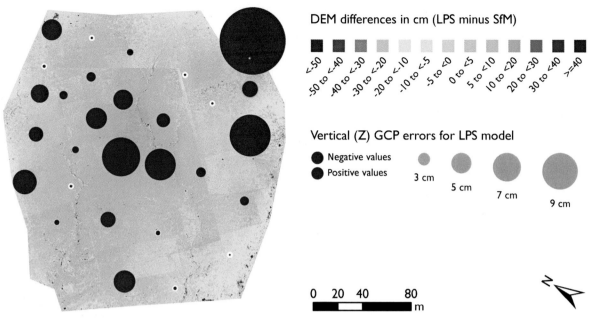

Fig. 3-14 DEM of difference (DoD) of surface models and RMS errors. LPS: DEM created with *Leica Photogrammetry Suite* from 58 near-vertical images taken at 105 m flying height with regularly spaced overlaps; SfM: DEM created with *Agisoft PhotoScan* from 260 multiscale, vertical to low-oblique images, taken at 105 and 190 m flying height with much greater overlaps. Both the DoD and the GCPs show a doming effect, where the LPS model is arching up in the center of the study area and down at the margins. The DoD also reveals patches with slight elevation offsets caused by imprecise stereopair orientation during the bundle alignment. Images taken with fixed-wing UAV and mirrorless interchangeable-lens camera; photogrammetric processing by F. Steiner and IM (see also Steiner 2015).

GCPs; see Wackrow and Chandler 2008; James and Robson 2014; Eltner and Schneider 2015).

3-3.8 Challenges of DEM Extraction From SFAP

The ultra-high GSD and low flying heights compared to conventional aerial photography pose some challenges for the automatic extraction of 3D-point coordinates by image matching that are specific to SFAP. Because the camera records the light reflected from the visible surface of all objects present in a scene, the matching algorithms generally extract height points from whatever is closest to the camera and that possibly covers and obscures the actual terrain surface. DEMs derived from automatic matching procedures are therefore inherently DSMs rather than DTMs devoid of aboveground features.

The accuracy with which objects rising above the terrain are captured, or the degree to which they may irritate the matching algorithms, depends greatly on their properties. Moving objects—vegetation in the wind, vehicles, people, or animals, shadows wandering between image acquisition times—may result in serious mismatches. Highly reflective or quite smooth and textureless surfaces (e.g. ice, snow, smooth sand) as well as deep shadows may result in information gaps, just as hidden areas (sight shadow) in steep terrain, behind vertical walls or high vegetation.

DEM extraction from SFAP images is especially prone to such errors because of the high spatial resolution and small areal coverage. The relative height errors caused by shrub cover or trees may be quite large compared to the relief undulations, and the areas obscured by shadow, where few matching points would be found, may result in large information gaps with respect to DEM pixel size. Also, vertical objects in SFAP cause comparatively large sight shadowing because of the low flying height, while proportionally large vertical objects rarely exist in small-scale images.

Consider for example the following problems (Fig. 3-15; see also Fig. 11-22) that were identified at various gully monitoring test sites (Marzolff and Poesen 2009), but would apply similarly for river banks, coastal cliffs, built-up areas, and other typical SFAP motifs.

- The image matching process makes no difference between the soil surface and objects covering this surface, e.g. vegetation (V). Depending on the canopy density, the irregular, discontinuous surface of trees, shrubs, or tall grasses may not result in a high density of height points, but correlations are often found even for individual branches and small patches of herbs. The interpolated surface represents more-or-less fragmentary vegetation canopy rather than soil surface in these cases.

- In sunny survey conditions, steep walls averted from the sun cast a deep shadow (S) onto parts of the ground surface. Little image texture is available for the matching process in these areas, and a lack of

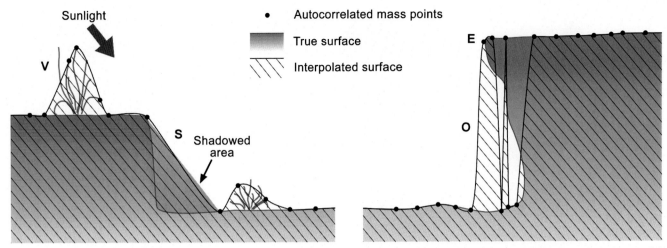

Fig. 3-15 Schematic representation of errors in automatic height-point extraction for a varying terrain surface caused by morphology and illumination effects. V—vegetation cover; S—shadowed area; E—illuminated edges; and O—overhanging walls. *Modified from Marzolff and Poesen (2009, Fig. 5).*

matched points may lead to false or less-inclined slopes. The same effect happens where sight shadowing occurs due to the photograph's central perspective (Giménez et al. 2009), which is also common for vertical walls of buildings and for the ground surface beneath trees (see Fig. 3-13).

- Where walls and edges (E) are directly exposed to the sun, lack of image texture by their direct illumination may lead to a low number of matched points along sharp edges or to mismatches resulting from the large x-parallax caused by the steep drop. This may result in rounded rather than sharply defined edges of gullies, river banks, cliffs, or buildings.
- Natural scarps occurring with gullies, river banks, or cliffs commonly feature overhangs (O) where fluvial or coastal erosion has undercut the steep walls. Because the central perspective of the camera may look beneath this undercut, height points may be sampled here as well. The algorithm for surface interpolation (raster DEM or TIN) would then link neighboring (i.e., as determined from horizontal coordinates) height points by a best-fitting surface and consequently produce artifacts of peaks and pits. This is unavoidable as neither the connectivity of the points with respect to the (unknown) true surface is known nor the possibility of more than one z value per x/y location is given in the 2.5D format of TIN or raster DEMs. A similar problem may occur for transparent surfaces such as glass (Fig. 3-16) or water.

In order to correct matching errors caused by vegetation, shadow, excessively steep relief, and overhanging or transparent objects, the primary 3D point cloud or the finished DEM or TIN usually needs some editing (see also Chap. 11-6). Several of these effects may be mitigated by filtering of the point cloud for unwanted vegetation points or abrupt elevation changes, but this may also eliminate wanted points as well, reduce detail, and potentially cause large data gaps (Javernick et al. 2014; Passalacqua et al. 2015).

3-4 SUMMARY

Photogrammetry comprises all techniques concerned with making measurements of real-world objects and terrain features from images. Applications include the measuring of coordinates, quantification of distances, heights, areas and volumes, preparation of topographic maps, and the generation of 3D point clouds for surface reconstructions, DEMs, and orthophotographs. In recent years, the development of technologies coupling photogrammetric principles with computer-vision concepts and algorithms—in particular, SfM-MVS—has led to significant advances in 3D geodata acquisition from digital images.

Understanding the geometry of a single photograph is the basis for all measurement techniques. A number of simple equations may be used for deriving measurements from single vertical photographs taken over flat terrain. However, they do not apply without restriction for oblique imagery or varying relief. Both cause image scale to vary across the scene, and undulating terrain results in radial relief displacement of features rising above or dipping below the horizontal plane at the image center.

The relief displacement caused by varying image depth changes with the position and angle from which the terrain is viewed. This fact is exploited by the human ability for stereoscopic vision, both in real life and in stereophoto analysis. By determining the relative

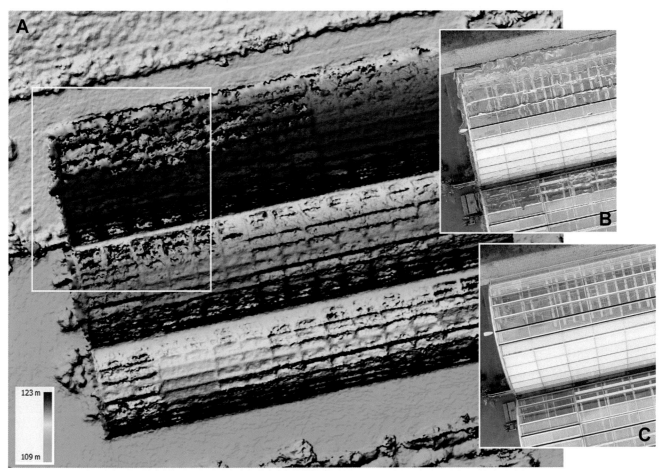

Fig. 3-16 Artifacts in photogrammetry products caused by transparency of glass surfaces at a greenhouse at Frankfurt University's Science Garden. (A) DSM; (B) subset of orthophoto; (C) subset of one of the original airphotos used for surface reconstruction. Due to the varying viewing angles and roof angles, some of the glass panes were reflecting the light strongly, while others were transparent to the camera, showing the interior of the greenhouse. In these places, the unfiltered point cloud extracted in the SfM-MVS process is ambiguous and both DSM and orthophoto show strong errors for the greenhouse roof. Images taken with on-board camera of quadcopter UAV; image processing by IM.

displacement of an object within two images (the stereoscopic parallax), its height may be visually or mathematically estimated. In classical photogrammetry, stereoscopic airphotos are typically acquired with regular overlaps along blocks of parallel flightlines, but any set of images taken with similar scales and sufficient overlap for a satisfactory base-height ratio may be used for creating stereomodels.

Stereomodels enable various kinds of manual and automatic 3D measurements using classical or SfM-based photogrammetric techniques. This involves the establishment of the geometric relationship between the images and between the image coordinate system and object-space coordinate system with high precision, requiring knowledge of the internal camera geometry and external camera position. The usual workflow includes the identification of tie points for relative alignment of the overlapping images, the georeferencing of the stereomodels with ground control points and their simultaneous orientation in object space with ground control points using aerial triangulation techniques such as bundle-block adjustment.

The resulting oriented stereomodels may be used for manual measurement and mapping in a stereoviewing environment. More common is the automatic extraction of dense 3D point clouds based on image-matching techniques to create high-resolution topographic data such as raster-format DSMs, DTMs, or vector-format equivalents such as triangular irregular networks (TIN) and meshes. Orthophotos, which are corrected for relief distortions and have map-like geometric properties, may be created as part of the photogrammetric 3D-modeling workflow. Recent software packages for SfM-MVS photogrammetry have reached a high degree of automation and integration of all steps of this workflow. This has made photogrammetric analysis accessible to the non-specialist and offers exciting new opportunities in the geosciences.

The accuracy of 3D coordinate measurements by SFAP-based photogrammetry and the uncertainties of the derived high-resolution topographic data depend on a number of factors, above all the flying height and image scale. They have been found similar to the quality of alternative field-based methods, i.e., terrestrial LIDAR or laser-scanning (TLS). Challenges specific to SFAP and UAS imagery exist because of their short object distance and high resolution, which make them prone to errors associated with vegetation, vertical walls, and shadowed or textureless surfaces. However, with due understanding of error sources and suitable editing actions, excellent results may be achieved in small-format aerial photogrammetry.

4

Lighting and Atmospheric Conditions

All things in nature are dark except where exposed by light.
Leonardo da Vinci (All Quotes 2016)

4-1 INTRODUCTION

How an object appears in an aerial photograph depends on the way in which it is illuminated and the position of the camera relative to the object and source of illumination. Natural sunlight is tremendously diverse in its characteristics, which include direction, diffusion, harshness, and color (Zuckerman 1996). Thus, natural light varies with season, time of day, latitude, altitude, cloud cover, humidity, dust, and other ephemeral conditions.

Light quality may be described as hard or soft (Defibaugh 2007). The former is typical under clear sky during midday hours, while the latter is found in cloudy conditions and early or late in the day. To achieve gentle illumination and warm colors, professional landscape photographers prefer the lighting conditions just after sunrise or before sunset, when a diffuse golden glow fills the sky. However, typical aerial photography is taken during midday hours when the sun is relatively high in the sky, in order to provide for full illumination or toplighting of objects as seen from above. Under these conditions, more blue light is available, especially in shadows. For purposes of the following discussion, we assume that most SFAP takes place under clear sky between midmorning and midafternoon hours.

Traditional large-format aerial photography is done in the vertical mode; however, many newer remote-sensing systems are designed to operate in a variety of vertical and oblique modes. This introduces much greater flexibility for possible viewing angles relative to sun position and a given target (Fig. 4-1). Considerable theoretical and experimental research has been undertaken in order better to understand the phenomenon of multiview-angle reflectance, which is the variation in reflectivity depending on the location of the sensor in relation to the ground target and sun

position (Asner et al. 1998). In addition, multiangular reflectance involves *interaction of light with three-dimensionally structured surfaces into which light partly penetrates* (Lucht 2004).

In principle, multiview-angle reflectance varies in three dimensions around an object. In practice, this situation is often restricted to the solar plane, which is the vertical plane that includes the sun, ground object, and aerial sensor. The bidirectional reflectance distribution function (BRDF) refers to variations of reflectivity with different viewing angles, as demonstrated within the solar plane (Fig. 4-2). Note the position of the sun and differences in reflectivity both toward and away from the sun. Reflection toward the sun is called backscatter, and reflections away from the sun are forward scatter. Of course, considerable radiation is also scattered in the third dimension to either side of the solar plane in both the back and forward directions.

In addition to viewing angle and sun position, many other factors influence lighting and reflectivity typically encountered for small-format aerial photography. These include the nature of objects on the Earth's surface as well as atmospheric conditions. Some of these vary with seasonal regularity; others are temporally irregular or ephemeral in nature. The following sections elaborate various lighting and atmospheric effects for SFAP.

4-2 MULTIVIEW-ANGLE EFFECTS

Few surfaces reflect incident light in a perfectly diffuse manner, and multiview-angle effects are everywhere. Consider a newly mowed lawn or harvested crop field. Distinct stripes are visible both on the ground and from the aerial vantage (Fig. 4-3). These stripes reflect passage of the mower back and forth across the field such that the grass or crop stubble is bent at opposed angles for alternate stripes. As this example demonstrates, multi-angular reflectance is a basic property of the natural world, and this has many implications for small-format aerial photography. Directional reflectance

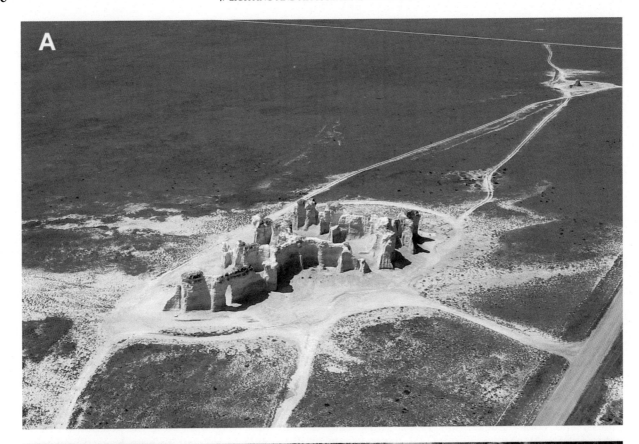

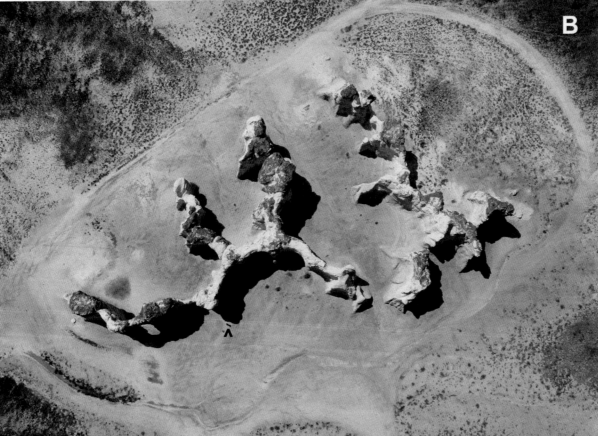

Fig. 4-1 Chalk buttes surrounded by short-grass prairie in the Smoky Hill River valley of western Kansas, United States. (A) Low-oblique view showing cluster of buttes with an arch. Individual buttes stand 8–10 m high. (B) Vertical view of same butte cluster. Note shadows and light coming through the arch in the butte wall. Shadow of SWA is visible just above the arrow (^). Kite photos taken with a compact digital camera (Aber and Aber 2009, Fig. 35).

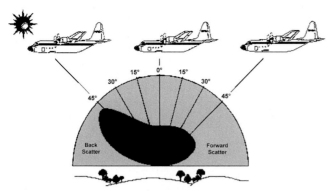

Fig. 4-2 Diagram of aerial photography and typical BRDF. Amount of reflectivity in the solar plane is indicated by the black oval. Maximum reflectivity occurs directly back toward the sun. Illustration not to scale. *Modified from Ranson et al. (1994, fig. 1).*

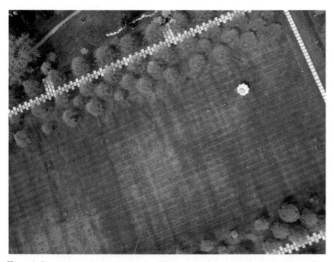

Fig. 4-3 Vertical photograph of lawn with mowed grass. Note linear mowing pattern. The large "birdie" is an outdoor sculpture on the campus of the Nelson-Atkins Museum of Art, Kansas City, Missouri, United States. Helium-blimp photo taken with a compact digital camera.

anisotropy represents the sum of differential reflection by objects that have complicated three-dimensional geometry (Lucht 2004). Any scene comprises certain geometrical properties in terms of the sizes, shapes, angles, and positions of reflective elements, such as tree and grass leaves, waves on water, roof tiles, beach pebbles, and glacier ice crystals. Furthermore, each of these geometric elements reflects certain wavelengths of light more strongly than others (see below).

Vegetation has particularly complex reflectance geometry. Consider, for example, a forest. Some sunlight is reflected directly from the leaves in the crown of the canopy, some is reflected from middle levels, and some light penetrates the forest floor and is reflected upward through the canopy. Volumetric scattering and transmission by leaves send some radiation off in other directions within the canopy, where further scattering, transmission, or absorption may take place.

Another strong influence on reflected radiation is shadow casting. Trees, grass, soil clumps, pebbles, or other irregularities of the surface cast shadows. Each discrete object has an illuminated (bright) side and a shadowed (dark) side. The sizes, shapes and spatial arrangement of shadows have a strong influence on overall scene brightness, and depend on the angle of viewing in relation to the sun position (Fig. 4-4). These factors give rise to two special lighting effects—sun glint and the hot spot, both of which are observed in the solar plane.

Sun glint is direct, specular, forward reflection from an optically smooth (mirror) surface, such as water, glass, or metal, in which the angle of incident sun light equals the angle of reflection. This phenomenon is also called the sun spot or solar flaring (Teng et al. 1997). The most common reflective materials involve water bodies and man-made metal structures. Water surfaces with ripples or waves may produce a variant called sun glitter, in which each wave surface forms a small reflecting facet (Fig. 4-5). Likewise, the waxy, smooth leaves of water lilies may produce sun glint (Fig. 4-6). With illumination

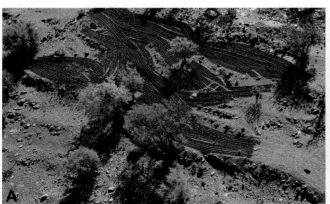
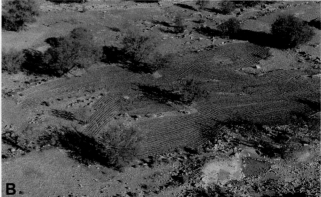

Fig. 4-4 Brightness and saturation of rough surfaces such as agricultural fields may vary strongly with viewing angle. In these oblique views, a freshly plowed field near Aït Baha, South Morocco, is seen in low November sun from northwest (A) and southwest (B). Images taken 30 s apart with on-board camera of quadcopter UAV by M. Kirchhoff and R. Stephan with IM. Farming in this rural part of the Anti-Atlas is done by manual labor with donkey plows; see also Fig. 10-24.

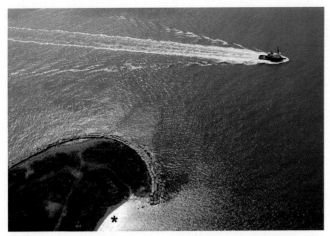

Fig. 4-5 Sun glint and glitter. Low-oblique view of sun glint from smooth water (*); sun glitter from ripple and wave surfaces elsewhere in the scene. South Padre Island, Texas, United States. Kite photo taken with a compact digital camera.

Fig. 4-7 Hot spot displayed in an oblique view of a citrus plantation near Taroudant, Morocco. Shadows are absent at this antisolar point, giving the impression of overexposure at the center of the image. Fixed-wing UAV photograph taken with a digital MILC by S. d'Oleire-Oltmanns and IM.

from the side, green leaves and white flowers of the lilies are clearly visible. But when the camera is positioned opposite the sun, lily leaves are rendered glaringly bright by near-perfect specular reflection.

Sun glint is quite common in oblique views taken toward the sun; it is seen less often in vertical views. Sun glint and glitter are observed in small-format aerial photographs frequently compared to traditional large-format images, because of the wider field of view and rectangular-format cameras often employed for SFAP (Mount 2005). The occurrence of sun glint in vertical views increases for photographs taken in late spring or early summer when the sun is highest in the sky or in imagery from low latitudes where the sun is always high overhead.

The hot spot is the position on the ground in direct alignment with the sun and camera. It is located at the antisolar point, which is the point on the ground opposite the sun in relation to the camera (Teng et al. 1997; Lynch and Livingston 2004). The hot spot appears brighter than its surroundings, as if that position is overexposed in the image (Fig. 4-7). This phenomenon is also known as the opposition effect or shadow point, because the shadow of the platform that carried the camera may appear at the center of the hot spot (Fig. 4-8; Murtha et al. 1997).

The hot-spot phenomenon has received a great deal of investigation, and most agree that its primary cause is a result of shadow hiding (Hapke et al. 1996; Leroy and Bréon 1996; Lucht 2004). This effect derives from

Fig. 4-6 Two low-oblique views of water lilies in a basin, taken from different viewing angles. Note different appearance of the lily leaves and submerged vegetation. (A) Sun position to the left of the viewing direction. (B) Sun position opposite the camera. Science Garden at Campus Riedberg, Frankfurt University, Germany. Taken with on-board camera of quadcopter UAV.

Fig. 4-8 Antisolar point marked by the shadow of a small helium blimp in lower right portion of this vertical view of a formal rose garden. The camera rig was fixed directly below the blimp's keel. Taken with a compact digital camera.

shadows cast by objects of all sizes, from sand grains on a beach to field crops to forest trees. Furthermore, the color of the hot spot differs from that of the surroundings (Lynch and Livingston 2004). This is because scattered blue light, that normally illuminates shadowed zones, is absent from the hot spot vicinity. Thus, the hot spot typically appears more yellow (lacking in blue). For example, dark green forest appears light yellowish green at the hot spot (Fig. 4-9).

In addition to shadow hiding, other factors may contribute to the hot spot (Lynch and Livingston 2004). Small rounded grains (sand and pebbles) may act as lenses that collect light and reflect it back toward the sun. Likewise mineral crystals within rocks may function as

internal corner reflectors, and crystal faces may act as tiny mirrors. Light may be back reflected from tiny liquid droplets, such as dew or tree resin. Finally coherent backscatter may contribute to the opposition effect. The combination of these factors with shadow hiding creates marked hot spots in many situations for small-format aerial photography.

The hot spot is commonly observed in oblique views taken opposite the sun; it is evident less often in vertical views. As with sun glint, the presence of the hot spot in vertical views increases with use of a wide-angle lens, for late spring or early summer imagery, or from low latitudes. The hot spot is particularly conspicuous when the color and brightness of the subject are more-or-less uniform.

In the authors' experience, hot spots are most noticeable for terrain in which the ground cover is relatively homogeneous, such as forest or prairie canopy, agricultural fields, pastureland, and fallow or bare ground. Care must be taken, when interpreting such images, not to mistake this special lighting effect for different qualities of the objects in the scene, e.g. less healthy trees, sparser grass cover, or degraded soil patches (see also Fig. 10-36). For terrain with more complex land cover, the hot spot may not be so obvious. This applies often to urban scenes which contain large variations in the intrinsic colors and brightness of objects.

The foregoing discussion suggests that the appearance of the landscape changes dramatically with different viewing directions relative to sun position. This leads to a general assessment of the visual quality of oblique or wide-angle vertical images acquired with small-format aerial photography (Fig. 4-10). In general, better oblique images are acquired in the azimuth range

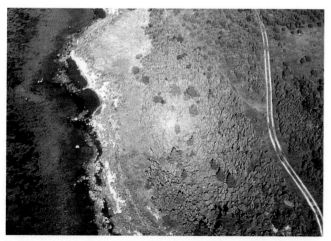

Fig. 4-9 Hot spot at scene center in canopy of pine-spruce forest. The hot spot has a pale yellowish-green color compared to the normal dark-green color of the surrounding forest. Baltic coast of Vormsi, Estonia. Kite photo taken with a compact analog camera.

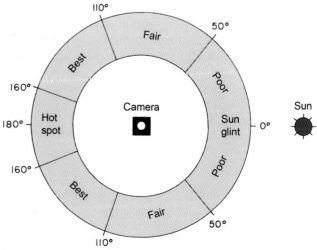

Fig. 4-10 Schematic azimuthal (plan) diagram of lighting conditions for oblique small-format aerial photography relative to the sun position. The indication of image quality according to direction is a subjective visual assessment. *Modified from Aber et al. (2002, Fig. 5).*

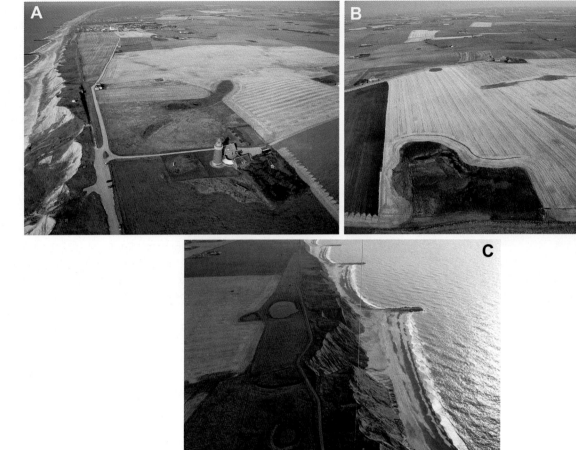

Fig. 4-11 Effect of viewing direction on oblique image quality relative to azimuth of the sun. (A) View toward ~160 degrees; note shadow of lighthouse. (B) View toward ~120 degrees; note shadow of tractor to left. (C) View toward ~40 degrees; notice sun glint along right edge. A and B depict good color with moderate brightness contrast. C is heavily shadowed and displays excessive contrast. Bovbjerg Klit, North Sea coast of Denmark. Kite photos taken with a compact digital camera.

50–160 degrees relative to the sun position. This viewing range represents a balance of shadows and highlights with more-or-less uniform brightness levels. Views toward the sun (<50 degrees azimuth) suffer from excessive shadowing, high contrast, and poor depiction of color; furthermore, sun glint may be present. On the other hand, views directly opposite the sun may include the hot spot, wherein details are hardly visible due to lack of shadows. Fig. 4-11 demonstrates visible changes in image quality with different viewing directions over a coastal setting in western Denmark.

4-3 BIDIRECTIONAL REFLECTANCE DISTRIBUTION FUNCTION

Qualitative variations in scene brightness and contrast depending on viewing angle and sun position are commonplace in small-format aerial photography, as noted above. The goal of the bidirectional reflectance distribution function (BRDF) is to model these variations quantitatively

(Lucht 2004). The BRDF is based on viewing and illumination angles as well as complex geometrical and optical properties of objects in the target scene. Considerable effort has been made to understand BRDF better for various types of land cover, particularly different vegetation canopies. One approach is to model mathematically the reflective plants and canopy geometry. Some models are based on radiative properties of plants (Nilson and Kuusk 1989), whereas others depend on geometric-optical considerations (Schaaf and Strahler 1994).

In either approach, the models may be tested against actual sensor measurements, in other words ground truth. Such field experiments begin with a radiometer mounted on a ground-based goniometer (Fig. 4-12). The radiometer moves around the target object in order to collect reflectivity values from all azimuthal and zenithal directions at close range (2 m). From slightly higher vantages, NASA's Parabola radiometer may be operated from a vehicle-mounted boom up to 5 m high or suspended from cables attached to towers up to 30 m high (Bruegge et al. 2004). Parabola is capable

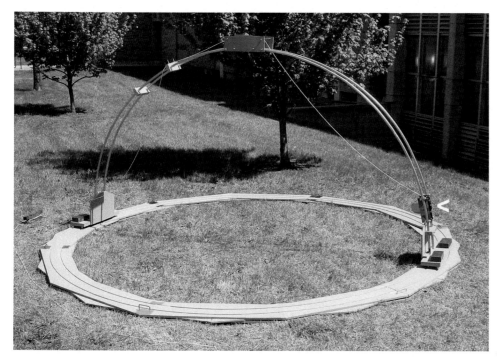

Fig. 4-12 Goniometer for field measurements of solar reflectivity from ground objects. The radiometer (<) moves up and down the semicircular arch, which rotates a full 360 degrees to capture reflectivity measurements in all possible directions. The base is ~4m in diameter. *Taken from Landis and Aber (2007, Fig. 7).*

of panning and tilting to acquire measurements in all look directions over a target area. Airborne BRDF instruments include POLDER and ASAS, which are typically flown at heights of 3000 m or higher (Schaaf and Strahler 1994; Leroy and Bréon 1996). Three general observations have come from field observation of multiview-angle reflectivity of vegetation canopies (Murtha et al. 1997).

- Canopy reflectance is greatest when the sun is behind the sensor, in other words the camera records light that is backscattered from the canopy toward the sun. Maximum reflectance is located at the antisolar point, which produces a hot spot in the image due to shadow hiding.
- Canopy reflectance increases overall with higher solar zenith angles.
- Canopy reflectance is relatively uniform for vertical or near-vertical images, particularly those acquired with narrow fields of view.

One goal of BRDF research is to relate ground and aerial multiview-angle effects to observations collected from space-based remote-sensing systems (e.g. Salomon et al. 2006). Between ground-based and relatively high airborne BRDF instruments, however, the height range from 30 to 1000 m is a little-explored interval for multiview-angle reflectivity. Small-format aerial photography is particularly well suited within this range to acquire all viewing angles from vertical to high oblique. Thus, SFAP represents an effective and relatively inexpensive means for low-height field experiments and testing of BRDF models (e.g. Burkart et al. 2015; Rasmussen et al. 2016; Roosjen et al. 2017). Likewise, the role of

BRDF for interpretation of aerial photographs also is increasingly recognized (e.g. Verhoeven 2016).

4-4 MULTISPECTRAL EFFECTS

As humans, we view the world through a narrow range of electromagnetic radiation, the visible spectrum (approx. 0.4–0.7 μm wavelength; see Fig. 2-1). Film photography extends this range from near-ultraviolet to near-infrared (0.3–0.9 μm). Black-and-white infrared film was developed in the 1920s and was utilized for aerial photography already in the 1930s (Colwell 1997). World War II spurred a great need for aerial camouflage detection, and color-infrared (CIR) film was perfected. Nowadays both film and digital CIR cameras are available for small-format aerial photography (see Chap. 6).

The "color" of objects depends upon what parts of the spectrum are observed. This is obvious, for example, when comparing panchromatic (gray tone) images with equivalent color images. However, objects that appear similar in visible light often have quite different appearances in other portions of the spectrum. Diffuse reflectivity or albedo for most common surficial materials ranges from <10% for clear water to nearly 100% for fresh snow. Photosynthetically active vegetation, for example, typically has albedo of 50%–70% in the near-infrared portion of the spectrum.

Different parts of the spectrum may be photographed by using various combinations of films, electronic detectors, and filters. Photographs are routinely taken in b/w panchromatic, b/w minus blue, b/w infrared, color-visible, color-infrared (minus blue or minus red),

and multiband types (see Chap. 6). Near-ultraviolet photography is also possible for special applications. As an example, color-infrared film is exposed to green, red, and near-infrared wavelengths, which are depicted, respectively, as blue, green, and red in the photograph. This shifting of invisible bands to visible colors is called false-color imagery (see Fig. 2-5).

The case of vegetation is most instructive. Photosynthetically active "green" vegetation has a unique spectral signature (Fig. 4-13). Leaves selectively absorb blue and red light, weakly reflect green, and strongly reflect near-infrared radiation. No other materials at the Earth's surface have this spectral signature. On this basis, CIR imagery plays a key role for analysis of all types of vegetation—crops, prairie grass, emergent aquatic plants, and forests.

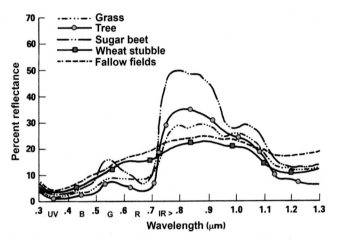

Fig. 4-13 Typical spectral signatures for common objects for near-ultraviolet, visible, and short-infrared radiation. Note the distinctive reflectance for active vegetation (sugar beet, tree, grass). *Adapted from Short (1982, Fig. 3-5B).*

Water, likewise, has a distinctive appearance in CIR images. Although clean and turbid water differ in their visible reflectivity, depending on the amount of suspended sediment, both strongly absorb near-infrared radiation. Thus, water bodies typically appear dark blue or black in CIR photographs, unless photosynthetically active vegetation is floating on the water surface. CIR images are typically taken using a yellow or orange filter in order to remove blue light from the image. This renders shadows much darker, as scattered blue light illuminates shadowed zones. Thus CIR images that contain active vegetation, water bodies, and shadowing are often high contrast—quite bright and dark portions with little midrange of brightness. Furthermore, darkening of water and shadows tends to exaggerate the appearance of sun glint and the hot spot (Fig. 4-14).

Numerous laboratory and field studies have demonstrated that the BRDF effect displays strong spectral variation for vegetated surfaces (Sandmeier 2004; Burkart et al. 2015). This is a consequence of multiple scattering effects within vegetation canopy and selective absorption of certain wavelengths. In general, high-absorbing red light shows the strongest response, whereas high-reflecting near-infrared is the weakest, and green is intermediate.

4-5 LATITUDE AND SEASONAL CONDITIONS

The position of the sun is a critical factor for controlling the amount and quality of light available to illuminate the Earth's surface. Latitude, day of year, and time of day determine where the sun would be located for any site. The normal expectation of toplighting for small-format aerial photography means the sun should

Fig. 4-14 Special lighting effects are enhanced in color-infrared imagery. (A) Sun glint (*) and glitter from fish hatchery ponds; water is dark blue; Pueblo, Colorado. (B) Hot spot at scene center on canopy of deciduous trees; shadows are black; Elkhorn Slough, California. Kite photos taken with an analog SLR camera.

be relatively high in the sky to avoid excessing shadowing of the landscape, and a further criterion is usually cloud-free sky for best illumination of the ground. This combination of clear sky and high sun position is ideal for most SFAP applications. In addition, it is usually desirable to avoid sun-glint and hot-spot views.

For some parts of the world, however, these conditions are rarely or never realized. At Tromsø, Norway (~69.7° N), for example, even at noon on summer solstice, the sun is not high in the sky (Fig. 4-15). At the other extreme, the sun is nearly overhead at midday in the tropics, which greatly increases the chances for sun glint or the hot spot in vertical photographs. Even in middle latitudes during summer, it is possible at noon to capture the hot spot and sun glint in the same vertical view (Fig. 4-16). To avoid this predicament, SFAP should be conducted in the midmorning or midafternoon, be-

fore or after the sun has reached its full height. Similar seasonal and time-of-day considerations apply in other circumstances in order to achieve optimum sun position for a given site or application.

The character of clouds is the second main factor for successful small-format aerial photography. Although cloud-free conditions are often assumed best, uniformly indirect lighting from high clouds or overcast sky is preferable to direct sunlight for some applications. Many parts of the world have persistent, even perennial cloud cover. This includes much of the tropical region. For example, the deltas of the Amazon River and Zaire (Congo) River are rarely photographed without cloud cover by astronauts (Amsbury et al. 1994). Tropical mountains are especially prone to cloud cover. Many tropical regions experience monsoon seasons with continual clouds and rain for months.

Another setting known for extended cloud cover is mid- and high-latitude maritime environments, for example coastal British Columbia in Canada, southern Alaska in the United States, the British Isles, and Norway. On some islands, the sun is seen only a few days a year—Faeroe Islands (northwest of Scotland) and Kerguelen Islands (southern Indian Ocean). On the other hand, deserts and semiarid regions have abundant sunshine most of the year. However, dry climate combined with strong wind gives rise to frequent dust and sand storms (Amsbury et al. 1994).

Many regions of the world experience a regular progression of seasonal conditions that influence ground cover and human land use. Most noticeable are seasonal changes in water bodies and vegetation, both natural and agricultural, that may help to distinguish between different types of plants (Fig. 4-17). For many SFAP applications, particular criteria of ground cover may be necessary. For example, land surveys for property appraisal or population census may specify leaf-off conditions, in order that human dwellings and structures are seen clearly beneath deciduous trees. On the other hand, agricultural monitoring must be conducted periodically during the growing season. Thus, the time of the year may be determined by requirements of the SFAP mission.

As this discussion suggests, achieving optimum lighting for small-format aerial photography is often difficult or may be practically impossible in some situations. Logistical considerations provide further limitations, as people and equipment must be in place to take advantage of favorable lighting and atmospheric conditions (see Chap. 9). Every platform has its own requirements regarding weather conditions, especially wind, and the time of the day for a photographic survey may be dictated by the presence or absence of wind. Given the reality of SFAP, it is sometimes necessary to proceed with less-than-ideal conditions in order to complete a mission. Some of the effects of cloud cover and other atmospheric disturbances are elaborated in the next section.

Fig. 4-15 Midday view of Kvaløysletta near summer solstice showing long shadows. Note poles, sign post, and trees in foreground. Near Tromsø, Norway at ~69.7° N latitude in June. Kite photo taken with a compact analog camera.

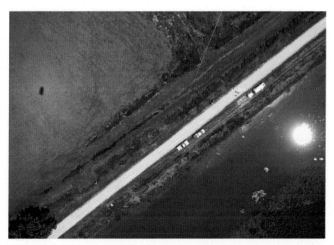

Fig. 4-16 Vertical shot that includes both the shadow point (left) on aquatic vegetation and sun glint (right) on still water in a wetland channel. Image acquired near noon, a few days before summer solstice at ~40° N latitude. Helium-blimp photo taken with a compact digital camera by S. Acosta and JSA; Loess Bluffs National Wildlife Refuge, northwestern Missouri, United States.

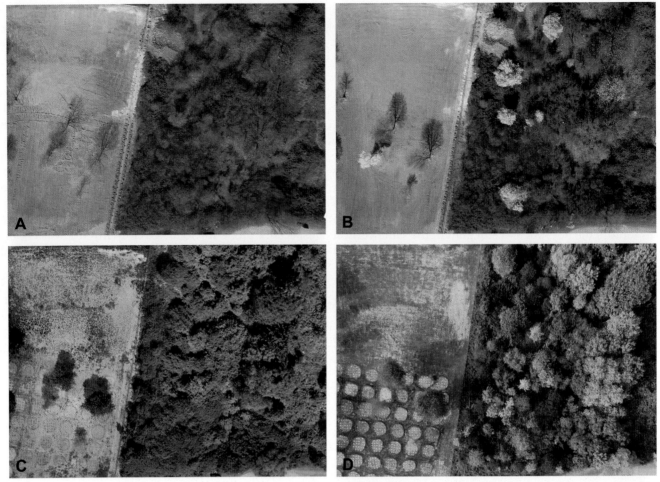

Fig. 4-17 Small woodland with wild fruit trees, maple, poplar, willow, walnut, and other deciduous trees with dense undergrowth of bramble and grasses, adjoining fallow land freshly leveled for a botanical test site at Frankfurt University's Campus Riedberg, Germany. Four seasons in 2017–18. (A) During leaf-off conditions in late winter; (B) early bloomers (mostly wild cherry) and first leaves in early spring; (C) masses of nearly uniform green on the day of summer solstice; (D) a range of Indian Summer colors in autumn. Note how the shadows falling unto flat ground reveal the shapes and structures of the trees. Taken with on-board camera of quadcopter UAV.

4-6 CLOUDS

Clouds play a critical role for effective small-format aerial photography. The nature and optical properties of clouds vary enormously from high, thin cirrus clouds of ice crystals to dense ground fog. In addition to ice and/or water droplets, clouds may consist of dust, smoke, and other minute debris in the atmosphere, which are derived from both natural and human sources. The particles of clouds range in size from <1 μm diameter to a maximum of ~100 μm. Clouds are intrinsically white, as they absorb practically no visible light and all wavelengths are scattered equally (Lynch and Livingston 2004). The impact of clouds for SFAP depends on their altitude relative to the camera. Clouds positioned above the camera mainly affect the amount and quality of incoming radiation and how it illuminates the ground; whereas, clouds below the camera influence both incoming radiation and light reflected upward from the ground.

Beginning with clouds above the camera level, cloud cover has two main impacts on the visual appearance

of aerial photographs, namely reduction of shadows and poor color definition, which result overall in low-contrast images (Fig. 4-18). As clouds become thicker and less transparent, the ground beneath becomes increasingly dark and uniformly illuminated mainly with blue light such that shadows of individual objects disappear. Shadows are visual clues to relief and texture of features in the photograph, and without any shadows, these objects may be difficult to identify. This affects vertical aerial photographs in particular, which often have a "flat" appearance without shadows.

The color in shadowed zones below clouds is rich in blue light and poor in green and red, which gives rise to the dull blue-gray color palette of cloudy weather. Under heavy cloud cover, color largely disappears from the landscape. Nonetheless, even in the case of moderate cloud cover good SFAP may be conducted in many situations, if the ground is uniformly illuminated. In the case of wispy cirrus clouds, however, the visual impact for most SFAP is minimal. High, thin clouds slightly reduce

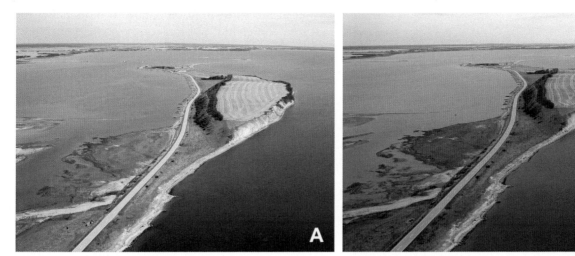

Fig. 4-18 Effect of cloud cover on image quality for a Scandinavian coastal scene. (A) High-oblique view under mostly sunny conditions. Colors are well defined and the image has good brightness contrast. (B) Similar view taken a few minutes later under cloud cover. Colors are dull and image has low contrast. Fegge, island of Mors, Limfjord district of northwestern Denmark. Kite photos taken with a compact digital camera.

solar brilliance without significantly degrading shadows or color. This could be advantageous, in fact, for scenes that have high intrinsic brightness contrasts for ground objects, for example dark green coniferous forest next to white beach gravel. Thus, altitude and thickness of clouds render considerable variation in colors displayed at the Earth's surface.

Discontinuous or patchy cloud cover results in a mosaic of illuminated and shadowed zones on the ground (Fig. 4-19). This is usually the worst possible lighting situation for effective SFAP, as the bright areas may be overexposed and the dark spots are underexposed with little of the image in the midrange of brightness (Fig. 4-20). Still, patchy cloud cover may be utilized successfully in

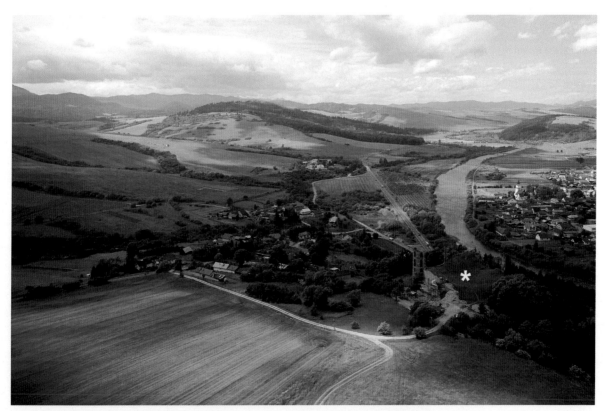

Fig. 4-19 Landscape of the Poprad River valley and town of Plavec (right side), northeastern Slovakia. The primary target was Plavecsky Hrad (*), but the castle ruin is hardly visible under a cloud shadow. This picture was taken during a transition between largely cloud-free sky a few minutes earlier and completely cloudy conditions a few minutes later. Kite photo taken with a compact digital camera; compare with Fig. 5-4.

Fig. 4-20 A whim of nature has spread clouds as if intentionally obscuring the main object of this scene. The large gully system cutting into agricultural fields near Taroudant, Morocco, is nearly blanketed by shadows, and only its upper right part is illuminated well. The stark difference between light soil surfaces and dark shadows brings compositional imbalance into this image, which already contains a challenging combination of patterns and textures. Fixed-wing UAV photograph taken with a digital MILC by S. d'Oleire-Oltmanns and D. Peter with IM.

some instances to draw attention to illuminated foreground and central portions of the scene, which are of particular interest, while leaving the periphery and background in cloud shadows (Fig. 4-21). In addition to casting shadows, clouds also may reflect white light to brighten the ground in places. This effect is visible on homogeneous surfaces, such as lakes and seas (Fig. 4-22).

The examples of clouds discussed thus far are positioned above the camera. Clouds located below the camera—between the camera and the ground—may have all the same effects as higher clouds by limiting incoming solar radiation. In addition, low clouds scatter light reflected upward from the ground, thus further degrading

Fig. 4-22 High-oblique view over the Gulf of Finland with patchy cloud cover. Note dark cloud shadows on water surface as well as bright zones from cloud reflections. This effect is noticeable over homogeneous surfaces, such as water, but is not recognized so often on land. Island of Vormsi, Estonia. Kite photo taken with a compact analog camera.

Fig. 4-21 The foreground is well illuminated, and the background is shadowed by clouds. This visual contrast directs the viewer's attention to the main subject—the recreational development adjacent to the lake. Helium-blimp photo taken with a compact digital camera by A. Uttinger and JSA; Lake Wabaunsee, Kansas, United States.

image quality. Although such conditions should be avoided normally for SFAP, it may be necessary to cope with low clouds in some situations. For example, summer in the eastern United States and southeastern Canada is a time of hazy sky due to a combination of high humid-ity and industrial pollution. Thus, poor visibility is fre-quently the case even on "clear" days (Fig. 4-23).

Smoke and smog are widespread around the world. Natural fires are started by lightning strikes, sponta-neous combustion, and volcanic eruptions. However,

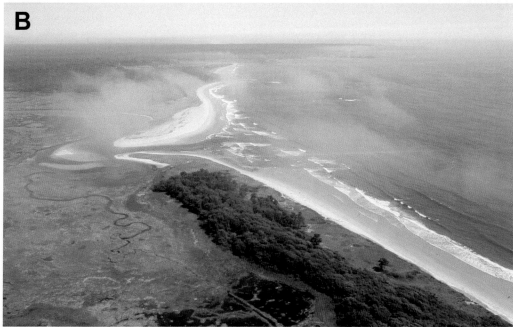

Fig. 4-23 Poor visibility is typical of the eastern United States during the summer. (A) Nearby tow plane is clearly defined, but the ground below is depicted poorly through the haze, and the background is hardly visible. Hand-held photo taken with a compact digital camera from a manned glider; Elmira, New York. (B) Fog drifts in from the Atlantic Ocean over Laudholm beach and the mouth of Little River; Wells, Maine. Helium-blimp photo taken with a DSLR camera by JSA and SWA with V. Valentine.

most fires and smoke nowadays are related to human activities—clearing forests, prairie fires, burning agricultural waste, oil and gas fires, burning fossil fuels for transportation and industry, etc. Far from being an isolated problem, smoke is a common seasonal or perennial condition that may affect small-format aerial photography. In some cases, smoke spreads regionally from many small fires, for example from burning agricultural waste and crop stubble at the end of the growing season (Fig. 4-24) or spring burning of the tallgrass prairie to maintain grassland habitat (Fig. 4-25). In other situations, smoke has a significant point source, such as a coal-fired electric power plant or cement factory.

Fig. 4-24 Regional smoke from widespread burning of agricultural waste and crop stubble in autumn creates a hazy appearance in a high-oblique view over this wetland scene. Mannikjärve Bog, Estonia. Kite photo taken with a compact analog camera.

Fig. 4-25 Controlled prairie burning is a spring ritual to maintain tallgrass habitat in the Flint Hills of eastern Kansas. (A) Smoke billows up from a wall of fire. Note shadow from smoke cloud. (B) Smoke surrounds the camera rig. In spite of the smoke, a diffuse hot spot is visible in upper center of picture (*). Kite aerial photos taken with a compact analog camera by SWA and JSA with M. Lewicki.

4-7 SHADOWS

The issue of shadowing in an image is strongly connected to the latitude, time of day, and cloud aspects. With direct illumination by the sun, all three-dimensional objects or surface features cast a shadow if they project into the paths of the light rays between sun and ground. Shadowing in aerial images is most prominent at early morning and later afternoon and increases with higher latitudes. The darkening effect of shadowing increases with longer wavelengths as these are less subject to atmospheric scattering. For the same reason, shadows on a clear and dry day are much more pronounced than with slightly overcast conditions and a dusty or humid atmosphere, as discussed above.

Shadowing may occur at various scale levels in an image. A steep slope may cast a shadow onto a valley floor and opposite valley side, the shadow of a tree may obscure the ground beneath, and shadowing between clods of earth may reveal the texture of a freshly plowed field. Shadows might both be desired or unwanted depending on the purpose of the image; they may emphasize as well as obscure objects and surfaces in a scene (Fig. 4-26).

For visual interpretation of aerial images, shadowing may be extremely helpful as it offers clues to the third dimension, which two-dimensional images lack. Shadows may aid identification of the form and function of buildings or types of trees in vertical images (Fig. 4-27), outline the profile of a sharp edge in the terrain (Fig. 4-28),

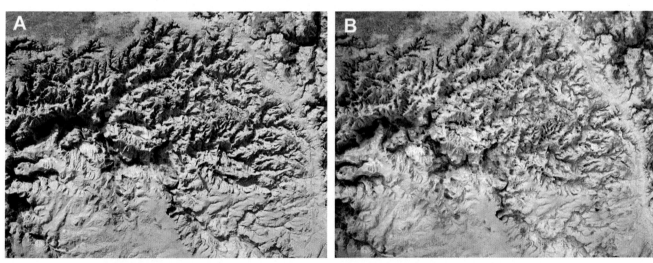

Fig. 4-26 Vertical images of gully erosion on an abandoned Moroccan field at Talaa near Taroudant. (A) Shadows emphasize the various depths and degrees of ruggedness of the geomorphologic forms carved by surface and subsurface erosion processes. (B) Image taken a few minutes later under cloud cover. The indirect lighting improves the visibility of details in all parts of the gully, but takes away most depth impression, making it impossible to distinguish different levels of incision. Kite photos taken with a DSLR camera.

Fig. 4-27 Every tree appears twice in this image of a burned pine forest near Castejón de Valdejasa, Province of Zaragoza, Spain. The long shadows cast by the afternoon sun are much larger from the vertical vantage point than the soot-blackened skeletons of the pines, obscuring great parts of the image. Fixed-wing UAV photograph taken with a DSLR camera by C. Claussen, M. Niesen, JBR and IM.

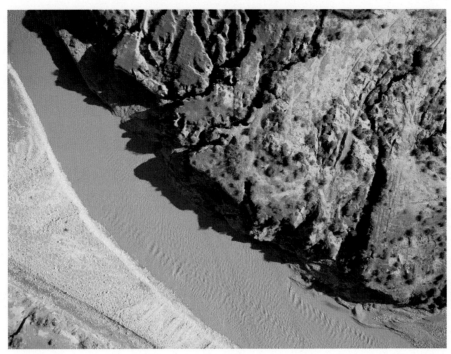

Fig. 4-28 The height and jaggedness of Oued Ouaar's eroded river bank are emphasized by afternoon shadows in this vertical view taken near Taroudant, Morocco. Fixed-wing UAV photograph taken with a digital MILC by S. d'Oleire-Oltmanns and D. Peter with IM.

disclose the course of a power transmission line, or reveal archaeological and historical landscape features. Shadows may be quite dramatic in some cases (Fig. 4-29).

Geomorphologic and geologic features and landforms at various scale levels—rock crevices, erosion rills, fault lines, dells or dolines, dunes or coastal cliffs, stepped or terraced slopes—could be rendered nearly invisible or at least unfathomable when melting into the landscape background on an image without shadowing. In contrast, late afternoon sun might model even subtle

Fig. 4-29 Low-height, vertical view of "Big Brutus" at the Mining Heritage Museum near West Mineral, Kansas, United States. One of the world's two largest power shovels, it stands 50 m tall with a working weight of 5000 metric tons. Shadow creates a silhouette side view of the machine. Note people for scale standing in upper left corner. Helium-blimp photo taken with a compact digital camera (Aber and Aber 2009, Fig. 72).

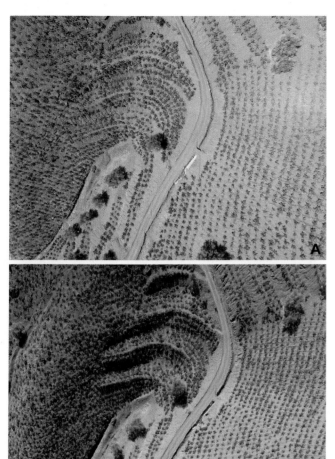

Fig. 4-30 Vineyards on the 30-degree steep slopes of a small valley in the Axarquía, Montes de Málaga (Spain). (A) The midday image gives few clues as to the relief forms due to the lack of shadows. Note also the antisolar point in the upper right image quarter that further adds to the flat appearance of the scene. (B) Late afternoon illumination reveals the diagonal direction of the valley below the small road, the four terraces in its upper reaches, and erosion rills at the terrace banks in the upper left. Taken with on-board camera of quadcopter UAV.

variations of surface height, such as gradual relief undulation or small erosion rills (Fig. 4-30).

Shadows may also play a misleading role when interpreting image depth. The human brain makes an unconscious assumption that the light source comes from the upper left corner of the scene so that shadows fall toward the lower right side of raised objects. This happens because we are accustomed to illuminate whatever we work at from an opposite position, not from behind our elbow. Positioning the light source to the lower right, so that shadows are cast toward the top or left side of view, leads to a well-known optical illusion, in which the terrain appears to have inverted relief (Fig. 4-31). To avoid this misinterpretation, rotate the vertical image so that shadows are cast toward the lower right direction.

Fig. 4-31 Vertical view of deeply eroded badlands in a sedimentary river terrace near Foum el Hassane, South Morocco. (A) Shadows cast from upper left to lower right emphasize the mesa-like structures remaining of the original surface and the V-shaped erosion channels between; note shadow of kite flyer standing on badland surface, upper left. (B) Same image rotated so that shadows fall in opposite direction. Many viewers may see inverted relief in this version, with sharp ridges and flat, sunken depressions.

In digital image analysis, shadows are usually undesirable as they change the spectral response of objects with otherwise homogeneous or identical reflectivity. For spectral classification algorithms, this results in misclassified or unclassified areas (see Chap. 11-6). To avoid this effect, masking techniques or topographic

normalization may be applied (Colby 1991; Zhan et al. 2005). Photogrammetric analysis by both visual stereoscopy and automated image matching is strongly hampered in dark shadow areas (Fig. 4-32) and may lead to considerable measurement errors (Giménez et al. 2009). The resulting spatially varying data quality of image classifications and surface models subsequently also afflicts time-series analyses and monitoring by remote sensing.

On the other hand, shadows might actually enable automatic detection of objects or surface types by adding typical patterns or structures to the image which could be enhanced and extracted by filtering, image segmentation, and texture analysis (Fig. 4-33; Marzolff 1999; Shackelford 2004). A difficult problem both for intentionally achieving and avoiding shadowing is that the degree of shadowing is dependent not only on sun elevation and object height but also on the relative position of the objects or surface structures to the incident rays of light. Similar to multi-angle viewing effects, the same structures may have different appearances throughout the image depending on their orientation (Fig. 4-34; see also Giménez et al. 2009).

Fig. 4-32 Bank gully at the Rambla Salada, Murcia Province in southern Spain. (A) Indirect lighting from an overcast sky uniformly illuminates all areas in this image, which completely lacks shadows. Details of the gully bottom are clearly visible. (B) Strong sunlight casts a dark shadow from the steep gully wall onto its bottom. Image classification or stereoscopic photogrammetric analysis in this area is not possible, and comparison between the two monitoring dates is difficult. Hot-air blimp photographs with analog and digital SLR cameras.

Fig. 4-33 Fallow field in northern Spain. (A) After several drought years, remains of the pattern created by plowing 5 years previously are still visible in the early morning sunlight. (B) Digital texture and Fourier analysis were used to create this map of different microtopographic surface positions (ridge and furrow), corresponding to different types of soil crusts. Hot-air blimp photograph with analog SLR camera. Field of view ~24 m across. *Taken from Marzolff (1999, map 1A and 4A).*

Fig. 4-34 Changing its direction by ~45 degrees in the center of this vertical kite image, an erosion rill on a fallow field turns from an inconspicuous feature into a starkly prominent incision. Note sun azimuth indicated by the kite flyer's shadow (upper right). Bardenas Reales, Province of Navarra, Spain. Subset of original photograph taken with a DSLR camera.

4-8 SUMMARY

Knowledge of the various effects related to illumination situations and to the reflectance properties of target objects is important for acquisition planning as well as interpreting of SFAP. Small-format aerial photographs typically are taken under clear sky when the sun is relatively high to provide for good toplighting of the Earth's surface, although uniformly indirect lighting from high clouds or overcast sky is preferable in some situations. The position of the camera relative to the ground and sun plays a key role for determining the nature of reflected solar radiation reaching the camera. Anisotropic variations in reflectivity, depending on sun position and angle of viewing, give rise to the bidirectional reflectance distribution function (BRDF). Within the solar plane, two positions yield special lighting effects. Sun glint occurs when the angle of solar incidence is equal to the angle of reflection directly toward the camera. This is common in oblique or wide-angle vertical views looking toward the sun. The hot spot is located at the antisolar point, which is the spot on the ground in direct alignment with the camera and sun. The hot spot is seen often in oblique or wide-angle vertical views in the direction opposite the sun.

Small-format aerial photography is done routinely in the visible and near-infrared portions of the spectrum. Many types of spectral combinations may be photographed, ranging from conventional panchromatic to color-infrared. All objects display spectral signatures, which is one basis for recognizing their composition. Vegetation is particularly distinctive. Active "green" vegetation absorbs blue and red light, weakly reflects green, and strongly reflects near-infrared radiation; this spectral signature is unique among materials at the Earth's surface. The portrayal of invisible spectral bands as visible colors is called false-color imagery.

Achieving the optimum lighting conditions for SFAP may prove difficult or even impossible depending on many factors—latitude, time of year, local weather conditions, special mission requirements, logistical limitations, platform capability, etc. The presence of shadows in an image may be desired for interpretation or automatic analysis purposes, but it also may be inconvenient and obscure valuable information. In practice, SFAP often must be done when sun position, cloud cover, and other factors are less than ideal. Even under unfavorable lighting conditions, it is still possible in many situations to acquire effective small-format aerial photographs by carefully selecting viewing directions, time of day, variable cloud cover, or other factors. One of the great advantages of small-format aerial photography is its flexibility for adapting to a wide range of lighting and weather conditions in the field.

5

Photographic Composition

An image is an abstraction of reality. Composing an image is an act of imposing order on the world, to fit within the confines of the image space. Taylor (2014, p. 10)

5-1 INTRODUCTION

Photographic composition is much more than simply aiming the camera at the subject and taking a picture that is in focus and properly exposed for the ambient lighting conditions. Photographic composition has to do with the subjective reaction of people who view and interpret the image, in other words the aesthetic characteristics of the photograph. Many books have been written about landscape photography from an artistic point of view, for example Caulfield (1987), Shaw (1995), and Zuckerman (1996). Fewer have approached the artistic vantage of aerial landscape photography (e.g. Evans and Worster 1998). In the last decade, drones have become prevalent in aerial photography as an art (e.g. Deutsches Jugendinstitut 2016), and an increasing number of professional as well as non-professional aerial photography artists publish their work on Internet platforms such as *Instagram* or *Dronestagram*.

In SFAP taken for scientific and survey purposes—such as nearly all photographs in this book—the artistic quality, breathtaking vantage points, or spectacular bursts of color are not of primary importance. But good image composition may still make the difference between just a useful visual recording or an image that immediately conveys to the viewer an explanatory synthesis about the making of a landscape, the nature of a geomorphological process, or the disturbance factor of an ecosystem.

In general, *good photographic technique is identical regardless of the camera used* (Shaw 1995, p. 5). Digital cameras offer some advantages as well as limitations compared with traditional film cameras (Wildi 2006), although nearly all professional photographers now work exclusively with digital equipment. In any case, nearly all literature on this subject is based on the *frog's-eye view* from the ground. The *bird's-eye view* of SFAP opens new vistas and considerations for effective composition. SFAP views from above tend to simplify the subject's surroundings and produce a more abstract image overall (Taylor 2014).

The most important variable for successful outdoor photography is correctly exposing the image to the available light. The roles of toplighting, sun/camera position, shadows, multispectral effects, and atmospheric conditions were discussed in the previous chapter. Technical aspects of SFAP camera operation are reviewed in the next chapter. This chapter focuses on the end results, namely the basic elements that comprise attractive pictures.

5-2 BASIC ELEMENTS OF PHOTOGRAPHIC COMPOSITION

Photographic composition begins with color (or gray tones); it is through color variations that we see and interpret what is present in the picture. The visible objects in the scene are further defined based on their sizes, shapes, patterns, textures, and contrast with each other. Additional visual elements include the relative placement and balance between objects in the picture. Photographic composition has much in common with landscape painting, and many general guidelines have been elaborated over the centuries for creating effective visual imagery in both media. Like all such rules of thumb, however, exceptions often lead to dramatic pictures. Further considerations apply to small-format aerial photography because of its unusual vantage looking down from above.

5-2.1 Oblique and Vertical Views

The high-oblique view is similar to much ground-based landscape photography because the horizon and sky appear. The position of the horizon is generally the

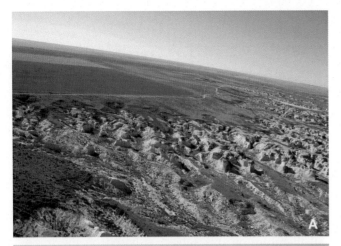

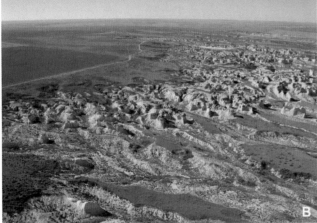

Fig. 5-1 High-oblique views showing the horizon in tilted (A) and nearly level (B) positions. The latter is preferred in most situations. Site known as Little Jerusalem, an area of chalk badlands in western Kansas, United States. Kite photographs with a compact digital camera.

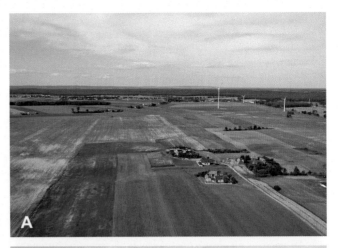

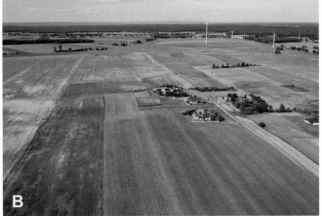

Fig. 5-2 Two high-oblique views of a typical rural landscape in northwestern Poland. (A) Ideal rule of thirds for horizon position. (B) Horizon positioned near the top. The latter is preferred for most SFAP applications, as the sky adds little to appreciation of the scene. Also note better color definition of ground objects in the latter view. Kite photographs taken with a compact digital camera.

most important visual element of such pictures. To begin with, it is extremely important that the horizon appears in nearly level position rather than tilted at an odd angle (Fig. 5-1). This is quite simply the way people are accustomed to seeing the world, and it is what they expect when the horizon is visible (Wildi 2006). For low-oblique views, the horizon is not visible, and it is therefore generally not so important that the scene appear in horizontal position.

The general *rule of thirds* dates from the 1790s (Taylor 2014) and is often applied to the placement of the horizon in landscape photographs, in other words the horizon should appear approximately one-third of the vertical distance from the top (or bottom) of the picture (Caulfield 1987). Seldom, if ever, should the horizon divide the picture in half (Wildi 2006). For SFAP, however, the blue sky itself is rarely of interest; the emphasis is on ground features, so the horizon is often better placed near the top of the scene in order to minimize

the empty sky portion of the picture (Fig. 5-2). This also provides for better exposure of light conditions on the ground. In some cases, however, distinctive or unusual clouds in the distance may be especially attractive, and so the horizon is placed at the lower third position (Fig. 5-3). The *golden triangle* is another, similar approach for placement of objects within the image frame, which may be achieved by judicious cropping (Fig. 5-4).

Compared to the more familiar oblique vantage, vertical SFAP tends to create an alienation effect especially for those viewers who are less used to working with maps, airphotos, and satellite images. This could make the image both more attractive and more difficult to read (Fig. 5-5). By adopting the unusual view straight from above that humans do not often have in real life, the perspective changes and the third dimension of the landscape and objects shrinks, sometimes beyond recognition. Even common objects—trees, buildings, flowerbeds, coastal cliffs,

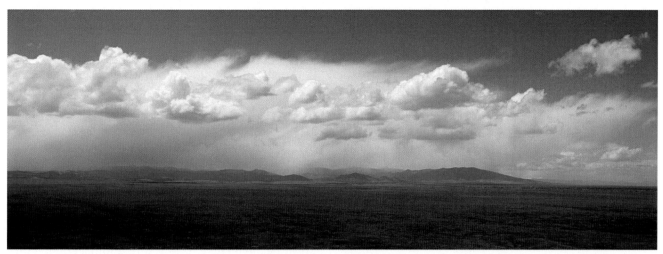

Fig. 5-3 Dramatic clouds and rain falling over the San Juan Mountains in the distance. These clouds are visually much more interesting than is the flat and barren desert in the foreground. San Luis Valley, south-central Colorado, United States. Kite photograph taken with a compact digital camera.

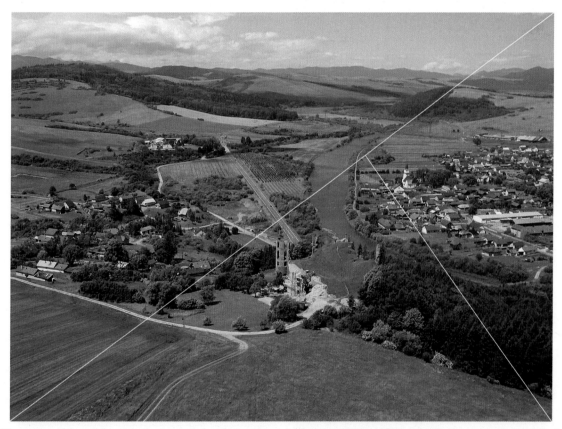

Fig. 5-4 Illustration of the golden triangle approach for placing objects in the scene. Ruins of Plavecsky Hrad (castle) appear in the lower triangle, village of Podzámok is in the left triangle, larger town of Plavec is in the right triangle, and the Poprad River curves through all three triangles. Kite photo taken with a compact digital camera, northeastern Slovakia.

to name just some appearing in this chapter—present themselves in a strange way, creating a surprising or stunning sensation for the viewer. This estrangement effect is a well-known concept in decorative and performing arts.

With the camera high in the sky, it may be difficult for the photographer to judge the best image angle and position with respect to the subject. In recent years, technological advancement has made first-person view (FPV), also called video piloting, a routine technique in unmanned aerial systems (see Chap. 8). The image as seen by the camera is wirelessly transmitted to a video monitor—e.g. laptop, tablet, smartphone, or

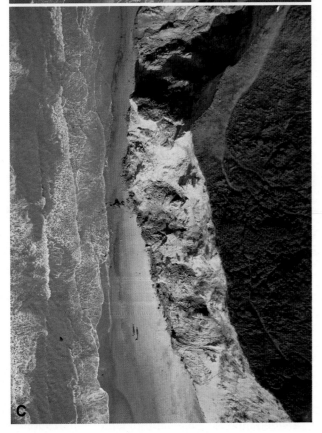

goggles. Thus, the image composition may be judged and adapted in real time, making it much easier to achieve an optimal view of the scene. Nonetheless, aircraft movement, vibration, and delay in camera function may spoil the perfect shot, so it is a good idea to take many pictures, just as all professional photographers do in practice.

5-2.2 Linear Features

Linear features are commonplace on the Earth's surface, both natural and man-made in origin. Such features may be straight or curved, continuous or discontinuous, and are depicted by differences in topography, vegetation, soils, land cover, or land use. The treatment of linear elements may have a strong impact on the image composition. Generally straight linear features should not run vertically or horizontally across the picture, especially near the center of view; diagonal arrangement is much more pleasing (Fig. 5-6). In some situations, linear features may be the dominant visual elements present in a scene, and their diagonal placement may create dramatic views (Fig. 5-7).

Most straight linear objects on the Earth's surface are man-made structures, ranging from fencelines to airport runways (Fig. 5-8). Straight, linear features of natural origin are generally not so common. Fractures of various types in soil, bedrock, or ice often appear as straight features. When viewed from above, distinct linear patterns may be seen (Fig. 5-9). Curved linear features are still more pleasing to view (Wildi 2006; Taylor 2014), such as wandering roads (Fig. 5-10) or meandering streams (Fig. 5-11). C-shaped and S-shaped curves are classic forms, although finding an ideal S-shaped curve from the aerial vantage is easier said than done (Caulfield 1987).

5-2.3 Image Depth

An important element for creating a 3D impression is depth of field, namely focusing sharply only on portions of a scene, while the foreground or background remains softly blurred. However, this is not applicable for SFAP,

Fig. 5-5 Three views from different perspectives of the coastline at Mårup, Denmark. (A) Ground view taken at eye height of the photographer, (B) high-oblique view, and (C) vertical view. Although the oblique aerial view allows a much larger field of view than the terrestrial position, the perspective is still familiar as it resembles vantages such as looking out of high buildings or down from mountain tops. The vertical view, in contrast, is much more exciting and slightly dizzying. Different heights in the landscape are not immediately apparent; the four segments of ocean, beach, cliff, and meadow have an increased distinction by colors and textures, while relief as the most characteristic quality of this landscape is subdued. (B and C) Kite photographs taken with a compact digital camera.

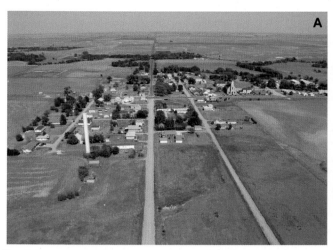 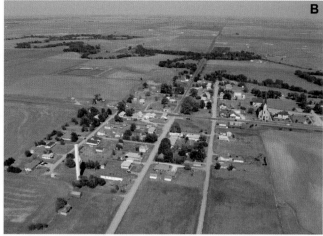

Fig. 5-6 Two high-oblique views over the small town of Liebenthal in western Kansas, United States. (A) Road running vertically across the image center is visually dominant and detracts from the rest of the picture. (B) Slight shift in camera vantage and viewing direction with diagonal roads. The latter draw the eye across the scene, so the viewer looks at all parts of the picture. Kite photographs taken with a compact digital camera.

Fig. 5-7 Strong diagonal elements may be utilized for visual emphasis. Close-up view of reservoir dam and spillway. The small bridge downstream reinforces the diagonal alignment. Fall River Lake, Kansas, United States. Kite photograph taken with a compact digital camera.

where the subject distance is always large and the lens focus set to infinity. Thus, image depth has to be created by the composition itself. Linear features, as we have already seen in the preceding section, are an excellent element for adding dimensions to an oblique aerial photograph (Fig. 5-12).

Another possibility is to structure the image into foreground, middleground, and background. This, too, is not easy to achieve; the opportunities for using distinct objects as foreground elements are rare owing to the high vantage point. Instead, the three depth zones may be composed from horizontally aligned changes

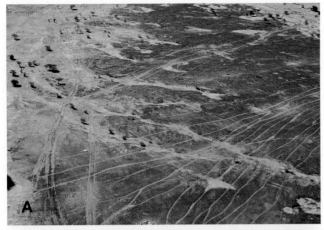

Fig. 5-8 Straight linear features may be dominant visual elements. (A) Paths created by people and animals crossing their ways in cars and on foot in northern Burkina Faso. The stones covering the ground surface—pisolith from laterite crusts—are shifted off the beaten track, exposing the light sandy soil beneath. Kite photograph taken with an analog SLR camera. (B) Fences and roads draw the eye to the cattle pens at the center of this scene from the High Plains of southeastern Colorado. Kite flyers at upper left; image taken with a compact digital camera.

Fig. 5-9 Multiple sets of cross-cutting linear fractures are exposed in this granite outcrop at Point Pinos on the shore of Monterey Bay, Pacific Grove, California, United States. Vertical kite photograph taken with a compact digital camera.

in landscape color or patterns and the horizon as background element (Fig. 5-13). Additional image depth is achieved when both sky and ground contain elements that emphasize perspective by diminishing sizes and parallels converging to the vanishing point (Fig. 5-14). In vertical aerial photography, depth is not an essential compositional issue, although interesting effects may be achieved with shadows (see Chap. 4).

5-2.4 Pattern and Texture

Pattern refers to the arrangement of discrete objects, which individually are visible distinctly and form some more-or-less regular arrangement with each other. Highly ordered patterns are usually man-made, for example vehicles in a parking lot, fruit trees in an orchard, crop rows, or gravestones in a cemetery (Fig. 5-15). Natural and seminatural surfaces, either vegetated or bare, may also make for interesting patterns originating from various geo-ecological or geomorphological processes, as many figures throughout this book illustrate (e.g. Chap. 10). The nature and temporal change of patterns are among the most fascinating aspects of SFAP in the geosciences, where the mutual interactions between form and processes and their expression in patterns are of fundamental interest.

Texture, on the other hand, involves elements that are too small to appear clearly as individual objects but still impart a distinct grain or fabric to the picture, such as waves on water, trees in a dense forest canopy, roof shingles, or prairie vegetation. The difference between pattern and texture is largely a matter of spatial resolution. Features that create texture at small scale may appear as distinct pattern elements at larger scale.

Patterns in an image may be pleasing and enjoyable to the observer (Fig. 5-16), but also could be boring if their alignment and orientation are too regular and their content too monotonous. Patterns often have a most satisfying effect if combined with other elements breaking their uniformity or with other patterns and textures of different scales (Fig. 5-17).

5-2.5 Color

Stereoscopic color vision is the most important human sense (Drury 2001). The nature of color is, thus, a key element in photography. A huge amount of subjective discourse and quantitative research has been devoted to the subject of visible color, human perception of color, and color in nature (Lynch and Livingston 2004). A full discussion is well beyond the scope of this book, so only a few basic aspects of color are reviewed here. For more in-depth discussions of color in photography, see for example Langford and Bilissi (2011) and Taylor (2014).

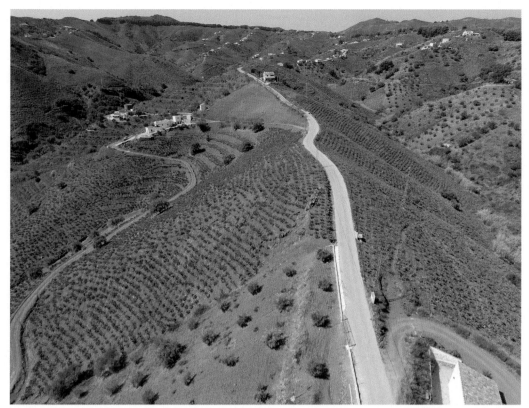

Fig. 5-10 Curving roads run along the crest and wind down the steep slopes of vineyards in the Axarquía near Málaga, southern Spain. The slightly diagonal course and the tapering of the centerline leads the eye from the lower edge into the image background, adding depth and dynamics to the scene. Taken with on-board camera of quadcopter UAV.

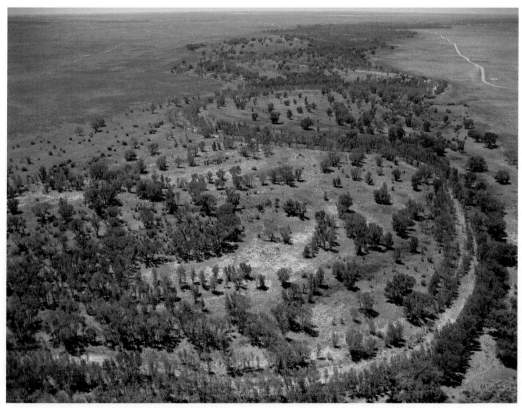

Fig. 5-11 Meanders of the dry channel of the Cimarron River, southwestern Kansas, United States. Such almost perfectly symmetrical S-shaped curves are rare in nature. Kite photograph with a compact digital camera by SWA with P. and J. Johnston.

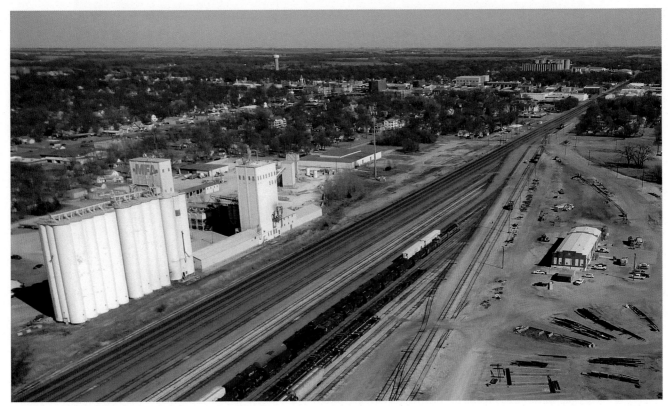

Fig. 5-12 Diagonal rail lines converging in the distance reinforce the perception of depth in this high-oblique overview of the BNSF Railway switching yard at Emporia, Kansas, United States. Kite photograph taken by JSA and D. Leiker with a compact digital camera.

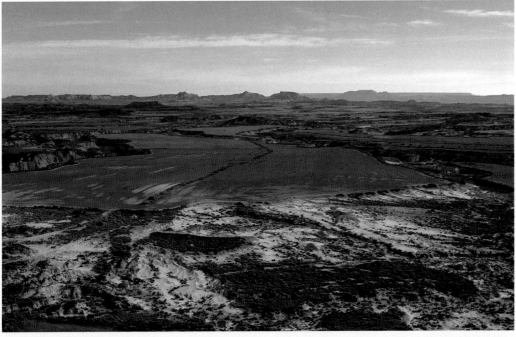

Fig. 5-13 Roughly following the rule of thirds, this view is divided into a foreground of eroded rangeland, a middleground of green fields and hills, and a background where the structural platforms of the Ebro Basin create a silhouette before the sky. Bardenas Reales Natural Park in the province of Navarra, Spain. Kite photograph with a DSLR camera.

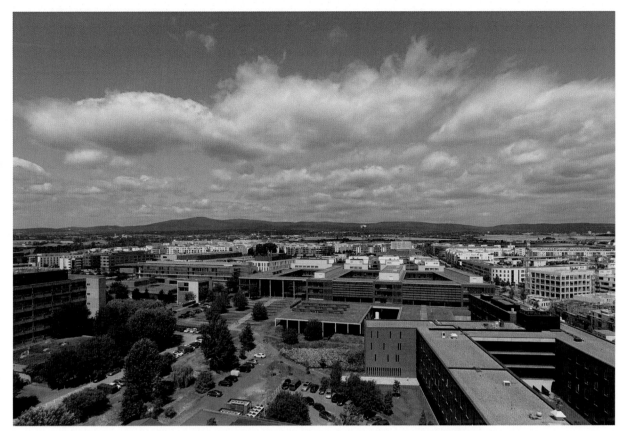

Fig. 5-14 Although opposing the ideal rule of thirds, the low placement of the horizon gives additional depth in this wide-angle view of Frankfurt University's Campus Riedberg, Germany. Clouds as well as buildings converge toward the background of the Taunus mountain range, which reaches an elevation of 880 m ASL at the Großer Feldberg. The campus in the foreground is home to the university's science faculties; the Geocenter is visible in the lower right. Taken with a first-person view camera on-board a quadcopter UAV.

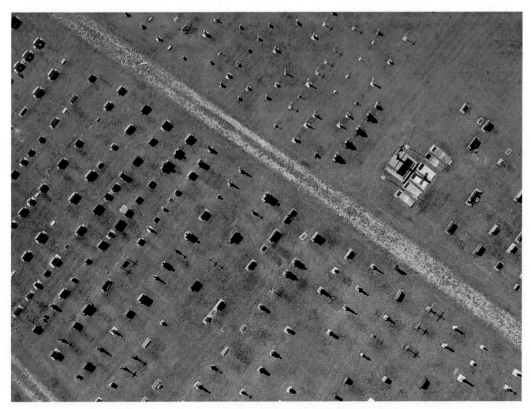

Fig. 5-15 Near-vertical view of headstones arranged in rows of a cemetery. Note distinctive shadows cast by stones and grave markers; also notice relief displacement. Liebenthal, Kansas, United States. Kite photograph taken with a compact digital camera.

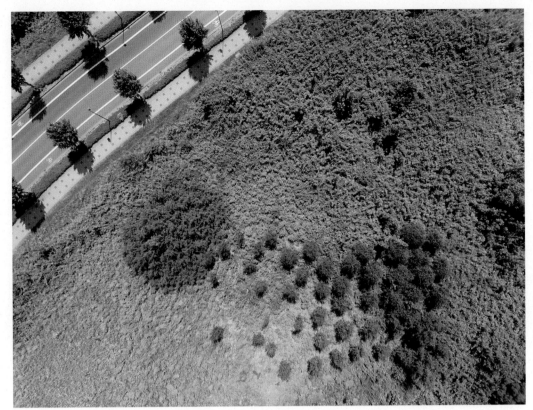

Fig. 5-16 An ecological-compensation area next to a linden-lined avenue makes for a joyfully dotty theme. The circular elements of trees and bushes come in different sizes and arrangements and are partly mirrored by their shadows. Parallel rows of tiny square paving slabs and stark lines of road markings give contrast to the scene. Quadcopter UAV with on-board camera, Altenhöferallee at Frankfurt-Riedberg, Germany.

Fig. 5-17 A variety of patterns and textures discriminates different land uses in this vertical image of a landscape near Baza, Province of Granada, Spain. Flat, narrow valleys are dotted with olive trees of different ages and sizes, north-exposed slopes and abandoned fields at hilltops show the mottled texture of steppe vegetation, and south-exposed slopes and fallow fields are lined with erosion rills and tillage patterns. On a flat surface in the lower right, a newly planted olive grove has the most regular pattern in the image. The SFAP team's cars stand out at the lower right corner with tiny color accents. Fixed-wing UAV photograph with digital MILC by C. Claussen, M. Niesen, and JBR.

The primary colors—blue, green, and red—are also called additive colors, because they may be combined in various amounts to create all visible colors of the spectrum. Subtractive colors, also known as complementary colors, are created by removing (subtracting) an additive color from white light (Table 5-1). The human eye, video display, and digital photography depend on additive colors, whereas printing and film photography are based on subtractive colors. In printing a color image from a computer display, for example, the printer must translate additive colors of the monitor into corresponding combinations of subtractive colors for the printer.

Several quantitative means exist to define color. One approach is based on the proportions of primary colors and their intensities. Another well-established means for defining color is the *Munsell Color* system, which is based on three attributes of color that are often illustrated in a wheel diagram (Fig. 5-18). It is widely used in the geosciences for describing soil and rock colors, and is similar to the HSL or IHS color space implemented in many graphics programs.

- Hue—Actual spectral color such as red, yellow, green, and blue. Hue is designated by a number and letter: 5R (red), 10YR (yellow-red), or 5GY (green-yellow), etc.
- Value—Lightness or brightness of the color. Value ranges from zero for pure black to 10 for pure white.
- Chroma—Intensity or saturation of the color. Chroma begins with zero for neutral (gray) and increases with no set upper limit.

Common rock and soil colors, for example, are moderate yellowish brown (10YR 5/4), light olive gray (5Y 5/2), and pale red purple (5RP 6/2). Moderate yellowish green (10GY 6/4) and brilliant green (5G 6/6) are typical vegetation colors (Rock-Color Chart Committee 1991).

Colors may be described in general as hot (warm) or cold (cool). The former includes red, orange and yellow; the latter are violet, blue, cyan, and green. Hot colors represent longer wavelengths; cold colors are shorter

Table 5-1 Relationship of primary and subtractive colors.

Primary colors	Wavelength	Subtraction from white
Blue	0.4–0.5 μm	Yellow (green + red)
Green	0.5–0.6 μm	Magenta (blue + red)
Red	0.6–0.7 μm	Cyan (blue + green)

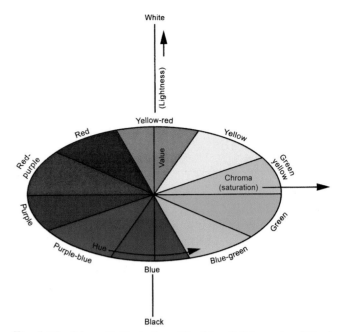

Fig. 5-18 Schematic illustration of the *Munsell Color* system. Wheel arrangement of hue, value, and chroma. *Adapted from Rock-Color Chart Committee (1991).*

wavelengths (see Fig. 2-1). Most of the Earth's surface is covered by objects of cool or neutral colors: green vegetation, blue-green water, tan-brown soil, etc. Hot colors are much less common and, so, tend to stand out in aerial photographs, especially when the hot colors are bright compared with the background (Fig. 5-19). It is because

Fig. 5-19 Vertical view of summer cabins and boat docks on a recreational lake. The bright red vehicle stands out in this otherwise dull winter scene dominated by neutral gray-brown and cool colors. Without the red splash of color, this picture would be quite drab. Lake Kahola, Kansas, United States. Kite photograph taken with a compact digital camera.

hot colors are generally lacking in nature, that people are attracted to autumn foliage, painted-desert scenes, wildflowers, and similar bright, warm colors. In fact, hot and cold colors induce a pseudo depth perception—hot colors appear closer and cold colors seem farther away from the viewer (Eyton 1990; Stroebel 2007).

5-3 COMBINING COMPOSITIONAL ELEMENTS

The combination of multiple visual elements creates the most dramatic photographs from an aesthetic point of view. In SFAP, the interrelation of different landscape elements, natural processes, and human activities often results in a complex and visually attractive blend of shapes, patterns, and textures. The concept of compositional balance refers to the placement and relative visual impact of objects in the picture (Wildi 2006).

Most pictures consist of a main subject and secondary subjects arranged within a less conspicuous background. In general, the main subject should not be located at the geometric center of the photograph. The main subject should be offset toward the top, bottom, or one side—following the rule of thirds or golden triangle—to create a more dynamic image. In some cases, no main or secondary subject exists, for which repetition of similar elements leads to visual balance and is pleasing to the eye (Taylor 2014).

The human eye quickly scans a visual image and unconsciously is attracted to certain objects, namely people, bright colors (especially red), areas of high contrast, linear features, and geometric shapes (Taylor 2014). Such elements should be arranged to keep the viewer's gaze within the image. The following examples demonstrate the potential of multiple visual elements to create striking images.

Rose garden—The vertical photograph of a formal rose garden depicts strong linear and circular elements (Fig. 5-20). Although the garden has an extremely symmetrical form, its placement in the image gives a dynamic effect. The parallel and orthogonal walkways run diagonally through the scene. They intersect at the circular fountain, which forms the visual main subject, and which is offset below the geometric center of the image. The rotation and offset result in truncation of the main subject, but the missing part of the garden is easily mirrored in the viewer's mind. A perfectly straight and centered placement would be boring in comparison.

Most of the scene is medium green lawn grass with strong contrast between the bright paved walkways and dark tree shadows. Red and yellow rose flowers form tiny dots of color in the otherwise green, tan, and gray scene. Shadows fall toward the lower right corner, but obscure little of the ground area. Smaller pattern and texture elements include the rectangular lattice of arbors, arrangement of individual rose plants, and faint mowing lines in the lawn. A few people stand in random positions

Fig. 5-20　Vertical view of formal rose garden in early summer. Loose Park, Kansas City, Missouri, United States. Helium-blimp photo taken with a compact digital camera.

on the walkways or in the lawn. Finally, sun glitter from waves in the fountain adds a sparkling touch.

Bicycle riders—The portrait format of bicycle riders emphasizes the curving path of the trail and stone wall leading the eye from the near right corner to top left edge of this scene (Fig. 5-21). Most of the picture consists of neutral gray, green, and tan colors. Brightly colored wind-surfing kites stand out prominently, and shadows are perfectly proportioned to depict silhouettes of the bicycle riders. Sand, rocks, vegetation, and water waves display a rich variety of textures and small pattern elements. A well-composed photograph does not necessarily need color as a visual element, as the next few examples for nearly monochromatic scenes demonstrate.

Agricultural fields—There is strong tension in the bisected view of the nearly bare soil surfaces of abandoned and newly created agricultural fields in South Morocco (Fig. 5-22). On the left side, linear erosion forms dendritic patterns accentuated by deep shadows. Following the course of the gullies, the eye is drawn toward the main wadi that creates a sharp partition meandering from the upper center to the lower third of the image.

Fig. 5-21 Low-oblique view of recreational park and bicycle path. Foster City, San Francisco Bay, California, United States. Kite photograph taken with a compact digital camera.

The completely flat right side is exclusively characterized by the small-scale patterns and texture of bulldozer tracks, soil clods, and plowed-up boulders.

Fishing lagoon—Similar contrasts between two subjects, linear and textural elements, exist in this view of a small lagoon (Fig. 5-23), where sun glint from waves on the water surface forms distinctive, intersecting curved patterns. Most of the picture consists of nearly monochromatic gray and green-gray colors with high brightness contrast. The linear dock with right-angle bends juts from the upper left corner, but without reaching the center. The dock also has neutral gray colors, and shadows fall toward the bottom of the view. The juxtaposition of artificial linear and natural curved elements in different scales creates a visual conflict that draws the eye back and forth between the two patterns.

Gully erosion—Linear elements of different qualities are overlaid with an irregular punctual pattern in the vertical photograph of a wide gully cutting into a near-flat *glacis d'accumulation* in Burkina Faso's Sahel (Fig. 5-24). Small rills forming dendritic networks unite in progressively broader fluvial channels; the position of the gully approximates the rule of thirds with both the main drainage line and its upper edge. The comparatively homogeneous glacis area in the upper part of he image is delimited by the cauliflower-like outline of the gully edge. From top to bottom, the size and density of bushes and trees dotting the scene increase.

Turbine blades—Wind-turbine blades stored in a railway depot display a remarkable pattern in this vertical view (Fig. 5-25). The strongly linear, parallel, and diagonal alignment is softened by the wave-like shape imparted by curved blades, but vegetation or other natural features are completely lacking in this industrial setting. Tiny dots of orange around the service truck give some color in this otherwise monochromatic scene that displays high contrast between white blades and black shadows. The service truck provides a scale object to establish the size of blades. Small features that add interest include seams and bolts on blades and vehicle ruts in the ground.

Bog colors—Raised bogs may display spectacular autumn colors (Fig. 5-26). The bright green, gold, and red colors represent various species of *Sphagnum* moss, which contrast with dark water pools and dull gray-green dwarf pine trees in this Estonian bog. This scene lacks a main subject; rather it is composed of color, pattern, and textural elements that are repeated throughout the image more or less uniformly in distribution, but without creating a strong pattern. Shadows fall in the lower right direction. Nothing of human origin is visible, and no objects of known size or shape are present; thus, the photograph has no scale reference. This image demonstrates the remarkable spatial complexity of a completely organic, natural environment.

Fig. 5-22 Vertical view of abandoned and eroded (left side) and newly leveled (right side) agricultural fields on a sedimentary fan near Taroudant, South Morocco. Fixed-wing UAV photograph with digital MILC.

Fig. 5-23 Low-oblique picture of coastal lagoon and fishing dock. Grand Isle State Park, Louisiana, United States. Award-winning kite photograph taken by SWA and JSA with a compact digital camera.

Fig. 5-24 Vertical view of gully erosion near Gorom-Gorom, Province of Oudalan, Burkina Faso. Kite photograph taken with an analog SLR camera.

Fig. 5-25 Wind-turbine blades stored in the BNSF Railway depot, Emporia, Kansas, United States. Kite photograph taken with a compact digital camera by JSA and D. Leiker.

Fig. 5-26 Vertical shot of raised bog displaying autumn color. This picture won the photography award in the Science and Engineering Visualization Challenge from the U.S. National Science Foundation (AAAS/NSF 2005). Field of view ~100 m across; Mannikjärve Bog, Estonia. Kite photograph taken with a compact digital camera (Aber et al. 2002).

5-4 PHOTOGRAPHS VERSUS HUMAN VISION

Photographs are often considered to be accurate portrayals of visual scenes. However, photographs do not record images in the same way the human eye and brain would respond to the identical scenes. For the following discussion, we ignore special techniques, such as filters and infrared. The discussion focuses on natural-light photography under sunlit conditions. There are several fundamental ways in which photographic images differ from what is seen by the human eye.

- Field of view—Camera lens focal length determines the field of view which is focused onto the electronic detector array or film. A focal length roughly equal to the diagonal size of the sensor (~50 mm for full-frame 35 mm cameras) approximates the central zone of the human visual field. A wide-angle lens compresses more field of view onto the image plane, whereas a telephoto lens severely limits (crops) the field of view (Fig. 5-27). The human eye provides for an extremely wide angle of peripheral vision, up to ~160 degrees in most people. This peripheral vision is good for recognition of gray-tone patterns and is highly sensitive for detection of movement, but has almost no color capability. Photographs do not provide a similar peripheral field of view—the softly edged elliptical viewing field of the photographer is sharply trimmed to the image frame.

- Dynamic range—This refers to the range of highlights and dark features that are properly exposed in a photograph. Beyond this range, dark objects are black and bright objects are white (blown out). Latitude, on the other hand, is a more limited range of f-stops (within the dynamic range) that may produce a usable image (Chapman 2013). Conventional color-slide film has a total latitude of about five f-stops (Shaw 1995). Modern digital cameras have improved latitude, depending on camera model, sensor capability, light settings, image format, and processing. Latitude of digital cameras is generally in the range of 8–12 f-stops. The human eye, in contrast, has much greater latitude equivalent up to nearly 24 f-stops (McHugh 2018).

- Color saturation—Our visual system adapts itself to changes in light intensity and color temperature, but the color rendition of color film and electronic sensors may be different from the human eye. People tend to prefer vibrant, rich, saturated colors in photographs.

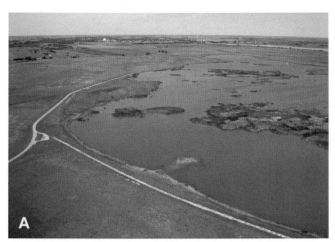 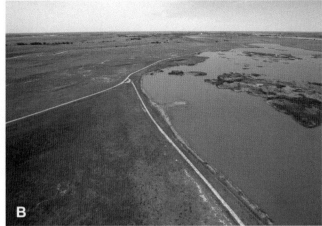

Fig. 5-27 Standard (A) and ultrawide-angle (B) fields of view over the Nature Conservancy marsh-and-meadow complex at Cheyenne Bottoms, Kansas, United States. The latter suffers some geometric distortion in order to compress the wide field of view into a standard image frame. Kite photographs taken with compact and SLR digital cameras from approximately the same vantage on the same day.

In the age of analog photography, film makers responded to this preference in different ways. Some manufacturers favored color-saturated films, whereas other films rendered color as close as possible to reality (Zuckerman 1996). Similar differences are apparent in color recorded by digital cameras and in the algorithms that convert from the raw digital numbers to RGB values in JPG files (see next chapter). Most digital cameras have a selection of settings for white balance or color modes that allow the user to adapt the color temperature or color range and intensity.

Given these and other factors, it should be clear that a photographic image of a scene is different in several ways from the human visual impression of that same scene. The photograph represents a selection of certain elements—field of view, exposure range, and color saturation, which are in general different than a human observer would sense. On the other hand, a photograph is a permanent record of the scene, while the human impression is stored as a visual memory that cannot be reproduced fully or accurately for analysis or sharing with others.

5-5 SUMMARY

Although artistic aspects are not of primary importance in SFAP taken for scientific purposes, good image composition may greatly enhance the explanatory power of an image taken for earth-resource applications. Aerial photography shares many compositional elements with ground-based photography. However,

the bird's-eye view afforded by small-format aerial photography opens new vistas for image composition. For high-oblique views, generally the horizon should be nearly level and little sky should be visible. Vertical views present a much less familiar perspective of the landscape, which may result in an estrangement effect that makes the image both more attractive and more difficult to read.

Linear features, both straight and curved, draw the viewer's eye into the picture, and the placement of linear objects has a strong influence on the overall visual impact of the image. Patterns, especially at different scales or combined with other elements, may be important aspects for making an image interesting and enjoyable to the observer. Color is the fundamental basis of image recognition. In general, people react more favorably to warm colors than to cool colors; warm colors stand out and may create a pseudo depth perception. The combination of multiple visual elements creates the most dramatic photographs from an aesthetic point of view. The interrelation of different landscape elements, natural processes, and human actions often results in a complex and visually attractive blend of shapes, patterns, and textures.

Photographs differ in several significant ways from human vision including field of view, dynamic range, and color saturation. Furthermore, humans normally perceive the world in stereoscopic vision from ground level. Small-format aerial photographs represent a permanent image record; whereas, human vision is stored in memory that cannot be reproduced fully or accurately.

6

Cameras for SFAP

I hate cameras. They are so much more sure than I am about everything. John Steinbeck in a letter to his editor, 1932 (Steinbeck et al. 1975)

6-1 INTRODUCTION

A plethora of cameras is available for small-format aerial photography. In general, these cameras are relatively compact, light-weight, and capable of operating in largely automated modes. In fact, any camera designed primarily for hand-held use on the ground may be adapted for manned or unmanned small-format aerial photography from a variety of platforms. SFAP cameras range from inexpensive, disposable film cameras to high-end, professional-grade digital cameras.

In spite of what appear to be great differences between various cameras, all have certain basic components—lens, diaphragm, shutter, and image plane within a light-proof box. Most also have either an optical viewfinder or a monitor screen to depict the image, although neither is required for unmanned aerial photography. Geometry of the lens and image format determine the scene area focused onto the image plane. The diaphragm and shutter control the amount of light to expose each photograph. Conventional analog cameras are designed to accept film of certain format or width—for example 35 mm, 70 mm, 5 in., or 9 in. Cameras for 35-mm film first appeared in the 1920s and became the standard for hand-held cameras as well as small-format aerial photography for the remainder of the 20th century (Taylor 2014).

Most popular analog cameras are for 35-mm film, whereas professional photographers tend to employ 70-mm format cameras. The even larger formats are utilized mainly for scientific, engineering, and survey applications. For purposes of SFAP, digital cameras have largely superseded film cameras. Nonetheless, basic principles and much terminology that evolved for film cameras apply also for digital cameras. The following discussion begins with analog cameras and proceeds to digital cameras with an emphasis on those aspects that are most useful for SFAP.

6-2 FILM CAMERA BASICS

The basis for traditional analog photography is light-sensitive chemicals in the film emulsion. Such photochemical imagery depends upon the reaction to light of minute silver halide crystals, which undergo a chemical change when exposed to ultraviolet, visible, or near-infrared radiation. This photochemical change may be developed into a visible picture. The sensitivity of chemical photography ranges from about 0.3 to 0.9 μm wavelength. The lower limit is based on available ultraviolet energy and strong atmospheric scattering; film spectral sensitivity determines the upper limit.

Different parts of the spectrum may be photographed by using various films and filters. In fact, many film-and-filter combinations have been developed for routine and special purposes in aerial photography (Table 6-1). Photographs are routinely taken in b/w panchromatic, b/w extended red, b/w infrared, color-visible, color-infrared (Fig. 6-1), and multiband types.

Multiband photography is taking simultaneous photos in different portions of the spectrum. Early attempts at color photography in the 19th century were, in fact, based on separate b/w photographs in blue, green, and red bands that when viewed together simulated natural

Table 6-1 Common film types and uses in conventional aerial photography: B/W = black-and-white (gray-tone) photos.

Film type	Uses of film
B/W visible	Panchromatic, normal visible
B/W extended red	Panchromatic, haze penetration
B/W infrared	Ultraviolet, visible, or infrared
Color visible	Normal color: blue, green, and red
Color infrared	False color: green, red, near-infrared

77

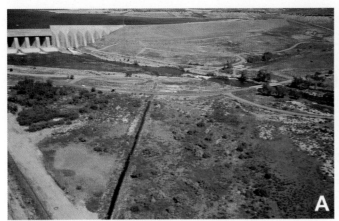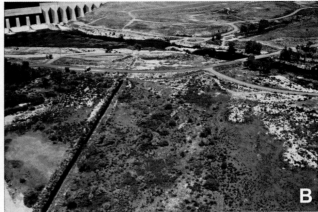

Fig. 6-1 Color-visible (A) and color-infrared (B) 35-mm film photographs of the Arkansas River valley below Lake Pueblo, Colorado, United States. In B, active vegetation appears in pink, red, and maroon colors on the floodplain. Kite photographs taken with analog cameras.

color (see Chap. 1-2.1). Another variation is four-band photography with separate b/w photographs in blue, green, red, and near-infrared bands. As an example, the *Apollo* 9 mission in 1969 included a photographic experiment in which four coaxially mounted *Hasselblad* 70-mm film cameras were used to acquire multiband imagery (Lowman 1999).

6-3 DIGITAL CAMERA BASICS

During the 1990s, digital still cameras were developed for general and scientific use, and the capability of digital cameras advanced rapidly in the early years of the 21st century. These cameras employ electronic devices to sense light. The sensor is essentially a microscopic array of semiconductors that measures light intensity in a raster grid. The picture is made up of many small squares—also called cells or pixels (picture elements).

Early digital cameras of the 1990s could not deliver the high spatial resolution possible with conventional film. However, within the past 15 years, digital cameras with large megapixel sensors have come on the market at moderate cost. These cameras produce images that surpass the sharp detail of 35- and 70-mm films. In fact, digital technology has replaced film for most photography, except for the low-end disposable-camera market and special high-end applications.

6-3.1 Types of Digital Cameras

A large choice exists for compact, point-and-shoot digital cameras, which are small, light-weight, and easy to use. They have built-in zoom lenses that usually reach from wide angles to moderate telephotos (Fig. 6-2A). Technically, and in terms of image quality, they are less advanced than interchangeable-lens system cameras. System cameras include at least two components, the camera body and a separate lens, and further

components may be added such as an interchangeable viewfinder, electronic flash, and motor drive. The most common type is the single-lens reflex (SLR) camera that was invented in the late 19th century. The digital SLR (DSLR) is a modern variant of this approach (Taylor 2014). They feature parallax-free optical viewfinders, interchangeable lenses and filters, and larger sensors (see below) than compact cameras. Within the general category of system cameras, two types have emerged.

- Traditional DSLR designs evolved from film SLR cameras that feature a mirror-and-pentaprism system and optical through-the-lens viewfinder (Fig. 6-2B). Camera body, battery, and lenses are all large and heavy and, therefore, represent a difficult choice for SFAP in spite of outstanding image quality.
- Mirrorless interchangeable-lens cameras (MILC) lack the mirror-and-pentaprism system and optical viewfinder and are, thus, considerably smaller and lighter than traditional DSLR cameras (Fig. 6-2C and D). They retain the advantages of interchangeable lenses, use of filters, and large sensor arrays. Some models feature electronic viewfinders in addition to the display screen.

In terms of radiometric and geometric image quality, mirrorless interchangeable-lens system cameras are currently the most attractive choice for SFAP. Recent years have seen an increasingly wide range of high-quality MILC with large sensors and fixed-focus lenses. Compared to DSLR cameras, the lack of an optical viewfinder—not of interest for SFAP—and a moving mirror reduces weight, size, and vibration. Their usually rather slim and brick-shaped form makes them easier to fit into confined spaces of UAV bodies or pendant camera mounts.

Full-frame sensor MILCs are currently offered by *Canon, Leica, Nikon,* and *Sony*. Particularly attractive in terms of reduced payload for SFAP platforms are MILC models with reduced lens diameter compared to tradi-

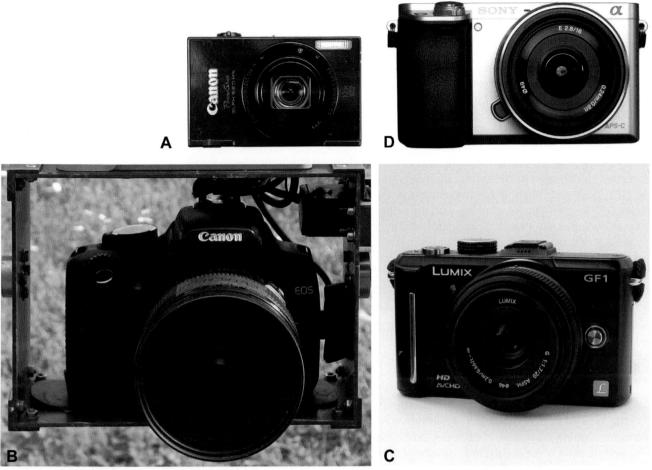

Fig. 6-2 Different types of digital cameras issued between 2005 and 2015 that have been used by the authors for many years in various tethered and free-flying platforms; shown here in comparable scales. (A) *Canon PowerShot Elph* 520 HS (*Ixus*) compact camera. The body measures ~5½ by 8½cm, and the sensor is 10MP. (B) The *Canon EOS* 350D (*Digital Rebel*) with 8 MP APS-C sensor (see Fig. 6-4) was among the authors' first DSLRs. Shown here in a kite rig, fitted with a with 20-mm lens that has been taped to secure the focus set to infinity. (C) The 12MP *Panasonic Lumix* DMC-GF1 with 20-mm lens is small and light enough to be carried by a fixed-wing UAV (see Chap. 8-4.2). It was one of the first MILCs on the market and uses the Micro Four-Thirds standard, with reduced lens diameter compared to full-frame DSLRs. (D) The *Sony* α6000 MILC with 16-mm lens and UV/haze filter has an APS-C sensor with 24MP. Camera body measures ~6½ by 12cm, and total weight including battery is ~0.4kg. This MILC is a popular camera model offered by many UAS manufacturers as a standard payload for their platforms.

tional SLR mounts, which is made possible with sensors of the APS-C or Micro Four-Thirds (MFT) class (e.g. *Sony* α6000 series, the *Panasonic Lumix* DMC-G line and the *Olympus* PEN series). A variety of this camera type are lens-style MILC that have no noteworthy body at all as camera control and display are taken care of by the photographer's attached smartphone. The *Sony QX1* for example has become quite popular with UAS manufacturers as a payload option. In addition, the rapid increase of the use of optical cameras in UAS has led to the development of dedicated remote-controlled MILC that are not designed to be hand-held, such as the *DJI Zenmuse* series (see Fig. 8-15B).

Between these main types of compact and system cameras, several other designs exist. The so-called bridge cameras with their large zoom ranges have an appearance and manual exposure control possibilities similar to system cameras, but non-interchangeable lenses and the smaller sensors of compact cameras. At the high-price and high-quality end, there are also a few digital cameras of the classic rangefinder type (compact design, manual focusing mechanism, fixed single-focus lens) best known in the mid-20th century.

Still a drawback for many digital cameras, especially compact models, is the comparatively long shutter delay and slow frame rate. Although all cameras feature a continuous drive mode, the image repeat speed may be as slow as 1 fps, and maximum shots in a row are usually limited to 3–10 images. In normal mode, the interval required between repeated exposures is often as long as 3–4s for compact cameras, which is problematic for fast-moving platforms such as fixed-wing UAVs.

Designed for burst-mode and video recording and suitable as payload even for small UAS or kites are

body-worn action cameras that are robust, compact, and light-weight. The *GoPro Hero* series, for example, is a popular choice with the first generations of multirotor UAS and DIY drone kits, in spite of the geometric disadvantages of its ultrawide-angle lens. Meanwhile, small quadcopter-type UAS are usually fitted with fully integrated, on-board cameras (Fig. 6-3; see also Fig. 8-16). These tiny cameras are reduced to the essential basics, a sensor and a fixed-focus lens. As they are designed for remotely controlled aerial imagery, they can afford to dispense with all the usual components required for handling a camera—viewfinders, displays, mode dials, etc. Camera stabilization for avoiding motion blur is achieved with electronic gimbals, and surprisingly long exposure times are possible. Their minimalistic design with lack of moving parts makes them actually attractive also with respect to photogrammetric stability (see also below and Chap. 8).

In addition to optical cameras for normal color photography, multispectral and thermal cameras specifically designed for UAS are increasingly available. These are discussed in Section 6-5.

6-3.2 Digital Image Sensors

Picture quality for film cameras is determined mainly by the type of lens because the same film may be used in many cameras. For digital cameras, however, the lens as well as sensor capability determines picture quality because both vary greatly in different camera models (Meehan 2003). Digital cameras typically employ shorter lens focal lengths because most electronic detectors have smaller dimensions than 35-mm film.

Sensor size is one way to compare different types of cameras. For SFAP, consider a traditional 35-mm film camera. The film image size is 36 by 24 mm, which is known as full frame. Some high-end digital system cameras have full-frame detector arrays, but most common digital cameras do not. The relationship between detector size and full frame is the crop factor (Fig. 6-4). For example, the APS-C format has a crop factor of 1.5 (detector size = 24 by 16 mm), which gathers less than half as much light compared with a full-frame sensor. Many point-and-shoot digital cameras have still smaller sensors and larger crop factors, and popular smartphone cameras have crop factors >7. The size of the sensor, particularly sensor cell size (pixel pitch), is a critical factor for determining image quality in digital cameras. Smaller sensor cells generate increased noise and have restricted ISO and dynamic ranges, all of which compromise image quality (Taylor 2014).

Compact digital cameras mostly display an image length-to-width format, known as aspect ratio, of 4:3, and the sensor is typically only 1/36 the size (6.0 crop)

of full-frame sensors. MILC and DSLR cameras usually have the 3:2 aspect ratio, same as 35-mm film, with sensor sizes typically 40%–100% the size of a 35-mm negative. Movie format, in contrast, has an aspect ratio of 16:9 which is semipanoramic in format. The largest sensors used in system cameras may have pixel densities below 3 MP/cm^2, while the smallest sensors currently built into compact cameras are only around 6×4 mm in size and have pixel densities up to 43 MP/cm^2. The much smaller pixel size of point-and-shoot camera sensors is the main reason for the difference in image quality (noise

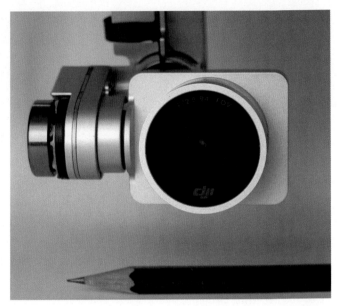

Fig. 6-3 Integrated on-board camera of the *DJI Phantom* 3 quadcopter UAS, with 1/2.3 in. *Sony* sensor for 12 MP stills or 4K videos and 3.61-mm lens (20-mm equivalent). This camera is mounted to an electronic gimbal and fully controlled by the UAS on-board computer via an app on a mobile device; power supply is outsourced to the drone battery. It is basically reduced to sensor and lens; the camera body measures a mere 3.5 by 4 by 1.2 cm—smaller than a matchbox.

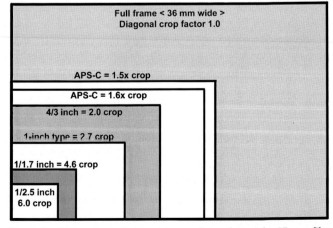

Fig. 6-4 Comparison of sensor sizes and crop factors for 35-mm film (full frame) and various digital cameras. *Based on Dempsey (2016).*

and dynamic range) between digital compact cameras and system cameras (Langford and Bilissi 2011; Clark 2016a,b).

Two main types of electronic detectors are employed in digital cameras, nowadays, known as the charge-coupled device (CCD) and complementary metal oxide semiconductor (CMOS). Both employ an array of semi-conductors (usually silicon) to detect light intensity; their differences are in terms of architecture of semiconductor structure (Kriss 2007; Langford and Bilissi 2011).

According to a filter placed on top of each sensor, each semiconductor in the array detects light energy for only one primary color—red, green, or blue. The result is an image mosaic of three colors; the missing color values for each pixel are later interpolated from neighboring pixels by demosaicking algorithms (Fig. 6-5). The most popular arrangement for filters is the Bayer pattern, which has twice as many green filters as red and blue filters. This takes into account the green peak in solar energy and enhanced green perception in the human eye (Fig. 6-6).

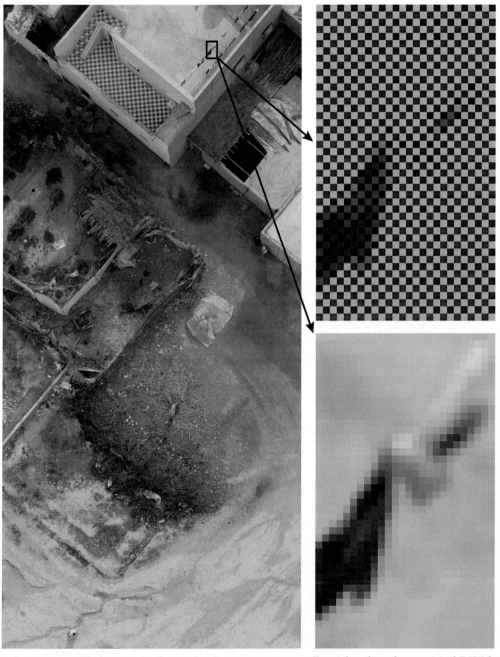

Fig. 6-5 Subsets of a vertical aerial photograph taken with a Bayer pattern sensor. Top right subset shows original RAW format with mosaic pattern, left and bottom right subset shows demosaicked version exported as TIF. Taken with digital MILC from fixed-wing UAV at El Houmer, South Morocco.

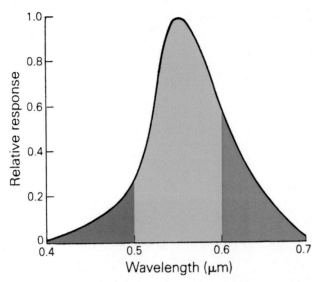

Fig. 6-6 Overall sensitivity of the human eye to photopic (daylight) vision. Blue and red sensitivity are much less than green. *Based on Drury (2001).*

The main disadvantages of these sensors are associated with the difficulties of demosaicking. The resulting image may contain artifacts, especially in areas of fine color patterns, and is strongly influenced by the algorithms used to reconstruct missing pixel color values and deblur the image. Numerous solutions have been published on dealing with these problems (Trémeau et al. 2008). The within-camera image-processing software is proprietary for each camera model, and individual digital cameras may produce noticeably different versions of the same scene. As an alternative to in-camera processing, dedicated RAW processing software, e.g. *Raw Therapee*, offers a choice of different algorithms for demosaicking. The influence of different Bayer demosaicking algorithms on the geometric quality of the resulting images—crucial for photogrammetric measurement—has been discussed by Perko et al. (2005) and Shortis et al. (2005).

6-3.3 Digital File Formats

The original measurements of each sensor cell are typically converted to digital numbers (DN) with 12-bit resolution, which are referred to as RAW image values. The RAW file format represents the complete and lossless spectral information as recorded by the sensor and may be saved as such by some compact cameras and all digital system cameras. For most digital cameras, the default setting for image capture is an automated within-camera processing, which allows saving the images in 8-bit JPEG format. JPEG is a standard image format with excellent compression capacities, fast access times, and immediate usability for viewing, printing, and web posting. However, such in-camera processing and image compression reduce the original information present in a scene in several ways; default or user-set parameters for demosaicking, white balance, exposure, sharpening, color enhancement, etc. are applied, and the original image is changed forever.

The numerous implications of using JPG vs RAW file formats with respect to scientific photography are discussed in detail by Verhoeven (2010). A key advantage of saving an image in RAW rather than JPG is that the photographer retains full control over the processing of the data when converting the raw measurement values to an image file, for example by custom histogram adjustment for images with both bright and dark areas (see below and Chap. 11). This may be done using the camera manufacturer's proprietary decoding software or other image-processing software capable of RAW converting. The drawbacks of the RAW format are much larger storage size and slower access. Also, many remote-sensing and photogrammetry software packages do not yet support direct reading of RAW file formats, making post-processing and conversion to TIF or JPG a necessity.

6-4 CAMERA GEOMETRY AND LIGHT

A geometric relationship exists between the lens focal length, image format, area (angle) of view, and the amount of light that reaches the film or electronic sensor. Many cameras are equipped with zoom lenses that allow the user to vary the focal length. The lens aperture and shutter speed are fundamental controls for how much light reaches the film or image sensor. Film speed or ISO digital rating determines how much light is required for correct exposure of the photographic emulsion or electronic detector elements. Each of these factors is examined in turn.

6-4.1 Focal Length

All but the simplest camera lenses are compound lenses made of multiple glass elements (Kessler 2007). Rays of light entering the lens are refracted within the lens in such a way that they seem to converge in a single point on the optical axis (the front nodal point) and leave from a single point on the optical axis (the rear nodal point). The distance between the rear nodal point when the lens is focused at infinity and the focal plane or image plane is called focal length (Wolf et al. 2014). Shorter focal lengths result in wider angles of view and vice versa. The angle of view also depends on sensor size (Table 6-2). Single-focus lenses are often denominated by their angle with respect to human vision, i.e. normal-angle (or standard), wide-angle, or telephoto lens.

Table 6-2 Table showing diagonal angles of view for lenses of different focal lengths and sensors with different crop factors. Gray shading indicates approximate focal length that captures a view as our eyes would in the primary field of vision (so-called standard lens). Angles to the upper right of this diagonal are wide-angle lenses, those to the lower left are telephoto lenses. Based on data presented by Taylor (2014).

Focal length (mm)	1/2.5 in. (6.0 crop)	1/1.7 in. (4.6 crop)	2/3 in. (3.9 crop)	1 in. (2.7 crop)	4/3 in. (2.0 crop)	APS-C (1.5 crop)	APS-H (1.3 crop)	Full frame (1.0 crop)
6	51°	65°	72°	96°	110°	126°	135°	143°
10	32°	42°	48°	67°	82°	99°	110°	122°
14	23°	30°	35°	51°	64°	80°	91°	105°
18	18°	24°	28°	41°	51°	66°	77°	90°
24	14°	18°	21°	31°	40°	52°	62°	74°
28	12°	16°	18°	27°	34°	46°	54°	65°
35	9°	12°	14°	22°	28°	37°	45°	54°
50	7°	9°	10°	15°	20°	27°	32°	40°

As the angle of view depends on both the focal length and the image area, a normal angle for a digital camera with a small sensor chip is achieved with a shorter focal length than a normal angle for an analog small-format film negative (36×24 mm). Nevertheless, lenses for digital cameras are often characterized by their 35-mm film-equivalent focal lengths, because many photographers are familiar with traditional small-format cameras, and digital sensor chips are not standardized in size as is 35-mm film. With few exceptions, compact cameras today have zoom lenses with variable focal lengths, whereas lenses with single focal lengths as well as zoom lenses are available for system cameras.

6-4.2 Lens Aperture

The aperture of the lens opening, which is controlled by the diaphragm, is given by a value called *f*-stop, which is defined as lens opening diameter divided by lens focal length. *F*-stop is thus a fraction. On most cameras, *f*-stop values are arranged in sequence such that each interval represents a doubling (or halving) of light values. Smaller *f*-stop denominator values mean more light enters the camera; larger values indicate less light. The typical sequence of *f*-stops is given below (Shaw 1995). Most lenses operate in the range *f*/2.8 to *f*/22.

f/1, *f*/1.4, *f*/2, *f*/2.8, *f*/4, *f*/5.6, *f*/8, *f*/11, *f*/16, *f*/22, *f*/32

Although the *f*-stop values as fractions are useful as a comparable aperture definition for lenses of all sizes, the absolute amount of light entering the camera is still dependent on the lens diameter. Smaller lens diameters— as used in compact cameras and smartphones in contrast to full-format system cameras—allow fewer photons to reach the image plane during a given exposure time. For digital cameras, this in turn means greater image noise (Clark 2016b).

6-4.3 Shutter Speed

The length of time the shutter remains open is called shutter speed. On most cameras, shutter speed values are arranged in sequence such that each interval is twice as long (or short) as the next. In other words, changing shutter speed by one interval either doubles or reduces by half the time interval. Longer intervals mean more light enters the camera; shorter intervals indicate less light. The typical sequence of shutter speeds is given below in seconds (Shaw 1995). Intermediate values may exist depending on the camera characteristics, and some recent DSLRs reach even faster shutter speeds up to 1/8000.

1, 1/2, 1/4, 1/8, 1/15, 1/30, 1/60, 1/125, 1/250, 1/500, 1/1000, 1/2000, 1/4000

For SFAP, fast shutter speeds are indispensable as most platforms either move fast (fixed-wing UAVs) or cause considerable vibration (kites, multirotor UAVs) unless well-stabilized by gimbal mounts. Slow shutter speeds may cause the images to be blurred, especially for cameras with small pixel sizes. The slowest shutter speed acceptable for a given platform, camera, and camera mount is best tested prior to an SFAP survey under typical conditions, e.g. for varying wind speeds and aircraft velocities (see also Chap. 8-4.2).

The degree and effect of motion blur depends not only on the shutter speed but also on the camera's shutter mechanism (Sieberth et al. 2016). Nearly all consumer-grade cameras with CMOS sensors have rolling shutters that expose the image lines sequentially, similar to a satellite scanner. This leads to additional blurring and distortion effects that are most prominent in fast-moving objects (e.g. speedy cars or rotating wind turbines) or for fast camera movements, i.e. high flying velocities. Global shutters, in contrast,

expose the complete image sensor simultaneously, but have not yet crossed the divide between industrial- and consumer-grade cameras (Grigonis 2018).

6-4.4 Film Speed or ISO Rating

Different photographic emulsions on film vary greatly in their sensitivity to light—some require little, others need much light to properly record an image. This factor is known as film speed, which is indicated by a standard ISO rating. Low ISO values indicate "slow" films that need much light. High ISO values, in contrast, are typical of "fast" films that require little light. The latter have larger silver halide crystals in the emulsion, which tend to give a grainy texture to the image. Typical film speeds are displayed below. The main speeds are given in bold, and intermediate speeds are shown for one-third increments (Shaw 1995).

12, 16, 20, **25,** 32, 40, **50,** 64, 80, **100,** 125, 160, **200,** 250, 320, **400,** 500, 640, **800,** 1000, 1280, **1600**

The same concept is used for indicating the sensitivity of digital camera sensors. The standard setting of ISO 100 corresponds to the light sensitivity of an ISO 100 film, and may be increased to 200, 400, or up to 6400 for current compact cameras, while high-end digital system cameras may feature even higher ISO settings. A higher ISO setting amplifies the signal from the sensor, so less light is needed for the photograph. However, this procedure also amplifies the sensor noise, both for intensity and color, which in turn creates the impression of a grainier image, quite similar to high-speed photographic film. Some aerial photographs presented in this book were taken with ISO 100 film speed or sensor setting, although many were taken at much faster speeds up to ISO 1600.

6-4.5 Camera Exposure Settings

Settings for image exposure are best understood using the concept of stops. A stop is defined as doubling or halving of any factor that affects the exposure (Shaw 1995). Notice that values for each variable—shutter speed, f-stop, ISO rating, or film speed—are arranged by doubling intervals. Among these variables there is a relationship called reciprocity. In other words, changing one variable by one stop may be matched exactly by changing another variable in the opposite direction by one stop.

For photographs under bright sun, which applies for most SFAP, the sunny $f/16$ rule could be employed (Caulfield 1987). For a given film or sensor under full-sun conditions, the shutter speed should be the approximate inverse of the ISO rating at $f/16$. For example, ISO 200 film—or a digital sensor at ISO 200 setting—should be exposed at $f/16$ and 1/250 shutter speed under bright sun conditions.

The exposure factors have other influences on the resulting photograph. In general faster shutter speeds are desirable for SFAP in order to "freeze" the motion between the airborne camera and the ground. This necessitates using high ISO ratings and/or lower f-stops. High ISO ratings tend to result in lower image quality, due to grainy appearance, in comparison to lower ISO ratings. However, sensor technology has advanced considerably with respect to light sensitivity in recent years, and the range of ISOs acceptable for high-quality SFAP has increased considerably for newer camera models. Lower f-stops reduce the depth of field, which refers to the range of distance over which the image is in good focus. For ideal SFAP, a fast shutter speed should be combined with low ISO settings and a medium to high f-stop setting. However, this combination often does not work in practice. SFAP, thus, represents a trade-off involving these factors.

Most modern cameras employed for SFAP utilize built-in light meters and automatic adjustment of shutter speed and f-stop. Such automated photography introduces certain artifacts in the picture-taking process. Inexpensive point-and-shoot cameras normally have a light meter that is separate from the lens or viewfinder; whereas the light meter in an SLR camera operates through the lens. The latter is clearly preferable, as the meter registers the light actually entering the camera through the lens.

Advanced point-and-shoot and all system cameras allow the user to set a priority for shutter speed or f-stop. For example, cameras with a high-speed (sports) mode select the fastest possible shutter speed in order to minimize blurring effects of camera or object motion. Fast shutter speed is highly desirable for effective SFAP, but represents a compromise with lower f-stops. Assuming the ground target is at infinite focal distance, depth of field and thus f-stop should be negligible factors. However, image sharpness usually is better at medium f-stops due to higher lens aberrations and diffraction at low and high f-stops (Langford and Bilissi 2011).

Camera meters normally determine exposure settings based on a medium gray tone—equivalent to the light reflected from an 18% gray card—to represent the average value sensed by the light meter. This works well for a scene in which most objects are uniformly lighted—for example blue sky and green trees or grass. However, the results may be unsatisfactory for a scene comprised of bright highlights and dark shadows, such as sunlit hill tops and valleys in shadows or for scenes that are generally brighter or darker than average. Some objects are intrinsically bright—snow, ice, concrete, chalk, deciduous trees, and grass; other objects are naturally dark—burned ground, basalt, asphalt, conifer trees, etc.

For scenes with mixed illumination, the bright features would be overexposed and washed out, and the dark objects remain nearly black and lacking in details (see Chap. 5-4). This applies particularly for high-oblique images with large portions of bright sky and may require optimizing the exposure settings manually for the main features of interest in the scene. In the case of a generally bright scene, the image would be under-exposed because the camera aims at a medium gray tone, while a generally dark scene could be overexposed for the same reason. These effects may be avoided with most cameras by adjusting the exposure correction factor accordingly.

For systematic coverage of larger areas with overlapping images (see Chap. 9-6) it may be advisable to set a fixed combination of shutter speed and *f*-stop rather than relying on auto-exposure settings. For areas with high spatial variability of brightness and colors (including patchy cloud shadows), continuous adaptations to a medium gray tone of each image during the survey would result in constantly changing image exposures (Fig. 6-7; see also Fig. 11-5). Obviously, choosing an ideal fixed exposure setting for a camera up in the air is most easily done with real-time video downlink of the imagery, e.g. UAS with live-view cameras. A good method would be to fly over an area with mixed brightness, adjust the exposure settings for optimal balance in manual mode, or use the auto-exposure (AE) lock function for maintaining the same exposure throughout the survey.

6-4.6 Image Degradation

Photographs do not record the energy reflected off their motifs flawlessly. Chemical and physical characteristics of films and image sensors may introduce

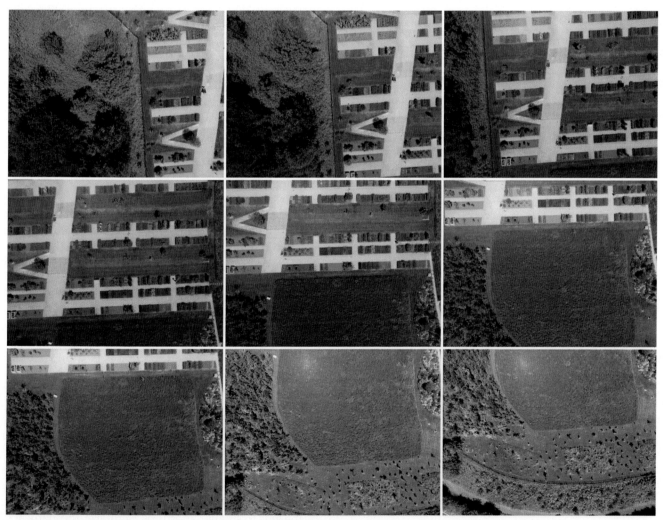

Fig. 6-7 Series of nine images from a systematic vertical survey, taken in auto-exposure mode in 5-s intervals along a straight flightline. Changing overall scene brightness caused the camera to vary the exposure time continuously between 1/1400 and 1/600 s while maintaining the same aperture. Note how the brightness of gravel paths, grass, and woodland changes between images. Taken with on-board camera of quadcopter UAV at Frankfurt University's Campus Riedberg, Germany.

unwanted effects and artifacts into an image. Also, the lens is crucial for image quality, and some degree of distortion always is introduced into the optical paths by deviations from a perfect central perspective. The most frequent types of distortions and artifacts are briefly described in the following (see also Langford and Bilissi 2011 and Chap. 11-3 for more details).

- **Radial distortion** slightly changes the image scale with increasing distance from the image center. Short focal lengths (wide image angles) typically show barrel distortion, which causes straight lines to bend outward, while long focal lengths (telephotos) tend to exhibit pincushion distortion, which causes straight lines to bend inward (Figs. 6-8 and 6-9). These effects are usually stronger in zoom lenses than fixed-focus lenses. Radial distortion may be determined with camera calibration (Fig. 6-10; see also Section 6-6). Correction is possible both in-camera (for many recent models) or with image processing software.

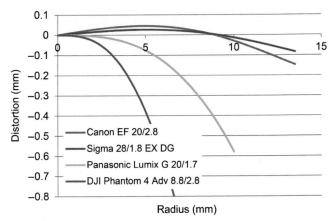

Fig. 6-10 Typical radial distortions for four fixed-focus lenses of different camera types (seen in Figs. 6-2 and 8-16B), as derived from test field and self-calibration. The *Canon* EF and *Sigma* lenses are wide-angle SLR mount lenses that show slight pincushion distortion near the image center (radius<5mm) and increasing barrel distortion toward the edges. The *Lumix Pancake* is a Micro Four-Thirds lens (40-mm equivalent) built for extra flatness with clearly stronger barrel distortion. The strongest barrel distortion is shown by the small 24-mm equivalent lens of the integrated *DJI Phantom* 4 quadcopter camera. Maximum radii shown here are limited by the varying sensor sizes.

Fig. 6-8 Barrel distortion (left) and pincushion distortion (right) are typical optical lens aberrations leading to the bending of straight lines.

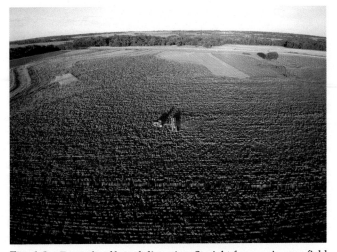

Fig. 6-9 Example of barrel distortion. Straight furrows in crop field are strongly curved toward bottom as is the horizon at top. Taken with a compact digital camera from a quadcopter UAV, east-central Kansas. *Courtesy of O. Karr.*

- **Chromatic aberration** is caused by the inability of a lens to focus all wavelengths onto the same plane (longitudinal CA) and/or by varying magnification of different wavelengths (latitudinal CA). With increasing distance from the image center, the three primary colors become slightly offset, causing a color-fringe effect around contrasty edges (Fig. 6-11). Ultrawide-angle lenses and the extreme focal lengths of super-zoom lenses are most prone to chromatic aberration. The color offset in the image bands may be corrected with some image-processing packages.
- **Colored fringes** also could be caused around overexposed image areas by overflowing electrical charge (blooming) or near high-contrast boundaries by aberration effects associated with microlens arrays placed onto some sensors (purple fringing; Langford and Bilissi 2011). Blooming and purple fringing are not easy to correct, and the first is best prevented by avoiding overexposure.
- **Vignetting** describes the gradual darkening of an image toward the edges and corners (Fig. 6-12) and may have different causes, all of which are related to the lens design (Ray 2002; Kessler 2007). Optical vignetting results from the reduction of the effective lens opening for oblique light rays because the lens diaphragm is set back from the front rim of the lens tube. Thus, it may be reduced or cured by stopping down the lens to smaller apertures. Similarly, mechanical vignetting is caused by too long extensions of the lens (filters, lens hoods) that narrow the effective lens opening; in this case, the image corners are blackened out.

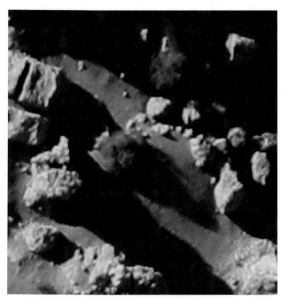

Fig. 6-11 Chromatic aberration causes colored fringes around the edges of long afternoon shadows cast by soil clods in a dry river bed in South Morocco. Subset of a kite photograph taken with DSLR; aberration effect is strongly exaggerated for illustration purpose.

Fig. 6-12 Vignetting of an aerial photograph showing experimental reforestation plots near Guadix, Province of Granada, Spain. Hot-air blimp photograph with analog SRL; vignetting effect enhanced artificially for illustration purpose.

Finally, natural vignetting or natural light falloff, which is described by the \cos^4 law, occurs with all lenses but is more prominent for wide angles.

The darkening effect by vignetting is usually quite small, but it may become more obvious when several images are stitched together in a mosaic. As wide-angle lenses are frequently used for SFAP and vignetting generally is at its worst when the lens is focused at infinity, some contrast and brightness adjustment may be necessary for correcting vignetting effects in aerial photographs. The vignetting effect may be reduced or enhanced by some image-processing software.

Other than the distortions listed above, image noise is independent of focal length and aperture. It is defined as the random variation of pixel values caused by fluctuations of the signal transmitted by the sensor. While there are several sources of noise (Langford and Bilissi 2011), they all result in high-frequency brightness and color variations (image speckles), which are more pronounced at low signal-to-noise ratios. Thus, noise is most prevalent in dark image areas (e.g. hard shadows in SFAP images), for high ISO speeds (where the sensor signal is amplified to provide for poor light conditions) and for small sensor cells (compact and smartphone cameras with high megapixel numbers). Image noise may be smoothed and made less conspicuous with image processing, but choosing a good-quality sensor with large pixels is probably the most important remedy against noise.

6-5 COLOR-INFRARED AND MULTISPECTRAL IMAGERY

Wavelengths beyond the visible spectrum may be captured with analog film as well as digital sensors. Color-infrared film is sensitive to visible and near-infrared portions of the spectrum. In normal practice, a yellow filter is employed to eliminate blue and ultraviolet wavelengths. In some cases, orange or red filters may be used to further restrict visible light from reaching the film. Color-infrared film carries no ISO number; nor do conventional light meters provide correct indications of near-infrared radiation.

Taking photographs with color-infrared film requires manual settings for exposure based on estimates of available light—considerable trial-and-error testing is necessary (Marzolff 1999; Aber et al. 2001a). A final and nearly insurmountable problem is that since about 2005 most commercial photo laboratories no longer process color-infrared film. For digital SFAP, there is a choice between dedicated multispectral or even hyperspectral cameras, or modified digital cameras normally used for visible photography, which are covered in the following sections.

6-5.1 Multispectral Digital Cameras

One of the first color-infrared digital cameras of relatively small size, which was suitable for SFAP, was the Agricultural Digital Camera (ADC) by *Tetracam*. This camera employs a 3.2 megapixel CMOS sensor that operates in the spectral range 0.52 to 0.92 μm wavelength (green, red, and near-infrared). A permanently mounted long-pass filter behind the lens blocks blue and ultraviolet light, and the camera has a robust machined-aluminum body (Fig. 6-13).

The primary applications for the *Tetracam* ADC camera are, as the name suggests, agriculture as well as forestry and other studies involving vegetation, soil, and

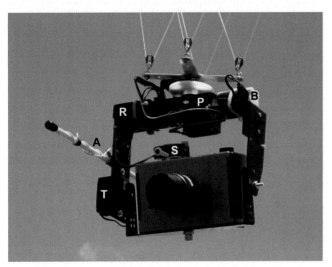

Fig. 6-13 *Tetracam* ADC digital, color-infrared camera in a remotely operated radio-controlled rig for kite or blimp aerial photography. R—radio receiver, P—pan servo and gears, B—NiMH battery pack, A—antenna mast, S—shutter miniservo, and T—tilt servo. Camera rig built by JSA.

water. The camera was designed to be operated on the ground or from manned or unmanned aircraft either by hand or remote control. The camera produces results that are quite comparable with color-infrared film photography (Fig. 6-14). However, manual focusing and adjusting light settings have proven problematic for SFAP.

UAS applications for agricultural crop management and research have increased dramatically in recent years. Since the days of these first color-infrared digital cameras, numerous small-format multispectral cameras in various price ranges have been developed that cover the visible (VIS) and near-infrared (NIR) spectrum and even beyond (e.g. Verger et al. 2014; Candiago et al. 2015; Zaman-Allah et al. 2015; Hoffmann et al. 2016; Potgieter et al. 2017). Weights have decreased to a degree that easily enables the use of such sensors on small quadcopter UAS; for example, the current 3-band successors of the *Tetracam* ADC, the ADC Snap and ADC Micro, weigh only 90 g, and the tiny 2-band *Sentera* NDVI or NDRE comes at 30 g.

Even more spectral possibilities are given by multisensor arrays. Examples commonly used with current UAS models are the 4-band *Parrot Sequoia*, the 5-band *MicaSense RedEdge* M (Fig. 6-15), or the 6-band *Tetracam* MCAW. All use synchronized monochrome sensors that capture a narrow band—the red edge, see Chap. 11-4—between red and near-infrared in addition to VIS and NIR bands. Some allow to custom-define the spectral sensitivities by narrow-band optical filters in order to match the requirements for specific vegetation signatures. For reliable quantitative evaluation of the recorded DN, e.g. in vegetation indices, these cameras require radiometric calibration (e.g. Verger et al. 2014). Compared to standard camera sensors, the sizes of most multispectral sensors are still quite small (usually 1.2 to 3.1 MP), but take

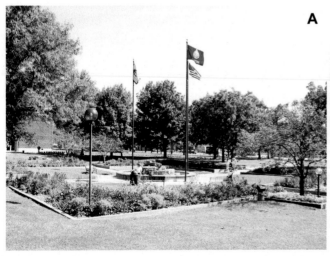
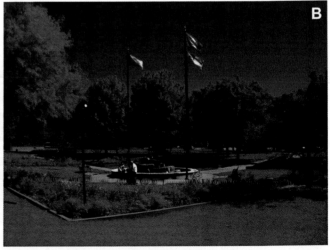

Fig. 6-14 Digital ground photographs of a late-summer garden scene in color-visible (A) and color-infrared (B) formats. Active vegetation appears in bright red-pink colors in the latter. Also some artificial fibers and dyes are highly reflective for near-infrared (Finney 2007), as seen in the flags. Compare with Fig. 6-1.

Fig. 6-15 A typical multisensor multispectral camera designed for UAS (*MicaSense RedEdge*-M). This model has five narrow spectral bands (blue, green, red, red edge, and NIR), is about the size of a compact camera (9.4×6.3 cm), and weighs 170 g.

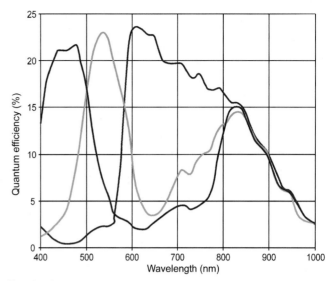

Fig. 6-16 Typical response curves for CCD and CMOS image sensors without NIR blocking filters showing the transmission response after the light passes through the mosaic color filter over the image sensors. A hot mirror usually added to such a sensor blocks wavelengths above 700–750 nm. *Adapted from sensor specifications given by Prosilica (2009).*

full spectral measurements for each pixel in contrast to the Bayer filter mosaics typical for standard cameras (see above).

Beyond the near-infrared spectrum, the choice of UAS sensors is currently broadening fast, with hyperspectral, thermal, and LIDAR scanners already available—exciting options for the near future of unmanned remote sensing, but clearly beyond the scope of this book. For a thorough review of multispectral, hyperspectral, and thermal sensors suitable for UAS remote sensing, the reader is referred to Yang et al. (2017) and Manfreda et al. (2018). An exhaustive list of current UAS sensors from optical to LIDAR is given in Van Blyenburgh (2018).

6-5.2 Standard Cameras Modified for NIR Sensitivity

Another possibility for taking pictures in the near-infrared spectrum is via custom modification of consumer-grade digital cameras. All digital camera sensors are sensitive not only to visible but also to near-infrared light (Fig. 6-16). In order to prevent these longer wavelengths from degrading the quality of normal-color images, a blocking filter (hot mirror) that allows only visible light to pass is placed in front of the sensor. By removing this hot mirror, the spectral sensitivity of the sensor cells to near-infrared light could be employed for photographs in two ways. The blocking filter is replaced either by an infrared (visible-light blocking) filter for pure NIR photography or by a clear filter for preserving the whole spectral sensitivity of the detector (UV to NIR). NIR SFAP using modified digital cameras has been successfully employed for agricultural studies (Hunt et al. 2011; Mathews 2014; Rasmussen et al. 2016),

forest and floodplain vegetation analysis (Hernández-Clemente et al. 2014; Van Iersel et al. 2018), and archaeological prospecting (Verhoeven 2008).

Certain digital cameras may be modified for blue, green, and near-infrared (B/G/NIR) imagery, in which red light is excluded (Sankaran et al. 2015a). The normal red channel is replaced by near infrared in the resulting false-color image (Fig. 6-17). At first glance, color-infrared images from conventional G/R/NIR cameras may appear quite different from B/G/NIR images. For conventional G/R/NIR false-color images, active vegetation is typically bright pink, red, or maroon in color, and water bodies are completely black (see Figs. 2-5 and 4-14). Generations of photointerpreters have learned and become accustomed to this format (e.g. Philipson 1997).

B/G/NIR imagery, on the other hand, depicts vegetation as orange and water bodies are dark blue (Table 6-3). Upon first viewing such images, many photointerpreters may be confused. After some time to adjust visual expectations, however, the orange false-color format of vegetation becomes no more strange than for traditional red-pink CIR images. The commonly used normalized difference vegetation index (NDVI; see Chap. 11-4.1) may also be calculated from B/G/NIR imagery. The red NDVI has been favored for traditional CIR aerial photography and space-based imagery, because blue is strongly scattered in the atmosphere. For low-height SFAP, however, atmospheric scattering is negligible and, so, the blue NDVI may be utilized.

Conventional color-infrared (G/R/NIR) images tend to enhance shadows and special lighting effects, as noted before. The same holds true for B/G/NIR imagery

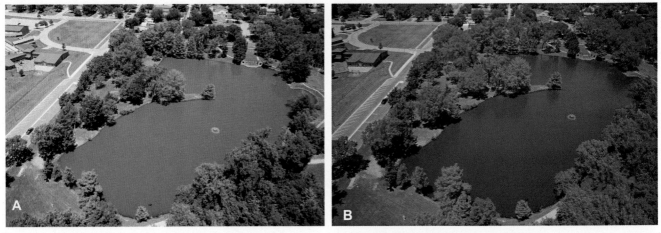

Fig. 6-17 Normal color (A) and color-infrared (B) views of a pond surrounded by various types of active vegetation. In color-infrared, grass and deciduous trees are bright orange, conifers are dark orange, and water is dark blue. Kite photographs taken with specially modified *Sony* α6000 MILC (see Fig. 6-2). Emporia, Kansas, United States; JSA with T. Nagasako.

Table 6-3 False-color combinations for G/R/NIR and B/G/NIR imagery and the typical appearances of photosynthetically active vegetation and clear water bodies. Taken from Aber et al. (2018, Table 1).

Type of Imagery	False color	Vegetation	Clear Water
G/R/NIR	G = blue R = green NIR = red	Red + blue = maroon	Blue excluded = black
B/G/NIR	B = blue G = green NIR = red	Red + green = orange	Blue allowed = dark blue

Fig. 6-18 An intense hot spot appears left of scene center in this view of prairie and woodland. B/G/NIR false-color image in which active vegetation appears orange; dead trees are gray skeletons. Kite photograph taken with a modified *Sony* α6000 MILC; eastern Kansas.

(Fig. 6-18). However, internal lens reflections may happen in oblique views looking toward the sun (Fig. 6-19). This may be a consequence of longer near-infrared wavelengths refracting differently than shorter visible light in the lens (Finney 2007).

6-6 SFAP CAMERAS FOR PHOTOGRAMMETRIC APPLICATIONS

Photogrammetric analysis of small-format aerial imagery presents additional challenges for the cameras employed. Because photogrammetry is based on precise measurements, the geometric stability of the camera becomes a key factor for reconstructing 3D objects from two-dimensional photographs (see Chap. 3) and for accurate surface data collection from stereo images. Consumer-grade cameras lack many of the features included in metric cameras specifically designed for photogrammetry (e.g. fix-mounted, immovable camera components, near-perfect lenses, and calibrated focal lengths).

Fig. 6-19 Bright pink-white streaks are caused by internal lens reflections in this B/G/NIR false-color image. Kite photograph taken with a modified *Sony* α6000 MILC; eastern Kansas.

Paradoxically, many technical advances digital cameras have seen since the early 2000s may actually impede their value for photogrammetric applications. Dust removal vibration and image stabilization (reducing the effect of camera shake during slow shutter speeds by sensor or lens counter-movements), autofocus, and in-camera lens distortion correction are designed for improving image quality, sharpness, and geometry. However, they introduce destabilizing parameters into the interior orientation of such cameras that may even change from image to image during an aerial survey.

Nevertheless, off-the-shelf small-format cameras have been employed successfully for photogrammetric analysis for more than 20 years (Warner et al. 1996; Fryer et al. 2007), even with the more rigorous traditional photogrammetric approaches. The more recent development of Structure from Motion–Multi-View Stereo (SfM-MVS) photogrammetry is comparatively less demanding with respect to camera characteristics (see Chap. 3). Regardless of the photogrammetric approach, however, image quality and geometric integrity, and thus camera considerations, play a significant role for the accuracy of photogrammetric measurements (Carrivick et al. 2016; Mosbrucker et al. 2017).

Numerous studies have investigated the effects and accuracies associated with different types of cameras, lenses, and sensor chips (e.g. Chandler et al. 2005; Shortis et al. 2006; Rieke-Zapp et al. 2009; Thoeni et al. 2014). Currently, MILC-type cameras offer the best relation between weight and quality for small-format aerial photogrammetry, but depending on a project's specific requirements, other options exist. Some of the most important aspects to bear in mind when choosing a camera for aerial photogrammetric purposes are listed below.

6-6.1 Camera Lens

Lenses with a single focal length are clearly preferable to zoom lenses in terms of stability, accuracy, and precision (Shortis et al. 2006). This makes interchangeable-lens system cameras the primary choice for small-format photogrammetry. Reviewing the accuracies of SfM-photogrammetric datasets reported in 67 publications, Mosbrucker et al. (2017) found that using a fixed-focus lens, rather than a zoom lens, resulted in significantly higher vertical accuracy. Especially for calibrated cameras or when self-calibrating procedures are used, the focal length between images should be kept as invariable as possible. In order to prevent changes in focal length, it is preferable (if possible) to deactivate autofocus and manually focus the lens at infinity before mechanically fixing the focus ring with tape, screws, or adhesives (see Fig. 6-2B). With regard to the MILC and SLR cameras, detaching the lens from the camera body

and thus changing the lens should be avoided as well as lenses with image stabilization systems.

Most suitable for photogrammetric analysis are moderate wide-angle lenses, with 35-mm equivalent focal lengths between 24 and 35 mm. Their wider viewing angles as compared to standard or telephoto lenses cause larger stereoscopic parallaxes, which is favorable for heighting accuracy (see Fig. 3-10). Also, their geometry is most easily described by the commonly used camera calibration models (James and Robson 2012). This does, however, not apply to ultra-wide angles, such as fisheye lenses, which should be avoided.

6-6.2 Image Sensor

For digital cameras, larger image sensors with bigger sensor cells are usually preferable to smaller sensors. Larger pixels capture more photons during exposure, which means lower signal noise (Clark 2016a). This not only allows larger ISO ranges but also improves the image quality and the reliability of the light measurements between multiple images. Stereo-matching procedures for digital elevation-model extraction rely on measurements of correlation between pixel values of two images. Therefore, higher point densities and accuracies may be expected for images with low noise (e.g. Marinello et al. 2008; Grün 2012; Eltner and Schneider 2015). Investigations comparing cameras with different sensors—from smartphones over small action cameras to compact cameras and professional full-frame DSRLs—have shown that larger sensor sizes generally result in an increase of reconstructed point densities and accuracies (e.g. Thoeni et al. 2014; Niederheiser et al. 2016). The latest models of consumer-grade quadcopter UAS with integrated, gimbal-stabilized cameras feature high-quality 1-in. sensors with up to 20 MP. Their comparative photogrammetric quality remains to be investigated.

Most digital cameras designed for hand-held photography have some type of image stabilization (IS) system, either implemented in the lens or as in-body sensor stabilization. Also, many interchangeable-lens cameras are equipped with sensor vibration systems for dust removal. Both features may change interior camera geometry and alter interior orientation values between consecutive images (Rieke-Zapp et al. 2009). These stabilization and vibration systems should be avoided or at least disabled for small-format aerial photogrammetry.

6-6.3 File Format

In order to avoid artifacts by image compression, which could degrade measurement accuracy and stereo-matching results, lossless image formats (RAW, lossless TIFF, lossless JPEG) are more favorable than lossy

JPEG compression. Only RAW image storage allows preserving the full 12-bit image information and the customized post-processing that is desirable for sophisticated exposure corrections. RAW storage format might also be advisable in order to prevent in-camera lens distortion correction—often auto-applied to JPGs, as this might introduce additional geometric instability into the interior orientation and complicate later self-calibration procedures. The possibility of fully controlling the conversion process of RAW measurement values is considered an advantage over in-camera conversion by most professionals and researchers (Verhoeven 2010), although Rieke-Zapp et al. (2009) demonstrated that different RAW development software may have significantly different effects on the photogrammetric measurement accuracy yielded with the images.

6-6.4 Camera Calibration

Camera calibration significantly improves the accuracy of photogrammetric analyses. Self-calibration has become an integral part of photogrammetric processing of non-metric imagery, particularly in SfM-MVS workflows (see Chap. 3). Chandler et al. (2005) found that radial lens distortion errors effectively constrain the accuracies achievable, making accurate modeling of lens distortion an important issue for the use of consumer-grade digital cameras.

For non-metric cameras, calibration reports are not provided by the manufacturer, but methods of camera calibration applicable to digital consumer-grade cameras have evolved rapidly over the last decades (Wackrow 2008). Various calibration software, both commercial and non-commercial, exists as well as prefabricated 3D test fields with photogrammetric target points. However, these test fields are designed for close-range photogrammetry and usually are too small to be suitable for calibrating images focused at infinity (as in the SFAP case). For precalibration of SFAP cameras, a larger test field is required, e.g. with high-precision targets mounted on the cornered walls and courtyard of a building.

For small-format aerial photogrammetry, the commonly used alternative to test-field calibration is camera self-calibration during the actual project, where the elements of interior orientation—the focal length, the position of the principle point and one to several lens distortion parameters—are determined at the same time as the object point coordinates. The quality of the results, however, is highly dependent on the number, precision, and distribution of the ground control points involved as well as the image-network geometry (Wackrow and Chandler 2008; James and Robson 2014; Harwin et al. 2015; see also Tables 3-1 and 3-2).

6-7 SUMMARY

Any camera designed primarily for hand-held use on the ground may be adapted for small-format aerial photography. In spite of a tremendous range in cost and quality of such cameras, they all have certain basic components—lens, diaphragm, shutter, and an image sensor (film or electronic detector) within a light-proof box.

Traditional cameras record photographs in the light-sensitive chemicals of the film emulsion. Spectral range is ~0.3 to 0.9 µm wavelength (near-ultraviolet, visible, near-infrared). Digital cameras have come to dominate the market in the early 21st century, as cost has declined and quality has improved rapidly. Digital image sensors employ an array of tiny semiconductors to detect light intensity; two main types are the charge-coupled device (CCD) and the complementary metal oxide semiconductor (CMOS). Mirrorless interchangeable-lens cameras, compact point-and-shoot, and integrated onboard quadcopter drone cameras are now the most commonly used types for SFAP applications.

Three main controls of image exposure are the lens aperture (*f*-stop), shutter speed, and detector sensitivity (ISO rating). These factors are related by reciprocity such that changing one variable by one stop may be matched exactly by changing another variable in the opposite direction by one stop. In most cameras for SFAP, automatic light settings are utilized. However, this may create problems for scenes with mixed illumination or highly contrasting bright and dark features. The geometrical and technical characteristics of the camera lens and sensor may have important influence on image distortions and artifacts. Successful SFAP may require adjusting typical default camera settings optimized for hand-held photography to meet the specific demands of remotely triggered aerial photography.

Color-infrared film photography traditionally utilizes the green, red, and near-infrared (G/R/NIR) portions of the spectrum that are color coded, respectively, as blue, green, and red in the resulting false-color image. For 3-band digital cameras either G/R/NIR or B/G/NIR imagery is possible, which results in different false-color combinations. Both may be utilized to create the normalized difference vegetation index (NDVI). Multisensor arrays specifically designed for UAS may capture even more spectral bands, including narrow red-edge bands between visible red and NIR.

Photogrammetric analysis of SFAP involves additional challenges. Among the important considerations are the camera lens, image sensor, file format, and camera calibration. In general, digital interchangeable-lens system cameras with single-focus lenses are most suitable for photogrammetric purposes and should be operated without image stabilization or dust removal functions.

7

Manned and Tethered Platforms and Mounts

One sky, one world: the wind knows no borders, and the molecule that hits my kite today was probably flying over Chile yesterday and will be in Mongolia next week. (Chorier 2016)

7-1 INTRODUCTION

Mankind has devised diverse types of flying machines that reach into the atmosphere and low-space environment. Since the Chinese invention of kites centuries ago, an irresistible urge has led people to fly higher and faster above the surface of the Earth. Ranging in size and complexity from small paper kites to the International Space Station, virtually all these flying platforms may be adapted for small-format aerial photography. The emphasis for this chapter is on relatively low-height platforms that are either free-flying and manned or unmanned and tethered to the ground. Small, free-flying unmanned aircraft systems (UAS) and unmanned aerial vehicles (UAV) are treated in the next chapter.

The most basic distinction is whether the platform is manned or unmanned. The former is necessarily large enough to lift a person safely along with photographic equipment. The latter may be relatively small. Manned lifting platforms, such as airplanes, helicopters, hot-air balloons, blimps, and ultralights, are fairly expensive to operate and normally require a trained pilot, ground-support crew, and some kind of launching and landing facilities. Unmanned platforms are much more variable in their technical specifications. The requirements for lifting capability and platform safety are less stringent with unmanned platforms; the cost and technical expertise needed to operate such systems also vary greatly. Unmanned platforms may operate in an automated fashion once airborne, or they may be radio-controlled remotely by a person on the ground.

A further distinction may be made between powered and unpowered platforms. The former become airborne through some kind of artificial thrust provided by a motor or engine. Airplanes, autogyros, helicopters, and rockets utilize a variety of wings, blades, rotors, and fins to create lift and/or stabilize the vehicle in flight. These aircraft move with moderate to high velocity; even the helicopter that appears to hover is in fact rotating its blades rapidly against the air. All powered platforms vibrate and move relative to the ground.

Unpowered platforms achieve their lift either through neutral buoyancy (balloons and blimps) or via resistance to the wind—kites and sailplanes. Regardless of the kind of platform, any vibration or movement of the camera relative to the ground creates the potential for blurred imagery. Balloons, blimps, and gliders that drift with the wind move slowly relative to the ground and have minimal mechanical vibration. Tethered platforms—balloons, blimps and kites—tend to vibrate and swing with the wind. The following sections, which present selected examples of SFAP platforms, also include discussions on their characteristics affecting image acquisition, quality, and other properties, and exemplary uses taken from the literature.

7-2 MANNED AIRCRAFT

Single-engine airplanes are conventional platforms for manned SFAP. Most such planes are not built for this purpose and are not particularly effective for SFAP. With some modifications, however, small airplanes may be utilized for aerial surveys. A good example of this approach is a crop-seeding airplane adapted by mounting a camera system in an existing port on the bottom of the fuselage (Fig. 7-1). The camera is controlled via a Wi-Fi connection to a smartphone operated by the pilot, Brian Bird. Photographs are typically taken at heights about

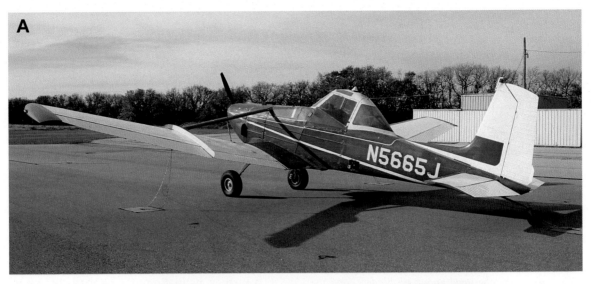

Fig. 7-1 Small, single-seat airplane normally used for crop seeding operations. (A) Overview of plane at the Hillsboro airport, Kansas, United States. (B) Camera is mounted in a fixed vertical position in an open port (∧) between the wings.

1000 to 3000 ft (~300–900 m) above the ground. This approach is particularly useful for covering a large area or following a long survey route, such as tracing the historic Santa Fe Trail across the Great Plains of the United States (Fig. 7-2).

A similar approach for manned SFAP was used by Li et al. (2005) for high-resolution imagery and analysis of informal settlements or shantytowns in South Africa. They employed a *Piper Arrow* 200 light aircraft, in which a custom-built camera mount was fitted into the porthole below the passenger seat. Brunier et al. (2016) employed SFAP taken with a full-frame DSLR from a microlight aircraft for mapping morphological changes of a beach in French Guiana. For detecting gullies in a high-resolution DEM, Castillo et al. (2014) conducted a stereo-photogrammetric SFAP campaign over a 400-ha area using a digital system camera mounted on a small aircraft.

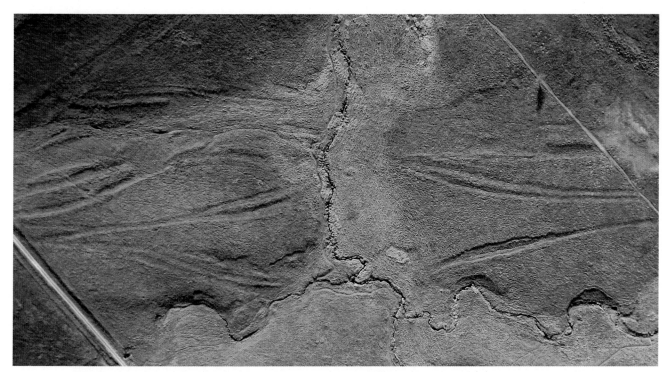

Fig. 7-2 Braided series of ruts on the Santa Fe Trail cross the scene from northeast (left) to southwest (right). The image was acquired from about 2000 ft (~600 m) height early in the morning with low sun angle to highlight shadows in the ruts. Field of view approximately half a km across. Near Lehigh, Kansas. *Courtesy of B. Bird (2014), used with permission.*

In many cases, a small helicopter, such as the *Robinson* R44, is preferable to a fixed-wind airplane. Helicopters are highly maneuverable and with the doors removed provide a large field of view for the photographer. However, hiring a helicopter is pricey with cost often greater than $1000 per hour (Marom 2016).

The arena of gliders and ultralight aircraft, rich with experimentation since the 1960s, has evolved into light-sport aircraft. For innovative pilots, mechanics, and photographers, light-sport aircraft has become the successor of earlier *Cessna, Piper,* and other small airplanes of the 20th century. Light-sport aircraft (LSA) is defined by the US Federal Aviation Agency (FAA) according to these criteria, which apply to both powered and unpowered vehicles (Experimental Aircraft Association 2017).

- Maximum gross takeoff weight: 1320 lbs. (1430 lbs. for seaplanes).
- Maximum stall speed: 51 mph (45 knots).
- Maximum speed in level flight: 138 mph (120 knots).
- Seats: 2 (max.).
- Engines/motors: 1 (max. if powered.).
- Propeller: fixed-pitch or ground adjustable.
- Cabin: unpressurized.
- Landing gear: fixed (except for seaplanes and gliders).

7-2.1 Powered Light-Sport Aircraft

Light-sport aircraft are supplied nowadays mainly by small companies. The relatively low costs of purchasing, building, and operating manned LSA have proven popular. One suitable model, for example, is the *Challenger* II produced by Quad City Challenger of Moline, Illinois, United States. It is a two-seat LSA and ultralight trainer with an overhead wing and pusher motor (Fig. 7-3). The long-wing version increases the glide ratio and is the optimum configuration for stable, slow-speed SFAP.

The SFAP capability of the *Challenger* II was field tested over the Ocala National Forest near Deland in central Florida, United States. An experienced pilot flew the LSA, and W.S. Lowe was the co-pilot/photographer. He employed a hand-held *Canon* digital camera with a zoom lens and optical image stabilization. The flight path was designed to place the sun behind the plane and photographer for oblique views toward ground features of interest (Fig. 7-4). This test flight demonstrated the advantage of manned SFAP for selecting targets of opportunity and positioning the aircraft to best advantage for acquiring suitable photographs.

Among the most daring SFAP conducted from manned LSA is the motorized paraglider operated by G. Steinmetz of the United States. His flying machine

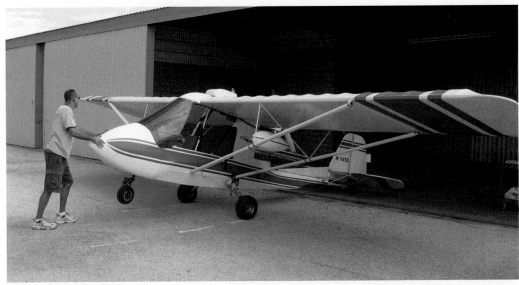

Fig. 7-3 *Challenger* II light sport aircraft (LSA) for potential small-format aerial photography. Aircraft is light enough for one person to move it on the ground. Overhead wings and large open windows allow good views for the photographer. *Courtesy of W.S. Lowe, used with permission.*

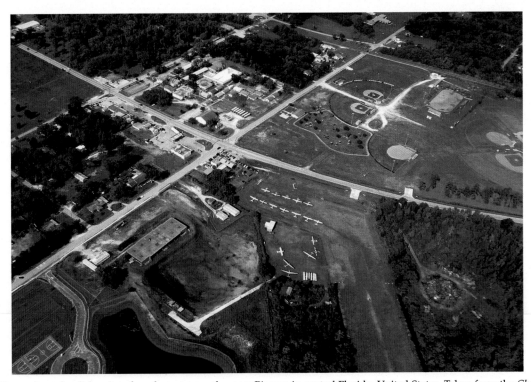

Fig. 7-4 Oblique view of a glider airpark and sports complex near Pierson in central Florida, United States. Taken from the *Challenger* II light sport aircraft at a height of ~340 m (~1100 ft). *Courtesy of W.S. Lowe, used with permission.*

consists of a large parafoil kite from which he hangs with a small gasoline-powered propeller strapped to his back (Tucker 2009). The whole contraption weighs <45 kg and is highly portable. Steinmetz has flown extensively in Africa and China, although he has suffered some serious crashes, and he has been involved in some legal issues in the United States (see Chap. 12-2). In spite of his undoubted photographic success, it seems unlikely that many others would follow Steinmetz's lead for this high-risk means of manned SFAP.

Various uses of powered LSA are documented in the literature spanning a wide range of applications.

A microlight aircraft was used by Mills et al. (1996) as a slow-flying alternative to faster light aircraft, allowing them to achieve the necessary stereoscopic overlap for photogrammetric aerial surveys in Great Britain. The US Department of Agriculture, Rangeland Resources Research Unit in Cheyenne, Wyoming has developed a manned ultralight airplane to acquire very-large-scale aerial imagery (Hunt et al. 2003). The aircraft is a *Quicksilver GT 500* single-engine, single-pilot plane that flies a mere 6 m above the ground. However, LSA are not likely to become major factors for SFAP in the United States because commercial use or work-for-hire is prohibited by the FAA (Aircraft Owners and Pilots Association 2016).

7-2.2 Unpowered Light-Sport Aircraft

Unpowered LSA include manned gliders, also known as sailplanes, which may be launched via ground or aerial towing to achieve sustainable height for continued flight. Hang gliders, paragliders, motorgliders, and autogyros are closely related manned aircraft. Gliders are essentially large, manned, untethered kites. Modern gliders are highly sophisticated aircraft that have evolved during the past century, just as powered airplanes have developed. Soaring is a popular sport, and many associations and museums exist around the world to support this type of flight.

As platforms for SFAP, gliders have considerable potential compared with other types of manned aircraft. The most important advantages are maneuverability combined with quiet operation. For two-seat gliders, the copilot may concentrate on photography while the pilot rides the air currents (Fig. 7-5). Pictures with hand-held cameras are mostly limited to oblique views (Fig. 7-6), unless the glider is put into a steep roll for a look straight down. A remotely operated camera rig could be placed in a special compartment in the nose or body of the glider, which would provide more control for aiming the camera. The main disadvantage of using gliders, aside from the high cost associated with most manned aircraft, is their need for towing to become airborne. Aerial range is variable, depending on weather conditions, but gliders may be transported effectively on the ground in specially built trailers (Fig. 7-7).

SFAP also may be conducted from hang gliders (Open Photographic Society 2017). Typically a wide-angle compact digital camera is fixed to a structural member of the glider, such as the outer part of a wing, and triggered via a cable controlled by the pilot. Resulting pictures may show the pilot, the landscape below, or some combination of pilot, hang glider, and landscape. Such SFAP, however, should be undertaken only by an experienced hang-glider pilot.

Fig. 7-5 Two-seat high-performance glider during preflight preparations. Wing to rear of seats provides good lateral views. Note small windows in canopies; windows may be opened during flight for taking photographs. Harris Hill National Soaring Museum near Elmira, New York, United States.

Fig. 7-6 Low-oblique view of drive-in movie theater with the Chemung River in the background. Few active outdoor movie theaters are still operating in the United States. Photo taken from glider shown in previous figure near Elmira, New York, United States.

Fig. 7-7 Trailer for transporting a glider cross country. Harris Hill National Soaring Museum near Elmira, New York, United States.

7-3 LIGHTER-THAN-AIR PLATFORMS

Lighter-than-air platforms, which obtain their lift based on Archimedes' principle of buoyancy, comprise various balloons and blimps that may be manned or unmanned, tethered or free-flying, and powered or unpowered. Contrasting with the spherical shape of a balloon, a blimp has an elongated, aerodynamic shape with fins. Strictly speaking, the term blimp refers to a free-flying airship without internal frame structure, which maintains its shape by the overpressure of the lifting gas. However, the term blimp is often, as in this book, also used for tethered or moored airships, including those where the lifting medium is hot air.

Balloons and blimps are widely employed nowadays for meteorological sounding, commercial advertising, sport flying, and other purposes. Manned, hot-air balloons are, in fact, quite popular (Fig. 7-8), but lack positional control unless tethered. Near-calm conditions are necessary for launching and landing, which often restricts flights to dawn and dusk times of day with consequences for lighting conditions (Fig. 7-9).

Owing to their comparatively low level of high-tech components, unmanned, tethered lighter-than-air platforms have been employed for SFAP for many decades. Their suitability for aerial surveys using various instruments from compact cameras to multisensor systems is well documented. Among the most basic versions,

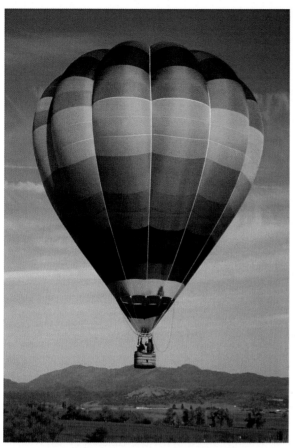

Fig. 7-8 Hot-air balloon, *Dragon Egg*, of Jane English lifting off from a field near Mount Shasta, northern California, United States. This is a relatively small balloon that can carry four people.

a simple plastic bag containing the lifting gas was employed by Ullmann (1971) for SFAP of bogs in Austria. Examples for the use of helium balloons include the coastal and periglacial geomorphic studies by Preu et al. (1987) and Scheritz et al. (2008), the photogrammetric documentation of archaeological sites by Altan et al. (2004) and Bitelli et al. (2004), and vegetation studies in wetlands and semiarid shrubland conducted by Baker et al. (2004) and Lesschen et al. (2008), as well as wetland vegetation mapping at Akanuma marsh, Japan by Miyamoto et al. (2004).

For an investigation on salt-marsh eco-geomorphological patterns in the Venice lagoon spanning different spatial scales, Marani et al. (2006) suspended a double-camera system (VIS and NIR) from a helium balloon operating at low height (~20 m), and a similar system was used by Jensen et al. (2007) for wheat crop monitoring. In order to sidestep costly satellite imagery and conventional aerial photography with a low-cost remote-sensing method applicable in developing countries, Seang and Mund (2006) have used SFAP taken from a hydrogen balloon for various applications in regional and urban planning, monitoring of degraded forest, and basemap compilation for infrastructure projects in Cambodia.

Tethered spherical balloons are, unfortunately, highly susceptible to rotational and spinning movements (Preu et al. 1987). For SFAP, more aerodynamically shaped airships, namely blimps, are preferable, because they align themselves with the wind direction. Various researchers have employed helium blimps: Pitt and Glover (1993)

Fig. 7-9 Early morning picture looking south toward Mount Shasta taken from the hot-air balloon (in previous figure) about 150 m high above Shasta Valley, northern California, United States. Note morning fog in the distance and heavy shadowing of ground.

for the assessment of vegetation-management research plots, Inoue et al. (2000) for monitoring various vegetation parameters on agricultural fields, Jia et al. (2004) for evaluating nitrate concentrations in agricultural crops, and Gómez-Lahoz and Gonzáles-Aguilera (2009) for 3D virtual modeling of archaeological sites. The suitability of blimps even for heavy high-tech sensors at greater flying heights (up to 2000 m) was proven by Vierling et al. (2006), who used a 12-m helium blimp as a multisensor platform for hyperspectral and thermal remote sensing of ecosystem-level trace fluxes.

Hot-air blimps as camera platforms have been developed and employed for many years by two of us for investigations on soil erosion and vegetation cover (e.g. Marzolff and Ries 1997, 2007; Marzolff 1999, 2003; Ries and Marzolff 2003). The same hot-air blimp and its prototype predecessor were used for archaeological applications documented by Hornschuch and Lechtenbörger (2004) and Busemeyer (1994). The construction and handling of such blimps are discussed in the following sections, even though UAS (see Chap. 8) are easier to apply and today are used much more frequently than tethered hot-air blimps. The balloon, blimp, and kite community remains alive and active, nonetheless. Particularly during scientific workshops and meetings, such advantages as uncomplicated authorization schemes and easy handling are appreciated. There is not always the need or place for using an advanced UAS.

Because of their light weights and comparatively large surface areas, lighter-than-air platforms, especially balloons, are relatively difficult or impossible to fly in windy conditions. This wind susceptibility is even increased and thus positively exploited by the so-called *Helikite*, a hybrid of helium balloon and kite combining the advantages of both platforms. Examples for investigations conducted with this rather unusual platform are given by Verhoeven et al. (2009) for aerial archaeology and Vericat et al. (2009) for monitoring river systems.

At the extremely large end of lighter-than-air platforms, the US Air Force built a huge blimp measuring 370 ft (113 m) long and holding ~40,000 m^3 of helium (Shachtman 2011). Known as *Blue Devil Block* 2, the enormous, optionally manned airship was intended as a spy drone to hover at 20,000 ft (~6100 m) over war zones for surveillance and gathering high-definition imagery. It was first inflated in 2011 inside a hanger, however, owing to technical complications the project was canceled in 2012 and the blimp put into storage.

7-3.1 Lifting Gases

Several lighter-than-air gases could be employed as the lifting medium—hydrogen (H$_2$), helium (He), methane (CH$_4$), and hot air (FAA 2007). Hydrogen is the lightest of all gases and is used occasionally for SFAP (Keränen 1980; Gérard et al. 1997; Seang et al. 2008). However, hydrogen and methane are both explosive and highly flammable; they are not considered further for obvious safety reasons, which leave helium and hot air as the gases of choice for most balloon and blimp applications.

Helium has a lifting capacity of about 1 g/L, whereas hot air lifts only about 0.2 g/L. Thus, for a given volume, helium lifts approximately five times more weight than does hot air. In addition to a larger and heavier envelope, a hot-air platform also needs to carry a gas tank and burner in order to stay aloft for more than a few minutes. This added weight reduces the potential payload a hot-air system could carry.

Helium is created as a byproduct of radioactive decay within the solid Earth. Continental crust, which is enriched in uranium and other radioactive elements, is a constant source for helium. Because it is inert, helium does not combine with minerals in the crust, but it does readily dissolve into fluids such as ground water and natural gas; the latter typically contains 0.2% to 1.5% He by volume. Eventually helium reaches the surface, for example in hot spring water (Persoz et al. 1972), and is released into the atmosphere. Earth's gravity is too weak to retain the helium molecule (single He atom), so it ultimately escapes into space.

Helium was little known prior to the 20th century. This changed with the discovery that helium is a significant component of natural gas in some situations. Throughout most of the 20th century, helium was regarded as a strategic resource for military and industrial purposes in the United States. In the 1990s, however, all helium production was privatized (National Research Council 2000). Nowadays helium extracted from natural gas is the only commercial source, and the United States is the major supplier. Helium is also produced in Algeria, Poland, Qatar, and Russia. As an industrial commodity, compressed helium is widely available in the United States in steel cylinders that may be purchased or rented from gas distributors (Fig. 7-10).

Beginning in 2012, however, a worldwide helium shortage began to drive cost upward, and availability became problematic. In the United States, the cost of balloon-grade helium increased more than tenfold. The US Congress took action in 2013 to keep open the national helium reserve for auction sales to private industry and the public (Phys.org 2013). Since then, the helium shortage has eased, but cost remains high.

Helium has significant lift and definite safety advantages compared with hot air, but helium is either quite expensive or simply not available in many countries around the world. Conversely propane, cooking gas, or other types of natural gas may be found just about everywhere for firing a hot-air balloon or blimp. Because

Fig. 7-10 Helium tank and balloon filler valve. (A) Helium cylinder mounted on a hand truck for easy transport. This tank weighs ~65 kg when full and contains ~7 m^3 of helium. It is shown here with the safety cap in place (top of tank). The cap is required whenever the tank is transported or stored. (B) Close-up view of valve and nozzle for inflating balloons or blimps. The valve is opened by bending the black tip. This valve must be removed for transportation and storage of the tank.

commercial gas tanks are too large and heavy for model airships or do not allow extracting liquid gas, they need to be decanted into special gas bottles. It has proven extremely important to use a fine-meshed gas filter in this process to prevent the transfer of small dirt and rust particles from commercial gas tanks into the flight bottles (Fig. 7-11). Filtering is also advisable for the gasoline used as fuel for small combustion engines. Even if the degree of fuel purity is standardized nowadays, old tanks and barrels are often rusted inside, and a spluttering motor in the air may terminate not only the flight but also the aircraft and camera.

7-3.2 Helium Blimp

The small helium blimp that we have used extensively is 4 m long and has a gas capacity of ~7 m^3

Fig. 7-11 Small gas filter used for preventing dirt and rust particles from entering the special hot-air blimp gas bottle during filling from commercial gas tanks.

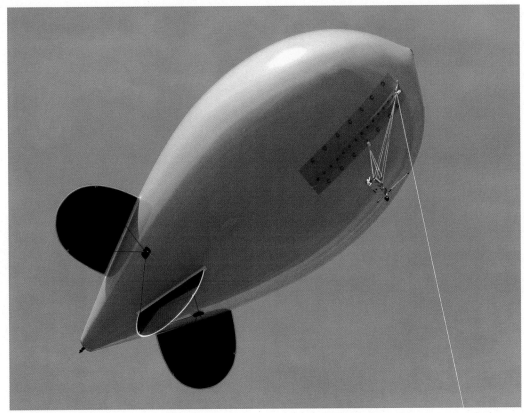

Fig. 7-12 Helium blimp ready for flight with radio-controlled camera rig and Picavet suspension attached to keel. Blimp is 4 m (13 ft) long and contains ~7 m^3 of helium; tether line extends to lower right.

(Aber 2004). The blimp has a classic aerodynamic shape with four rigid fins for stability in flight. It has a payload lift of ~3 kg, which is 2–3 times the weight of camera rigs and has proven to be an adequate margin of safety for blimp operation. The camera rig, which is the same system utilized for kite aerial photography (see below), is attached to a keel along the bottom of the blimp (Fig. 7-12). The blimp is secured and maneuvered using a single tether line of braided *Dacron* with a breaking strength of 90 kg.

All equipment may be transported in the back of a small truck or trailer including one large helium tank that holds ~7 m^3, which is just enough to inflate the blimp one time. Field operation is relatively simple; first, a large ground tarp is laid out, and the blimp is inflated on this tarp (Fig. 7-13). Once inflated, a camera rig is attached and tested. The whole preparation and inflation procedure takes about half an hour and requires only two people. As with other tethered aircraft, the blimp may be flown up to 500 ft (~150 m) above the ground in the United States without filing a flight plan with the nearest airport (see Chap. 12-2).

The blimp may be sent aloft and brought down repeatedly to change camera rigs or to move to new locations around the study site. In principle, the blimp could remain aloft until the helium gradually leaks out,

a period of several days. In practice, blimp aerial photography is conducted normally at a single study site in 1 day, from midmorning until midafternoon, when the sun is high in the sky. At the end of each session, the helium is released, as there is no practical means to recover it in the field.

This blimp has been utilized under conditions ranging from completely calm to moderate wind speeds in rural and urban settings. The blimp has proven quite stable in calm to light wind and remains relatively stable in wind up to 10–15 km/h. Under light wind, the blimp may be maneuvered quite precisely relative to ground targets. Stronger wind, however, tends to push the tethered blimp both downwind and down in height so that surrounding obstacles may become troublesome.

This particular blimp is relatively small and easy to handle, which results in excellent portability for reaching any site accessible to a four-wheel-drive vehicle. Furthermore, small blimps of this type are widely available for advertising purposes and are low in cost. Given repeated use over a period of years, the lifespan of such a blimp is on the order of a decade, after which microleaks become too numerous to repair.

Many larger helium blimps have been employed by other people for SFAP. In some cases, a permanently inflated blimp is stored and transported in a big trailer.

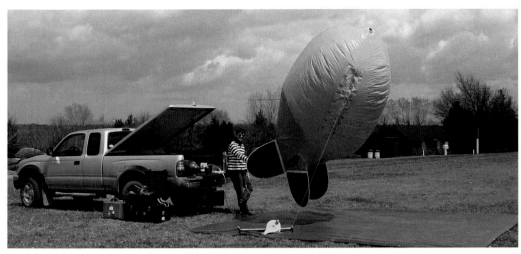

Fig. 7-13 SWA inflates the blimp on a canvas tarp. The helium tank, deflated blimp, camera rigs, and all other equipment are transported in the back of the small four-wheel-drive truck, which may reach remote locations.

In this case, none or only some of the helium has to be released. This reduces the costs significantly and enables several ascents on successive days. In other cases, a blimp may remain in the air over a study site for long periods of time—days or weeks. Special fabrics and wind-resistant designs are necessary for success with such extended usage. Larger and more robust blimps mean higher costs for equipment and helium, and are generally less portable in the field.

7-3.3 Hot-Air Blimp

Spherical hot-air balloons experience the same stability problems as helium balloons. If they are free flying, they are simply uncontrollable, and in tethered mode they start turning erratically even at quite low wind velocities. In addition, the internal pressure inside the hot-air balloon needs to be relatively high in order to prevent deformation of the envelope in light wind. Therefore, hot-air balloons are not well suited as camera platforms. For these reasons, it is no surprise that this kind of camera platform is almost forgotten nowadays, although it was the first platform used for aerial photography by Gaspard Tournachon (see Chap. 1).

Tethered hot-air systems as camera platforms have emerged since the late 1970s particularly in archaeology. In this field of research, a high need exists for quickly producible, detailed images for documenting excavations in remote areas (Heckes 1987). The hot-air blimp introduced by Busemeyer (1987, 1994), which was also used by Wanzke (1984) for the documentation of excavations in Mohenjo-Daro in Pakistan, is the prototype on which all such blimps are constructed by *GEFA-Flug* (Aachen, Germany). These hot-air blimps combine the principle of an open hot-air system with an elongated, egg-shaped blimp equipped with tail empennages.

Owing to the streamlined shape and tail empennages, the blimp is more aerodynamic than a spherical balloon and aligns itself with the wind. Thus, the air vehicle becomes much easier to control from the ground even with a light breeze. In case of increasing wind, the envelope may get pushed in at the nose, but a safe landing is still possible as this affects the uplift properties only slightly. The danger for an ignition of the envelope owing to a wind gust blowing the fabric into the burner flame is rather low for the blimp in contrast to a balloon. The concept and functionality of this airship, its construction, and its use for aerial photographic surveys were presented and discussed in detail by Marzolff (1999).

Two of the authors, IM and JBR, have employed hot-air blimps over many years, a smaller one with about $100 \, m^3$ volume and a load capacity of 5 kg and a larger one with $220 \, m^3$ volume providing a carrying capacity of ~25–40 kg. The smaller version ranges at the lower border for model airships, but has the crucial advantage that the individual parts may be transported by one person each (Fig. 7-14). Only four people are necessary to carry the equipment even to remote study areas. Unfortunately, the smaller model is comparatively susceptible to wind influence because the net-lifting capacity of only 5 kg does not leave a wide scope for "heating against the wind."

In the following sections, the most important components and their functioning are explained using the larger hot-air blimp—the *Goethe monitoring blimp* belonging to the Department of Physical Geography of Frankfurt's Johann Wolfgang Goethe University (Fig. 7-15). The monitoring blimp comprises four main components—the envelope, burner frame with camera mounting, remote-control device, and tether ropes. Additional equipment for the inflation phase (Fig. 7-16) includes a tarpaulin, a large inflation fan, and miscellaneous tools.

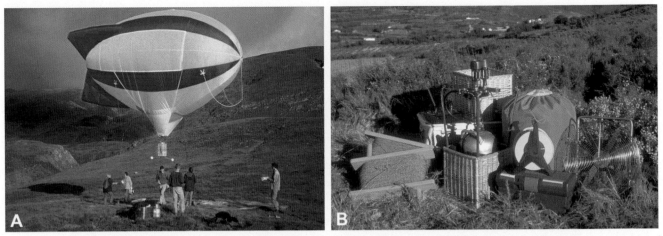

Fig. 7-14 Small 100 m³ hot-air blimp built by *GEFA-Flug*. (A) In the alpine conditions of the Spanish Pyrenees, carrying capacity and wind susceptibility of this model reach their limits. (B) Small packing size makes it easy to transport to remote regions such as high mountain ranges; no single part is heavier than 15 kg.

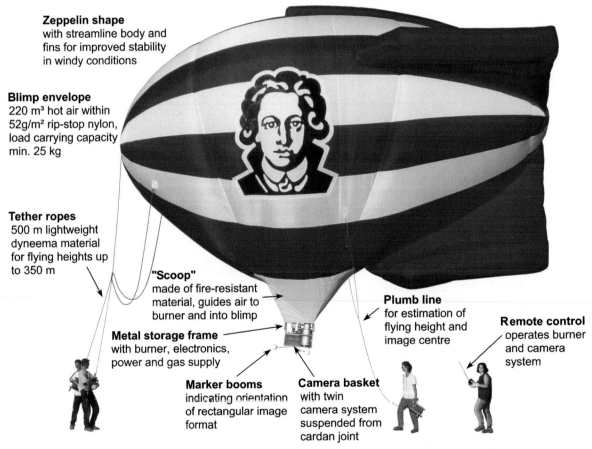

Zeppelin shape
with streamline body and
fins for improved stability
in windy conditions

Blimp envelope
220 m³ hot air within
52g/m² rip-stop nylon,
load carrying capacity
min. 25 kg

Tether ropes
500 m lightweight
dyneema material
for flying heights up
to 350 m

"Scoop"
made of fire-resistant
material, guides air to
burner and into blimp

Metal storage frame
with burner, electronics,
power and gas supply

Marker booms
indicating orientation
of rectangular image
format

Camera basket
with twin
camera system
suspended from
cardan joint

Plumb line
for estimation of
flying height and
image centre

Remote control
operates burner
and camera
system

Fig. 7-15 The hot-air *Goethe monitoring blimp* carries the logo of Johann Wolfgang Goethe University, Frankfurt am Main, Germany. Blimp and frame constructed by *GEFA-Flug* and by the technical workshop staff of the Faculty of Geoscience and Geography. *Modified from Ries and Marzolff (2003, Fig. 2).*

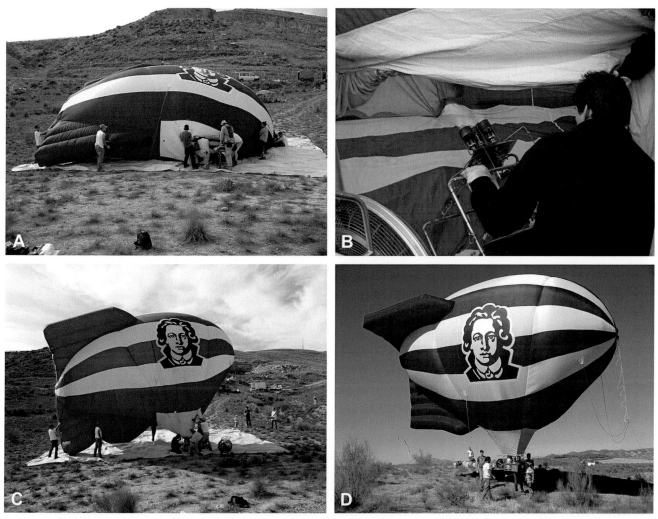

Fig. 7-16 Launching the blimp. (A) Blimp envelope is spread out on two fabric-reinforced, 50 m² plastic tarpaulins and inflated with fresh air by means of a 5.5 PS fan of the kind frequently used for manned balloons. (B) Once enough space has filled inside the body, the burner is positioned to face the blimp spine and the air is heated with intermittent blasts. (C) As the envelope is released and rises, the most critical phase of the launch begins. The uplift force is already strong, but the blimp still needs to be held tightly and heating discontinued until the burner frame is securely fixed to the scoop. (D) Fully inflated airship in launch position. After testing all valves again, the camera unit is attached and tested. The blimp is quickly heated then and lifts up to a safe height >30 m.

Blimp envelope—The envelope consists of tear-proof, polyurethane-coated, 52 g/m², heavy, rip-stop nylon and has a length of 12 m, a height of 6 m, and a width of 5 m when inflated. The airship has a volume of 220 m³ and does not need any additional inner stabilization. For the three tail empennages a specific airflow is necessary. On top of the blimp the hot air is drawn off into a tube that is externally sewn onto the envelope. Through this tube the air reaches the distributing chamber which is separated from the main body in the rear end. From there the hot air is directed into the three empennages. These fins are characterized by an unfavorable ratio of large cooling surface to low volume; therefore, they are kept in shape only with a constant influx of hot air. But these three fins are essential for achieving a stable position;

tethered on its nose, the blimp always aligns itself in the prevailing wind direction.

At the bottom of the combustible envelope, the so-called scoop is attached, which is made of fire-resistant *Nomex* material and connects the blimp body to the burner frame. It is open to the front in order to allow an inflow of outside air to compensate for the permanent air loss through the envelope seams. At the scoop, two steel cables encompassing the envelope end in metal chains to which the burner frame is attached with carabiners.

Burner frame with camera mount—The burner frame consists of a steel-tube frame with a collapsible burner panel, an exchangeable gas bottle, and a plug-in camera unit. Four 100,000 kcal/h Carat liquid-phase burners produce flames ~90 cm in height. They are capable of

heating up the air inside the envelope to a maximum of 140 °C. The burners are screwed onto the burner panel beneath which the electronic control with two magnetic valves is situated. The gas is kept in an aluminum bottle with a net weight of 5.6 kg and a filling capacity of 11 kg of gas. The gas bottle is strapped underneath the burners but is easy to retrieve.

The gas is extracted in the liquid phase with an immersion pipe and fed to the valves through a steel-reinforced tube equipped with a gas filter. Additionally, the burners are supplied with a mixture of propane and butane from a commercially available 0.7 L multigas cylinder. This gas is used to produce an approximately 20-cm-high pilot flame, which is permanently ablaze in all burners and may be ignited by an electronically controlled piezo igniter. The remote control is not used until the blimp floats and is ready for departure. The gas supply is sufficient for approximately 45 min of flight.

The net carrying capacity of the hot-air blimp ranges between 25 and 40 kg depending on ambient temperature and the amount of fuel in the gas bottle. The system is particularly suitable for different flight altitudes, especially with regard to the fact that it becomes increasingly lighter during the flight owing to gas consumption. Accordingly, in the beginning of the flight the lower, and later on the higher flying heights should be scheduled. The camera mount is inserted into the burner frame as a separate plug-in unit; it sits underneath the burner and next to the gas bottle. Power supply for the mount is established automatically with a plug connection. The cameras are protected from damage in rough landings by a robust wicker basket or polystyrene-walled aluminum frame, open at the bottom to ensure free sight for the cameras (Fig. 7-17).

Remote control—Piezo igniter, pilot flame, and main burner valve as well as camera servos and camera trigger are all operated with a commercial remote-control device (e.g. *Graupner* mc 16/20). The remote control is equipped with a pulse-code-modulation (PCM) fail-safe device that is programmed to close all valves automatically in case of problems with radio reception, external signals, or a failure of the transmitter. This is quite important to make sure that uncontrolled burning could be avoided—permanent burner blasts would lead to overheating and possible inflaming of the envelope. The radio signals are transmitted on the frequency band locally used for model aircraft (e.g. 40 MHz in Spain).

Tether lines—As the blimp is a captive airship, its position may be controlled from the ground by means of two tethers. For this purpose extremely light ropes made from PE-coated *Dyneema*, an extremely strong polyethylene fiber with low elongation and twist and high breaking strength, are used. The ropes are fixed to

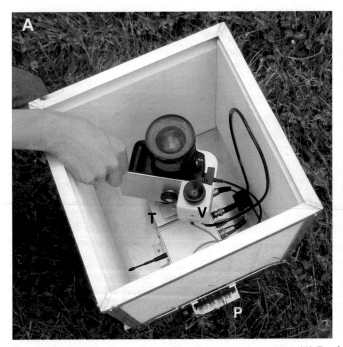

Fig. 7-17　Upside-down views of box-type camera mounts. (A) Box built from aluminum and polystyrene; V—Video camera as navigation aid, T—Pan-servo turntable, P—Plug establishing connection to the batteries and radio receiver. Mounting system built by the technical workshop staff of Trier University's Faculty of Geography and Geoscience. (B) Dual-camera system with simultaneous image capture. Note the two aluminum booms indicating the orientation of the image format to the photographer on the ground. Basket box made from plywood, wicker, and aluminum. Mounting system originally built by *GEFA-Flug* with extensive modifications by the technical workshop staff of Frankfurt University's Faculty of Geoscience and Geography.

the envelope via a trapezoid of lines attached to the bow and front flanks of the blimp body. A rubber expander in the trapezoid minimizes the jerky pulls that are passed onto the airship during fast maneuvers by the ground crew. When in flight, the blimp's bow always points toward the wind; this enables stable maneuvering and free influx of fresh air into the scoop. Additionally a third rope, the plumb line, hangs down vertically from the envelope. It is marked every 5 m in order to allow an estimation of the flying height and to indicate the current position of the airship (approximate image center) to the crew on the ground.

7-4 KITE AERIAL PHOTOGRAPHY

Kites were among the earliest platforms used for aerial photography, beginning in the 1880s (Batut 1890; see also Chap. 1). Starting in the late 20th century, kites have experienced a renaissance for SFAP as a fascinating hobby for photographers around the world, who share their techniques, experiences, and images via the Internet (e.g. Beutnagel 2006; Benton 2010; Chorier 2018a).

In relation to these activities, scientific applications of kite aerial photography are comparatively rare, but of increasing technical sophistication. Several researchers, including the authors, have used kites for geomorphological investigations (Bigras 1997; Boike and Yoshikawa 2003; Marzolff et al. 2003; Marzolff and Poesen 2009; Smith et al. 2009; Feurer et al. 2018), vegetation studies (Gérard et al. 1997; Aber et al. 2002, 2016), archaeological documentation (Bitelli et al. 2001), and other applications (Aber et al. 1999; Tielkes 2003; Wigmore and Mark 2018).

Kite aerial photography (KAP) is highly portable and flexible for field logistics, adaptable for many types of cameras and sensors, relatively safe and easy to learn, and has among the lowest costs overall compared with other types of SFAP. KAP is also less affected by privacy and safety concerns as well as legal restrictions than UAS photography (see Chap. 12), which makes kites an interesting alternative to quadcopters, hexacopters, fixed-wing UAV and other autopiloted remotely controlled aircraft (Duffy and Anderson 2016; Feurer et al. 2018). These characteristics explain the enduring interest in KAP from the popular and sport level to high-end scientific applications.

The basic deployment of kite aerial photography is depicted in Fig. 7-18, which illustrates the typical setup for the kite, camera rig, and ground operation. Central themes for KAP are the types of kites, necessary kite-flying equipment, ground operations, and camera rigs, which are described in the following sections based primarily on the authors' experiences spanning more than two decades.

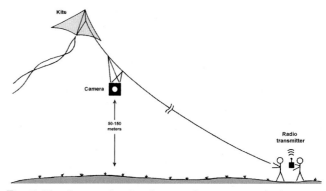

Fig. 7-18 Cartoon showing the typical arrangement for kite aerial photography. The camera rig is attached to the kite line. The camera rig may function autonomously or a radio transmitter on the ground may control operation of the camera rig. The kite line normally is anchored to a secure point on the ground. Not to scale. *Modified from Aber et al. (2003, Fig. 1).*

7-4.1 Kites for SFAP

Many types of kites could be employed, but no single kite is optimum for KAP under all circumstances. Various kinds and sizes of kites are utilized depending on wind conditions and weight of the camera rig. The goal is to provide enough lift to support the payload—normally ranging from 1 to 3 kg. For a given camera rig, large kites are flown on lighter wind and smaller kites for stronger wind. Kite designs fall in two general categories.

- **Soft kites**—have no rigid structure or support to maintain their shape. The kite inflates with wind pressure and forms an airfoil profile, like the wing of an airplane, which provides substantial lift. Soft kites have several advantages for KAP. They have quite low weight-to-surface-area ratios, they are exceptionally easy to prepare and launch, and they are a breeze to put away—just stuff the kite into a small bag. For light-weight travel or backpacking, soft kites are the type of choice. Among the most popular soft kites for SFAP is the *Sutton Flowform* (Fig. 7-19). Many other types of soft airfoils are utilized for SFAP, ranging in size up to >10 m^2, and are able to loft substantial payloads. Soft kites typically fly at a low angle to the ground, and they do have a tendency to collapse when the wind diminishes, so a watchful eye is necessary while in flight.

- **Rigid kites**—employ some type of hard framework to give the kite its form and shape. Traditional supports of wood and bamboo are replaced in most modern kites by graphite rods and fiberglass poles. Their weight-to-surface-area ratios are intrinsically greater than soft kites, but rigid kites do have some important advantages for KAP. The primary capability is to fly well in light breezes without the danger of deflating and crashing. The frame maintains the kite's proper

Fig. 7-19 The *Sutton Flowform* is a wind-inflated soft airfoil that flies well in moderate to strong winds (Sutton 1999). This side view shows the kite with two 4½-m streamer tails, which greatly improve its stability. Flowforms come in several sizes; this one is 16 ft² (~1½ m²) in surface area.

aerodynamic shape regardless of wind pressure. Many rigid kite designs are suitable for KAP. Delta kites, for example, have a basic triangular shape, are exceptionally easy to fly, and the wing dihedral provides stability in flight (Fig. 7-20). Although frame members may be disassembled, long poles might be troublesome for packing and traveling.

The rokkaku style is the favorite rigid kite of the authors (Fig. 7-21). This traditional Japanese kite has a low weight-to-surface-area ratio, and through centuries of design improvements it has achieved an elegant status among kite flyers. It provides the greatest intrinsic lifting power compared with other types of rigid kites in our experience, and rokkakus tend to fly at a high angle to the ground. Rokkakus may be somewhat unstable in near-surface ground turbulence, but once aloft they are remarkably smooth and powerful. We utilize rokkakus for the majority of our KAP, choosing for each survey from a selection of different sizes, tails, and tether lines depending on the current wind conditions.

7-4.2 Kite-Flying Equipment

Beginning with items attached to the kite itself, the tail is an important option (see figures above). Tails generally increase the stability of kites, but at a price of increased weight and drag, which could make the kite fly at a lower angle. Under light, steady wind, the tail may not be needed, particularly for the rokkaku. However, a tail may be essential for strong, gusty, or turbulent wind conditions. When to use a tail is based on experience; test flying the kite without a camera rig is a good idea to judge the wind conditions aloft and possible need for a tail.

Kite line is the next critical component. JSA and SWA typically use a 300-pound (135 kg) braided *Dacron* line for most kites; in light, stable wind a 200-pound line may be utilized. The line is wound on a simple hoop or hand-cranked reel, which is firmly anchored (Fig. 7-22). For the large rokkaku kites used by IM and JBR, where the kite line also serves as the rail track for pulling up the camera sledge (see below), even stronger and more rigid lines made from PE coated *Dyneema* are used. Some kite flyers prefer *Kevlar* line, which is strong, thin, and light; however, we consider it rather dangerous because of its ability to cut like a knife through gloves, clothing, and skin.

Whenever handling the kite line or reel, gloves are highly recommended to protect the hands. Some kite

Fig. 7-20 Delta kites for SFAP. (A) Wingspan of 11 ft (~3.4 m). This kite is well-suited for lifting camera rigs in moderate to strong wind conditions. (B) Wingspan of 19 ft (~6 m). A powerful kite good for light to moderate wind or high-altitude. Both shown flying with 6-m-long tube tails to improve stability.

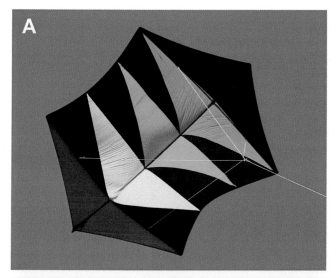

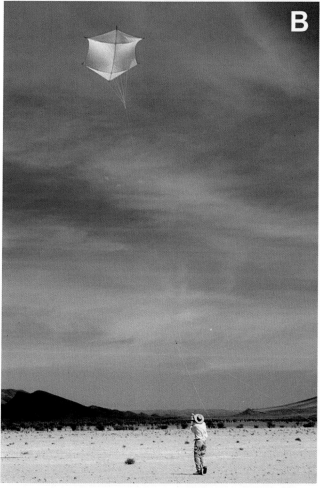

Fig. 7-21 Rokkaku kites for SFAP. (A) Large rokkaku used by JSA and SWA measures 7½ by 6 ft (~2.3×1.8 m) with about 36 ft² (3.3 m²) of lifting surface. (B) Still larger rokkaku of IM and JBR. This kite is designed for lifting an SLR camera with sledge-type rig (see below) even in lighter winds. It is 2.5 m tall by 2.0 m wide. Rokkaku kites may fly in steady wind without a tail.

flyers use *Kevlar* gloves, but the authors have found thick leather to be most practical. For securing the kite line, as well as tether lines for blimps and balloons, several knots, bends, and hitches are particularly useful (Fig. 7-23; Budworth 1999; Pawson 2004; Jacobson 2008).

How to attach the camera rig to the kite is a question with many solutions. Nearly all modern KAP is conducted with the camera rig secured to the kite line, some distance down the line from the kite itself (see Fig. 7-18). The purpose of this arrangement is to remove the camera from line vibrations and sudden movements of the kite. Two basic methods are the pendulum and Picavet suspensions. Both may be combined with a cable-car system in kite aerial photography or directly attached to a kite line.

- **Picavet suspension**—String-and-pulley cable system that attaches to a kite line or a blimp keel at two points (Fig. 7-24). It was devised by a Frenchman, Pierre Picavet, in 1912 as a self-leveling platform for a camera rig suspended from a kite (Beutnagel et al. 1995). A typical Picavet suspension hangs 1–2 m below the kite line or blimp keel, and the two attachment points are spaced a similar distance apart, resulting in a triangular arrangement. The Picavet suspension is typically fixed on the kite line, and the camera is raised and lowered by letting out or taking in the kite.
- **Pendulum suspension**—Stiff rod made of aluminum, fiberglass, carbon, or even a flexible wire. The pendulum suspension may be combined with a sledge-and-pulley system running on the kite line (Fig. 7-25). This approach allows raising and lowering the rig and changing the camera, lens, battery, or storage card without having to bring the kite down. However, care must be taken that the friction of the sledge wheels on the kite line does not cause electrostatic charging of the camera mount. Mysterious camera malfunctions, which were observed during several surveys in hot and dry environments, were finally attributed to this problem. It was resolved by replacing the original aluminum wheels with ceramic wheels and inserting a plastic barrier into the pendulum staff.

7-4.3 KAP Camera Rigs

The main tasks of the rig are holding and operating the camera while in flight. Apart from image capturing functions, the rig may also control camera orientation, that is the horizontal (pan) and vertical (tilt) position of the camera lens. Removable mounts have several advantages. Most importantly, they may be attached after launching the kite and detached before the landing

Fig. 7-22 Kite line anchors and reels. (A) Line attached to a cleat on a wooden handle that is anchored to a steel fence post set in stone. The extra line is wound on a simple plastic hoop. (B) *Strato-spool* reel contains 1000 ft (~300 m) of braided *Dacron* line. The spool handle is locked with the blue strap, and the whole apparatus is anchored to a steel fencepost (not shown). The reel is about 2½ feet (¾ m) long.

Fig. 7-23 Selected knots and hitches for kite aerial photography. (A) Sheet bend, an excellent knot for joining two lines of equal or unequal diameter. (B) Fisherman's (English) knot. Each line is tied in an overhand knot around the other line, and then the two knots are pulled tight. One of the strongest and most resistant to slippage of all bends for tying two lines together. (C) Lark's head (cow hitch), a simple knot used to tie a ring into a line. (D) Anchor (fisherman's) bend, two half hitches in which the first half hitch is locked by an extra round turn. This is the authors' favorite means to attach kite flying line to snaps and rings. Knots by JSA.

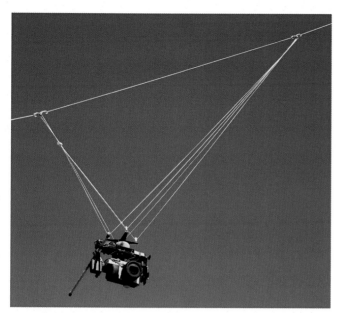

Fig. 7-24 Picavet suspension system. Note the use of double hooks to fix the suspension at two points on the kite line. The camera platform remains level regardless of the angle of the kite line.

phase of the flight, decreasing the crash risk for the camera. In addition, the camera position relative to the aircraft may be adjusted more freely with a separate rig than with fixed mounts. Finally, the camera rig may be used for several platforms—kite, balloon, blimp—and enable separate packing and maintenance of the sensor unit.

Most single-camera mounting systems include the basic functions for camera position (pan and tilt) and shutter trigger, which may operate automatically or be controlled by radio from the ground. In this relatively simple approach, no video downlink or other on-board equipment is involved in the mounting system. The camera position is estimated by visual observation of the camera from the ground and by radio-control settings. Many pictures are taken to insure that the ground target is fully covered from appropriate viewing angles.

A standard, double U-shaped camera mount includes a cradle to hold the camera, a rotating frame in which the cradle tilts, and small servos to accomplish these movements (Fig. 7-26; see also Fig. 2-12). Such a rig for a compact camera normally weighs 0.5 to 1.5 kg,

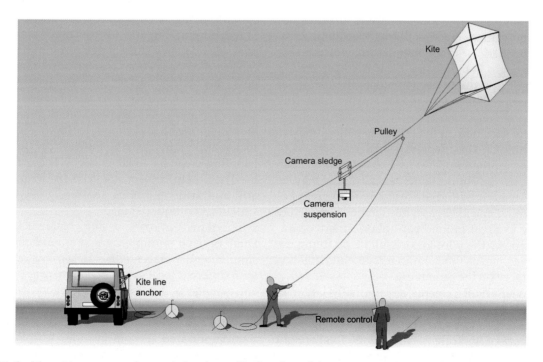

Fig. 7-25 Method for raising a camera rig on a sledge along a kite line. A pendulum suspension system with camera sledge made from aluminum. Sledge wheels are ceramic; aluminum pendulum staff connected by hard plastic block to break electrical conductivity between kite line and camera rig. Not to scale. *Modified from Marzolff et al. (2002, Fig. 5).*

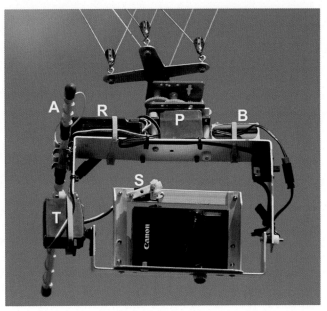

Fig. 7-26 Typical single-camera rig for kite aerial photography. A—antenna mast, which is removable and may break away during a rough landing, R—radio receiver, P—pan servo and gears, B—battery pack, T—tilt servo, and S—microservo for shutter button. *Canon PowerShot 520 HS*, a 10-megapixel camera with a red body (see Fig. 6-2). Original rig built by B. Leffler (California, United States) and modified by JSA for this camera model.

including the camera, battery, and other components, with weight depending mainly on the specific camera model. Aluminum is the usual building material for the frame and camera cradle, although titanium, plastic, wood, fiberglass, or other materials may be used for lighter or stronger components. Each KAP camera rig is custom-built in order to accommodate the particular specifications for the camera model and its triggering mechanism (Fig. 7-27).

An extreme variation on the lighter-is-better theme is known as autoKAP. This involves a small electronic controller that is preprogrammed to move the camera position and trigger the shutter automatically. This may be done in a systematic pattern or could be random in position and timing. In either case, this method completely removes any in-flight ground control of camera operation, which allows the pilot to concentrate on flying the kite, and which means that a radio receiver and antenna are not necessary on the camera rig.

Conventional DSLR cameras are normally larger in size and heavier than point-and-shoot cameras and, thus, require larger mounting systems with stronger servos, bigger battery, and other components. Total weight is typically >1.2 kg. Lens interchangeability means that longer lenses and filters may be employed. In fact, a large lens could be the heaviest single component of the camera rig, which might substantially affect the balance of the mounting system. In order to save moving parts which need precise adjustment, the shutter servo

may be replaced with an electronic shutter control (Fig. 7-28). Alkaline camera batteries could be replaced with lithium-polymer-ion (LiPo) batteries, depending on camera models; LiPo batteries weigh about 40% less than alkaline and provide long-lasting power.

So-called mirrorless interchangeable-lens cameras (MILC) have developed rapidly and become popular within the past few years. They offer the advantages of DSLR cameras, such as lens interchangeability and use of filters, but without the internal mirror assembly (see Chap. 6). MILC are smaller and lighter than DSLR cameras, which is a definite plus for kite aerial photography. KAP camera rigs, thus, may be compact and light weight in design (Fig. 7-29).

Primary design criteria for the camera mounts presented thus far are light weight, rugged components, and reliable camera operation. One consequence of this approach is that all parts of the rig are exposed with little or no protection to the elements. The mount, electronic parts, and camera are potentially vulnerable to dust, debris, and water as well as possible damage during impacts with the ground or obstacles (Fig. 7-30). In actual practice, the authors have experienced only a few mechanical failures or damage for these types of camera rigs.

In some situations, however, more robust mounting systems may be favored in order to protect the camera apparatus better from blowing dust, salt, or sand as well as other harsh environmental elements or difficult flying conditions. Fig. 7-31 shows two sturdy, warp-resistant SLR rigs with pan and tilt functions, electronic shutter release, and heavy-duty batteries; both weigh >2 kg with camera. For protection against dust, sand, and dampness, the battery packs, radio receiver, microswitches, and (for the second rig) pan servo are enclosed in boxes. The servo and radio-receiver batteries may be switched off when unused and charged without removing via the socket outlets, minimizing the need for disassembly and handling wear for delicate parts. These rigs have been used successfully for many years by IM and JBR in semi-arid and arid conditions, mastering several near-crash situations without damage.

For some purposes, a single camera is not enough. Dual- or even multiple-camera mounts may be used for simultaneous images either in various spectral ranges, with different focal lengths/image scales, or from different vantage points for stereo imagery. Multiple-sensor mounts also may combine cameras with such non-imaging spectral measurement devices as spectroradiometers or thermal-infrared sensors in order to collect multispectral information about the viewing target (e.g. Vierling et al. 2006). Such rigs are by necessity larger in size and heavier than single-camera mounts, which makes flying them potentially more challenging. In order to minimize weight, some functions and extra devices may be omitted as described for selected rigs below.

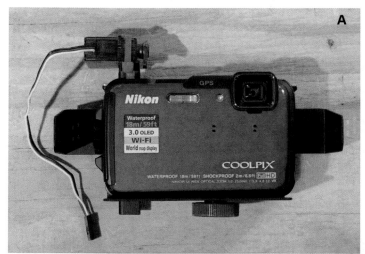
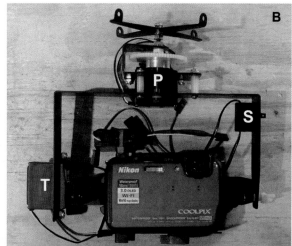
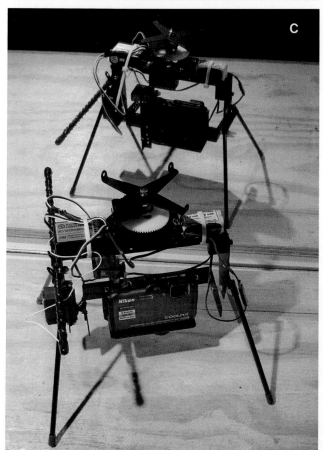
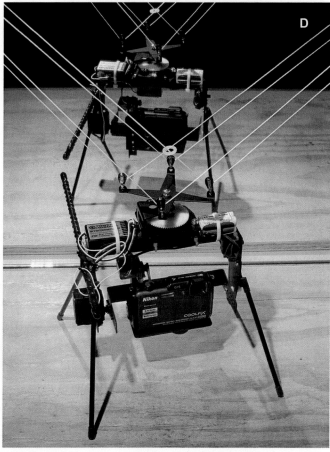

Fig. 7-27 Construction of a typical radio-controlled camera rig for kite aerial photography (see Fig. 2-12). The *Nikon Coolpix* model AW 110 camera is waterproof, so there is no external socket for electronic shutter control. Rig built by JSA; rig kit from brooxes.com (http://www.brooxes. com/). (A) Camera cradle with micro-servo on post to trigger the shutter button. Note the large red tripod mounting screw. The position of the mounting screw is critical for balancing the camera in the rig and placement of other components. (B) Main frame with tilt servo (T), pan servo and gears (P), Picavet cross (top), and power switch (S). (C) Complete frame standing on legs with radio receiver and antenna (left) and battery pack (right). Mirror view shows backside of rig. All wiring is loosely connected at this stage for testing servo action and camera movement. (D) Final assembly with Picavet suspension. All wiring is tucked in and secured with zip-ties, so there are no loose ends to get tangled. The legs normally are removed during flight.

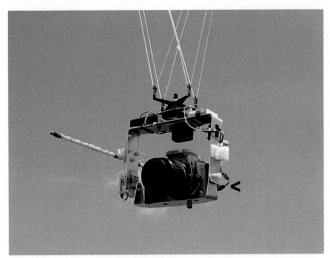

Fig. 7-28 Mounting system for a conventional DSLR camera. Aluminum frame and cradle with pan and tilt controls similar to previous example. The primary difference here is an electronic interface to control the camera shutter (<), which eliminates one servo. In this configuration total weight of the rig and camera is 1.3 kg, but with a larger lens weight could exceed 1.5 kg. Rig built by B. Leffler (California, United States).

For multispectral systems, two cameras are commonly mounted side by side with minimal separation between the lenses (see Fig. 7-17). A typical configuration is for one camera to acquire color-visible or panchromatic photographs and for the other to take simultaneous color-infrared images (e.g. Jensen et al. 2007; Verhoeven 2008). For the example shown in Fig. 7-32, camera pan and tilt positions are fixed on the ground prior to each flight and cannot be changed once the rig is in the air. The camera shutters are triggered electronically to produce dual images of identical scenes (see Fig. 2-5). As the two images are usually to be combined into a single multiband image for analysis, careful mounting of the two cameras is important. Any further separation and any relative tilt between the cameras increase the parallax between the two images, which in this case should be avoided.

For simultaneous stereo SFAP, two cameras need to be mounted some distance apart. The length of the boom determines the air base B that together with the flying height H_g controls the base-height ratio and thus the amount of stereoscopic parallax (see Chap. 3-3)—the longer the boom, the better is 3D perception. In the example shown in Fig. 7-33, the boom position is always mounted parallel to the kite line or blimp keel, in order to minimize wind resistance, and camera tilt angle is fixed on the ground prior to each flight. Once in flight, tilt and pan positions of the cameras cannot be changed. Each camera is triggered simultaneously to acquire pairs of overlapping images (see Fig. 2-9).

In principle, dual- or multicamera systems are attractive. But, in actual practice dual-camera KAP rigs have proven troublesome to operate in the field in part

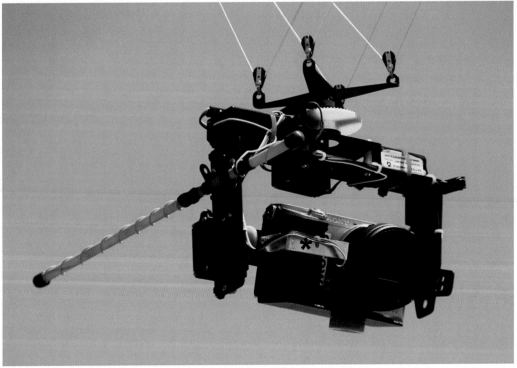

Fig. 7-29 Kite aerial photography rig for a *Sony* α6000 MILC. Overall rig design similar to previous examples. The shutter is triggered by an infrared LED mounted on an aluminum post in front of the camera's IR sensor (*). Total weight of mount, camera and batteries is ~0.85 kg. Rig built by JSA; kit from brooxes.com (http://www.brooxes.com/); infrared shutter trigger by J. Gentles (http://www.gentles.info/KAP/index.htm).

Fig. 7-30 Results of a hard crash on dry soil. Tilt servo gear broken, titanium frame slightly bent, and antenna wire (*yellow* staff) pulled out of the radio receiver. The camera and kite were undamaged, and the broken rig could be repaired in the field by replacing the tilt servo gear and radio receiver. Original rig built by B. Leffler (California, United States). This *Canon* S70 has been in service for more than a decade by SWA and JSA. It remains reliable and currently performs in an auto-KAP rig.

because of their greater weight. The awkward shape of the stereo rig is liable to swing quite a bit in the wind, which makes acquiring vertical shots difficult. Precise alignment of cameras and simultaneous triggering are also problematic. Thus, considerable effort is necessary to utilize dual-camera rigs effectively for kite aerial photography.

7-4.4 Ground Operations

After selecting a suitable open space, free from obstacles and safety hazards (see Chap. 9), the first step is to launch the kite in order to judge wind conditions. It is a good idea to let the kite fly above the level of trees or other obstacles for several minutes in order to observe its behavior. Once the kite has reached a stable flying position, the camera rig is attached and tested. Two approaches may be utilized to lift the camera rig to appropriate height for KAP either by letting the kite line out farther or by use of a sledge running up the kite line (see Fig. 7-25).

For vertical photography, where the exact camera position is more important than for oblique photography, the position of the launching place relative to the study site requires careful planning, because the wind direction, flight angle, and desired camera height have to be taken into account. There is never a possibility of changing the camera height only in a vertical ascent. Changing the flying height of the kite by playing out the line (if the rig is directly attached to the kite line) or by pulling the camera up (when using a sledge-and-pulley system) also changes the horizontal location of the camera. Depending on the camera attachment method, there are two different approaches for surveys taken from varying flying heights.

• With the fixed-suspension method, start from a launching place closer to the study site and low flying heights. Then change to increasing flying heights by letting the kite up farther while simultaneously moving the kite anchoring point away from the site.
• With the sledge-and-pulley system, start from a launching place farther away from the study site and high flying heights. Then proceed to lowering the camera sledge while or before moving the kite anchoring point toward the site.

Depending on the pulling power of the kite, which is mainly a function of wind speed, kite size, and camera

Fig. 7-31 Two mounting systems with pan and tilt functions for DSLR cameras designed for robustness, increased protection of all parts, and minimal requirements for disassembly. Frame and cradle from aluminum; camera triggered by electronic remote-control release. Rigs built by the technical workshop staff of Frankfurt University's Faculty of Geoscience and Geography.

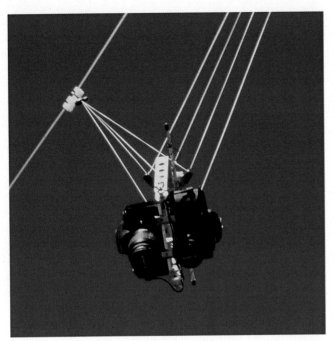

Fig. 7-32 Dual-camera rig for kite or blimp aerial photography, shown here in a vertical position. Two SLR cameras are mounted bottom to bottom for simultaneous pictures of the same scene in color-visible and color-infrared formats. Total weight of this rig and cameras is 1.5 kg. Rig built by B. Leffler (California, United States).

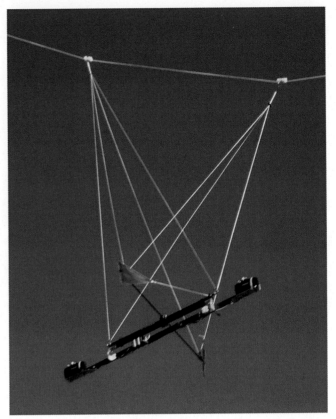

Fig. 7-33 Stereo-mounting system for kite or blimp aerial photography. The boom is ~1 m long with cameras at each end. The small dihedral wings (*red*) are designed to keep the rig parallel to the wind. Total weight of this rig and cameras is ~1 kg. Rig built by B. Leffler (California, United States).

payload, different methods of anchoring may be chosen. Kites for compact cameras and light-weight suspensions could be held by the kite flyer with the great advantage of good mobility for positioning the camera directly above the desired spot on the ground. This should be conducted with a safety harness around the waist and hips serving as the anchor; the kite reel and line should never be held only by hand.

Larger kites capable of lifting SLR camera rigs cannot be held by a single person, at least not when the wind is strong enough to keep the kite with camera aloft. They need to be anchored to something heavy or fixed like a fence post, car, or suitable boulder (see Fig. 7-22). This makes it much more difficult to position the kite or move it during the survey in order to cover larger areas with contiguous images. By slowly driving the anchoring car or redirecting the kite line with the help of one or two people and a pulley system (Fig. 7-34B) as a deflection point, a change of position is possible even for stronger kites.

Keep in mind, though, when planning the positioning operation, that it is difficult to pull a large kite in strong wind into a new position against the wind—it is much easier to move downwind with the kite. Being busy with getting the kite aloft and operating the camera rig, one tends to forget that it might be even more difficult to bring it all down again safely, a task that may require several people in strong wind (Figs. 7-34A and 7-35).

Owing to the combinations between kite, camera, and anchoring points described above, it may in many cases be difficult for the kite flyer to judge the exact location on the ground directly below the camera. For this purpose a spotter, usually the camera operator, may stand next to the ground target in order to give directions to the kite flyer by a two-way radio or via further team members positioned between the two. The kite flyer and camera operator may be separated by several 100 m and may not be able to see each other because of intervening trees, hills, or other obstacles. A laser range finder could be employed to measure the distance and/or height of the kite or camera rig.

In some KAP systems, the camera has a video downlink, so the operator may view directly the scene to be photographed. However, this approach adds weight and complexity both for the airborne camera rig as well as ground operation, which may lead to greater chances for equipment failure or procedural mistakes in the field. By the time a target or particular look angle is determined in the video viewer, the camera usually has moved on to a new position, so attempting to frame the perfect shot this way is rarely practical.

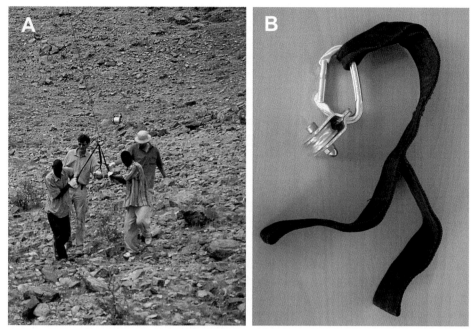

Fig. 7-34 (A) Pulling down a kite after a photographic survey at an inselberg near Gorom-Gorom, Burkina Faso. The wind was so strong that the team had to wait an hour until it started to diminish, when four men managed to get the kite back to the ground; note gloves. This method also could be used to reposition the camera over a desired ground target. (B) Two-person version of the pulley with nylon straps for pulling down the kite line.

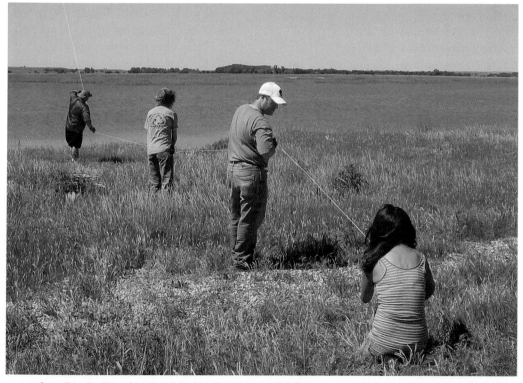

Fig. 7-35 Three people pull in the line of a giant delta kite (wingspan ~6m) flying over open water, while the kneeling person cranks the line onto a reel. All are wearing leather gloves. Cheyenne Bottoms, Kansas, United States.

The authors prefer a basic approach without a video downlink. In this case, the position of the camera is judged from the ground, usually by watching the camera rig with binoculars or using a spotter, and many pictures are taken and stored on large memory cards. Modern digital cameras have large monitors, so it is easy to review results in the camera immediately after bringing the camera rig down. Thus, the success of the mission could be evaluated quickly so that additional KAP may be conducted if necessary.

7-5 SUMMARY

Much innovation in recent years has led to many kinds of platforms utilized for small-format aerial photography. Aircraft include potentially any and all types of flying machines, which may be manned or unmanned, powered or unpowered, heavier or lighter than air, and free flying or tethered to the ground. At a minimum, successful SFAP under various conditions depends upon a platform that is capable of lifting the necessary camera rig and maintaining a position above a desired spot on the ground or flying a line or grid of ground coverage.

For the most part, manned platforms are larger, require an experienced pilot, are more expensive to operate, and need greater logistical support compared with most unmanned aircraft. Small, single-engine airplanes, helicopters, and light-sport aircraft (LSA) are manned platforms often utilized. While not specifically designed for aerial photography, these aircraft may be modified for effective SFAP. They have the advantages of maneuverability and putting the photographer in direct sight of potential ground targets.

Unmanned and tethered aircraft include lighter-than-air platforms as well as kites. Helium and hot-air blimps have proven safe and effective in calm to light wind for SFAP surveys under a variety of local circumstances. Helium has greater lifting ability, but is high in cost and not easily available in many parts of the world. Fuel to fire the burners of a hot-air blimp is readily available just about everywhere, but the larger blimp envelope and burner system are rather expensive, require considerable logistical preparation, and need several people to operate in the field.

Kites are the democratic SFAP platform available at relatively low cost to anybody with a desire to fly a kite and take photographs from above. Soft and rigid kites of various types and sizes are suitable for a range of wind conditions and lifting capability. The rokkaku style kite is recommended herein for most situations. The camera rig is typically secured to the kite line some 10s of meters below the kite using either a pendulum or Picavet suspension system. Camera mounts may be fully functional rigs controlled by a photographer on the ground or autonomous rigs that take pictures automatically. On the ground, kite flyers must be fully cognizant of site conditions including wind direction, potential obstacles, and the need to maneuver the camera into certain heights or positions relative to target features of interest.

In regard to all these potential platforms, the selection is based on practicality. Cost, availability, pilot experience, camera or sensor specifications, site conditions, logistics, repeated use, and other factors may influence which kind of platform is selected. In the end, what matters, of course, is successful acquisition of usable aerial imagery for the application at hand.

8

Unmanned Aerial Systems

What we are witnessing [with drones] is nothing less than the grand democratization of aerial photography. For better or worse, there is simply no turning back. George Steinmetz (2018)

8-1 INTRODUCTION

Unmanned aerial systems (UAS), also known under several other terms (see below) and more popularly called drones, have proliferated in recent years. They have now become the prevalent means of taking SFAP from low heights not only for the geosciences but also in a wide range of civil, commercial, and governmental applications concerned with surveying, mapping, monitoring, inspection, and surveillance. Their presence in the skies and news have become so evident that *Time* recently titled a Special Report issue devoted to UAS "The Drone Age" (Time 2018).

UAS are free-flying, powered aircraft that may be flown remotely by a pilot on the ground or programmed to fly autonomously along specified routes to designated waypoints. The rapid development in UAS technology during the last decade has emerged from significant advances in microchips, global positioning system (GPS), and inertial navigation system (INS) technology, as well as autonomous navigation, high-efficiency batteries, and miniaturized digital cameras.

UAS vary greatly in their aeronautical characteristics, sizes, purposes, costs, reliability, pilot qualifications, and legal restrictions (see also Chap. 12). This chapter focuses on those UAS designed primarily for civilian applications in general and SFAP in particular, with a strong emphasis on the types and sizes typically used in the environmental and geosciences.

Along with their rise in application and research, the literature on remote sensing based on UAS has grown exponentially during the last decade, and quantitative summaries of this development are given in Colomina and Molina (2014), Cummings et al. (2017), and

Yang et al. (2017). All major journals in the remote sensing, geographic information, and environmental sciences (not to mention those in the computer, telecommunication, and engineering sciences) are currently competing with review papers on the use of UAS in applications and research (e.g. Pajares 2015; Stöcker et al. 2017; Torresan et al. 2017; Hardin et al. 2018; Manfreda et al. 2018; Rhee et al. 2018).

Beginning in 2011, UAS special issues and proceedings of dedicated UAV conferences (e.g. UAS4ENVIRO, UAV-g) have been published with often interdisciplinary perspectives on the topic, e.g. in *GIScience & Remote Sensing* (Hardin and Jensen 2011), *Remote Sensing* (Pajares Martinsanz 2012; Lucieer et al. 2014c; Emery and Schmalzel 2018), *International Journal of Remote Sensing* (Simic Milas et al. 2018b), and by the ISPRS (Grenzdörffer and Bill 2013; Armenakis 2015; Stachniss et al. 2017). A new open-access journal named *Drones* has been launched by MDPI in 2017 (Gonzalez-Aguilera and Rodriguez-Gonzalvez 2017).

Beyond the peer-reviewed academic literature, there is a vast body of useful Internet resources (e.g. diydrones.com, dronezon.com, rcgroups.com, to name but a few) as well as practical guidebooks (e.g. Cheng 2016) with up-to-date information on UAS technology, models, operational use, navigation tutorials, applications, and economic potential. The global drones market, which was valued at $6,800 million (USD) in 2016 and is expected to grow up to $36,900 million by 2022 (Gonzalez-Aguilera and Rodriguez-Gonzalvez 2017), is one of the fastest growing sectors of the thriving geoinformation market.

Commercial surveying is clearly driving the development of professional UAS (Drone Industry Insights 2018) and amateur videographers that of consumer-grade small quadcopters. However, the community of geoscientific researchers benefits also strongly from the current advances in both sectors, and the majority of post-2010 SFAP publications referenced throughout this book are indeed based on UAS as remote-sensing platforms.

Given the dynamics of UAS technology, this chapter does not endeavor to cover the topic in full details, but rather give a general overview of UAS types, common characteristics, and some specific examples for UAS familiar to the authors. For more in-depth information on the technological aspects, see for example the *Handbook of Unmanned Aerial Vehicles* (Valavanis 2018) and current articles in journals of engineering and computing sciences (e.g. Toro and Tsourdos 2018).

8-2 TERMINOLOGY

A somewhat bewildering variety of terms and acronyms exists for describing the types of platforms covered in this chapter. Undoubtedly, "drone" is the colloquial term most commonly used in everyday language for a small aircraft without an onboard human pilot. Originally introduced in the 1940s as the official US Navy designation for unmanned target aircraft (Granshaw 2018), the term has been shunned by many civilian users of UAS due to its association with often debated military operations. However, this slightly dubious connotation of the term seems to have faded away more recently as it has been replaced in the general public mind by the omnipresent image of small consumer-grade quadcopters. Drone is now also increasingly used in popular scientific contexts and governmental applications. But in professional and academic environments, including this book, more specific terms are preferred.

In scientific and particularly in regulatory and legal contexts, the words vehicle and aircraft are usually components of a compound term that refers to either the platform, i.e. the flying machine, or a system comprising the platform and additional other elements necessary to enable flight (Dalamagkidis 2015; Granshaw 2018). The most common terms in academic and professional usage are UAV (unmanned aerial vehicle) or UAS (unmanned aerial system or unmanned aircraft system), which includes both remotely piloted and autonomously navigated aircraft. In little-used varieties of the term, the U may also stand for unpiloted or uninhabited. "Unmanned aircraft system" is the preferred term of the US Federal Aviation Administration (FAA) and the European Aviation Safety Agency (EASA), as the aircraft component stresses the need for airworthiness, and the system includes ground-control stations, communication links, and launch and retrieval operations in addition to the vehicle (Dalamagkidis 2015).

Other common terms are RPA (remotely piloted aircraft), which has replaced—for regulatory reasons—the earlier used RPV (remotely piloted vehicle), and RPAS (remotely piloted aircraft system). These are seen as distinctive from UAS by the International Civil Aviation Organization (ICAO), as the latter includes fully autonomous aircraft not allowing pilot intervention, which are primarily used in military situations (ICAO 2015; Granshaw 2018). The term RPAS is most commonly used in contexts of explicitly civilian aviation regulation. Given the scope of this book, it is worth noting that none of the currently valid definitions—not even those addressing the "system" (e.g. European Aviation Safety Agency 2009)—includes any reference to cameras or other sensors carried by the unmanned, remotely, or autonomously piloted aircraft.

This short overview of terminologies with their varying civil, military and legal connotations reflects some of the sensitivities connected to drones as SFAP platforms. Other than kites or blimps, drones carry with them the slightly dubious air of potential privacy invasion as well as clandestine or even dangerous missions. This image is sure to remain ambivalent for some years to come, until the presence of civilian uses will have become an unquestioned part of our everyday life.

We have decided to use the term UAV in this book wherever the platform itself as an aerial vehicle is meant, and UAS where we refer to the complete SFAP system including the camera, control devices, etc. The choice of UAS/unmanned aerial system is in accordance with the prevalence of the term over unmanned aircraft system or RPAS in the geoscientific (i.e. non-military and non-administrative) context.

8-3 UAS TYPES AND COMMON CHARACTERISTICS

The broad term unmanned aircraft encompasses a large variety of platforms with regard to aerodynamic concept, airframe type, size, weight, range, flying altitude, endurance, degree of autonomy, etc. For example, maximum take-off weight (MTOW) may range from grams to >10,000 kg, speeds may vary from hovering to >1000 km per hour, and flying times may reach from minutes to days (Van Blyenburgh 2015). An exhaustive listing of worldwide UAS producers and models is given in the annually updated *Yearbook on RPAS* by Van Blyenburgh (2018).

The US (374 models) and China (311 models) currently clearly dominate the market for UAS, followed by France, Israel, Russia, Germany, the United Kingdom, and Italy with 116–55 models (Van Blyenburgh 2018, p. 124, Fig. 4). Of these, only a part is of interest for the civilian geoscientific community employing UAS in research and application, that is, those typically classified as micro (or small) and mini UAS (with MTOW of 5 or 25 kg, respectively), permissible flying heights of a few hundred meters, and ultra-short ranges and endurances of typically below 10 km and 2 h. The 25 kg threshold constitutes a significant MTOW limit in many national

regulations (see Chap. 12; Stöcker et al. 2017). The categories of micro and mini UAS are also by far the most produced (62% of the 1970 models currently recorded; Van Blyenburgh 2018, p. 125, Fig. 6).

Two primary approaches for unmanned aerial platforms, the airplane and the rotorcraft, are the basis for the following types most commonly used in these UAS categories.

- Fixed-wing UAV (Fig. 8-1A, see Section 8-4)—The self-propelled fixed-wing UAV is sustained in the air by the aerodynamic forces created by the aircraft's forward movement. Thrust is generated by a propeller, and navigation is enabled by flight-control surfaces in the wings and (if existing) tailplane, namely rudder, elevator, and aileron. A fixed-wing UAV cannot hover, as it needs movement to stay aloft, but it has the advantage of fairly long flight times (typically 45–60 min) and, thus, may cover considerable areas up to several 100 hectares during a single mission.
- Single-rotor UAV or helicopter—Helicopters have a single main rotor with horizontally spinning blades that provide the airflow required for vertical lift (Fig. 8-1B). An additional tail rotor, which is smaller and vertically mounted, is needed to counteract torque. The helicopter is navigated by tilting of the main and tail rotors individually or collectively. Compared to a multirotor, it has much larger and slower spinning blades, which means greater efficiency. Therefore, helicopter UAVs have quite long flying times and accept heavier payloads. However, they are mechanically complex and rather costly, and their long rotor blades can cause serious injuries and damages. Therefore, they are comparatively less popular as unmanned platforms for SFAP.
- Multirotor or multicopter UAV (Fig. 8-1C, see Section 8-5)—Multirotor UAVs are variations of the helicopter theme that come with four (quadcopter), six (hexacopter), or eight (octocopter) rotors. They are able to start and land in confined spaces and hover in near-stationary position over a target site. Multicopters are less efficient than fixed-wing UAVs as they need energy not only to move forward but also to hold themselves in the air against gravity. Combined with their usually slower speed, this makes them less suitable for large-area coverage.
- Hybrid VTOL UAVs (see Section 8-6)—The advantages of fixed-wing and multirotor UAVs are combined in hybrid systems that are kept in the air by airflow over their wings but have additional rotors to enable vertical take-off and landing (VTOL). These platforms are currently much in the focus of UAS developers, and several models have come on the market quite recently, with more varieties to be expected in the near future.

Some authors would classify tethered blimps and balloons as UAVs, as well (e.g. Everaerts 2008), but these are not remotely navigable and therefore included in the previous chapter on manned and tethered platforms. Finally, powered paragliders (Fig. 8-2) are another type of unmanned aerial platform. They are sustained in the air by a parafoil with wing-shaped cross-section like those used for manned paragliders and similar to soft kites (see Chap. 7-4). They have been employed for SFAP by several researchers, including the authors, in the late 2000s (Thamm and Judex 2006; Dunford et al. 2009; Aber et al. 2010a) but have quickly been left behind by the rise of electrically powered, less-dangerous, and more-easily navigable UAS.

Another important consideration when deciding which type of UAS to use is the degree of customization offered to the user. Ready-to-fly, commercial solutions with integrated system components (including the camera and ancillary devices) and proprietary control software might be the most carefree to start with. More professional UAS often have a modular design, allowing to upgrade the system with various add-ons, to choose from different sensor payloads, or even to acquire several interchangeable sensor modules for quick alteration in the field.

Alternatively, do-it-yourself (DIY) or kit UAS assembled from individual airframe, sensor, and computer parts with generic control software may be custom-built to meet specific requirements and preferences. For those willing to accept the technical challenges, the wide choices of open-source UAS hardware and software components currently available offer an enormous potential for constructing bespoke research UAS (e.g. Cummings et al. 2017; Ebeid et al. 2018).

In the following subchapters, brief introductions to the most important components and common characteristics of micro and mini UAS are given, before specifics and practical uses of fixed-wing and multirotor UAS along with exemplary models are described in the last sections.

8-3.1 UAV Power, Batteries, and Airframe Materials

With few exceptions of UAVs powered by two-stroke combustion engines running on gasoline (see Figs. 8-1B and 8-2), the fixed-wing and multirotor aircraft of the micro and mini classes have brushless electric motors. The maneuverability, endurance, and safety of a UAV depend much on the characteristics of the battery, and future improvement in battery technology is still one of the main aspects in drone development. The majority of UAVs use advanced battery types, mostly rechargeable lithium-ion-polymer (LiPo) batteries.

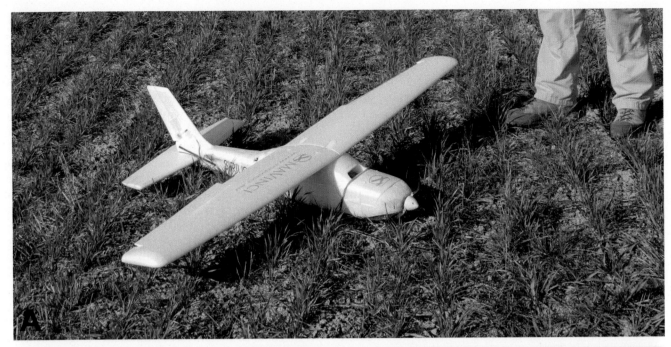

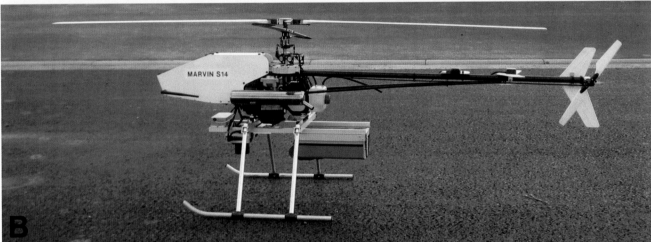

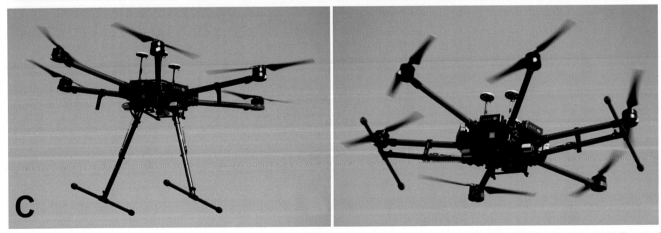

Fig. 8-1 (A) *MAVinci Sirius* I is a battery-powered, fixed-wing UAS with 1.6-m wingspan and a total weight of 2.7 kg, including 12 MP optical camera. (B) Main rotor of the *MARVIN S14*, a helicopter UAS, has a diameter of 1.8 m. The aircraft is powered by a gasoline engine (note tank and exhaust pipe) and has a payload capacity of ~6 kg. (C) large hexacopter, *DJI Matrice* 600 Pro. Capable of lifting multiple cameras and/or sensors with payload weight up to 6 kg. Landing gear extended (left) and retracted in flight (right); flown by C. Pettit and A. Allison.

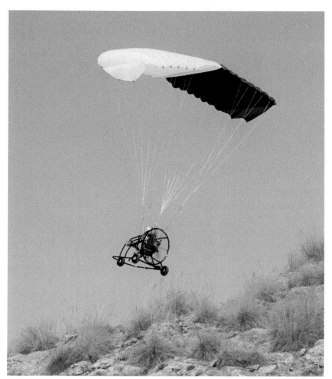

Fig. 8-2 Gasoline-powered paraglider built by *ABS Aerolight Industries*. A single propeller shielded by a protective grating provides propulsion. The $4.5\,m^2$ parafoil is attached to the chassis with 32 lines, which are used to control the wing-flaps for navigating. *Courtesy of G. Rock.*

LiPo batteries have quite high energy density and a very low rate of self-discharge; they are able to deliver large amounts of current rapidly. They are, however, expensive, need special care, deteriorate with age, and are also potentially dangerous. LiPo batteries need to be charged carefully with suitable battery chargers that are configured to balance the battery cells. They are best stored partially charged, that is, neither full nor empty, which calls for regular conservation charging even if the battery is not used for some time.

Over-charging, over-heating, or short-circuiting of LiPo batteries could cause them to burn or even explode. They are therefore classified as dangerous goods by many delivery services and airlines, and the transportation mode, weight, and number of LiPos allowed in shipping or carrying may be restricted. Special fire-resistant LiPo safe-bags are highly advisable, or may even be required for storing and transporting such batteries.

Many UAS, foremost the easy-to-fly amateur consumer drones, are now using so-called smart batteries that have an integrated battery management system. These batteries convey information about the state and charge of their cells to the charger and thus control the charging process. During flight, they deliver the same information to the UAS control system, allowing accurate estimations of the remaining flying time. Smart batteries

are also able to control the self-discharging process, making them altogether much easier to use and maintain.

Among other factors, such as sensor payload, wind speed, temperature, and average amperage draw, the battery capacity is the main factor determining endurance, or maximum flying time of the aircraft. But the benefits of higher capacity batteries are partly outweighed by their increased size and weight, and the net payload remaining for the sensor is reduced. Batteries often constitute a significant part of a UAS' overall weight (and price), and may typically range between 0.5 and 2 kg (see also Sections 8-4 and 8-5).

Light weight is also an important consideration when it comes to UAV airframes (i.e. the main structure of the platform), as every gram spared increases payload capacity and flight endurance. The majority of fixed-wing and multirotor airframes are made from carbon fiber-reinforced polymers (CFRP), usually just called carbon composite or carbon fiber (Red 2009). This material, made of polymer binders such as epoxy and carbon fibers as reinforcers, is light and extremely strong. However, carbon fiber structures do not deform, but crack and splinter on impact, and once a composite airframe is broken, it is difficult or impossible to repair.

Other common materials for fixed-wing UAVs, particularly for the flying-wing variety (see Section 8-4), are polymeric foams, made for instance from polypropylene or other polyolefins (e.g. EPP or EPO). These are dense, sponge-like materials that are quite tolerant of crashes, may be bent back into shape when deformed and glued where broken or torn. Cheap and brittle foams from polystyrene such as *Styrofoam* are sometimes used in simple model airplanes, but are not a serious option for UAVs.

8-3.2 Navigation and Flight-Control Systems

Remotely piloted platforms do not necessarily need navigation systems to fly—they may also be manually flown by a human pilot in visual line-of-sight without feedback about position and attitude from the aircraft to the remote control. However, autonomous and assisted flight modes require exact knowledge and control of the UAVs position and attitude. A global navigation satellite system (GNSS) receiver and an inertial measurement unit (IMU) are therefore central components of the flight-control system.

Global satellite navigation (GPS or its Russian, European, and Chinese equivalents, GLONASS, Galileo, and BeiDou) allows the aircraft to determine its position in real time. This position is used for navigating the UAV and also for tagging aerial photographs with coordinates that may later be used for georeferencing and photogrammetric orientation. Both absolute and relative accuracy of this position are highly dependent on the receiver

design and GNSS antenna quality as well as local measurement conditions, such as atmospheric disturbance and satellite shadowing. The microwave signals from the satellites are subject to fluctuations and noise that limit the accuracy of GNSS measurements to the range of 1–10 m. Combining signals from various GNSS greatly improves accuracy, and most recent UAS are able to receive signals from GPS plus further systems, depending on the region.

Many professional-grade UAS are now equipped with real-time kinematic (RTK) or post-processing kinematic (PPK) GNSS. These achieve much higher accuracies in the centimeter range by measuring the position of the mobile unit—the UAV—simultaneously to that of a static base station with known coordinates. This base station may be set up by the user, for example on a trigonometric point or on a user-defined reference point (see Fig. 9-16). Reference positions are also provided by satellite positioning services, such as SAPOS in Germany or CORS in the United States. The positional error determined for the base station may then be deducted from the mobile unit's position in real time (RTK) or by post-processing (PPK). The disadvantage of RTK is the need for an uninterrupted communication link between base and UAV, which is sometimes difficult to realize especially for larger survey ranges. PPK, in contrast, is regarded as more reliable and more accurate by some manufacturers and users, as there is no risk of data loss and the mathematical solutions are more rigorous than real-time error reduction.

In any case, the high accuracies provided by RTK/PPK GNSS are not actually needed for flight control, but—together with attitude information from the IMU—for precise exterior orientation parameters of the imagery. If the position and orientation of the image plane in space are known a priori, ground control is not needed for photogrammetric processing (see Chap. 3), saving time, and effort in the field. Most RTK/PPK UAS manufacturers now claim accuracies of ~3 cm horizontally and ~4 cm vertically or better. In practice, such accuracies are not easy to achieve, and setting up an RTK GNSS correctly is a non-trivial task that may require quite some knowledge of geodetics.

Besides position, automated navigation involves knowledge of the rate of acceleration and attitude of a UAV—its pitch, roll, and yaw (Fig. 8-3). These are measured in real time with an IMU, which is a sensor composed of gyroscopes, accelerometers, and sometimes also magnetometers. The IMU values are processed by the inertial navigation system (INS) to detect and control the relative orientation, velocity, and position of the moving aircraft with respect to an inertial reference frame. Additional sensors may be added to aid navigation, such as barometers or ultrasonic sensors, for measuring the aircraft's altitude.

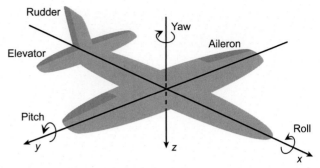

Fig. 8-3 The three principal axes of an aircraft, with their origin at the center of gravity. Pitch about the lateral or y-axis raises and lowers nose and tail. Roll about the longitudinal or x-axis raises and lowers opposite wings. Yaw around the vertical or z-axis turns the aircraft to the right or left of its direction of motion. For fixed-wing aircraft, pitch, roll, and yaw are controlled by the elevator, aileron, and rudder (flight control surfaces in the wings). For multicopters, the three angles are controlled by differentially adjusting the relative speeds of front and back, right and left, and clockwise and anticlockwise rotors.

Increasingly, computer-vision systems based on visual sensors are used for obstacle detection, navigation in-doors, or under otherwise GNSS-devoid conditions, and for precise hovering and landing (Lu et al. 2018; see also Section 8-5). Due to the different sound and light reflection properties of water, however, ultrasonic and vision sensors should be disabled when flying over water surfaces to avoid misinterpretations of aircraft altitude by the flight-control system.

On board the aircraft is also a flight-data recorder or black box, which logs all sensor measurements as well as commands received from the UAS' remote control. Thus, a complete record of the flight may be recovered from the aircraft even in case of lost communication links to the ground station. Together, these components of measurement devices, processing hardware, and software programs make up the flight-control system of the UAS, often simply called autopilot. Thus, flight controllers are highly sophisticated systems of numerous components, and they usually constitute a significant portion of a UAS' overall price. An overview of their technical aspects is given for example in Colomina and Molina (2014), and an impression of the wide choice of autopilots and IMUs/INS suitable for UAS is given by the listings in Douxchamps (2017) and Van Blyenburgh (2018).

A UAV equipped with an autopilot flight-control system may be flown in two different modes:

- Fully autonomous—Navigating along a set of waypoints, the aircraft follows a flightline that has been predefined by the user with flight-planning software (usually integrated in the control station, see below). Velocity, pitch, roll, and yaw are automatically adjusted to keep the platform stable and steady without any input by a human pilot. Depending on the UAS, autonomous mode might also include automatic

landing. Fully autonomous modes are especially useful in SFAP surveys for capturing systematically overlapping stereoscopic images for large-area photogrammetric processing (see Chaps. 3-3 and 9-6).

- Assisted or semiautomatic mode—Flying speed and direction are controlled by a human pilot via a remote-control device, but simplified to easily controllable navigational commands such as flying straight, descending vertically, turning sharply left, or increasing speed. The pilot does not need to take care of or even know about the complex interactions between the flight-control surfaces in the wings and varying thrust of one or more propellers that are needed for such assumedly simple tasks. Gusts of wind or turbulence are counterbalanced by automatic flight stabilization. Assisted mode allows flexible and customized positioning and navigation particularly in multirotor SFAP surveys. It is less commonly used for fixed-wing surveys. However, fixed-wing UAVs often need to be landed by a human pilot in assisted mode, as ground conditions are rarely suitable for fully automatic landing.

Various additional automated functions of the flight-control system might be combined with both autonomous and assisted flight. Many of them are fail-safe features as part of the risk management policy that in some countries is even a legal requirement for operating a UAS (Stöcker et al. 2017). Such features are designed to get the aircraft into a safe state or terminate the flight securely in case of loss of radio-control link, loss of GNSS signal, hardware failure, or battery depletion. Moreover, convenience functions help the pilot to navigate the UAV more easily along special flightpaths.

The following automated functions typically offered by micro and mini UAS are those most relevant for SFAP surveys.

- Safety waiting state—When GNSS signal is lost for longer than a predefined threshold, the aircraft is kept aloft in a safe state; e.g. automatic slow orbiting in current position for fixed-wing, or hovering for rotorcraft UAVs.
- Automatic emergency landing—Triggered when battery charge falls below critical state. Some fixed-wing UAVs are equipped with parachutes for this purpose.
- Return home—The UAV may autonomously return to the recorded home point (usually the launching point) upon request, or forcedly when batteries run low or communication with the ground station is lost.
- Bounding box or maximum distance range—The flying range of the UAV in assisted mode might be restricted to a user-defined maximum range for security, acting as an invisible wall that obliges the aircraft to turn back. The default would normally be the approximate visual line of sight.

- Obstacle detection—Usually based on visual sensors, this feature dynamically adapts the flightpath to obstacles, overriding the pilot's command in assisted mode or the preplanned flightlines in autonomous mode.
- Orbiting or point-of-interest mode—This mode lets multirotor UAVs follow a circular path while adjusting the forward orientation of the aircraft toward a central object. In SFAP surveys, it is useful for taking convergent oblique imagery to provide full 3D coverage and stabilize the image network (see Chaps. 3-3 and 9-6).
- Terrain follow mode—Some UAVs are able to accommodate for changes in relief height during flight, adjusting altitude automatically relative to local ground elevation.

The high degree of automation and the convenience of assisted flying modes allow even beginners to fly fixed-wing or multirotor UAVs rather effortlessly and intuitively. Out-of-the-box small consumer quadcopters are in fact treacherously easy to fly, even without studying the numerous written or video tutorials available. Larger, high-end professional multicopters and fixed-wing UAS may be much more difficult to master and require thorough instructor-led training. Despite the latest advances in autonomous and assisted navigation, learning to fly a UAV safely and competently requires time, suitable training sites, and substantial practice. Keep in mind that an SFAP survey may have rather specific requirements with respect to image framing, orientation, and network, and that local flying conditions may differ greatly in terms of wind, obstacles, lighting, etc. (see Chap. 9). Much more sophisticated flying skills and reactivity to unpredictable situations are needed for successful SFAP than just being able to keep the drone in the air.

Regarding the fail-safe "return home" function, the authors know of several instances in which consumer-grade drones simply flew away and either were never found or crashed into trees and could not be recovered. The authors witnessed a supposedly experienced UAS pilot lose control of a quadcopter, which flew through a crowd of people and crashed at high velocity. A former US Air Force officer, turned civilian UAS pilot, told us that learning to fly manually a radio-controlled fixed-wing UAS was one of the most difficult things he had ever done. Such anecdotes reinforce the need for UAS pilots to practice their skills.

8-3.3 Ground Station and Communication Systems

The absence of a human pilot in the aircraft—the unmanned or uninhabited attribute of the UAS—is enabled by relocation of the human share of flight control

to the ground and numerous communication links between the system components. Ground-control stations comprise commanding and reporting devices and have seen substantial technical development in recent years along with those in computer and telecommunication sciences (Colomina and Molina 2014).

The minimum requirement for remote piloting is a remote-control (RC) device with radio-communication link to the flight-control system of the aircraft, so the pilot on the ground may give basic navigation commands in manual or assisted flight mode. Full control of the UAS, however, involves additional hardware and software, such as a laptop computer, tablet, or smartphone with a proprietary or generic control program, radio transceivers for multiple frequencies and channels, and possibly a wireless Internet modem.

The most commonly used communication technology is Wi-Fi in the 2.4 GHz band, and some UAS may use additional frequency bands (e.g. 5.8 GHz, 868 MHz or 900 MHz) for separate information transmission or redundancy. The traditional band 72 MHz is reserved for model airplanes in North America, Argentina, France, Italy, and Japan (FAI 2018). The US Federal Communications Commission (FCC) keeps close track of UAS radio operation, has found some companies in violation of using unauthorized frequencies or too-powerful transmitters, and has imposed stiff civil penalties (Krueger 2018).

The ground-station monitor shows the data transmitted from the aircraft (flight telemetry) and other devices in real time, such as status of flight and control-station batteries, RC radio link, GNSS reception, position, altitude and speed of the UAV, and camera live view. Threshold values for all parameters are predefined by the manufacturer or user set, and warning messages or color codes are shown when they are exceeded. The flight of the UAV may be followed visually in a map viewer showing the current (and, if applicable, preplanned) flightpath on top of an online or locally stored base map (Fig. 8-4).

Most commercial UAS control software now integrates UAV real-time control with preflight planning and post-flight processing functions. Alternatively to proprietary software, other commercial, open-source, or freeware ground-station applications also exist that support numerous UAS and flight-controller types (e.g. *UgCS*, *DroneDeploy* or *ArduPilot*'s *Mission Planner*). Many allow creation and transfer of new flight plans while the UAV is in the air, so the survey plan may be revised or enlarged without stopover landing.

For UAS with live-video downlink, First Person View (FPV) may allow the pilot to see what the camera sees in real time, either on a monitor (integrated into the ground-control station or separate) or in video goggles. The video signal may be transmitted wirelessly via analog

Fig. 8-4 Tablet linked to radio controller for UAS mission. The site map and flight lines are displayed on the monitor.

transmitters and receivers, or via digital systems. High-quality HD video transmission is becoming increasingly common, particularly for commercial multirotor drones targeting the movie-making industry. Regarding SFAP, FPV is obviously a great help for precise framing of images, for example when a test site needs to be neatly covered in a single shot, or for a meticulously composed oblique image with a particular viewing perspective. It is also helpful for complex navigation tasks in hazardous terrain such as between trees, buildings, or steep slopes.

Apart from controlling the aircraft, the other important task of the ground station is operating the imaging sensor. The same RC used for navigating the UAV or a separate one—for flight-control systems supporting dual-operator flights—may be used for operating the camera. Depending on the camera system, complete control over all camera settings (see Chap. 6-4) may be given during the flight, or the actual camera settings may have to be preset before launching. The camera may be triggered manually or automatically in interval mode. The RC is also used for adjusting the viewing orientation of gimbal-mounted cameras (see Chap. 8-5 on multirotor UAS below).

8-4 SELF-PROPELLED FIXED-WING UAS

Before autopiloted fixed-wing UAS became more widely available to researchers and other civilian users in the mid-2000s, model airplanes modified for carrying a camera and flown remotely through visual contact had already been used for SFAP (e.g. Fouché and Booysen 1994; Quilter and Anderson 2000; Hunt et al. 2005; see also

Fig. 8-5 *Multiplex Easy Star* model airplane modified for SFAP, built by B. Graves. A small digital camera is mounted for oblique views to the forward port (left) side of the plane. The camera and shutter microservo are secured quite simply with rubber bands.

Fig. 8-5). Flying such aircraft requires considerable experience of the pilot to start with, and even more experience and technical skills for navigating the plane to an exact predefined location before triggering the camera, or covering large areas in systematic flightline arrangements. This became easier when GPS/INS flight-stabilization systems and autopilot flight controllers found their ways into model aircraft in the mid-2000s (e.g. Hardin and Jackson 2005; Espinar and Wiese 2006; Jones IV et al. 2006), upgrading them to unmanned aerial vehicles.

8-4.1 Fixed-Wing Design and Flying Characteristics

Today's fixed-wing UAVs come in two main variants, like their manned equivalents. Relatively conventional airplane types have a distinct fuselage, large main wings, and a smaller horizontal stabilizer or tailplane (see Fig. 8-1A). So-called flying wings are tailless without a horizontal stabilizer (Fig. 8-6). The wings usually have a more triangular or delta-shaped planform, and the fuselage is merged seamlessly into the wings or lacking altogether. Flying wings differ from conventional airplanes in their aerodynamic characteristics. Their whole-body airfoil generates more lift and has lower aerodynamic drag, but their lack of a tail assembly with stabilizer surfaces makes them less stable in pitch and yaw.

Flying-wing designs are particularly popular in the small UAS class with light sensor payloads for agricultural applications, possibly also due to their sleek body with comparatively few protruding parts that may be damaged when landing on crop-covered or rough fallow fields. Another reason for their popularity in the small UAS category might also be that the flying-wing appearance better conveys the idea of a modern high-tech drone, while the fixed-wing aircraft more resembles a traditional model airplane. For larger payloads, nonetheless, conventional-tailed, fixed-wing UAV are usually required or preferable for better stability.

In most small fixed-wing UAS, the sensor is completely concealed in the plane fuselage beneath the wings. It is fix-mounted, may be embedded in foam or rubber damping, and is aligned with the three principal axes of the aircraft (Fig. 8-3)—hence, any rotation of the UAV is directly transferred to the camera, and free panning and tilting of the sensor is not possible. Larger UAS with more space for a payload bay may employ a so-called flat mapping gimbal, a 2-axis gimbal that keeps the sensor plane parallel to the ground while the airplane is moving. 3-axis gimbals of the pendulum type, as typical for rotorcraft UAS (see next section), are obviously difficult with fixed wings for aerodynamic reasons, and impossible for belly-landing models. Some recent UAVs featuring landing gear do, however, use outside-mounted gimbal units that allow tilting and rotating the camera for oblique views in 360° directions.

Fixed-wing models with landing gear may be launched in the traditional way from a runway, but this

 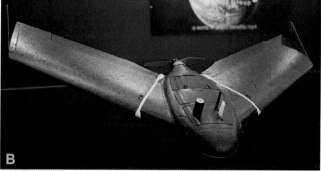

Fig. 8-6 Two flying-wing UAVs. (A) *AgEagle*, designed and marketed mainly for agricultural applications of aerial crop imagery. It carries a color-infrared digital camera for producing NDVI images. This catapult-launched flying wing is made from carbon-composite material; wing span is ~1.4m, weight is 3.2kg (AgEagle 2018). (B) *SenseFly eBee* X is equipped with RTK/PPK GNSS and accepts various sensor modules. Its foam body with a wingspan of ~1.2m weighs 1.4kg. Not visible here is the *senseFly S.O.D.A.* 3D camera carried by this model, which rotates perpendicular to flight direction for taking oblique as well as nadir images for improved 3D capture.

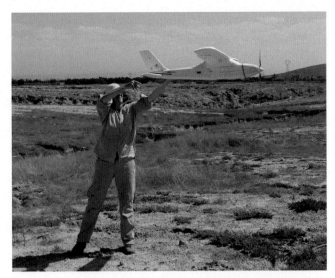

Fig. 8-7 Hand-launching of a fixed-wing UAV (*MAVinci Sirius* I).

requires sufficiently long, even, and hard surfaces which often are not present at geoscientific research sites. Also, the motor needs to be powerful enough to create the acceleration required for take-off. Most micro UAVs of the airplane type are hand-launched (Fig. 8-7). This requires a second person besides the operator with the RC, and a controlled horizontal pushing of the plane in the air with the propeller running at full throttle, which may be quite dangerous if carelessly done.

Many flying wings (which have no fuselage to grip) and many larger fixed-wing airplanes are launched by catapult. Various types of catapult systems exist for giving the aircraft the necessary acceleration to take off: among others, pneumatic, hydraulic, or mechanical systems. In the most common variety for micro and mini UAS, the plane is clamped into a cradle tensioned by a bungee cord or nylon rope which is then released to propel the platform into the air at a suitable angle (Fig. 8-8). This eliminates the need for a runway, avoids possible contact with the airscrews, and saves battery energy in the starting phase.

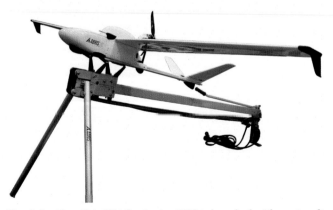

Fig. 8-8 The *Abris Flirt* fixed-wing UAS is launched with a catapult and landed with a parachute system.

Finally, landing of fixed-wing aircraft may again be done on a runway or otherwise even surface for models with wheels or skids. Some models use parachutes for landing. But most flying wings and airplanes without landing gear are belly-landed, which obviously is rather risky and stressful for both the material and the pilot. It requires not only suitably flat ground surfaces, such as short grass, evenly plowed fields, or smooth tarmac, but also sufficient space for low-angle approach. Few fixed-wing UAVs have thrust reversal capability, which means that speed needs to be reduced by shutting off the motor as early as possible before gliding in for landing (see also below). Choosing an appropriate site and pilot position for landing before even launching the aircraft is an important task in flight preparation—once the UAV battery is running low at the end of the survey, there may be not much time left to think about where to find a clear area and a good position to control and monitor the touchdown process.

In summary, the main strengths of fixed-wing UAS are their aerodynamic efficiency and stability, the comparatively long endurance (usually 45–60 min), and suitability for large survey areas. The main disadvantages are the need for horizontal landing space and lack of hovering capacity, that is, precise image positioning and small-area coverage, as well as restriction to (near-) vertical image orientation.

8-4.2 Example for a Fixed-Wing Micro UAS

A typical fixed-wing micro UAS, the *MAVinci Sirius* I (already seen in Figs. 8-1A and 8-7), has been used by two of the authors and their teams from Frankfurt and Trier universities since 2010 for SFAP monitoring of numerous study sites in Germany, Spain, and Morocco (d'Oleire-Oltmanns et al. 2012). The system comprises the UAV with optical sensor, a ground station with flight-planning, flight-controlling and post-processing software, an RC, and a transceiver for communication link between plane and ground-station laptop. The aircraft is based on a model airplane made from *Elapor*, an EPO-type foam that is rugged and quite easy to repair—some glue and duct tape are actually all that is needed for repairing occasional smashes during landings before flying again. The carbon rod-supported wings and tailplane are fully detachable for packing. The plane has a wingspan of 163 cm and a length of 120 cm; its brushless electric motor runs on a 5300 mAH battery. Weight including battery is ~2.2 kg without payload. At a ground speed of 45–85 km/h, the endurance with 550 g payload is up to 50 min.

In our case, a 12 MP mirrorless interchangeable-lens camera (MILC) is used as an optical sensor (*Panasonic Lumix* GF1 with 20-mm Pancake lens; see Fig. 6-2C). It is fix-mounted in the payload bay beneath the wings

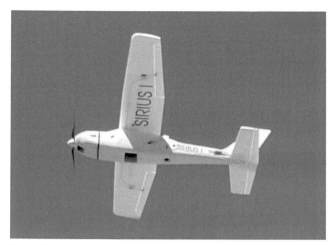

Fig. 8-9 The camera payload of the *MAVinci Sirius* I is completely concealed in the fuselage of the UAV, pointing through the opening in the plane bottom. In spite of numerous belly landings on rough ground that left their scars in the EPO foam material, the lens, which is set back by 3 cm, was never damaged during touchdown.

(Fig. 8-9). At the time of acquisition, this camera was one of the first MILCs on the market, featuring several characteristics important for the photogrammetric analysis of the images (see Chap. 6-6), which include lighter and smaller than a DSLR, fixed focal length, comparatively large 4/3 image sensor, lossless RAW file format, and lack of image stabilizer. The camera exposure is triggered by the flight controller in regular intervals. The GPS coordinates transferred from the flight log may be added to the image EXIF headers in a post-processing procedure.

The UAV may be flown manually by experienced pilots, semiautomated by the less experienced, or in fully autonomous mode, from hand-launching to automatic landing. The latter is the primary choice for photogrammetric surveys, where exposure interval, flight-path orientation and spacing, and flying height are automatically computed by the flight-planning software *MAVinci Desktop*, optimizing the survey setup for the desired GSD and photogrammetric overlap (Fig. 8-10). At the turning of each flightline, the roll of the UAV may reach large angles up to 60°, where the image axis is off-nadir until the plane is level again. Hence, and to ensure full vertical stereoscopic coverage, a rather large overshoot must be taken into account—this always results in a considerably larger total area covered by the flight plan than the actual target area. Large numbers of oblique images at the flightline ends may be avoided by restricting the camera triggering to a maximum pitch/roll angle (e.g. 10° off-nadir).

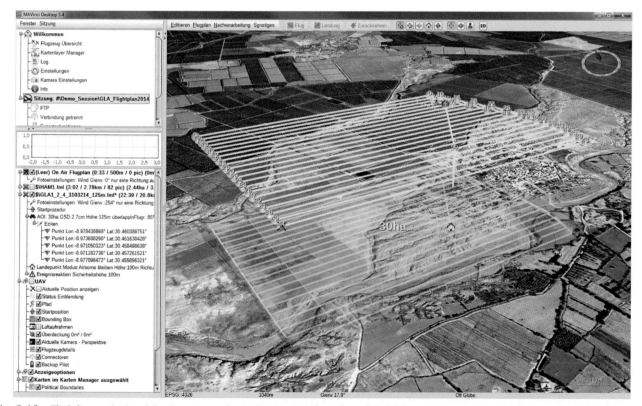

Fig. 8-10 Flightlines calculated for the survey of a 30-ha site near Taroudant, South Morocco; screenshot of *MAVinci Desktop* ground-control and flight-planning software in 3D oblique view. The survey was planned with high endlaps and sidelaps for multiview stereo analysis; green shaded areas indicate at least 3 overlapping images out of at least two different flightlines, red is one image only. The total area covered is ~48 ha. During the flight, the real-time flightpath of the UAV could be monitored in this viewer, along with telemetry data, battery status of all devices, etc.

Wind speed and direction should be taken into account when designing the flight plan. In practice, it is a good idea to use higher overlaps than required as the plane would be much faster out than back in wind direction. Flying perpendicular to the wind reduces speed variations, but causes the aircraft to yaw off the flight direction, which results in skewed image overlaps. Wind speeds higher than 40 km per hour are not recommended.

We have found the *MAVinci* UAS excellently suited for regular stereo-photogrammetric surveys of a few hectares up to several square kilometers. One of the largest single-flight surveys we conducted covered a total area of 4.5 km² with 26.5 km flight length from 500 m above ground (d'Oleire-Oltmanns et al. 2012). Survey areas exceeding the maximum size that may be covered with a single battery may automatically be partitioned into smaller blocks with separate flight plans to be carried out after intermediate landings for battery changes.

The limit of survey area and GSD achievable with such an airplane UAS is actually not an upper limit, but a lower limit. The minimum flying height in stereoscopic surveys is a function of focal length, sensor size, desired endlap (at least 60%, see Chap. 3), and fastest camera exposure interval. In RAW mode, the image repeat rate is slower than in JPG (due to much larger file sizes)—in the case of the *Panasonic Lumix* GF1, the maximum trigger rate for RAW is ~2.3 s, which results in a minimum flying height of 92 m for photogrammetric surveys with minimum 60% endlap.

Alternatively for smaller GSDs and lower flying heights, the sidelap between flightlines may be increased to give full stereoscopic coverage. However, there is also a limit to the spatial resolution that is sensibly acquired with fixed-wing UAS. At an average ground speed of 50 km per hour, taking SFAP with a typical shutter time of 1/1000 s would result in 1.4 cm forward movement of the aircraft during exposure. Any imagery with GSD less than ~2 cm would thus be severely blurred.

The lack of hovering capacity and minimum ground speed of a fixed-wing UAV make it also difficult to frame a small target area precisely with well-positioned stereoscopic images. For small study sites, such as the 0.4-hectare HAM1 gully, we have increased the number of images with varying coverage by using high sidelaps between flightlines and repeating the same flight plan with different rotations (Fig. 8-11). This leads to more flightlines crossing the target object (see also d'Oleire-Oltmanns et al. 2012). The relative size of the overshoot zone required for turning between flightlines may get quite large for such a small survey area—in this particular case, ~10 times the actual target area.

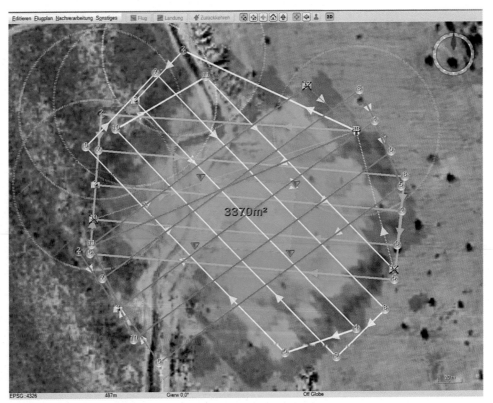

Fig. 8-11 Flightlines calculated for the survey of a small gully site at Oued el Hamar, South Morocco (compare Fig. 14-2H); screenshot of *MAVinci Desktop* ground-control and flight-planning software in 2D vertical view. The same flight plan was used three times here with different angles. Note how the flightline sequence follows a spiral pattern, as adjacent flightlines are too close (25 m spacing) for the UAV's turning radius. Target area is 0.4 ha; actually covered area is ~4 ha.

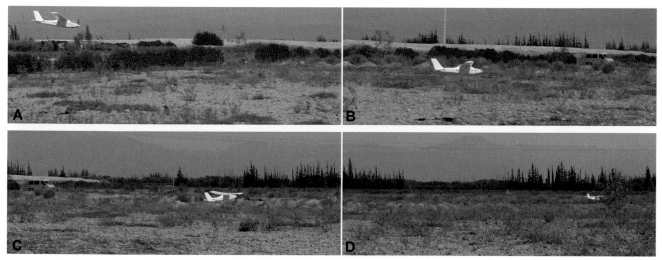

Fig. 8-12 *MAVinci Sirius* landing sequence on a sun-heated field in South Morocco. The motor is shut off some meters above ground (A), and the UAV descends in gliding (B). Only decimeters above ground, thermal uplift raises the aircraft again (C), which lengthens the landing approach by about 30 m (D).

The *MAVinci* UAS also features a half-autonomous, assisted flying mode. In this mode, the pilot may freely navigate the plane but is permanently supported by the autopilot. Software-controlled interaction of rudder, aileron, and elevator enables the pilot to directly turn the UAV left or right without losing height, and the plane is automatically stabilized against turbulence. Safety thresholds such as maximum turn radii and flying range (bounding box) apply automatically. In practice, we have used the assisted flying mode for nearly all landings, as we have found the terrain of our geomorphological study areas usually too rugged for fully autonomous landing.

Fig. 8-12 shows a sequence of photos taken during a typical landing at a study site in Morocco, where surface temperatures in autumn are quite high. To make the UAV slow down for landing, the motor needs to be shut off some meters above ground (Fig. 8-12A), which reduces the navigation options to left-right turning. The plane descends and slows down while gliding (Fig. 8-12B) until it touches the ground and is stopped by friction. In hot conditions, however, we have often experienced a sudden rearing up of the plane just decimeters above ground by thermal uplift, which may considerably lengthen the landing approach (Fig. 8-12C and D). Slight quick left-right movements of the RC stick may help to bring the plane down faster, but need to be carefully administered to avoid crashes. We have found it necessary to provide for ample extra space both in length and width of the anticipated landing site to avoid ticklish situations.

8-5 MULTIROTOR UAS

Since small and consumer-grade multicopters first entered the market in the late 2000s, substantial progress has been made in flight and sensor stabilization. The initial difficulties with blurred images due to shaky movements and rotor vibration have been largely solved in recent models, which feature advanced IMUs, flight controllers, and 3-axis gimbals.

The main differences of rotorcraft varieties used in UAS are the number and arrangement of rotors and thus propellers. Although bicopters and tricopters also exist, the most common types of rotor arrangements are quadcopters (four), hexacopters (six), or octocopters (eight). In essence, more rotors mean not only greater speed and maneuverability, larger payload capacity, and higher safety and stability but also larger size, weight, and price. MTOWs for multicopters used in research and professional applications typically range between <2 kg for small quadcopters to well over 20 kg for large octocopters.

Compared to fixed-wing UAVs with the same weight, the endurance of multicopters is generally shorter as they need much more power to be sustained in the air. Octocopters may reach quite fast flying velocities, but this comes at the price of power consumption. Most multicopters cannot exceed more than 15–30 min flying time under optimum conditions (calm or light wind).

8-5.1 Multirotor Design and Flying Characteristics

In contrast to fixed-wing aircraft, the axes of the rotors are vertically oriented, so the propellers rotate horizontally and generate vertical lift. Therefore, multirotor UAVs have the considerable advantage of vertical take-off and landing (VTOL) capabilities. To enable hovering and flying in a balanced state, half of the propellers rotates clockwise, while the other half rotates

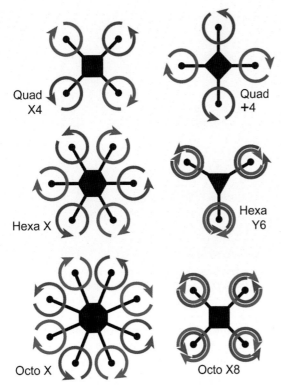

Fig. 8-13 Various rotor configurations for multicopters. Blue rotors spin clockwise, orange rotors spin counter-clockwise. Y6 and X8 multicopters have equally sized coaxial rotors (one on top of the other; lower rotors represented here by inner circles). Other variations exist as well, e.g. + configurations for hexacopters and octocopters.

counter-clockwise. The arrangement of the rotors with respect to forward flying direction may vary in all types. An X4 quadcopter, for example, has two of the four rotors facing forward, while a +4 quadcopter is turned by 45° to have one rotor facing forward (Fig. 8-13).

Hexacopters and octocopters may have all rotors in the same horizontal plane, or they may be configured in a coaxial arrangement (Y6 and X8 multicopters), with one set of propellers on top of the other. The rotor arms themselves or their status LEDs are color coded in order to indicate forward direction of the aircraft to the pilot on the ground. In this regard, visual line-of-sight means the pilot on the ground can actually see the color coding to know the forward and backward directions of the aircraft.

There are several pros and cons to the various configurations, but the technical and aerodynamical details associated with different rotor numbers, configurations, propeller sizes, motor powers, etc. are beyond the scope of this book. A consideration of practical interest is that for quadcopters with x-shaped arrangements, forward flight is more stable compared to a + configuration, and the propellers are less prone to get into the camera's field of view when the UAV pitches forward. Coaxial Y6 and X8 multicopters have the advantage of being more compact than standard hexacopters and octocopters as their arms are shorter, but they are also less efficient. To keep the bottom propellers out of view, the camera needs to be mounted lower beneath the central platform, which increases the height of the landing gear as well as the camera movements that need to be compensated by a longer gimbal.

If all propellers rotate with the same speed, their opposing torques (rotational forces) are balanced. Hovering is achieved when the thrust of all rotors is equal to the gravitational and wind forces acting on the aircraft. Accordingly, the UAV would ascend or descend with proportional increase or reduction of thrust for all rotors. To make the UAV turn left (i.e. yaw), thrust needs to be higher for the clockwise rotors and vice versa. Roll of the aircraft (i.e. movement to left or right) is achieved by increasing the relative speed on the opposite side (i.e. right or left rotors). Likewise, pitch (movement forward or backward by tilting of the multicopter) is controlled by increasing the relative speeds of the rear or front rotors, respectively.

Obviously, the more rotors, the more challenging it is to balance the individual rotor forces exactly right for navigating the aircraft precisely and safely. Luckily, a multicopter UAS pilot is largely relieved of the responsibility, as multicopters are always navigated with assistance by the flight controller, if not fully autonomous, in missions preplanned through ground-station software (see Section 8-3.3). The flight-control system takes care of the required differential thrust management and reduces the navigational tasks for the operator to comparatively simple RC stick motions—up, down, left, right, forward, backward.

This makes a multicopter freely navigable in all directions, with continuously variable speeds between stationary and several 10s of km per hour. Fine control of speed and movement of the UAV along complex flightpaths with these quite sensitive controls still requires considerable practice. But with some experience, the excellent maneuverability together with FPV—a quite common feature now for multirotor UAS—allows accurate positioning to take SFAP of exactly the area and viewing angles required for specific purposes (see also Chap. 9-7). With the additional help of a barometer, ultrasonic sensor, or visual-distance sensor for precision landings, UAV may be landed by the human operator or the autopilot in tightly confined spaces and spot-on positions (Fig. 8-14).

As with fixed-wing aircraft, it is still advisable to choose the launching and landing spots carefully even before starting the multicopter—if anything goes wrong with the communication link, most UAS would autonomously return to this home point for automatic landing. The camera is often mounted just centimeters free of the ground, making stone cover or rough soil surfaces

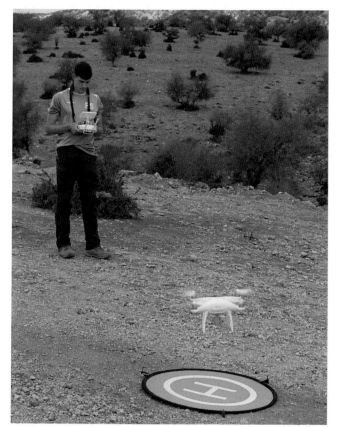

Fig. 8-14 Using the live-video image on the RC display and assisted by ultrasonic and visual sensors, multirotor UAS may be landed quite precisely. A landing pad is helpful for protecting the UAS from swirling dust even when the site is free of stones and grass.

Fig. 8-15 (A) Rubber dampers isolate the camera mount from the airframe of a quadcopter to avoid transfer of high-frequency vibrations from the rotors. (B) 3-axis electronic gimbal, here seen as a component of a dedicated UAS camera with interchangeable lens (*DJI Zenmuse* X5).

a potentially dangerous factor, and spinning propellers must not get caught in vegetation. A landing pad such as the one used in Fig. 8-14 is helpful for protecting the UAS from swirling dust or in high grass.

Other than with fixed-wing UAS, a multicopter sensor is hardly ever fix-mounted (i.e. with sensor axes immovably aligned to the aircraft axes). Rotorcraft have much higher vibration than airplanes, which makes it necessary to use some sort of dampers between the platform and sensor and electronically stabilized camera mounts—particularly if the UAS is designed for aerial videography. Small, hollow, rubber balls (see Fig. 8-15A), silicon pads, or foam tape are commonly used to isolate camera mounts (as well as flight controllers) from the high-frequency, low-amplitude vibrations of the rotors. In addition, the camera axes are stabilized and controlled by electronic gimbals. These are pivoted supports based on the same IMU and brushless motor types as used for the aircraft itself.

Most multicopter gimbals nowadays have three axes that allow stabilizing (or deliberately controlling) roll, pitch, and yaw of the sensor (Fig. 8-15B). The latter may be fixed relative to the forward direction of the UAV; this is a requirement for cameras suspended between non-retractable landing-gear struts. Or it may allow free rotation by 360°, so the camera's direction is completely independent of the UAVs orientation in space. Electronic gimbals are technically highly sophisticated devices and need to be precisely configured and fine-tuned for their particular payloads. If well calibrated, they are able to keep the sensor remarkably stable even in fast flight and windy conditions, allowing surprisingly long exposure times.

As a general (albeit simplified) rule, maneuverability, flight stability, and wind resistance for rotorcraft UAVs increase with more rotors, and hexacopters and octocopters are safer than quadcopters due to redundancy in case of motor failure. Other than a quadcopter, a hexacopter or octocopter is able to fly if one or even more motors fail. More rotors also mean greater lifting force for a larger payload. Therefore, hexacopters or even octocopters are often used in UAS designed for research purposes that employ heavier and expensive high-quality cameras with large sensors, multispectral or hyperspectral multisensor arrays, or LIDAR scanners. In the following, a small selection of different multirotor UAS the authors and their colleagues have used in their research is briefly described.

8-5.2 Examples for Multirotor UAS

For quick reconnaissance, for use with students in introductory classes in UAS remote sensing, for ease of use and transportation, and for the comparatively lesser legal restrictions of micro UAS, we have found small quadcopters an excellent means for taking SFAP of sites with limited sizes. Since its release in 2013, the *Phantom* series by the Chinese technology company *DJI* has become the epitome of a small quadcopter drone. Originally designed and marketed as an amateur and hobby drone for filmmaking and photography, the *Phantom* quadcopter has been extremely popular also with professionals and researchers (e.g. Cook 2017; Koci et al. 2017; Gudino-Elizondo et al. 2018). At the time of writing, the latest model, *Phantom* 4, has made the move toward the high-precision, survey-grade UAS category with an upgraded RTK version (DJI 2018).

Beginning with version 3, the *Phantoms* are equipped with integrated on-board cameras (Figs. 8-16 and 6-3) that easily rival the capabilities and quality of current good compact cameras at a fraction of their size and weight. The *Phantom* 4 Advanced+ model seen in Fig. 8-16B has a 20 MP 1-inch CMOS sensor with 24 mm-equivalent lens mounted on a 3-axis electronic gimbal. Its total weight is <1.4 kg, including the 5870 mAh smart LiPo battery—sufficient for up to 30 min total mission time. Due to its low weight, it is exempt from the legal requirement for a pilot's Certificate of Knowledge (for UAVs >2 kg) effective in Germany, as well as from individual flying permits (for UAVs >5 kg). Outside the numerous flight-restricted zones, it may be flown within visual line-of-sight in heights up to 100 m above ground by anyone. This makes it particularly attractive for many (see Chap. 12 for further details in the United States and other countries).

The ground-control station comprises an RC device operating in the 2.4 GHz range, and a mobile device (smartphone or tablet) or—in the case of our model—an Android display device integrated into the RC. The camera's view is transmitted to the monitor via video downlink for FPV, and video goggles may optionally be employed. The *Phantom* quadcopters may be flown manually or along waypoints at (theoretically) up to 72 km per hour with the help of a proprietary app, *DJI GO*. Alternatively, various third-party and open-source ground-controller apps exist that support the *Phantom* series and also enable planning and conducting fully autonomous missions. The pilot may choose from numerous flight modes for assistance in complex navigation tasks, and various fail-safe features (see Section 8-3.2) are available, including a quite advanced obstacle-detection and collision-avoidance system based on visual sensors (Fig. 8-16B).

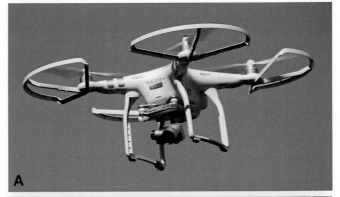

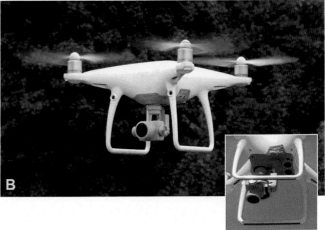

Fig. 8-16 Two quadcopters from the *DJI Phantom* series. (A) *Phantom* 3 Advanced, fitted with propeller guards. These guards protect against injuries, but are also useful for rough-surface landings to avoid propeller breaks if the UAV topples. Flown by A. Allison and C. Pettit. (B) *Phantom* 4 Advanced+ features several sensors for obstacle avoidance and precision navigation. Two forward vision sensors are placed at the upper end of the landing struts (large image), two downward vision sensors and two ultrasonic sensors are positioned behind the camera gimbal (small image).

The *Phantom* 3 and 4 quadcopters presented here are fully integrated out-of-the-box UAS. However, even small ready-to-fly quadcopters may be adapted with suitable mounts for varying camera systems (Fig. 8-17). For specific requirements, where various factors concerning navigation and image acquisition may be dictated by the research question and research site, more modifiable UAS or DIY assembly kits offer great possibilities for constructing a bespoke UAS.

A good example for such a purpose-designed UAS is the modular *BlackSnapper* XL PRO RTF quadcopter presented in the following (Fig. 8-18). Its setup is ideally suited for the SFAP surveys in steep-slope viticulture conducted by Trier University's Physical Geography Department. This UAS remote-sensing project is part of an international European research project (*DiverFarming*) on diversified cropping systems under

Fig. 8-17 *3D Robotics Iris* quadcopter equipped with a thermal-infrared camera mounted in fixed vertical position. Flown by C. Pettit and A. Allison.

low-input agricultural management practices. The UAS is based on a carbon-fiber x-type airframe with multipurpose double center plate that allows customized configuring with various types and sizes of rotors, propellers, landing gear, camera-mount adapters, gimbals, etc. In this case, it is equipped with *DJI* E1200 rotors and

17-inch (~43cm) carbon propellers. The *DJI* A3 flight-control system uses three IMUs and three GNSS units, which offer high redundancy. It is coupled here with the *DJI Lightbridge2* ground station and video-transmission system and supplemented by *UgCS* software for flight planning and ground control. *UgCS* also allows adapting the flightlines to varying topography by maintaining a constant height above ground.

The chosen flight controller supports the use of separate RCs for navigating the UAV and for controlling the camera and gimbal. This was an important prerequisite for taking SFAP in steep-slope vineyards, where fully automated UAS missions may be impeded by the complex terrain. Manual navigation also offers better potential to adapt the flightpaths to the varying situations given by different vine-training systems and row orientations (see Chap. 17). With the second RC, the task of controlling the camera's exposure settings and viewing angles may be taken over by another operator, so the pilot may fully concentrate on the UAV.

A rubber-dampened camera-mount adapter attached to the main platform may be fitted with various sensors, such as optical, multispectral, or thermal cameras. In Fig. 8-18, the *BlackSnapper* is seen with the *DJI Zenmuse* X5, a 16 MP Micro Four-Thirds MILC with 15-mm lens (30-mm equivalent) and up to 1/8000s shutter speed.

Fig. 8-18 *BlackSnapper* XL PRO RTF quadcopter, purpose-built from a DIY assembly kit to optimize the UAS for close-range aerial surveys in steep-slope viticulture. The flight controller (concealed below center plate) supports two remote-control devices for pilot and photographer, respectively. Sensors may be exchanged depending on required images; here seen with a gimbal-stabilized MILC (*DJI Zenmuse* X5). Notice the red and green running lights reflected on the floor beneath the rotors.

This camera is specifically designed for UAS photography and videography and comes with its own 3-axis electronic gimbal. This allows tilting the camera from −90° (vertical) to +30° (upward oblique) and panning by nearly 360 degrees, independent of the quadcopter orientation.

The UAS is powered by 6S LiPo batteries of 10,000 or 16,000 mAh for ~15 or 25 min flying time, respectively. In this particular *BlackSnapper* setup, the choice in Germany between flying times becomes a matter of legal restrictions. The basic airframe weight is only ~1 kg, but increases to 2.9 kg with flight controller, GNSS antenna and rotors, and to 3.5 kg with camera plus gimbal. Adding one or the other battery (i.e. 1.3 or 1.9 kg), the total weight is either just under or over 5 kg. In Germany, this is the threshold for permission-free UAV flights, which means that longer flying times (using the 16,000 mAh battery) require an individual flight permit (see Chap. 12-3).

The total size of the quadcopter with rotors is 90×87×34 cm. It does not need to be disassembled for packing—by folding up the arms, propellers, GNSS antenna, and landing gear; its size shrinks to a quite compact 57×38×25 cm (Fig. 8-19). Altogether, its modular design makes it an extremely flexible platform for various UAS remote-sensing applications. For example, the DLR Mosel (Rural Development Center Moselle) is currently testing the *BlackSnapper* UAS with a *MicaSense*

Fig. 8-19 The *BlackSnapper* UAS of the previous figure folds up to much smaller size for packing. *Courtesy of M. Seeger.*

RedEdge camera (see Fig. 6-15) for color-infrared SFAP and vegetation indices analysis.

Even larger payloads or multiple camera systems may be carried by hexacopters or octocopters with higher lifting capacity and greater redundancy, meaning also better safety, for costly sensor equipment. More complex sensors often also mean additional auxiliary parts such as special mounts, numerous cables, and extra batteries or antennas. Fig. 8-20 shows a *DJI Spreading Wings* S900 hexacopter with a diameter of ~1.3 m including propellers that allows for an 8.2 kg MTOW. It is equipped with

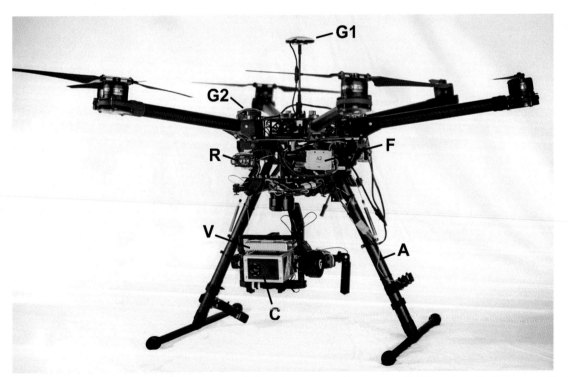

Fig. 8-20 Large *DJI Spreading Wings* S900 hexacopter. G1—UAV GNSS receiver, G2—camera GNSS receiver, F—flight controller, R—ground-station communication receiver, A—receiver antenna (second one on other strut), C—dual thermal/optical camera, V—video transmitter for FPV. *Courtesy of A. Kaiser and G. Rock.*

two GNSS receivers (one for the UAV, and one for the camera) and a *DJI* A2 flight controller with *FrSky* receiver. The *Gremsy T1* gimbal supports a *TeAx ThermalCapture Fusion Zoom*, a professional dual UAS camera with 10× optical zoom. The two sensors are aligned to take and overlay in real-time thermal and visual imagery. On top of the camera sits an *Amimon Connex* transmitter for Full HD video downlink to the ground station. The sturdy landing struts of the UAS are retractable in flight to give full 360° view for the camera.

Regarding alternating use of multiple sensors, multirotor UAS are more flexible than fixed wings as they are less restrictive with respect to sensor mounts and dimensions. Infinite other setups of multicopters for SFAP and UAS remote sensing are possible considering the abundance of components available for designing custom-built systems. Many low-cost and open-source solutions are available for multicopter (as well as fixed-wing) UAS control systems, among others the *ArduPilot* flight-control software, *Pixhawk* autopilot hardware, *Raspberry Pi* computers as on-board CPUs, *CHDK* software for remote-controlling cameras, and *Mission Planner* ground-control station software.

8-6 HYBRID VTOL UAS

In the previous sections, it has become clear that both fixed-wing and multirotor UAS have their pros and cons. The main strengths of the former—higher speed and greater endurance that are optimal for larger surveys—are somewhat complementary to those of the latter—capability for hovering and vertical take-off and landing, which are optimal for small sites and confined landing spaces.

Over the last 5 years, UAS development has increasingly concentrated on systems that combine the benefits of both approaches (Saeed et al. 2018). These hybrid VTOL aircraft may start and land vertically like a rotorcraft, but cruise with high speed and efficiency like an airplane. The idea goes back to the 1950s, when first attempts of integrating fixed wings and rotors were made in manned aviation. Although some VTOL types are used in military service, they have not succeeded in civilian aviation, mostly due to their high complexity, weight, and cost. Regarding UAS, hybrid VTOL systems are generally more challenging for autonomous flight-control systems, as they need to manage vertical, transitional, and horizontal flight modes.

Hybrid VTOL UAVs may be broadly categorized as tail-sitters and convertiplanes. A tail-sitter starts and lands on its tail, and the whole aircraft is tilted by 90° for horizontal flight. Fig. 8-21 shows a *WingtraOne*, a tail-sitter VTOL developed by a Swiss university spin-off from ETH Zurich. It uses two fixed-pitch rotors for

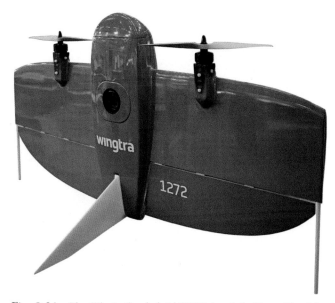

Fig. 8-21 The *WingtraOne* hybrid VTOL is a tail-sitter with ~1.3 m wingspan, weighing 4.5 kg. It is seen here with the *Sony* RX1RII camera module, a full-frame MILC with 42 MP resolution, and may be upgraded with PPK GNSS.

vertical flight and hovering. When the UAV is tilted by deflection of the control surfaces in its wings, the rotors provide forward thrust as in flying-wing UAVs. In test surveys by the manufacturer, it has been able to cover 320 ha in a single one-hour flight at 120 m flying height with 2.8 cm GSD (Wingtra 2018).

Convertiplanes, on the other hand, maintain their orientation during starting, cruising, and landing. The transition between vertical and horizontal flight is accomplished by tilting of the rotors only (e.g. Thamm et al. 2015), tilting of the wings and rotors together (Cetinsoy et al. 2012), or by integrating the propulsion systems of a rotorcraft and self-propelled fixed wing in a dual-system UAV (e.g. Pircher et al. 2017). An example for the latter is shown in Fig. 8-22. This *Héliocéo Fusion* is a union of a quadcopter and an airplane-type fixed wing, designed for large-area missions up to 800 ha. Using the four lower rotors, it is capable of VTOL and hovering, while the fifth rotor may propel the aircraft forward in fixed-wing flight mode.

In their review on presently available hybrid UAVs and their techniques, Saeed et al. (2018) found the convertiplane, in particular the tilt-rotor type, more dominant than the tail-sitters. This is mainly due to the simpler mechanisms and controllability. Regarding future development, a particular challenge remains in the high power consumption of VTOL UAVs when they are in vertical mode, which quickly reduces endurance and range to normal multicopter grade.

Currently, hybrid VTOLs carrying imaging and LIDAR sensors are mainly aimed at the professional surveying sector. As the demand for long-range, flexible

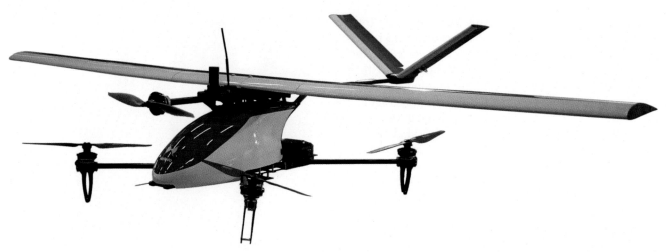

Fig. 8-22 *Héliocéo Fusion*, a dual-system convertiplane combining the flying characteristics of a quadcopter and a fixed-wing UAV. It comes in three different sizes between 2 and 2.7 m wingspan and is equipped with RTK/PPS GNSS.

UAS increases, also in the service and delivery sector, we may expect an even stronger focus on further development of these systems in the near future, and a broader choice of hybrid UAS in various price categories. Clearly, this will also be highly beneficial for the geoscientific community. The advantages of airplane aerodynamics combined with VTOL and hovering capacities are obvious for many study sites and research questions presented throughout this book.

Many times, we have had to change or even cancel taking SFAP with our fixed-wing UAS only because the wind was coming from the wrong direction for our landing site, or we could not find a suitable landing site at all. Even more than vertical take-off and hovering, vertical landing is a highly desirable feature that will unlock the potential of SFAP for an even-greater variety of study sites and research questions.

8-7 SUMMARY

Unmanned aerial systems (UAS), also called unmanned aerial vehicles (UAVs), remotely piloted aircraft systems (RPAS) or drones, have become the prevalent means of taking SFAP from low heights in the geosciences as well as many other geospatial applications and research disciplines. UAVs are free-flying, powered aircraft that may be flown remotely by a pilot on the ground or autonomously. They are mostly powered by electric brushless motors running on LiPo batteries. Their light-weight airframes are built from carbon fiber-reinforced polymers or polymeric foams.

In addition to the flying vehicle or platform, the term "system" includes ground-control stations, communication links, and launch and retrieval systems. All UAS have in common that their flight is controlled by advanced autopilots based on global navigation satellite systems (GNSS) and inertial measurement units (IMUs). Many professional-grade UAS are equipped with high-precision RTK/PPK GNSS, so ground-control points would not be required any more for high-accuracy georeferencing of the airphotos.

Via Wi-Fi communication with the ground-control station, commonly accompanied by live-view video downlink, the pilot on the ground is able to navigate the aircraft in assisted flying mode, or compile and monitor autonomous missions where the UAV automatically follows preprogrammed waypoints. The same operator, a second person, or the flight-control system may operate the camera to take photographs in regular intervals or specific positions.

The broad term unmanned aircraft encompasses a large variety of platforms with regard to aerodynamic concept, airframe type, size, weight, range, flying altitude, endurance, degree of autonomy, etc. The civilian geoscientific community employing UAS in research and application most commonly uses those typically classified as micro and mini UAS. These have maximum take-off weights of 5 or 25 kg, respectively, which are often subject to differing legal restrictions.

Two primary approaches for unmanned aerial platforms, the airplane and the rotorcraft, are the basis for the two most commonly used UAS types. A fixed-wing UAV is propelled forward by the thrust generated by a vertically spinning propeller, and navigation is enabled by flight-control surfaces in the wings and (if existing) tailplane. Multirotor UAVs are variations of the helicopter theme that come with four (quadcopter), six (hexacopter), or eight (octocopter) rotors. They are navigated through differential thrust of the clockwise and counterclockwise rotors.

The advantages of fixed-wing UAVs are their high speed, efficient aerodynamics, and thus greater

endurance that are optimal for larger surveys. They may cover considerable areas up to a few square kilometers during a single mission. However, most fixed-wing UAVs need suitably flat and long landing space, if not a starting runway, and they cannot hover and are less suitable for small sites. Multirotors, on the other hand, are capable of vertical take-off and landing and of hovering in near-static positions. But they are less efficient than fixed-wing UAVs as they need energy to hold themselves in the air against gravity. The resulting shorter endurance combined with their usually slower speed makes them less suitable for large-area coverage.

Recent UAS development increasingly concentrates on hybrid VTOL systems that combine the benefits of both approaches. These aircraft may start and land vertically like a rotorcraft, but cruise with high speed and efficiency like an airplane. Two general types are tail-sitters and convertiplanes. The advantages of integrating the strengths of both fixed-wing and rotorcraft in one system would lead to considerable development of hybrid VTOL systems in the near future. Independent of the type of platform, the growing flexibility of UAS and increasing choices of commercial as well as custom-tailored systems are exciting prospects for the geoscientific communities.

9

SFAP Survey Planning and Implementation

Base all your work on the reality of the field; there
lies the truth if you are clever enough to extract it.
D. Shearman (1958). Quoted by Dewey (2004)

9-1 INTRODUCTION

A successful SFAP field survey often depends on the ability to react flexibly to a plethora of complications—the more of these that may be anticipated and planned for in advance, the more likely one would return with plenty of good images. SFAP could be undertaken quickly and spontaneously, for example with a light-weight minimal kite system for an afternoon at the beach. But it usually takes more time and effort to prepare and conduct the survey of a specific site for scientific purposes.

Many aspects would depend directly on the research question, that is on the characteristics of the forms, structures, and processes one wants to observe and on the deductions one plans to draw from the imagery. This might strongly influence the preparation and overall setup of a survey. The considerations related to planning a field survey, which are discussed below in more detail, include

- Travel and equipment logistics.
- Accessibility, flight obstacles, wind, and other site characteristics.
- Personnel required.
- Ground control.
- Flight planning regarding the desired image area, scale, and resolution.
- Legal issues (see Chap. 12).

Some of these issues require that the location, size, and characteristics of the survey area are already fairly well known, but this is not necessarily always the case. There are many situations for which not much is known about a site where SFAP is being planned. The authors often have been invited by other colleagues to take aerial photographs of biological test plots, archaeological remains, architectural monuments, or nature preserves at sites not previously familiar to us. In many cases, our hosts knew little or nothing about the logistical requirements or weather conditions necessary for successful SFAP.

Often the initial information about the site is limited to a rough estimation of size and directions how to get there. Luckily, in times of *Google Earth* and online map services, it has become much easier to gather information about remote areas around the world. Maps as well as satellite and aerial images may be extremely helpful in SFAP mission planning even for previously known sites, offering possibilities of distance measurements, ground-control preparation, access planning, assessment of obstacle problems, and even flightline planning for autopiloted aircraft.

9-2 TRAVEL AND EQUIPMENT LOGISTICS

For a successful mission, the SFAP equipment and personnel must be available to reach the study site at the desirable time of day or year to meet the goals of the project. This invariably requires travel for people and transport of baggage. The logistics could be as simple as packing kite aerial photography equipment in the car for a weekend trip. Still this depends upon good weather conditions—sunshine and favorable wind, which are not always so easy to arrange in practice. At the other extreme, the mission may require extensive authorization procedures, preflight planning, and site preparation on the ground, and involve considerable equipment and personnel to operate the SFAP platform. The logistics for this sort of project could take weeks if not months to organize.

Travel options depend to a large extent on the type of SFAP platform as well as location and conditions of the study site. Nearby sites adjacent to paved roads are the easiest to reach, of course. In such situations, the photographer has few limits on how much equipment

and how many field assistants to take to the site. On the other hand are distant or remote locations with poor transportation connections—reached in the final stage perhaps only by footpaths. In these cases, a minimal amount of equipment and personnel would be desirable.

Often the last few kilometers on the way to a specific study site are the most difficult, even in case of rather good travel connections. Paved highways turn into gravel roads, which diminish to dirt tracks, and end in footpaths. During the wet season or a sudden rain storm, such tracks may become impassable even for all-terrain vehicles (Fig. 9-1). For cases of generally or temporarily bad accessibility, the equipment needs to be packed in a way that enables transportation by means of human (or animal) carriers (Fig. 9-2). Specially designed hand-drawn carts with oversized wheels allow passage across loose sand or wet soils (Fig. 9-3).

Waterproof transportation boxes made of plastic or aluminum are necessary requirements in order to bring flight and camera equipment to the study site facing bad weather and difficult terrain. Accordingly, the best practice we have found over the years is to use several relatively small, sturdy, dust- and splash-proof cargo or storage boxes with specially fitted, but easily replaceable foam liners for fixing and padding the camera equipment (Fig. 9-4).

International travel to study sites presents further difficulties, especially if flying commercial airlines, because of customs and security concerns about the purpose of travel and the unusual items in the baggage. The authors have been questioned many times at airports and border crossings about the nature of our equipment. Various cameras, batteries, kites, radios, electronic devices, and other odd-looking gadgets seem quite suspicious to security inspectors. On the other hand, off-the-shelf consumer drones such as the *DJI Phantom* series have become so common in recent years that airport security and customs have become quite familiar with the sight. It is highly advisable, however, to check national customs regulations well before traveling, as some countries have restrictions or import bans on UAS (see Chap. 12).

Certain types of platforms require fuel for power or gas for lift (see Chaps 7 and 8). Helium is commonly used for inflating balloons and blimps. However, there are few commercial sources of helium in the world; helium is either quite expensive or simply not available in many countries, and long-distance transport of heavy helium tanks is usually not feasible for most SFAP. The helium is normally lost when the blimp or balloon is deflated; equipment for recovering and reusing helium is expensive and heavy.

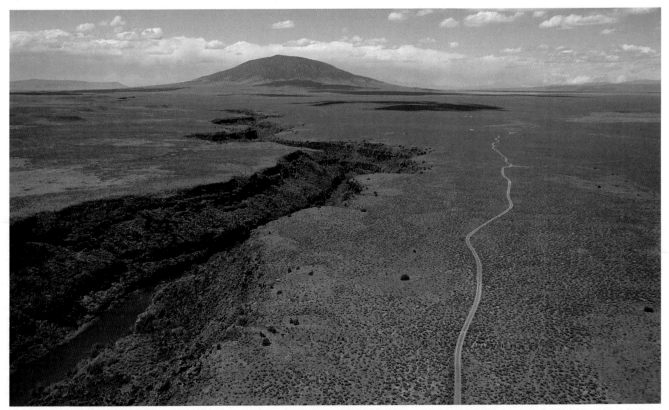

Fig. 9-1 Access road to SFAP site in northern New Mexico, United States. This dirt track is many kilometers long across the sagebrush desert and would quickly become impassable during thunderstorms, which are common in the spring and summer. Río Grande gorge to left is about 215 ft (~65 m) deep; Ute Mountain in the background. Kite photo taken with a compact digital camera by JSA with T. Nagasako.

Fig. 9-2 Tackling the 400-m altitude difference between the last possible parking spot (see valley bottom) and a high-mountain survey site in the Cuenca de Izas, High Pyrenees, Spain. JBR (second from left), with the hot-air blimp envelope on a frame-carrier pack, shares the weight of the burner system with one of his students at the beginning of a 1½-hour ascent. *Courtesy of J. Heckes.*

Fig. 9-4 Airline-suitable travel baggage for international kite aerial photography. (A) Cargo box is checked for luggage containing kites, line reel and anchor, extra batteries, radio controller, spare parts, tools, etc. The cargo box is 82 cm long. The smaller camera case is carry-on luggage. (B) Waterproof, foam-padded case contains two complete camera rigs and accessories. The foam padding may be modified to fit different camera rigs. The case is 46 cm long.

Fig. 9-3 Specially constructed hand truck with oversized wheels for transporting a cargo box over loose sand or wet soil. Wheels are 30 cm in diameter and 18 cm wide, the frame is oak, and the front legs fold back while moving. Designed and built by JSA.

Hot-air balloons and blimps are an option where helium is not available, because propane or cooking gas to fire the burner may be found just about everywhere. Decanting gas from commercial gas bottles into fuel tanks modified for flying requires a special adaptor and tube kit. Gas-powered model airplanes and some multirotor UAVs require fuel that is highly flammable. Transport of such fuels is strictly prohibited on commercial airlines, so a local source would be necessary. Electric-motor power would be more desirable in such cases, as the batteries could be recharged or replaced locally. However, some countries and airlines restrict the transport of large LiPo batteries.

One of the issues faced when traveling abroad is different types of domestic electricity. In the United States and Canada, standard outlet electricity is 120 V

and 60 Hz. But this varies greatly in other countries around the world, for instance 100 V/50 Hz in Japan, 127 V/60 Hz in Brazil, and 240 V/50 Hz in Kenya (World Standards 2018a). For western and central Europe, the standard is 230 V and 50 Hz. Most portable devices (laptops, tablets, cameras) have transformers that are able to accept this range of voltages and cycles, but that still leaves the problem of diverse outlet designs, of which there are some 15 types worldwide (Fig. 9-5). In some cases, the authors have modified or customized socket-plug connectors for necessary electricity to power devices or recharge batteries while traveling.

Overall, SFAP logistics is usually a matter of common sense and experience. A rule of thumb is to employ a system that is robust, easy to transport, and, most

Fig. 9-5 Typical electrical outlet sockets and plugs for Slovakia and Poland along with some adapters for American plugs. American plugs include types A and B; most of continental Europe utilizes types C, E, and F (World Standards 2018b).

importantly, capable of acquiring the necessary type of imagery. More equipment—platforms, cameras, fuel, radios, monitors, and other devices—means that more things could go wrong during travel or at the SFAP field site. Careful preflight planning and logistical preparations may eliminate many potential problems; still, mishaps cannot be avoided completely and should be expected. In the authors' experience, battery power is the biggest single issue for equipment failures in the field. Spare parts and backup equipment are often essential for completing a mission.

9-3 SITE ACCESSIBILITY AND CHARACTERISTICS

9-3.1 Local Site Accessibility

Accessibility of a site is an important consideration for unmanned SFAP, as the survey system is controlled by one or more operators on the ground. Obviously, accessibility is of particular importance for tethered systems (Chap. 7), but it is usually also required for free-flying UAVs (Chap. 8), which are much safer flown within sighting distance. In Germany, for example, the flying distance of a UAV is legally restricted to the range of sight (see Chap. 12). For a small quadcopter UAV, this may be as little as 200 m.

Depending on the system and size of the area, the operator(s) may need to move around quite a bit, making accessibility and ease of action a rather central issue. Some sites may be impossible or difficult to access owing to their conditions (wetlands) or conservation status (nature reserves); others just may be difficult to move or navigate in because of tall weeds, fences, rugged terrain, forest, high mountains, etc. As a general guideline, the more difficult the terrain, the more personnel may be recommended to help with navigating, relaying messages, taking bearings for flight directions, etc.

Direct accessibility by vehicles may be an issue with large and heavy equipment, although most of the systems presented in this book could be transported by foot or small boats with a little goodwill and exertion and have indeed often been so by the authors. Some systems have special requirements for launching places (e.g. size, flatness, local wind conditions, distance to obstacles), which also may mean that the operators have to walk some distance after launching the system if no convenient spot could be found directly at the site.

9-3.2 Flight Obstacles

Reading about Charlie Brown in the comic strip *Peanuts*, if not through personal experience, has taught us that trees are the nemesis of kites. When a kite or its tail becomes caught, it is important not to pull on the kite line, as this would only drag the kite deeper into the tree. Let the line go slack. With luck, wind may lift the kite out of the tree. Otherwise climbing the tree may be the only means to recover the kite (Fig. 9-6). Most such incidents happen because of inattention by the kite flyer; a moment spent adjusting the camera rig or other equipment may be just the instant when the kite makes a loop or takes a dive.

Actually trees and other obstacles present problems for all types of tethered or free-flying platforms. Tangling a blimp tether at the top of a tall tree, for instance, leaves few options for recovering the blimp and camera rig. The most dangerous obstacles are high-voltage power lines, along with telephone wires, railway power lines, radio towers, light poles, and other electrical sources. Dry tether lines normally are not conductive for electricity, but may become conductors when damp, which represents a serious safety issue in cloudy, foggy, or rainy weather. The best solution is simply to keep well

Fig. 9-6 Rokkaku kite caught in a tree at a cemetery study site. The kite and its tail were recovered without damage. Kansas, United States.

away from any such electrical hazards. Other potential obstacles for tethered platforms include buildings, steep cliffs, and high river embankments.

Recent models of multicopter UAVs are increasingly equipped with sensors for obstacle detection (Lu et al. 2018; see also Chap. 8). When the collision-avoidance system is enabled, the aircraft will automatically decrease speed and fly around or over the obstacle it has detected. However, depending on the sensitivity of the sensor and physical properties of the obstacle, the system may not function correctly. Low-light condition, water surfaces, or thin objects such as power lines may hamper obstacle detection, and the pilot should never fully rely on the aircraft's ability to find its way safely.

In a safety hierarchy are first and foremost people—both the SFAP operators and bystanders, followed by buildings and vehicles, wildlife and natural features, and lastly the camera rig and platform. This order of priorities should be kept clearly in mind before and during each flight by all members of the survey team. Once the device is in the air and everyone's attention is upward, many dangers may be overlooked on the ground.

9-3.3 Wind Conditions

Regarding survey planning, the position of the site within the windscape may be important for the choice of platform or for navigation planning because of typical regional or local winds that cause windward and leeward situations. For kites, the wind direction always must be taken into account when choosing the launching site, but also for most other SFAP platforms wind susceptibility is more-or-less crucial. Certain types of platforms favor calm or low-wind conditions, whereas other aircraft are suitable for stronger winds. Both wind direction and speed may vary at different heights above the ground, especially in alpine or desert terrain, and throughout the day. On a global basis, zonal wind patterns are consistent over broad regions (Aber et al. 2015):

- Trade winds—blowing from the northeast in northern hemisphere and southeast in southern hemisphere.
- Horse latitudes—weak and variable wind approximately 30° north and south latitudes; the main desert belts.
- Westerlies—blowing from the northwest or southwest depending on the season, north and south middle latitudes.
- Polar easterlies—blowing from the northeast in northern hemisphere and southeast in southern hemisphere.

Around the world, average daily wind speed typically reaches a peak in the afternoon for most locations regardless of latitude or altitude, and wind may be nearly calm overnight and in the early morning (Aber et al. 2015). Usually the wind direction varies during the course of a day, particularly in coastal regions, which may experience diurnal reversal. During the day, as the land warms up a refreshing sea breeze flows inland, but at night the wind shifts and blows offshore.

Seasonally varying wind systems mainly have to be considered in the subtropics and marginal tropics. In North and West Africa, for example, the Harmattan provides excellent kite flying conditions in the dry period in winter; the same applies to the Cierzo in northern Spain and the Mistral in the western Mediterranean area. In summer these regions are dominated by calm or thermally induced local winds. Similar seasonal winds are encountered in many parts of the world, for example the Santa Ana, a hot desert wind from the east or northeast in southern California. In the authors' experience, coastal wind is most favorable, whereas desert wind is the most variable, unpredictable, and difficult for SFAP missions.

Even within the small range of flying heights of SFAP platforms, variability of wind velocity and direction may be an issue to be considered in launching, flying, and landing. Depending on weather conditions and local relief, the wind may be much stronger at 100 m above ground and blow from quite different directions. In hot weather, particularly over bare ground at midday, thermal convection may be strong close to the surface. This could be difficult if not dangerous in the landing phase of fixed-wing aircraft, leading to sudden uplift only decimeters above the ground and considerable lengthening of the approach way (see Fig. 8-12).

Choice of platform and mission specifications need to take such regional, local, and seasonal wind patterns into account. Close attention to weather conditions is essential leading up to any SFAP mission, particularly regarding predicted wind and cloud-cover conditions. A combination of camera platforms for different wind velocities, including a system for calm conditions, has proven of value for the authors. For long-term environmental monitoring purposes, it is generally preferable to take the pictures always in the same season and to adapt the camera platform to the wind velocity prevailing at that time.

9-4 HIGH-ALTITUDE SFAP

Humans are an unmistakably low-altitude species (Rankin 2016). Half of all people live below 165 m altitude, >85% are below 1000 m, and only 6% live more than a mile (~1600 m) high. Thus, it is no surprise that most SFAP has been undertaken at relatively low altitudes. Chorier attempted kite aerial photography at 5600 m at Khardung La pass in the Jammu and Kashmir province of northern India, but was thwarted with strongly gusty wind and temperature of −15 °C. He did succeed nearby in the village of Khardung just below 4000 m altitude (Chorier 2016). This is the highest successful kite aerial photography known to the authors.

Even higher altitudes of ~4300 m were reached in a study by Immerzeel et al. (2014), who monitored the

debris-covered tongue of the Lirung Glacier in the Nepalese Himalaya using a small fixed-wing UAV. The current record lies with a custom-built quadcopter UAV (a *Black Snapper* type, see Chap. 8-3) that was flown at 8000 m ASL below the summit of Mount Everest in 2016 (Fischer 2016)—the pilots did, however, wisely shun the even thinner air, higher wind speeds, and incalculable risks for man and machine at the actual summit.

For purpose of this discussion, high altitude is considered to be those regions above ~1000 m in elevation, and tremendous scientific interest exists for all types of environments at these high elevations. Global warming in mountain regions and related geomorphological changes provide a challenge for SFAP. Retreat of alpine glaciers around the world documents the shrinking cryosphere, for example (Burkhart et al. 2017). Changes in permafrost soils, landslides, debris flows, and mountain floods are some short-term processes whose spatial distribution and change dynamics are of great interest in the near future. The same applies for vegetation including subalpine forest and alpine tundra impacted by climate change. Human activities such as forest cutting, overgrazing, building operations, and hiking and sports tourism also have consequences in high-altitude environments.

The force that holds up a winged aircraft is determined by relative wind speed and air density acting on the lifting surface. At high altitude, lower air density means that fewer and lighter molecules (per air volume) flow over the lifting surface at a given wind speed. Air density is governed by three factors—pressure, temperature, and humidity. The combination of these factors determines potential lifting power of a particular winged platform for a given wind speed.

The standard atmosphere is an ideal model of atmospheric conditions (Table 9-1). These values reveal that density decrease is fairly slight up to about 1000 m high. At higher altitudes, however, air density declines significantly. At 3000 m, for example, air density is only about ¾ that of sea-level density. However, this assumes the standard atmospheric temperature of −4.5 °C at that altitude. At higher temperature comfortable for field work and full battery power, say 20 °C, air density is considerably less.

These conditions impact all types of winged platforms, both manned and unmanned. In the case of kites, for example, several components could be adjusted to compensate for decreased air density at high altitude—use a kite with greater intrinsic lift, increase the size of kite, use a train of multiple kites, and reduce the weight of the camera rig (Aber et al. 2008). In general, rigid kites, particularly the rokkaku type, provide the greatest intrinsic lifting power compared with other types of kites (see Chap. 7-4). For fixed-wing aircraft, lower air density would lead to higher flight speed at the same energy input. At

Table 9-1 Standard atmospheric conditions for temperature, pressure, density, and density percentage according to altitude. Based on data from Engineering ToolBox (2003).

Altitude (m)	Temp (°C)	Pressure (hPa)	Density (kg/m^3)	Percent
Sea level	15.0	1013	1.23	100
1000	8.5	900	1.11	90
2000	2.0	800	1.01	82
3000	−4.5	700	0.91	74
4000	−11.0	620	0.82	67
5000	−17.5	540	0.74	60

the same speed, accordingly, the available weight-bearing capacity would be lower. Multirotor small UAS would likewise expend more battery power to stay aloft, thereby reducing flight time. Many UAS manufacturers are currently testing their aircraft under high-altitude conditions in order to offer customers more specific details on their performance for high-mountain applications.

Helium balloons and blimps, filled to capacity, have considerably less lifting ability at high altitude compared with lower altitudes. Likewise, hot-air systems at high altitudes have less lifting power for a given difference in air temperature than they would have in lower regions. On the other hand, the lifting power increases with a larger temperature gradient between the air outside and the air within the balloon. As high mountain areas are usually colder than lower regions, this effect compensates to a large extent for the change in lifting capacity. A hot-air balloon operated at 850 hPa pressure and 15 °C difference in air temperature, for example, can carry the same payload as it could at 1000 hPa and 25 °C temperature difference.

High-altitude SFAP often takes place in or near mountains. Mountain ranges typically create strong local climatic effects, which include colder temperature, enhanced cloud cover (Fig. 9-7), and more precipitation than for adjacent lowlands. Mountain peaks and valleys are well known for rapid weather changes. Swirling wind funnels along valleys and over passes with frequent and abrupt changes in direction and strength; alternating updrafts and downdrafts are routine.

In many high-mountain regions, airfields even for small single-engine microlight aircraft are either non-existent or not usable throughout the year. By using unmanned SFAP platforms, higher risks could be taken under difficult flight conditions. Finding a suitable open space for unmanned SFAP may be a challenge in forested mountains, and access to alpine areas above timberline may be quite limited. Areas with good access are often sites with other human structures and activities that could prove risky for tethered platforms (Fig. 9-8).

Fig. 9-7 Cumulus clouds beginning to build during the morning over the High Tatry Mountains, while the adjacent foreland remains cloud free. By afternoon, the mountains are completely cloudy and rain is likely. Similar conditions prevail in many mountain systems during spring and summer monsoon seasons. Near Spišska-Bela, Slovakia; kite photo taken with a compact digital camera by SWA and JSA with I. Duriška.

Fig. 9-8 Meteorological observatory atop Kojšovská hol'a at 1246 m (~4120 ft) altitude in southeastern Slovakia. Kite flyers (*) are positioned on the downwind side of the observatory buildings and towers to avoid any chance of mishap. Access to this site required permission and carrying equipment by foot approximately 1 km up a steep path. Taken with a compact digital camera.

The combination of cloud cover, variable wind, and limited access makes for difficult SFAP in many mountain settings, and small manned aircraft may be particularly dangerous to operate under these conditions as well.

The authors have conducted considerable high-altitude SFAP with both kites and blimps, in spite of such limitations. In general, thinner air with increasing elevation is not a serious problem up to about 2500 m.

Thin air does become more significant above 2500 m, particularly at usual temperatures (20–30 °C) for typical field work during the growing season. High plains, mountain forelands, and broad intermontane valleys offer excellent SFAP situations with relatively open terrain (Fig. 9-9). Mountains are more difficult, however, because of frequent cloud cover, gusty wind, and limited ground access (Fig. 9-10).

Fig. 9-9 Panoramic view of Elephant Rocks in the right foreground and fog-covered San Juan Mountains in the background on the western edge of San Luis Valley, Colorado, United States. Elephant Rocks are erosional features in volcanic strata on the edge of the San Juan igneous province. Kite aerial photograph at ~2440 m (~8000 ft) elevation. *Taken from Aber et al. (2008, Fig. 7).*

Fig. 9-10 Mount Maestas (left) and Spanish Peaks (right background) as seen from La Veta Pass in south-central Colorado. US highway 160 crosses the bottom of scene. Access to the ground launch site at ~9400 ft (2865 m) elevation was via a jeep trail. Kite photography was conducted with extremely turbulent wind as thunderstorms grew rapidly nearby. Taken with a compact digital camera. Access to private land courtesy of J. Estes.

9-5 GROUND CONTROL

For all applications that involve measuring and mapping, ground control is necessary for georeferencing and geometric correction of the images (see Chap. 3). Ground-control points (GCPs) are features that appear on the photographs and whose locations in a reference system are known (Warner et al. 1996; Chandler 1999; Wolf et al. 2014). Given the typically large scales of SFAP images and small sizes of the covered areas, GCPs are usually small but well-defined natural features or pre-marked artificial features whose coordinates have to be determined in the field using total stations or global navigation satellite systems (GNSS).

The geometric accuracy of a map derived from the photographs depends strongly on the accuracy and precision with which GCPs were measured in the reference system and identified in the image. Therefore, care has to be taken that the quantity, distribution, and quality of ground control match the purpose of the survey and resolution of the images. Various studies have analyzed the role of GCPs for the accuracy of SFAP-derived photogrammetric products such as DEMs. Recommendations on GCP deployment and optimization may be found for example in Clapuyt et al. (2016), James et al. (2017a,b), and Martínez-Carricondo et al. (2018).

9-5.1 GCP Installation

Establishing ground control may be a time-consuming and costly part of the survey and must not be underestimated. As discussed in Chap. 3, a theoretical minimum of three GCPs is necessary for adjusting an image to a reference coordinate system. In reality, more GCPs are necessary to cover an area with differing elevations well enough for georeferencing and to ensure that sufficient GCPs appear on each photograph (see Chap. 11-2). For more advanced photogrammetric analysis, a surplus of GCPs is advisable which could be used as check points and enable error assessment of DEMs derived from the images (Chandler 1999).

The points should be distributed roughly evenly (but preferably not in exact geometric patterns) over the area including its edges so they represent the different terrain heights (Fig. 9-11A) and might be seen easily from above (i.e. not too close to trees, bushes, or walls so they are not concealed by shadows or objects tilted due to relief displacement). When using total stations for coordinate measurements, it is also advisable to check during installation of the GCPs if they could be arranged so they are easily visible from one common vantage point (see below).

Especially when establishing permanent ground control for monitoring purposes, a detailed plan or sketch of the site and the control-point positions (Fig. 9-11B) is extremely valuable for avoiding GCP confusion during image processing and for rediscovering the points in the field in future missions. Although the airphotos themselves help to locate the GCPs, the first survey might not have covered the complete marked area and patterns on the ground might have changed, so jotting down additional information referring to the ground-view perspective could be quite helpful, for example, "on highest point of small bump" or "2 m south of tallest dead pine tree."

The position of the control point has to be fixed with some pinpoint object such as a metal pole. Pieces of construction steel or water pipe are useful and cheap options and easily available around the world from plumbing or hardware stores in the local industrial park. During the SFAP survey, the points need to be marked additionally with target signals for easy identification and accurate location in the image, preferably with eye-catching shapes and colors contrasting well with the natural background. If the ground cover is uniform, for example, grassland, and without features that allow an unambiguous allocation of the images, it might be necessary to use different markers in order to distinguish the individual points.

The size and design of the target signals influence their visibility in the airphoto—they should be large enough to be identified easily in the image and yet enable the user to locate the actual point position accurately. Consider the example given in Chap. 2 with a vertical photograph acquired at a height of 100 m with 35-mm lens and 0.009 mm pixel element size: the GSD is 2.6 cm. In order to be recognized as a distinct object, the target signal has to be at least 3–5 times larger than the GSD (8–13 cm). Depending on the "background" of the surface cover, this object could still be completely lost between patterns of vegetation, stones, and clumps of soil, so it would be best to surround this pinpoint signal centered over the GCP with something conspicuous, again 3–5 times larger, for example, approx. 40 cm in diameter.

Depending on the nature of the study, temporary or permanent ground control may be desirable. For long-term monitoring, permanent control points that endure years or even decades are best, while for a one-time survey, a GCP life-time of a few hours for measuring the GCPs and taking the aerial photography might be enough. For long-term monitoring of various study sites in Spain, permanent GCPs were installed by hammering 40 cm (15-in.) long pieces of 2 cm (¾-inch) metal water pipe into the ground so they protrude a few centimeters. A 30×30 cm red cardboard square with central hole is fitted over the pipe before the survey and secured by a long carpenter's nail on windy days. For improved definition of the point location, a white ring is painted around the edge of the pipe hole (Fig. 9-12A). An even better definition of the exact location and height of the GCP (important for photogrammetric accuracy) could be achieved by fixing a circular target made from a CD and metal washer with a long nail and drop of glue to

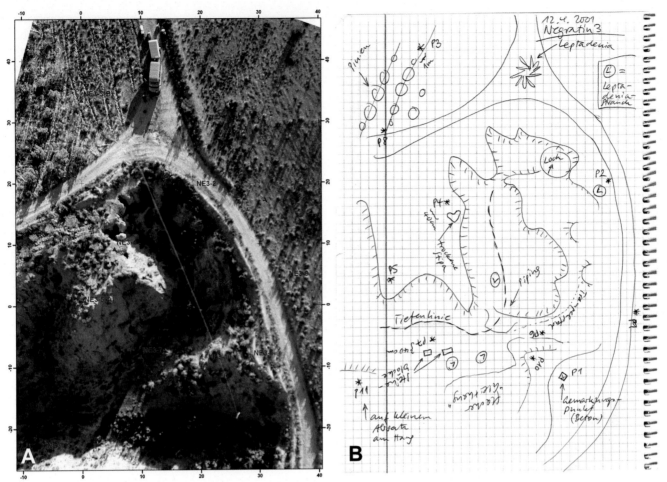

Fig. 9-11 Gully Negratín 3 near Baza, Granada Province, Spain. (A) Image map with ground control points. GCPs are distributed in and around the gully at varying terrain heights. (B) Field-book sketch indicating the positions of GCPs and landmarks for orientation in the field. Note the internal distortions of the sketch map compared to the corresponding image map A, which result from the difficulties of overseeing a complex terrain while mapping from different vantage points. Sketch taken from IM's field book.

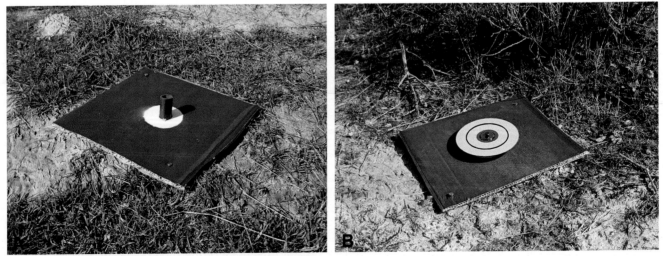

Fig. 9-12 Permanent GCPs made from a piece of metal water pipe. (A) GCP marked with a 30-cm cardboard target signal for the survey. (B) Top-precision GCP design. The exact top end of GCP is additionally marked with a circular target made from a CD labeled with target rings. A metal washer is mounted in the center of the CD to hold a large nail inserted in the GCP pipe, and the CD is temporarily fixed with a few drops of glue to avoid displacement by wind.

Fig. 9-13 The GCPs shown in previous figure appearing in aerial photographs with GSD ~3cm. (A) GCP marked with red cardboard with white center ring; (B) GPC additionally marked with CD target.

the pipe's top end (Fig. 9-12B). Both types of target make the GCP clearly definable in the aerial image (Fig. 9-13).

After the survey, the pipe should be covered with something protective and conspicuous like big stones to warn animals from stumbling and to make it easier to retrieve a year or two later (Fig. 9-14). Keep in mind that it might be quite difficult to find something as small and inconspicuous as a piece of metal pipe unless well

Fig. 9-14 Stone cairn built to mark a buried soil-temperature probe at a long-term study site approximately 12,900ft (~3930m) in elevation. Such markers last many years without being disturbed; pry bar is ~45cm long. Sangre de Cristo Mountains, south-central Colorado, United States.

marked with something intentionally recognizable. When covered by vegetation or buried by soil, such markers also may be found again with a metal detector. However, the utilization of these devices is not allowed in all countries because they are often applied by tomb raiders and hobby archaeologists for illegal purposes. In Spain, for example, even carrying a metal detector in a vehicle is indictable. The reader is therefore advised to seek information about the local regulations before employing a metal detector.

In many countries, metal pipes have a high value; they likely might be dug out by the local population and utilized for a more-sensible purpose. Color-marked stones as well are eye-catching and seem too valuable to let them lie around in the field, so children tend to gather and carry them away. On a wasteland site in the periphery of El Houmer village in South Morocco, the installation of permanent GCPs seemed useless considering the continuing destruction by erosion and the many uses a piece of water pipe might have for the village youths. As a quick and easy method of GCP marking, red rings with 15–20cm diameter were painted directly on the hard bare ground with spray paint (Fig. 9-15). Both SFAP and coordinate measurements were taken on the same afternoon.

Signals like these are quite sufficient if a local reference system for scaling and georeferencing photographs is needed in a one-time only survey. If permanent references are required for re-establishing the same coordinate system in future surveys, additional measurement of "natural" control points that have a high potential of surviving over years is also a good option. Examples for these could be sharply defined edges of utility pole foundations, gaps between pavement tiles, or conspicuous cracks in rocky outcrops (Fig. 9-16).

Fig. 9-15 Temporary GCP for one-time use installed by applying spray paint to the bare soil surface; highly enlarged. El Houmer rill-erosion test site, South Morocco.

9-5.2 GCP Coordinate Measurement

Given the large image scales and high pixel resolution for the SFAP emphasized in this book, coordinates for the GCPs usually have to be determined by terrestrial survey with a total station (Chandler 1999), providing a measurement precision of ±10 mm. Similar precisions may be achieved with real-time kinematic or post-processing kinematic global positioning systems (RTK/PPK GPS) or other high-precision GNSS. These are, however, quite expensive devices, and not always at hand in low-cost SFAP projects. Unlike GPS survey, terrestrial survey with a total station for measurement within a particular reference system requires preexisting trigonometrical points with known coordinates—a feature that is bound to be absent at many SFAP sites. In this case, an arbitrary local coordinate system has to be used, which could be transposed later by offsetting and rotating the local system in order to adjust it to the desired reference system (see Chap. 11-2). However, some sort of link to the latter is still required, for example, two points in the local system that also have been measured by GPS and which are visible in other, georeferenced, remote-sensing images like those provided by *Google Earth*.

If a global or national reference system is not required, using a self-defined local system throughout also could have advantages. This approach enables the surveyor to align the axes of the system to match with the site of interest, for example, line up the *y*-axis with the direction of a river bed or oblong test plot. Apart from aesthetic aspects—largely empty maps with diagonal stretches of stitched images just do not look as pleasing as a perfect-fit layout—an optimal alignment of study area and coordinate system also saves much file size in raster data.

Fig. 9-16 A rocky outcrop (A) with a distinct small notch (B) is being surveyed at test site OUF1d near Tamait Oufella, Morocco. In areas of intense land use—in this case heavy grazing and argan-fruit collection—artificial control points may be removed by local people over time. This durable "natural" control point has a higher life expectancy than a metal tube and may serve as base reference for future GCP measurements by RTK GPS or total station.

When setting up the total station for measurement in the field, it is advisable to choose a spot for the tripod that has a clear view of all GCPs. This is best checked, if in doubt, with the help of the person holding the reflector staff. If the GCP distribution does not permit a single measurement station and a local coordinate system is used, at least two points measured during the first round need to be measured again in the second; this would enable combining the two measurement sets into the same coordinate system by a mathematical transposition.

The authors are able to report generally positive experiences with most local populations during SFAP activities in various countries around the world. The ascent of blimps, kites, and drones is a spectacle that often attracts an audience (Fig. 9-17). However, curious bystanders often want to talk, ask questions, move in close, take photographs, or even handle equipment, and this interruption could be a distraction at a critical moment for the people flying the SFAP platform or operating the airborne camera system.

Most people are interested and supportive without having any objections against the flying machines or the activities. Nevertheless, this attitude could change quickly, regardless of the country, when survey markers are set out and equipment, such as a total station, is unpacked or employed. People become apprehensive that some type of building or development is about to take place without their prior knowledge and which might damage their land, economic stability, or privacy. Even parking a vehicle in an unexpected location could raise concerns by land owners, who may call the local police to investigate. Sensitive explanation, particularly by a local colleague, and authorization papers are necessary, but still may not clear up all reservations. One of the most important points is providing frank information to the local population concerning the purpose of the flight and survey activities, preferably before a confrontation happens in the field.

9-6 FLIGHT PLANNING CONSIDERATIONS

Flight planning depends on the nature of the study site and its surrounding terrain as well as the type of photographs that are required for the project. A basic distinction should be made between: a) general scene coverage, and b) mapping and cartographic or photogrammetric applications. The former may involve a combination of oblique and vertical shots, whereas the latter would necessitate vertical imagery, or vertical stereo imagery, which might be supplemented by oblique stereo imagery when using multi-view photogrammetry. For oblique SFAP, sun position and shadows relative to the camera location are key factors for achieving desirable lighting. But lighting conditions and the presence or absence of shadowing are also an important aspect for vertical SFAP (see Chap. 4) and may determine if an overcast or sunny day is chosen for a survey, and which time of day is preferable.

Collection of vertical imagery over a study site ideally includes complete coverage by individual photographs that overlap each other in a predetermined pattern. Professional-grade autopiloted UAS always include

Fig. 9-17 Because most SFAP platforms are visible from a distance, visitors from the local population are not rare during a survey. Bear in mind, when unpacking the survey equipment in the field, that it might be useful to delegate one of the team members as a visitor manager, because it might be necessary to enforce the look-but-do-not-touch and do-not-talk-to-the-pilot principles. Here, JBR is keeping the village youths away from dangerous kite lines near Gangaol, Burkina Faso.

flight-planning and navigation software that enables the pilot to formulate a mission and develop flight plans that the UAV will follow during the survey. This usually involves digitizing the outlines of the survey area on a basemap or satellite map and indicating the desired GSD, stereoscopic overlap, and other parameters. Optimal flightlines are then calculated automatically to cover the area in the shortest flying time and with the smallest number of images. Consumer-grade small UAS might not include sophisticated software for flight planning and autonomous navigation, but an increasing number of freeware or low-cost apps that serve these purposes may be found on the web. *Litchi* for *DJI Phantom*, *Pix4dcapture*, and *UgCS*, for instance, were popular apps at the time of writing that support the most common drone models on the market.

Flight-planning software is based on the same equations and principles outlined below, which may also be employed for determining optimal flying heights for kites or blimps, or for planning a mission of a manually navigated fixed-wing or multirotor aircraft. The equations could easily be implemented in spreadsheet software to enable quick calculations for various sensors and survey purposes. For determining area size and flightline positions, online image-map services such as *Google Earth* or orthophoto viewers provided by national mapping agencies (e.g. *Geoportal* in Germany, *IGN SignA* in Spain, or the *NationalMap Viewer* in the United States; Fig. 9-18) become extremely useful.

Nevertheless, for many SFAP platforms, the practical implementation of a survey may be rather far off a preconceived mission plan. Kites do not often obediently comply with the flying-height wishes of their handlers; blimps prefer to turn their nose to the breeze rather than following a pattern of straight flightlines; and small UAS may veer off course in a strong side wind. Even so, and regardless of the platform and its maneuverability, air survey calculations should be an integral part of any mission planning in order to ensure the best possible imagery for the intended application.

Fig. 9-18 Screenshot of the map and orthophoto viewer by the German national mapping agency BKG (© Copyright Bundesamt für Kartographie und Geodäsie). Online map services such as these are useful tools for preparing SFAP surveys. Here, the width of the Science Garden at Frankfurt University's Campus Riedberg is being measured to determine the size of the area for an UAS survey (see Fig. 2-2).

9-6.1 Planning Image Scale and Resolution

One of the following questions is usually the first to be addressed in this context:

- What is the size of ground details to be distinguished, i.e. what GSD is desired?
- What is the size (width and length) of the area to be covered?

The answers to these questions determine at the least the target flying height and minimum number of images required, but they might also affect the choice of camera lens or even camera model and the platform to be used.

If the image GSD is of primary concern, the flying height above ground that is necessary for the target GSD may be calculated for a given lens focal length by transformation of Eq. 3-4. This flying height and the focal length in turn determine the area covered by the camera image format (Eq. 3-3). If the calculated area turns out smaller than desired, there are now three possibilities:

- Change lens to a shorter focal length or increase flying height. Both would result in a larger area being covered, but also would proportionally increase GSD.
- Cover study area with multiple overlapping and adjacent photographs rather than a single image. This would result in additional field effort and expenses during image processing as the individual images have to be georeferenced, mosaicked, and color-balanced (see Chap. 11-2).
- Change image pixel size by choosing a camera with smaller CCD element size.

If the size of the area covered by a single photograph is of primary concern, the width and length of the area are usually of greater interest than its extension in units of area. Consider a study site or object with a certain shape; its width and length would have to fit onto the image format completely if it is to be captured by a single image. Unless the width/length ratio is identical with that of the camera sensor, care has to be taken that the target flying height is calculated using the side of the area that is longer in comparison to the image. This would result in the image covering more than the required area in one direction, rather than cropping the area in the other direction. Remember that all these calculations only apply for the ideal case of the camera being in exactly the right position at exactly the right height; depending on the controllability of the SFAP platform and camera alignment, a generous amount of error margin should always be allowed.

When deciding on the area to be covered by the photographs for a monitoring project, the expected changes—for example, the upslope movement of gully headcuts, the shifting of river meanders, the retreat of glaciers, etc.—have to be taken into account from the beginning. The image area should be chosen to provide enough room for the expected changes, so the time series would in the earlier images also show the yet unchanged areas and allow for comparison and interpretation of the changes documented in the later images.

9-6.2 Stereoscopic and Large-Area Coverage

Stereoscopic coverage of a study area is necessary for photogrammetric analysis of terrain heights and orthophoto correction, but even if no such advanced analysis is intended, stereophotos may help enormously with visual photointerpretation (see Chap. 10-4). There are two possibilities for achieving stereoscopic coverage: in-flight simultaneous image acquisition with two cameras or along-flight consecutive image acquisition with a single camera. There are advantages and disadvantages associated with both stereoscopy methods.

- In-flight simultaneous image acquisition is achieved with two cameras mounted at a fixed distance, for example, a twin-camera boom. This has the advantage that the stereo images always have the same scale and relative alignment. The amount of image overlap and stereoscopic parallax, however, differs with flying height, as the photogrammetric base (see Chap. 3-3) is predetermined. In order to achieve accurate stereoscopic measurements, the base-height ratio should be at least 0.25 (Warner et al. 1996). For the stereo boom presented earlier (see Chap. 7-4), this would result in optimal flying heights below 4 m! Although much smaller base-height ratios are sufficient for 3D viewing and photointerpretation, the stereo-boom solution is not recommended if photogrammetric measurements are intended. Another difficulty is that few SFAP platforms are suitable for supporting a stereo-boom. For kites, the boom represents a considerable challenge as an entanglement with the kite line and Picavet lines become more likely, and movement and vibration of the boom may impair image quality. Stable constructions require a considerably higher weight-bearing capacity. In case of a blimp, this capacity may be at hand but, nevertheless, the maneuverability is restricted as well by the boom, making take-off and landing operations more vulnerable as compared to flights with only one camera.
- Along-flight consecutive images could achieve better base-height ratios as their distance may be controlled by the operator during the flight. Depending on the platform, however, it may be difficult to ensure image pairs with the same flying height and scale and with regular alignment and spacing (see Fig. 3-9). In this case, more is definitely better; the more images that are taken, the better is the choice for selecting those images that provide optimal stereo coverage for analysis.

Tips for navigating individual platforms for stereo coverage are presented in Chaps 7 and 8. Similar considerations apply to non-stereoscopic coverage of larger areas with multiple images for creating seamless image mosaics.

Generally, covering an area with a regular pattern of overlapping images is better with free-flying platforms, which may be navigated more easily along straight lines than could tethered platforms. Ideal flightline patterns, as in Figs. 3-7 and 3-8, require a sophisticated combination of flying height, focal length, image extent, aircraft velocity, and exposure interval. This is most easily realized with dedicated flight-planning software and autopiloted UAS (Fig. 9-19A), but also possible to achieve in manual navigation (Fig. 9-19B).

Particularly for larger survey areas, it is also advisable to calculate the expected flight-path length and from this the total duration of image acquisition. Adding from experience the typical times required for launching, navigating to starting point and between lines, and landing the aircraft will give a rough estimate of the total survey time. This may then be compared with the expected battery time based on temperature and wind. Large survey areas may have to be divided into individual parts for intermediate landing and battery change.

The exposure calculations for stereo-survey flightlines in the following are useful for planning SFAP missions with free-flying aircraft with reasonably constant velocity, for example a manually navigated small quadcopter UAV. At first, a decision needs to be made about which of the variables are dependent and which are independent. With a given aircraft and camera, the most easily adaptable variable for determining image ground cover and GSD would be the flying height. In order to achieve regular stereoscopic overlaps, the exposure interval then needs to be matched with the flying speed or vice versa, depending on the characteristics of aircraft and camera. The following sequence of calculations is therefore typical:

- Calculate image scale S $(1/s)$, image ground cover A, GSD, and flying height H_g as shown earlier (Eqs. 3-1 to 3-4).
- Decide for the orientation of the rectangular image format with respect to the flight direction.
- Calculate the length of base B for the desired forward overlap PE (Eq. 3-5).
- Calculate the exposure interval ΔT or ground velocity V_g, depending on which of those is predetermined by the camera or platform (Eq. 3-6).

9-6.3 Flight Planning for Oblique SFAP

Classical aerial photogrammetry relies mostly on vertical imagery (see Chap. 3), and flight planning for oblique images is traditionally not a part of survey

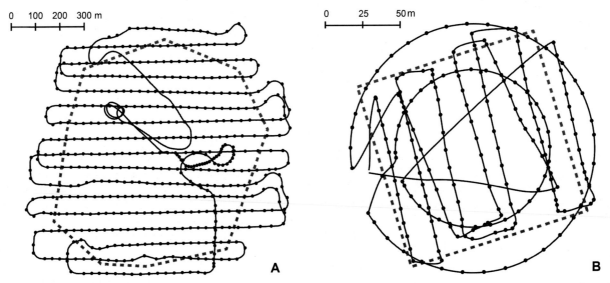

Fig. 9 19 Typical flight paths resulting from aerial surveys based on the designs in Figs. 3-7 and 3-8, respectively; target-area outlines shown in pink. Photos (black dots indicate image centers) were taken in interval mode. (A) Flight path of a fully autopiloted SFAP survey, planned with *MAVinci* flight-planning software and conducted by fixed-wing UAS (*MAVinci Sirius* I). The two swirly patterns result from the airplane's circling in order to gain and loose height during ascent and descent. Note the overshooting of the plane toward north at the flight-line turns, caused by southerly winds. The landing phase (beginning after last photo) was navigated manually. The 60-ha target area covers an agricultural catchment at Las Bañales, Province of Navarra, Spain. (B) Flight path of a manually navigated SFAP survey with quadcopter UAS (*DJI Phantom* 4). This survey was designed for use in SfM-MVS photogrammetry, with large endlaps of up to 90%. The area was covered with parallel lines of vertical images at the beginning and lines of slightly oblique images at the end of the survey. Additionally, two circular rounds of convergent oblique images were flown in semi-automated point-of-interest mode. Target area is a 120 m × 120 m test site in open argan woodlands at Tamait Oufella near Agadir, Morocco, with the aim of capturing the full 3D shape of the trees (see also Chap. 16).

planning. With the increasing use of Structure from Motion–Multi-View Stereo (SfM-MVS) approaches for reconstructing 3D point clouds and models, oblique imagery is now becoming a more integral part of SFAP surveys—see the example of the OUF1d woodland site presented above. However, exact planning of coverage, image overlaps, and stereoscopic parallax for oblique and convergent imagery would require much more complicated equations than those for vertical imagery. Manual planning of stereoscopic surveys with oblique images is therefore not realistically done.

Gradual variations of camera tilt, orientation, and height based on the calculations for vertical imagery are suggested, instead, for complementing the classical vertical survey designs. Care should be taken, however, to avoid unfavorable constellations of nadir angles in oblique stereophotos; rotating images around their perspective center, for example, would maintain the angles of convergence under which objects appear in the images, and thus extinguish stereo-parallax (see also Chap. 3-3.1 and 8-3). Practical guidance on acquiring networks of vertical and oblique images for SfM-MVS may also be found in James and Robson (2014) and Smith et al. (2016).

A case where oblique images may also become useful is the coverage of steep terrain with roughly straight slopes. Rather than taking vertical shots with strongly varying scale in each image, the camera could be tilted so the image plane is parallel with the terrain surface. This eliminates differences in scale and GSD within each image and reduces sight-shadowing by vegetation and varying perspectives relative to ground surface (Fig. 9-20). Preplanning of the required image tilt may be accomplished with the help of a digital elevation model (if available), a topographic map with contour lines, or with a clinometer in the field.

Apart from these rarer cases of oblique stereo imagery, the oblique vantage is often chosen to depict the spatial relationships of objects and features within the landscape in a more pictorial fashion that is readily perceived by the general public. The geometric distortions of single-point perspective, relief displacement, and scale variations are accepted, and the emphasis is given to best lighting, shadow placement, tilt angle, position of the horizon, and other factors that impact the visual scene. In general, views looking away from the sun without excessive shadowing and without the hot spot are preferred (see Chap. 4).

The type of flying platform, terrain conditions, wind direction, and other factors influence what sort of oblique imagery may be acquired under favorable conditions. Either the camera or the platform itself must be able to tilt to the side, which would exclude those systems designed exclusively for nadir imagery. Given a camera system that is able to tilt, rotation is also desirable to acquire views in various compass directions relative to sun position, shadows, and ground features. With this capability, side-by-side overlapping images may be acquired and joined together to create panoramas that depict broad swaths of the landscape (Fig. 9-21). Many recent consumer-grade multirotor UAS aimed at taking spectacular videos or stills have panorama tools directly implemented in their flight-control apps, so the stitching of the images may already been done in-camera.

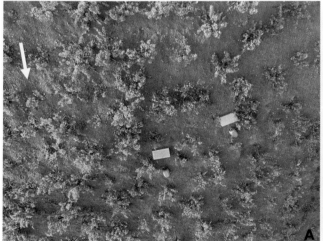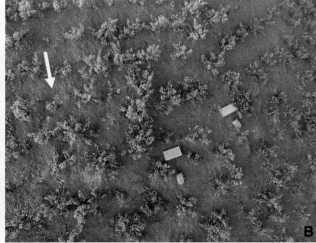

Fig. 9-20 Close-up view of a vineyard on a 30°-steep slope in the Axarquía, Montes de Málaga (Spain), with two Gerlach troughs (sediment collectors) for soil-erosion measurements. White arrows indicate main slope direction. Taken with on-board camera of quadcopter UAV. (A) Vertical image. Scale decreases from top to bottom in image A, so the plant size and distribution seem to vary between upper and lower slope, and perspective onto the low-growing vine shrubs changes. (B) High-oblique image with $\nu \sim 60°$ (image plane parallel to main slope). Compared to A, image B has a "flatter" appearance with more regular plant distribution because roughly the same scale is maintained. The radial distortion of the vines due to the central perspective is similar at top and bottom of the image. Here, scale variations are only present close to the right edge, where the slightly plan-convex slope bends away from the camera.

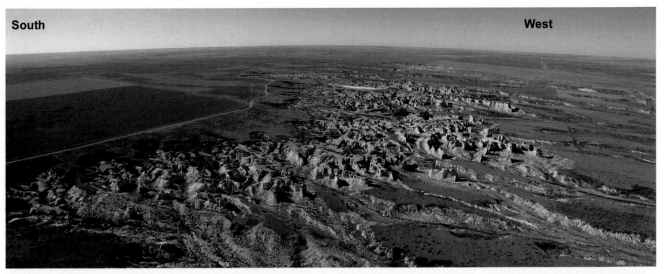

Fig. 9-21 Eroded chalk badland site known as Little Jerusalem in western Kansas. This high-oblique panorama was assembled from two overlapping wide-angle images looking toward the west and south. The images were acquired in midmorning in November, when sun angle was relatively low; note long shadows of chalk buttes cast toward the right. Kite photos taken with a compact digital camera; compare with Fig. 5-1.

9-7 FLIGHT PLANNING EXAMPLE

The following example for step-by-step planning an SFAP survey is drawn from an ongoing research project that aims at analyzing degradation processes of soil and vegetation in open argan woodlands in South Morocco (Ries and Marzolff 2017). Each of 30 test sites measures 1 ha (100 m × 100 m) and is to be covered generously—including a 10 m margin—by single-image overviews as well as by highly overlapping stereo imagery suitable for SfM-MVS photogrammetry.

The rather dense trees, rocky stone cover, and lack of open, smooth terrain for landing are inconvenient for tethered platforms as well as fixed-wing UAVs. The latter are also not capable of taking well-aimed oblique images. Together with the small size of the survey area, these requirements lead to a small multirotor UAS as the most suitable platform. The chosen survey system is a *DJI Phantom 4 Advanced UAS* (see Chap. 8-5.2) that carries an onboard camera (FC6310) with 8.8-mm focal length and a 13.2 mm × 8.8 mm image sensor (5472 × 3648 pixels). A WorldView satellite image acquired for the project was used as a base map for survey planning (Fig. 9-22), but any high-resolution online imagery service would serve the purpose as well.

GCPs would have to be deployed around and within the area, and a total number of 15 was chosen for this purpose. From the satellite images and prior field visits it was clear that there was no chance of finding a single viewpoint between the trees for total-station measurements of the GCPs, so it was decided to take a RTK GPS along for the mission.

9-7.1 Calculations for Complete Coverage With Single Image

As the target area is square in contrast to the rectangular image sensor, the target scale needs to be calculated with respect to image width using Eq. 3-1:

$$S = 1/s = d_W / TA_W = 8.8 \, \text{mm} / 120 \, \text{m} = 1 / 13{,}636$$
$$\left(\text{with } d_W = \text{image width and } TA_W = \text{target area width} \right)$$

This scale results in a longer area covered than necessary (area length $TA_L = 13.2 \, \text{mm} \times 13{,}636 = 180 \, \text{m}$, see green outline in Fig. 9-22). In the case of this camera, the sensor width equals the focal length f, and therefore the flying height equals the ground-area width. Generally, the target flying height may be determined from Eq. 3-2:

$$H_g = f \, x \, s = 8.8 \, \text{mm} \times 13{,}636 = 120 \, \text{m}$$

The ground size of a pixel (Eq. 3-4) calculates as

$$GSD = \left(8.8 \, \text{mm} / 3648 \right) \times 13{,}636 = 3.3 \, \text{cm} \left(\sim 1.3 \, \text{inches} \right)$$

Thus, the whole area of interest would fit into a single image if the camera was positioned and oriented as depicted in Fig. 9-22 at a flying height of 120 m, yielding a resolution of 3.3 cm on the ground.

9-7.2 Calculations for Stereoscopic Area Coverage

For stereoscopic coverage of the 120 m × 120 m target area aiming at SfM-MVS photogrammetric analysis

Fig. 9-22 Screenshot of GIS project used for flight planning at the OUF1d test site area (Morocco), with high-resolution satellite image (RGB=NIR/Red/Green). The area of interest is a 1 ha test site (black dashed line) plus 10 m margin (pink), the corresponding ideal image footprint for complete coverage is shown in green. The yellow rectangle shows an exemplary image footprint from the prospected stereo coverage with 1.3 cm resolution. *WorldView* 3 satellite image provided as EO Third Party Missions data by the European Space Agency under Project ID 36256.

(see Chap. 3-3.5), a GSD of 1.3 cm was desired. Flying height and image area are therefore recalculated using Eqs. (3-4) (resolved for H_g) and (3-1) (resolved for D):

$$H_g = f \, x \, GSD \, / \, (\text{pixel size}) = 8.8\,\text{mm} \times 1.3\,\text{cm}$$
$$/ \, (8.8\,\text{mm} \, / \, 3648) = 47.4\,\text{m}$$

which results in an image-area coverage of approximately 71 m by 47 m (see Fig. 9-22, yellow outline):

$$D_L = H_g \, / f \, x \, d_L = (47.4\,\text{m} \, / \, 8.8\,\text{mm}) \times 13.2\,\text{mm} = 71.1\,\text{m}$$

$$D_W = H_g \, / \, f \, x \, d_W = (47.4\,\text{m} \, / \, 8.8\,\text{mm}) \times 8.8\,\text{mm} = 47.4\,\text{m}$$

Owing to the survey purpose—generating a detailed 3D dense cloud and digital surface model (DSM) of the woodland for analysis of tree-crown density, structure, and shape—it was decided to use large endlaps and sidelaps of 80% and 40%, respectively. Regular overlaps are most easily achieved with a manually navigated UAV when taking pictures in interval mode and maintaining as steady a speed as possible. Although the first-person view system of the *Phantom* 4 transmits the camera image as real-time video to the remote-controller display, it is helpful for the pilot to know beforehand under which conditions the desired survey pattern may be attained. Therefore, the next step was to calculate the target flying speed or ground velocity (V_g) from the required image base (B).

Using Eq. 3-5, the image base in longitudinal sensor direction calculates from the percentage endlap (PE) as:

$$B_L = D_L \, x \, (1 - PE \, / \, 100) = 71.1\,\text{m} \times (1 - 0.8) = 14.2\,\text{m}$$

From this image base and the *Phantom* 4's exposure interval of 3 s, the required ground speed of the aircraft may be determined by Eq. 3-6 as:

$$V_g = B / \Delta T = 14.2\,\text{m} / 3\,\text{s} = 4.7\,\text{m/s} \quad \text{or} \quad 8.3\,\text{km/h}$$

Finally, a general idea of how many flightlines and how many images per line are needed to cover the target area, so the distance between flightlines is calculated from the desired sidelap (PS) next, using again Eq. 3-5:

$$B_W = D_W \, x \, (1 - PS / 100) = 47.4\,\text{m} \times (1 - 0.4) = 28.5\,\text{m}$$

Dividing the target area width and length by B_W and B_L, respectively, the numbers of flightlines and images per line are calculated (with one additional image for stereoscopic coverage of the full length):

$$TA_W / B_W = 4.2 = 5 \text{ flightlines}$$

$$\left(TA_L / B_L \right) + 1 = 8.4 + 1 = 10 \text{ images}$$

From these considerations, the total number of images in our ideal vertical coverage scheme may be calculated as 50. Even when adding the distance between flightlines, these could still be taken in <5 min. So with a typical battery time of 20 min, this leaves plenty of time for taking the already planned overview images from 120 m, too, in addition to the time required for launching, positioning and landing the quadcopter.

The above flight-planning example is quite typical for many SFAP surveys the authors have conducted at their study sites where a specific target area was determined by the objects of interest—for example, a test plot, an erosion gully, a small woodland, or a botanical garden. The survey at OUF1d was actually conducted as planned above in October 2018 with the mentioned UAS. In addition to the overview images (see Fig. 9-23) and the vertical stereoscopic flightlines, parallel flightlines with slightly oblique images and two circles of convergent oblique images were taken for capturing the full 3D shape of the trees. The actual flight paths are shown in Fig. 9-19B. Note the slight variations in image distance (caused by manual control of the flying speed) the impossibility of maintaining exactly parallel and evenly spaced flightlines, and the comparative precision of the circular paths that were controlled by a special point-of-interest mode of the UAS.

Prior to the UAS survey, GCPs of the type shown in Fig. 9-13B were deployed around and within the area as previously planned. However, permanent marking by a metal tube seemed not worthwhile because it would be difficult to find such a small object again between the little varied maze of trees and stones that

Fig. 9-23 Vertical overview of test site OUF1d (east-northeast is up), taken from 120 m height with onboard camera of a quadcopter UAV (*DJI Phantom* 4 Advanced) by R. Stephan, M. Kirchhoff, and IM. The flying height and image area correspond exactly to the prior planning, but the alignment is slightly rotated to the ideal green rectangle in Fig. 9-22 due to the difficulty of precisely framing a shot between so many trees on a small display. In contrast to the satellite image used for flight planning, this airphoto was taken during the dry season in October 2018, giving the trees a quite different appearance.

would make it difficult to recognize a specific spot again. As reference points for future repeat surveys, a few metal tubes were installed in inconspicuous places beneath dense shrub. To make sure that some permanent reference would survive if even these control points were lost, selected points of rock outcrops were also surveyed and well documented with photos and descriptions (Fig. 9-16).

9-8 SUMMARY

A successful SFAP survey requires planning of various issues, of which some may need to be prepared well ahead. This process is aided by good knowledge of the study site gained from personal experience, maps, satellite images and airphotos, and local colleagues. For a given SFAP mission, both equipment and personnel must be available at the appropriate time of year under suitable weather conditions. This usually requires some travel and shipment of necessary equipment, which may prove difficult for international missions.

The accessibility of the site by automobile or boat as well as for the survey personnel on foot may be an important consideration when choosing the survey system, as some sites could be impossible or difficult to enter and navigate on the ground. Site characteristics—obstacles, topography, lighting, wind—also may influence field procedures and choice of platform. High-altitude SFAP presents special circumstances because of thin air and alpine weather effects.

For all applications that involve measuring and mapping, ground control for georeferencing and geometric correction of the images is necessary. Given the large scale of SFAP images, measuring coordinates of the ground control points (GCPs) would usually require the high accuracies of a terrestrial survey by total station or by differential GPS. Temporary GCPs are sufficient for one-time surveys; permanent GCPs need to be installed for long-term monitoring purposes. Careful targeting with colors that contrast well with the surrounding area helps to identify the GCPs in the photographs.

Although many SFAP platforms are not navigable precisely, some basic air survey calculations should be an integral part of any mission planning in order to ensure the best possible imagery for the intended application. Target flying heights may be calculated prior to the survey for the desired area coverage or ground sample distance (pixel resolution), and the possibilities of achieving stereoscopic coverage may be assessed for a given platform and camera system. Such calculations may help to assess if the desired image characteristics could be realized with the existing equipment and which compromises or adaptations could be necessary. For oblique imagery, emphasis is given to best lighting, shadow placement, tilt angle, position of the horizon, and other factors that impact the visual scene.

10

Visual Image Interpretation

One picture is worth ten thousand words. Proverb attributed to numerous sources (Martin 2018).

10-1 INTRODUCTION

Visual interpretation of aerial photographs is based on recognition of objects, as seen from above, in pictorial format. This visual recognition often takes place without any conscious effort by the interpreter. Nonetheless, several basic features aid in the examination and interpretation of airphotos (based on Teng et al. 1997; Berlin and Avery 2004; Jensen 2007).

- Tone or color—Gray tone (b/w) and color are how we recognize and distinguish objects. The tone or color of an object helps to separate it from other features in the scene, especially for features with high contrast. Color may be an important clue to the object's identity—water, soil, vegetation, rocks, etc.
- Shape—Natural shapes tend to follow the lay of the land. Cultural (human) shapes, on the other hand, are often geometric in nature with straight lines, sharp angles, and regular forms. In monoscopic images only plane shape may be appreciated fully, although an object's height or relief may be detected to some extent by shadow or relief displacement. In stereoscopic images, the full three dimensions become apparent.
- Size and height—Absolute size and height are important clues that depend on scale of the photograph. Some object sizes are common experience, for example a car, tree, house, etc. But many objects seen on airphotos are not so obvious, and height may be difficult to judge in vertical airphotos. Always check photo scale for a guide to object size.
- Shadow—Shadows are often useful clues for identifying objects, as seen from above. Trees, buildings, animals, bridges, and towers are examples of features

that cast distinctive shadows. Shadows on the landscape also help with depth perception. Photographs without shadows often seem "blank" and difficult to interpret. On the other hand, too much shadowing may obscure features of interest.

- Pattern—The spatial arrangement of discrete objects may create a distinctive pattern. This is most apparent for cultural features, for example city street grids, airport runways, agricultural fields, etc. Patterns in the natural environment also may be noticeable in some cases, for example bedrock fractures, drainage networks, sand dunes, etc.
- Texture—This refers to grouped objects that are too small or too close together to create distinctive patterns. Examples include tree crowns in a forest canopy, individual plants in an agricultural field, ripples on a water surface, gravel sheets of different grain size in a river bed, etc. The difference between texture and pattern is largely determined by photo scale.
- Context—The site location of objects and their association with other objects and patterns are often important for aiding interpretation, as well as their geographical context (climate zone, landscape type, etc.). Seen in isolation, the meaning or purpose of an object might not be self-explanatory from its appearance. For example, without knowledge of a larger context, a small shack between varying patches of vegetation next to a train track might be interpreted as part of an area of allotments or community gardens by one observer, and as belonging to an informal settlement or slum at a megacity fringe by another. Land cover and land use are important clues to help identify related features in the scene, as well as reference to existing maps or census data for ancillary information. This is often a matter of common sense and experience for image interpretation.

Each of these basic features is seldom recognized on its own. Rather it is the combination of visual elements

that allows interpretation of objects depicted in an aerial photograph. These elements are explored in further detail with selected SFAP examples later in this chapter and in the case studies. An additional feature aiding in image interpretation is image depth or relief height, and some methods of stereoscopic viewing are presented in the last section of this chapter.

10-2 IMAGE INTERPRETABILITY

Visual identification of objects in vertical airphotos normally requires ground sample distance (GSD) three to five times smaller than the object itself (Hall 1997), as noted before (Chap. 2). For example, to positively identify a house ($\sim 10 \times 10$ m), the camera/image system needs to achieve a GSD in the range of 2 to 3 m. Factors other than spatial resolution often affect the ability to recognize objects, however. Contrasts in color and brightness are important clues as are size, shape, context, shadows, and other factors noted above. Keep in mind that with increasing height above the ground, atmospheric effects begin to degrade image quality regardless of nominal spatial resolution.

With these limitations in mind, a perceptual measure of image quality or interpretability has been developed. This measure is the US National Imagery Interpretability Rating Scale—NIIRS (Leachtenauer et al. 1997). An image rating depends on the most difficult interpretation task that may be performed, which indicates the level of interpretability that may be achieved (Table 10-1).

Manned-space SFAP, as practiced on space-shuttle and space-station missions, provides images of the Earth's surface for rating levels 1–3. Rating levels 4–6 are typically attained by conventional aerial photography and high-resolution commercial satellite imagery (Fig. 10-1), and sometimes level 7 is possible. However, the highest rating levels (8–9) are generally not available for civilian use. These highest NIIRS rating levels may be acquired, in many cases, with SFAP from low-height platforms (Fig. 10-2).

10-3 SFAP INTERPRETATION

The basic visual aspects of airphoto interpretation are illustrated with small-format aerial photographs representing selected common themes. Typically several of the basic features noted above are combined for interpretation of the subjects discussed below. This review is not intended to be exhaustive, but rather to introduce the general concepts of interpretation as applied to small-format aerial photography. For in-depth discussion of airphoto interpretation, readers should consult Philipson (1997), Berlin and Avery (2004), Jensen (2007),

Table 10-1 The civilian U.S. National Imagery Interpretability Rating Scale levels (0-9) and examples of interpretation tasks. Based on Leachtenauer et al. (1997).

Rating level	Interpretation tasks
0	Interpretability precluded by obscuration, degradation, or poor resolution
1	Distinguish between major land use classes: urban, agricultural, forest, etc. Detect medium-sized port facility Distinguish between runways and taxiways at a large airport Identify regional drainage patterns: dendritic, trellis, etc.
2	Identify large (800 m diameter) center-pivot irrigated fields Detect large buildings: hospital, factory, etc. Identify road pattern: highway interchange, road network, etc. Detect ice-breaker tracks in sea ice; detect wake of large (100 m) ship
3	Detect large area (800 m square) contour plowing Detect individual houses in residential neighborhoods Detect trains or strings of railroad cars on tracks Identify inland waterways navigable by barges Distinguish between natural forest and orchards
4	Identify farm buildings as barns, silos, or residences Count tracks along railroad right-of-way or in train yards Detect basketball court, tennis court, volleyball court in urban area Identify individual tracks, control towers, or switching points in railroad yard Detect jeep trails through grassland
5	Identify Christmas-tree plantation Recognize individual train cars by type: box, flat, tank, etc. Detect open bay doors of vehicle storage buildings Identify large tents within camping areas Distinguish between deciduous and coniferous forest during leaf-off season Detect large animals (elephant, rhinoceros, bison) in grassland
6	Detect narcotics intercropping based on texture Distinguish between row crops and small grains Identify passenger vehicles as sedans, station wagons, etc. Identify individual utility poles in residential neighborhoods Detect foot trails in barren areas
7	Identify individual mature plants in a field of known row crops Recognize individual railroad ties Detect individual steps on stairways Detect stumps and rocks in forest clearings or meadows
8	Count individual baby farm animals: pigs, sheep, etc. Identify a survey benchmark set in a paved surface Identify body details or license plate on passenger car or truck Recognize individual pine seedlings or individual water lilies on a pond Detect individual bricks in a building
9	Identify individual seed heads on grain crop: wheat, oats, barley, etc. Recognize individual barbs on a barbed-wire fence Detect individual spikes in railroad ties Identify individual leaves on a tree Identify an ear tag on large animals: deer, elk, cattle, etc.

Fig. 10-1 *Ikonos* satellite image showing a portion of Fort Leavenworth military base, Kansas, United States. Vehicles are clearly visible on roads and in parking lots; parking pattern—diagonal or parallel—is evident. The smallest features that may be identified (under enlargement) are individual parking stalls, which gives an interpretability rating of 6. The slightly fuzzy appearance demonstrates the spatial limitation of such imagery. Panchromatic band (green + red + near-infrared) with 1 m spatial resolution, August 2000. Image processing by JSA.

Fig. 10-2 Vertical SFAP of a pond with emergent leaves of the American lotus (*Nelumbo lutea*). Individual leaves are clearly visible around the margin of the pond; these leaves are typically about one foot (~30 cm) in diameter. The dock is ~15½ m long. GSD for the original image is ~5 cm, and the NIIRS rating is 8. Kite photo taken with a compact digital camera.

Fig. 10-3 The man-made pond in the foreground trapped recent runoff and has a high content of yellowish-brown suspended sediment. The next pond downstream did not receive this sediment and has a clean, dark blue appearance. Central Kansas, United States. Kite photo taken with a compact digital camera.

and similar texts on this subject. Classical textbooks with emphasis on geoscientific subjects are Lueder (1959), Schneider (1974), and Kronberg (1995).

10-3.1 Water and Drainage

Water is the most widespread feature on the surface of the Earth. Water bodies exist in many forms—natural or seminatural such as seas, lakes, rivers, estuaries, bayous, lagoons, and artificial such as reservoirs, ponds, retention basins, canals, harbors, etc. As many of these are affected by global-change processes concerning water availability and water use, their protection and maintenance are gaining in importance. Owing to their high potential for such tasks, which often require rapid response, SFAP and UAS imagery are already playing an increasing role in the observation and monitoring of water bodies and flood inundation areas (e.g. Niedzielski et al. 2016; Manfreda et al. 2018; Rhee et al. 2018; see also Chap. 15).

In aerial photography water color is most obvious, and the color of water bodies is a good indication of the amount and type of suspended sediment. Clean water reflects blue light weakly, but reflectance drops off sharply for green and red light and is essentially zero for near-infrared radiation. Thus, clean water typically looks dark blue or sky colored in visible imagery. Suspended

sediment impacts the color of water, which depends on the sediment composition and turbidity (Fig. 10-3).

Aerial photography of water bodies often displays sun glint and glitter (see Fig. 4-5). Although usually considered undesirable, under some conditions sun glint is advantageous for identifying small water bodies that would otherwise be difficult to distinguish (Fig. 10-4).

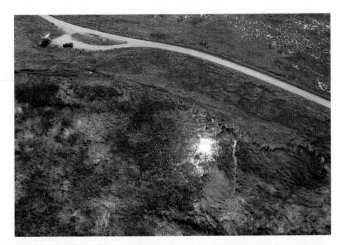

Fig. 10-4 Low-oblique view over marsh at The Nature Conservancy, central Kansas, United States. Sun glint highlights the presence of standing water in the pool beneath a cover of dead cattail thatch; water would otherwise not be visible. Kite flyers at upper left; photo taken with a compact digital camera.

Conversely, sun glint may aid recognition of small, emergent islands within larger water bodies, and sun glitter may highlight the pattern of wind-driven waves on water surfaces (see Fig. 5-23).

Water flooding also may assist in interpreting subtle relief variations in an area, revealing shallow depressions and drainage structures that otherwise would not be identifiable. Fig. 10-5, for example, contributed to recognizing the importance of beaver activity in floodplain evolution in a study by John and Klein (2004). Beavers in large numbers have inhabited the river systems of central Europe and North America until the middle ages and 19th century, and beaver-induced biogeomorphological processes may be expected to have influenced the floodplain sediments and alluvial soils significantly. This raises many exciting questions in fluvial geomorphology.

In color-infrared imagery, for which blue light is excluded, water bodies are usually dark blue to black regardless of suspended sediment or water depth (see Chap. 6-5). This fact may be used to advantage for distinguishing muddy water from wet, bare soil of similar visible color (Aber et al. 2009). However, color-infrared images over water are subject to strong sun glint that may degrade image interpretation (Fig. 10-6).

Stream, delta, and tidal channels of various sizes and types are the products of erosion and deposition by concentrated water flow. Such channels are integrated into patterns found in nearly all land and coastal regions of the world (Fig. 10-7). Individual channels are recognized in airphotos by the presence of water, vegetation, shadows, and other characteristic features (see Fig. 5-11). Networks of channels define drainage patterns that are useful clues for interpreting the geology and geomorphology of the landscape. Such patterns are developed at all scales and spatial resolutions from huge river systems covering subcontinental areas to tiny gully networks (Fig. 10-8).

10-3.2 Geomorphology

Landforms and geomorphological processes are often highly influenced by water and drainage, especially on the spatial scales captured by SFAP. The high resolutions of SFAP here offer interpretation possibilities not given with conventional airphotos. While geomorphological processes forming the landscape cannot be seen directly in an aerial image, and rarely may be observed in the field, the correlative forms and deposits may become apparent to the skilled observer by characteristic shapes,

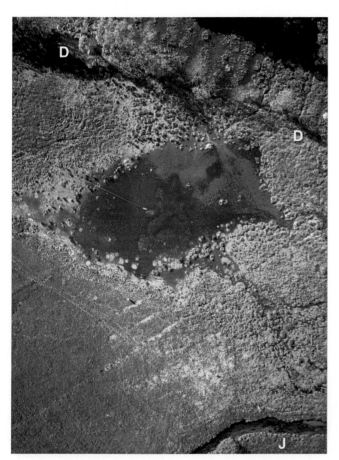

Fig. 10-5 Flooding caused by a beaver dam in the Jossa Valley near Mernes (Spessart), Germany. On the inundated floodplain between the Jossa River (J) and the main irrigation ditch (D) crossing the upper part of the image, a multichannel drainage network and small lake have developed. The water table also traces a series of parallel ditches running at right angles to the main ditch; they are the remains of *Rückenwiesen*, a 19th century irrigation system. More recent drainage ditches are revealed by water and yellow-flowering buttercups in the lower image half. Field of view ~150 m across. Hot-air blimp photograph by JBR, IM and A. Fengler with an analog SLR camera.

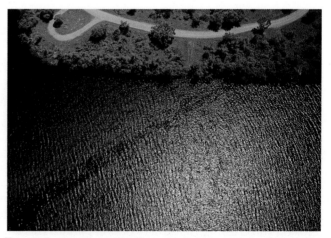

Fig. 10-6 Strong sun glint from water surface creates a glaring effect that distracts from other features in this color-infrared view. Kite photo with an MILC camera by JSA with T. Nagasako; southeastern Kansas, United States.

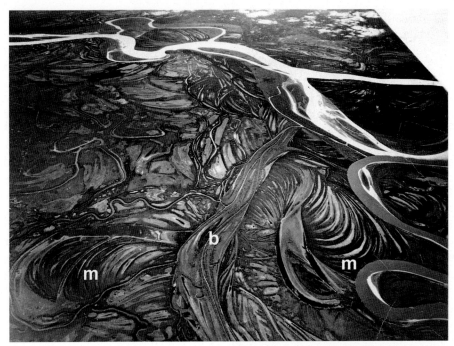

Fig. 10-7 Oblique aerial photograph of the junction of the Koyukuk River (dark) and silt-rich Yukon River (light) at right side of scene in Alaska, United States. Note the intricate patterns formed by braided (b) and meandering (m) channels. *Original image taken by the US Army Air Corps in 1941; published by Péwé (1975, Fig. 35). Image downloaded and modified from Wikimedia Commons https://commons.wikimedia.org/wiki/File:Junction_of_the_ Yukon_and_Koyukuk_Rivers,_Alaska.jpg August 2018.*

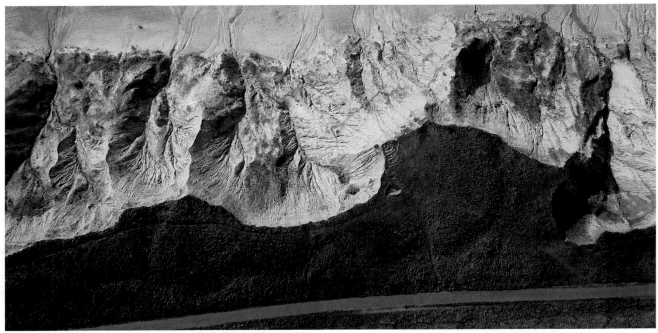

Fig. 10-8 Vertical view of multiple ravines with dendritic channel patterns on the North Sea coastal cliff at Bovbjerg Klit, western Denmark. Walking path across grassy cliff top is ~1½m wide. Kite photo with a compact digital camera.

patterns, and textures (Marzolff 1999; Fig. 10-9). Smooth, homogeneous surfaces tell of soil sealed by splash erosion and crusting; dense networks of parallel rills and residual enrichment of stones on the surface may be the result of strong sheet-wash processes. Sediment fans of accumulated material patterned with desiccation cracks

at the outlet of larger rills testify to their geomorphodynamic activity.

Beneath the edges of a wide gully cutting into a nearly flat *glacis d'accumulation* in Burkina Faso's Sahel (Fig. 10-10), soil debris broken off the walls creates patterns on the ground where it has not yet been washed

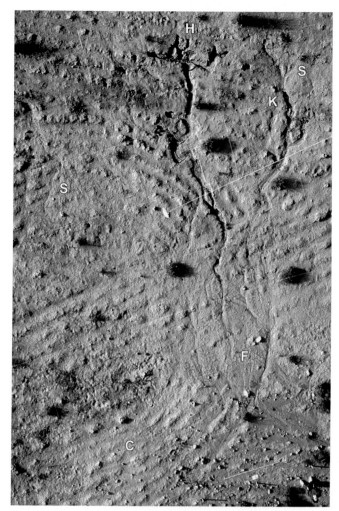

Fig. 10-9 Rill erosion on fallow land in the Spanish Ebro Basin near María de Huerva, Province of Zaragoza. White measuring stick in lower right corner is 2m long. S—strong sheet wash with small rills; H—headcut of large rill; K—knickpoint where small rills merge and incise to form larger rill; F—sediment fan of accumulated material eroded from the rill; C—soil crusted by splash erosion and week sheet wash. Hot-air blimp photo with an analog SLR camera.

Fig. 10-10 Gully erosion near Gorom-Gorom, Province of Oudalan, Burkina Faso. (A) Piping process (arrow) and desiccation cracks, traced by vegetation in the vertic soil of the glacis d'accumulation, play an important role in developing and shaping the gully. Field of view ~30m across. Kite photo taken by IM, JBR and K.-D. Albert with an analog SLR camera. (B) Seen from the ground, the undercuts carved by runoff water flowing over the gully's edge become apparent. Soil clumps below the wall have broken off the rim along the desiccation cracks.

away by runoff water. Clearly visible drainage lines have been carved within the gully by the first storms at the beginning of the rainy season. Some islands and peninsulas are left of the former surface, mostly where tree roots strengthen the ground. In spite of the obviously heavy sheet-wash processes, the gully rim itself is sharply edged above the washed-out hollows in the more erodible subhorizon (Fig. 10-10B).

An explanation is offered by the polygonal pattern of the emerging grass cover on the surrounding glacis: the vertic character of the soil leads to the development of fine-webbed desiccation cracks. It is along these tension cracks that clumps of soil break off along the gully edge when the soil dries up again. Also, when water infiltrates through the cracks, not only vegetation development is encouraged but also subsurface erosion, leading to overhanging walls and piping processes (Albert 2002).

On an abandoned agricultural field heavily affected by soil erosion in south Morocco (Fig. 10-11), a natural dendritic pattern is linked to an anthropogenic parallel pattern. In a vain endeavor to stop gully erosion, the field was leveled with a bulldozer some years before. The resulting grooves now channel the surface runoff into thousands of small parallel rills, encouraging incision and subrosion. The rills continue to merge into larger rills and gullies that retrace the former, pre-leveling drainage network. The statistical analysis of the drainage network shows that more than one-third of the

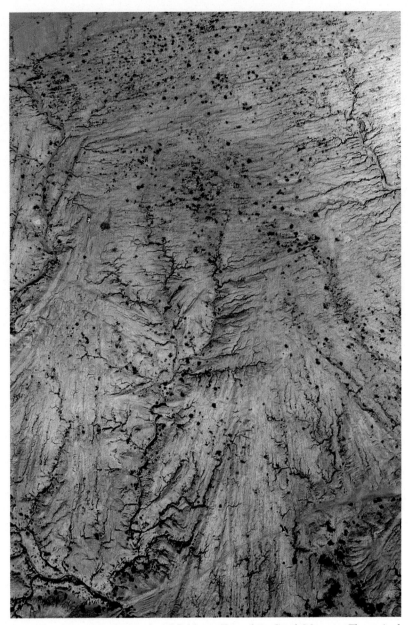

Fig. 10-11 Rill and gully erosion on an abandoned agricultural field near Taroudant, South Morocco. The main drainage lines have a dendritic pattern, while the small rill tributaries follow the parallel patterns carved by a bulldozer during land leveling some years previously. Field of view ~75 m across. Kite photo by IM, JBR and A. Kalisch taken with a digital camera.

total rill length is directly predetermined by the mechanical intervention (Kalisch 2009).

This example demonstrates the difficulties that may arise for GIS-based soil-erosion modeling when the spatial scale of the elevation data does not capture the micro-relief. Consider the resolution of modern LIDAR-based digital elevation models as typically offered by national mapping agencies (e.g. 1 m in Germany, 1 to 10 m in the United States, 5 m in the United Kingdom). Water flow diverted by such micro-relief structures would not be correctly predicted by them. Stereoscopic SFAP, however, offers the possibility of generating extremely high-resolution elevation models with GSDs match-

ing the micro-topography. Recent developments in 3D modeling with structure-from-motion photogrammetry have led to a tremendous increase of geomorphological studies based on SFAP-derived topographic data (e.g. Carrivick et al. 2016; Eltner et al. 2016; Smith et al. 2016; see also Chap. 11-6 and Chap. 14).

Evidence for various erosion processes also may be seen in this image of a river bank at a Moroccan wadi, or ephemeral river bed (Fig. 10-12). Linear erosion has cut deep rills and gullies into the thick Quaternary deposits. In many places, piping holes as predecessors of rills are well visible (subsets A and B). From comparison with other sites and research on the role of land-leveling

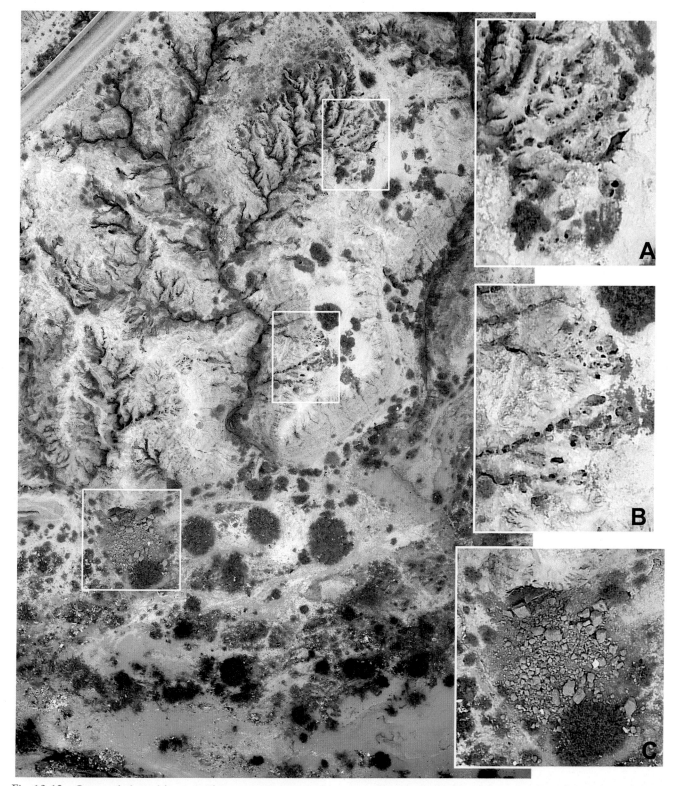

Fig. 10-12 Geomorphological forms testifying to various erosion processes at the river bank of Oued Ouaar near Taroudant, Morocco. Subsets A, B—piping holes; subset C—mass wasting. Blue and white specks between bushes at the wadi floor are plastic trash washed along by the river from nearby villages. Taken with a digital MILC and fixed-wing UAV.

in gully erosion (Peter et al. 2014; see also Chap. 14), we may infer that this site has most probably been used as an agricultural field earlier, and that the piping process particularly affects the (presumed) former plow horizon. At the steep edge of the river bank, fresh heaps of soil clumps testify to mass wasting as yet another active erosion process (subset C).

A further example from high elevation in the Spanish Pyrenees presents an altogether different aspect of geomorphology (Fig. 10-13). A vertical view onto a 40° high-mountain slope depicts vegetation patterns brought about by periglacial geomorphic processes. The freeze-thaw cycles in this alpine area have created solifluction lobes in the form of minute terraces. While each step's surface, which is stretched by soil creep, is without cover, the front of each lobe is bordered by thick turf that retards the gelisolifluction process.

10-3.3 Vegetation and Agriculture

After water, vegetation is the next most common land cover, including natural, agricultural, and other human-modified plantings and ranging from formal gardens, to tropical forests, to tundra. Given that most active, emergent vegetation is green, visible color is often less important for interpretation than are other visual clues such as size (height), shape, pattern, texture, and context. These factors are especially important for interpretation of wetland vegetation (Fig. 10-14). In the case of forest canopies, for example, the size, shape, and pattern of tree crowns are most noteworthy in addition to seasonal phenological characteristics (Murtha et al.

Fig. 10-14 Plant heights, patterns, textures, and color variations are visual clues for recognizing distinct vegetation zones in coastal wetlands. Salt marsh and tidal channel, Mississippi Sound, United States. Kite photo taken with a compact digital camera.

1997). Furthermore, it should be understood that nearly all vegetation is managed, manipulated, or altered by human activities in various obvious or subtle ways, which impart additional distinctive aspects for photo interpretation.

Consider this view of mixed conifer and deciduous forest in north-central Poland (Fig. 10-15). Both conifer and deciduous trees are present in distinct stands. The conifers are dark green to blue-green in color and conical in shape. Deciduous trees, in contrast, are light green to yellow-green in color and have billowy or tufted crowns; some display autumn colors (right background). In addition, linear and rectangular boundaries mark some stands, which represent artificial plantings. The same view taken in winter would show even greater contrast between the conifers and bare deciduous trees.

As another example, regard this view over bottomland forest of the Missouri River floodplain taken in early spring (Fig. 10-16). Cottonwood (*Populus deltoides*) trees

Fig. 10-13 Close-up vertical shot of steep mountain slope with turf-banked solifluction terracettes in the Spanish Pyrenees near Tramacastilla de Tena, Province of Huesca, Spain. Slope descends from right to left; blimp flyer near scene center for scale. Hot-air blimp photo by IM, JBR and J. Heckes taken with an analog SLR camera.

Fig. 10-15 Low-oblique, autumn view over mixed forest near Mława, north-central Poland. Kite photo by JSA and D. Gałązka taken with a compact analog camera.

Fig. 10-16 High-oblique, early-spring view across the Missouri River valley floodplain forest at Fort Leavenworth, Kansas, United States. Kite photo taken with a compact analog camera.

The same applies for many non-cultivated vegetation patterns, which may result from a complicated amalgamation of different factors related to seed dispersal, water availability, nutrients, soil crusting, mechanical disturbance, and many more. Both humans and animals are behind the intricate patterns in this vertical view of pastureland (Fig. 10-17). The slightly diagonal background texture of faint stripes traces the top-right to bottom-left plowing direction on the former agricultural field. Smaller bushes are still oriented along these lines due to the higher soil humidity in the furrows. Sheep and goats crossing the area from top left to bottom right leave trails that converge and curve around dense clumps of bushes but fan out more parallel and straight where there is little vegetation.

display green flowers, but leaves have not yet sprouted. The dark appearance of the forest floor is because the understory was intentionally burned a few days before the picture was taken. The cottonwood trees are arranged in curved, linear patterns that reflect natural morphology, soils, and drainage on the floodplain surface. To the right, an open, green strip marks an abandoned river channel that is too wet for trees to grow. Knowing the vegetation phenology, human activity, and geomorphological context are all essential for interpretation of this image.

Its land-use history also shows up in the vegetation patterns in Fig. 10-18, where shrubs encircle a grassland area in a meandering boundary. The image was taken in a small catchment in the mountains of the Spanish Pyrenees, which was arable land until the second half of the 20th century. This particular field, which is bordered by grove-hemmed brooks and stone walls, was abandoned in the 1970s and only occasionally used for sheep grazing since. Subsequently, a spiny broom (*Genista scorpius*) common in Spanish matorral began invading the enclosure from the side, divulging its ballistic dispersal mechanism in a wavy encroachment front.

Fig. 10-17 Vertical view of grazing land formerly used as a cereal field, near Talaa, Morocco. Field of view ~180 m across. Old plowing furrows still determine faint patterns of soil structures as well as vegetation distribution. Superimposed is a newer pattern of animal tracks, alternately fanning out and converging between dense clumps of bushes. Fixed-wing UAV photograph taken with a digital MILC by S. d'Oleire-Oltmanns and D. Peter with IM.

Fig. 10-18 Abandoned farmland in the Arnás Catchment in the Spanish Pyrenees near Jaca, Province of Huesca, Spain. Note wavy vegetation front marked by dashed white lines. Hot-air blimp photo by IM, JBR and M. Seeger taken with an analog SLR camera.

Agricultural fields are human-managed vegetation plots, ranging from fruit orchards to rice paddies, that typically have sizes, shapes, and patterns determined by property boundaries as well as drainage and contour of the land (Fig. 10-19). Where soil is fertile and land is relatively flat, people tend to impose various geometric field shapes—square, rectangle, circle, etc. (Fig. 10-20). Where land is steeper, terraces and contour plowing follow hill slopes to minimize erosion and retain water (Fig. 10-21). Rocky, sandy, steep, or erosion-prone lands, as well as lands too dry or wet for crops, are normally left in pasture or range for hay or livestock grazing (Fig. 10-22).

Most agricultural crops are annual monocultures, for which knowledge of crop phenology and local agricultural practices are essential for successful interpretation (Ryerson et al. 1997). As an example, consider winter wheat, a major crop in the High Plains of southwestern Kansas. The wheat is planted and begins growing in early autumn, overwinters, grows rapidly in the spring, and is harvested in early summer. From autumn

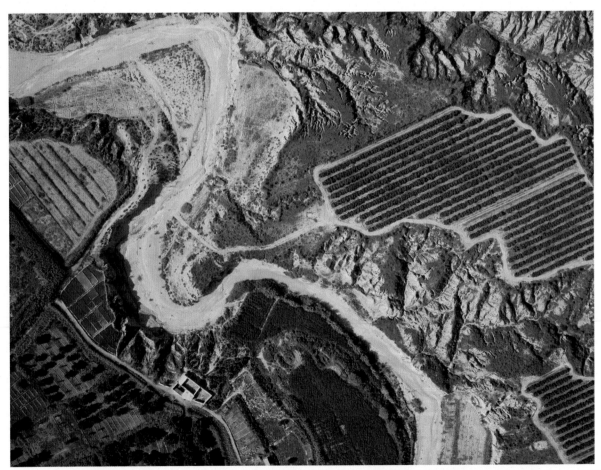

Fig. 10-19 Agricultural fields are pushing to the limits of every available flat surface near Taroudant, Morocco. On the left side of Oued Ouaar's dry river bed, traditional horticulture and agroforestry farmland is patterned into small rectangular patches (*azoun*) for flood irrigation. Between the deeply eroded badlands on the right site, drip-irrigated citrus plantations have been established by large agro-industrial companies. Taken from 500 m flying height with a fixed-wing UAV and MILC by S. d'Oleire-Oltmanns and D. Peter with IM.

Fig. 10-20 Two types of agricultural fields on the foreslope of the High Tatry Mountains near Spišská Bela, Slovakia. (A) Large fields represent cooperative farms that date from communist times. The bright yellow crop is rapeseed (*Brassica napus*), which is a source of vegetable oil, bio-diesel fuel, and animal feed ingredient (Pol'noseervis 2018). (B) Long narrow stripes, known as "noodles," are each privately owned and farmed separately. A single noodle may be as narrow as ~2m and have 16 or more owners. This pattern of farming is a legacy of the Austro-Hungarian Empire. Kite photos with a compact digital camera by JSA, SWA and I. Duriška.

Fig. 10-21 Terraced fields on sloping land under fallow conditions. Dark stripes represent water and wet soil behind terraces following heavy rain. Smoky Hills, central Kansas, United States. Kite photo taken with a compact digital camera.

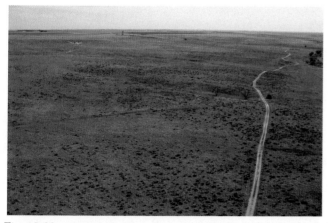

Fig. 10-22 Grazing land in a dry year on the High Plains of southwestern Kansas, United States. Kite photo taken with a compact digital camera by SWA with P. and J. Johnston.

until late spring, it is the only active crop in the region. Furthermore, the semiarid climate limits winter wheat growth in non-irrigated fields to every other year. In other words, each field is used for growing wheat one year and stands fallow the next year in order to accumulate soil moisture. This so-called dry-farming practice results in a patchwork of fallow fields intermingled with crop fields that alternate every other year (Fig. 10-23), a common agricultural pattern in arid and semiarid regions around the world.

In rural mountain regions of Africa, South America, and Asia, small-scale subsistence farming done by manual labor is still widespread. Cereals and pulses are commonly grown for domestic consumption, often in the form of speculative rainfed agriculture. In semiarid and arid areas that are marginal for crop cultivation, agroforestry systems reduce the agro-climatic risk. In the mountain regions of South Morocco, for example (Fig. 10-24), barley is cultivated in open argan woodlands. Plowing and sowing are done depending on precipitation, and fields are left bare in times of drought. Argan fruit are harvested for their valuable oil, and the open woodlands are used for pasturing of goats, sheep, and camels (see also Chap. 16-3.)

Impacts of drought and flooding, disease and insect infestation, and many other factors may be evaluated to various degrees in all types of SFAP—panchromatic, color-visible, and color-infrared. Low-height SFAP with ultra-high spatial resolutions may even be used to identify and count individual plants, such as flowering orchids (Fig. 10-25), for analyses of local species distribution and abundance.

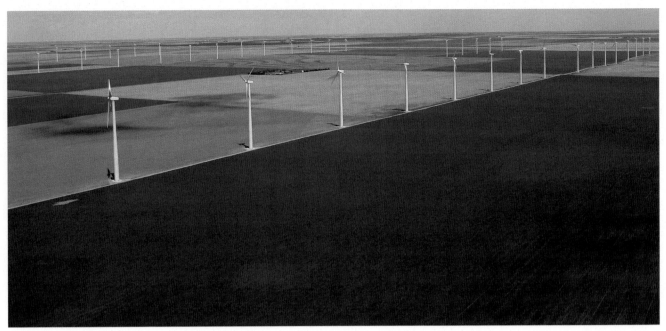

Fig. 10-23 Winter wheat fields (dark green), fallow fields, and wind turbines on the High Plains of southwestern Kansas, United States. Early spring scene; kite photo with a compact digital camera.

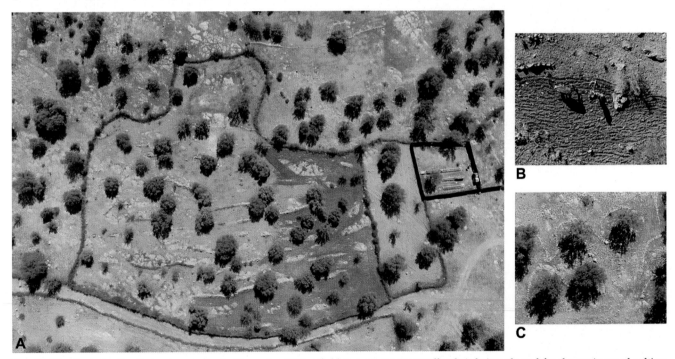

Fig. 10-24 Just after the first autumn rains in November 2018, a field in open argan woodlands is being plowed for domestic cereal cultivation on the mountain slopes of the High Atlas near Agadir, South Morocco (A); downslope is up in this view. Farming in this area is done with single-chisel donkey plows (B), as cash for hiring tractors is sparse, and the fields are too small for mechanized cultivation with many rocky outcrops. Fieldstones are piled up to form contour-parallel bands on the field and in semicircles (*demi-lunes*) around the argan trees (C) to preserve runoff water. Taken with on-board camera of quadcopter UAV by R. Stephan and M. Kirchhoff with IM.

Active, green vegetation has quite distinct spectral characteristics (see Fig. 4-13), which are most obvious in color-infrared photography (Fig. 10-26). The strong near-infrared reflectivity of active "green" leaves was discovered more than a century ago, and is known as the Wood Effect after Prof. R.W. Wood who first photographed this phenomenon in 1910 (Finney 2007). Near-infrared radiation (~0.7 to 1.3 μm wavelength) is strongly scattered by leaf cell walls, and some near-infrared energy passes through an individual leaf and may interact with adjacent leaves or soil. Red and blue light are absorbed by chloroplasts for photosynthesis.

Fig. 10-25 Vertical view of marshland from 25 m flying height, Messeler Hügelland near Darmstadt, Germany. (A) Full image of apparently little structured grass vegetation (note the directional reflectance anisotropy, discussed in Chap. 4-2, which is quite conspicuous in this wide-angle view). (B) Contrast-enhanced subset showing the details captured by the high GSD of ~5 mm. Yellow buttercup, bluish-white lady's smock, and purple western marsh orchids (*Dactylorhiza majalis*). 45 individuals of the latter may be counted on this 10 m^2 area. Taken with on-board camera of a quadcopter UAV by IM with S. Dietmann and R. Stephan.

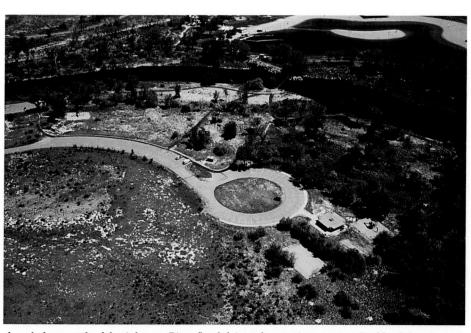

Fig. 10-26 Color-infrared photograph of the Arkansas River floodplain and recreation area near Pueblo, Colorado. Active vegetation appears in bright red, pink, and maroon colors. Kite photo taken with an analog SLR camera and yellow filter.

Thus the ratio of near-infrared to red or blue is an indicator for photosynthetically active vegetation. This gives rise to several vegetation indices, such as the normalized difference vegetation index (NDVI), which are important for ecological studies of biomass, leaf area index, and photosynthetic activity (Tucker 1979; Murtha et al. 1997; see also Chap. 11-4).

10-3.4 Cultural Heritage and Archaeology

This section deals with historic and prehistoric human-made structures including houses, churches, canals, roads, mills, monuments, graveyards, and other constructions. Size, shape, pattern, shadow, context, and other basic visual clues are important for recognizing and identifying such human structures, whether modern or ancient (Fig. 10-27). Long after the above-ground structure is removed, covered over, or destroyed by the passage of time, traces of the foundations, alterations of the terrain, or disturbances in the soil are preserved.

Consider the Amache Relocation Center that operated briefly during World War II near Granada, Colorado. Japanese Americans, mostly from California, were forced to live here in wooden barracks that had no insulation and no furniture—conditions were primitive. It reached a capacity of more than 7500 evacuees in October 1942 (Amache Preservation Society 2017), two-thirds of whom were American citizens. At this time, it was the tenth largest city in Colorado. In all, more than 10,000 Japanese-Americans were incarcerated there, as people came and went. Today Amache is a ghost town. Nonetheless, the street network and building foundations are well preserved and clearly visible from above (Fig. 10-28).

Another historical example is the Fruitland schoolhouse that was built in the mid-1860s in eastern Kansas.

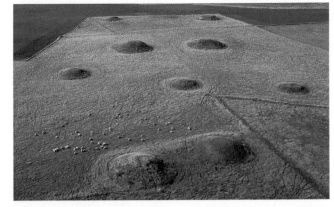

Fig. 10-27 Stone Age and Bronze Age burial mounds at Ramme Dige, a protected site in western Denmark. Overview of multiple mounds with sheep grazing in between. Shadows and vegetation patterns help to define the mounds. Recent field boundaries form low, linear ridges across the site. Kite photo taken with a compact digital camera.

The school was an educational and religious center through the late 19th century, but then was abandoned. Building stones were removed and reused elsewhere; the site became overgrown with dense vegetation and was effectively lost. Ruins of the schoolhouse were revealed following a wildfire in 2012 that burned or killed most vegetation at the site (Fig. 10-29). Outlines of the building foundation measuring 9-meter square and a surrounding stone wall were revealed clearly. Based on this rediscovery, detailed archaeological investigations are underway using UAS platforms to survey the site (Allison and Pettit 2019).

Aerial photography has long been utilized to find, document, and map archaeological sites. Human structures tend to display regular, linear, geometric shapes, and patterns that contrast with natural objects. These

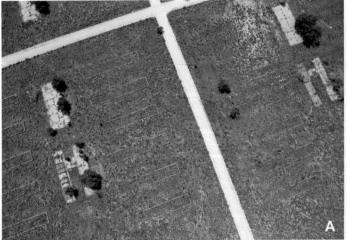

Fig. 10-28 Amache Relocation Center near Granada, Colorado, United States. (A) Each rectangular foundation represents a barrack that measured 20×120 feet (~6×37 m) and was divided into six living quarters of slightly different sizes (NPS 2004). (B) Vertical view over the remains of the high school building. Kite photos taken with a compact digital camera.

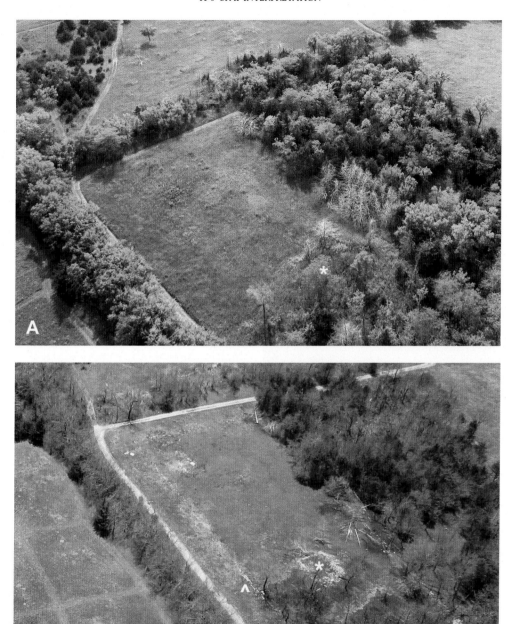

Fig. 10-29 Ruins of the Fruitland schoolhouse complex dating from the late 19th century, eastern Kansas. (A) Close-up oblique view in which no building or wall remains are visible. The schoolhouse foundation (*) is obscured by vegetation. Helium-blimp photo taken with a compact digital camera (2008). (B) Following a wildfire, the schoolhouse foundation (*) and a perimeter wall (^) are clearly visible. Kite photo taken with a compact digital camera (2013).

patterns may be recognized in airphotos by subtle variations in vegetation cover, soil color, and shadows—crop, soil, and shadow marks (Berlin and Avery 2004). The Knife River Indian Villages in central North Dakota are an example. This US National Historical Site consists of Hidatsa and Mandan villages that were settled around

AD 1300 and occupied until the mid-19th century. The villages were the focus of a trading network that encompassed a vast region between the Great Lakes and northern Rocky Mountains.

Each village contained several dozen earth lodges. The villages moved and were rebuilt over the centuries

such that remains of several hundred earth lodges are preserved as circular depressions, each about 10–12 m in diameter. The earth lodges are still quite distinct in spite of agricultural land use at the site in the late 19th and early 20th centuries. Depressions mark the former interior floors of lodges, which were built at ground level—not dug out. Surrounding each depression is a raised rim composed of material that fell off the lodge wall and roof. Some portions of the site are mowed, so the lodge remains may be seen easily on the ground (Fig. 10-30). Other portions are covered by prairie grass, shrubs, and brush.

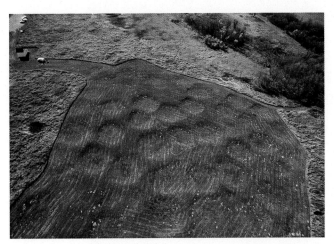

Fig. 10-30 Super wide-angle view of the Big Hidatsa Village site showing several dozen earth-lodge remains in the mowed portion. Kite flyers are standing in upper left corner of the scene. Taken with an analog SLR camera by JSA with B. Jacobson and S. Salley. Central North Dakota, United States.

Earth lodges in these unmowed portions are not obvious from the ground, but are quite evident from above because of variations in vegetation cover (Fig. 10-31).

On the basis of SFAP reconnaissance, it appears that the entire terrace surface at Knife River Indian Villages is covered by earth-lodge remains (Aber 2006). This includes both the mowed portions and the intervening unmowed tracts of the site. The total number of earth lodges is unknown, but must be at least several hundred. This saturation coverage of earth lodges may represent the cumulative effects of villages that shifted or migrated in location during several centuries of site occupation.

Several settlements of Medieval origin are distinctly visible today as mounds of pottery shards and stones in this oblique view of the dunes of Oursi in Burkina Faso (Fig. 10-32). These settlement mounds have extremely high runoff rates, up to 90%, as measured by rainfall simulations, and limited infiltration capacity, thus encouraging linear erosion in the sandy Pleistocene dune deposits downslope (Marzolff et al. 2003). The gullies are now already cutting into the archaeological layers, and it is of high interest to both geomorphologists and archaeologists researching this site if the hilly surface relief seen today actually represents the historical settlements or if it has developed by erosion only fairly recently (Albert 2002).

Subtle variations in crops and lawns often reveal buried archaeological features that could be nearly invisible on the ground. In this regard, drought conditions may accentuate variations in vegetation cover that depict archaeological remains (Eriksen and Olesen 2002). Likewise, seasonal growth of vegetation, particularly in

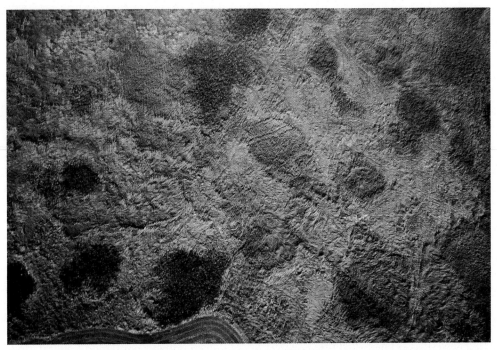

Fig. 10-31 Vertical view of an unmowed portion of the Big Hidatsa Village site. Circular patches and patterns in nearly dormant vegetation give clear indications of earth-lodge remains. Kite photo by JSA with B. Jacobson and S. Salley taken with a compact analog camera.

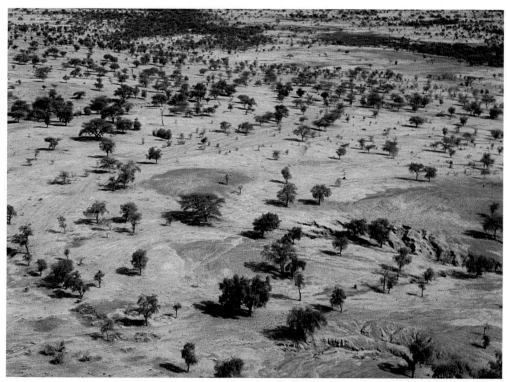

Fig. 10-32 Medieval settlement mounds (West African Iron Age) at the Oursi Dunes, Province of Oudalan, Burkina Faso. The high runoff rates of the mounds' shard-and-stone composition cause gully erosion between the individual sites. Oblique kite photo by IM, JBR, and K-D. Albert with an analog SLR camera.

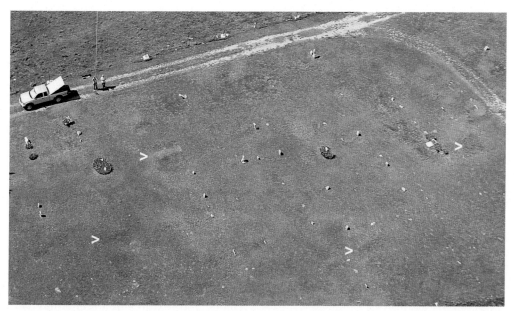

Fig. 10-33 Several suspicious rectangles in grass color (>) may indicate unmarked graves in this Exoduster (Black-American) cemetery near Dunlap, Kansas, United States. Most burials date from the late 19th and early 20th centuries. Kite photo taken in early spring with a compact digital camera by JSA with J. Schubert.

spring or autumn, may be critical for recognizing buried features. Consider, for example, the problem of locating unmarked graves in cemeteries. Past disturbances of soil may be shown by slight changes in vegetation, soil color or moisture, and micro-topography (Fig. 10-33).

10-3.5 Soils

Soil discolorations in aerial photography are helpful aids for archaeology as well as soil science. From the small-scale distribution of soil units, conclusions about thickness and degradation state of the soil may be drawn.

Not only old postholes, pits, or walls may be detected from soil-color changes, but also individual soil horizons distinguished by their colors (Fig. 10-34). Topsoils (Ah horizon) rich in humus are usually darker than the parent material (C horizon) in which the soils have developed. Subsoil horizons that are situated in between usually show their own distinctive colors, mainly brown or reddish brown (B horizon). This is typical at least for the loess landscapes in Europe, Asia, and North America with their Luvisols, Chernozems, and Kastanozems.

Where the soils are eroded, truncated profiles develop, exposing the underlying soil horizons or even the parent material (Fig. 10-35). Such erosion areas may be detected easily from the air by their lighter colors. However, as Fig. 10-36 illustrates, care must be taken not to misinterpret variations of soil color, which may also result from mechanical disturbances, or be caused by the various multiview-angle effects discussed in Chap. 4-2. The latter is especially common for finely harrowed, dry soil surfaces viewed from an oblique vantage.

Fig. 10-35 Considerable differences in color on a gently sloping field near Nieder-Weisel (Wetterau), Germany indicate areas with intense (C horizon) and less intense (Bt horizon) erosion. Slope direction indicated by arrow. Helicopter aerial photograph taken with hand-held SLR camera by A. Fengler.

Truncated horizons are particularly frequent in the landscapes of central and southern Europe and of the Near East that have been cultivated for millennia. In the United States and southern Canada, soils that were still largely intact until two centuries ago have been affected severely also by mechanized agriculture (Fig. 10-37). Knowledge of the intensity and small-scale distribution of soil impairment is today particularly important for precision farming techniques. Soil mapping from remotely sensed images requires a soil surface largely devoid of vegetation and a homogeneous, preferably fine-aggregated condition of a dry soil surface. In central Europe, such conditions may be found for only a few days between the end of February and mid-May. Thus, flexible timing of aerial surveys, such as offered by SFAP, is needed for soil mapping applications.

Fig. 10-34 Late-Neolithic moat fortification near Ottmaring-Niendorf in Lower Bavaria, Germany. The fort was built for reasons of defense before 5500 BP. The course of the palisade trench may be detected easily from the dark lines in the image center. Its left lower edge is missing or not visible anymore following the erosion of ~50 cm of soil since the abandonment of the settlement. The central rise where the fort is situated and the ridge running uphill to the left show considerably lighter tones than the rest of the field. Here, topsoil rich in humus has been eroded, ringed by a narrow band of the Luvisols' dark-colored Bt horizon. Farther downslope in direction of the trench, the medium-brown colluvium built up from the material eroded upslope covers everything else. SFAP taken from a light airplane by R. Christlein in 1982. *From Christlein and Braasch (1998, plate 18).*

10-3.6 Human Actions in Shaping the Landscape

Humans are shaping the surface of the Earth in many ways, and few images in this book show landscapes untouched by human influence—so the role of men and women in creating or influencing the patterns, shapes, colors, and textures in a scene may be more or less directly deduced from many SFAP examples we have discussed in this chapter. But the ready availability and exceptionally high spatial resolution of SFAP also allow capturing people in immediate action, which may emphasize or even reveal their role in structuring a landscape or altering a natural process.

Consider the image of the newly created agricultural field across the eroded fallow land in South Morocco that we have described earlier (Fig. 10-11). Neither the

Fig. 10-36 Agricultural fields on loess soils near Adenstedt in Niedersachsen, Germany, in early spring. (A) A clearly lighter patch of soil at the lower end of the bare field, where truncated profiles are not expected, testifies to an old pit that has been infilled with ex situ material several years before this image was taken. (B) Few differences in soil are actually present in this field. The variations in soil color are a combined result of reflectance anisotropy, subtle changes in slope, and a wide-angle camera lens. A hot-spot effect (see Chap. 4-2) is clearly visible to the upper left of the image center. Taken with on-board camera of a quadcopter UAV by IM with JBR and M. Seeger.

Fig. 10-37 An extensive prairie dog (*Cynomys ludovicianus*) town had been leveled and plowed a few years before in order to grow crops on the High Plains in western Kansas, United States. Surface burrows are clearly evident by circular structures, and subsurface burrows are shown by light patches and wiggly lines in this loess soil disturbed by both human and animal activities. Kite photo with a compact digital camera.

former state of this field nor the way in which it was prepared may be gleaned from this image. A few kilometers away, the making of a new field is documented by another photograph (Fig. 10-38). At the bank of the ephemeral river Oued Ouaar, an old agricultural field has long been rendered useless by deeply incised gullies. A bulldozer is busy restoring the original pre-erosion ex-

tent of the field by leveling the less eroded interrill areas, scraping topsoil off the remaining surface and pushing this material into the erosional concavities.

At the end of the day, the field will once again reach right to the edge of the steep river bank visible in the lower left image corner. As the bulldozing is done in a top-down approach from the upper positions, the gully

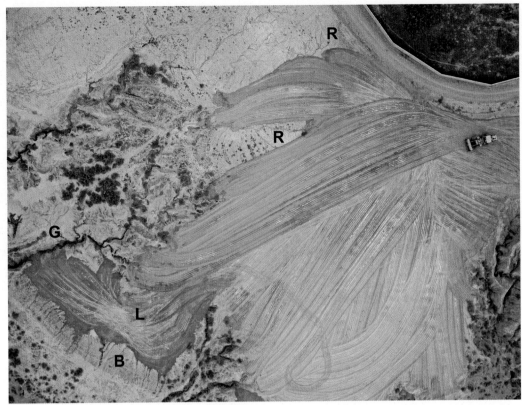

Fig. 10-38 Land-leveling in progress at the river bank of Oued Ouaar near Taroudant, Morocco (just downriver from Fig. 10-19). Smaller rills (R) in the little eroded upper areas of the former field are eliminated when the topsoil is scraped off the remaining surface and shoved into the deeper gullies (G), creating unconsolidated infills. The bulldozing will be continued until an even, but lowered field surface (L) is re-established reaching up to the edge of the steep river bank (B). Fixed-wing UAV photograph with digital MILC.

systems become buried in poorly compressed, unconsolidated infills prone to piping, sacking, and dispersion, while the non-eroded surroundings are considerably lowered by this process. Such infilled bank gullies with unchecked connectivity to the local base level tend to be reactivated quite fast, when the freshly provided soil material is eroded by subsequent rainfall events (see also Peter et al. 2014 and Chap. 14).

Similar cut-and-fill operations with earth-moving equipment occur when steep hillslopes are modeled into terraces. In this image of an excavator in action (Fig. 10-39), a former vineyard in southern Spain has been converted into a terraced mango plantation—a prevalent type of land-use change in the hinterland of the Costa Tropical, where investment in this popular cash-crop has replaced avocado plantations and real estate as business targets in recent years.

In this case, the farmer had second thoughts about the extent of his plantation, and one year after its creation, the excavator is now relocating the steep track a few meters downslope. This makes it possible to elongate each terrace by 10–12 m to the left and create space for 3–4 additional mango trees. But where the track had once been carved into the hillslope, each terrace step has yet to be shaped into form and built up by excavated soil material. Some years into the future, sacking and erosion processes might show a preference along this earlier plantation boundary. This image would then help to explain an otherwise mysterious spatial pattern.

The trail of dust stirred up by the excavator and the cones of fine debris below the track also tell of the off-site effects associated with such landscape remodeling. The slope, which has immediate connectivity to a small river, is coated with easily erodible, fine-grained material, and a considerable sediment load will be transported by the river within the next days, to be deposited in the coastal zone of the Alborán Sea only 20 km away.

These two examples have shown that human endeavors in managing a landscape may have ambiguous if not negative effects on geomorphological process dynamics. But obviously, humans also play an active role in controlling erosion, in their own interest. At the lower edge of an almond plantation, an earthen dam has been plowed up by the farmer to protect the field against a large gully system retreating upslope into the Pleistocene valley fills

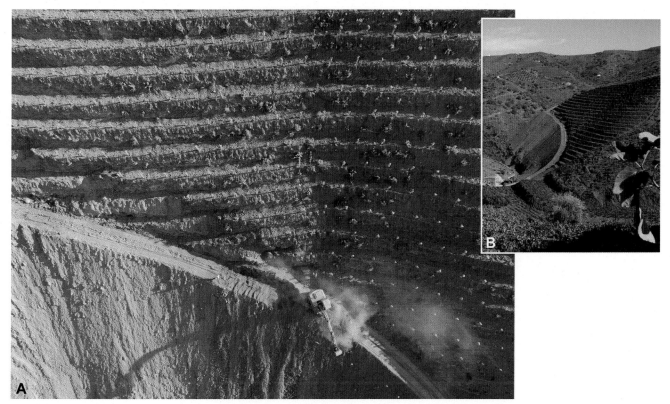

Fig. 10-39 (A) Remodeling of a terraced mango plantation on a steep hill in the Montes de Málaga, Spain. The original position of the bordering track (lower right corner) is being shifted downslope by the excavator. On the left side of the image, the track's former course is still visible as an indentation, below which the extended terraces have not yet been fully built up. One-year-old mango trees, spaced ~3m apart, are best visible in the shaded part in the lower right; the larger and irregularly spaced bushes are weeds and resprouting vines, evidence of the former land use at this site. Taken with on-board camera of a quadcopter UAV. (B) View of the whole plantation illustrating the extreme gradient, taken from the opposite side of the valley two days earlier.

(Fig. 10-40). Exceptionally heavy rainfall events in September 2009 resulted in high runoff rates in the upslope almond plantation and in the accumulation of a small pond retained by the earth dam. This aerial photograph was taken shortly after the pond—its extent still visible in muddy gray soil colors—had drained by a dam breach.

At the moment of exposure, the farmer is caught in the act of repairing the breached dam by dumping fieldstones collected in the plantation into the hole. However, the surging flow of water, diverted off the main drainage line by the dam, had already carved deep rills into the slope below, in a topographical position that is contradictory to the natural hydrological flow direction at this site (see also Fig. 14-6 and Marzolff et al. 2011). Nine years later, the mending of the dam, now covered in more soil, is not conspicuous any more, but the deeply incised diverted drainage lines are still visible today.

As these situations show, the knowledge about human influence in landscape evolution processes may be important for understanding the background of forms and patterns, their spatial distribution, and temporal variability. The interference of humans in enhancing, controlling, diverting, or hindering natural processes may considerably contribute to the rates of change in a landscape—both in negative and positive ways (see also Fig. 18-1). Taken at the right moment, SFAP may thus help to unravel the role of humans in shaping landscapes at various spatial and temporal scales.

10-4 STEREOSCOPIC VIEWING

In Chap. 3, the fundamentals and benefits of stereoscopic analysis already have been introduced. However, stereoscopy also might be useful for visual interpretation disregarding quantitative measurements—many aspects of a scene may reveal themselves to the observer more clearly or exclusively in 3D view. Arthur Batut, the pioneer of kite aerial photography, already noted in 1890:

These [stereoscopic] images have the enormous advantage of making the smallest details distinguishable with remarkable clarity due to the sensation of relief, which might pass completely unnoticed in a single photograph. (Batut 1890; translation by IM)

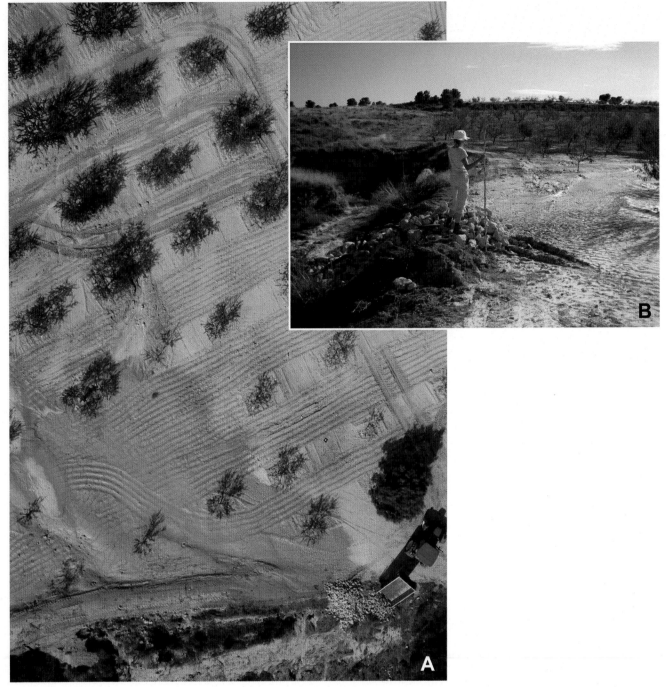

Fig. 10-40 An earthen dam at the lower edge of an almond plantation is being repaired after heavy rainfall events to protect the field against gully erosion near Zarcilla de Ramos, Province of Murcia, southeastern Spain. (A) Vertical hot-air blimp photograph taken with a DSLR camera. Note the darker and grayer tone of the area upslope of the dam, where a small pond of runoff water had just drained after the dam break. (B) Terrestrial view along the dam and still wet surface behind, taken shortly after the beginning of the repairs from the right edge of the area in A.

Of the image interpretations given in this chapter, many could be strongly supported by stereoscopic viewing (e.g. Figs. 10-8, 10-12, 10-13, 10-30, 10-38 to 10-40). Generally, stereoscopic viewing may be achieved either with or without optical aids, including the following approaches (Jensen 2007).

- Place the images in reading distance (left image to the left and right image to the right side), relax eyes as if looking at infinity until the two images fuse into an unfocussed third 3D image in the middle, and focus back on this stereo model (try with Figs. 2-9 and 11-19).
- Place the images in reading distance (left image to the right and right image to the left side), let the lines of sight cross until the two images fuse into a third 3D image in the middle. Note: using this method on the stereo images in this book will cause relief inversion.

- Print one image in red and the other in blue, green, or cyan on top of each other to create anaglyphs, and use corresponding anaglyph lenses to view.
- Arrange the images under a lens or mirror stereoscope (see Fig. 2-10).
- Use stereoviewing software and hardware, for example, electronic shutter lenses.

The first two methods are a matter of practice; some people are able to do this easily, but most cannot without causing considerable eye strain and/or headache. These methods are only useful for an aid-free, quick appraisal of a stereoscene, and zooming in on details is obviously not feasible. Anaglyphs are easy to realize and work well for most people, but they are color-distorting, a real nuisance to the human brain, and not recommended for serious work. Stereoscopes and their digital realizations are clearly not only the best but also the most expensive option.

Irrespective of the viewing method, the images need to be orientated so they reflect their relative position at the moment of exposure. For SFAP images, this is usually not as simple as placing them next to each other in parallel, as SFAP surveys often do not result in regularly aligned flightlines with consistent overlaps (see Fig. 3-9). In photogrammetry software, the relative orientation is computed via GCPs and tie points.

The manual method for reconstructing the flightline between the two exposures, which needs to be aligned to the eye base of the observer, is illustrated by Fig. 10-41. Mark (or for quick casual viewing roughly identify and memorize) the center point (principal point, o) in each image and also its corresponding point (o') in the other. Then lay out both images with the center points at the outside and their corresponding points at the inside so all fall on one straight horizontal line. There are two ways to do this (the whole arrangement may be turned by 180°); in case of sunlit scenes it is best to choose the variant where the shadows are cast toward the lower right rather than the upper left in order not to confuse the brain (see Fig. 4-31). The ideal spacing between the two images depends on the viewing method and the observer's liking.

In the following, three stereoviewing methods of practical use for SFAP are briefly described; the orientation technique presented above works for all of them.

10-4.1 Creating Simple On-Screen Stereoviews

Sometimes, even a quick appraisal of the relief structures in a scene may be beneficial for interpreting a scene. Also, before choosing an image pair for printouts, anaglyph creation, or photogrammetric analysis, it may be useful to assure oneself of its stereoscopic quality. Even with a decent overlap, which is easy to assess in monoscopic view, the stereo impression might be unsatisfactory owing to unfavorable image tilts or differing scales, both typical situations for SFAP. The latter may

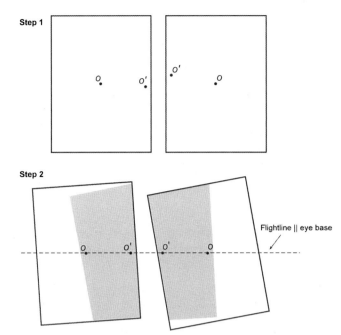

Fig. 10-41 Relatively orienting two images for stereoscopic viewing. Step 1: identifying the image centers o (by using the image corners) and their corresponding points o' (by using the image contents). Step 2: rotating both images so all points lay on a horizontal line parallel to the eye base; 3D viewing is possible in the stereo-area shaded in gray.

be remedied by scaling one image to fit the other prior to printing them, but the former could only be cured by choosing different stereopairs.

Simple freeware image viewers (e.g. *IrfanView*) are useful tools for such checks (Fig. 10-42). Opened side by side, the images may be scaled and rotated following roughly the orientation procedure described above. With a little practice, the parallel-eyes method (or, if preferred, the cross-eyed method) is quite helpful for selecting the optimal images from a survey series.

Even more convenient are stereoviewing tools that allow the user to rotate and scale the images for relative orientation and then offer the choice to display them for parallel-eyed, cross-eyed, anaglyph or even shutter-lens viewing. A variety of useful freeware is available on the Internet (e.g. *StereoPhoto Maker*).

10-4.2 Using Printouts Under a Stereoscope

Stereoscopes are optical devices that help to view the two images separately and with relaxed eyes. Lens or pocket stereoscopes permit viewing the full overlap area of prints up to 10 cm x 13 cm or parts of larger prints (see Fig. 2-10). Mirror stereoscopes are designed to accept standard 23 cm × 23 cm metric airphotos and therefore work well also with A4/US letter-sized prints (Fig. 10-43). Most models come with magnifying options up to eight times. They are large enough for allowing the analyst to draw beneath them, so it is possible to trace objects identified in the stereoview with a pen onto one

Fig. 10-42 Two vertical aerial photographs of Barranco Rojo near Botorrita, Province of Zaragoza, Spain, oriented for stereoscopic viewing on a computer screen. The right image has been rotated and slightly enlarged to match up with its stereopair. The parallel-eyes method may be used to view this scene in 3D. Hot-air blimp photographs taken with a DSLR camera.

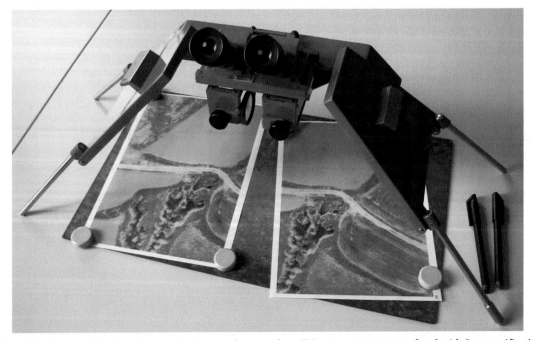

Fig. 10-43 Two A4 printouts of the images shown in previous figure under a *Zeiss* mirror stereoscope fitted with 8× magnification binoculars.

of the images or a transparent overlay. However, remember that this sketch would not have the geometric properties of a map as it contains all distortions present in the base image.

To prepare printouts for use with a stereoscope, checking and if applicable scaling them first as described above is advisable. Especially when intended to be viewed at high magnification, a high printing resolution (600 dpi minimum) is necessary, or image details would be veiled by the printing dots. High-resolution photo-quality printouts or photographic prints are best suited.

10-4.3 Digital Stereoviewing

As with analog stereoviewing, on-screen stereoviewing requires that each of the two images is perceived by one eye only. There are various hardware and software solutions for this that separate the two images either by color, by time, by polarization, or by viewing angle. The simplest solution is the anaglyph method mentioned above; it requires no special graphic cards or hardware besides cheaply available anaglyph glasses. This is also a useful and financially feasible method for displaying 3D views to a larger audience via video projector, and the authors use it frequently in student courses.

Excellent 3D views may be created with dedicated stereographic cards, suitable display devices, and stereo-eyeware, using for example the quad-buffered OpenGL stereo mode. With the active shutter-glasses method, the two images are displayed alternately with a frequency depending on the monitor refresh rate (Fig. 10-44). LCD shutter glasses alternately block one of the images in synchronization with the display. This method relies on high monitor refresh rates (120 Hz minimum are required to avoid flickering). Another method is the superimposition of the images through polarizing filters and the use of passive polarized glasses. Stereo-display systems based on the same technique use two LCD monitors mounted at an angle with a semireflecting beamsplitter mirror between them, a dual-head graphics card, and polarized glasses for viewing.

Finally, autostereoscopic display devices have for the last 20 years or so offered the possibility of aid-free 3D viewing. A stereogram is composed of vertically interleaved lines from the two stereo images, and an equally slitted barrier or lenticular plate is placed in front of this view. When viewing the screen from the right distance, the barrier or the lenses on the lenticular plate block the view of the left image's lines to the observer's right eye and vice versa. Thus, a true stereoscopic image using the human 3D perception ability is created. The asset of 3D viewing without glasses is, however, reduced by a weaker feeling of image depth compared to the quad-buffered stereo systems (Torres et al. 2013). Also,

Fig. 10-44 The stereopair shown in Fig. 10-42 displayed in quad-buffered stereo mode on a computer monitor, to be viewed with wireless active shutter glasses activated by an infrared emitter (top left and center). Alternatively, the system shown here could be used for anaglyph viewing (red-cyan glasses top right).

Shan et al. (2006) have found that autostereoscopic technology may be employed for photogrammetric stereo measurements but yield 16%–25% lower precision than the more commonly used shutter glasses methods.

10-5 SUMMARY

Interpretation of aerial photographs begins with basic aspects—color, size, shape, pattern, texture, and shadows—combined with scene context and experience of the interpreter. Visual recognition of objects in vertical images normally requires a ground sample distance (GSD) three to five times smaller than the object itself, although other non-spatial factors also may impact interpretability. Atmospheric effects tend to degrade image quality with increasing height regardless of spatial resolution. SFAP from low height may provide interpretability ratings in the range 7–9, noticeably higher than conventional airphotos or high-resolution satellite imagery.

Visible color is diagnostic for suspended sediment in water bodies, whereas color-infrared imagery is most appropriate for vegetation. Cultural features tend to display linear and geometric shapes and patterns that contrast with natural objects for both modern urban and rural features as well as prehistoric remains. Subtle

crop, soil, and shadow marks may reveal the presence of buried archaeological features. Often, the most interesting information in an image does not reveal itself immediately but rather indirectly by visual clues to the conditions and processes that induce a certain pattern, shape, or color. Stereoscopic images offer additional possibilities of visual image interpretation. Various methods for stereoviewing from quite-basic to high-tech solutions exist.

For the presented and other applications of SFAP, knowledge of conditions on the ground and familiarity with local human activities are invaluable for improving image interpretation. In monitoring studies, temporal changes of forms and patterns give additional clues. Ephemeral, intermittent, or one-time-special circumstances may reveal features that are not normally visible. Taken at the right moment, SFAP may show people in immediate action, which may emphasize or even reveal the role of humans in shaping landscapes or altering natural processes. The scientific benefit arises from the coupling of ground evidence by conventional field work and the visual information gleaned from SFAP, which may lead to a deeper understanding of the natural and cultural processes and features present at a site.

11

Digital Image Processing and Analysis

Οἱ δ' ἀριθμοί πάσης τῆς φύσεως πρῶτοι.

(Numbers are the ultimate things in the whole physical universe.)
Pythagoras (quoted by Aristotle in Metaphysics 1985b, 4th century BCE)

11-1 INTRODUCTION

Basically, a digital image is just an array of numbers arranged in rows and columns. Processing an image by enhancing its contrast, correcting its geometry, or classifying it into various categories means processing numbers with mathematical and statistical algorithms. The same image-processing techniques that are used for analyzing remotely sensed images from multispectral satellite sensors may be applied to small-format aerial photography (SFAP) (e.g. Bähr 2005; Jensen 2007, 2015; Mather and Koch 2010; Richards 2013; Lillesand et al. 2015; Liu and Mason 2016). Some current image-analysis approaches in various applications of UAS remote sensing are reviewed for example in Pajares (2015), Smith et al. (2016), and Manfreda et al. (2018).

Again, this chapter is intended to be neither exhaustive nor a replacement for dedicated textbooks and software manuals, but it is meant to cover selected aspects that the authors consider specific or particularly useful for digital analysis of SFAP. It begins with aspects of geometric corrections and registration, continues to image-enhancement techniques, image transformation and classification, and concludes with analysis of photogrammetrical generation and analysis of digital surface and terrain models. The final sections give a brief overview of software suitable for SFAP processing and issues of photo manipulation.

11-2 GEOMETRIC CORRECTION AND GEOREFERENCING

Correction of geometric distortions and georeferencing to a common object coordinate system are necessary for many SFAP applications, for example quantitative analysis of areas and distances, monitoring projects, or integration of various data sources in a geographical information system (GIS). The first decision to be made concerns the reference coordinate system to be used; the second concerns the image rectification method. Finally, covering large areas with high-resolution SFAP might require mosaicking several images together.

11-2.1 Reference Coordinate Systems

Two basic types of coordinate systems exist for geographic data, namely geodetic coordinate systems based on map projections and geographic coordinate systems based on latitude and longitude (for details, see Hake et al. 2002; Longley et al. 2015; Bill 2016). The main difference is that projected, geodetic coordinates are Cartesian coordinates with two equally scaled orthogonal axes. Distances and areas calculated in these reference units are comparable across the globe. Geographic (unprojected) coordinates, on the other hand, are polar coordinates defined by a distance (the radius of the Earth) and two angles (between a given location and the equator and between this location and the prime meridian). Because the spacing between lines of longitude decreases from the equator to the poles, they are not useful for comparing distances or areas across the globe. However, they are useful as a comprehensive global system unaffected by distortion issues associated with map projections. The following coordinate systems may be considered appropriate for georeferencing SFAP:

- The national map projection system locally used for topographic mapping, for example, the ETRS89/UTM system in Germany or the state plane systems in the United States. This is most useful when the images are to be combined with other, existing datasets such as topographic maps or digital cadastral data. It requires the connection to the national system by nearby trigonometric points or highly precise differential global

positioning system (DGPS or RTK-GPS) when measuring ground control points.

- An arbitrary local coordinate system (see Chap. 9-5). This is useful when correct scale, area, and distances are required but absolute position of the study site within a national or global system is not a necessity because no data with other spatial references have to be overlaid. Local coordinate systems subsequently may be transposed into national reference systems by rotating and shifting them, either by adjusting them visually over other referenced image data in a GIS, or by mathematical transformation of the coordinates in a spreadsheet or conversion program (e.g. for Helmert transformations).
- No predefined coordination system at all but image file coordinates. For some applications, not even scale, areas, or distances are of interest because relative values such as percentage cover or mean normalized difference vegetation index (NDVI) value are the only output information required. If the image is not significantly distorted, it does not need to be geometrically transformed. Even time-series and change analysis may be carried out when subsequent images are relatively referenced to the first by image-to-image registration.
- Geographic coordinates in decimal degrees or degrees, minutes, and seconds. This worldwide reference system (see above) is useful because of its universality and global availability, but has the already mentioned disadvantage of angular coordinates. Unless the study site is situated near the equator, images referenced in lat/lon should be projected into a geodetic coordinate system for displaying or printing, or they would appear badly stretched. Also, a coordinate precision adequate for the small ground sample distances (GSDs) of SFAP requires many decimal places. Consider that one degree of latitude equals ~111 km; thus, a centimeter precision for a point on Frankfurt University's Campus Riedberg requires recording a latitude coordinate as precise as 50.1714072° N.

11-2.2 Image Rectification

Basically, three different types of distortion may be present in an SFAP image: lens distortion, image tilt, and relief displacement (see Chap. 3-2). The most precise method, orthorectification, has already been introduced in Chap. 3-3.6, as it is a photogrammetric process that requires the orientation of the images relative to the terrain in object space. In orthorectification, the relief displacement is determined with the help of a digital elevation model (DEM) and eliminated for each image pixel. Polynomial rectification is another option that only requires ground control points (GCPs) and may be carried out with any GIS or remote sensing software.

Polynomial equations formed by ground control point coordinates and their corresponding image-point coordinates are used in order to scale, offset, rotate, and warp images and fit them into the ground coordinate system (Mather and Koch 2010). The highest exponent of the polynomial equation (the polynomial order) determines the degree of complexity used in this transformation—first-order transformations are linear and can take account of scale, skew, offset and rotation, while second- and third-order transformations (quadratic and cubic polynomials) also may correct non-linear distortions.

There is no general solution as to which transformation order and how many GCPs are needed for a good georectification. Mathematically, three, six, or 10 GCPs are necessary for first-, second- or third-order transformations, but for increased reliability, at least twice as many are advisable. The over-determination of the equations would then allow to compute a best-fit polynomial with least squares residuals. The residual errors are, however, only a measure of the goodness of the fit and not necessarily of the rectification quality for the complete area (Mather and Koch 2010). Because the polynomials are computed from the GCP points only and then applied to the entire image, they only produce good results if the GCP locations and distribution adequately represent the geometric distortions of an image. For low-altitude aerial photographs, which are subject to radial displacement, this is usually difficult to achieve.

Vertical or oblique images of flat terrain (Figs. 3-1 and 3-3) may be quite successfully rectified with first- or second-order polynomials, but the relief distortions present in images of variable terrain are much more difficult to correct (consider the impossibility of fitting a second- or third-order polynomial to the surface shown in Fig. 3-2). Although higher orders of transformation may be used to correct more complicated terrain distortions, the risk of unwanted edge effects by extrapolation beyond the GCP-covered area increases.

Further similar methods of image rectification using GCPs exist, that is, spline transformation or rubber sheeting with piecewise polynomials. These methods optimize local accuracy at the control points, and are therefore also highly sensitive to errors in the GCPs. All of these methods have in common that the rectification of the image areas between the GCPs is interpolated by the polynomial equation and not a direct function of radial relief displacement. Thus, the rectified image would not be truly and completely distortion-free. While polynomial rectification by GCPs may well be sufficient for low-distortion images or applications with limited demand for accuracy, seriously distorted images and more precise applications require full modeling of the distortion parameters (relief displacement, lens distortion, and image obliqueness) in a photogrammetric orthorectification process.

Thus, a highly exact geometric correction requires time, effort, a digital elevation model, and excellent ground control. Many SFAP applications may not really need such efforts, and depending on the image and relief characteristics, simpler solutions might be quite sufficient. Because establishing ground control every time a survey is conducted is costly and time-consuming (see Chap. 9-5), it could be a useful method to supplement or even substitute control points with image-to-image rectification in monitoring projects. Non-referenced images may be warped onto a first, thoroughly rectified image by image-to-image registration, picking homologous points in both the reference and input images. This may be done manually or with software for automatic point matching (e.g. *IMAGINE AutoSync*).

So how does one judge how correct is good enough? This is always a question of relating the residual error to the desired spatial information detail. The following concerns could play a role in this decision.

- Maximum location accuracy to be expected with a given GSD.
- Desired accuracy for locating or delineating individual, well-defined features.
- Required accuracy for measuring changes in monitoring projects.
- Achievable precision of object delineation.

Consider a project where the invasion by a non-native plant species in an estuarine wetland reserve is to be assessed by quantifying the percentage of affected vegetation cover from aerial photographs. Here, precise orthorectification with <2 cm error would certainly be a wasted effort for several reasons. The images would be affected little by relief displacement because of the flat terrain; a measurement accuracy in the centimeter range is not required for the purpose; and indeed the delineation precision of something as fuzzy as vegetation patches would be much inferior to 2 cm.

Another application might be monitoring the development of sharp-edged ephemeral rills on a hillslope during one season and relating their retreat rates to precipitation and runoff measurements. In this case, the measured changes may be grossly inaccurate if the image time series were rectified using only a few GCPs with check-point RMS errors in the decimeter range.

The differences in horizontal accuracy achievable with various rectification techniques for a situation with variable terrain are illustrated with Fig. 11-1. This vertical photograph of a long gully cutting into a shallow depression between two agricultural fields was taken from 82 m height above field level with an original image scale on the sensor of 1:4100. The altitudinal differences present in the scene amount to ~4.5 m (top of field-bordering ridge to bottom of gully). Forty-one GCPs were measured with a total station; 22 of those were used for georectifying

the image with different methods in *ERDAS IMAGINE* and *Leica Photogrammetry Suite*, while 19 were reserved as check points for error assessment.

Results show that the abrupt relief changes (see cross-profile in Fig. 11-2) cause relief displacement that cannot be corrected sufficiently with polynomial transformations. Although a large number of GCPs was used, the third-order transformation shown in Fig. 11-1A leaves considerable residuals at both control and check points, with a maximum displacement of 43 cm. Rubber sheeting—a piecewise non-linear polynomial transformation—results in no errors at the control points, but even larger errors at the check points (Fig. 11-1B). This confirms that the GCPs, in spite of their good distribution and abundance, are not able to represent the variations in terrain height adequately. The image is now geometrically correct at the control points, but still distorted in the areas between, with a total RMS error of nearly 30 cm at the check points.

By far the best results are achieved with orthorectification (Fig. 11-1C), where the image is differentially corrected using a digital elevation model. This was realized by setting up a photogrammetric block file with both interior and exterior orientation information (see Chap. 3) and triangulating several overlapping images. A digital elevation model (DEM)—or, more specifically, a digital surface model (DSM), as vegetation and other objects above the terrain surface are included—was extracted from the image shown in Fig. 11-1 and its stereopartner. This DSM provided the necessary height information for computing and correcting relief distortion. The residual planimetric errors amount to only about 3–4 cm of total RMS and are due to the small remaining errors in triangulation and accuracy of the DSM. The point cloud extracted by automatic image matching was subject to vegetation effects in many places (see Fig. 3-15). The highest GCP RMSE was found at a control point that is half hidden between dense tussock grasses at the gully floor.

In many cases, the presence of vegetation is a challenge for orthorectification of SFAP. The convenience of highly automated SfM-MVS workflows for 3D surface modeling and orthophoto mosaicking (see Chaps. 3-3.5 and 3-3.6) may lead to the temptation of creating outputs with the highest possible detail, that is, dense point clouds, DSMs and orthophotos with GSD-equivalent resolutions. However, such surface models derived from automatic matching procedures capture all features visible to the camera, for example, treetop as well as within-crown leaves and branches. Vegetation canopy may be more or less compact and may yield quite rugged and fragmented "surfaces" in the model. If these detailed DSMs are used for orthorectification, peculiar artifacts may result from the endeavor to correct the planimetric position of each leaf (Fig. 11-3A).

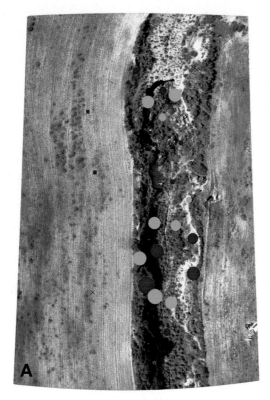

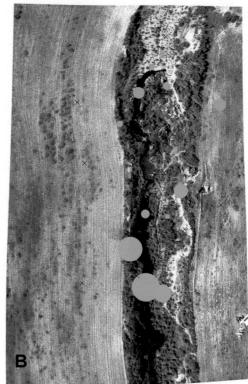

GCP position in reference system

× used as control point in rectification

× used as check point in rectification

RMS errors in reference units

Radius proportional to linear RMS, exaggeration 5 x

● error at control point

● error at check point

75 cm
50 cm
25 cm

		A 3rd order polynom [cm]	B Rubber-sheeting [cm]	C Ortho-rectification [cm]
GCPs	Min RMS	1.08	0.00	1.05
	Max RMS	42.89	0.00	11.19
	Total RMS	17.90	0.00	3.73
Checks	Min RMS	1.64	2.07	0.63
	Max RMS	38.44	71.98	6.57
	Total RMS	21.83	29.25	3.09

Fig. 11-1 Georectified images of gully Bardenas 1, Bardenas Reales, Province of Navarra, Spain. Kite photo taken with DSLR camera by JBR, IM, and S. Plegnière; image processing by IM. (A) Rectified by third-order polynomial transformation. (B) Rectified by non-linear rubber sheeting. (C) Orthorectified using a DEM derived from the same image and overlapping stereopair. Location and RMS errors of 22 control points and 19 check points shown by diagram radius with fivefold exaggeration. GSD of all rectified images is 2.5 cm.

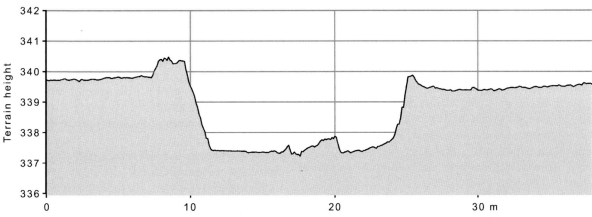

Fig. 11-2 Cross-profile through the middle part of the gully in Fig. 11-1, derived from the DEM used for orthorectification.

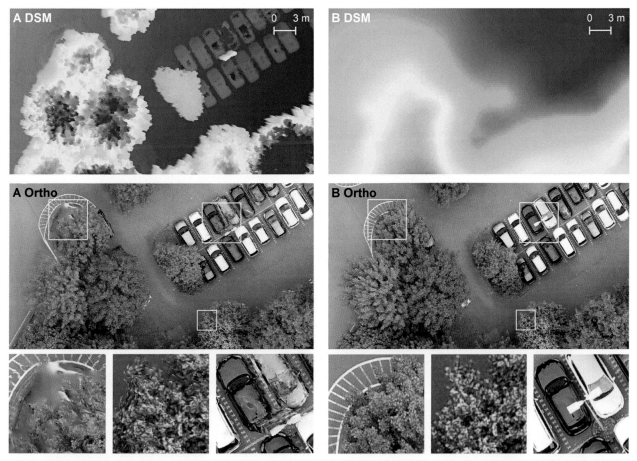

Fig. 11-3 Subset of digital surface model and orthophoto mosaic created with *Agisoft PhotoScan* with two different workflows. Vertical airphotos taken at Campus Riedberg, Frankfurt University, with on-board camera of quadcopter UAV; image processing by IM. (A) DSM computed from 2.5D mesh with high face count derived from mildly filtered ultra-dense 3D point cloud and corresponding orthophoto mosaicked from 6 images. (B) DSM computed from strongly smoothed (factor 10) 2.5D mesh with low face count derived from sparse 3D point cloud and corresponding orthophoto mosaicked from 3 images. Note artifacts in canopy and sight-shadowed areas, at strongly specular car roofs and beneath the high lamp post on version A (subsets). These areas are not planimetrically correct in version B, but devoid of weird internal distortions.

Difficulties may also arise for abruptly high-rising objects and highly reflective surfaces. Depending on the purpose of the orthophoto, it may therefore be advisable to compute a smoother surface model for use in orthorectification, and reduce the number of input images for mosaicking to avoid too many edge effects at the stitching seamlines (Fig. 11-3B). If only individual single trees or sparse low vegetation are present in a scene, an alternative would be to produce a digital terrain model (DTM) from ground-surface points only for use in orthorectification (see Section 11-6).

11-2.3 Image Mosaics

SFAP survey planning often requires compromising about small GSD of the images and large area coverage (see Chap. 9). In order to achieve a desired degree of detail, it might be necessary to take multiple images for a given area that subsequently need to be assembled into an image mosaic. In this way, even unmanned SFAP may cover considerable areas with high resolution, provided a platform capable of traveling longer distances is used, for example, a fixed-wing airplane (see Chap. 8-2).

The term mosaicking is commonly used in remote sensing and geoinformation sciences when contiguous images are joined to form a single image file. However, this does not necessarily require that the images be georeferenced—rather than using GCPs for positioning the individual images in a common reference coordinate system it is also possible to use any homologous image objects for a relative spatial adjustment of the photographs (uncontrolled mosaic). This may be done either in remote sensing and GIS software or with dedicated photo-editing software, with varying degrees of automation.

Most digital camera software now includes so-called stitching functions, and there is a large choice of free and commercial panorama software for fully automatic merging of multiple photographs into larger composites. These tools may produce results that are visually highly appealing (see Fig. 11-4), but they are not geometrically correct. Note the angular skew and straight edges of the left image tiles in Fig. 11-4. If the mosaic were georectified, the edges would be bent and warped following the changing relief heights of the hillslopes, similar to the bottom edge of Fig. 11-1C. Remote sensing or GIS software is required for georeferenced (controlled) mosaics, which may be constructed from image tiles previously geocorrected with polynomial transformations or orthorectification. Orthorectification and mosaicking may also be carried out as a final step in a workflow of classical or SfM-MVS-based photogrammetric terrain extraction (see Chap. 3-3.6).

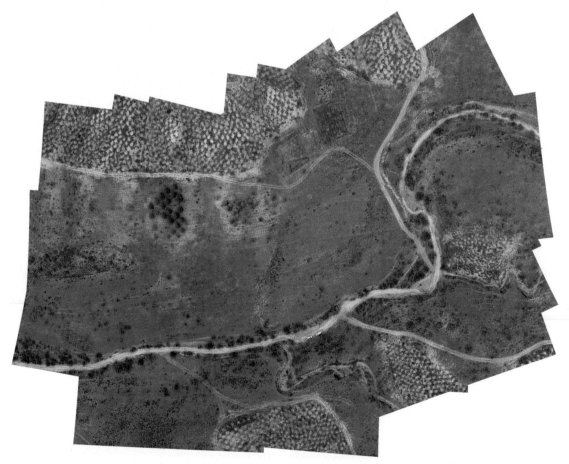

Fig. 11-4 Uncontrolled image mosaic created with *Hugin* panorama software from 27 aerial photographs taken from 150 m height by an auto-piloted fixed-wing UAV with DSLR camera. The mosaic covers a 600 m stretch of the Rambla de Casablanca near Guadix, Province of Granada, Spain (northeast is up). The hillslopes at the top and bottom are dotted with small terraces recently installed for a reforestation project; two patches with pine trees left of the image center are the remains of an earlier, failed reforestation attempt. Photos by C. Claussen, M. Niesen, and JBR; image processing by IM.

Regardless of controlled or uncontrolled and no matter which software is used, image mosaics mercilessly reveal exposure differences across or between photographs unless color matching between the stitched images is carried out in order to conceal the seams. Not all software capable of stitching adjacent images together may provide color-correction tools, and matching the image tiles for a balanced overall impression may be only partly successful especially for large mosaics with strongly varying brightness distributions (Fig. 11-5).

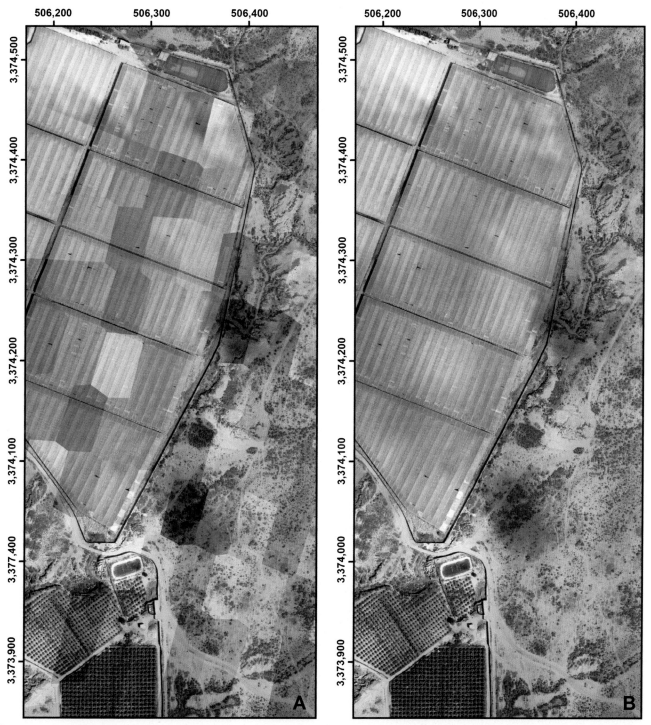

Fig. 11-5 Controlled image mosaic (UTM coordinate system) of an agricultural scene near Taroudant, South Morocco, created with *Agisoft PhotoScan* from 94 orthorectified aerial photographs. (A) Original images mosaicked without color corrections. (B) Original images mosaicked with color-dodging corrections. Slight contrast enhancement applied subsequently to both mosaics. Note the perfect color-adaptation in the lower part of the mosaic in version B, and the remaining smudges of darker shades where cloud shadow had obscured parts of the scene during the SFAP survey. Fixed-wing UAV photographs taken with MILC in auto-exposure mode by IM, JBR, and M. Seeger; image processing by IM.

11-3 IMAGE ENHANCEMENT

SFAP images for scientific applications are taken usually with the intention to show certain information about a site or an area; thus, optimizing the visual interpretability of an image with image enhancement techniques is often the primary concern. As discussed in Chap. 6-4.6, photographs taken with small-format cameras are not without radiometric deficiencies. Image-degrading effects such as chromatic aberration (CA), vignetting, and noise may be corrected partly or completely with camera software or professional image-editing software. This may minimize or remove radiometric flaws determined by lens and camera characteristics. However, the image objects themselves also may be responsible for visual shortcomings, especially regarding color contrast. Image enhancements may range from fine adjustments for improving the general visual appearance to considerable modifications aimed at emphasizing certain information. The following sections cover some of the enhancement methods the authors most frequently use on their SFAP images.

11-3.1 Correcting Lens-Dependent Aberrations

Lens-dependent aberrations are circular effects centered on the optical center of the image. Therefore, it is important to correct them before cropping or warping the image. Most photo-editing software packages and some modules of professional remote sensing software include tools for correcting vignetting, CA, and lens distortion. Depending on the camera model, these corrections might also be applied automatically, that is, in-camera to JPG files, so the user does not even get to see the original distortions any more. Shooting in RAW mode avoids these automatic corrections, which gives more control to the photographer.

The degree of vignetting depends on lens characteristics, aperture, and exposure and is thus not an invariable effect—it is difficult to correct automatically and its correction settings may have to be judged visually for each image. Using sliders for the amount and progression radius of the lightening, the brightness of the image is modified until the light falloff toward the corners is compensated. Correcting for vignetting, which is most noticeable in homogeneous, light portions such as the sky or bare soil, may be sensible not only for aesthetic reasons but also prior to image classification in order to balance the spectral characteristics of the scene.

The correction of CA and lens distortion involves not brightness or color modifications but geometric transformations of the image. Latitudinal CA is rectified by slight adjustments of the image channel sizes, usually by radially scaling the red and blue channels individually to match the size of the green channel. Radial

lens distortions (see Figs. 6-8 and 6-10) are lens-specific geometric distortions that are best corrected with lens-specific and focal-length-specific settings using dedicated software such as *PTLens* or *Adobe Camera Raw*. It is also possible to correct radial lens distortion visually, but only for scenes where its degree could be judged from the deformation of straight lines or grids—something that is usually not the case for SFAP. Correcting radial distortions prior to quantitative image analysis might be especially useful if the image is to be georectified using simple polynomial equations.

11-3.2 Contrast Enhancement

Most aerial photographs covered in this book show landscapes of all sorts, and few of them abound in striking colors with lively contrasts. Even more than high-oblique images, vertical aerial photographs for geoscientific applications tend to be restricted to earth-tone shades of green, brown, and beige. Yet exactly the subtle differences in color shades may be interesting for distinguishing certain soil properties or vegetation types.

Various ways exist for manipulating the distribution of tones across the brightness range between 0 and 255 (for an 8-bit image), all of which modify the image histogram that shows the relative frequency of occurrence (*y*-axis) plotted against pixel values (*x*-axis). Depending on the software used, the following methods might be available (e.g. Mather and Koch 2010; Langford and Bilissi 2011; Richards 2013; Jensen 2015).

- Simple global brightness and contrast controls.
- Advanced controls for specific color and brightness ranges.
- Histogram adjustments using levels.
- Histogram adjustments using curves/graphic functions.

Color enhancements may be done in any of the available color spaces (see Chap. 5-2.5). For example, instead of manipulating the three primary colors, namely red, green, and blue, the saturation component of the IHS color space may be used for slight enhancement of dull colors due to backlit situations. Using the intensity and saturation components of the IHS system would not change the hues in the image, while enhancements in the RGB space are able to produce complex color shifts.

Consider the view of a network of erosion rills on a river terrace (Fig. 11-6). This is what the original image looks like, shot as RAW and converted to TIF without any additional processing. The monotonous colors of the loamy sediments differ little from the darker hue of the terrace's rock-strewn surface in the upper and lower right. The indirect light of the overcast day renders the image nearly devoid of shadows. The histograms of image values reflect the homogeneous visual impression

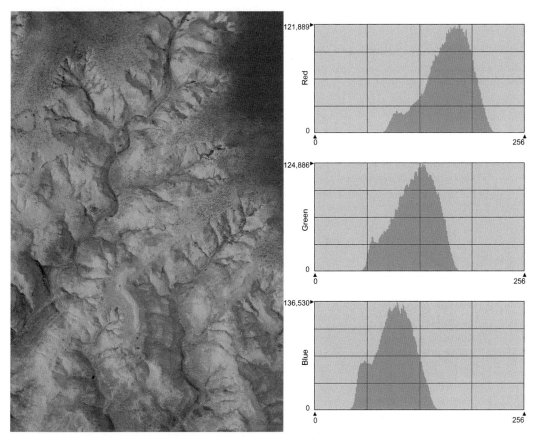

Fig. 11-6 Vertical kite photo (with image histograms) of rill and gully erosion on a sedimentary river terrace near Foum el Hassane, South Morocco. Taken with a *Canon EOS* 350D (Digital Rebel XT) with 28-mm *Sigma* lens, no image processing applied. Field of view ~70 m across; photo by IM, JBR, and M. Seeger.

Fig. 11-7 Image in previous figure after histogram contrast enhancement. Image processing by IM.

by a unimodal distribution in the midranges. The slight broadening and shift toward the higher values from blue to red results in the overall brownish image hues. It is obvious that the scene does not exploit the dynamic range of the sensor, monitor, or printer at all; each band covers only 40%–50% of the possible brightness values.

Fig. 11-7 shows the same image after a contrast enhancement that expanded the histograms between their extremes, slightly saturating the high ranges. The scene is now a bit unnatural with respect to what we would actually see with our own eyes in the field, but it reveals remarkable variations in the seemingly homogeneous sedimentary layers of the terrace. The smooth crusted top surface now has a distinctive pinkish shade where bare of rocks, while the layer immediately underneath and another one farther below appear bright with a turquoise tinge. Where the two main gullies have cut deeper, the sediment is much darker and reddish-brown again. The color differences result from differences in pedogenetic processes, proportions of organic and inorganic material, and grain sizes in the individual layers, which have been deposited during the Late Glacial and Early Holocene (Andres 1972). These layers are now revealed by the incision of the gully into the material, and the sedimentary archive has become visible.

A similar contrast enhancement was applied to this view of sand-sage prairie vegetation (Fig. 11-8). In the original image, only subtle variations in colors and shadows may be seen. Disregarding the bright gravel road and dark shadows of the trees, the brightness values present for the vegetated areas of the scene only covered 25%–30% of the 8-bit dynamic range. By stretching them to the full 256-value range, great variations of color, texture, and shape in the vegetation cover become apparent. Individual

sagebrush (*Artemisia* sp.) bushes become quite distinct as pale-green clumps on subtle sand dunes. Between dunes, circular swales with dark green prairie grass are apparent. Orange spots are patches of prairie wildflowers.

In the examples discussed above, the camera sensor's dynamic range was wider than the scene required. Starting with simple linear contrast stretches (min-max or about ±2.5 std. dev.) often yields good results with such images. A more difficult case is the presence of deep shadows in a scene (see Chap. 4-7). A contrast stretch as applied in Fig. 11-7 would deepen them even further, obscuring the shadowed objects still more and increasing their radiometric difference to the sunlit parts of the image. This might impede further image processing such as classification or stereoscopic feature extraction.

In Fig. 11-9, the original image of a heavily shadowed scene is compared with two contrast-enhanced versions. Note the strongly bimodal distribution of the original image values shown in Fig. 11-9D (gray histogram) and the generally dark appearance of the desert scene. In real life, the scenery was much brighter with dazzling light, but the automatic, non-corrected exposure settings of the camera have resulted in comparative underexposure (see Chap. 6-4.5). The surfaces and objects obscured by the shadow are of the same type as those illuminated by the sun, so the shadows would decrease or even disappear if the two peaks would be moved or even merged together. The colored histograms in Fig. 11-9D, belonging to the image in Fig. 11-9B, are the result of a piecewise contrast enhancement using a graphic histogram modification (see e.g. Richards 2013; Jensen 2015).

The graph line is used to map the original image values (shown along the x-axis) to the desired output values (shown along the second y-axis). Breakpoint *a* increases

Fig. 11-8 Sand-sage prairie vegetation in sand hills of western Kansas, United States. Kite flyers next to abandoned farmstead at upper right edge of view. Original photo taken by JSA and SWA with a digital compact camera; image processing by IM. (A) Original image without processing. (B) Contrast-enhanced version emphasizing variations in vegetation cover. Small pale-green clumps in lower and left sides are sagebrush on dune crests; dark green prairie grass in swales and around farmstead; orange indicates wildflowers in bloom.

the brightness values of the shadow peak to a level corresponding to the mean values of the sun peak. To counteract the resulting tonal compression of the sunlit regions, breakpoint b raises their highest values to the maximum file value 255. Finally, the graph line is flattened a little at the depression between the shadow peak and the sun peak by inserting breakpoint c, compressing the original values where few pixel counts exist.

Even less contrast between shadowed and sunlit regions are left in Fig. 11-9B (with histograms in Fig. 11-9E). The two histogram peaks have moved closer, in the blue channel even melted together. This is the result of a more sophisticated contrast enhancement realized with professional photo-editing software (*Adobe Lightroom*). Here specific tonal ranges were modified separately in

succession, addressing the lights, darks, and shadows individually.

The contrast enhancements presented above were carried out on 8-bit images that are already compressed versions of the originally higher dynamic range the sensor had recorded. Stretching parts of the histogram to greater contrasts results in missing brightness values or jumps between color shades (banding) as may be seen from the shadow peaks in Fig. 11-9D. For strong adjustments, this effect may even become visible to the naked eye in the enhanced image. It may be avoided by processing the image in RAW format at higher radiometric resolution (12 or 14 bit) and converting it to an 8-bit file afterward. As computer screens and printers (let alone our eyes) cannot make use of the larger image depth anyway, the

Fig. 11-9 Vertical aerial photograph of gully erosion near Icht, South Morocco. Field of view ~35 m across; kite photo taken with DSLR camera by IM, JBR, and M. Seeger; image processing by IM. (A) Original image without processing. (B) Piecewise linear contrast enhancement using the histogram function modification in D. (C) Non-linear contrast enhancement using various tonal corrections in photo-editing software. (D) Histograms of the original image (in gray) and the contrast-enhanced image B (in color), with modification graphs (see text for explanation). (E) Histograms of the contrast-enhanced image C.

(Continued)

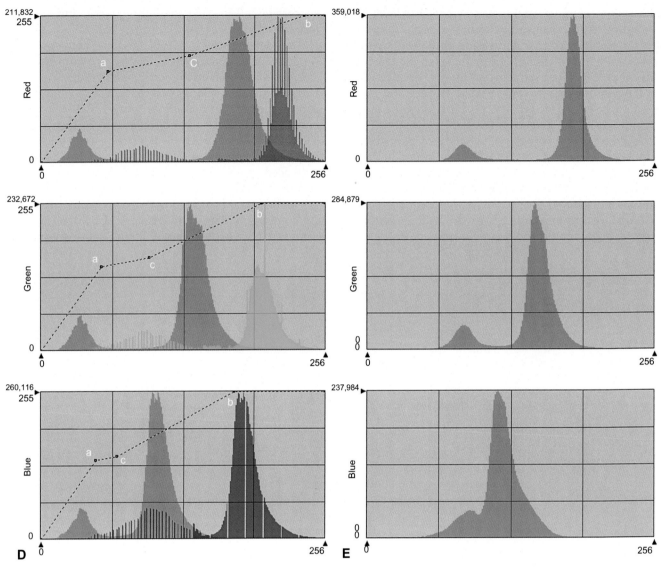

Fig. 11-9, Cont'd

reduction to 8 bit would not degrade the image quality, but the banding caused by the contrast stretch would be smoothed out to invisibility. Working with RAW imagery offers many advantages for post-processing that are beyond the scope of this book; for more details the user is referred to the wide choice of manuals on digital photo processing (e.g. Verhoeven 2010; Langford and Bilissi 2011).

The examples discussed so far are meant to improve color contrasts throughout the image. In some cases, however, it might be useful to enhance or even overenhance only parts of the image in order to maximize the discrimination of tonal ranges associated with certain types of features. This is illustrated with an agricultural scene (Fig. 11-10), where only the image values associated with the fallow field were stretched in the histogram, followed by a strong saturation boost in the IHS color space. As a result, the assumedly homogeneous field now shows clear

distinctions of different zones, from blackish blue, to yellowish brown, to pink, to light cream colored. Such techniques are useful mapping aids for soil survey and may help to reduce the number of bore holes in field sampling by up to 50% (Fengler 2007). A convenient way to optimize contrast stretches for specific image areas is to zoom into this region and use the option for dynamic range adjustment for the current display extent, which exists in many image-processing and GIS software packages.

11-3.3 Image Filtering

Image filtering involves so-called neighborhood operations, in which the value for each pixel in the scene is recalculated based on the values of surrounding pixels. In a simple example, the value for a pixel represents the average of surrounding pixels as defined by a window or convolution mask with the target pixel at the center.

Fig. 11-10 Agricultural fields near Nieder-Weisel (Wetterau), Germany. Hot-air blimp photograph with analog SLR camera by A. Fengler and JBR; image processing by IM. (A) Digitized transparency slide, corrected for slight vignetting. (B) Color stretch and saturation boost applied for enhancing fallow land area.

Typical square window sizes are 3×3, 5×5, 7×7, and so on (Fig. 11-11). This type of manipulation is called a low-pass or low-frequency filter, and the result blurs the image by smoothing out pixel-to-pixel variations. This approach may utilize simple averages or other statistical functions for calculating the value of each pixel in the image, and windows with other shapes may be employed (Jensen 2015). In any case, larger windows create more smoothing or blurring of the visual image. Low-pass filters may be useful for reducing noise or other undesired high-frequency patterns in order to homogenize

areas with similar spectral properties and bring out more clearly the detailed patterns in an image.

The opposite is to enhance small pixel-to-pixel variations, known as high-pass filtering or sharpening. First a low-pass filtered version of the original image is produced; then the low-pass value for each pixel is subtracted from twice the original value (Jensen 2015). The effect is to magnify the local variations between pixels. A further filter type is edge enhancement, which is designed to highlight boundaries within the image; many types of edge enhancements exist and are available in image-processing software.

Unsharp mask is a traditional darkroom technique adapted for digital imagery. This filter brings out edge detail and is usually the last operation applied for image processing. For general display, unsharp mask is recommended (Fig. 11-12). However, over or more sharpening should be avoided, as it creates many small artifacts.

11-4 IMAGE TRANSFORMATIONS

Image transformations are operations that reexpress the existing information content of an image by generating a new set of image components representing an alternative description of the data (Mather and Koch 2010; Richards 2013). Some authors (e.g. Jensen 2015; Lillesand et al. 2015) group multispectral transformations under image enhancements because they are designed to increase the visual distinctions between image features and offer a changed look at a scene. Image transformation techniques include spectral ratioing, principal components analysis (PCA), color-space transformations, image fusion for pan-sharpening, and Fourier analysis. The latter, which transforms an image from the spatial domain into the frequency domain (Mather and Koch 2010), may be useful for analyzing or eliminating specific patterns

Fig. 11-11 Highly magnified view of a tombstone from Fig. 5-15 displaying individual pixels in the original image. Windows of 3×3, 5×5, 7×7, and 9×9 are indicated. Such windows are the basis for low-pass filtering, which blurs or smooths the image.

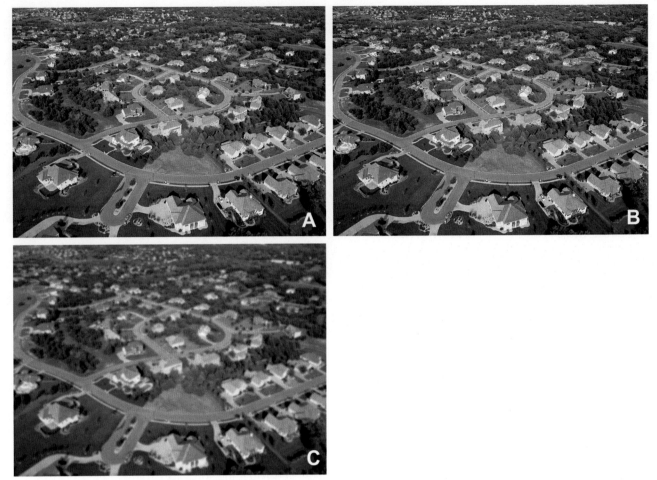

Fig. 11-12 Examples of image filtering. (A) Starting image that has been cropped and given brightness enhancement, but without any sharpening or blurring. Helium-blimp photo taken with a compact digital camera over suburban housing district in Manhattan, Kansas, United States. Image processing by JSA done with *Adobe Photoshop* software. (B) Unsharp mask, amount = 30%, radius = 2 pixels. (C) Gaussian blur, radius = 5 pixels.

from an image (see Fig. 4-33B; Marzolff 1999); however, it is a complex technique rarely used for SFAP processing and shall not be discussed further here. Pan-sharpening, too, is a technique not used for SFAP, but for multiresolution satellite sensors such as *WorldView* or *GeoEye*.

11-4.1 Image Ratios and Vegetation Indices

An image ratio is the result of dividing the pixel values of one image band by the corresponding values in another image band. The effect is that spectral variations between the image bands are enhanced while brightness variations are suppressed. This makes image ratios useful for two main purposes, namely distinguishing more clearly between features with subtle color differences and reducing the shadowing effect in sunlit scenes (usually called "topographic effect" in remote sensing, because relief is the main cause for shadowing in small-scale images).

Owing to their high resolution and low flying height, SFAP images are often strongly subdivided into sunlit

and shadowed parts (see Chap. 4). Fig. 11-13A shows a vertical view of pine trees in a reforestation area in southern Spain. Stark shadows are cast by the trees onto the bare soil, low shrub and grass vegetation, and also onto neighboring trees. In the bottom part of the image, the steep slopes dropping into a dry valley are also heavily shadowed. Classifying this image, for example, for analyzing pine canopy and shrub/grass cover, would result in serious misclassifications because the brightness differences by shadowing are much greater than the spectral differences that distinguish the cover types.

In order to suppress the darkening effect, the ratio between the green and blue image bands was calculated after adding a constant value of 25 to the green band (Fig. 11-13B). This offset constant was necessary because of the slightly different shadowing factor due to higher scattering of the blue wavelengths (see also Mather and Koch 2010). In the resulting ratio image, the pine trees clearly stand out against the shadowless background of light soil and grayish shrub and grass cover. The tus-

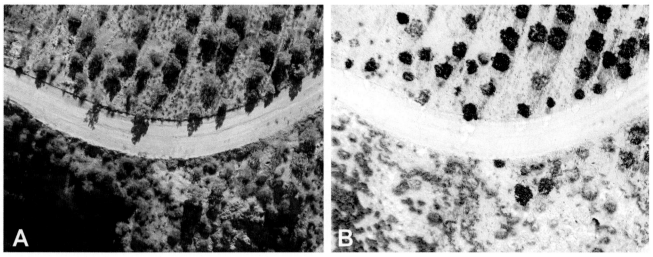

Fig. 11-13 Open pine forest near Negratín Reservoir, Province of Granada, Spain. (A) Hot-air blimp photograph taken with DSLR camera by JBR, V. Butzen, and G. Rock. (B) Ratio image of green and blue image band (white: ratio value = 1, black: ratio value >3). Image processing by IM.

socks on the steep slope in the lower left are now even better discernible than their sunlit counterparts. Such ratio images may be useful as an additional image channel in multispectral classification, helping to reduce the spectral confusion between sunlit and shadowed areas (Marzolff 1999; see also Fig. 11-18).

Even more important is the role of image ratios for enhancing spectral characteristics of minerals or vegetation. Vegetation is a surface cover type with characteristic spectral reflectance curves (see Fig. 4-13). The steep slope between the near-infrared (NIR) and red wavelengths—called the "red edge" (RE)—occurs for no other ground-cover types, and describing it with image ratios using these spectral bands has long been an important method for investigating biophysical parameters of vegetation. Vegetation indices are designed to indicate, for example, leaf area index (LAI), green biomass, percentage cover, chlorophyll content, or protein content, while normalizing effects of shadowing and illumination variation. For crop analysis, as an example, NDVI imagery could reveal weed infestation, insect damage, disease, irrigation conditions, plant stress, yield biomass, growth vigor, and other factors. An overview of various vegetation indices is given by Jensen (2007).

The most commonly known vegetation index, the so-called normalized difference vegetation index (NDVI), calculates as the ratio of the difference between NIR and red divided by their sum (Tucker 1979; Lymburner et al. 2000). Variations exist where the red is replaced by blue or green spectral values. With the advent of red edge spectral bands in satellite and UAS sensors in recent years, the normalized difference red edge index (NDRE) has been developed (Potgieter et al. 2017; Simic Milas et al. 2018a).

$$NDVI(red) = (NIR - red) / (NIR + red)$$

$$NDRE = (NIR - RE) / (NIR + RE)$$

In either case, values range from −1 to +1 with high positive values indicating emergent, photosynthetically active vegetation. The NDVI is particularly useful for ecological studies of biomass, leaf area index, and photosynthetic activity (Murtha et al. 1997). The NDRE is highly correlated with canopy chlorophyll, and less prone to saturation for dense biomass crops in peak season.

NIR wavelengths may also be captured with small-format cameras (see Chap. 6-5), and a number of SFAP studies have employed this index or its G(reen)NDVI variation for research in vegetation conditions and agricultural crop growth parameters (e.g. Buerkert et al. 1996; Hunt et al. 2005, 2011; Jensen et al. 2007; Berni et al. 2009; Mathews 2014; Sankaran et al. 2015a; Zaman-Allah et al. 2015). Practical applications of vegetation indices from UAS imagery may be found increasingly in precision agriculture with the aim of increasing crop yields (Zhang and Kovacs 2012; Sankaran et al. 2015b), although transferring the well-established procedures of vegetation indices computation from satellite-image resolutions to the ultra-high UAS resolutions is challenging (Candiago et al. 2015).

For such quantitative as well as for qualitative image analysis (see Chap. 11-5), the consistency of reflectance values recorded in the image dataset is of particular importance. Different digital camera images from the same survey or from varying dates may show radiometric variations due to varying exposure settings, solar illumination, multiview-angle effects, and atmospheric conditions

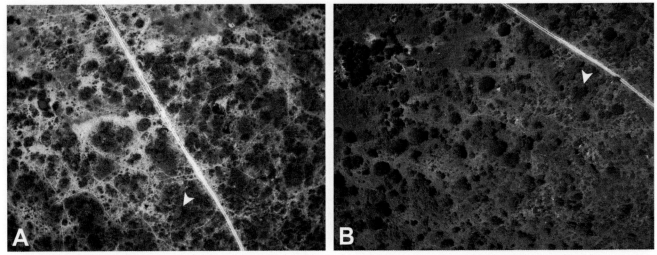

Fig. 11-14 Savanna landscape in Kruger National Park, South Africa. Two images from a time series of color-infrared aerial photography taken with a digital *Tetracam* ADC from helicopter by M. Delgado, S. Higgins, and H. Combrink. (A) November 2008. (B) March 2009. Early-flushing trees (see arrow for example) clearly stand out in the November image with high infrared reflectance, but appear darker in the March image. The areas covered by the two images do not coincide exactly; use pond in upper left and dirt track for orientation. *Courtesy of M. Delgado.*

(e.g. Rasmussen et al. 2016). If ratio values are to be correlated with field measurements or compared over time in a monitoring project, it might therefore be necessary to perform some kind of radiometric calibration. A feasible method is to photograph, at the beginning, end, or during the survey, some unchanging standard objects such as colored panels or white reflectance standards and cross-calibrate the values derived from the image with these reference values. Such procedures have been reported, for example, by Inoue et al. (2000), Hunt Jr et al. (2005), Higgins et al. (2011), and Verger et al. (2014).

Fig. 11-14 shows two images from a time series taken in Kruger National Park for a research project conducted by the universities of Cape Town (South Africa) and Frankfurt am Main (Germany). Spatial and seasonal patterns of NDVI along a rainfall gradient in savanna landscapes were investigated with small-format color-infrared photography (taken with a *Tetracam* ADC camera) and hyperspectral spectroradiometer measurements. The aim was to improve the understanding of savanna leaf phenology by determining the partial contribution of trees and grasses to the total landscape greenness.

Two types of datasets were derived from the images, a land-cover map distinguishing grasses, early- and late-flushing trees, and an NDVI times series of 10 dates (Fig. 11-15). NDVI value statistics were then calculated for the three vegetation cover classes. The high temporal and spatial resolution of the images allowed, for the first time, for the contributions of grasses and early- and late-flushing trees to NDVI values to be distinguished, and it could be shown that grasses and the two types of trees have different leaf deployment strategies (Combrink et al. 2009; Higgins et al. 2011).

The Kruger National Park study is a good example for the advantages SFAP may present over conventional remotely sensed images in terms of spatial and temporal resolution. Satellite imagery with medium to low spatial resolution, common in vegetation conditions research, would not allow distinguishing clearly between the three cover types. High-resolution satellite imagery, on the other hand, is too expensive or too infrequently collected to meet the requirements of a time series adapted to site-specific phenological cycles. For this study, the National Park administration's helicopter was used as the sensor platform, but was replaced by a helicopter UAV later because of the logistical and financial efforts associated with the manned platform.

11-4.2 Principal Components Analysis and Color-Space Transformations

PCA is often used as a method for data compression in multispectral and hyperspectral imaging with the aim of statistically maximizing the amount of information from the original *n*-dimensional image into a much smaller number of new components (Mather and Koch 2010). SFAP images certainly do not present challenges to the analyst in terms of dimensionality, but PCA still may be interesting for natural-color SFAP because it transforms the three original image bands (blue, green, and red) into statistically uncorrelated bands. As the correlation of spectral values within the visible range of the spectrum is usually particularly high, this may result in an altogether different, colorful view of the scene. An example is given in Fig. 11-16, where the vertical view

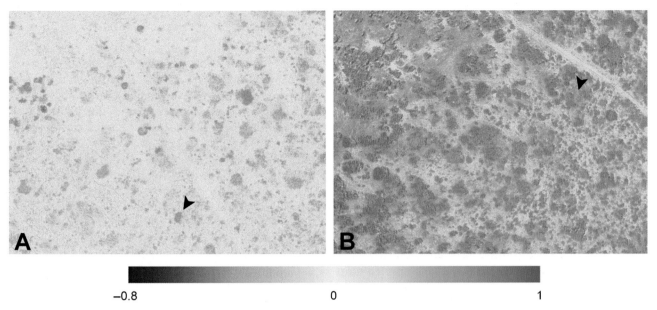

-0.8 0 1

Fig. 11-15 NDVI datasets derived from the images in previous figure. Image processing by M. Delgado. (A) November 2008, mean NDVI 0.19. (B) March 2009, mean NDVI 0.56. Early-flushing trees (see arrow for example) show the highest NDVI values in the November image, but have been overtaken by the late-flushing trees in March. *Courtesy of M. Delgado.*

of the highly patterned, but rather color-monotonous landscape shown in Fig. 5-17 was transformed by PCA. Note the striking variations of colors on the allegedly homogeneous fallow field left of the center and the new olive grove in the lower right corner, and the vivid green distinction of the larger trees at the image center.

Similar effects may be achieved with color-space transformations, for example, conversion of the image from the RGB to IHS color system (Chap. 5-2.5). As with ratio images, PCA components and IHS image bands may improve classification results for object classes which are otherwise difficult to distinguish in the original RGB bands (Laliberte et al. 2007).

Fig. 11-16 Principal components image (RGB = PCA1, PCA2, PCA3) of the aerial photograph shown in Fig. 5-17. Image processing by IM.

11-5 IMAGE CLASSIFICATION

The pixel values in a digital or scanned analog photograph are the result of spectral reflectance measurements by the sensor or film. Thus, they carry detailed quantitative information about the spectral characteristics of the surfaces or objects depicted, usually in an image depth of 8 or 12 bits per band. No human interpreter is able to appraise visually the subtle differences that may be recorded with such high radiometric resolution. Also, the small patterns and fine spatial details presented by different ground-cover types often make it impractical, if not impossible, to map their distribution by hand. Image classification techniques aim at the automatic identification of cover types and features using statistical and knowledge-based decision rules (Mather and Koch 2010; Richards 2013; Jensen 2015; Lillesand et al. 2015).

Classical pixel-based methods of image classification are based on the recognition of spectral patterns by analyzing solely the brightness values of the individual pixels across multispectral bands. However, while spectral reflectance—color—is the most important quality distinguishing individual ground-cover types in an image, it is by no means the only one, and shape, size, pattern, texture, and context also may play important roles for identifying features (see Chap. 10). Elements of spatial pattern recognition, knowledge-based rules, and segmentation and (geographic) object-based image analyses (OBIA or GEOBIA) techniques have gained in importance during the last 20 years since very high-resolution satellite imagery has become available. Beyond looking

at individual pixels only, these techniques analyze groups or patches of pixels in their spatial context.

Well-established methods both for unsupervised and supervised multispectral classification exist. The challenge for the analyst is to describe the object classes that are desired for the final map in terms of well-distinguished spectral classes. In spite of their reputation as uncomplicated, easy-to-use image data, this may be surprisingly difficult with small-format aerial photographs. One of the great assets of SFAP—its high spatial resolution—is also a drawback for multispectral image classifiers (e.g. Zweig et al. 2015). The fine details of color, texture, light, and shadow that are recorded for the objects with GSDs usually in the centimeter range often bring about within-class variance that may be higher than the spectral differences between classes. In addition, reflectance values in the visible spectrum are much more highly correlated with each other than in the longer wavelengths recordable with electronic scanners operating in the full width of the infrared spectrum. And finally, brightness variations within the image (vignetting effects, multiview-angle effects, shadowing) and between images (exposure differences, viewing-angle differences) are more prominent in SFAP images than for satellite images or metric large-format cameras at high flying altitudes.

Accordingly, the number of studies employing automatic classification techniques for small-format images is still quite rare compared to those using visual interpretation, manual mapping, and photogrammetric measuring. Some researchers use simple thresholding procedures to classify just two or three classes. Marani et al. (2006), for example, successfully extracted small intertidal channel structures by SFAP thresholding. In a study that used UAS imagery for validating low-resolution MODIS satellite observations of Arctic surface albedo variations, Tschudi et al. (2008) also used thresholding for classifying ice cover, melt ponds, and open water, as the gray-scale nature of their scenes made more complicated multispectral methods dispensable.

Classification techniques may be used to derive not only qualitative but also quantitative information from images. Fig. 11-17 illustrates the unsupervised classification procedure employed for deriving detailed maps of percentage vegetation cover in a study on vegetation development and geomorphodynamics on abandoned fields in northeastern Spain (Marzolff 1999; Marzolff et al. 2003; Ries 2003). Film (35 mm) photographs taken

Fig. 11-17 Procedure for classification of vegetation cover shown with subset of a hot-air blimp photo taken with an analog SLR camera. Six-year-old fallow land formerly cultivated with barley near María de Huerva, Province of Zaragoza, Spain. Field of view ~6 m across. (A) Georectified image. (B) Classified percentage cover (white=0%, black=100%). (C) Mean filtered classification. (D) Final map in five vegetation cover classes. The influence of the old plowing furrows running diagonally from top left to bottom right is clearly revealed.

from a hot-air blimp were georectified to 2.5cm GSD (Fig. 11-17A) and classified into 15–20 spectral classes with an unsupervised ISODATA clustering algorithm. These classes were then allocated to percentage vegetation cover based on field observations and close-range reference images (Fig. 11-17B). The aim was to produce a vegetation map with distinct zones that representatively described the cover patterns in a predefined classification scheme. Therefore, the classified dataset was filtered with a 5×5 mean filter (Fig. 11-17C), recoded into five cover classes, and again filtered with a 7×7 majority filter (Fig. 11-17D; see also Marzolff 1999). The resulting map shows that on the 6-year-old fallow land, vegetation is sparse and mostly limited to the slight depressions of the old plowing furrows.

Often, the microstructural details depicted by the high resolution of SFAP together with shadowing effects (cast shadow, internal vegetation canopy shadowing) necessitate more sophisticated supervised classification procedures even for "simple" object classes. Lesschen et al. (2008), for example, found that the supervised maximum likelihood method was the only one that allowed distinguishing bare soil from vegetation patches in vertical SFAP of a semiarid environment and also classified the shaded areas correctly. The example from a comparable field site in Fig. 11-18A shows that heavily shadowed images (compare with Fig. 11-13A) may still be difficult to classify correctly. Using an additional ratio band for suppressing shadowing effects significantly improved the results in this case (Fig. 11-18B). Although the ratio-classified image still shows some misclassifications at the edges of cast shadows, shrub and grass cover in shaded areas are classified much better, and the pine tree canopy appears less frayed.

The limitations of traditional pixel-based classification approaches for identifying compound objects and patterns in high-resolution imagery—which concerns not only SFAP and UAS imagery but also very-high-resolution satellite images—are increasingly being addressed by much more complex approaches of (GE) OBIA. OBIA comprises image segmentation, feature extraction, and expert-knowledge classification concepts. By analyzing spatial as well as spectral information, the algorithms aim at delineating meaningful objects at multiple scales rather than classifying individual pixels (Blaschke 2010; Blaschke et al. 2014; Jensen 2015). The process may also incorporate any other spatially distributed variable such as elevation or slope. Similar to the exponential rise of studies using UAS imagery and SfM-MVS photogrammetry for the creation of high-resolution topographic data in geomorphology (see Chaps. 3-3 and 11-6), OBIA approaches in classifying UAS images and orthophoto mosaics for vegetation and land-cover mapping have expanded rapidly in the last decade. A number of studies have shown that object-based classification yields higher accuracies than pixel-based methods (e.g. Kraaijenbrink et al. 2016; Pande-Chhetri et al. 2017).

Extensive work on object-based classification of natural-color and NIR SFAP for rangeland monitoring has been done at the Jornada Experimental Range in New Mexico, United States, and other sites by Laliberte and colleagues (Rango et al. 2006; Laliberte et al. 2007, 2010; Laliberte and Rango 2011). As the potential of natural-color RGB imagery for distinguishing plant types and other ground cover is limited due their spectral similarity in the visible light range, many studies incorporate not only multispectral information (e.g.

Fig. 11-18 Supervised maximum likelihood classification of the image shown in Fig. 11-13A; image processing by IM. (A) Classification of original RGB image. (B) Classification of composite of green image band and ratio image of green and blue image band shown in Fig. 11-13B. Dark green = pine trees; medium green = grasses and shrubs; light green = bare soil.

Laliberte et al. 2011; Peña et al. 2013; Mathews 2014) but also digital surface models (DSM) as ancillary data in the classification process. Komárek et al. (2018), for example, found that the fusion of visible and multispectral imagery with thermal imagery and a vegetation height model improved classification results of land cover and vegetation types at the Prague University arboretum.

The advantage of multivariable and multitemporal OBIA including multispectral and vegetation height data is also reported for non-woody vegetation such as aquatic plants (Husson et al. 2017) or river-floodplain vegetation (Van Iersel et al. 2018). Furthermore, the use of DSMs as one variable in the object-based classification process allows classifying plants not only by type but also by dimensions such as height and volume (e.g. Torres-Sánchez et al. 2015; De Castro et al. 2018).

Not surprisingly, DSMs also improve automated mapping of non-vegetation structures that have distinct morphological characteristics but limited spectral contrast, such as cliffs and ponds on glacier surfaces (Kraaijenbrink et al. 2016) or agricultural terraces (Diaz-Varela et al. 2014). Such classification approaches based on fusion of spectral and heighting information clearly profit from the now commonly used photogrammetric workflows that integrate production of DEMs and orthophotos from the same image set.

For ultra-high-resolution imagery such as SFAP, object-based classification techniques have brought considerable progress in automated mapping. The user should be aware, however, that unlocking the potential of OBIA for a particular application may come at high computational and conceptual costs. OBIA classification workflows do not come ready-made and easily transferable and need to be carefully parameterized for specific imagery.

11-6 PHOTOGRAMMETRIC MAPPING, MODELING, AND ANALYSIS

The analysis of remote sensing images may involve both qualitative and quantitative aspects. With the exception of multivariable approaches including DSMs, the image enhancement, transformation, and classification methods discussed in the previous sections work in 2D space, creating "flat" map products. For measuring, mapping, and quantifying in 3D, photogrammetric methods of analyzing stereo images are used (see Chap. 3). These may be roughly categorized in manual-visual mapping methods and automatic extraction of 3D coordinates. Some approaches applicable for SFAP that the authors of this book judge the most useful and commonly applied are introduced briefly in the following sections.

11-6.1 Manual Measuring and Mapping From Stereomodels

In a single image, the location of a point is given by its positions x, y. Its corresponding 2D object space coordinates X, Y may be determined by some method of georeferencing as described in Section 11-2. When measuring from stereo images that have been relatively and absolutely oriented in a ground coordinate system (see Fig. 3-11), the stereoscopic parallax of a point is measured additionally for deriving its height Z. All stereoscopic measurement devices—analog parallax bars for stereoscopes, analytical stereoplotters, digital photogrammetric workstations—make use of the principle of the floating mark or cursor. Small marks etched onto a glass bar or superimposed as dots or crosses of light are displayed over the left and right images independently. By adjusting their position so that they fuse into a single mark at the exact location of the point to be measured, the x-parallax and thus the height of the point may be determined.

The floating mark is perceived by the operator as resting exactly on the terrain surface when the left and right marks are placed on corresponding points, that is, over the same feature in the two images (Fig. 11-19). Most digital photogrammetric workstations offer the possibility of automatically adjusting the floating cursor height when the mouse is moved over the terrain. This is accomplished by the same digital image correlation techniques that also are used for automatic tie point generation and 3D point-cloud extraction (see Chaps. 3-3.4 and 3-3.5). This technique saves the operator continually adjusting the x-parallax to changing terrain height; however, its success does significantly depend on local image contrast, texture and pattern.

Apart from individual measurements of 3D point positions, distances, areas, volumes, angles, and slopes, digital photogrammetry systems with stereoviewing facilities allow the direct stereoscopic collection of georectified 3D GIS vector data as point, line, or polygon features. These may then be used in GIS software for further editing, analysis, and visualization as well as combination with orthophoto maps. Such softcopy stereoplotting techniques are basically the fully computerized implementation of traditional stereoplotting methods (e.g. Wolf et al. 2014), where the movements of the floating mark in the analog stereomodel were mechanically transmitted to a tracing pencil on a sheet of paper (mechanical stereoplotters) or converted into coordinates recorded by a linked CAD system (analytical stereoplotters). The high-end technologies for digital stereoviewing that are required for 3D mapping were briefly introduced in Chap. 10-4.3.

Stereoscopic mapping as opposed to mapping from 2D imagery has three major advantages:

- Result is distortion-free because the floating-mark positions are automatically converted to object coordinates.

Fig. 11-19 Floating mark (stereo cursor) positioned at the edge of an erosion channel in a digital stereomodel (subset). Image width ~4.3 m, height of channel wall ~2.3 m. Vertical kite photos taken with a DSLR camera at the Bardenas Reales, Province of Navarra, Spain. Use the first stereoviewing method described in Chap. 10-4 to view this image pair stereoscopically.

- Terrain height information (spot heights, contour lines) may be mapped.
- Identifiability and delineability of three-dimensional objects are much improved.

In geomorphology, in particular, the analysis of stereoscopic imagery has innovative potential for an improved understanding of landforms and their associated process dynamics. Fig. 11-20 is an example for a large-scale topographic map of the gully also shown in Fig. 11-1. It was digitized with *IMAGINE Stereo Analyst* using a photogrammetric block file created with *Leica Photogrammetry Suite* and prepared for cartographic visualization with *ESRI ArcGIS*. This map could not have been compiled in the same detail from the already presented 2D imagery because features such as the drainage lines, the gully edges, or the heaps of soil material broken off the gully walls are difficult or impossible to identify and delineate precisely without depth information. The distribution of collapsed gully wall material and vegetation cover within the gully provides indications of recent and past gully development, helping to look back in time from this first image of a long-term monitoring project (see also Giménez et al. 2009).

One problem associated with stereoviewing SFAP image blocks is that the variations in scale and orientation are often higher than usual with traditional aerial photography—even kite aerial images intended to be "vertical" may easily be tilted 5–10° from nadir, and differences in flying height of a few meters between consecutive images also are not uncommon. Depending on the stereoviewing software used, this may result in the whole stereomodel appearing tilted and distorted, which is difficult to view. Choosing stereopairs with strong tilt or >5% scale difference should therefore be avoided. Quick-check techniques like the one shown with Fig. 10-42 are helpful for looking through a large image series.

11-6.2 Generation and Analysis of 3D Point Clouds and Digital Elevation Models

Stereo-photogrammetrically created maps such as those in Fig. 11-20 do not give a continuous representation of the Earth's surface. An introduction to automatic extraction of dense 3D point clouds from digital stereomodels was given in Chap. 3-3. There are various data models for storing three-dimensional surface elevations. In the geographical information sciences, data formats are traditionally used that do not truly capture 3D, but 2.5D information—only one Z value per X,Y location may be stored. These may be stored in raster format (DEM) or in vector format (triangular irregular network, TIN).

Drainage rill/undercutting drainage rill

Plunge pool

Collapsed gully wall material

Dense vegetation

Fallow field

----- Gully edge, piping hole edge

——— 0.5 m contour

Fig. 11-20 Topographic map of gully Bardenas 1, Bardenas Reales, Province of Navarra, Spain (compare Fig. 11-1). Based on kite photography taken with a DSLR camera by JBR, M. Seeger, and S. Plegnière; photogrammetric analysis and cartography by IM.

True 3D format may be stored in 3D point clouds or 3D meshes. While the former has become rather common in GIS environments through terrestrial or aerial laser-scanning data or LiDAR (TLS and ALS with point clouds in LAS format), 3D meshes are still more common in the computer-vision domain. Both 3D formats play an increasing role in SFAP and UAS

remote sensing as SfM-MVS photogrammetry with its computer-vision background is gaining in popularity (see Chap. 3-3.5).

Digital elevation model or DEM is actually a general term for what may more specifically be a surface model (DSM), including surficial cover such as vegetation and buildings, or a terrain model (DTM), which represents bare-earth ground surfaces only (e.g. Lillesand et al. 2015; Carrivick et al. 2016). DEMs derived by automatic extraction of 3D coordinates from optical remote sensing data are inherently DSMs (with the partial exception of LiDAR, which may look through vegetation though not buildings). This is particularly true for SFAP, where GSDs and heighting resolution are very high and even low vegetation cover and small plants (e.g. lawn, weeds, wispy bushes) will be present in a photogrammetrically produced 3D point cloud.

Depending on the research focus, SFAP-derived photogrammetric elevation models may be used for analysis of the actual terrain surface (preferably with true ground-level DTMs) or for the analysis of height and volume of the above-ground features, particularly vegetation (with DSM). If a DTM is required, the point cloud needs to be manually edited or automatically filtered to remove points that do not represent bare earth. Manual editing is cumbersome, and best done in a stereoscopic viewing environment as discussed above. For automatic filtering and classification, two basic characteristics of the points may be used: their color properties or their (relative) height. The first method requires that spectral information is transmitted from the original imagery to the extracted points, so points with certain colors—e.g. green vegetation—may be classified and removed. The second is based on removing points whose height and angle relative to the lowest point in a given neighborhood exceed specified thresholds.

Various such filters exist (Passalacqua et al. 2015) and are able to remove individual trees or model roughness from sparse vegetation (e.g. Hugenholtz et al. 2013; Javernick et al. 2014), but may prove of limited success in landscapes of high relief complexity and dense vegetation. An example for an easy case is given in Fig. 11-21, where regularly spaced orange trees, hedges, and other medium-sized objects in rather flat terrain were successfully filtered from the DSM without affecting small-scale topography. Filtering tools are integrated in many photogrammetry packages, but dedicated point-cloud processing software such as *CloudCompare* or *LASTools* offer even more advanced techniques for filtering and classification.

The option to produce both a DSM and a DTM from the same set of images is of particular interest for studies on vegetation volume and height. By subtracting the DTM from the DSM, a normalized DSM (nDSM) or canopy height model (CHM; see Fig. 11-21C) may

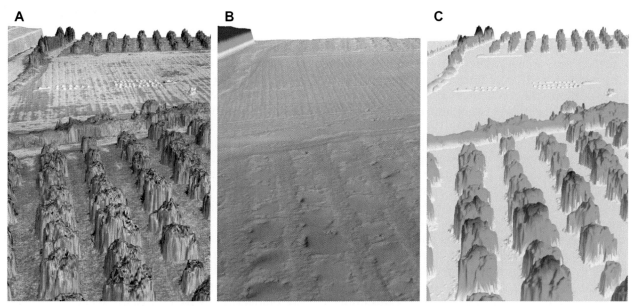

A B C

Fig. 11-21 Perspective view of three elevation models of an agricultural scene near Taroudant, Morocco, comprising orange-tree plantations, hedges, fallow land with beehive boxes, and a greenhouse. Based on fixed-wing UAV photographs taken with MILC; SfM-MVS photogrammetric processing by IM. (A) DSM from unfiltered dense point cloud, draped with orthophoto. (B) DTM with trees, hedges, and beehive boxes removed through automatic point-cloud filtering optimized for tree dimensions. Note that the micro-topography of the fallow field has been retained. (C) Normalized DSM or canopy height model (CHM), computed as DSM-DTM. The beehives boxes (30 cm high) stand out clearly as well as the varying heights of the orange trees (up to 4.5 m).

be produced. If true 3D data—dense point clouds or 3D meshes—are used for this operation, quite accurate volume quantifications are possible. For 2.5D data—raster DEMs or 2.5D meshes—volume accuracy depends on the shape of the plants, but heighting accuracy has been found promising (Lisein et al. 2013; Zarco-Tejada et al. 2014; Torres-Sánchez et al. 2015). The detection of treetops and delineation of individual trees is a common application of CHMs, where the inverted model is analyzed with watershed segmentation algorithms. Studies using CHMs for vegetation-structure analysis and biomass estimation may be found for example in ecosystem research (Hernández-Clemente et al. 2014; Cunliffe et al. 2016; Alexander et al. 2018), precision viticulture (Matese et al. 2017), and forest management (Panagiotidis et al. 2017; Torresan et al. 2017; Otero et al. 2018).

DTMs representing the actual ground surface have manifold uses in the geosciences for ultra-high-resolution terrain analysis. Especially geomorphology as a discipline has profited from the potential of SFAP for creating such high-resolution topographic data. Various geoscientists, including the authors, have extracted detailed elevation models with classical photogrammetry (e.g. Hapke and Richmond 2000; Henry et al. 2002; Marzolff et al. 2003; Scheritz et al. 2008; Marzolff and Poesen 2009; d'Oleire-Oltmanns et al. 2012).

In recent years, Structure-from-Motion photogrammetry with UAS imagery and other SFAP has seen a dazzling increase of applications in all fields of geomorphology ranging from microplot to catchment and landscape scale, for example, coastal morphology (Mancini et al. 2013; Brunier et al. 2016), periglacial landforms (Bernard et al. 2017), landslide mapping (Cook 2017; Lucieer et al. 2014a), fluvial morphology (Javernick et al. 2014; Tamminga et al. 2015), rill, gully, and badland erosion (Eltner et al. 2015; Smith and Vericat 2015; Wang et al. 2016) and micro-topography of agricultural and natural relief (Lucieer et al. 2014b; Ouédraogo et al. 2014; Eltner et al. 2018). Several automatic mapping procedures have been proposed for linear erosion forms (Castillo et al. 2014; Bazzoffi 2015; Eltner et al. 2015). For reviews of various applications in geomorphology and physical geography, see also Smith et al. (2016) and Eltner et al. (2016).

Accuracy issues of small-format aerial photogrammetry and challenges of DEM extraction have already been discussed in Chap. 3-3. Obviously, high precision and trueness of terrain models are desirable for many reasons, for example, for accurate representations of form and thus precise quantifications of area and volume, for monitoring topographic change and for correct computation of derivatives such as slope, flow accumulation, and other topographic attributes. The highly automated, encapsulated black-box workflows for bundle alignment, georeferencing, point-cloud extraction and direct DEM generation from stereoscopic image sets are fast and tempting. But their increasing ease of use and visually stunning results tend to conceal the deficiencies

in precision and accuracy of the raw dataset of extracted height points and of the derived elevation models. Therefore, the user should be aware of the limitations of the methodology in every step of the workflow, adapting parameters and procedures where appropriate in order to optimize the reconstruction of the "real-world" surfaces. Some exemplary issues and situations are discussed in the following.

The image-matching process for 3D point extraction is controlled by a set of strategy parameters defining search and correlation window sizes, correlation coefficient limits, etc. Particularly in classical photogrammetry software, the default values for these parameters might not be ideal for SFAP as they are designed for the standard airphoto case where relief energy is lower relative to flying height. Slight adaptions of the matching parameters might improve point density and quality (Lane et al. 2000; Marzolff and Poesen 2009; Smith et al. 2009). For example, a comparatively higher remaining y parallax resulting from lower triangulation accuracy of non-metric images may be taken into account by increasing the search size in y direction that limits the distance of the corresponding point search to the epipolar line. Higher image noise and resolution may result in low point density, which may be counteracted carefully by increasing the correlation window size and decreasing the correlation coefficient limit. An increased search size in x direction may also be necessary if high elevation differences such as steep scarps, causing larger x parallaxes, are present in the scene.

Some situations may call for multiple adaptations of the standard DEM generation workflow. Consider the case of vertical or even overhanging terrain, such as high-mountain rockscapes, undercut cliffs, river banks, or gully headcuts. The vantage of vertical images would capture the steepest areas only partially, resulting in a lack of information in the point clouds. In addition, the interpolation of the 3D points, which may in part be sampled from concave terrain positions, would result in errors at overhangs and undercuts (see Fig. 3-15). This has numerous consequences for the study design. First of all, the image-acquisition survey should include oblique imagery pointing at the steep areas more directly. This in turn might affect the choice of SFAP system, as not all platforms and camera mounts allow for varying the image nadir angle (see Chaps. 7 and 8). Depending on the size and accessibility of the site, terrestrial imagery could be taken in addition to vertical SFAP to solve this problem.

Next, an appropriate photogrammetry software would have to be chosen that allows to combine vertical and oblique imagery, possibly even taken with varying scales. Classical aerial photogrammetry is much less suited for this than Structure-from-Motion approaches, which are designed for multiview, multiscale image

networks. Once a 3D point cloud has been created, it is important to retain the true three-dimensional information and not degrade it to 2.5D format by converting it to a raster DEM or TIN. Consequently, the tools for analyzing the surface model might differ from standard GIS methods and require appropriate plugins or specialized 3D analysis software.

An example for all this is given in Fig. 11-22. This gully, which has developed between greenhouses and citrus plantations in an agricultural area near Taroudant, Morocco, exhibits the typical undercuts of active bank gullies in sedimentary deposits (cf. Marzolff and Poesen 2009). In a SFAP survey conducted at the site in 2014, only (nearly) vertical images could be taken as the fixed-wing UAV employed (*MAVinci Sirius* I; see Chap. 8-2) does not allow to vary the camera angle. In addition, photos of the gully walls were taken from the ground with the same camera type (*Panasonic Lumix* GF1). Ground control points (GCPs) were installed and measured with a total station prior to the survey. *Agisoft PhotoScan* was used to process vertical images only, and again the vertical and terrestrial images combined in order to analyze the difference between the approaches.

The mesh-to-mesh distance analyses from a representative section of the gully wall were computed as Hausdorff distance (Cignoni et al. 1988) in *Meshlab*. Fig. 11-22 shows that a model constructed from vertical images alone would clearly underestimate the gully volume, regardless of whether 2.5D or 3D storage format is used. The four cavities of the scoured-out undercuts are as deep as 0.5 m with respect to the gully edges. The 3D mesh (Fig. 11-22B) is hardly better at capturing the gully-wall forms than 2.5D TIN model (Fig. 11-22A), and seems to be even slightly overshooting the roundness of the upper wall sections. Only the addition of oblique images looking into the cavities allows proper modeling of the gully form (Fig. 11-22C).

Apart from a similar approach combining aerial and terrestrial images for gully measuring by Stöcker et al. (2015), photogrammetric analysis of overhanging and undercut surfaces has so far mostly been reported for terrestrial imagery (e.g. Ružić et al. 2014; Frankl et al. 2015). An exception is the work by Kraaijenbrink et al. (2016), who took advantage of low flying altitude in combination with a wide-angle lens and oblique photos caused by UAV instability for reconstruction of an overhanging ice cliff.

Additional considerations apply for topographic change analysis. SFAP records topography at a given moment in time—the geomorphological processes forming the landscape cannot be seen directly in the image, but they may be deduced from their correlative forms (see Chap. 10-3.2) and, better yet, analyzed from time series (e.g. Fig. 2-6, see also Chap. 14). Change analysis is therefore an important method in the geosciences, and it is crucial to be aware of errors in reconstructing surface

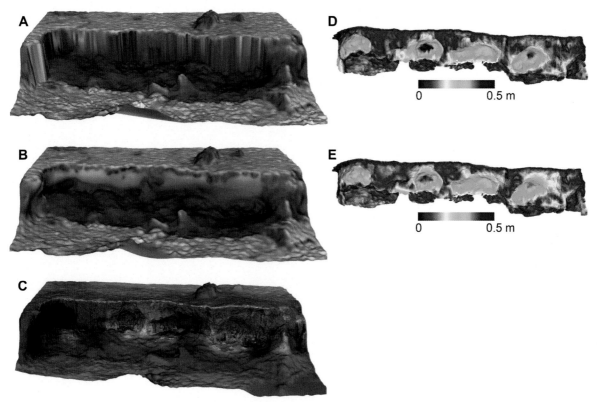

Fig. 11-22 9-m-long gully-wall section of the large Gully Gchechda, near Taroudant, Morocco. Overhangs and undercuts cannot be sufficiently modeled from vertical SFAP only, but need supplementary oblique imagery. (A) 2.5D model (TIN) from vertical SFAP only. Note the allegedly vertical straight gully walls; (B) 3D model (mesh) from vertical SFAP only. Note the rounded and partly indented gully walls; (C) 3D model (mesh) from vertical SFAP and additional oblique images. Note the striking depth of the four cavities in the gully wall; (D) distance between model A and C; (E) distance between model B and C. Image processing by IM.

topography, converting between data formats, and comparing different time steps (e.g. Passalacqua et al. 2015).

DEMs of differences (DoD) are commonly used for quantifying topographic changes at various scales (for SFAP examples, see Eltner et al. 2015; Smith and Vericat 2015; Tamminga et al. 2015; Marteau et al. 2017; Mosbrucker et al. 2017; Eltner et al. 2018; see also Fig. 14-7), and in this context, the reproducibility of the DEMs is an important issue (Clapuyt et al. 2016). One way to account for the errors and uncertainties in a DEM and its propagation to the DoD is to calculate the minimum level of detection threshold (LoD) (Lane et al. 2003; Wheaton et al. 2010) in order to distinguish between noise and actual change in the DoD. Changes below this threshold may then be eliminated from volume calculations, or reported as uncertain.

Uncertainties in surface reconstruction may also propagate to primary and secondary topographic attributes derived from the DEMs, that is, slope, curvature, flow paths, flow accumulation, connectivity index and others (Wilson and Gallant 2000), and automatically extracted geomorphological features (e.g. Castillo et al. 2014; Eltner et al. 2015). Figs. 11-23 and 11-24 show results from an investigation into the hydro-geomorphological reliability of DEMs created from different sets of images

taken during the same aerial survey. The study site, which has a total area of 4.5ha, is an abandoned field at El Houmer in South Morocco (see also Fig. 10-11, taken 5years earlier). It has been affected by rill and gully erosion for decades and was repeatedly levelled with bulldozers—the flatter top part more recently than the rest—in order to be cultivated or used as building ground for the sprawling village.

Four different subsets of images (varying number, scales, and viewing angles) were chosen to generate seven different DEMs with classical photogrammetry (LPS; *Leica Photogrammetry Suite*) and SfM-MVS (SfM01-04; *Agisoft PhotoScan*; for details see Steiner 2015). GIS tools (ESRI *ArcGIS*) for modeling drainage lines and watersheds were used, and the differences between the datasets were analyzed. The precision of automatic drainage-network detection is clearly dependent on rill depth (Fig. 11-23). Even narrow rills (with respect to GSD) are modeled with high precision where they are deeply incised. Shallow rills and diffuse flowpaths in the head section of the gullies, however, are highly sensitive to small variations in terrain heights. For the analysis in Fig. 11-23A, the stream-defining threshold ($20\,m^2$ of flow accumulation area) was chosen so as to capture as

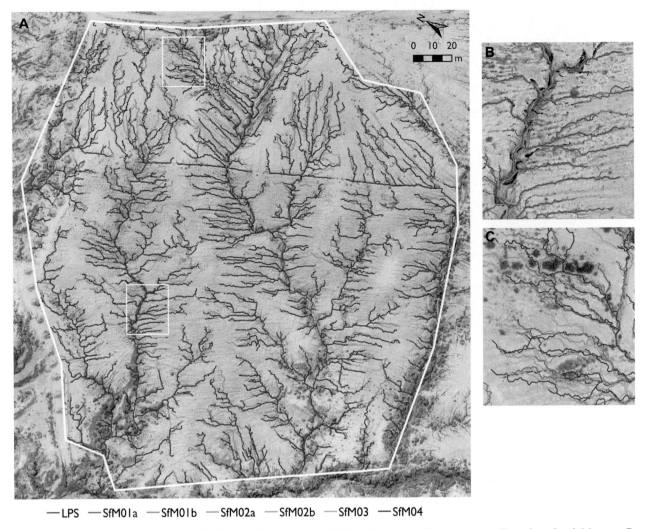

—LPS —SfM01a —SfM01b —SfM02a —SfM02b —SfM03 —SfM04

Fig. 11-23 Comparison of drainage networks derived from various DEMs for a field site at El Houmer near Taroudant, South Morocco. Based on fixed-wing UAV imagery taken with a MILC by S. d'Oleire-Oltmanns with D. Peter and IM. Photogrammetric and GIS analysis by F. Steiner with IM. (A) Differences between five drainage networks (SfM01a and SfM02a not shown here), with LPS model as reference and SfM04 ortho-photo as background. Deeply incised rills are modeled with high precision, but diffuse flowpaths in the flat head sections differ between the models. (B) Detailed subset of all seven drainage networks shows good match in areas with incised gullies. (C) Detailed subset with poor match in flat and featureless areas as well as disturbing influence of vegetation.

many incised rills visible on the orthophoto as possible. In the flatter sections of the study area (particularly the newly levelled top part), this single threshold value is, however, not optimal and captures diffuse flowpaths rather than linear incisions. When the LPS drainage network is taken as a reference, the SfM networks differ by 32%–38%. The deviations are as low as 4% for high hydrological stream orders (i.e. deeper incised gullies; e.g. Fig. 11-23B) and clearly higher (up to 49%) for first-order rills, particularly in areas of little structured, flat surfaces (Fig. 11-23A).

Similar variability is shown in the watershed analysis conducted for a random selection of 100 hydrological junctions (pour points). The comparison of two models (differing by image number and scale) in Fig. 11-24 reveals that small differences in surface elevations and thus flow direction may cause large differences in the watersheds.

Here, congruency (shown in green) is 80%, discrepancy is 17% (rose), and 3% of watershed (tan and violet) are only present in one or the other model (Steiner 2015).

Obviously, the variabilities between these models, which were all created from images taken with the same camera in one single survey, have implications for accuracies of linear erosion monitoring and rill/interrill erosion modeling based on high-resolution DEM, and also for quantification of diffuse sheet erosion. Other studies investigating areas with relatively low non-linear soil-erosion rates in agricultural plots and watersheds (Ouédraogo et al. 2014; Eltner et al. 2015; Pineux et al. 2017) or badlands (Smith and Vericat 2015) show that so far, high accuracies of erosion estimates derived from UAS remote sensing are still limited to small-area studies and not yet competitive for larger survey ranges and the landscape scale. In addition, processes such as

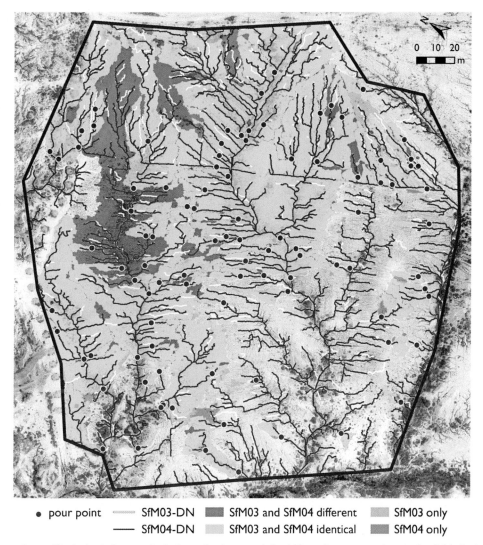

pour point ⚋⚋ SfM03-DN ▉ SfM03 and SfM04 different ▉ SfM03 only
⚋⚋ SfM04-DN ▉ SfM03 and SfM04 identical ▉ SfM04 only

Fig. 11-24 Comparison of hydrological watersheds (contributing areas) for 100 random pour points at the field site in the previous figure, based on two different DEMs. 17% (in rose color) of the area are draining to different pour points in the two models.

compaction, consolidation, swelling, and shrinkage need to be taken into account when quantifying sediment yield using DoDs (Eltner et al. 2018).

These issues pose exciting research challenges for geomorphologists in the next years, and interesting technological and methodological improvements may be expected in the near future. The possibility of high survey repeat rates, in particular, presents considerable advantages for monitoring erosion events compared to conventional measurement techniques. Erosion test plots, rainfall simulations, or rill-flow experiments, for example, require high efforts in the field and involve many uncertainties and error sources (e.g. Ries et al. 2013). Image-based 3D modeling of surfaces is currently one of the most promising approaches in research on erosion rates and other geomorphological processes. The foreseeable further increase in spatial and temporal resolution and automatic processing of large datasets and the expectable improvements in accuracy will continue to strengthen the role of aerial (as well as terrestrial) small-format photography in the geoscience.

11-7 PHOTO FORENSICS

Faked or doctored photographs have been around since the mid-19th century, nearly as long as photography itself (Petrovich 2012). Rapid development of sophisticated image-processing software has led to an increase in highly manipulated or faked photographs in this century. Such digital doctoring of images has even reached peer-reviewed science publications, at which level it may be considered scientific misconduct (Farid 2017). Photo forensics has emerged as a means to evaluate images and to detect excessive manipulation. Forensic analysis is based on the physics and geometry of light from the imaged object, through the camera lens, onto the electronic detector, converted into a digital matrix, and finally processed by software into a viewable image.

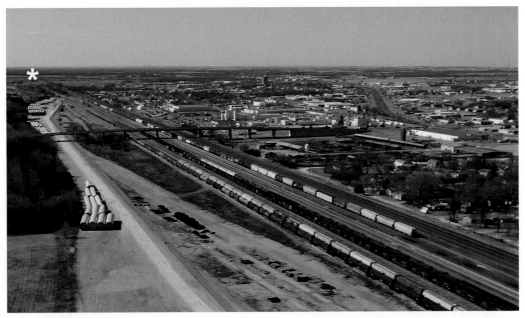

Fig. 11-25 Parallel, multiple railroad tracks appear to converge in the left distance at the vanishing point (*) near the horizon; this image has received minimal enhancement. BNSF Railroad at Emporia, Kansas. Kite photo taken with a compact digital camera by JSA with D. Leiker.

All digital images represent flat, 2D renderings of 3D space; thus, all photographs contain geometric distortions, as discussed in previous sections. Analysis of image geometric properties is one means to detect faked photos (Farid 2017), and this approach is especially applicable for aerial photographs. Detailed photo forensics is well beyond the scope of this book, but a few fundamental concepts may be introduced.

Any image must preserve basic properties of perspective, of which the vanishing point is particularly useful as an indicator of scene integrity (Fig. 11-25). Vanishing points may be referenced to determine the orthocenter of a photograph, in other words the principal point, as one means to verify geometric authenticity.

Shadows are another geometric feature that often apply to aerial photographs. Shadows must be *physically plausible and consistent throughout the scene* (Farid 2017, p. 79). As noted in previous sections, the human eye expects the light source to be positioned above and left of the scene such that shadows fall toward the lower right. It is often convenient to rotate vertical images to achieve this visual effect. This does not change the image in any significant way, however, as the relationships of all objects and their shadows remain plausible and consistent (Fig. 11-26).

Knowing that nearly all digital images are manipulated in some way, it is worthwhile to review what the authors consider appropriate for routine visual image enhancement and display of aerial photographs:

- Rotation to level the horizon in high-oblique images or to make shadows fall toward the lower right in vertical shots.
- Limited cropping of the image following rotation or to emphasize features of interest.
- Limited contrast adjustment to saturate the dark and light ends of image brightness.
- Limited adjustment of individual color bands or color balance.
- Limited sharpening, such as unsharp mask, to bring out details of objects in the scene.
- Discrete annotation of objects or positions within the photograph.
- Mosaicking or stitching of overlapping images taken at (nearly) the same time of the same scene, as noted in the image caption or explanation.

Likewise, it is worth remarking on what represents excessive manipulation in our opinion:

- Excessive adjustment of individual color bands or extreme light-dark contrast.
- Pasting or joining together images that are not originally part of the same scene or were taken at greatly different times.
- Heavy filtering such as blurring and oversharpening.
- Adding or deleting any ground features present in the scene.
- Using image-processing routines to produce painting or other special effects.
- Any type of significant alteration that is not explained in the image caption.

These general guidelines apply to images intended for routine visual display of landscapes and human activities. In some cases, nonetheless, highly manipulated, ratioed, transformed, and classified images may

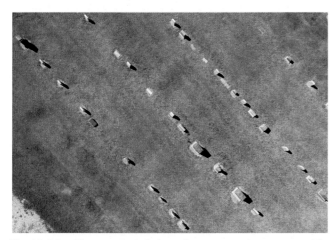

Fig. 11-26 Close-up vertical view of gravestones in a cemetery. The original image was rotated ~90° and cropped for this result, but otherwise it received minimal enhancement. All shadows fall toward the lower right corner and show consistent geometric relationships with the tombstones. Such shadow details apply to all other features in the image including individual blades of grass in the lawn. Kite photo taken with a compact digital camera.

be utilized to depict specific features or for quantitative analysis of objects present in the scene, as described in previous sections. Likewise, some artistic manipulations may verge on the abstract. Such derived images should be identified and explained clearly to avoid misconception. A clear difference exists between an image presented in a scientific publication for documentation of a landscape phenomenon on the one hand and a photograph displayed in an art gallery for visual stimulation on the other. Nonetheless, the boundary between acceptable and excessive manipulation of an image is often a judgment decision by the photographer.

According to Edward Steichen, *every photograph is a fake from start to finish … a purely impersonal, unmanipulated photograph being practically impossible* (quoted in Oser 2014). This is perhaps an extreme view, but it is essentially correct that all photographs represent in several ways mere samples and abstractions of reality that are influenced by human perception.

11-8 SOFTWARE FOR SFAP ANALYSIS

So which software is most suitable? This depends to a large degree on the image-processing tasks to be carried out. A huge range of computer programs exists from quite simple to highly sophisticated, and from free shareware to five-figure expenses. With respect to SFAP applications, image-processing software falls in two important main categories, namely those that understand geocoordinate systems, and those that do not. Another possible distinction is between programs for image visualization and optical enhancement only, and programs

offering additional techniques for extracting secondary information, both qualitative and quantitative, about the objects and areas pictured.

Table 11-1 is an attempt at summarizing and comparing different software types with respect to typical image-processing and photogrammetry tasks. Exemplary software packages named here are those most often used by or known to the authors, but do not imply any general preferences, recommendations, or quality judgements. In addition, dedicated freeware or shareware packages exist for nearly all individual tasks listed that are specialized on certain image-processing procedures (e.g. *PCI Geomatica FreeView* for viewing numerous geospatial file formats, *PTLens* for lens-dependent corrections, *RawTherapee* for developing RAW image format, *Stereo Maker* for stereoviewing, *Bundler* for bundle adjustment and tie-point/sparse point cloud generation, *PMVS2* for dense 3D point-cloud generation).

Increasingly, standard remote sensing and photogrammetry software is being adapted or complemented by tools for ultra-high resolution aerial imagery. Recently most major GIS and remote sensing software packages have extended their functionality toward photogrammetric processing of SFAP and UAS images by providing SfM-MVS plugins (e.g. *OrthoStereoMate* for *QGIS*, *Drone2Map* for *ArcGIS*, *IMAGINE UAV* for *ERDAS IMAGINE*).

11-9 SUMMARY

Image-processing techniques are mathematical or statistical algorithms that change the visual appearance or geometric properties of an image or transform it into another type of dataset. Many established image-processing techniques exist in the remote sensing sciences, and they may be applied to small-format aerial photography just as to satellite imagery or conventional large-format airphotos.

Geometric correction and georeferencing are a prerequisite for most measurement and monitoring applications, and planning and preparing ground control prior to the survey is essential in these cases. Precise geocorrecting of SFAP taken over varied terrain may not be a trivial task, usually necessitating photogrammetric techniques for digital elevation model (DEM) extraction. Image mosaics, controlled or uncontrolled, are commonly created to cover larger areas with high-resolution photographs taken from low heights.

Some degree of image enhancement is applied to most SFAP in order to improve the visual appearance or correct lens-dependent aberrations. Histogram adjustments and filtering are particularly useful techniques. New datasets that show an image in another light may be derived by image transformations, for example, ratioing,

Table 11-1 Summary of software packages usable for SFAP and supported processing tasks.

	Simple image-viewing freeware	Camera software	Professional fully fledged image editing software	GIS software	Remote sensing software	Classical photogrammetry software	Structure-from-motion photogrammetry software	3D point cloud and mesh processing software
Import of camera-specific image formats	O	●	O	–	–	O	O	–
Camera-specific image enhancements[a]	–	●	O	–	–	–	–	–
Radiometric enhancements[b]	●	●	●	O	●	O	O	–
Image scaling/resolution change	●	●	●	●	●	O	O	–
Image georeferencing by GCPs	–	–	–	O	●	●	O	–
Image orthorectification	–	–	–	O+	O+	●	●	–
Creation and overlay of GIS vector data	–	–	–	●	O	O	O	–
Map layouting	–	–	–	●	●	O	–	–
Image classification	–	–	O	O+	●	–	–	–
Vector object extraction	–	–	O	O+	O+	O+	–	–
Stereoscopic viewing	–	–	–	O+	O+	●	O	O
3D analysis/DEM extraction	–	–	–	O+	–	●	●	–
3D point cloud editing and analysis	–	–	–	O+	–	O+	O	●
Software examples	Irfan View	All digital camera brands	Adobe Photoshop, Adobe Lightroom, GIMP, ImageJ	ESRI ArcGIS, QGIS, GRASS, SAGA GIS, Intergraph GeoMedia	ERDAS IMAGINE, TerrSet/IDRISI, ENVI, GRASS, PCI Geomatica, SAGA GIS	IMAGINE Photogrammetry, SocetSet, VirtuoZo, LISA, Photo-Modeler, MicMac	Agisoft PhotoScan, SF3M, Pix4-D, 123D Catch, MicMac, OpenDroneMap	Cloud-Compare, Meshlab, LASTools

[a] White balance, optionally lens distortion correction, chromatic aberration, vignetting.
[b] Contrast, color adjustssments, filtering.
●, Available; O, sometimes, indirectly or partly available; O+, usually available as add-on module; —, not available.

principal components analysis (PCA), or color-space transformations. One of the best-known methods is the computation of a vegetation index from color-infrared images, which enhances the characteristic spectral reflectance of plants and may be correlated with biophysical parameters such as leaf-area index, biomass, or chlorophyll content.

Converting an image into a raster map identifying different ground-cover types or other categories is accomplished with image-classification techniques. The small GSDs, high within-class variances, and low range of spectral bands that are typical for SFAP present, however, a challenge to traditional pixel-based classification algorithms. Classifying beyond simple thresh-

olding tasks for two or three categories might require individual adaptation of standard classification methods. Object-based image analysis (OBIA or GEOBIA) developed for high-resolution imagery is increasingly used for classifying SFAP and UAS imagery.

Arguably the largest advances in SFAP processing in recent years have been made in stereo-photogrammetric mapping, modeling, and analysis, predominantly based on Structure-from-Motion (SfM) approaches. Digital photogrammetry allows stereoscopic measuring and mapping and automatic 3D point cloud extraction for DEM creation. SFAP may, thus, be the base for extremely detailed high-resolution representations and virtual models of 3D terrains and features, which offer exciting potential particularly for geomorpholog-

ical research. In this context, the high spatial resolution and low flying heights present specific challenges for the quality and accuracy of SFAP-derived geodata. These are currently being addressed by numerous research studies.

The processing of images invariably leads to the question of what is allowed or not in terms of image manipulation. The discipline of photo forensics has emerged as a means to evaluate images and to detect fakes. Which software to use for image processing of SFAP depends to a large degree on the intended analysis. Sophisticated tasks may require expensive specialized remote sensing or photogrammetry software, but various freeware and shareware packages also exist that may be employed successfully for advanced processing.

12

SFAP Legal Issues

Kites are the old-fashioned, rule-abiding and decidedly un-controversial cousins of drones. D. Mehta (quoted by Maskeri 2016)

12-1 INTRODUCTION

Having worked through basic principles and technical issues, the aerial photographer also must be cognizant of local rules and regulations for flying and taking small-format aerial photographs (SFAP). Just as with manned aircraft, the operation of free-flying unmanned aerial systems (UAS) as well as tethered unmanned aircraft—balloons, blimps, and kites—comes under the legal constraints of aviation laws in most countries. Also, restrictions may exist for taking photographs from the air of certain objects or areas, for example, public buildings, military grounds, power plants, nature reserves, or private houses. A worldwide survey of national status or existence of regulations for UAS is given by Stöcker et al. (2017) in an overview study for the year 2016.

The regulations for SFAP may be quite specific regarding the type of aircraft, flying height, survey area and mission purpose, and restrictions may range from none or few to special requirements of aircraft signaling, insurance obligations, or even absolute prohibition. Usually, third-party liability insurance coverage and overflight permission from the site's owner or the local municipal administration are prerequisites for obtaining flying authorizations from aviation authorities.

It is also important to note that some countries have strict rules for export and reimport of UAS, depending not only on size and acquisition cost but also on other unexpected criteria. As an example, for a fixed-wing UAV of a certain brand to be exported from Germany to a non-EU country, customs authorities required a Carnet-ATA for export and reimport. However, such a procedure was not necessary for a small quadcopter since its maximum endurance is less. In Germany, the Federal Office of Economics and Export Control (Bundesamt für Wirtschaft und Ausfuhrkontrolle, BAFA) provides information about these issues.

Keep in mind, when planning a mission, that investigating and obtaining flying authorizations may take some time, as one authority's permit may depend upon those of other agencies. Unfortunately it is not always obvious who is responsible for the permissions. If a civil authority grants the flight permission, it is still possible that involved police, military, or other authorities may recognize problems. National parks, monuments and nature reserves often have restrictions. Long-term experience has shown that personal contact with involved officials and demonstration of the survey devices as well as presentation of examples of aerial photographs adds to a positive solution. This is particularly true if only geographically, geomorphologically, or bioscientifically related objects are to be photographed.

It should be considered, nonetheless, that aerial photographs are frequently made for espionage purposes, both military and commercial; therefore, various people may be suspicious. This includes public officers as well as commercial enterprises and private land owners. This applies especially to UAS and other free-flying aircraft, as opposed to tethered systems; the latter have limited scope and may be maneuvered and observed more closely. Considering blimps and kites, one can expect far more positive reactions from civil society as well as public authorities than for drones, since these are often used for spying and military actions. This may make a decision regarding the camera mounting system worth considering.

All necessary permits and insurance policies should be carried personally into the field and ready to present immediately if required. Nothing is more annoying than having the aircraft positioned directly above the study site in perfect lighting conditions, and then be forced to break off the survey before taking the first photo by the local police or civil guard because the necessary papers with the right seals are lacking.

Considering the differing national regulations and the wealth of individual rules, it is not possible in this

book to give an accurate and up-to-date list of all legal issues. The reader should refer to the each country's body of aviation laws and related rules, which continues to evolve. In Europe, regulations of various countries are currently being revised, so the validity of statements in this chapter could be limited in duration.

Information about current regulations may be gathered from aeronautical authorities, insurance companies, and model-flying associations. Nevertheless, the following sections aim to give an introduction to some of the diverse legal conditions that apply in selected countries. This review deals primarily with unmanned platforms for SFAP, including powered and unpowered as well as moored and free-flying. The following is given for information only and without responsibility for any eventual errors or omissions.

12-2 REGULATIONS IN THE UNITED STATES

In the United States, many laws and regulations apply to photography in general; however, these laws did not change as a result of the terrorist attacks on September 11, 2001. According to Krages (2012, p. 15), *photographers have a qualified right to take photographs when in a public place,* which includes the national airspace. Nonetheless, photographers may be subject to arrest and prosecution for disorderly conduct, trespassing, and loitering. For example, flying low over a property for aerial photography may be considered trespassing in some circumstances, particularly if such photographs violate a person's privacy.

The United States represents a varied set of conditions for small-format aerial photography, as regulated by the Federal Aviation Administration (FAA). Potential platforms for unmanned SFAP fall into several categories including UAS, moored balloons and kites, amateur rockets, free-flying balloons, and model aircraft. A further important distinction is hobby versus commercial use. Hobby use is strictly personal or recreational in nature and not connected in any way to a person's job or profession. Commercial use involves any type of salary, commission, work-for-hire, consulting fee, royalty, honorarium, grant funding, or payment of any amount in cash or in kind. Thus, for instance, a teacher, who gives a UAS demonstration for her or his students, is operating in a commercial mode (see below).

The national airspace is available for public access, except where restricted for military, nuclear, security, safety, environmental, or wildlife-habitat reasons. For example, operation of kites, balloons, and UAS is generally prohibited at US National Wildlife Refuges without special permission (Fig. 12-1). Similar prohibitions vary by state, county, and city. In Oregon, for instance, aerial photography of military installations requires

prior written permission, and Churchill County, Nevada has extreme restrictions on photographing any military equipment or activities (Krages 2012).

No private land owner may limit overflights for the purpose of taking aerial photographs; however, both private and public land owners may restrict access to their properties on the ground. *Posted* or *No Trespassing* signs are commonplace (Fig. 12-2). For all ground operations, it is recommended to obtain prior approval from local authorities or land owners for launching and landing SFAP platforms, as well as for vehicle parking, equipment setup location, opening gates, crossing fences, etc.

National and state laws prohibit the harassment of protected species (Krages 2012). Harassment could include photographic activities that disrupt or disturb wildlife. For example, UAS could mimic the flight of falcons, hawks, or other predators about to attack ground-nesting birds. Likewise the passing shadow of a kite or blimp might be interpreted in the same way (Fig. 12-3). Thus, special care is necessary to obtain permission and operate SFAP platforms within restricted guidelines in nature preserves (see Fig. 1-2).

Two cases from Kansas may be cited as cautionary tales. First is *National Geographic* photographer Steinmetz (see Chap. 7-2.1). In 2013, Steinmetz flew a motorized paraglider over a cattle feedlot in southwestern Kansas to acquire photographs for a series of stories on food. Flying through the national airspace over the feedlot and taking pictures with a hand-held camera were completely legal activities, because property, including domestic animals, does not have privacy rights (Krages 2012). However, Steinmetz launched from private land without permission. He and his partner subsequently were arrested for trespassing and briefly held in jail before posting bond (Tepper 2013).

The second Kansas example involves kite aerial photography over a private lake. The SFAP session was done with the knowledge and permission of the lake owners and resident caretaker. While the kite was in flight and camera operating, the kite flyers were approached by workers from the local electric-utility company, who insisted that the kite must be taken down (Fig. 12-4). They claimed the kite was flying over an electric distribution line and, thus, represented a safety hazard. However, the electric utility neither owns nor controls the airspace over its right of way and could not legally enforce this order. Nonetheless, the kite was taken down routinely in order to avoid a confrontation.

Rules for flying tethered platforms, such as balloons, blimps, kites or gyrogliders, are spelled out in FAA Part 101 (GPO 2012). Such aircraft may be flown up to 500 ft (152 m) above the ground without a special permit in most circumstances. Flying such platforms higher, however, requires filing a flight plan with the nearest airport. On the other hand, manned aircraft should not

Fig. 12-1 Superwide-angle view looking northward over Rachael Carson National Wildlife Refuge surrounded by suburban housing. Nesting birds in the salt marsh are particularly sensitive to nearby activity on the ground or overhead, which they may interpret as predators. Special permission was necessary to conduct SFAP using a tethered helium blimp that had to be flown at least 90 m (NWR minimum height) and not >152 m (FAA maximum height) above the ground. Silent and near-motionless blimp operation at this height minimized possible disturbance of birds on their nests. Photo taken with a DSLR camera by SWA, JSA and V. Valentine; Maine, United States.

be flown below 500 ft height in the countryside and not below 1000 ft in urban areas. No person may operate a moored balloon or kite:

- >500 ft above the surface of the earth.
- <500 ft from the base of any cloud.
- From an area where the ground visibility is less than 3 miles.
- In a manner that creates a hazard to other persons or their property.
- Within 5 miles of the boundary of any airport (adapted from GPO 2012, p. 882).

Further restrictions deal with lighting and marking for nighttime and daylight flight and rapid deflation for balloons. This rule has additional requirements and restrictions for operation of unmanned free balloons and amateur rockets, which also might be used for SFAP (e.g. Dunakin 2008). Part 101 does not make any distinction between hobby and commercial uses or applications, nor does it specify any pilot qualifications.

Model aircraft is separate category for FAA regulations (Fig. 12-5). Conventional fixed-wing model aircraft certainly have been utilized for SFAP in the past (e.g. Quilter and Anderson 2000), and small UAS platforms fall under

Fig. 12-2 No trespassing signs are commonplace in the United States for both private land and public facilities. California has strict laws that prohibit loitering near posted industrial facilities (Krages 2012). Near Palm Springs, California.

the umbrella of model aircraft rules. Specifically the FAA has defined a model aircraft as *an unmanned aircraft that is (1) capable of sustained flight in the atmosphere; (2) flown within visual line of sight of the person operating the aircraft; and (3) flown for hobby or recreational purposes* (FAA 2014). For SFAP

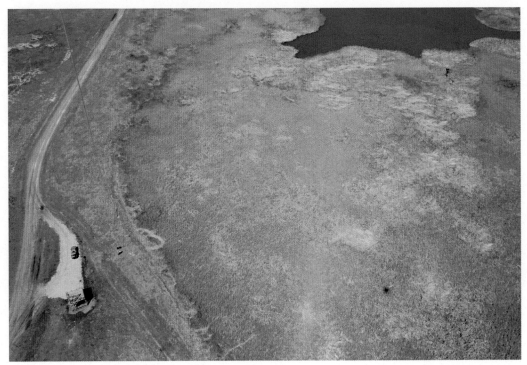

Fig. 12-3 During launch and landing, when it is low, a large kite casts a distinctive shadow. Kite shadow (lower right) moving quickly across the marsh could be interpreted by birds nesting in the cattail thatch as a swooping predator. Kite flyers at lower left; taken with a MILC. The Nature Conservancy, Cheyenne Bottoms, central Kansas, United States.

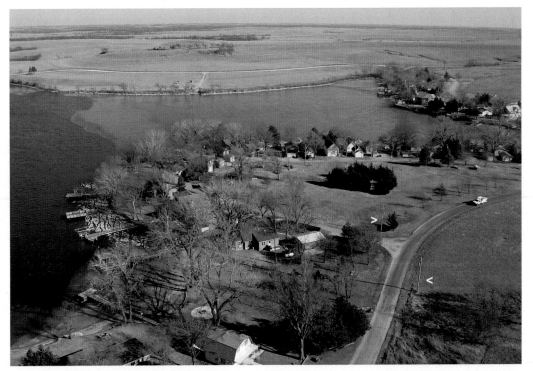

Fig. 12-4 Kite aerial photograph at Lake Kahola, Kansas. Launch point was from private land with permission. The tethered kite and camera were flying ~100 m above the electric-utility right of way, which services that private land. Utility poles are marked (<); approaching electric-utility truck is visible on right side. Contrary to the opinion of electric-utility employees, this use of the national airspace is entirely legal in the United States, as the kite did not pose an imminent hazard to the distribution line. Photo taken with a compact digital camera by JSA and J. Schubert.

Fig. 12-5 Radio-controlled, gas-powered model helicopter that could be fitted with a tiny digital still or video camera. Helicopter is highly maneuverable, but noisy; rotor diameter is ~1.35 m. Flying such a model aircraft requires considerable pilot skill.

applications, the third item is of most importance, namely that *the aircraft is flown strictly for hobby or recreational use.* The only exception is the commercial small UAS pilot qualification noted below.

The distinction between hobby and commercial operation does play a significant role for small UAS aircraft regulations, which are given in FAA Part 107, as finalized in 2016. Some basic considerations apply to both hobby and commercial UAS (adapted from FAA 2016a,b).

- UAS operator must be registered. US citizen or permanent resident or registered visitor.
- UAS must be labeled with owner's registration number.
- Aircraft weight including payload or cargo >0.55 pounds and <55 pounds (25 kg).
- Visual line-of-sight (VLOS) of the pilot with unaided vision sufficient for aircraft control.
- Operation during daylight hours only.
- Must yield right of way to other aircraft and avoid airports.
- Maximum speed 100 mph; maximum height 400 ft.
- Aircraft may not operate over anybody not directly participating in the mission.
- Never fly over groups of people, sports events and stadiums, nor under covered structures.
- Minimum weather visibility of 3 miles from control station.
- Avoid emergency-response situations, such as fires, accidents, and floods.
- No careless or reckless operations, and never fly under the influence.

The primary difference between hobby and commercial use is for pilot qualifications. For hobby UAS, the only requirement is minimum age of 13 or accompanied by a person 13 or older. A person operating a small UAS for commercial purposes, on the other hand, must be at least 16 years old and either should hold a remote pilot airman certificate with a small UAS rating or be under the direct supervision of a person who holds a remote

pilot airman certificate. Of the restrictions noted above, most may be waived for commercial flight, *if the applicant demonstrates that … operation can safely be conducted under the terms of a certificate of waiver* (FAA 2016a). The FAA also issued a memorandum regarding the educational use of unmanned aircraft systems. The memorandum has three key parts (FAA 2016c):

- *A person may operate an unmanned aircraft for hobby or recreation … at educational institutions and community-sponsored events provided that person is (1) not compensated, or (2) any compensation received is neither directly nor incidentally related to that person's operation of the aircraft at such events.*
- *A student may conduct model aircraft operations … in furtherance of his or her aviation-related education at an accredited educational institution.*
- *Faculty teaching aviation-related courses at accredited educational institutions may assist students who are operating a model aircraft … provided the student maintains operational control of the model aircraft such that the faculty member's manipulation of the model aircraft's controls is incidental and secondary to the student's.*

The FAA (2016c) has ruled that student operation of model aircraft for science, technology, and aviation, as well as television or film production, as part of their coursework is classified as hobby or recreational use of UAS. On the other hand, faculty who are compensated for teaching or conducting research are not engaged in hobby or recreational activity and, thus, would need to operate under commercial rules for UAS. Nonetheless, faculty may provide limited assistance to students who are operating UAS as part of their coursework or curriculum.

Avoiding emergency-response situations is a key part of the FAA restrictions, as demonstrated by the recent Spring Creek Fire in southern Colorado (Fig. 12-6). The fire was sparked by human activity on June 27, 2018, quickly spread, and eventually burned >108,000 acres (>43,000 ha), the third largest wildfire in Colorado history (Mitchell 2018). As the fire rapidly expanded on June 30, a drone was spotted flying in the fire zone, and all aerial fire-fighting was suspended immediately. Local law enforcement was dispatched to search for and arrest the drone pilot. Soon after, aerial fire-fighting flights resumed. The next day, the Incident Management Team posted a strongly worded announcement (InciWeb 2018):

Yesterday, a drone flight caused all air operations to shut down. Drones prevent essential firefighting activities, and can cause aircraft to crash, killing pilots and crews. PLEASE DO NOT FLY DRONES. Please report any suspected drone use to law enforcement.

As a result of several wildfire-drone incidents, Colorado lawmakers introduced a bill in the US Congress: *Securing Airspace For Emergency Responders Act* (Staver 2018).

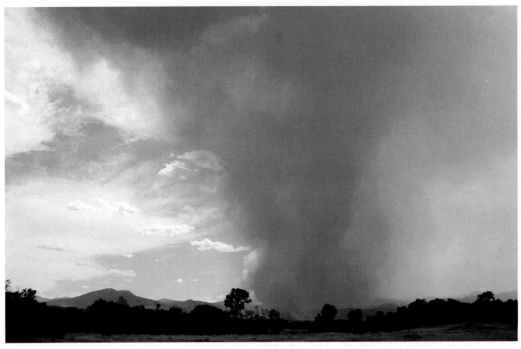

Fig. 12-6 Billowing smoke from the Spring Creek Fire on June 30, 2018, the day aerial fire-fighting operations were grounded temporarily because a small UAS was seen flying in the vicinity. Burning in the Culebra Range, Sangre de Cristo Mountains, south-central Colorado, United States.

If approved, this law would make flying an unauthorized drone over a wildfire a federal felony crime. The bill is currently undergoing consideration in the Senate Judiciary Committee as of late 2018.

The concept of drone delivery of packages has been in the news for several years, but recently in Florida drones were used in failed attempts to smuggle contraband items into state prisons (Figueroa 2018). Stories of these types reinforce negative public perception of small UAS.

12-3 GERMAN REGULATIONS

In Germany, several laws and orders are in force concerning the use of unmanned model aircrafts. The current versions of these statutes are published by the German Federal Aviation Administration (LBA 2014a).

Since 2017, Germany has its own new drone ordinance, which regulates opportunities and risks of using free-flying, remotely controlled aircraft (BVDD 2018). A drone is defined as an unmanned aerial vehicle. Aviation legislation distinguishes between unmanned aviation systems and model aircraft. According to §1 of the air traffic act, unmanned aerial systems are exclusively commercially used devices. Aircraft models, on the other hand, are private, that is, devices used for the purpose of sports or recreational activities.

Drones offer great potential both privately and commercially, and they are increasingly applied. The more

drones ascend, the greater the risk of collisions, crashes, or accidents. In order to open up opportunities for drone technology and at the same time significantly increase the safety in the airspace, regulations were initiated. In addition to issues of security, also privacy was improved. Significant regulations include

1. Labeling requirement—All model aircraft and unmanned aerial systems with a take-off weight of >0.25 kg must be labeled in order to be able to identify the owner quickly in the case of damage. Labeling is carried out by means of a sticker with name and address of owner. Besides application of plaques, labeling would also be accepted by means of an aluminum sticker with address engraved. It is important that the plaque is permanently and fireproof-labeled and firmly connected to the device.
2. Certificate of knowledge—For the operation of model airplanes and unmanned aerial systems from 2 kg, proof of knowledge is required. The proof is done by: (a) valid pilot license, (b) certification after examination by a body recognized by the Aviation Agency (also possible online), minimum age 16 years, or (c) certification after instruction by a designated air sports association (DMFV or DAeC) or an association commissioned by it (applies only to model airplanes), minimum age 14 years.
3. The certificates are valid for 5 years. No proof of knowledge is required for operation on model airfields. The website of the Aviation Agency lists

currently recognized bodies from which certificates may be acquired (LBA 2014b).

4. No license—For operating model airplanes and unmanned aerial systems below a total mass of 5 kg, no permission is required. Operation by public authorities is generally exempt from authorization if necessary for their duties, as well as operation by organizations with safety functions, for example, Fire brigades, THW (disaster relief), German Red Cross, etc. Whether universities are included is worth learning from the competent aviation authority.

5. Permit—A permit is required for operation of model airplanes and unmanned aerial vehicles over 5 kg and for operation at night. This is issued by the responsible state aviation authorities, which differ between the federal states. As the authors have experienced, the grant of permission for scientific purposes is usually given. In addition, a permit is required when flying in a restricted area (ED-R). Further information on the application process is available at the Federal Office for Air Traffic Control (BAF 2017).

6. Opportunities for future technology—Until now, commercial users needed a permit for operation of unmanned aerial systems regardless of the weight. In the future, permission to operate unmanned aerial vehicles below 5 kg will no longer be required. In addition, the existing general ban on operation for distances beyond sight is removed. National aviation authorities can allow this in the future for devices from 5 kg.

7. Operating ban—A ban on operating applies for model aircraft and unmanned aerial systems:
 - out of sight for equipment under 5 kg
 - in and over sensitive sectors, for example, locations of police and emergency services, hospitals, gatherings, specific facilities such as prisons or industrial facilities, supreme and upper federal or state authorities, and nature reserves
 - above and at a lateral distance of 100 m from federal highways, federal waterways and railway facilities, unless the competent authority has explicitly consented to the operation
 - in airport control zones (also arrival and departure areas)
 - above military facilities and organizations and above mobile facilities and troops of the German army in the course of maneuvers and exercises
 - at a lateral distance of 100 m from boundary of industrial plants as well as power generation and distribution plants
 - at height above 100 m above ground, unless at areas for which a general permit has been granted for the use of model aircraft and for which a supervisor has been appointed, or, unless it is a multicopter, the operator holds a valid license as a pilot or has a

certificate of knowledge. Operation of multicopters above 100 m above ground is not permitted even with proof of knowledge. Exceptions to this rule may only be granted by the competent authority
 - above residential areas if take-off weight exceeds 0.25 kg or if the aircraft or its equipment are capable of receiving, transmitting, or recording optical, acoustic, or radio signals. Exception: The person affected by the operation above the property explicitly agrees to the operation.
 - weight > 25 kg (applies only to "Unmanned Aerial Systems").

The competent authority may allow exception from the prohibitions if the operation does not present a risk to the safety of air traffic or public safety or public order, in particular a violation of data protection and nature protection, and due account is taken of the protection against aircraft noise. Particularly in the case of an operation beyond sight, the competent authority may require an objective safety assessment.

8. Obligation to give way—Unmanned aviation systems and model aircraft are obliged to avoid manned aircraft and unmanned free balloons.

9. Use of video glasses—Flights involving application of video glasses are allowed up to a height of 30 m, up to a weight of 0.25 kg or if another person is constantly observing and able to alert controllers to emerging risks. This is applicable to operation within sight.

Liability and compulsory insurance for unmanned aerial systems and model aircraft are not changed by this new regulation. Unmanned aviation systems and model aircraft are like all aircraft already subject to regulations on liability for third party damage in accordance with § 33 et seq. LuftVG. As this concerns the operation of an aircraft, accidents caused by so-called drones are generally not covered by personal liability insurance. A specific owner liability insurance (Halter-Haftpflichtversicherung) is required (see Section 12-5).

12-4 REGULATIONS IN SELECTED COUNTRIES

Flying-height regulations differ considerably in individual countries elsewhere. In the United Kingdom, for example, normal flying ceiling for tethered kites is only 60 m, which is not enough height for many SFAP purposes. Special application to the Civil Aviation Authority (CAA) is required to fly higher, but the application procedure may take 3 weeks for approval, and then the scheduled mission could be spoiled by bad weather.

In late December 2018, Gatwick airport, the second largest in the United Kingdom, was shut down when multiple rogue drones were seen flying in the vicinity. Some 140,000 travelers were affected by about 1000

flight delays and cancellations during 36 h of chaos (BBC News 2019). Gatwick Airport Limited offered a £50,000 reward "for information leading to the arrest and conviction of those responsible for disrupting flights," but as of early January 2019, no suspects had been charged. Drone sightings have increased at airports in other countries as well, including the United States and Germany.

Across the sea to the east, Denmark is a country where many forms of kite flying and kite festivals are extremely popular, especially along the North Sea coast (Fig. 12-7). The maximum kite flying height is 100 m (Knetemann 2016). Japan, on the other hand, has no height restriction for flying kites (T. Nagasako, pers. com.). In Spain, a special pilot permission is necessary since 2015 and the legal entity needs to be registered by the flight security agency. For further information contact: drones.aesa@seguridadaerea.es.

India is a country well known for strict security; in fact, taking any kind of aerial photograph is prohibited under nearly all circumstances. In order to conduct kite aerial photography, Chorier had to obtain permissions from various governmental agencies, and he had to carry permits with him or risk arrest by local police which happened several times (Chorier 2016). In other cases known to the authors, people who attempted SFAP met with stiff resistance from Indian authorities. Dinesh and Dipa Mehta are currently the only professional kite aerial photographers in India (Maskeri 2016). They have conducted architectural and environmental SFAP in India as well as Bhutan for 15 years. Both Chorier and the Mehtas

have undertaken kite aerial photography at the Khumb Melas, the largest religious gatherings in the world. The Khumb Melas take place every 12 years at four locations and may attract >100 million people. Aerial photography is tightly restricted at these celebrations.

China is another country with strict regulations related to small-format aerial photography, as the authors learned during negotiations to conduct kite aerial photography in Tibet. For example, any form of radio transmitter, which may be necessary for operation of an aircraft or camera apparatus, is highly restricted. Likewise, China tightly controls geographic data and use of global positioning system (Dougherty 2016). Map displays and GPS positions are deliberately offset, in a manner similar to geographic distortions during the Cold War in the Soviet empire. This effectively rules out GPS-enabled aircraft and cameras.

Land ownership rights vary substantially in other countries. In Slovakia, for example, the public is allowed access to walk or drive a vehicle into harvested or fallow agricultural fields, as long as the ground is not disturbed. However, access or disturbance is prohibited in fields with planted or growing crops. Land owners may not restrict access to fallow ground, and such fields are often convenient places for SFAP operation (Fig. 12-8). The authors have conducted kite aerial photography in many locations throughout Slovakia and never encountered any concerns from the public or authorities about our activities.

In contrast, the Tatry Mountains of Slovakia and Poland are protected in national parks; all public, commercial, and scientific activities within these parks are strictly regulated.

Fig. 12-7 Wide, sandy beaches and sea breeze make the North Sea coast of western Denmark a mecca for kite flying. Launching a compact digital camera for kite aerial photography on the island of Rømø.

Fig. 12-8 Conducting kite aerial photography from a fallow (weedy) patch adjacent to crop fields. Near Spišska-Bela, Slovakia; photo taken with a compact digital camera by JSA, SWA and I. Duriška.

Obtaining permission for SFAP requires the assistance of local colleagues and may take considerable time, even months, to arrange in advance. Necessary permits must be carried in the field at all times while conducting SFAP in these circumstances (Fig. 12-9), and it is best to have local colleagues along to explain the activities and mission.

UAS, as noted above, represents a special category. To continue with the Slovak example, UAS are divided into three classes, namely, air toy, recreational, and commercial (Fig. 12-10). Regulations generally resemble those of the United States, and commercial operation requires a special license. Thus, for instance, a small UAS may be flown with a few common-sense restrictions (based on UAV Slovakia 2018):

• Do not fly over people or large crowds.
• Do not fly beyond line of sight or 1000 m, whichever is closer.
• Do not fly within 50 m of any building or vehicle not associated with the drone operation.
• Respect the privacy of others.
• Fly only during daylight and in good weather conditions.
• Do no fly over sensitive government or military areas; use of a camera may be prohibited.
• Fly at least 1.5 km away from densely built-up cities.

For the countries discussed here as well as any other country, relevant aviation rules, regulations, and policies should be consulted early on for planning a SFAP mission. Likewise the transportation of drones may be subject to restrictions, especially the LiPo batteries, which are considered dangerous goods by airlines. Summaries of UAS country regulations are available from *UAV Systems International* https://www.uavsystemsinternational.com/drone-laws-by-country/.

A prize-winning UAS photograph from Indonesia illustrates some of the issues. In 2014, *National Geographic* held its first drone aerial photograph contest, and >1000 pictures were entered from around the world. First prize went to *Flying with an eagle, Bali Barat National Park, Indonesia*, a close-up picture of an eagle in flight (Vrignaud 2014). Two aspects are troubling for this situation.

• Drone flight took place and picture was acquired in a national park.
• Drone was likely <1 m away from the eagle when the picture was taken.

Many people considered this situation as wildlife harassment. Raptors are often attracted to kites and other tethered platforms; once they determine the object is non-living, they lose interest. However, drones mimic bird flight characteristics and might be perceived as competitors or potential food; a collision surely would have injured the eagle. Whether this drone flight and photograph were legal in 2014 is unknown. However, Indonesia adopted a comprehensive aviation law (PM 90) in 2015 that deals with drone operation. In particular, any drone used for photography must have a license from the local authorized institution, that is, governor, regent, or mayor (Kriyasa 2016). In any case, the eagle picture certainly raises ethical concerns about appropriate use of UAS in sensitive situations.

Tatrzański Park Narodowy, ul. Chałubińskiego 42a, 34-500 Zakopane, tel/fax: 0-prefix-18 2063203 e-mail: sekretariat@tpn.pl

Zn.spr.: **NB-056/71/07** Symbol: **Geo** Numer **582** Zakopane, dnia **2007-04-20**

ZEZWOLENIE

na realizację badań na obszarze Tatrzańskiego Parku Narodowego

Kierownik tematu: Tytuł: prof. Imię: James Nazwisko: Aber

Instytucja: Emporia State University Ośrodek: USA Termin badań: od 2007-07-15 do 2007-08-15

Temat: Pilotażowe wykonanie zdjęć latawcowych w TPN dla zastosowań geologicznych

Uprawniony: **prof. J. Aber** Osób towarzyszących: **1**

Obszar badań: Cały obszar TPN. Z prawem: Zastosowania latawców do wykonania zdjęć fotograficznych.

Warunki realizacji zezwolenia: Z badań wyłącza się rejon Kominiarskiego Wierchu(oddz.275-280, 295-298). O każdorazowym wejściu należy powiadomić właściwe służby terenowe TPN.

Zezwolenie upoważnia do poruszania w wyznaczonym terenie TPN poza znakowanymi szlakami turystycznymi. Korzystający z zezwolenia mają obowiązek przestrzegania przepisów obowiązujących w strefie granicznej i w parku narodowym. Posiadacz zezwolenia zwolniony jest z opłat za wstęp do TPN. Prowadzący badania jest zobowiązany złożyć w Dyrekcji Parku pisemną informację z realizacji prac terenowych do końca grudnia każdego roku.

DYREKTOR

A

Fig. 12-9 Kite aerial photography in Tatrzański Park Narodowy (Tatra National Park), Poland. (A) Zezwolenie (permission) to conduct kite aerial photography for geological applications in the national park. Permit was approved in April 2007 for a limited period of KAP, July 15 to August 15, 2007. (B) Panoramic view toward northwest over Skupniów Uplaz ridge (lower center) in the Polish Tatry Mountains (Aber et al. 2008). Assembled from two images taken with a compact digital camera.

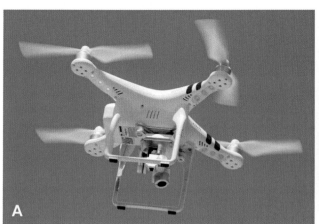 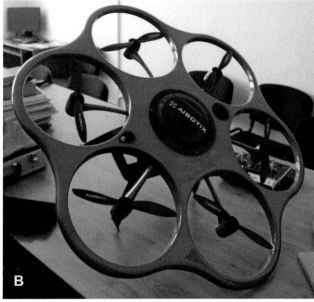

Fig. 12-10 Unmanned aerial systems in Slovakia. (A) small UAV, *DJI Phantom* with a tiny camera flying over a former open-pit mine site in Košice. (B) large UAV, *Aibotix* hexacopter on display indoors. The latter requires a fully licensed pilot for flight operation. UAVs demonstrated by P. Blišťan.

12-5 INSURANCE

Generally, third-party liability insurance is a requirement for obtaining flight clearance and also would be in the best interest of SFAP operators. From the example of insurance issues in Germany, it can be seen that the matter is not a trivial one. Since 2005, each model aircraft in Germany has to be insured independent of its weight. Private indemnity insurances cover the risks of model flights only in exceptional cases.

A summary of insurance offered for model builders and flyers by various organizations (*Deutscher Aero Club DAeC, Verband Deutscher Modellflieger DMFV, Deutsche Modellsport Organization DMO*) with identification of possible loopholes has been compiled painstakingly by Steenblock (2006). These insurance packages are included in the membership fee of the organizations and customized to the specific activities of the members.

From the point of view of a worldwide active German SFAP user, the membership in the DAeC appears the most sensible option because it is the biggest organization for pilots of all kinds in Europe and the insurance is globally valid. Model aircrafts are insured up to a total starting weight of 25 kg, and no copayment is required except in case of double-channel occupancy. Supplementary agreements also enable insurance of models heavier than 25 kg. For blimps and balloons, it has to be considered that the flight weight is not calculated just from the summed weight of the components but rather from the addition of component weight and the weight of the covered volume within the balloon, in other words the gas

(specific weight of air: $1.225 \, \text{kg}/\text{m}^3$, helium: $0.17 \, \text{kg}/\text{m}^3$, all assuming ICAO standard atmosphere). This complicated calculation may result in surprisingly large flight weights that exceed the 25 kg insurance limit, although all components together may weigh much <25 kg.

Another option is separate insurance policies that may be taken out by individuals or institutions with *Allianz* or in special cases also with the *Gerling* Insurance Group. In this case a specific model aircraft or blimp may be insured with the obligatory specification of its serial identification number. However, the insurance rates are significantly higher and are in the experience of the authors only suitable for heavier and larger aircrafts. Also, according to Steenblock (2006), these individual insurance packages show some loopholes in contrast to the organizational insurance offers, and consequently the authors recommend to check their conditions in detail before conclusion.

In other countries, individuals may seek insurance through hobby or professional organizations. In the United States, for instance, the American Kitefliers Association provides limited liability insurance at officially sanctioned kite competitions and tournaments. Another option is a professional rider that may be added to an individual's homeowner insurance policy. When acting in professional capacity, for example teaching a field-methods course in SFAP for a university, the individuals and activity may be covered by the institution. But the conditions and exclusions vary greatly with each type or source of insurance, so the SFAP operator needs to pay some attention to appropriate coverage.

12-6 SUMMARY

Legal constraints of aviation laws may apply for small-format aerial photography depending on the country, aircraft, and mission purpose. Regulations in various countries may be quite specific, and restrictions may range from none or few to special requirements. Relevant aviation rules, regulations, and policies should be consulted early on for planning a SFAP mission, and all necessary permits and insurance policies should be carried personally into the field and ready to present immediately if required. The help of local colleagues or informants is most useful in situations that may be unfamiliar to the photographer.

The United States represents a varied set of conditions for small-format aerial photography, as regulated by the Federal Aviation Administration (FAA). The national airspace is available for public access, except where restricted for military, nuclear, security, safety, environmental, or wildlife-habitat reasons; no private land owner may limit overflights for the purpose of taking aerial photographs. Potential platforms for SFAP have different sets of rules and regulations. A further important distinction is hobby versus commercial use. In general, moored unmanned aircraft fall under FAA Part 101. Model aircraft, including unmanned aircraft systems

(UAS), fall under FAA Part 107 guidelines. Commercial operation of UAS requires a remote pilot airman certificate with a small UAS rating.

In Germany, several laws and orders are in force concerning the use of unmanned model aircrafts. Since 2017, Germany has its own new drone ordinance, which regulates opportunities and risks of using free-flying, remotely controlled aircraft. Significant UAS regulations include labeling, certificate of knowledge, license, permit, future technology, operating bans for specific activities, obligation to give way, and use of video glasses. Liability and compulsory insurance are required for unmanned aerial systems and model aircraft.

Aviation laws and regulations as well as equipment limitations and ground access differ considerably in other countries ranging from highly restrictive (e.g. India and China) to relatively liberal (e.g. Denmark and Slovakia). In most countries, UAS represents a special category that may require a license or permission for SFAP. Third-party liability insurance is often a requirement for obtaining flight clearance and also would be in the best interest of all SFAP operators. Such insurance may be obtained individually and specifically for SFAP. Coverage may also come through institutional employment or flying organizations.

13

Geomorphology

Geomorphology is the science of scenery. Fairbridge (1968)

13-1 INTRODUCTION

Geomorphology is the study of the Earth's surface landforms. This study is both descriptive and quantitative; it deals with morphology, geomorphological processes, landforms, origins, and ages (Baker 1986). The ultimate goals of geomorphology are to understand the ways in which landforms are created and to document the evolution of landforms through time. The geomorphology of any region or site is the result of interplay involving three primary factors, namely process, structure, and time.

All Earth surfaces are subject to diverse physical, chemical, and biological processes that operate at greatly varying rates. Static landscapes do not exist; all landscapes undergo constant modification—some quite slowly, others rapidly, and almost instantaneously in certain cases, such as volcanic eruptions or asteroid impacts. The active processes also change through time so that every landscape is subject to continual evolution.

Internal processes are related to plate tectonics and to the surface effects of plate movements, as well as to other forces originating from the Earth's interior. External processes develop at or above the surface in the atmosphere, hydrosphere, cryosphere, or biosphere. They involve wind, water, ice, mass movements, or living organisms that modify landforms. Impacts and accumulation of extra-terrestrial materials are also external processes.

Internal and external processes combine with geologic structure and time to produce the observed landforms at the Earth's surface. Most landforms involve a considerable mass of material—bedrock and sediment, and so are slow to adapt when environmental changes take place. The geomorphology of a region, therefore, represents a long-term integration of environmental conditions and trends. A region's geomorphology is, thus, a reflection of both past and present environments, and

SFAP is an effective means to display such landforms (e.g. Dickinson 2009). SFAP offers also a great potential for measuring and quantifying landforms, as photogrammetric analysis allows to reconstruct 3D forms from stereoscopic images. High-resolution topographic data derived from 3D point clouds based on image-matching techniques such as Structure from Motion–Multi-View Stereo (SfM-MVS) have become an important tool for understanding Earth surface processes and landforms in geomorphological research (Tarolli 2014; Smith et al. 2016; see Chaps. 3-3, 11-6, and 14).

All the coauthors have long-term interests in various aspects of geomorphology, hence the emphasis here and in the next few chapters on case studies involving applications of small-format aerial photography for display and analysis of diverse landforms.

13-2 GLACIAL LANDFORMS

Modern glaciers and ice sheets cover approximately one-tenth of the world's land area. Of this, most glacier ice is found in Antarctica and Greenland with all other areas accounting for only about 5% of the total. During the Ice Age (Pleistocene Epoch) of the last 1 million years, glaciers and ice sheets expanded dramatically and repeatedly over large portions of northern Eurasia and North America as well as in mountains and high plateaus around the world. At times, the volume of glacier ice during the Pleistocene was at least triple that of today (Hughes et al. 1981).

Glacier ice is a powerful agent that created many distinctive landforms that are well preserved nowadays in regions of former ice expansion. Glaciers modify the landscape in three fundamental ways by erosion, deposition, and deformation. A given site may be subjected to each or all of these processes during the advance and retreat of a glacier, and repeated glaciations may overprint newer landforms on older ones. In addition, glacial meltwater is also an effective geomorphic agent that may

erode or deposit conspicuous landforms. The results are complex landform assemblages that represent multiple glaciations during the Pleistocene.

Aerial photography has long been utilized to illustrate, describe, interpret, and map diverse types of landforms created by glaciation (e.g. Gravenor et al. 1960). Traditionally this approach is based on medium-scale, panchromatic (gray tone), vertical airphotos taken from heights of several thousand meters. Satellite imagery has been utilized for more than three decades to display and analyze glacial geomorphology (Williams 1986). Low-height, oblique airphotos also have proven effective for recognizing and displaying various types of glacial landforms including eskers and drumlins (Prest 1983). The advantage of oblique views is the ability to visualize the three-dimensional expression of individual landforms within the surrounding terrain (Fig. 13-1). Moreover, photogrammetric SFAP analysis allows to model and monitor 3D change of glacial and periglacial landforms (e.g. Bernard et al. 2017; Hart et al. 2018) as well as the glaciers themselves (e.g. Immerzeel et al. 2014; Kraaijenbrink et al. 2016; Gindraux et al. 2017).

13-2.1 Glacial Erosion

Glacial valleys and fjords are among the most spectacular examples of combined erosion by glacier ice and meltwater. Such valleys may be 100s to >1000 m deep and extend from 10s to >100 km in length. They are typically found in mountains or rugged upland areas that were invaded by ice sheets or subjected to local valley glaciation, and are especially common where montane glaciers descended into the sea or large lakes.

The Finger Lakes occupy a series of long, straight valleys that penetrate the Appalachian Plateau south of the Lake Ontario lowland in west-central New York, United States (Fig. 13-2). The Finger Lakes are often described as inland fjords because of their deeply eroded bedrock valleys and thick sediment infill. The Finger Lake troughs were eroded by strong ice-stream flow coming from the north enhanced by high-pressure subglacial meltwater drainage (Mullins and Hinchey 1989).

Among the individual Finger Lakes, Keuka Lake is the most unusual because of its branched shape. SFAP was conducted with a small helium blimp at Branchport at the northern end of the west branch of the lake. Most of the surrounding land is heavily forested or agricultural, which limited ground access for SFAP, so an open school yard was utilized as the spot to launch the blimp. Oblique photographs were acquired with a primary focus on the valley of Sugar Creek to the north and West Branch Keuka Lake to the south (Fig. 13-3). These views emphasize the long, straight nature of the valley bounded by steep bluffs incised into the upland plateau.

13-2.2 Glacial Deposition

Glacial deposits underlie many notable landforms, of which drumlins and eskers are among the most distinctive. Drumlins are elongated, streamlined hills ideally having the shape of a teardrop or inverted spoon. They occur in fields containing dozens or hundreds to thousands of individual drumlins. They are arranged en echelon in broad belts or arcs behind conspicuous ice-margin positions, and the pattern of drumlins is thought to indicate ice-flow direction. Drumlins have complicated origins involving deposition, erosion, deformation, and meltwater action beneath ice sheets (Menzies and Rose 1987). Drumlins are the most-studied glacial landforms that exist. They have caught the attention of geoscientists,

Fig. 13-1 Overview of Lake Oro which occupies a glacial meltwater spillway south of the Dirt Hills, Saskatchewan, Canada. Note the steep valley wall on the right side. Kite flyers in lower right corner; photo taken with a DSLR camera and superwide-angle lens.

Fig. 13-2 SFAP taken from the space shuttle over the Finger Lakes district of western New York. Asterisk (*) indicates Keuka Lake. STS 51B-33-028, April 1985. Hand-held Hasselblad, 70-mm film, near-vertical view. *Courtesy K. Lulla, NASA Johnson Space Center.*

Fig. 13-3 Oblique views of glaciated valley at Branchport, New York, United States. (A) West Branch Keuka Lake looking south toward the sun. (B) Valley of Sugar Creek looking northward. The upland plateau in right background stands ~90m above the valley floor in foreground. Helium-blimp photos with a compact digital camera.

Fig. 13-4 Lake Saadjärve drumlin field in eastern Estonia. Lake Saadjärve (left) occupies an elongated trough, and a long, smooth drumlin extends into the distance on right. Another lake, Soitsjärv, is visible at extreme upper right. Kite photo with a compact analog camera.

especially geomorphologists, because of their elegant shape, their demonstrated orderliness, and their clear relationship to the flow of glaciers (Schomacker et al. 2018). Drumlins are common in many formerly glaciated regions, including eastern Estonia (Rattas and Kalm 2004; Fig. 13-4).

Eskers are long, fairly narrow ridges of sand and gravel. They may be straight or sinuous, continuous or beaded, single or multiple, sharp- or flat-crested. They vary from a few meters to 10s of m high, and may be <1 to 100s of km in length. Eskers are deposited from various types of meltwater streams under the ice or at the margin of retreating glaciers (Banerjee and McDonald 1975).

The island of Vormsi and adjacent seafloor in northwestern Estonia are especially well known for eskers (Aber et al. 2001b). These eskers were deposited in subglacial tunnels during the final phase of late Pleistocene ice-sheet glaciation of the region. One esker in particular may be traced across the island and shallow seafloor a distance of at least 26 km. Although slightly modified by postglacial sea action, the morphology of the esker is still quite distinct (Fig. 13-5).

13-2.3 Glacial Deformation

The combined pressure of glacier loading and forward movement of ice deformed soft sedimentary substrata in many locations, which resulted in conspicuous ice-shoved hills that may rise 10s to >200 m above surrounding terrain. In many cases, a depression marks the source of materials that were pushed into adjacent ridges. The combination of ice-scooped basin and ice-shoved hill is a basic morphologic form called a hill-hole pair

Fig. 13-5 High-oblique view looking over the esker at Rumpo on the island of Vormsi, Estonia. The road and pine forest follow the crest of the esker, which forms a peninsula in the shallow sea. Kite photo with a compact analog camera.

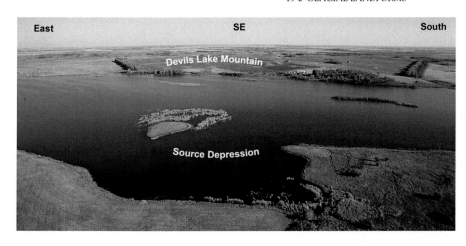

Fig. 13-6 Devils Lake Mountain seen from the northwestern side with the source depression in the foreground. Superwide-angle image; nearly all of the ice-shoved hill and source basin (lake) are visible. Helium-blimp photo with an analog SLR camera. *Based on Aber and Ber (2007, Fig. 4-3).*

(Aber and Ber 2007). A good example of a hill-hole pair is Devils Lake Mountain in northeastern North Dakota, United States. The ice-shoved ridge is approximately 4 km long, 1 km wide, and stands >50 m above the adjacent source basin (Fig. 13-6).

Denmark possesses many well-developed and long-studied glacial deformations and ice-shoved hills of various types (e.g. Pedersen 2014). Denmark is also a country famous for its wind power, which is most suitable for kite aerial photography. This method was employed by the authors for documenting ice-shoved hills in the Limfjord district of northwestern Denmark. The Limfjord is an inland estuary that was excavated in part by glacial thrusting of soft bedrock into nearby ice-shoved hills. Feggeklit is a small ice-shoved hill

in which dislocated, folded, and faulted bedrock was thrust up from the Limfjord basin (Pedersen 1996). The internal structure is well exposed in a cliff section (Fig. 13-7).

The Missouri Coteau upland of southern Saskatchewan, Canada has some of the largest ice-shoved ridges in the world. The Dirt Hills, for example, stand up to 300 m above the Regina Lake Plain to the north and 150 m above the adjacent Missouri Coteau; they encompass a region of ~1000 km² (Aber and Ber 2007). Composed primarily of dislocated and uplifted Cretaceous bedrock along with deformed glacial sediments, the hills have a distinct valley-and-ridge morphologic expression, in which each ridge represents the upturned edge of a bedrock fold or fault block (Fig. 13-8).

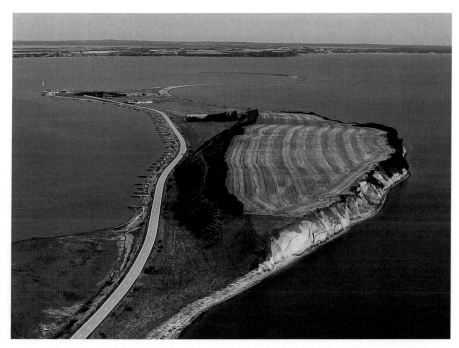

Fig. 13-7 Flat-topped hill at Feggeklit, northwestern Denmark. Cliff on the eastern side exposes deformed bedrock thrust up from the Limfjord in the background. The top of the hill was planed off by the overriding glacier. Kite photo with a compact digital camera.

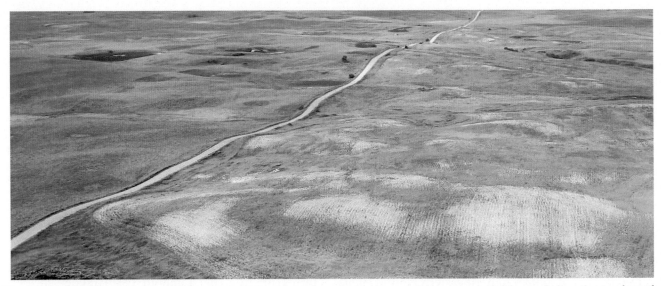

Fig. 13-8 This oblique view of a straight, east-west township road emphasizes the undulating, ridge-and-dale morphology that trends north-south over the crest of the Dirt Hills, southern Saskatchewan, Canada. North to right; kite photo with a compact digital camera.

13-3 RIVERINE LANDFORMS AND FLOODING

Rivers, like glaciers, are capable of erosion as well as sediment deposition under a wide variety of environmental conditions that lead to many typical landforms. Rivers and streams serve two basic functions in the landscape—to remove excess surface water and to carry away sediment. Erosion, particularly the development of gullies, is treated in Chap. 14, while larger channel forms and flooding are reviewed in this chapter. River channels fall in two basic categories, namely braided

and meandering (see Fig. 10-7). Braided streams have multiple, shallow, interweaving channels; they are associated with arid to semiarid climate, coarse sediment load, and high gradients close to mountain sediment sources (Fig. 13-9). Meandering streams, on the other hand, are usually single, deep, highly curved or looping channels that typically are farther downstream in humid climates with finer sediment loads and low gradients (Fig. 13-10; see also Fig. 5-11).

All streams and rivers flood and—unless highly regulated by human intervention in the form of engineering works—shape their surrounding floodplains in the

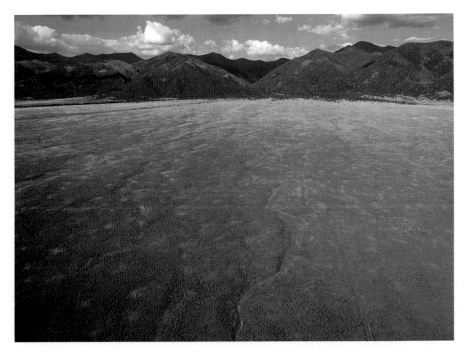

Fig. 13-9 Shallow (dry) braided channels cross the sagebrush-covered alluvial plain sloping away from the Sangre de Cristo Mountains. San Luis Valley, south-central Colorado, United States. Foreground elevation about 7800 ft (~2375 m); highest mountain peaks exceed 13,500 ft (~4115 m). Kite photo with a compact digital camera.

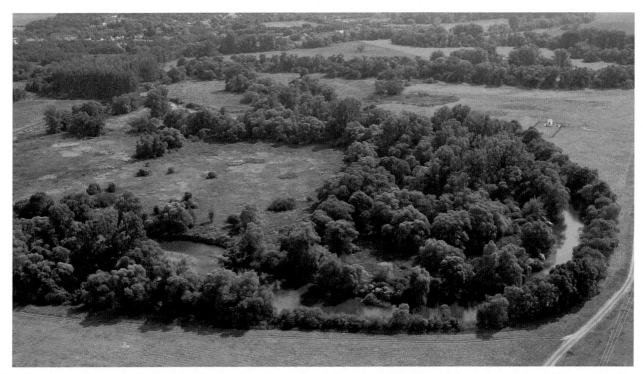

Fig. 13-10 Meander loop of the Hornád River, which here forms the border between Slovakia (right) and Hungary (left). The small building on right is a high-capacity water well for the city of Košice. Kite photo with a compact digital camera by SWA, JSA and J. Janočko.

process (Fig. 13-11). Flooding is a universal phenomenon which may occur in all climatic regimes and any size or type of drainage basin. Flooding is an entirely natural event that takes place on most streams every few years (Fig. 13-12). Flooding becomes a hazard when high water leads to human casualties, damage to structures, and impairment of human land use. Development of drainage basins for shipping, agriculture, water resources, recreation, and urban growth often results in increased frequency and larger magnitude of flooding. Any human modifications of the stream channel or drainage basin inevitably lead to changes in the hydrologic and

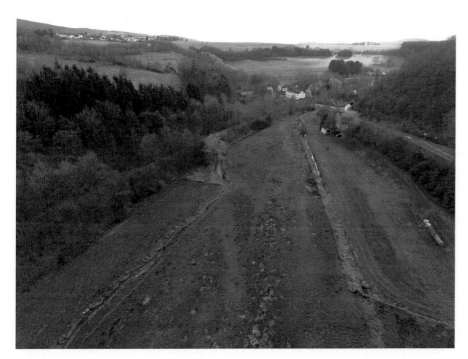

Fig. 13-11 Semi-regulated floodplain of the Thalfanger Bach near Dhronecken, a typical creek in an rural silvopastural area of the Hunsrück mountains, Germany. Regular flooding has shaped the small-scale topography of this seemingly flat valley bottom: Natural levees run alongside the creek (topped by a cow path on the right side), the lower and wetter parts of the slightly undulating floodplain are traced by clumps of rushes. A small ditch drains excessive water from the managed grassland and pasture. The course of the creek, straightened in the 1970s, has been renaturalized since during a rehabilitation project, following heavy spring flooding that reached a water level of 1.5 m above valley bottom. Taken with onboard camera of quadcopter UAV by IM and C. Heyl.

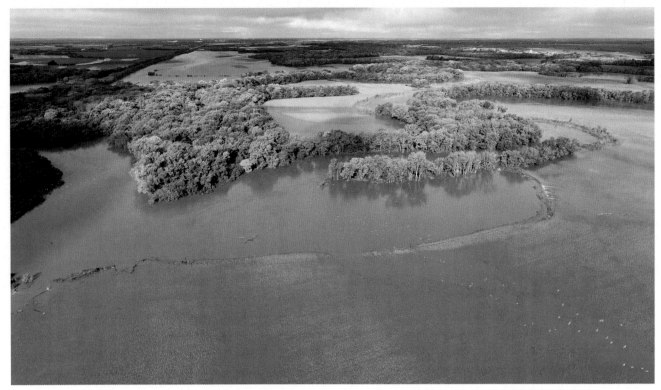

Fig. 13-12 Flood water at the confluence of the Neosho River (right) and Cottonwood River (left) has inundated cropland near Emporia, Kansas, United States. These rivers flood every few years. Taken with on-board camera of small quadcopter UAV. *Courtesy of A. Peterson.*

sedimentologic regimes of the stream. Resulting erosion and deposition of sediment may cause permanent changes in channel and basin geomorphology.

SFAP is an excellent way for documenting and analyzing rapid morphodynamic changes in river channels that might be difficult or even dangerous to investigate by classical field work. Visual interpretation of the photos as well as GIS-based terrain analysis of the derived DEMs is employed in many studies on fluvial dynamics, often including hydrological discharge data, with particular emphasis on braided river systems (e.g. Hervouet et al. 2011; Javernick et al. 2014; Tamminga et al. 2015; Brunier et al. 2016; Marteau et al. 2017).

13-3.1 Oued Ouaar, South Morocco

The Oued Ouaar is an ephemeral tributary to the Souss River in South Morocco, which flows into the Atlantic Ocean at Agadir. It runs south from the High Atlas (see also Fig. 13-35) and then turns sharply to the west, incising the upper part of the Ouaar alluvial fan in the Souss valley by about 9 m into the mostly fine-grained, alluvial-fan sediments (Fig. 13-13). The SFAP survey was conducted shortly after a flooding of the wadi in March 2014 and reveals the different bed-load components, ranging from clays and silts that are still settling in the stagnant water zone in the upper right corner, to fist-sized pebbles on the far right. The latter originate

from the gravel beds of the High Atlas Mountains, which are broken up during intense wadi floodings.

Channel-bed structures formed by the receding flood may be observed as well as older gravel terrace edges in the lower part of the image. The enlarged subset B shows the covering of the coarse-grained material by the fine-grained sediment delivered from a gully upstream. This small alluvial fan was cut by a transversal channel later, as can be seen by the edge. The complex sequence of scour, continuous transport during high floods as well as the subsequent fill of sediment in recent wadi beds is clearly discernable (see also Kirchhoff et al. 2019). Subsets C and D document the potential for photogrammetric and GIS-based terrain analysis to detect surface roughness, which may be directly related to grain size classes.

13-3.2 Río Grande del Norte, United States

The Río Grande begins in the San Juan Mountains of southern Colorado, flows into the San Luis Valley, continues southward into New Mexico, and eventually reaches the Gulf of Mexico. Along most of its course, the river passes through desert environments, but its headwaters and numerous tributaries drain snow-covered mountain ranges that exceed 14,000 ft (~4265 m) elevation. The flow of the river is much reduced nowadays by upstream extraction of water for irrigation and municipal usage (Fig. 13-14).

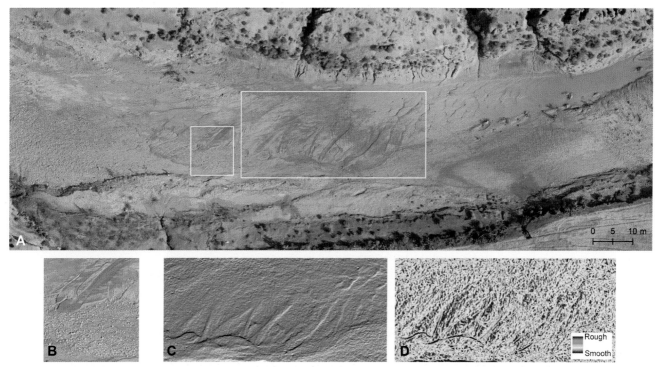

Fig. 13-13 A 160-m-reach of the Oued Ouaar near Taroudant (Morocco) shortly after spring flooding in March 2014. (A) Orthophoto mosaic created from vertical fixed-wing UAV imagery taken with a digital MILC; GSD is 3 cm. (B) Enlarged subset of river-bed section revealing consecutive erosion and deposition processes and various bed-load components. (C) Subset or river-bed section in a hillshade model, derived from the photogrammetrically extracted DEM. (D) The same subset in a roughness model, computed as 10×10 cm standard deviation of the DEM. Image processing by IM.

The upper portion of the river, known as Río Grande del Norte, has been strongly affected by tectonic events connected with faulting and volcanism in the San Luis Valley, which is part of the Rio Grande Rift system. Most recently uplift of the San Luis Hills blocked drainage and created a large lake. The lake was up to 45 m deep and covered much of the central and northern San Luis Valley. The lake overflowed and eroded a canyon across the San Luis Hills about 360,000 years ago (Ruleman et al. 2016), which led to the modern Río Grande del Norte. Nonetheless, a shallow basin still exists just north of the canyon, where the Río Grande is building a small delta (Fig. 13-15).

Across the San Luis Hills, the Río Grande has eroded a canyon through various volcanic and intrusive rocks (Fig. 13-16). Southward into New Mexico, the canyon becomes progressively deeper and exposes thick lava

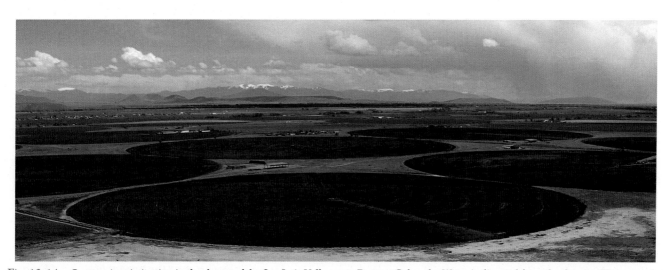

Fig. 13-14 Center-pivot irrigation in the desert of the San Luis Valley near Romeo, Colorado. Water is diverted from the Conejos River, a major tributary of the Río Grande, and delivered via canals and ditches to the fields. Snow-capped Culebra Range of the Sangre de Cristo Mountains in the far background. Kite photo with a compact digital camera.

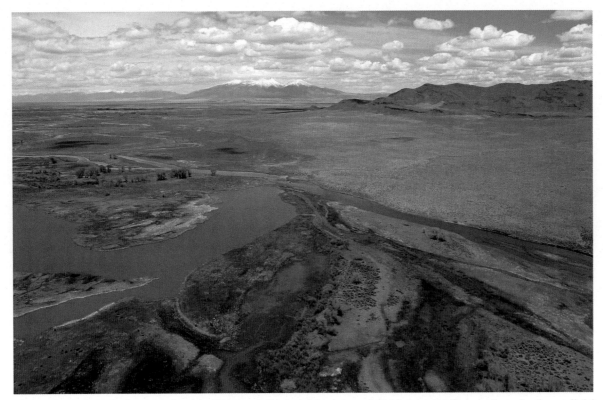

Fig. 13-15 Multiple, meandering channels of the Río Grande in the left background divide into distributary channels of a small delta in the foreground near Lasauces, Colorado. Sierra Blanca massif in the center distance supports multiple peaks >14,000 ft (~4265 m). Kite photo looking northward with a compact digital camera.

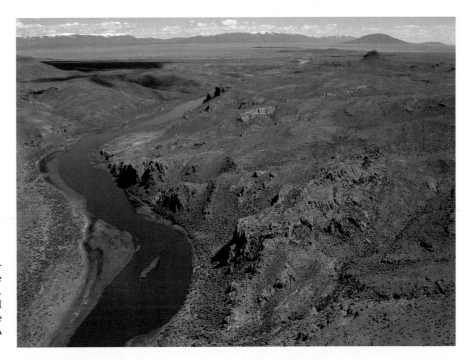

Fig. 13-16 Looking downstream (southward) over the canyon of the Río Grande del Norte across the Fairy Hills, Colorado. This section of the river is rated class I to II for easy canoe/raft trips (Bauer 2011). Kite photo with a compact digital camera by JSA and T. Nagasako.

flows (see Fig. 9-1). Steeper gradients and numerous rapids make for hazardous river canoeing and rafting with difficulty levels IV to V+ in some sections, suitable only for expert boaters (Bauer 2011). SFAP photography along these portions of the Río Grande could be quite helpful for previewing and planning river navigation (Fig. 13-17).

13-3.3 Hornád River Valley, Slovakia

The Hornád River marks the border between Hungary and Slovakia south of Košice, the second largest city in Slovakia. The broad floodplain is utilized primarily for agriculture, and the alluvial aquifer provides municipal

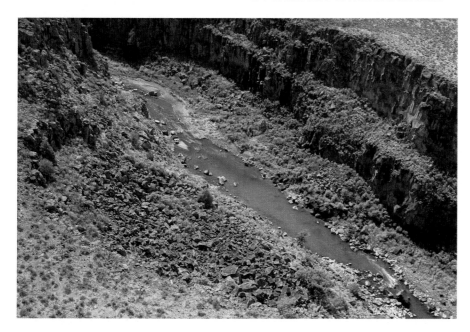

Fig. 13-17 Looking down into the canyon of Río Grande del Norte near Ute Mountain, New Mexico. The canyon here is approximately 200 ft (60 m) deep. Numerous boulders and rapids are visible in the river channel. Such details would be useful for river navigation; this section is class II difficulty for small boats (Bauer 2011). Kite photo taken with a compact digital camera.

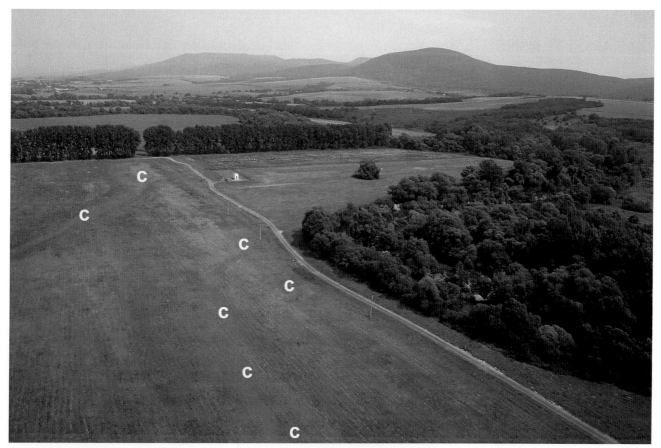

Fig. 13-18 Floodplain of the Hornád River, southeastern Slovakia. Flood channels (c) run over agricultural fields in the foreground from the river on right side. Kite photo with a compact digital camera by SWA, JSA, and J. Janočko.

water for Košice (see Fig. 13-10). The river is subject to frequent flooding; major floods took place in 2005 and 2009. Flood water follows shallow channels across the bottomland, deposits debris, and transports sediment (Fig. 13-18). In places, flood water has eroded large gullies.

A SFAP survey of the vicinity in 2016 revealed several new gullies that were not present in an earlier survey (2007). In particular, a raised, paved road acts as a dam on the floodplain; downstream from this barrier deep gullies were eroded during the flood of 2009 (Fig. 13-19).

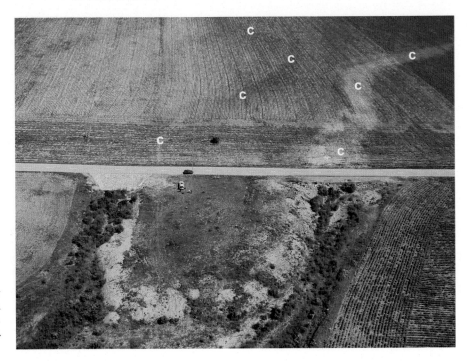

Fig. 13-19 Flood water from shallow channels (c) eroded deep gullies downstream from the road. Kite flyers beside vehicles. Taken with a compact digital camera by SWA and JSA with J. Janočko and M. Prekopová.

13-4 COASTAL LANDFORMS

The assemblage of landforms along any coast depends on several factors, most importantly wave energy and sediment supply. High-energy coasts with limited sediment supply tend to be erosional, as material is removed offshore or moved along the coast (Fig. 13-20). Coasts with moderate or low wave energy and abundant sediment, on the other hand, are characterized by various types of beaches, barrier islands, and deltas. SFAP has proven valuable for illustrating such diverse coastal landforms and beautiful scenery both in vertical and oblique views, and also for monitoring coastal morphology with digital photogrammetric analysis (e.g. Hapke and Richmond 2000; Mancini et al. 2013; Gonçalves and Henriques 2015; Jaud et al. 2016; Turner et al. 2016). Given the normal presence of people on beaches, flying UAS may be problematic in some cases (see Chap. 12). Kite flying is a popular beach activity, on the other hand, and is favored by usually consistent shore breeze.

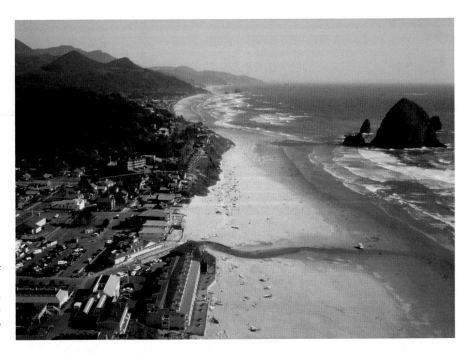

Fig. 13-20 Much of the western coast of North America is dominated by erosion. Canon Beach, Oregon, for example, is characterized by high-energy wave erosion of steep cliffs with limited sand supply. Kite photo taken with an analog camera.

13-4.1 Padre Island, Texas

Padre Island is among the most famous barrier islands in the world. Stretching >180 km from Port Isabella to Corpus Christi, it is the longest barrier island in the United States (Fig. 13-21; Weise and White 1980). A segment some 80 miles (~130 km) long makes up the Padre Island National Seashore, which includes the island, beach, and lagoon habitats. Most recreational activity focuses on the beach, of which 60 miles (~95 km) is open to public vehicular traffic (Fig. 13-22).

A transition from high-energy beach to quiet-water lagoon takes place across the island, and Laguna Madre separates Padre Island from the mainland. The lagoon is shallow, hypersaline, and subject to wind that drives water across tidal flats around its margins. Seagrass on the lagoon bottom is a rich and productive environment with high biodiversity, and emergent wetlands on tiny islands and margins of the lagoon are famous for shore birds and wading birds. Part of this environment is protected in Laguna Atascosa National Wildlife Refuge (Fig. 13-23).

13-4.2 Northwestern Denmark

Northwestern Denmark consists of the mainland peninsula Jutland, which faces the North Sea to the west, Skagerrak Sea to the north, and Kattegat Sea to the east. The land is underlain by thick, unconsolidated glacial deposits that are easily eroded into cliffs along the high-energy western coast (Fig. 13-24). Rapid erosion, particularly during strong winter storms, releases sediment that is transported northward by longshore drift. Some sediment eventually reaches the northernmost tip of Jutland at Skagen, which is a narrow strip of land that separates the Skagerrak from the Kattegat seas. This is a prominent navigation point for passing ships, and several generations of lighthouses have been erected beginning in the late 1700s. Skagen is a low, sandy, wind-swept landscape with long beaches and active sand dunes. It is a famous scenic and touristic locale (Fig. 13-25).

Compared with the western coast, the Kattegat side of northern Jutland presents a dramatic contrast as a low-energy coast with limited sediment supply, as demonstrated by the beach and shore zone at Hurup (Fig. 13-26).

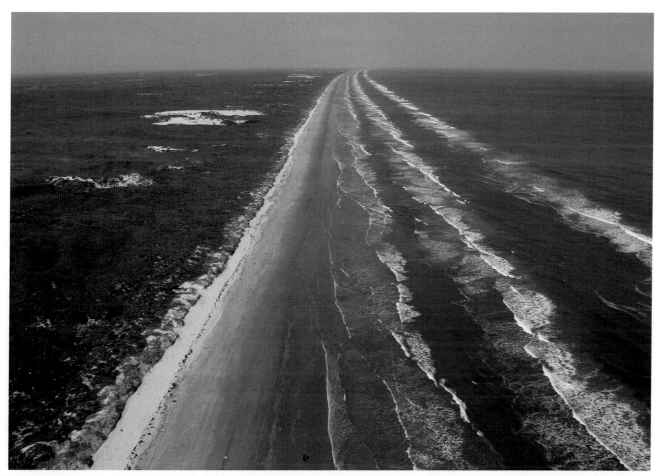

Fig. 13-21 Beach and foreshore zone of northern Padre Island, Texas, United States. The island dune field appears on the left side. This view demonstrates the remarkable length and continuity of the gently curved coast. Note person at bottom for scale. Kite photo taken with a compact digital camera.

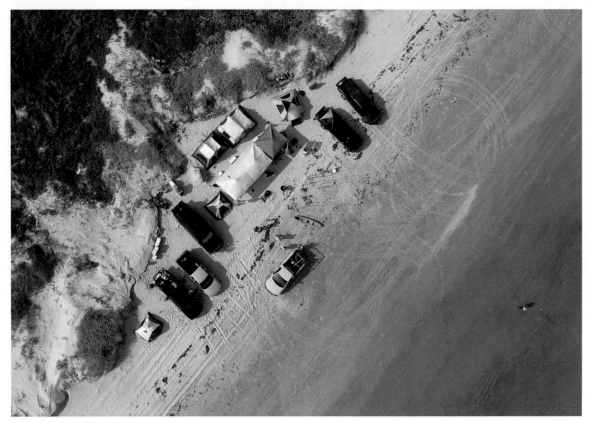

Fig. 13-22 Temporary camp on the beach for an annual fishing tournament at Padre Island, Texas. Vertical kite photo taken with a compact digital camera.

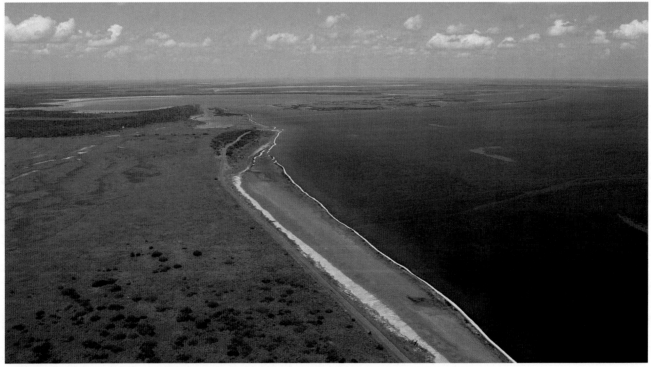

Fig. 13-23 Overview of Laguna Madre and the Texas mainland coast on the left. This environment supports diverse habitats and wildlife including the sandhill crane (*Grus pratensis*), roseate spoonbill (*Ajaia ajaja*), ocelot (*Leopardus pardalis*), and Texas gopher tortoise (*Gopherus berlandieri*). Kite photo taken with a compact digital camera.

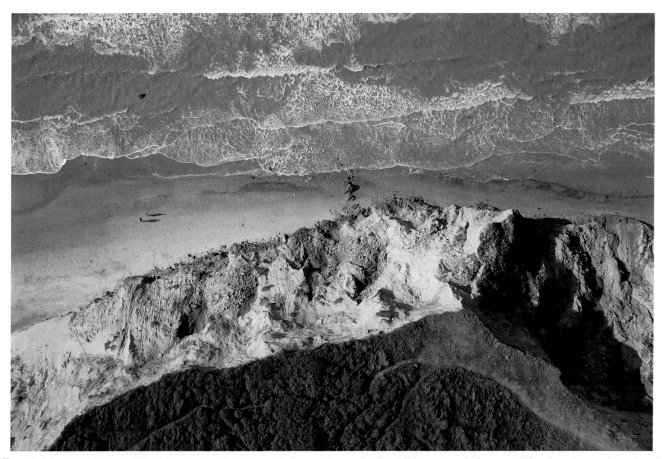

Fig. 13-24 Vertical shot of North Sea coast and cliff near Skallerup, Denmark. The cliff is composed of unconsolidated sand, gravel, mud, and boulders that are easily eroded by wave action during storms. The cliff stands approximately 30 m (~100 ft) tall; note two people on the beach for scale. Kite photo with a compact digital camera.

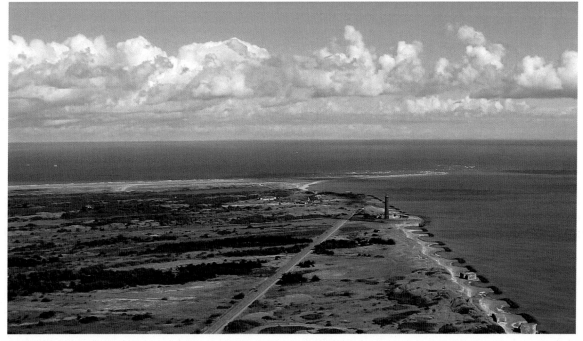

Fig. 13-25 View northward toward the tip of Skagen, Denmark, where an active sand spit is growing. Current lighthouse built of brick in 1858. Note boulder barriers along right side to protect the coast from erosion. Kite photo with a compact digital camera.

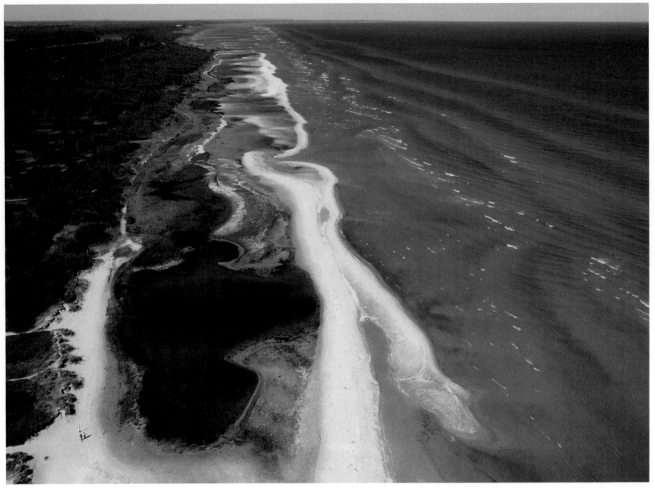

Fig. 13-26 View northward over the shore zone at Hurup, Denmark. Offshore sand bars run parallel to the beach which is separated from the mainland by narrow lagoons. Kite flyers in lower left corner; taken with a compact digital camera (Aber and Aber 2014).

Here a narrow and discontinuous sandy beach is separated from the mainland by small lagoons. Shallow offshore sand bars parallel the beach and are quite visible through the clear water.

13-5 TECTONIC LANDFORMS

Mountains, fault systems, volcanism, intrusions, and related deformations result from tectonic processes originating deep beneath the surface in the crust and mantle. Some generate conspicuous and spectacular landforms; others are subtle features hardly noticeable in the landscape. As an example of the latter, small kimberlite intrusions are present in north-central Kansas. In other places around the world, kimberlite pipes are a primary source of diamonds derived from at least 100 km depth, hence considerable investigations of Kansas kimberlite pipes for their potential economic value (e.g. Brookins 1970; Buchanan 1999; Kempton et al. 2019). A detailed SFAP

survey at one site revealed the subtle yet distinct topographic expression of the kimberlite pipe (Fig. 13-27).

Mountains result from tectonic collisions involving continental lithosphere (crust plus uppermost mantle). Such collisions typically take place at convergent plate boundaries and may include various combinations of large continents, smaller terranes, or oceanic materials. In most cases, mountains are intimately associated with current or former subduction zones, where an oceanic plate dives under another plate, as along the western coast of North America (Fig. 13-28), but in some cases the subduction zone may be far away from the site of mountain building.

As mountains rise up, they undergo rapid erosion, particularly in tropical settings, for higher altitudes, and where glaciated. A tremendous volume of sediment is transported and deposited in adjacent basins. Eventually mountain systems collapse under their own weight and erode down to low levels, such as the Appalachian Mountains of eastern North America and the Caledonian

Fig. 13-27 Winkler kimberlite pipe, Riley County, Kansas, United States. Normal-color photomosaic (above) and shaded-relief digital elevation model (below) derived from the airphotos. The pipe is clearly visible as the nearly circular feature on the left. Based on >600 individual digital photos taken from a quadcopter UAV. *Courtesy of A. Peterson (Kansas Geological Survey).*

Mountains in the Scottish Highlands. Although older mountains may be much reduced in size, often the associated basins survive and preserve a record of mountain building in their sedimentary strata. As discussed before, conducting SFAP in mountains and at high altitude is complicated by several factors (see Chap. 9); nonetheless, the results certainly justify the effort.

13-5.1 Rocky Mountains, Colorado and New Mexico, United States

The southern Rocky Mountains in Colorado and New Mexico have been studied intensively since the 19th century, but their tectonic origin has been controversial, as the mountain system is far from the subduction zones and plate collisions that took place along the western coast of North America. As recently as the turn of this century, some reputable geologists claimed that plate tectonics did not apply to the region (Baars 2000). However, now there is general agreement that deformation and uplift of the Rocky Mountains was caused by an extremely shallow subduction zone that extended nearly horizontally all the way from California to Colorado (Murphy et al. 1999).

Shortly after the Rocky Mountains were uplifted in the Eocene (~50 million years ago), the tectonic regime

Fig. 13-28 Coast ranges of central California consist of various materials scrapped off a subducting oceanic plate in the past. Terraces in the middle distance are former erosional shorelines, now uplifted high above sea level. Juvenile elephant seals are resting on the beach (see Fig. 1-2). Point Piedras Blancas on the Big Sur coast south of Monterey; kite photo with a compact digital camera.

changed from compression to extension, and the Rio Grande Rift system opened up along deep faults accompanied by extensive intrusions and volcanism. The result is a complex assemblage of structures and landforms.

The San Luis Valley (SLV) of southern Colorado and northernmost New Mexico is part of the Rio Grande Rift system. The SLV has been called the highest, largest, mountain desert in North America (Trimble 2001), and is the largest high-elevation valley in the world (Bauer 2011). It is a tectonic gash that splits the southern Rocky Mountains. The SLV is bounded on the east by the Sangre de Cristo Mountains (see Fig. 13-9) and on the west by the San Juan Mountains (see Fig. 9-9). The valley sank along deep bounding faults, and the resulting basin is filled with 1000s of meters of volcanic strata and sediments eroded from surrounding mountains. One of the most characteristic geomorphic features along the eastern side of the SLV are huge alluvial fans built of sediment washed down from the adjacent mountains (Fig. 13-29).

13-5.2 Carpathian Mountains, Poland and Slovakia

Eastward from the Alps, the Carpathian Mountains extend as a great loop across central and southeastern Europe. The western Carpathians are a classic thrust mountain belt with a salient that arcs northward into northern Slovakia and southernmost Poland. The mountains culminate with peaks of the High Tatrys that exceed 2600 m (>8500 ft) altitude (Fig. 13-30). The High Tatrys are supported by granite nappes thrust north-

ward over sedimentary strata. The two sides of the High Tatry display markedly different geomorphic expressions, however.

The northern Polish side rises up steeply from a linear boundary along the Podhale Trough (Fig. 13-31); the boundary represents high-angle faults and thrust blocks (MECC 2008a). The southern Slovak side of the High Tatry, on the other hand, is marked by large alluvial fans that have grown together along the mountain flank (Fig. 13-32). These fans are underlain by glaciofluvial gravel up to 400 m thick that washed out of the High Tatry during the Pleistocene. The thickness, geomorphic expression, and young age of the fans suggest significant mountain uplift during the past one million years, but the region is tectonically quiet nowadays.

The western Carpathians represent the collision of the Apulia plate that was thrust from south to north over the edge of the European tectonic plate. Apulia was either an independent terrane, a microplate, or a promontory of the Afro-Arabic plate (Janočko et al. 2006). Convergence during the Paleogene closed a former sea between Apulia and Europe. The Apulia-Europe suture zone is marked by chaotic rocks of the Pieniny Klippen Belt (MECC 2008b), which consists of Jurassic and Cretaceous sedimentary strata that are strongly deformed and mixed into a megabreccia or mélange (Fig. 13-33). Small-format aerial photography has proven useful for educational purposes, namely illustrating geologic structures and landforms of the western Carpathian Mountains.

Fig. 13-29 Alluvial fans slope steeply on the flanks the Sierra Blanca massif. These fans are composed of bouldery gravel and sand. Highest peaks exceed 14,000 ft, and the foreground is around 7800 ft in elevation, which gives 6200 ft (~1900 m) local relief. Kite photo with a compact digital camera.

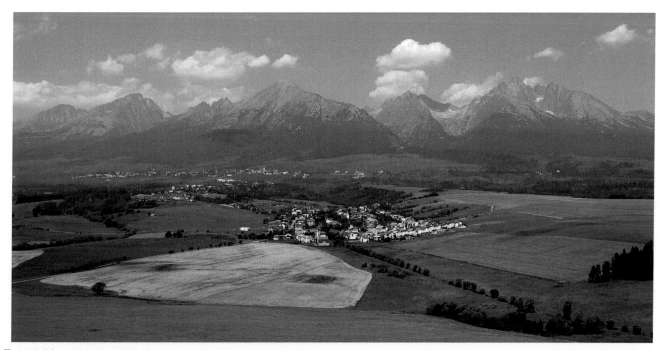

Fig. 13-30 Central portion of the High Tatry Mountains seen from the Slovak side. Lomnicky peak (to right) is the second highest peak in the Tatry at 2634 m. Village of Nová Lesná in the foreground. Kite photo with a compact digital camera.

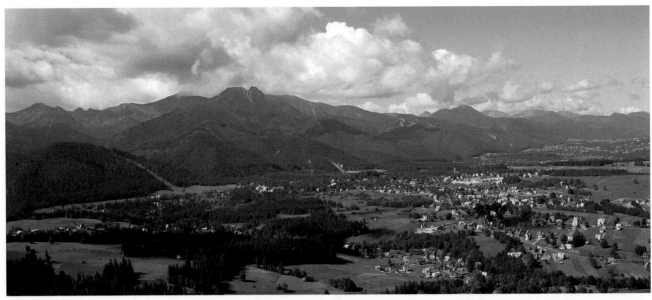

Fig. 13-31 Northern margin of the High Tatry at Zakopane, Poland. Note the straight, linear boundary of the mountain front running from left to right across scene center. Kite photo with a compact digital camera by JSA and SWA with M. Górska-Zabielska and R. Zabielski.

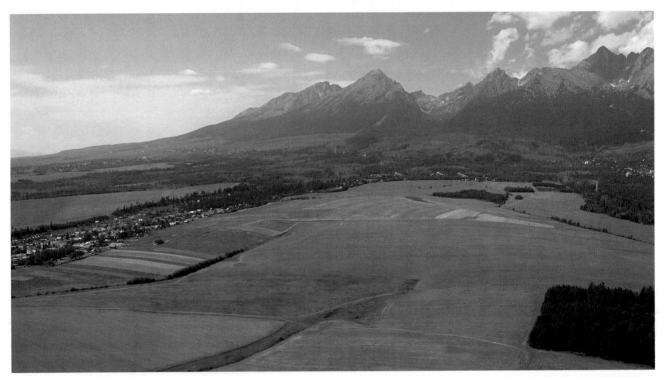

Fig. 13-32 Southern margin of the Slovak High Tatry. Alluvial fans make up the foreslope of the mountains in the foreground and left background. Steep, upper portions of the fans are forested, whereas lower slopes are devoted mainly to agriculture and small villages. Seen here in the vicinity of Stará Lesná; compare with Fig. 13-29. Kite photo with a compact digital camera by JSA and SWA with J. Janočko and B. Fricovsky.

13-5.3 High Atlas and Antiatlas Mountain System, Morocco

The Atlas is the largest alpine mountain system in Africa. Geologically and geotectonically, it belongs to the alpine fold-mountain belt that reaches from North Africa, across Europe and central Asia, and into southeastern Asia. On its southern side it forms the interface between the African and the Eurasian plates, a seismically highly active zone (Sébrier et al. 2006). The latest devastating earthquake occurred in 1960, destroying the city of Agadir and killing 15,000 people.

Geologically speaking, the border of Africa lies south of the High Atlas range in the Souss Basin. The transition

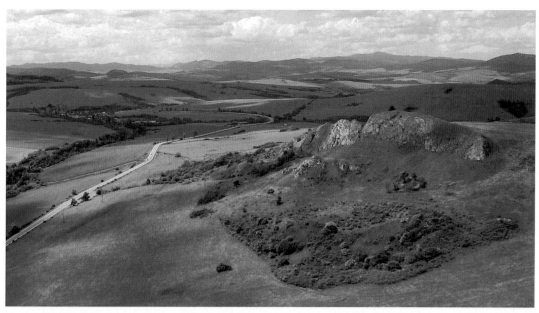

Fig. 13-33 Pieniny Klippen Belt near Kamenica, northeastern Slovakia. The hogback ridge on right is an isolated fault-block of limestone surrounded by more easily eroded strata. Kite photo with a compact digital camera by SWA and JSA with I. Duriška.

of the strongly folded Mesozoic mountain range preceding the High Atlas into the Souss Basin is formed by a number of interlinked alluvial fans, which, as a fan apron, represent an independent landscape between the high mountains and the interior of the basin. Coming from the High Atlas during the Quaternary, tributaries of the Oued Souss formed these alluvial fans. They show a typical fan geomorphology with slopes ranging from 10° at their northern edge to about 1.5° at the southern end.

Fig. 13-34 shows a northwest-facing part of these fans. There is the typical grain sorting of block-sized coarse material in the proximal part to silty grain sizes at the distal part. Today, small channels incise the surface 1 to 2 m deep. The land is used for speculative dry farming,

the field borders are defined with contour-parallel stone lines. Main use, however, is extensive grazing with goats and sheep. In arid years, the broadly dispersed argan trees (*Argania spinosa*) are the only food source for livestock. They are increasingly damaged by browsing and protected by strict grazing regulations.

Today, the wadis are deeply incised (5–10 m) into these alluvial fan sediments at the apex. During heavy rainfall events, they act as northern tributaries to the Souss River, transporting episodic flash floods from the High Atlas with a time delay of about 20–30 h into the basin. The sediment load transported from the mountains includes boulder-sized rock material. Only in rare cases are the settlements damaged, which are situated on the

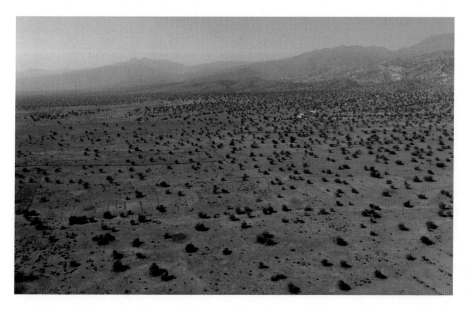

Fig. 13-34 Irguitène alluvial fan near Taroudant, Souss Basin in South Morocco. View facing west over the fan along the mountain range preceding the High Atlas. The density of argan trees is low, and many trees show impaired growth forms due to goat browsing. Taken with on-board camera of quadcopter UAV by R. Stephan, IM, and M. Kirchhoff. Compare with alluvial fans in Figs. 13-29 and 13-32.

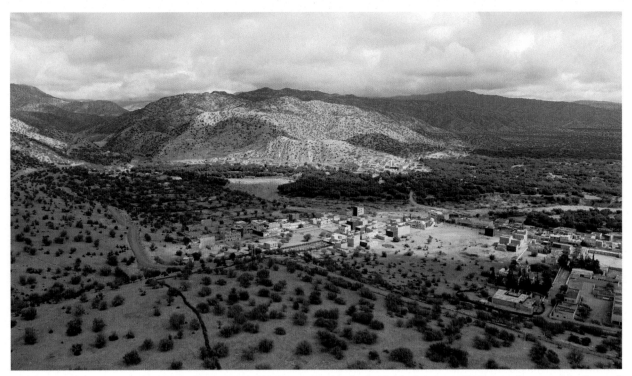

Fig. 13-35 Northeast-facing view to the cloud-covered High Atlas over Tamaloukt, South Morocco, a small village at the apex of the Ouaar alluvial fan. The argan woodland in the central and right part of the fan (foreground) is partly protected by fences. To the left of the fence and road, some severely grazed *Argania spinosa* are reduced to low conical bushes. Taken with on-board camera of quadcopter UAV by IM, R. Stephan, and M. Kirchhoff.

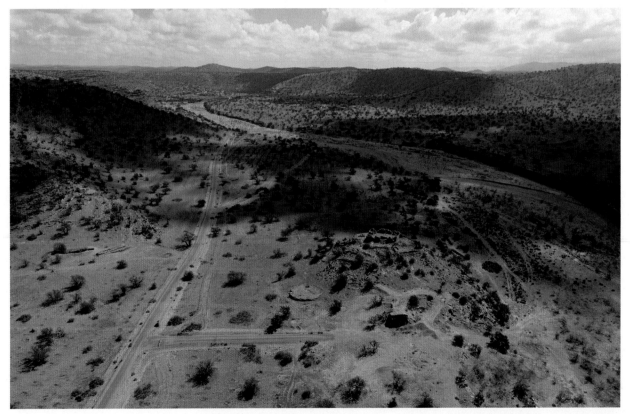

Fig. 13-36 Oued Aouarga near Aït Baha, South Morocco; view southeast to the western Antiatlas mountain system. The wadi bottom shows signs of highly active transport of coarse material and recent incision during the last winter. Geoarchaeologically interesting are the remains of an Agadir (grain storehouse) with a round threshing floor; these are the most important cultural heritage monuments in the Antiatlas region. Taken with on-board camera of quadcopter UAV by M. Kirchhoff and R. Stephan with IM.

flood-safe side of the channel (Fig. 13-35). As real wadis, the channel beds then fall dry again for months to years. In the vicinity of the settlement, denser argan forest is found. On private land, trees are better protected from grazing and uncontrolled deforestation. On the slopes of the mountain range preceding the High Atlas, however, grazing is less controlled and the open woodland is more degraded. With steeper slopes, the soils are significantly more degraded, and numerous rills and gullies may be observed.

On the south side of the Souss basin, the Antiatlas rises, a strongly peneplaned mountain system composed of Paleozoic rocks (Fig. 13-36). This region is climatically much drier than the High Atlas, and the wadis carry less water. However, fluvial extreme events also take place as may be derived from the existence of wide, gravel-filled channel beds with several recent gravel terraces and remnants of two recognizable Quaternary terraces. Mountain ridges and slopes are covered with open argan woodland. Clearly visible in the left part of the image are also regularly spaced planting pits from the latest reforestation program. At the time the airphoto was taken, many of the *Argania spinosa* saplings had already been grazed.

13-6 SUMMARY

Geomorphology is the study of the Earth's surface processes and landforms, and the geomorphology of any region or site is the result of interplay involving three primary factors, namely structure, process, and time. The geomorphology of any region represents a long-term integration of environmental conditions and is, thus, a reflection of both past and present environments including human modifications of the landscape. SFAP provides low-height, large-scale imagery that complements conventional aerial photography, satellite imagery, and ground observations for recognizing, mapping, quantifying, and interpreting diverse geomorphic landforms.

Glacial geomorphology consists of landforms created by glacier ice erosion, deposition, and deformation as well as erosion and deposition by glacial meltwater. The glacial processes operating at a site may change during the course of an individual ice advance and retreat, and glaciation happened repeatedly in many regions. The results are complex overprintings of landforms that represent multiple glaciations during the Pleistocene. Oblique SFAP views are particularly useful for depicting individual landforms; such views help to visualize landform assemblages that are typical of many formerly glaciated regions.

Rivers are capable of erosion as well as sediment deposition under a wide variety of environmental conditions that lead to many typical landforms. All rivers and streams flood periodically, which may result in human casualties, damage to structures, and impairment of human land use. Two basic forms of rivers are braided and meandering. The Río Grande del Norte was strongly affected by tectonic events connected with faulting and volcanism in the San Luis Valley; it has cut deep canyons across uplifted fault blocks and into thick lava flows. The Hornád River, on the other hand, is highly meandering within a broad bottomland, and is subject to frequent flooding. Both rivers are impacted by human conversions of land use.

Coastal landforms depend on several factors, most importantly wave energy and sediment supply. Padre Island illustrates a high-energy coast with a good sediment supply; it protects the low-energy and low-sediment environment of Laguna Madre. Coasts in northwestern Denmark represent both high- and low-energy environments with limited sediment supply. SFAP has proven valuable for illustrating riverine and coastal landforms and environments both in vertical and oblique views. SFAP is able to document changes and ongoing processes of change in a geomorphological context.

Mountains, fault systems, volcanism, intrusions, and related crustal deformations result from tectonic processes. Such features range from small and subtle, such as kimberlite pipes, to some of the largest and most prominent landforms on the Earth's surface. For large mountain systems and rift zones, SFAP is useful for portraying individual components such as fault zones, alluvial fans, and megabreccia zones. SFAP is also an excellent educational technique for illustrating all types of geomorphic features and landforms.

14

Gully-Erosion Monitoring

To the experienced geographer a map may illustrate perfectly the action of a stream working headward into higher land; but the student to whom the conception of headward erosion is new will certainly grasp the idea more readily from an aerial photograph. Willis T. Lee (1922)

14-1 INTRODUCTION

Gullies are permanent erosional forms that develop when water concentrates in narrow runoff paths and channels and cuts into the soil to depths that cannot be smoothed over by tillage any more. They are therefore the most severe form of soil erosion. Gullies occur all over the world mostly in semiarid and arid landscapes where high morphological activity and dynamics may be observed. Semiarid climate conditions and precipitation regimes encourage soil erosion processes through low vegetation cover and recurrent heavy rainfall events. Torrential rains with irregular spatiotemporal distribution result in high runoff rates, as the crusted and dry soil surface inhibits infiltration. In addition, widespread land-use changes of traditional agriculture toward both more extensive use, such as abandoned agricultural fields used for sheep pasture, and less-sustainable use,

such as almond plantations, prepare the ground for soil crusting, reduced soil infiltration capacity, and increased runoff, which together aggravate the risk of linear erosion downslope and cause considerable off-site impairment such as reservoir siltation (Poesen et al. 2003).

In this context, gullies link hillslopes and channels, functioning as sediment sources, stores, and conveyors. The high variability of gully retreat rates and their important contribution to total sediment yield particularly in agricultural areas has been attested by many studies (Castillo and Gómez 2016; Vanmaercke et al. 2016). From a review of gully erosion studies in semiarid and arid regions, Poesen et al. (2002) concluded that gullies contribute an average of 50%–80% of overall sediment production in dryland environments.

Gullying involves a wide range of subprocesses related to water erosion and mass movements, such as headcut retreat, piping, fluting, tension-crack development, and mass wasting (Fig. 14-1), and it is the complex interaction of these subprocesses on different temporal and spatial scales that complicates reliable forecasting by gully erosion models (Poesen et al. 2003).

The evaluation of gully development rates under different climatic and land-use conditions provides important data for modeling gully erosion and predicting impacts of environmental change on a major soil

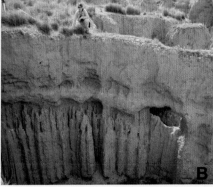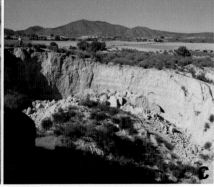

Fig. 14-1 Gully erosion in southeastern Spain. (A) Active headcut of small gully ~2.5 m wide and < 1 m deep. (B) Large gully with remains of piping hole and fluted walls typical for higher dispersible subhorizons. (C) Large gully filled with debris of collapsed sidewall.

erosion process. Numerous authors have investigated (non-ephemeral) gully development in different environments (e.g. Burkard and Kostaschuk 1997; Oostwoud Wijdenes and Bryan 2001; Vandekerckhove et al. 2001; Gábris et al. 2003; Martínez-Casasnovas et al. 2004; Avni 2005; Wu et al. 2008; Frankl et al. 2012), but still both methodological problems and a lack of comparability across study areas exist.

Poesen et al. (2002, 2003) therefore stressed the need for more detailed and more precise monitoring and modeling of gullies. In addition, the importance of understanding the temporal variability of gully-erosion rates as well as the role of land use and other potential control factors in the catchment area is emphasized by Vanmaercke et al. (2016). Lane et al. (1998) pointed out that the monitoring of the changes in form may provide a more successful basis for understanding landform dynamics than monitoring the process driving those

dynamics, as this morphological information may allow to estimate the spatial distribution of process rates. In this context, remote sensing is an obvious choice for monitoring gully erosion, as it allows the rapid and spatially continuous coverage of a site.

However, the measurement precision and repeat rate attainable with conventional remotely sensed images are not able to correspond with the process magnitudes and dynamics that are required for recording and investigating the short-term spatial and temporal variability of gully retreat (Ries and Marzolff 2003). Small-format aerial photography (SFAP), in contrast, has an excellent potential for gully-erosion research as it bridges the resolution gap between terrestrial and conventional aerial photography or very-high-resolution satellite imagery. However, when SFAP began to make a comeback in the late 20th century (Chap. 1-2), geomorphologists in general, and gully-erosion researchers in particular, were

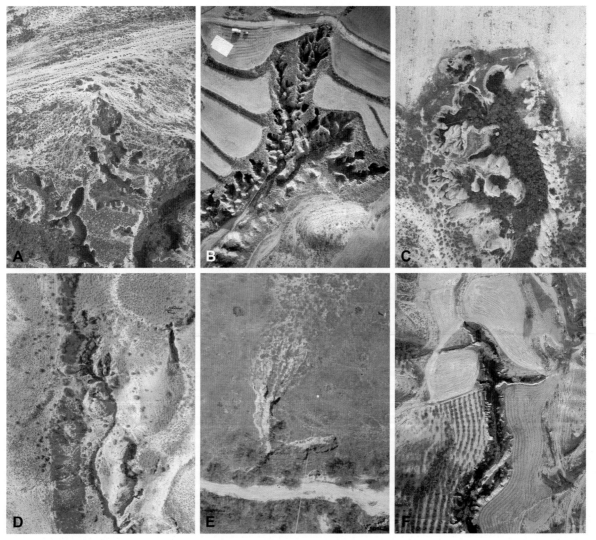

Fig. 14-2 Selected gullies monitored by SFAP in Spain (A–F), Morocco (G–K), and Burkina Faso (L and M). Kite and hot-air blimp photographs by IM, JBR, and collaborators, taken between 1996 and 2014. (A) Barranco de las Lenas. (B) Barranco Rojo. (C) Salada 1. (D) Freila. (E) Casablanca. (F) Belerda 1. (G) Gchechda. (H) Hamar 1. (I) Hamar 3. (J) Lam 1. (K) Gorom-Gorom. (L) Oursi.

comparatively slow to adopt this niche remote-sensing technique. Images, after all, are two-dimensional representations, and gullies are three-dimensional, often highly complex landforms. This presents specific challenges with respect to analysis methods and digital data formats that were not easily dealt with 30 years ago.

Until the early 2000s, most gully-monitoring studies using remotely sensed imagery therefore resorted to standard large-format aerial photographs with medium to small image scales, looking at medium- to long-term intervals (e.g. Burkard and Kostaschuk 1997; Vandaele et al. 1997; Nachtergaele and Poesen 1999; Vandekerckhove et al. 2003). It is only in recent years that the rapid development of both UAS and photogrammetric techniques—in particular, Structure from Motion–Multi-View Stereo (SfM-MVS)—has made SFAP of interest for a wider gully-erosion research community (e.g. Stöcker et al. 2015; Wang et al. 2016; Koci et al. 2017; Wells et al. 2017; Bennett and Wells 2018; Feurer et al. 2018; Gudino-Elizondo et al. 2018).

For 25 years, SFAP has been a core method for gully-erosion research in numerous studies conducted by the authors (Marzolff 1999, 2014; Marzolff et al. 2003, 2011; Ries and Marzolff 2003, 2007; Marzolff and Ries 2007; Seeger et al. 2009; Ries et al. 2016). The following sections summarize some of the work done with hot-air blimps, kites, and fixed-wing and multirotor UAS across semiarid landscapes in southwestern Europe and North and West Africa, illustrating the benefits of SFAP not only for quantifying but also for understanding gully-erosion processes by selected examples.

14-2 STUDY SITES AND SURVEY

The study areas are situated in Spain, Morocco, and Burkina Faso along a transect running from semiarid to subhumid Mediterranean and subtropical desert climate to tropical wet-dry regions (Fig. 14-2; for additional study sites, see gully images in Chaps. 2, 4, 5, 10 and 11). Thus,

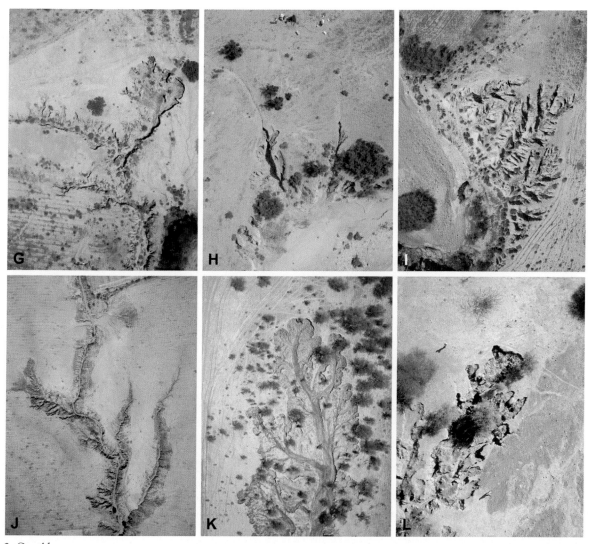

Fig. 14-2, Cont'd

they cover climatic regions where precipitation regimes are the most favorable for gully erosion. The gully environments range from agricultural areas and rangeland to deserts. Beginning between 1995 and 2010, >30 gullies of varying types, sizes, and ages have been monitored with stereoscopic SFAP in intervals of usually 1 or 2 years.

Both platforms and cameras have evolved over the years from more manually navigated and analog to autopiloted and digital. Depending on wind conditions and survey area size, a hot-air blimp (see Chap. 7-3.3) or a large rokkaku-type kite (see Chap. 7-4) was employed as a platform for analog (up to 2002) or digital single-lens reflex (DSLR) cameras. Since 2010, the platform used most is the *MAVinci Sirius* I (see Chap. 8-2), a fixed-wing UAV equipped with a digital mirrorless interchangeable-lens camera (MILC). Most recently, small quadcopter UAS (*DJI Phantom* 3/4) with integrated on-board cameras have joined the fleet.

The study sites that are monitored range from individual gullies to badland areas to whole gully catchments. The required image scales and resolutions vary depending on the processes observed and include detail photos as well as overview images. In order to take into account the different site extents and observation scales, the surveys are usually conducted at multiple flying heights. At all gully sites, ground control points (GCPs) measured with a total station or RTK-GPS in a local coordinate system are permanently or temporarily installed with steel pipes and marked with signals for the photographic survey (see Chap. 9-5). From the resulting stereoscopic images with extremely high ground resolutions of 0.5–10 cm, various techniques of analysis for measuring gully development and loss of soil material have been carried out with image-processing systems, geographic information systems (GIS), and digital photogrammetry.

14-3 GULLY MAPPING AND CHANGE ANALYSIS

During the early years of study, 2D measurements of headcut retreat and gully growth were accomplished by rectifying and—if required—mosaicking the photographs using GCPs installed in the surroundings of the gully. Thus, detailed mapping of the gully edges was possible despite the remaining relief displacement in the gully interior, which was not at the focus of the investigation and could not have been geocorrected accurately with polynomial rectification (see Chap. 11-2.2). In later project stages, 3D mapping in a stereoviewing environment and digital elevation model (DEM) extraction using digital photogrammetry software made it possible to map the complex gully forms even more precisely (see Fig. 11-20) and to create 2.5D or 3D models for measuring gully volume, analyzing hydrological flow, and delineating rill and gully catchments (Fig. 14-3; see also Figs. 11-22 to 11-24).

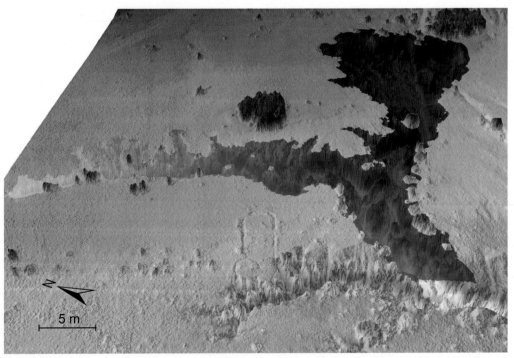

Fig. 14-3 Oblique 3D view of the digital elevation model of Gully Gchechda, near Taroudant, South Morocco, November 2011 (compare Fig. 14-2G). By constructing a "lid" for the gully (here seen in transparent gray) from the digitized gully edges, the gully volume below may be calculated. The covered part of the gully has a volume of 678 m³; it has grown fast by 274 m² (343 m³) since September 2009, with an annual maximum headcut retreat rate of 7.56 m. The headcuts of the eastern part continued to retreat by an average 1.1–1.2 m/a until March 2014, and slowed down to 0.15–0.25 m/a until October 2018 following changes in runoff conditions in the gully catchment.

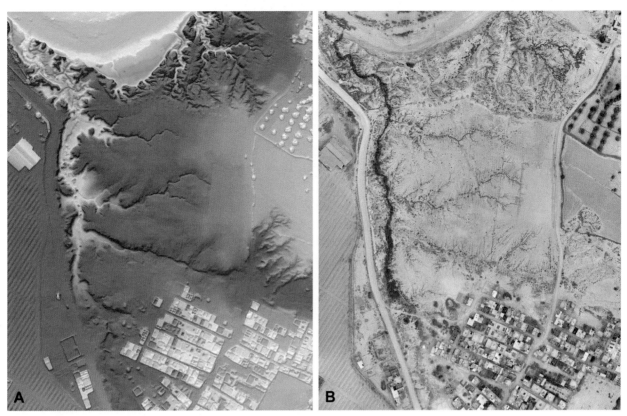

Fig. 14-4 Digital elevation model (A) and orthophoto mosaic (B) with 50 and 10 cm GSD of the 25-ha study area El Houmer, South Morocco (compare Fig. 3-13). For these datasets, 370 overlapping images were taken with an MILC on a fixed-wing UAV within 25 min flying time. Processing with SfM-MVS photogrammetry (as described in Chap. 3-3.5) was done without GCPs, using the images' exterior orientation from GPS/INS flightlog in a direct georeferencing approach. The positional accuracy is ~1.5 m, processing time was ~2 h. Image processing by IM.

Detailed change analysis from the multitemporal datasets for quantifying linear retreat and increase of gully area and volume at the site scale still requires precise ground control with GCP deployment and measurement as described in Chap. 9-5. At the study-area scale, lower resolution overview datasets may be processed with a direct georeferencing approach, using the GPS coordinates attributed to each UAS image during the flight (Fig. 14-4; see also d'Oleire-Oltmanns et al. 2012). Orthophotos and DEMs are used as a basis for maps of land use, relief, and hydro-geomorphological processes.

The following examples of gully development illuminate the variability in rates and control factors of gully evolution. Gully Gorom was monitored with SFAP over a period of three seasons in a project terminated in 2002; its change map is complemented with smaller scale satellite image data from 2007 (Fig. 14-5). Note the much coarser outlines of the last gully stage; high-resolution satellite data were a viable supplement in this case only because of the large size of the gully, the fast retreat rate, and the long final interval. The gully edges retreat along the full length of the gully, reshaping the gully form during each rainy season. The surrounding glacis area has little relief that might lead to preferential linear flow paths, apart from

the shallow main drainage line and some off-road tracks left by occasional vehicles driving alongside the gully. It is in the direction of these tracks that one of the lateral headcuts swings during the last monitoring interval.

Along the gully edges, mass wasting is the main reason for gully growth, and large clods of soil come to rest beneath the gully rim before being washed away by further erosion. Piping (subsurface erosion), often promoted by desiccation cracks at the headcut vicinity, is also involved in the retreat process (compare Fig. 10-10). Despite the great width of the gully, incision is only shallow and the heights of the sidewalls are only between 40 and 100 cm. The maximum depth of the central drainage channel is ~1.2 m. Within the part of the mapped gully, areal growth is quite regularly around 800 m² per year, but maximum linear headcut retreat varies depending on the spatial development of the gully's shape. High-resolution satellite images on *Google Earth* allow roughly to follow the development for another 10 years: Guided by criss-crossing tracks, the gully had changed its course by 90° until January 2017, with an increased annual retreat rate of ~21.2 m, growing an average 1020 m² per year.

Our research at >30 gullies confirms that gully growth is strongly related to the characteristics of topography,

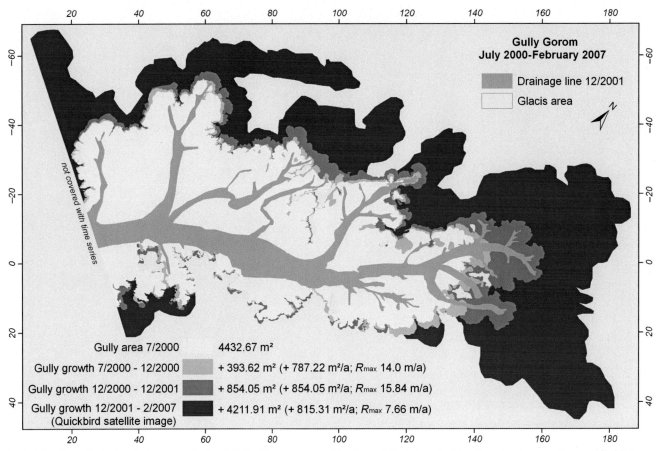

Fig. 14-5 Two-dimensional change analysis of Gully Gorom-Gorom, Province of Oudalan, Burkina Faso. Gully growth quantified between rainy seasons 2000 and 2001 (SFAP) and 2007 (*Quickbird*). Based on kite photography by IM, JBR, and K.-D. Albert; image processing and cartography by K.-D. Albert and IM.

substratum, runoff, and infiltration behavior as well as land use in the gully catchment. Many of these factors may be interpreted or analyzed and mapped with SFAP. A good example is Gully Salada 1, where human interaction plays an additional role (Fig. 14-6; see also Marzolff et al. 2011). Until 2004, this large gully cutting into the Quaternary deposits of the Guadalentín Basin in southeastern Spain was the fastest growing of the 14 Spanish gullies being monitored, with an average maximum headcut retreat of ~0.5 m (Marzolff and Ries 2007).

The immediately adjoining almond plantation, which was established only a few years before monitoring began, is kept weed-free by regular plowing. Soil crusting results in remarkably high runoff rates and in the formation of ephemeral gullies between the almond trees. To bar the gully from retreating farther into the plantation, the farmer had plowed up an earthen dam around the gully margin—a measure with limited success. Runoff from the plantation collected at the earthen dam subsequently resulted in subsurface erosion processes, creating a growing piping hole, which drained beneath a bridge remaining of the former dam (see also Vandekerckhove et al. 2003).

The piping hole increased rapidly in the following years, while the main gully was used as a rubbish dump, and building rubble was shoved repeatedly over its northern edge by tractors. In 2005, the upper part of the gully including the piping hole was completely filled with ~7000 m³ rubble and soil material (as quantified from stereophoto analysis) up to the level of the former surface, sloping into the remaining gully beyond an earthen dam (Fig. 14-6A). This dam reestablished the former border of the field; the missing almond trees were replanted between 2006 and 2008. By 2006, the infilling already had begun to subside and show large settlement cracks, preparing the ground for resumed piping processes. In September 2009, heavy rainfall events resulted in terrace and dam breaches, intense sheet wash and ephemeral gully erosion in the upslope almond plantation (see also Fig. 10-40). In spite of the gully infilling and leveling, the shape and development of the former piping hole and gully still control the spatial pattern of overland flow concentration on the field (Fig. 14-6B).

This example illustrates two important aspects for gully-erosion research: Firstly, earthen dams or loose

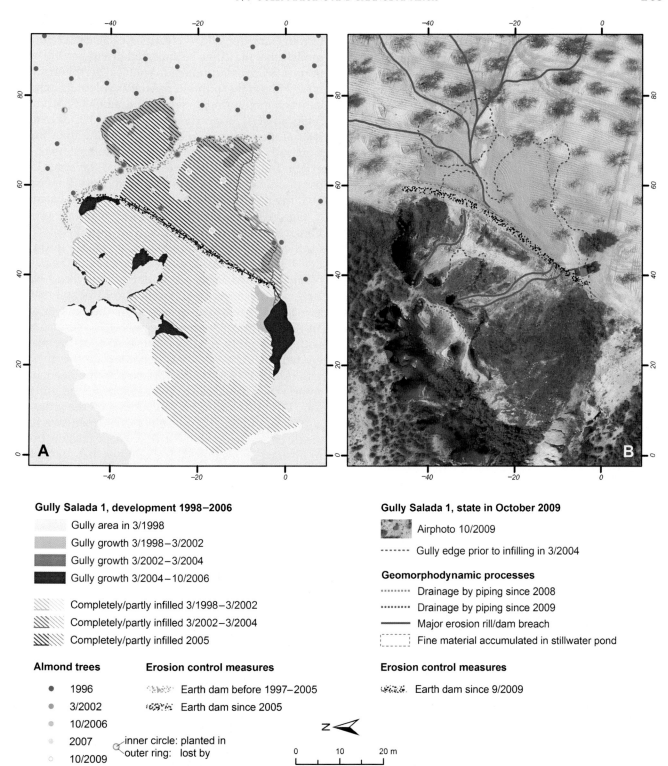

Gully Salada 1, development 1998–2006

Gully area in 3/1998

Gully growth 3/1998–3/2002

Gully growth 3/2002–3/2004

Gully growth 3/2004–10/2006

Completely/partly infilled 3/1998–3/2002

Completely/partly infilled 3/2002–3/2004

Completely/partly infilled 2005

Almond trees

- 1996
- 3/2002
- 10/2006
- 2007
- 10/2009

inner circle: planted in
outer ring: lost by

Erosion control measures

Earth dam before 1997–2005

Earth dam since 2005

Gully Salada 1, state in October 2009

Airphoto 10/2009

------- Gully edge prior to infilling in 3/2004

Geomorphodynamic processes

········· Drainage by piping since 2008

········· Drainage by piping since 2009

——— Major erosion rill/dam breach

Fine material accumulated in stillwater pond

Erosion control measures

Earth dam since 9/2009

N

0 10 20 m

Fig. 14-6 Evolution of Gully Salada 1, Province of Murcia, Spain, 1996–2009, with indication of gully erosion, drilling and piping, erosion control measures, and almond tree plantings. Based on hot-air blimp and kite photographs by IM, JBR, and M. Seeger; image processing and cartography by IM. (A) Gully growth and infilling between 1996 and 2006. (B) Gully state and geomorphodynamic processes in October 2009. For a more detailed development history of this site, see Marzolff et al. (2011).

stone dams built up for erosion control are not able to withstand the high runoff volumes during extreme rainfall events. On the contrary, by retaining water in temporary ponds they may boost piping processes and headward erosion at the dam. Secondly, long-term monitoring with intervals of 15 to 30 years—typical for studies based on conventional large-format aerial photographs—is not able to reveal the influence of ad hoc erosion control measures by farmers. The average retreat rates measured in long-term monitoring should therefore be regarded as potentially too low.

Vandekerckhove et al. (2003, Table 2), for example, measured no retreat for Gully Salada 1 between 1957 and 1981 from conventional airphotos. In the same study, they also observed negative change at other gullies due to infilling by tilling. Possible alternation of infilling and renewed erosion during long-term monitoring, however, cannot be detected unless shorter observation intervals are used. Capturing spatially continuous, high-resolution 3D data using SFAP is of high value for avoiding such methodological errors in gully monitoring (Marzolff et al. 2011).

Beyond 2D mapping and quantification, 3D photogrammetric analysis of stereo imagery has numerous advantages for gully-erosion monitoring. Various methods and methodological issues of photogrammetric SFAP processing applicable to gully-erosion research have already been discussed in Chaps. 3-3, 10-4 and 11-6. For example, the identification and delineation of gully edges is greatly improved when mapping manually in a 3D stereoviewing environment. Furthermore, automatic terrain extraction allows creation of 2.5D or 3D elevation models that may then be analyzed by cut-and-fill operations in a GIS environment to enable determining the total soil loss at the gully site as well as volumetric changes between monitoring dates. Photogrammetric 3D modeling from SFAP is clearly superior here to traditional terrestrial measurement methods. Modeling the complete form rather than taking sample measurements of gully extent and depth allows for example the stratification of volumetric change in erosion and deposition aspects, yielding results for the gully's own sediment balance.

Fig. 14-7 shows results from an exemplary observation interval at Gully Salada 3—a typical bank gully of the simplest, single-headcut U-profile form (see Fig. 4-31)—that illustrates the complexity of the patterns often simplified as "headcut retreat." Between 1998 and 2002, ~4.4 m^2 area, corresponding to 13 m^3 soil material, was lost to backward erosion at the headcut (Marzolff and Poesen 2009). In the same period, the surface height within the gully increased when 45% of the material eroded at the headcut was deposited on the gully bottom. Most of this came to lie close to the headcut, but some was washed farther downslope at the gully bottom. Limited erosion only took place on the gully floor, and its longitudinal profile obviously experienced an increase of gradient not due to downslope erosion, but due to upslope deposition. This illustrates that not all material eroded at the headcut leaves the system directly and causes off-site damage (e.g. by reservoir siltation). This

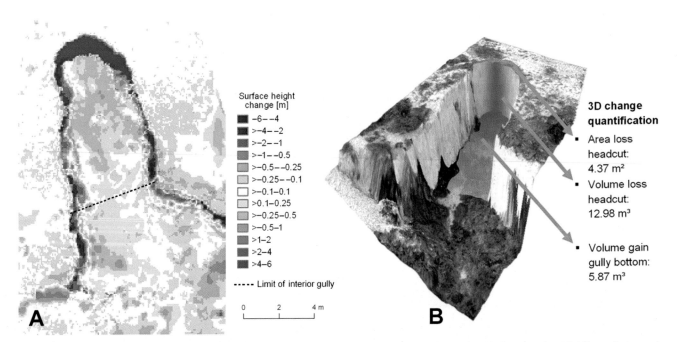

Fig. 14-7 3D change quantification of Gully Salada 3, Province of Murcia, Spain, between 1998 and 2002. Based on hot-air blimp photographs taken by IM, JBR, and M. Seeger; image processing and analysis by IM. (A) DEM of difference. (B) Orthophoto draped over 1998 DEM with summary of change measurements within the interior gully area.

function of a gully as a temporary sediment sink can only be detected with detailed 3D mapping from very high resolution imagery.

Fig. 14-7A also shows some of the difficulties associated with creating surface models for highly variable terrain (compare Fig. 3-15). Along the sidewalls, which contributed to the gully growth with another $0.7\,m^2$, the volume change visible in the change map must be considered somewhat inaccurate (note the improbable gain at the sidewall to the lower right of the calculation area limit). Here, the camera's perspective eye could not obtain an unobstructed view of the narrow and deep corridor carved by the gully, causing less inclined slopes in the 2002 model. With newer methods of SfM-MVS photogrammetry and 3D point cloud analysis, the combination of vertical and oblique imagery and true 3D data formats (rather than 2.5D) allow for considerable improvements in modeling and measuring such complex forms (see Fig. 11-22).

Gully-erosion studies usually report soil loss as linear, areal, and volumetric retreat rates, that is, positive gully development. However, in regions with high pressure on land as a resource, erosion-affected areas are increasingly being reclaimed as agricultural land, and negative development by infilling and leveling of ephemeral as well as permanent gullies and badlands may also be observed (Marzolff and Pani 2018). The example of Gully Salada 1 has already shown this for a region with moderately intensive rainfed agriculture in southern Spain. Although set in rural surroundings as well, the large sedimentary

fans of the Souss Basin (South Morocco) in contrast are characterized by highly dynamic land-use changes with transformations from traditional agriculture to vast agro-industrial plantations. The area is heavily dissected by gully erosion that was triggered by deforestation and the decline of sugarcane cultivation at the end of the 17th century; the resulting badlands reach deep between the modern fruit tree plantations and greenhouses (Fig. 14-8; see also Fig. 10-19).

With the aim of restoring the original pre-erosion surface form and extent of existing agricultural land, gullies and badlands are leveled with bulldozers and filled up with topsoil material scraped from the non-eroded surroundings, as may be observed in Fig. 10-38. The success of the leveling measures strongly depends on subsequent land-use type and soil-erosion protection. Leveled sites in the Souss show a clear amplification of interrill and gully erosion processes compared to undisturbed sites (Peter et al. 2014). Fig. 14-9 illustrates the case of Gully Glalcha 1, an old dendritic gully system incising the bank of a small wadi that was infilled with soil material scraped from the surrounding hillslopes in 2009 in order to create space for a vegetable field. However, the original macro-relief with shallow depressions draining over the steep wadi bank remained.

Linear incision took place in the old thalwegs immediately during the next rainy period in 2010, reactivating the old gully system and eroding at least $720\,m^3$ of infilled soil. Of these, at least $693\,m^3$ (~$1040\,t$) had previously been transferred by the leveling process from

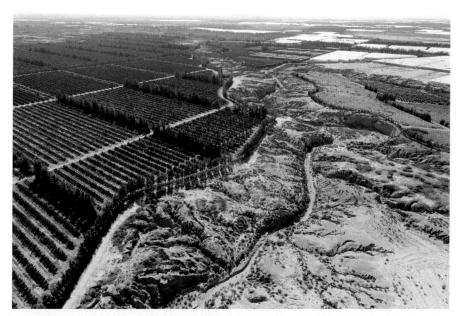

Fig. 14-8 Badlands with deep gullies along a wadi cutting into the Pliocene-Quaternary deposits of the Oued Irguitène sedimentary fan in the Souss Basin, South Morocco (view toward South). Citrus plantations and plastic greenhouses, predominantly for banana cultivation, have largely replaced traditional small-scale agriculture and rainfed cereal cultivation during the last 50 years, pushing upslope from the Souss River toward the foothills of the High Atlas Mountains. Taken with on-board camera of quadcopter UAV.

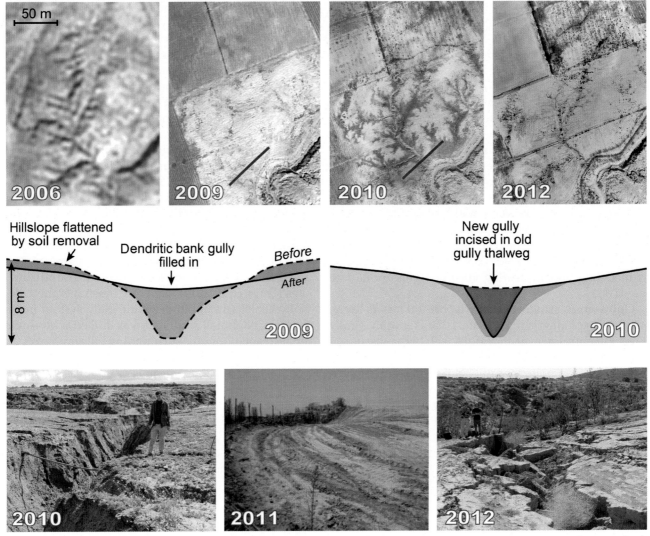

Fig. 14-9 Development of Gully Glalcha 1, near Taroudant, South Morocco. Top row: old gully system in 2006 (*Spot* satellite image), after leveling in 2009 (*Quickbird* satellite image), with renewed incision in 2010 and after second infilling in 2012 (SFAP taken with fixed-wing UAV). Central row: schematic diagram of gully evolution along the cross-profile shown as red line above. Bottom row: ground situation before and after second infilling.

the hillslopes into the gully channel and thus made available for linear erosion. When related to the gully catchment size (as derived by hydrological modeling from the regional-scale DEM; see Peter et al. 2014), the mean annual gully-erosion rate in 2009/2010 amounts to 204 m^3 per hectare (or 2 cm average terrain lowering). The mean soil depth removed by the remodeling of the terrain and gully infilling, in contrast, was even higher with 5.4 cm.

This volumetric quantification was computed by subtracting the gully DEM (Fig. 14-10) from a reconstructed pre-erosion DEM (d'Oleire-Oltmanns et al. 2012). The calculated soil loss must be considered a minimum value, as SFAP is not able to look beneath the surface for quantifying the subrosion processes that are taking place in the unconsolidated material of the infill. However, a closer look at the central part of the gully in Fig. 14-11

shows that SFAP is highly useful for qualitative assessments of the role of piping in gully erosion (see also Fig. 10-12 and Marzolff and Ries 2011). A second attempt of infilling at Gully Glalcha in 2011 was crippled again by subrosion and sacking processes. No additional attempts of gully-erosion control were made by the farmer, and recent SFAP from 2018 testifies to continued piping and side-rill incisions—a palimpsest of an old gully system that is still hidden beneath the surface.

As could be seen at Gully Glalcha 1, infilled bank gullies with unchecked connectivity to the local base level tend to be reactivated particularly fast. For preserving the newly reconstructed surface, protective measures at the outlet of the drainage area are imperative. Between Oued el Hamar and a small tributary wadi, a 13-ha interfluve area, which had occasionally been used for cereal dry-farming, was leveled in 2013 for a new citrus

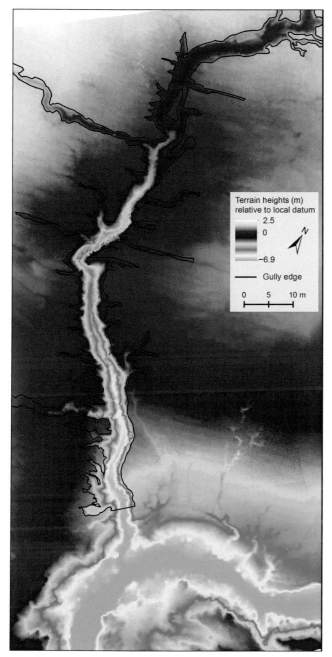

Fig. 14-10 Digital elevation model of Gully Glalcha 1 (subset) with 5 cm GSD, September 2010. Derived from vertical stereoscopic imagery taken with an MILC on a fixed-wing UAV by automatic DEM extraction; gully edge digitized manually in 3D view. Image acquisition, photogrammetric processing and cartography by S. d'Oleire-Oltmanns and IM.

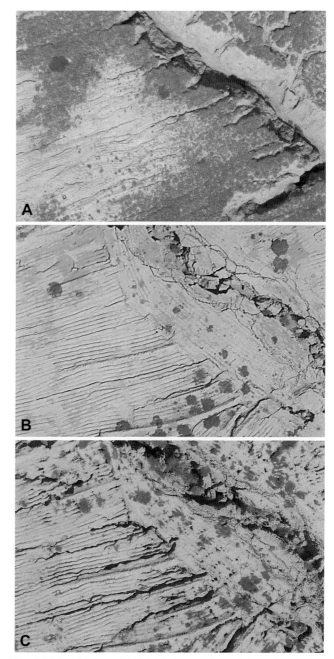

Fig. 14-11 Subsets of SFAP taken at Gully Glalcha 1 in 2010 (A), 2012 (B) and 2018 (C) continue to give evidence of an old gully system hidden beneath the repeated infillings of 2009 and 2011. Lateral rills draining into the gully follow the parallel leveling furrows. Strong signs of sacking may be observed along the main gully after the second infilling of 2011 (B and C). The cross-leveling by the bulldozer along the main drainage line of the gully creates a damming effect for the lateral rills. This triggers piping processes that allow the rills to drain beneath the infilling (see strings of piping holes in image C) and, in a feedback effect, intensifies deep headward erosion in the lateral rills.

plantation (Fig. 14-12). Numerous linear and dendritic bank-gully systems were infilled during leveling with soil material scraped off the flat ridge, and a low earth wall was formed at the edge of the field. 800 m of multistory gabions were built to protect the newly reconstructed wadi bank—resulting, however, in removal of point bars and narrowing of outside curves and the wadi bed. Some gabion foundations were already washed out

by 2015, but the edges of the new plantation were still intact at the time of writing in 2018.

This short overview of gully-erosion research illustrates the great potential of SFAP interpretation and analysis for monitoring dynamic landforms. More details

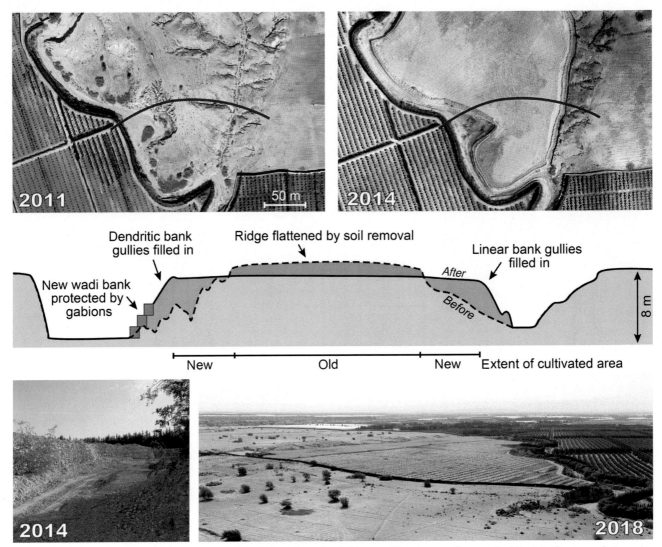

Fig. 14-12 Land-leveling of gullies at Hamar, north of Taroudant, South Morocco. Top row: southern end of the interfluve area between two wadis, dissected by bank gullies of various sizes and forms, seen before (2011) and after (2014) complete leveling and infilling with bulldozers. Orthophoto mosaics created from fixed-wing UAV imagery. Central row: schematic diagram of terrain remodeling along the cross-profile shown as red line above (the dendritic bank gully to the left may also be seen in Fig. 14-2 I). Bottom row: wadi after construction of gabion walls in 2014 (ground view looking south) and the complete 13-ha citrus plantation established on the leveled site in 2018 (oblique SFAP taken with quadcopter UAV, looking south).

about the gully development rates and their relation with local topography, substratum, and runoff and infiltration behavior in the gully headcut surroundings are given in the literature cited above. In summary, the development rates of the gullies vary strongly between individual study areas along the transect, and particularly the Spanish gullies retreat more slowly than expected. Improvements in 3D analysis methods during the last decade and thus increased possibilities of volumetric quantification have helped in revealing that the range of soil loss by gully erosion in different landscapes is even greater than the range of linear and areal retreat. In many cases, human activities aimed at soil-erosion mitigation have undesirable effects. In particular, land

leveling is boosting rather than controlling gully erosion processes. Thus, gully erosion will continue to be a major topic for both land owners and researchers. In this context, SFAP may well be expected to transform natural resource management and soil-erosion models in future years (Bennett and Wells 2018).

14-4 SUMMARY

Gullies are permanent erosional forms that develop in many parts of the world, particularly in arid and semi-arid environments. Gullies function as sediment sources, stores, and conveyors that link hillslopes to downstream

channels. Human land use, and especially changes in land use and remodeling of terrain, may accelerate gully expansion by head cutting, sidewall collapse, piping, floor erosion, and other processes, which lead to widespread land degradation and potential damage to human structures and activities.

Beginning between 1995 and 2010, >30 gullies of varying types, sizes, and ages have been monitored by the authors using stereoscopic SFAP. The results prove the value of capturing spatially continuous, high-resolution 3D data for detailed gully monitoring and demonstrate the advantages of SFAP over field methods and conventional airphotos. 2D and 3D change quantification based on the detailed maps and DEMs provides additional information on the differences in headcut retreat behavior which cannot be described by simple linear measures. The spatially continuous 3D survey of the entire form offers the possibility of volume quantification and of distinguishing different zones and processes of activity both at the gully rim and within the gully interior. Multiscale SFAP surveys allow to capture the situation in the gullies' surroundings, providing orthophotos and DEMs for maps of land use, relief, and hydro-geomorphological processes.

Our research confirms that gully growth is strongly related to the characteristics of topography, substratum, runoff, and infiltration behavior as well as land use in the gully catchment. Human activities aimed at soil-erosion mitigation—such as leveling, infilling, or dam building around headcuts—often have undesirable effects, boosting rather than controlling gully erosion processes. The continuing role of gully erosion in land degradation together with recent improvements in modeling and measuring such complex forms with UAS and SfM-MVS photogrammetry is securing SFAP a key role in gully-erosion research in the future.

Wetland Environments

The use of aerial photography has resulted in an essential advance in the understanding of mire structure. Aaviksoo et al. (1997, p. 5)

15-1 OVERVIEW

Wetlands include myriad environmental types: bayou, bog, fen, mangrove, marsh, moor, muskeg, pan, playa, sabkha, salina, swamp, tundra, and several more terms in other languages. Many of these names are united under the general term mire nowadays, but that still does not specify the basic characteristics of wetlands. A definition for what is a wetland often depends on who is asking the question and what development or study is proposed for a particular wetland site. The fact that wetlands may dry out from time to time complicates the attempt to describe wetlands in a simple fashion, and some wetlands may be dry more often than they are wet (Aber et al. 2012).

Many definitions for wetlands have been proposed and utilized over the years. Among the most widely accepted is that of Cowardin et al. (1979), which was adopted by the US Fish and Wildlife Service.

Land where an excess of water is the dominant factor determining the nature of soil development and the types of animals and plant communities living at the soil surface. It spans a continuum of environments where terrestrial and aquatic systems intergrade.

This definition comprises three aspects—water, soil, and living organisms, which are accepted by wetland scientists as the basis for recognizing and describing wetland environments (Fig. 15-1; Schot 1999; Charman 2002).

- **Water**—Ground water (water table or zone of saturation) is at the surface or within the soil root zone during all or part of the growing season.

- **Soils**—Hydric soils are characterized by frequent, prolonged saturation and low oxygen content, which lead to anaerobic chemical environments where reduced iron is present.
- **Vegetation**—Specialized plants, known as hydrophytes, are adapted for growing in standing water or saturated soils, such as moss, sedges, reeds, cattail, horsetail, rice, mangroves, cypress, and cranberries.

This triad is the modern approach for wetland definition under many circumstances that include greatly different environments. Notice that water quality is not specified—salinity varies from fresh, to brackish, to marine, to hypersaline; acidity may span the entire scale of naturally occurring pH values. Emergent vegetation ranges from heavily forested swamps to nearly bare playas and mudflats. Wetlands cover a substantial portion of the land and shore areas of the Earth (see also Chap. 13-4) and are present in all climatic and topographic settings around the world. Existing wetlands comprise an estimated 7 to 10 million km^2 or 5%–8% of the land surface of the globe (Mitsch and Gosselink 2007). However, as much as half of the world's wetlands have been lost to human development during the past few millennia.

For various environmental and economic reasons, much scientific research is directed toward wetlands, and many different techniques have been utilized to collect, compile, analyze, and synthesize data. Traditional ground mapping methods have been supplemented with the use of geographic information systems and remote sensing techniques for wetland research (e.g. Jensen et al. 1993; Juvonen et al. 1997; Barrette et al. 2000). Tiner (1997) noted the difficulty of wetland airphoto interpretation because of highly variable water, topographic, and vegetation conditions that may apply. He considered color-infrared imagery best for recognizing vegetated wetlands, and he emphasized the importance of photographic scale for setting spatial limits on wetland mapping. In this regard, SFAP has distinct

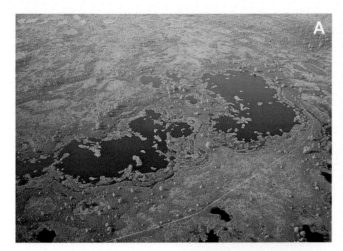

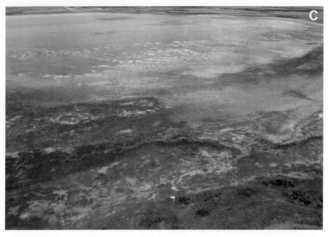

Fig. 15-1 Primary aspects of wetlands. (A) Water pools of various sizes and shapes occupy much of the surface of Nigula Bog in southwestern Estonia. A narrow, wooden footpath crosses the bottom of view. (B) Bare mudflat reveals typical gray-colored, organic-rich, oxygen-poor soil. (C) Zones of emergent and floating vegetation are revealed by distinct colors and patterns. B and C at Luck Lake, Saskatchewan, Canada. Kite photos taken with compact digital cameras.

advantages for certain types of wetland investigations (Aber and Aber 2001; Aber et al. 2002).

- High-resolution (1–5 cm), large-scale imagery is suitable for detailed mapping and analysis.
- Equipment is light in weight, small in volume, and easily transported by foot, vehicle or small boat under difficult field conditions—peat, mud, and water.
- Minimal impact on sensitive habitat, vegetation, and soil. Silent operation of kites and blimps does not disturb wildlife (see Figs. 1-2 and 12-1).
- Repeated photography during the growing season and year to year documents changing environmental conditions.
- Visible and near-infrared imagery in vertical and oblique vantages in all orientations relative to the sun position, shadows, and ground targets.
- Special lighting effects, such as sun glint, may aid in recognition of small water bodies (Amsbury et al. 1994; see Fig. 10-4).

- Lowest cost by far relative to other manned or unmanned types of remote sensing to achieve comparable high spatial, spectral, and temporal resolutions.

With the increased availability of untethered UAS in recent years, the photographic survey of wetlands, intertidal zones, coastal areas, and other water-covered landscapes has become even more achievable, and the high potential of SFAP for such investigations is increasingly recognized (e.g. Madden et al. 2015; Zweig et al. 2015; Husson et al. 2017; Kalacska et al. 2017). Special considerations are required by the necessity for looking through water when mapping submerged aquatic vegetation or submerged topography (Fig. 15-2), a matter that has been in the focus of several studies (e.g. Visser et al. 2015; Woodget et al. 2015; Chabot et al. 2018). Special attention is also necessary for potential impact of UAS operation on sensitive wildlife (e.g. nesting waterfowl and shorebirds).

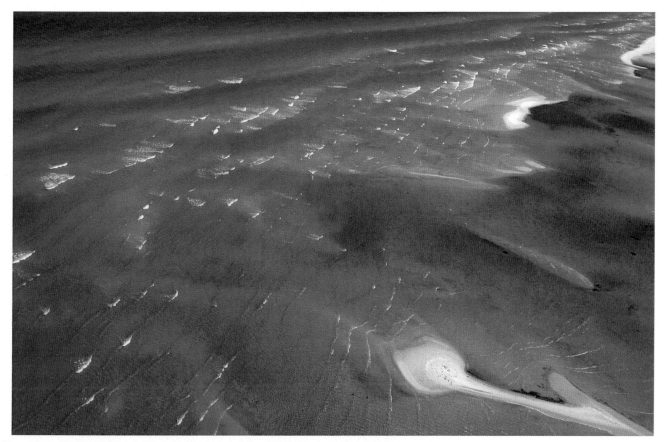

Fig. 15-2 Shallow offshore zone of the Kattegat coast at Hurup, northwestern Denmark. Detailed patterns and forms are visible in submerged sand bars seen through clear water. Kite photo taken with a compact digital camera.

15-2 RAISED BOGS, ESTONIA

Estonia is a small country rich in wetlands. Located at the far eastern end of the Baltic Sea, more than one-fifth of the territory is covered by swamps, marshes, fens, and bogs (Orru et al. 1993), and more than 40 wetland sites are protected as national parks, nature preserves, or mire conservation areas. Masing (1997) called bogs *monuments of nature* because they preserve in their peat deposits a record of past climates and environments. Indeed much of what we know about Scandinavian climate and environment of the past 10,000 years has been gleaned from intensive investigations of bogs.

On the ground, a raised bog presents a rather austere view. It appears to be a haphazard collection of peaty hummocks, muddy hollows, and water-filled pools. As seen from above, however, mires display complex and intricate patterns of vegetation and water bodies, which have resulted largely from organic evolution within the bog environment. For the bird's-eye view, various techniques of remote sensing have been applied for mire research in Estonia. These techniques range from satellite imagery (Aaviksoo and Muru 2008) and conventional airphotos (Aaviksoo 1988) to high-resolution, near-surface aerial photography (Aaviksoo et al. 1997).

In order to understand better the detailed spatial geometry of vegetation and water within bogs, kite aerial photography was employed at two mire complexes, Endla and Nigula, both designated as Ramsar wetlands of international importance (Aber and Aber 2001; Aber et al. 2002).

15-2.1 Endla Nature Reserve

The present reserve was created in 1985 as an expansion of the previous smaller Endla-Oostriku mire reserve. It is located immediately south of the Pandivere Upland in east-central Estonia. The Endla mire complex grew up in the depression of former Great Endla Lake (Allikvee and Masing 1988). Several remnants of this lake still survive, notably Endla Lake and Sinijärv (Blue Lake). The Endla mire system covers ~25,000 ha and contains several bogs separated by narrow rivers; significant springs rise in the western part of the complex. The lakes, bogs, and springs are important sources of recharge for the Põltsamaa River. Among the bogs, Männikjärve has been investigated intensively since the early 1900s (e.g. Sillasoo et al. 2007). A small meteorological station is located in the bog, and an elevated, wooden walkway allows visitors to travel across the bog without disturbing the surface.

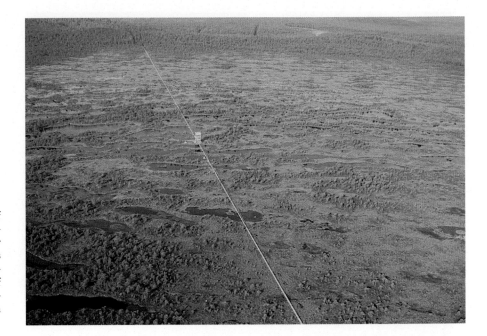

Fig. 15-3 Oblique westward view of Männikjärve Bog showing public observation tower and raised boardwalk. The tower is 10 m tall. The center of the bog contains water-filled pools in hollows between elongated peat hummocks that support dwarf pine trees. Kite photo taken with a compact digital camera by JSA and SWA with K. Aaviksoo and E. Karofeld.

Fig. 15-4 Vertical shot of Teosaare Bog illustrating the complex distribution of pools, hummocks, moss, and dwarf pine trees. White marker in lower center is 1 m². Kite photo taken with a compact digital camera by JSA and SWA with K. Aaviksoo and E. Karofeld.

Oblique views across the bog display overall patterns of hummock ridges, dwarf pines, hollows, and water-filled pools (Fig. 15-3). In close-up oblique and vertical views, it is possible to identify individual small trees, moss hummocks, faint trails, small potholes, and other structures (Fig. 15-4). Varieties of peat moss (*Sphagnum* sp.) are distinct in their autumn coloration—bright red, reddish orange, and greenish yellow (Fig. 15-5). Color-infrared images emphasize active moss around the margins of pools (Fig. 15-6).

15-2.2 Nigula Nature Reserve

Nigula is a typical plateau-like bog covering ~2340 ha with sparse trees and numerous small pools in southwestern Estonia. So-called mineral islands rise within the bog and support deciduous trees on nutrient-rich soil. Mire formation began as a result of infilling and overgrowing of an ancient lake following retreat of the last ice sheet from the region (Loopmann et al. 1988). The bog has been the subject of numerous investigations of

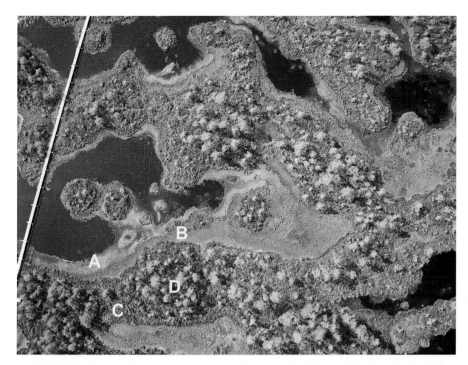

Fig. 15-5 Close-up vertical picture of pools and hummocks in the central portion of Männikjärve Bog. A—*Sphagnum cuspidatum* floating in water, B—*S. cuspidatum* at pool shore (barely emergent), C—*S. rubellum* above water table, D—Scots pine trees on hummocks along with dwarf shrubs—*Empetrum nigrum, Chamaedaphne calyculata, Andromeda polifolia,* and *Calluna vulgaris.* The boardwalk is ~60 cm wide. Kite photo taken with a compact digital camera by JSA and SWA with K. Aaviksoo and E. Karofeld.

Fig. 15-6 Color-infrared view of Männikjärve Bog. Active moss photosynthesis is concentrated at the margins of pools, as shown by bright pink and red in this false-color image. Compare with previous figure; kite photo taken with an analog SLR camera and yellow filter by JSA and SWA with K. Aaviksoo and E. Karofeld.

its characteristics (e.g. Ilomets 1982; Koff 1997; Karofeld 1998). A narrow footpath of wooden boards laid directly on the moss circles through the bog, and an observation tower is open for public use.

Oblique views depict the relationships of various components of the bog—pools, hummocks, vegetation zones, and mineral islands (Fig. 15-7), and vertical views reveal intricate spatial patterns (Fig. 15-8). Distinct vegetation zones are developed around the mineral island; these zones reflect variations in soil moisture and nutrients (Fig. 15-9).

15-2.3 Discussion

Wooden walkways provide good access to some portions of the study bogs, but wading through soft peat and knee-deep water is necessary to reach many areas. In this regard, the high portability of equipment is critical for successful kite aerial photography in the bog environment. The combination of late summer weather and early autumn vegetation color makes for excellent results in September. However, widespread burning of agricultural waste renders October photographs hazy

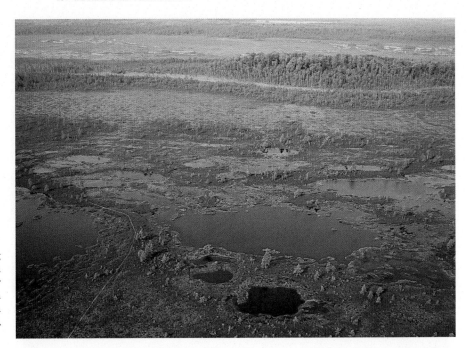

Fig. 15-7 Oblique overview of Nigula Bog looking toward the west. Narrow wooden footpath (~40 cm wide) is visible in lower left portion, and a mineral island appears in the right background. Kite photo taken with a compact digital camera by JSA and SWA with K. Aaviksoo.

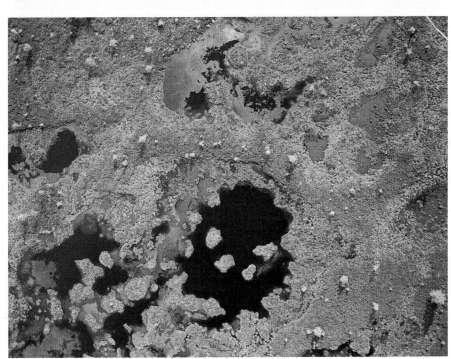

Fig. 15-8 Vertical view in eastern portion of Nigula Bog. *Sphagnum cuspidatum* forms a silvery green "mat" floating in parts of some pools. The reddish-brown zones include *S. magellanicum* and *S. rubellum*. Heather covers much of the mottled green surface along with a few small pines (note shadows). A portion of the footpath is visible in upper right corner. Kite photo taken with a compact digital camera by JSA and SWA with K. Aaviksoo.

(see Fig. 4-24), and low sun angle (at 58° N latitude) creates excessive shadowing after fall equinox.

High-resolution SFAP may be applied for microstructural investigations and analysis of mires at scales of 1:100 to 1:1000 (Masing 1998). The civilian imagery interpretability scale has 10 rating levels (0–9, see Chap. 10-2). The resolution of vertical kite aerial photographs (1 to 5 cm) provides for interpretability ratings of 7 or 8 (Leachtenauer et al. 1997). This ground resolution is an order of magnitude more detailed than conventional airphotos or high-resolution satellite imagery. The Estonian examples demonstrate remarkably intricate and complex spatial patterns and depict abundant open water (pools) developed within bogs at the microstructural level (see Fig. 5-26). On this basis, the areas shown by vertical SFAP (~1 ha) could be used as training sites for improved interpretation and classification of land cover depicted in conventional airphotos and satellite images.

A direct comparison of color-visible and color-infrared images favors the visible portion of the spectrum for

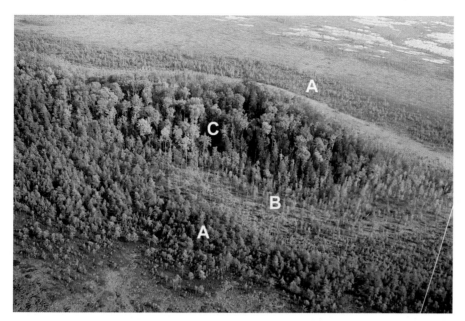

Fig. 15-9 Low-oblique view over Salupe-aksi, a tree-covered mineral island (a drumlin), in the middle of Nigula Bog. Notice the marked forest zones of the island. A—pine, B—birch (partly bare), C—ash, elm, maple, and other deciduous hardwoods, some of which display fall colors. Kite line crosses the lower right corner. Photo taken with a compact digital camera by JSA and SWA with K. Aaviksoo.

revealing overall variations and details for all types of land cover in bogs. The natural colors and relative ease of interpretation are advantages for color-visible imagery in both vertical and oblique views. Photosynthetically active green plants strongly absorb red (0.6 to 0.7 μm) light and strongly reflect near-infrared (0.7 to 1.0 μm) energy (Colwell 1974; Tucker 1979), which is shown vividly in color-infrared photographs. Moss (*Sphagnum* sp.), however, has a considerably lower near-infrared reflectivity, in general, compared to trees and grass. The seasonal peak of near-infrared reflectivity for moss occurs in late summer, whereas most deciduous trees and grass have their peaks in late spring and early summer (Peterson and Aunap 1998). Thus, interpretation of bog vegetation takes some care in terms of spectral characteristics and seasonal conditions.

Mires are normally rather dark features in most conventional airphotos and satellite images. The reason for this is apparent from examination of the color-infrared image (Fig. 15-6). The zone of active photosynthesis is distributed in narrow strips or clumps, no more than 1–2 m wide, at the margins of pools and hollows. Recognition of these patterns and photosynthetic activity requires submeter spatial resolution. In lower resolution imagery, however, strong near-infrared reflections from such narrow moss zones are blended with weak reflections from adjacent water, mud, and hummocks to create an average low value for each pixel in the image. These results suggest that while plant activity is low overall in late summer, bogs contain narrow zones within and around pools that support a high level of photosynthesis. This finding may have significant implications for accumulation of peat biomass, growth of bog microtopography, methane flux, and related environmental factors.

15-3 PRAIRIE MARSHES AND PLAYAS, KANSAS

Kansas is located in the Great Plains in the geographic center of the coterminous United States. The predominant natural land cover is prairie grass, which is mostly replaced today by agricultural cropland and rangeland. The state experiences a strongly continental climatic regime; the eastern portion enjoys a general water surplus, whereas the western part lies in the rain shadow of the southern Rocky Mountains and is relatively dry. Temperature undergoes a large seasonal range from below −20 °C to above 40 °C. Droughts and floods are recurring events.

Given the highly variable conditions imposed by continental climate, Kansas wetland environments are in a state of constant flux, which is dictated primarily by short- and long-term changes in available water. In spite of this stressful situation, many types of large and small wetlands are found throughout the state. The primary advantage of SFAP in this situation is repeated photography to document ephemeral events and year-to-year variations in these ever-changing wetlands. Two sites are subjects for long-term SFAP observations, Cheyenne Bottoms and Dry Lake (Fig. 15-10).

15-3.1 Cheyenne Bottoms

Cheyenne Bottoms is the premier wetland of Kansas. Located in the center of the state, it is considered to be among the most important wetland sites for migrating shorebirds and waterfowl in North America (Zimmerman 1995). Cheyenne Bottoms is famous for great flocks of migratory birds. More than 340 bird

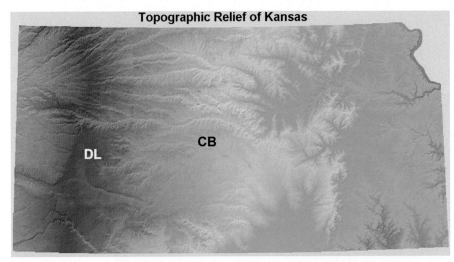

Fig. 15-10 Generalized elevation map of Kansas showing locations of two wetland study sites, Cheyenne Bottoms (CB) and Dry Lake (DL). Elevation slopes from more than 4000 ft (1220 m) along the western edge (purple) to less than 700 ft (215 m) on the southeastern border (blue). State boundaries correspond approximately to latitudes 37° and 40° N and longitudes 94.6° and 102° W. Image derived from United States 30-second digital elevation dataset.

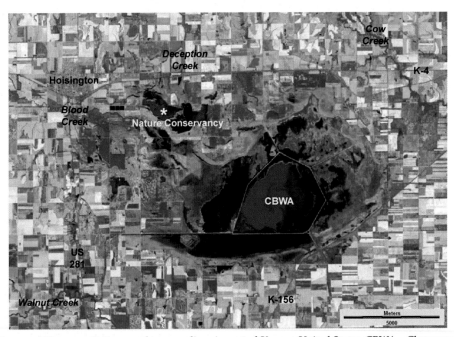

Fig. 15-11 Satellite image of Cheyenne Bottoms and surroundings in central Kansas, United States. CBWA—Cheyenne Bottoms Wildlife Area managed by the State of Kansas. Asterisk (*) marks location of long-term SFAP study site. Landsat false-color composite based on TM bands 2, 5, and 7 color coded as blue, green, and red; 10 July 1989.

species have been spotted at Cheyenne Bottoms, some of which are threatened or endangered (Penner 2009).

Cheyenne Bottoms occupies a large, oval-shaped depression (~166 km²) that is the terminal point for an enclosed drainage basin (Fig. 15-11). Cheyenne Bottoms is managed in part by the State of Kansas and partly by The Nature Conservancy (TNC) as well as by other private land owners. Beginning in the early 1990s, TNC started to acquire land in the upstream, delta portion of Cheyenne Bottoms, north and west of the state wildlife area. The management goal of TNC is to protect habitat for shorebirds and waterfowl as well as grassland birds through restoration and maintenance of natural marshes, wet meadows, mudflats, and adjacent grassland. In pursuing this goal TNC has undertaken substantial alterations of the previous agricultural land use in the areas it owns and manages.

An important concern of recent years was expansion of cattail (*Typha* sp.) thickets, which threaten to overspread open marshes and mudflats, thus rendering the habitat

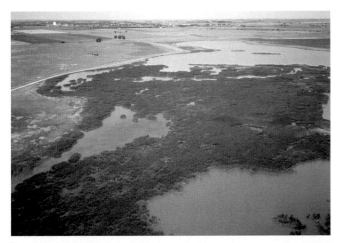

Fig. 15-12 Healthy cattail thickets (dark green) cover much of TNC marsh study site prior to drought. View toward west, May 2002. Kite photo taken with a compact analog camera by JSA and SWA with R. Penner.

less suitable for many migratory birds. Cattail may be controlled in several ways. However, TNC lacked heavy equipment for mechanical removal, had no means to artificially regulate water levels in the marshes, and initially rejected herbicides in this sensitive environment. Thus, TNC adopted a patient strategy to exploit recurring drought episodes, when dead cattail thatch might

be removed, as the primary means to control cattail infestation of its wetlands. Kite and helium-blimp aerial photography has been utilized to monitor TNC marshes annually since 2002 (Aber et al. 2006, 2016).

The spring of 2002, at the beginning of our study, marked the end of a favorable period for cattail expansion, and thickets filled much of TNC marshes (Fig. 15-12). During the next few years a series of droughts and floods took place, which culminated in a severe drought, and by the autumn of 2006 TNC marshes were completely dry. TNC staff launched an experiment to simulate the impact of heavy buffalo (*Bison bison*) grazing on the marsh complex. Dry mudflats were disked (plowed) up and dead vegetation thatch was mowed down (Fig. 15-13).

The spring of 2007 brought heavy rain, the marshes rapidly filled to overflowing (Fig. 15-14), and rains continued well into the summer leading to flooding of historic magnitude. Cheyenne Bottoms was inundated and became a huge, shallow lake for several months. As water receded and emergent wetland vegetation grew up, the presence of mosquito fern (*Azolla* sp.) was detected for the first time at TNC (Aber et al. 2010b), as revealed by its distinctive maroon color in autumn (Fig. 15-15). Floods and droughts since have continued to alternate repeatedly in TNC marshes (Fig. 15-16).

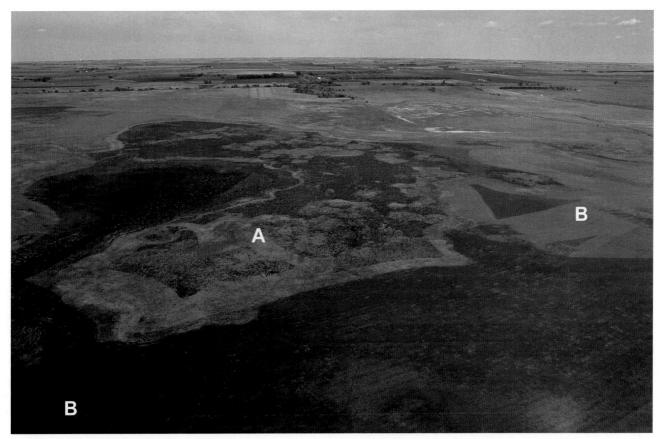

Fig. 15-13 Severe drought conditions culminated with completely dry marshes in October of 2006. Vegetation thatch is being mowed (A, note tractor), and mudflats are disked (B). Kite photo taken with a compact digital camera.

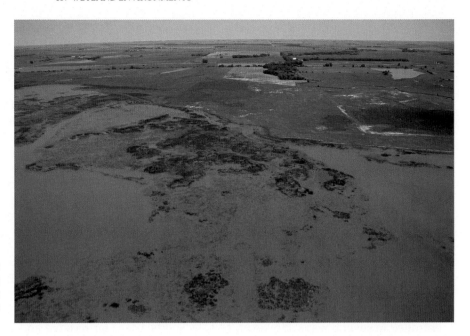

Fig. 15-14 Waxing flood conditions at TNC marshes in May 2007 following disking and mowing of previous autumn. Compare with previous figure. View northward; kite photo taken with a compact digital camera.

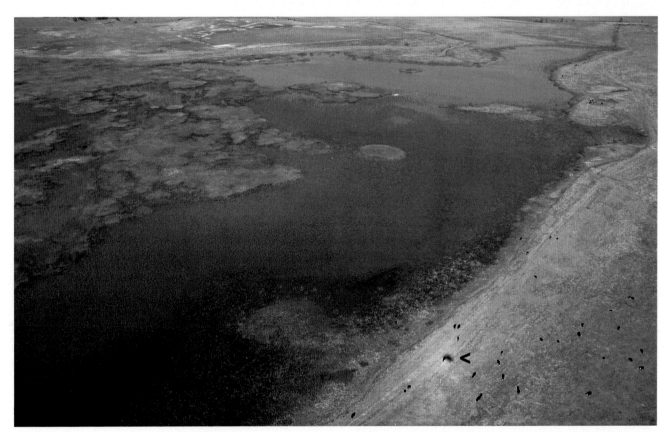

Fig. 15-15 Mosquito fern (*Azolla* sp.) floating on water surface is depicted by its maroon color in this oblique view over TNC marsh in October 2009. Cattle grazing on wet meadow in lower right. Helium-blimp photo taken with a compact digital camera; blimp shadow point indicated by arrow (<).

 The net result has been steady expansion of cattail thickets and reduction of open mudflats and pools (Fig. 15-17). TNC made the decision to use aquicide to control cattail and other emergent vegetation. Beginning in 2017, *Aqua Neat* was applied by aerial spraying over selected portions of the marsh habitat. This glyphosate aquicide is designed for control of emergent weeds and brush in wetland settings, including flowing or stagnant, fresh, or brackish water (Nufarm 2018). It is too soon at this point to evaluate long-term success and

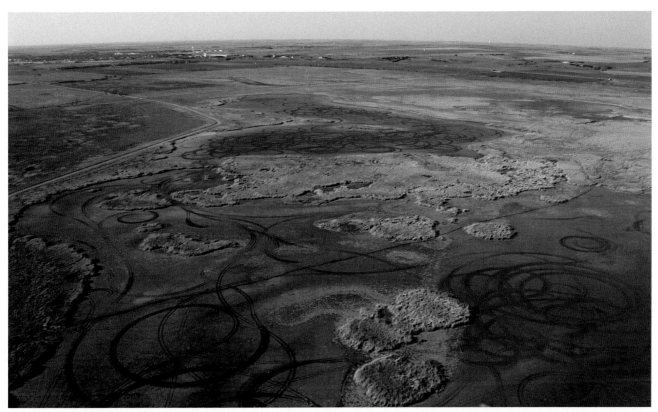

Fig. 15-16 Drought conditions in the autumn of 2012 allowed local youth to drive off-road vehicles on the dry mudflats. No permanent damage resulted from this unauthorized activity, however. View toward northwest with Hoisington in the background. Kite photo taken with a DSLR camera and superwide-angle lens.

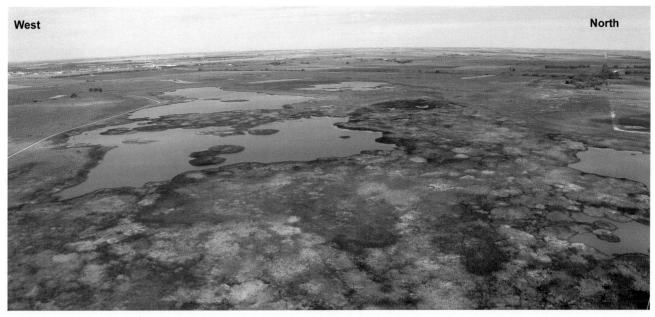

Fig. 15-17 Panorama looking toward the north and west. Extensive thickets of emergent vegetation cover the foreground in the spring of 2016. Assembled from two kite photos taken with a compact digital camera.

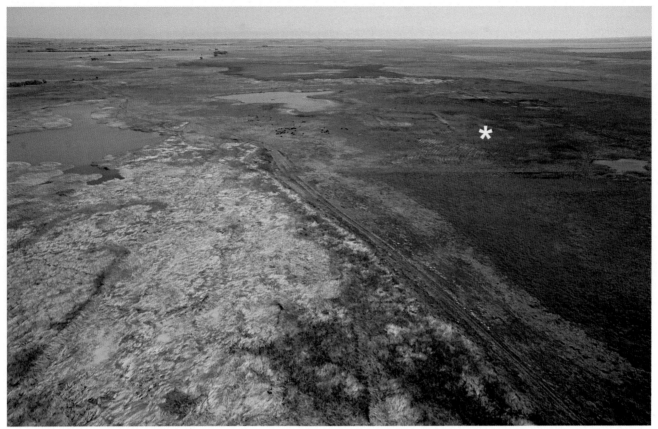

Fig. 15-18 View over TNC marsh looking toward the northeast. The area to the right (*) was sprayed with aquicide in August of 2017 and again in July of 2018. The left foreground was sprayed in July of 2018. The linear stripes reflect the pattern of aerial spraying; black dots in distance are cattle. Kite photo taken with an MILC, September 2018.

consequences (Fig. 15-18), but the aerial spraying program will continue as needed in future years.

Based on more than 15 years of SFAP throughout the growing season, certain patterns have emerged from these drought-flood cycles (Aber et al. 2016). Wet intervals are characterized by water-filled pools, emergent wetland vegetation, abundant migrating birds, and aquatic wildlife, plus an influx of sediment and nutrients. During droughts, conversely, surface water is scarce to absent, migrating birds bypass the vicinity, aquatic wildlife diminishes, and weeds appear on dry mudflats, which suffer wind erosion. In spite of these large, short-term environmental fluctuations, however, the marsh complex displays remarkable long-term stability. Nonetheless, cattails remain a management issue for TNC.

15-3.2 Dry Lake

Dry Lake is an intermittent water body at the terminal point of an enclosed drainage basin on the High Plains of west-central Kansas. This region is semiarid, typically receiving less than 50 cm of precipitation per year. Dry Lake is ~4 km long and about half a km wide, when full, which is a rare occurrence. In contrast to Cheyenne Bottoms, which has attracted a great deal of scientific attention, little is known about the geological circumstances of Dry Lake or its wetland environment. Dry Lake and surrounding land are privately owned with no public access, but we did obtain permission from local land owners to conduct scientific observations for educational purposes.

We conducted annual visits to Dry Lake for SFAP beginning in 2007, which was an exceptionally wet year (Fig. 15-19). During the next few years, water level declined and salinity increased. As the lake became hypersaline, the water turned various bright orange and rust colors (Fig. 15-20), which presumably was caused by carotenoid pigments in the cell membranes of halophilic microbes (Allred and Baxter 2016). Eventually the lake dried up completely (Fig. 15-21).

These dramatic changes in Dry Lake were observed and recorded only because of annual SFAP missions. The appearance of hypersalinity and halophilic mi-

Fig. 15-19 Dry Lake looking toward the southwest during the exceptionally wet spring of 2007. About half the lake is visible in this view. Note the small overturned boat in the foreground for scale. Kite photo with a compact digital camera by JSA and SWA with D. Leiker and C. Unruh.

Fig. 15-20 The eastern end of Dry Lake displays distinctive orange-colored water. This dramatic coloration was seen only once during 9 years of annual SFAP. Kite photo with a compact digital camera by JSA with B. Zabriskie (May 2010).

crobes stimulated considerable interest among our biological colleagues; however, these conditions proved to be ephemeral. The lake refilled and became less saline during the next few years. Changes in agricultural practices on adjacent private land and road closings brought our SFAP missions to an end during a high stand of water in 2015 (Fig. 15-22).

15-3.3 Discussion

Wetlands in the central and western portions of Kansas clearly are subject to large seasonal and interannual changes in their characteristics owing to climatic variations. According to the Nature Conservancy land steward, SFAP is the most effective type of remote

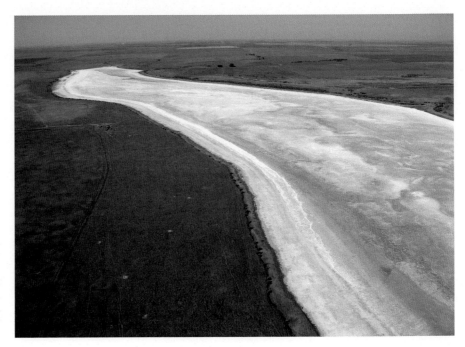

Fig. 15-21 Most of Dry Lake is visible in this view looking toward the southwest. The lake floor is completely dry and covered by a crust of salt; brine saturates the sediment just below the surface. Helium-blimp photo with a compact digital camera by JSA and SWA with B. Zabriskie and G. Corley (October 2010).

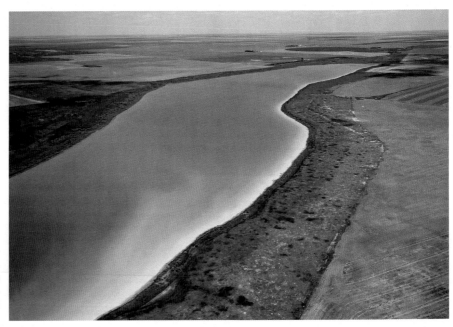

Fig. 15-22 Dry Lake completely full of water following repeated spring rains and runoff. Water had not been this abundant since the high stand of 2007, when our annual observations began. Kite photo with a compact digital camera (June 2015).

sensing for management applications at Cheyenne Bottoms, superior to conventional aerial photography or satellite imagery. This assessment is based on high spatial resolution and frequent temporal coverage that depict details of land management activities and their consequences for habitat conditions. In fact, kite aerial photography will be applied to assist and document

restoration of wetland functions for a former cropland (Fig. 15-23).

At Dry Lake, SFAP revealed ephemeral conditions that would not have been recorded otherwise due to its inaccessible location. Rapid response, relative ease of use, and low cost make SFAP an attractive tool for monitoring dynamic wetland environments in the Great Plains region.

Fig. 15-23 Former cropland in foreground was recently acquired by Ducks Unlimited and the Nature Conservancy next to the state wildlife area (background) at Cheyenne Bottoms, Kansas, United States. The intent is to restore wetland functions. A well-marked natural channel meanders across the center of this view. Kite photo taken with a compact digital camera (May 2018).

15-4 BIOCONTROL OF SALTCEDAR, COLORADO

Saltcedar is a shrub or small tree that is native to Eurasia. It comprises several species within the genus *Tamarix*, commonly called tamarisks, which were introduced in the United States beginning in 1823. During the Dust Bowl of the 1930s, saltcedar was planted widely for windbreaks and to control stream erosion in the Great Plains and western United States. Since then, however, saltcedar has spread rapidly becoming an invasive plant throughout arid and semiarid portions of the western United States and northern Mexico (DeLoach et al. 2007). Saltcedars form dense thickets in wetlands and along waterways, which disrupt native ecosystems. Saltcedar is also a phreatophyte that consumes large amounts of ground water—a valuable resource in the western United States (Zavaleta 2000).

Once established, *Tamarix* sp. is extremely tenacious and difficult to eradicate through mechanical (cutting) or chemical (herbicide) means. Because of this problem, the US Bureau of Reclamation (USBR) participated with several other governmental agencies in research on the biocontrol of saltcedar at one of several approved field research sites in the Saltcedar Biological Control Consortium (DeLoach and Gould 1998). A Eurasian leaf-eating beetle, *Diorhabda "elongata"* (saltcedar leaf beetle), now known as *D. carinulata*, is a natural enemy of saltcedar. In their larval and adult stages, *D. carinulata* eat the leaves and outer layers of stem tissue of saltcedar (but no other plants), and may defoliate the plant to such extent that it eventually dies.

The carefully managed international biocontrol program proceeded in several steps beginning with laboratory studies in the 1980s and ending with field releases of beetles into the wild (DeLoach et al. 2007). The eventual intent was to distribute *D. carinulata* widely to the public for biocontrol of saltcedar, once thorough research and review of its effectiveness and safety were demonstrated. Remote sensing was employed as part of this interdisciplinary research, primarily for identifying stands of saltcedar and evaluating the effectiveness of the biocontrol efforts (e.g. Everitt et al. 2006; Pu et al. 2008). A variety of methods were applied including standard color photography, videography, hyperspectral imaging, and vegetation indices; data and imagery were acquired from conventional manned aircraft at medium altitudes.

15-4.1 USBR Study Site

Field release of saltceder leaf beetles took place at the USBR study site near Pueblo, Colorado in 2001 (Fig. 15-24; see also Fig. 6-1). Research at this site focused on the biology and behavior of the beetle and the effects of their release on wildlife, saltcedar, and non-target vegetation (Eberts et al. 2003). In order to acquire low-height, high-resolution imagery, kite aerial photography was conducted twice during the 2003 growing season in May and August (Aber et al. 2005). Owing to the relatively high altitude (~1400 m) and thin atmosphere, large rigid delta and rokkaku kites were employed to provide sufficient lift. All manner of photographs was taken, including vertical and oblique views, color-visible and color-infrared analog and digital images.

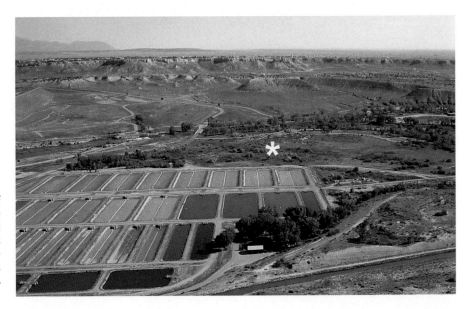

Fig. 15-24 Overview of US Bureau of Reclamation saltcedar-biocontrol study site near Pueblo, Colorado, United States. The study field (*) is situated on the floodplain of the Arkansas River between a fish hatchery and the river (behind). Kite photo with a compact digital camera by JSA and SWA with D. Eberts.

The photographs revealed little evidence of the effects of *D. carinulata* in late May, as supported by ground observations. By early August, however, beetle impact had become quite noticeable. Preliminary visual assessment of August images indicated that color-visible digital photographs provided the best display of defoliated saltcedar, which appears in a distinctive reddish-brown color (Fig. 15-25). The area of defoliated saltcedar may be extracted from images based on this color signature. *D. carinulata* consume some leaves, but they kill more foliage than they actually consume. Their method of feeding disrupts water transport to non-consumed foliage and causes leaves to die and turn reddish brown. Adult beetles move about the bush as they feed. A saltcedar un-

der attack, thus, may contain a 3D patchwork of healthy and dead portions.

As seen from above, healthy branches near the top may obscure defoliated lower branches. On the other hand, defoliated upper branches could allow healthy lower portions to show through and be visible from above. Thus, defoliation must be nearly continuous in the vertical profile of the saltcedar bush in order to appear clearly in vertical aerial photographs. Furthermore, dead leaves that fall off would not be included in the analysis. Based on these factors, quantitative analysis of vertical SFAP was considered to provide a minimum areal estimate for the amount of defoliation in saltcedar (Aber et al. 2005).

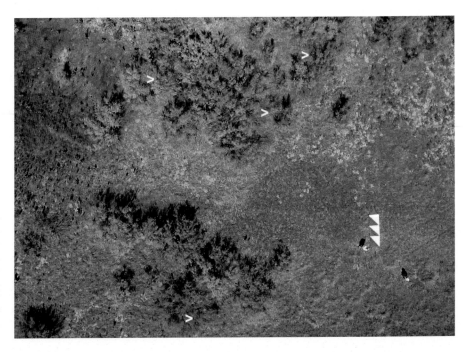

Fig. 15-25 Near-vertical shot over central portion of study site, August 2003. Ground cover is a patchwork of saltcedar thickets, salt sacaton grass, rabbitbrush and assorted weeds, and bare sandy soil. Camera operators are standing next to the north arrow, which is 4 m long. Defoliated saltcedar indicated by reddish-brown color (>). Kite photo with a compact digital camera by JSA and SWA with D. Eberts and V. Kalm.

Fig. 15-26 Ground view of largely defoliated saltcedar beside the Arkansas River near Holly, eastern Colorado. Midsummer image acquired in 2010.

Based on success at the Pueblo study site, kite aerial photography was adopted by the US Bureau of Reclamation as a means to document other biocontrol study sites. KAP also was utilized by scientists conducting similar biocontrol research at New Mexico State University. KAP proved effective for acquiring the type of low-height, high-resolution imagery necessary to monitor the effects of insect defoliation at the level of individual saltcedar trees. Advantages include relatively low cost of equipment and operation combined with flexible scheduling, convenient transportation to distant sites, ease of use in the field, and minimal impact on wildlife.

15-4.2 Status of the Saltcedar Biocontrol Program

Field releases of saltcedar leaf beetles took place at 10 sites in the western United States in 2001. Additional releases were made in 2003 and 2007 including northeastern Mexico. The impact was rapid in many areas; large tracts of saltcedar were cleared from river valleys (Fig. 15-26). The long-term and highly successful saltcedar biocontrol program came to an abrupt halt in 2010, however, as a result of a lawsuit brought by the Center for Biological Diversity and Maricopa Audubon Society. Rather than argue the scientific merits of the program in court, the US Department of Agriculture decided to shut it down. However, the moratorium actually may have little impact for those arid regions in which the beetles already were released and thriving on their own. In fact, *D. carinulata* has dispersed much faster than predicted and accomplished considerable reduction of saltcedar (Nagler et al. 2014).

15-5 SUMMARY

Wetlands cover substantial portions of the world's land and shore regions and represent significant components of the Earth's environment. Thus, wetlands attract considerable public interest and scientific attention, for which SFAP is well suited to provide low-cost imagery with high spatial, temporal, and spectral resolutions. Equipment is light weight, compact, and easily transported into wetland environments, and silent operation of some platforms—kites, blimps, balloons—does not disturb sensitive wildlife. SFAP is a means to overview restricted wetland preserves that may be closed to the public (Fig. 15-27).

SFAP may be taken in all possible orientations and directions relative to the ground target and sun position. This gives the capability to acquire images quite different from conventional airphotos, and so increases the potential for recognizing particular ground-cover conditions. The combination of high spatial resolution and frequent photography provides a means for focused investigations of specific sites, ephemeral conditions, and consequences of management practices in various types of wetland environments.

Masing (1998) envisioned a multilevel approach in mire research and mapping that ranges in scale from 1:10 (most detailed) to 1:10,000,000 (most generalized). Conventional airphotos and satellite imagery span the scale range 1:1000 to 1:100,000 and smaller. SFAP fills the scale range 1:100 to 1:1000 and, thus, bridges the gap between ground surveys and traditional remote sensing. This level of scale and resolution is best suited for permanent wetland study plots and control sites of limited size. SFAP represents one level of data acquisition in a multistage approach that includes ground observations, conventional airphotos, and satellite images.

Fig. 15-27 Panoramic view over Laudholm beach and the mouth of the Little River at the Wells National Estuarine Research Reserve on the Atlantic coast of southeastern Maine, United States. Aside from the beach, a path through the forest (lower left corner), and a small observation platform (*) this wetland environment is closed to the public. Two helium-blimp digital photographs stitched together for this superwide-angle view; JSA and SWA with V. Valentine.

Vegetation, Soil, and Soil Erosion

[Vegetation is] a highly dynamic and vital component that affects virtually all processes and therefore all geomorphological histories. John Thornes (Thornes 1990)

16-1 INTRODUCTION

In his introduction to the vegetation and soil erosion conference session at the European Geosciences Union's General Assembly 2009, John Thornes (2009), known internationally for his research in soil erosion and desertification processes particularly in semiarid areas, asserted that vegetation cover long has been accepted as a key factor for controlling overland flow, runoff, and soil erosion and soil protection. Since the 1940s, in fact, empirical, experimental, and modeling studies have confirmed the general relationship of vegetation cover and the intensity and extent of geomorphodynamic processes and have investigated the roles of changing land use, various agricultural crops, and grazing behavior.

A recent review of approaches and methods used to measure plant effectiveness in reducing runoff and erosion is given by Sandercock et al. (2017). They presented results for each of the major land units, hillslopes, and channels, and the properties of plants were evaluated. In two of the largest crop-producing countries, the United States and China, the distribution and development of conservation tillage methods including residue management practices are recommended for cropland management to reduce soil erosion rates (Nearing et al. 2017).

For extensively used mountain pastures, several case studies show that vegetation coverage decreases with increasing plant diversity when plants are distributed in a relatively homogeneous pattern, which leads to increased soil erosion. With heterogeneous plant distribution, however, vegetation coverage increases with plant diversity, and soil erosion is inhibited (Hou et al. 2016). Nouwakpo et al. (2018) recommended combining 3D data and traditional soil-erosion assessment techniques to study the effect of a vegetation-cover gradient on hillslope runoff and soil erosion in dwarf shrub areas. This combination improves the quantification of the impact of vegetation on runoff generation and soil erosion.

Based on the work by Elwell and Stocking (1974), numerous studies recording and evaluating land degradation have implicitly assumed a "clear" relationship between vegetation and soil erosion (Ries 2000). Their interdependence, which was established mainly for cropland and grassland, needs, however, to be looked at more closely in the case of Mediterranean fallow land, abandoned fields, and shrubland (e.g. García-Ruiz et al. 1996; Molinillo et al. 1997; Ries 2002). This also applies—albeit in a contrary way—to former intensively used and now abandoned vineyards in Germany (Rodrigo-Comino et al. 2018). Viticulture and related threats to soil erosion are covered in the following chapter.

The understanding of soil-type distribution resulting from processes of soil formation and soil degradation is the major objective of modern soil geography. Therefore, compiling soil maps continues to be an essential task for soil scientists. Together with digital elevation models and land-use maps, they form the basis for many questions and problems in physical geography—for example, concerning water balance and soil erosion—and have many other practical and scientific applications.

In all these environments, the small-scale variability and heterogeneity as well as the substantial change of vegetation cover associated with land-use change and vegetation succession give rise to a high complexity of geomorphological processes, which lead often to soil erosion (Fig. 16-1).

Fig. 16-1 Abandoned fields and gully erosion near María de Huerva, Province of Zaragoza, Spain. The terraced fields in the upper part of the image were abandoned in the 1930s, while the former cereal field in the upper right corner has lain fallow for only 6 years. Vegetation cover is patchy to extremely low on both areas following a period of several years with precipitation below average. Drought, grazing, soil sealing, and crusting (and to a trivial extent geographers clearing their tent pitches) are among the factors that keep vegetation cover sparse. The large gully, which drains into the Val de las Lenas, is among those monitored for many years in another study by the authors (see Chap. 14). Hot-air blimp photograph taken with an analog SLR camera in April 1996.

16-2 MONITORING VEGETATION AND EROSION TEST SITES

It is this high spatial and temporal variability of vegetation, runoff, and erosion patterns which render small-format aerial photography (SFAP) an especially suitable tool for documenting and monitoring them. Aerial photography taken from hot-air blimps, kites, and UAS, among other methods, have been employed by JBR, IM, and their groups since 1995 for investigating geomorphological processes and their relationships to vegetation development on areas under extensified land use, mostly abandoned fields and set-aside land in Spain. In particular, six test areas, 24 m × 36 m in size, and their surroundings were intensively monitored in 6- to 12-month intervals for the EPRODESERT project (Ries et al. 1998; Marzolff 1999; Ries 2000), yielding several hundred images at scales between 1:200 and 1:10,000 (areal coverage approximately 35 m^2 to 10 ha).

The image series taken at the test site María de Huerva 1 (MDH1, Fig. 16-2) documents the development of a former cereal field in the semiarid Inner Ebro Basin. At the time of the first image (Fig. 16-2A), this field had been set aside as fallow land for 5 years under the European Union's subsidized set-aside program. The extremely dry period in the preceding years—158 mm precipitation in 1995—kept vegetation cover as low as 7%. Soil sealing and crusting led to sheet and rill erosion and surface runoff coefficients up to 81% (Ries and Hirt 2008). Clearly visible are the ridges and furrows of the last tillage operation that are dissected by a large rill system in the image center (see also Fig. 10-9).

The following images document the development of the site for the next 3 years: 6 months later in April 1996 after a wet winter (Fig. 16-2B); another 5 months later in August 1996, following a weed-control tillage dictated by the EU set-aside program (Fig. 16-2C); in spring 1997 (Fig. 16-2D); 1 year later in spring 1998 (Fig. 16-2E); and in late summer 1998 (Fig. 16-2F). Note the high spatial concurrence of the images and scale that can be achieved with the hot-air blimp platform in repeated surveys. Similar time series were taken at five further test sites (Fig. 16-3).

Using image-processing and geographic information system (GIS) software for rectification and image analysis, a process-geomorphological information system was developed based on digital georeferenced test area maps

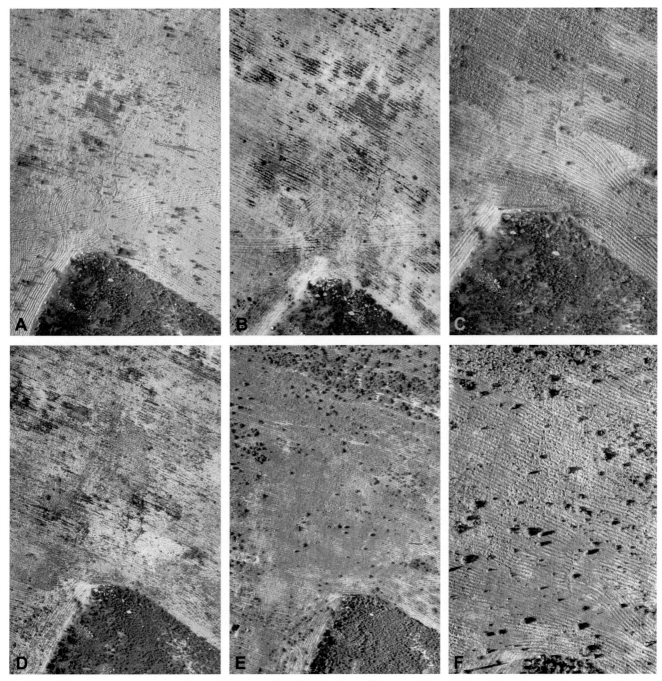

Fig. 16-2 Time series of the test site María de Huerva 1 (MDH1), Province of Zaragoza, Spain. Hot-air blimp photographs taken with analog SLR cameras. Field of view ~40 m across. (A) October 1995. (B) April 1996. (C) August 1996. (D) April 1997. (E) April 1998. (F) September 1998.

with 2.5-cm resolution (Fig. 16-4; Marzolff 1999, 2003). Visual photo interpretation combined with on-screen digitizing, digital image classification (see Fig. 11-17), and hybrid visual/digital classification methods enabled the detailed mapping of geomorphological processes, density and patterns of vegetation cover, as well as plant life forms. Change maps for vegetation and erosion were created by intersecting operations. Texture and Fourier analyses were employed to delineate automatically micromorphological structures caused by plowing (see

Fig. 4-33). After calibration of the cameras, digital elevation models (DEMs) could be generated from stereoscopic images by photogrammetric analysis. The DEMs with 25-cm resolution were used for computing slope and curvature maps as well as for simulation of potential flow paths over the test areas. Examples for the resulting maps are shown for one monitoring period of the test site MDH1 in Fig. 16-5.

Ten months after the soil crusts had been broken by tillage and encouraged by a wet winter, annual herbs

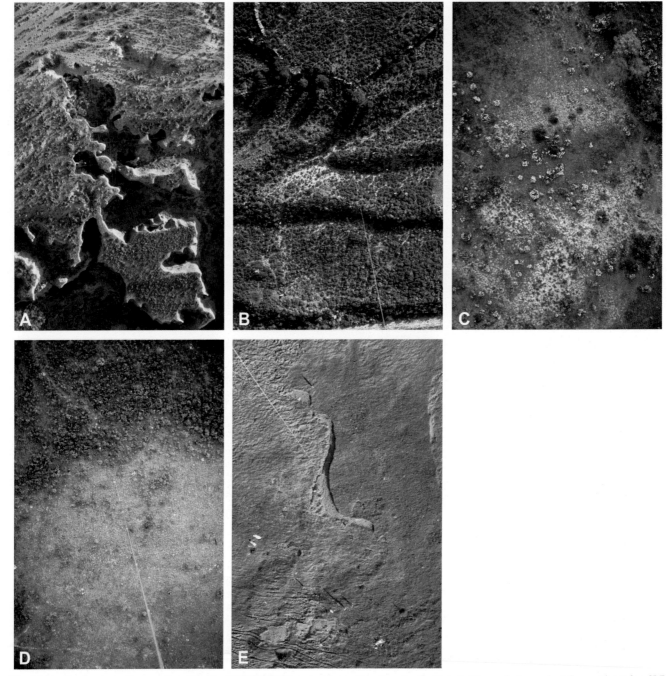

Fig. 16-3 Further test sites monitored by the EPRODESERT project in northeastern Spain. Hot-air blimp photographs taken with analog SLR cameras. Field of view ~40–60 m across. (A) María de Huerva 2, Inner Ebro Basin. (B) Sabayés, Pre-Pyrenees. (C) Bentué de Rasal, Pre-Pyrenees. (D) Arnás, Central Pyrenees. (E) Aísa, High Pyrenees.

and grasses started to recolonize the fallow land, leading to a total coverage of 41% in April 1997 (Fig. 16-5A). The favorable weather conditions continued into the following year, and vegetation cover increased further to 70% in April 1998, predominantly in those areas that had been tilled only superficially. However, the prevalent erosion processes observed on the site could not be suppressed everywhere by the increasing vegetation cover.

While sheet wash was stopped or diminished in many areas, one-fifth of the site experienced an intensification of sheet wash (Fig. 16-5D), and 45% of the unchanged area is actually still subject to moderate sheet wash. The spatial change patterns of both vegetation and erosion are remarkably detailed on this site, and contradictory developments often take place in proximity, although from a perfunctory assessment of the site on a field trip

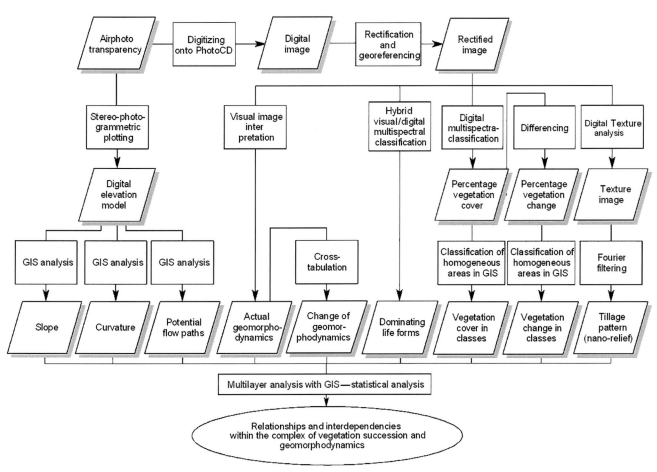

Fig. 16-4 Flow chart with the main interpretation and processing steps involved in assembling the process-geomorphological information system for the EPRODESERT test sites. *From Marzolff (2003, Fig. 5).*

or satellite image analysis, this would appear to be a typical rather homogeneous fallow field.

As expected, statistical analysis (predominantly by cross-tabulations and correspondence analyses, see Marzolff 1999) showed a generally negative correlation of geomorphological process activity with vegetation cover density for all study sites. However, relationships are much more complex than anticipated and vary considerably between climatic regions and within those for different plant life forms. An influence of microrelief on geomorphological processes exists mainly for linear erosion forms. The influence of topography as an erosion-controlling factor outweighs the role of vegetation density only when vegetation cover is sparse; in this case, nanorelief (e.g. tillage pattern on set-aside field) considerably influences pattern and intensity of geomorphological processes, also.

As a most important result, it was concluded that on the observed test sites erosion processes are occurring in patterns of high spatial frequency at far higher percentages of vegetation cover than tends to be assumed

by most investigations into land degradation (Marzolff 1999). Generally, a vegetation cover of 30%–40% is taken as a threshold beyond which runoff and soil erosion rates reach negligible amounts. In contrast, results of this study showed sheet erosion on fallow land with up to 70% overall vegetation cover. Looking at small-sized patterns, moderate sheet erosion is even observed at up to 90% vegetation density, and process dynamics may intensify during several observation periods even with increasing vegetation cover.

In the semiarid region in particular, where vegetation succession is limited by water stress, at least 60% vegetation cover is required in order to bring prevailing sheet erosion processes to a halt. A possible reason for the disparity between this threshold and the 30%–40% value identified by numerous authors may be the improved assessment of percentage vegetation cover on the basis of SFAP. Terrestrial observations (field mapping) and conventional airphoto or satellite analysis tend to overestimate vegetation cover owing to the shadowing between plants and leaves.

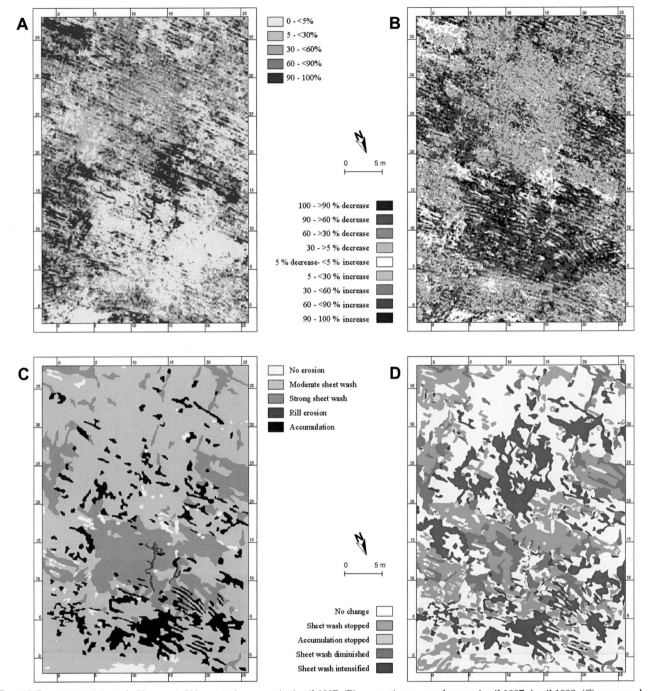

Fig. 16-5 Test site María de Huerva 1. (A) vegetation cover in April 1997. (B) vegetation cover change, April 1997-April 1998. (C) geomorphodynamics in April 1997. (D) change of geomorphodynamics, April 1997-April 1998. *Modified from Marzolff (2003, color plates 1–4).*

16-3 INFLUENCE OF GRAZING ON VEGETATION COVER

Grazing by sheep and goats is regarded as an important factor for vegetation and soil degradation, especially in semiarid landscapes. Browsing as well as treading impedes the regeneration of vegetation on many grazed areas in the Ebro Basin and the Pyrenees, and sheep trails encourage the development of erosion rills by exceptionally high runoff and erosion rates (Molinillo et al. 1997).

The Arnás catchment, located in the Upper Aragón River Basin of the Spanish Pyrenees, was cultivated totally with cereal until the middle of the 20th century. Since its abandonment, large parts of the catchment were affected by a process of natural plant colonization with matorral composed of *Genista scorpius*, *Buxus sempervirens*, and *Rosa gr. canina* (García-Ruiz et al. 2005). The field covered by this image map (Fig. 16-6; see also Figs. 16-3D and 10-18) was abandoned in the late 1970s and subsequently used as sheep pasture. Close to the

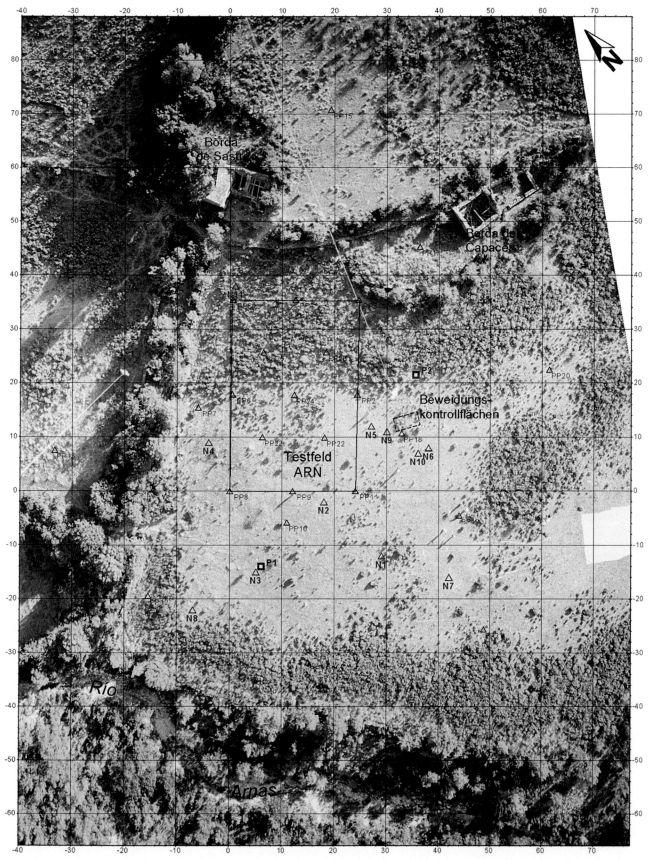

Fig. 16-6 Airphoto map with additional GIS layers of the test site (Testfeld) and its surroundings at Arnás in the central Pyrenees, Province of Jaca, Spain. The grazing control site (*Beweidungskontrollflächen*) is to the right of the image center. Blue triangles indicate rainfall simulation microplots, brown squares soil profile pits. Hot-air blimp photograph taken with an analog SLR camera by IM, JBR, and M. Seeger. Image processing by IM. *From Ries et al. (2000, Fig. 3).*

monitoring test site, a grazing control cage was installed in 1996. In the following years, plant species, vegetation cover, and height were recorded in regular intervals both within the cage and on the neighboring reference sites (Ries et al. 2003, 2004). The test site, as well as the grazing control sites, was monitored with aerial photography, and vegetation cover maps were prepared for all sites. The small image ground sample distance (GSD), the presence of the cage grating, and the high degree of shadowing between *G. scorpius* shrubs prevented the use of fully automatic image classification methods (see Chap. 11-5), and a hybrid method of multispectral thresholding and manual mapping had to be employed for the maps of the control sites (Fig. 16-7).

Results show that the exclusion of sheep from the area is able to boost vegetation cover significantly. While the reference-site cover is stable between 50% and 54%, vegetation cover within the cage increased from 60% to 92% between July 1996 and August 1998. The development of individual vegetation cover classes is equally interesting: 53% (cage) and 74% (reference site) of the areas initially show <60% cover by grass and herbs—the value shown to be an important threshold for reducing erosion processes from the aerial test-site monitoring. The percentage of these classes fell dramatically to 4% in the cage and at the same time increased slightly to 80% on the grazed reference site. Thirteen years after its installation, the control cage was completely filled with dense shrub growing out between the gratings.

Transferring the recovering rate of the vegetation from the control cage to the nearby monitoring test site showed that exclusion of sheep from the catchment would lead to nearly closed vegetation cover within only 2 years (Fig. 16-8; Ries et al. 2000). Interception by the protecting shrub canopy of *G. scorpius* matorral would reduce erosion rates even on the bare areas of the old trails beneath, where vegetation regeneration could be expected to be slower. In this study, high-resolution SFAP was able to capture patterns of vegetation exactly on the scale level where sheep have short-term influence on plant distribution.

Grazing patterns and arrangement patterns of trails are also essential factors that may lead to vegetation degradation and to soil erosion, depending on the degree of intensity and slope. In the Spanish Pyrenees, precipitation simulations on sheep trails showed average runoff coefficients of 58% and erosion values of $28\,g\,m^{-2}$. These are extremely high values compared to the surrounding area. It is also important to note that sheep trails might become erosion rills, even if they predominantly run diagonal to slope direction and thus at an angle of about 35° to 75° deviating from the direction of steepest drop. In Fig. 16-8A the diagonally running trails become

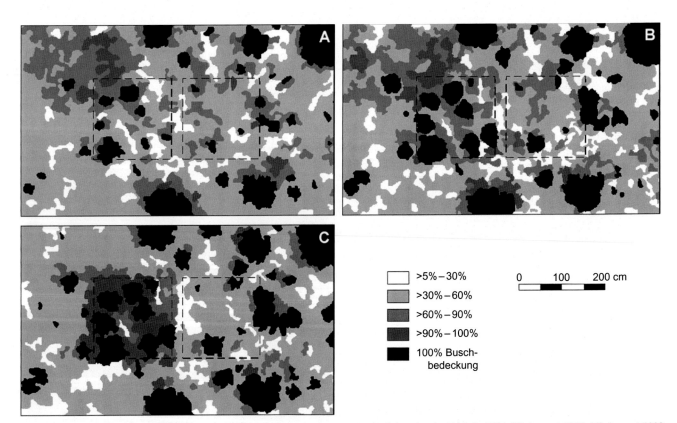

Fig. 16-7 Vegetation cover of the grazing control cage (left) and reference site (right) at Arnás. (A) July 1996, (B) August 1997, (C) August 1998. White to dark gray are grass and herbs cover classes, black is full shrub cover. Image analysis by IM. *Modified from Ries et al. (2000, Fig. 10).*

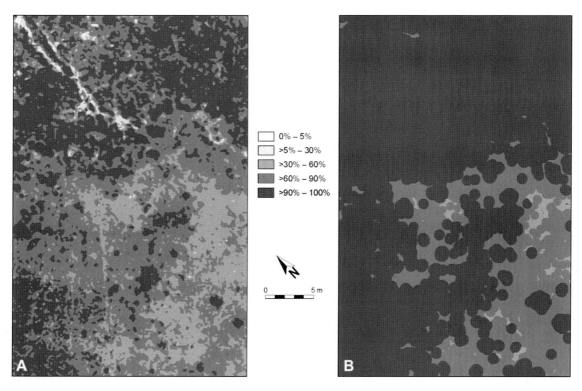

Fig. 16-8 Vegetation cover at the test site Arnás. (A) actual cover in July 1996, classification based on hot-air blimp photograph. Note the clearly visible open sheep trails between the shrubs where the sheep enter the test site through a wall opening in the upper left. (B) simulated vegetation cover in summer 1998, assuming that grazing was discontinued two years previously. GIS analysis based on the results shown in Fig. 16-7. Image processing by IM. *Modified from Ries et al. (2000, Figs. 7 and 11).*

visible in the top left corner through non-vegetated areas (0%–5%) located among areas of denser vegetation.

Nevertheless, hardly any data can be found about these biogeomorphological processes in the literature. Therefore the process dynamics of material disaggregation and translocation directly caused by trampling animals were quantified by means of experimental methods on test plots with a patchy pattern of tussocks and an open matorral of *Stipa tenacissima* (Ries et al. 2014). Gerlach troughs were installed in order to quantify material mobilization in different directions. The slope angle and the running speed of the animals were varied. Additionally, the amount of material that was loosened by the hooves of the goats was measured.

Results show that translocation rates were surprisingly high, and slope angles as well as running speed turned out to be important influencing factors. In downslope direction, each goat translocated rock fragments from between 0.6 and 6.5 g per square meter, depending on slope. The maximum translocation rate in movement direction reached $4.5\,g\,m^{-2}$ per goat for fast running and $1.3\,g\,m^{-2}$ per goat for slow motion. Additionally, each goat could loosen 14 g of soil material per square meter; this material could easily be removed by wind or water. Experiments with marked rock fragments on slopes of 4° and 11° showed that a flock of 45 goats translocates rock fragments with 3-cm diameter by a mean distance of 8.8 cm. While rock movement occurred in

all directions, most often the rock fragments were kicked forward downslope. Net mean downslope translocation rates varied between 1.5 cm and 6.6 cm corresponding with slope and the total number of rock fragments moved.

Fig. 16-9 shows a sheep-trail pattern on a field in the Souss Basin (South Morocco) that has been abandoned for 15 years. The intensively grazed area on the right is separated from arable land by a gully, which is about 2 m deep and flanked by a dirt road. Two places where the gully is traversed by sheep are easily recognizable. Accordingly, sheep trails run in a converging pattern toward the edge of the gully. Remarkably, the sheep tend to follow the old tillage lines stretching from bottom right to top left (Tumbrink 2012). The related microrelief is still visible 15 years after the last plowing because higher soil moisture in the furrows offers better growth conditions compared to the drier ridges. From a bio-geomorphological point of view, it may be stated that the succession of bushes along the tillage pattern has been influenced by trampling hoof kicks. If the development of bushes is hindered, straight trails are formed along which animals move quickly. Normally, on such a flat surface, a more irregular, net-like pattern is to be expected, with concentration and crossing points that correspond to moving and resting behavior of the animals during running and feeding.

According to Stavi et al. (2008, 2009a,b) and Pariente (2009), there is a basic differentiation of these open

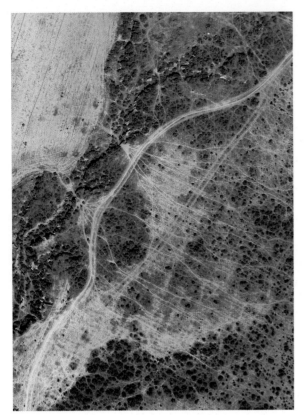

Fig. 16-9 Sheep-trail pattern on ~15-year-old abandoned field in the Souss Basin near Taroudant, South Morocco. Trail patterns concentrically approaching two gully transitions continue farther to the left (southeast) following old tillage lines from southeast to northeast. Taken with MILC from a fixed-wing UAV by S. d'Oleire-Oltmanns, IM and JBR.

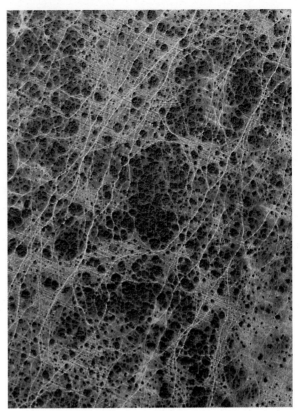

Fig. 16-10 Meshed pattern of dense shrub-intershrub-trail system. In contrast to Fig. 16-9, the direction of animal trails is perpendicular to the old tillage lines. The new grazing practice is thus hardly influenced by the old underlying tillage pattern. Taken with MILC from a fixed-wing UAV by S. d'Oleire-Oltmanns, IM and JBR.

dwarf-shrub areas into zones of larger shrubs or bush groups on the one hand and intershrub areas composed of annual grasses and bushy herbs on the other. While the former are avoided by sheep and goats and only affected at the margins, the intershrub areas are used for grazing. The trails cover the whole area in a mesh-like fashion, but avoid shrub zones where possible. In Fig. 16-10 a detail of a dense shrub-intershrub trail system is visible,

which shows a meshed pattern. The running direction of the animals is mostly perpendicular to the old tillage lines and hardly influenced by them.

Tumbrink (2012) analyzed such a meshed pattern of trails, shrubs, and intershrub by means of manual digitization. He found 72% intershrub area, 17% trail and concentration-points area, and only 9% shrub area (Fig. 16-11). This indicates the slow recolonization and

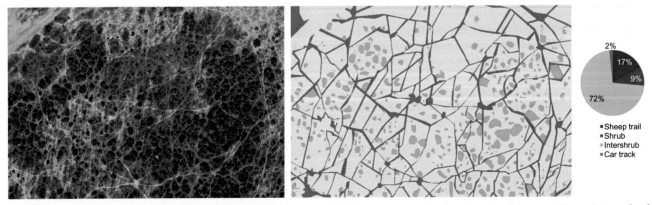

Fig. 16-11 Quantitative analysis by manual digitizing shows a large part of intershrub area, less trail area and concentration points, and only a small portion of shrub area (according to Tumbrink 2012). Due to constant and intensive grazing by sheep and goats, soil and vegetation degradation lead to slow recolonization. Airphoto taken with MILC from a fixed-wing UAV by S. d'Oleire-Oltmanns, IM and JBR.

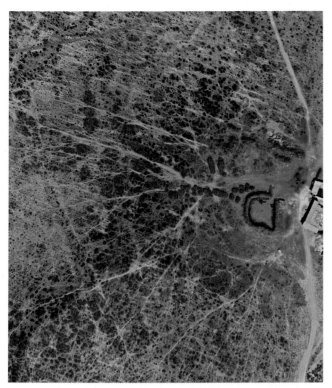

Fig. 16-12 Grazing pattern near sheep yard and shepherd's home. The dense trail system follows the old tillage lines (Tumbrink 2012). The trails are wider and vegetation is more degraded. In comparison with the other pictures, this clearly shows the difference between frequently and less frequently trampled surfaces. Taken with MILC from a fixed-wing UAV by S. d'Oleire-Oltmanns, IM and JBR.

upper part of the image clearly follow the old tillage lines (Tumbrink 2012). Here, trails are larger and vegetation density is obviously reduced. Daily running to the feed grounds and back to the watering trough noticeably left marks of degradation.

Excluding livestock from selected sites by walls of cement, mud bricks, or thorny shrub is common for protecting crops and tree plantations in the agro-industrial areas of the Souss Basin (see also Figs. 10-19 and 14-8). Goats, in particular, feed not only on grasses and low shrubs but also on trees, as they are good climbers. In the upper reaches of the Souss Basin's sedimentary fans and in the footslopes of the High Atlas mountains, remnants of the formerly ubiquitous open woodlands of endemic argan trees (*Argania spinosa*) still exist (see Chap. 13-5.3). They are the basis of a traditional agroforestry system with complex usage rights that include grazing by goats, sheep, and camels as well as speculative rain-fed agriculture in climatically favorable years.

In addition to the grass cover between the trees, which is sparse even in good years, the trees themselves are browsed by goats. Fig. 16-13 shows a steep slope with *Argania spinosa* in various growth forms at the end of the dry season in October 2018. The right part is fenced off and protected from grazing by a dense wall of thorny shrub. Low contour-parallel stone bands have been built for erosion protection. On the left side, the tree crowns are generally smaller, tree density is lower, and many argan saplings have not succeeded to reach tree stage at all. In the lower left corner, where goat herds ascending through a small valley turn right after the protective fence and climb up the slope, dwarfed conical shrubs of excessively browsed argan plants are more common than fully developed trees. Erosion rills have developed along the preferential trails of the animals and in other

high proportion of bare soil in cases where abandoned fields are intensively grazed by sheep and goats. Fig. 16-12 shows the nearby shepherd's home and his livestock yard, from where trails seem to spread in all directions—as one would expect. The most pronounced trails in the

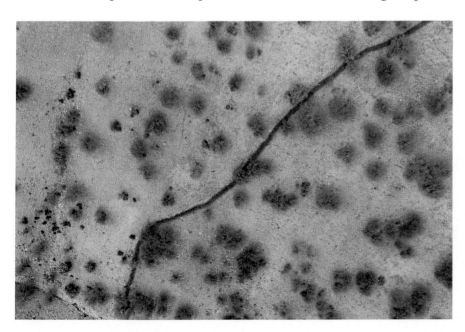

Fig. 16-13 Steep slope with argan woodland near Tamaloukt, South Morocco (compare Fig. 13-35). The fence separates a livestock-exclusion site (on right) from an area where goats commonly pass through on their way to hillslope pastures. The trees have little foliage at the end of the dry season, but the difference in tree density, crown size, and growth forms is still striking. Taken with on-board camera of quadcopter UAV by IM, R. Stephan and M. Kirchhoff.

parts of this non-protected area in the direction of steepest drop.

These examples illustrate clearly how grazing animals in such a semiarid environment shape their environment through their running and feeding behavior acting as bioengineers (Pariente 2009). In areas of land-use change, however, older land-use systems may continue to influence the movement routines of shepherd and livestock for decades after.

16-4 COMBATING DESERTIFICATION AND SOIL DEGRADATION

The protecting role of vegetation is the basis for many measures of erosion control, soil conservation, and rangeland management. Vegetation cover reduces splash erosion due to interception of rainfall, decreases overland flow, and improves infiltration of precipitation and runoff water into the soil. One example for such vegetation

regeneration measures was documented by SFAP on the wide and flat glacis areas of northern Burkina Faso (see Fig. 5-24), where the international non-governmental organization ADRA conducted tillage experiments in 2000 and 2001. A specially developed plow was used for carving deep furrows into the hard and bare clayey surface in order to reduce overland flow and encourage infiltration (Fig. 16-14). On the ridges piled up next to the furrows, various tree species were planted. It was expected that grasses would come up both in the furrows and the interlaced glacis strips, further increasing the erosion-control effects.

Experimental measurements of runoff and erosion rates on sites treated two rainy seasons apart showed that both factors were significantly reduced on earlier treated areas when compared to only recently treated sites, proving the short-term effectiveness of the measures. Kite aerial photography was taken to document the vegetation development and assess its spatial extent (Fig. 16-15). The increase of grass cover, here shown in the dry season of December 2001, was stunning. In view of improving the resilience of this vulnerable area to climatic change, livestock pressure, and increasing food security, the experiments were promising.

However, the success of the measures also depends on the future management of the improved sites. For a prevailing regeneration of the barren glacis areas and sustainable use as rangeland, grazing management strategies are of vital importance in a region where the number of cattle is directly correlated to fodder supply. Today, 18 years after the ADRA tillage experiments, a time series of high-resolution satellite images in *Google Earth* reveals that this aspect of the project has obviously failed. In particular, the area seen in Fig. 16-15B has seen a dramatic increase of livestock trails, radiating from a group of kraals that have since been established in the center of the site. Trail patterns quite similar to those

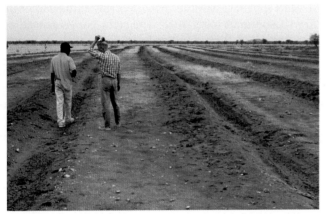

Fig. 16-14 Tillage experiments for soil conservation near Gorom-Gorom, Province of Oudalan, Burkina Faso. *Photo by JBR, July 2000.*

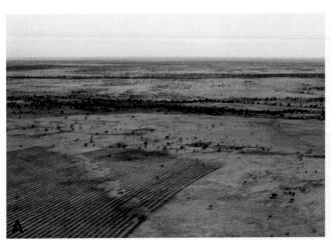
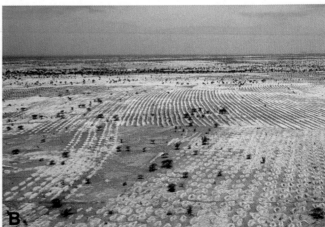

Fig. 16-15 Tillage experiment sites. (A) July 2000. (B) December 2001 (compare with recent satellite imagery in GoogleEarth at 14.51°, −0.16°). Kite aerial photographs taken with an analog SLR camera by IM, JBR, and K.-D. Albert.

shown in Figs. 16-9 and 16-12—but much lower vegetation cover—may be observed. While shrub and tree density has increased in some isolated patches of the ADRA project region, the effect on most of the areas has not been sustainable. Grazing could not be prevented long enough for a denser vegetation cover and trees to develop.

16-5 SOIL MAPPING AND SOIL DEGRADATION

In central Europe, conventional aerial photographs are of limited use for delineating soil units, because the fields are densely covered with vegetation or crop residue from May to September, the months in which most of the aerial photography surveys are carried out (Fig. 16-16). Winter crops, which are increasingly applied as catch crops, improve soil cover, also by plant residues, and nitrogen content. Therefore the soil surface is not visible during long periods. Accordingly, soil mapping is done by fieldwork using soil profiles and hand augers, usually in autumn, winter (if the soil is not frozen), and early spring. Such soil inventories with sampling by drilling and digging are quite time-consuming, so the distance between two sample points is rarely less than 20 m.

Instead, the delineation of the soil units is usually aided by the interpretation of local topography, such as changes in slope, escarpments, and breaks of profile that may occur, for example, between hillslope and floodplain, between convex slope shoulder and concave slope foot, or associated with vegetation and land-use changes. Soil samples are taken in the center of homogeneous-looking areas as well as along the assumed soil map-unit boundaries. This method usually brings coherent results but may lead in some cases to circular reasoning in subsequent geomorphologic/soil-scientific studies, when the actual distribution and explanation of soil units in maps are analyzed on the basis of the topography and the geomorphologic process knowledge.

This might result in causal connections such as "summit position on the topographic map equates to intense erosion that results in a truncated soil profile." Soil-unit boundaries on a soil map would be verified in most cases by a digital terrain model or contour map simply because of the intrinsic geomorphology background that the soil scientist relied on while compiling the map. Thus, two basic aspects have to be considered.

- Conventional soil mapping is usually based on expert knowledge from closely related disciplines. The map-unit boundaries are strongly correlated with changes in topography, vegetation, or land use.
- On areas that have been subject to land consolidation, which is particularly widespread in central and eastern Europe, this soil mapping technique is of limited use nowadays because such auxiliary topographic or structural features have been leveled out or cleared.

Our study on the current intensity and historic dimension of on-site soil erosion shows highly differentiated results and sometimes surprising distributions of soil units. This is particularly the case where the land-use history has been going on for centuries or even millennia.

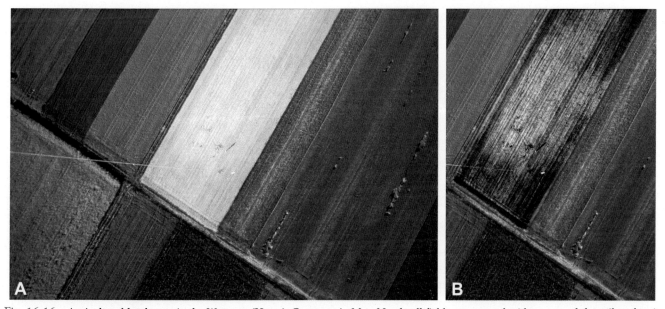

Fig. 16-16 Agricultural landscape in the Wetterau (Hesse), Germany, in May. Nearly all fields are covered with crops and the soil surface is visible on solitary fallow fields only. As the automatically controlled image exposure is balanced for the complete scene (A), fine differences in soil colors are even less discernible; strong histogram adjustments (B) may help to enhance them. Hot-air blimp photograph taken with analog SLR camera by JBR and A. Fengler.

16-6 SOILS AND LONG-TERM HUMAN LAND USE—AN IMPORTANT CONTRIBUTION TO GEOARCHAEOLOGY

In the periphery of a Neolithic settlement in the loess landscape in the Wetterau in Hesse, Germany, Fengler (2007) and JBR combined SFAP surveys with densely sampled soil mapping in order to document highly detailed patterns of soil units. The results were quite contradictory to initial expectations. Colluvium was found in ridge and other slope positions where geomorphologic process knowledge actually would rule out its existence. This soil distribution results from several millennia of human land use in the region, which brought about artificial changes in relief that influenced erosion conditions at different times and under different land uses.

Soil units could be identified, interpreted, and delineated on the basis of soil-surface colors captured by aerial photographs that were taken between February and April as well as in autumn. Similar to aerial archaeology (see Chap. 10-3.4) patterns became visible that could not have been detected from the ground perspective. At the same time, the limitations of airborne soil mapping became obvious. For example, soil moisture, treatment state, illumination conditions, and tillage directions have strong influences on soil color and thus on the interpretability of the aerial photographs. Without any fieldwork, an allocation of soil color to a specific soil unit is impossible, even for rather homogeneous sites, but made feasible with a small number of soil samples for reference. Mechanical tillage exerted for many decades has smudged the boundaries between formerly distinct soil units, thus rendering a clear delineation difficult. Image enhancement by histogram adjustments for increased color contrast may help to define such boundaries more clearly (see Fig. 11-10).

On the soil map of Butzbach/Nieder-Weisel (Fig. 16-17), the "Kleine Reiserbach" flows from west to east. Note the occurrence of Colluvisols south of the "Hoch-Weiseler Weg" on top of the ridge near the Neolithic settlement. On the field "Rechte Steinäcker" in the left half of the map, even a completely eroded rendzic Regosol is covered by colluvium (as indicated by the lighter shade of pink).

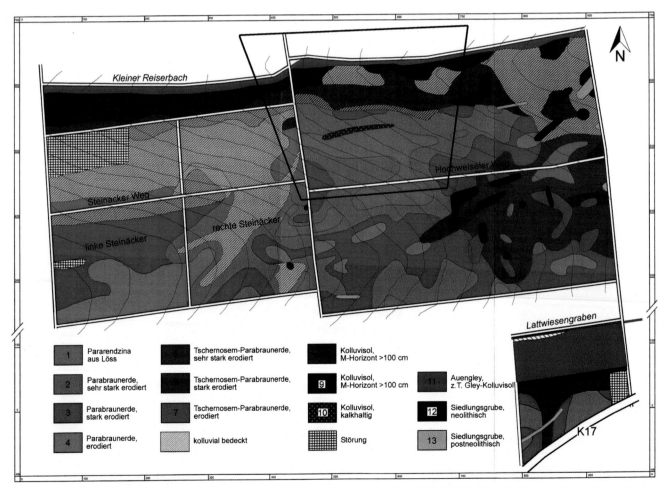

Fig. 16-17 Detailed soil map of the surroundings of the Neolithic settlement near Butzbach/Nieder-Weisel, Germany, according to the field survey by Th. Hock and St. Mohr. Area in black frame corresponds to next figure. *Modified from Fengler (2007).*

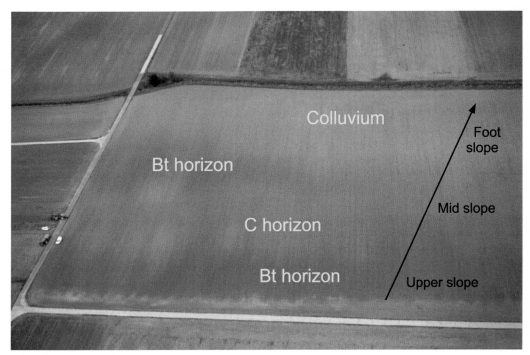

Fig. 16-18 Detail of the area in a low-oblique small-format aerial photograph taken from a light airplane by A. Fengler, March 1998. Arrow indicates slope inclination. Note tractors and vehicles on left edge of scene.

In the oblique SFAP image printed here with only slight tonal enhancement (Fig. 16-18), the light C horizon of the mid slope and the equally light colluvium at the foot slope are clearly distinguished from the darker bands of the Bt horizon areas. Although the boundaries of the soil units are blurred due to mechanized tillage, they are much easier to trace on the basis of this photograph than to delineate in the field, where the soil mapper lacks the synoptic overview of the gently rolling hills.

16-7 SUMMARY

Small-format aerial photography offers great potential for analyzing soil and vegetation patterns as well as biophysical and bio-geomorphological interrelations, particularly regarding soil erosion subsequent to vegetation degradation and/or diminished vegetation succession. Documenting and monitoring plant communities with heterogeneous distribution, for example the typically banded patterns of the low open shrubland of African tiger bush (*Brousse tigrée*), requires the use of corresponding image scales and resolutions that are most adequately provided by low-height photographs.

Changes of land use (agrarian systems and livestock husbandry) and climate and their impact on soil-erosion processes may be the greatest challenge that dryland research has to face in the next decade. Improving the understanding of the relationships between vegetation and soil erosion on different scale levels continues to be an important task for which SFAP is able to make remarkable contributions.

The examples from central Europe demonstrate that small-format aerial photography has proven to be quite useful for detailed pedogeographic and geomorphologic studies that improve and correct the expert knowledge gained on the ground. When mapped in detail, soils and soil erosion may be much more complicated than commonly assumed. In fact, simple assumptions may prove to be quite contrary to actual soil conditions in places with long histories of human land use. Unfortunately, too little research up to now has endeavored to transfer the potential of SFAP for the loess landscapes shown here to other soilscapes. The importance of varying soil-type distributions will inevitably increase in the age of precision farming. Especially for this purpose, high-resolution soil information is indispensable.

CHAPTER

17

Vineyards and Viticulture

In vino veritas (In wine lies the truth). Alcaeus of Mytilene (6th century BC)

17-1 INTRODUCTION

Viticulture and viticultural landscapes are among the oldest permanent cultivation systems on Earth and have been exported from the Mediterranean into all climatically suitable areas. These are predominantly the humid subtropics with winter rain and temperate latitudes with mild winters. Today, wine grows in California, Chile, South Africa, Southwest and South Australia, as well as many other similar places. During the millennia, growing and cultivation of grapevines and maturing wine have developed further—from the spicy and resinated, thickened syrup of ancient times, which was mixed with water for drinking, to the popular beverage of the Middle Ages, to the prosperity drink in the second half of the 20th century, and the predominantly mass-produced goods for the last 30 years.

In Europe, today's winegrowers focus on specialization to enhance quality and on a clear indication of origin—preferably awarded with quality labels. This has an impact on viticultural landscapes, the relief of vineyards, and the work processes. In the following, the changing climatic conditions, the forms of cultivation, and examples from Missouri (United States), Slovakia, Germany, and Spain are shown.

17-2 GRAPES, WINE, AND CLIMATE CHANGE

Viticulture is a major agribusiness spread around the subtropical and temperate regions of the world. Global wine production in 2015 was more than 28 million liters, led by France, Italy, Spain, and the United States, which accounted for more than half of the total (Trade Data and Analysis 2017). However, world production has declined

for the past several years to only 25 million liters in 2017, the lowest level since 1957 (Organisation Internationale de la Vigne et du Vin 2018). This decline is attributed mostly to adverse climatic conditions in Europe and South America.

Growing and harvesting grapes and making wine are complex activities with many variables, a long history of development, and much recent research. Grapes and the resulting wines are quite sensitive to climate. The vines also have a major influence on surface runoff, soil erosion, and soil-water balance.

In general, the date at which grapes ripen is mainly a function of summer temperature; warm, sunny weather results in an early harvest, and vice versa. Cold and frosty early summers may destroy young eyes, buds, or blossoms. Rainy and chilly summer and autumn days might lead to rotting grapes. However, a summer that is too dry may also influence the harvest. Then, sugar levels could rise, which leads to a higher quality of the grapes on the one hand but to a reduced harvest yield on the other.

Good historical records of the annual grape harvest have been compiled from towns in western Europe (France and Switzerland), and they are a proxy for climatic changes spanning the past several centuries including the Little Ice Age (Le Roy Ladurie 1971, 2004). For example, glaciers in the Swiss Alps responded to climatic shifts indicated by grape-harvest dates with a lag period of 5–7 years (Pfister 1981).

More recently global warming has impacted vineyards and wine production during the late 20th and early 21st centuries. Most of the potential flavor and quality of wine is created in the grape during the growing season and is already determined when the grapes are delivered to a winery. When to harvest grapes for a fine wine is a delicate balance between three factors (Nicholas 2015).

- Acid content—gradually decreases to a low level as grapes mature and ripen.
- Sugar content—gradually increases to a high level as grapes mature and ripen.
- Flavor potential—reaches a peak at grape maturity then begins to decline.

Grape acid content (pH) is related primarily to soil acid, depth, and age (Retallack and Burns 2016). Thus older, deeper soils with low nutrients (low pH) tend to produce grapes with less acid and more complex flavors, known as *gôut de terroir* (taste of soil). For a given soil and variety of grape, weather during the growing season is, thus, the most important variable for potential flavor.

For optimal grape ripeness and wine flavor, all three factors achieve best balance in about 3 to 4 months depending mainly on summer temperature (Nicholas 2015). Higher temperatures speed up ripening and lead to grapes with higher sugar content. Furthermore, highly acclaimed vintage wines are often produced in years that are dry in the month before harvest, which explains why dry-summer Mediterranean climate is favorable. The ripening process is highly sensitive for thousands of varieties of *Vitis vinifera* grapes, each of which has unique conditions of soil and climate (Fig. 17-1). For example, Pinot Noir and Riesling grapes prefer cool climate, whereas Cabernet is a warm-climate grape.

In spite of these differences, a global trend over the past few decades is increasing alcohol content in wine due to more sugar in grapes, as a consequence of warmer summer temperatures in all major grape-growing regions (Nicholas 2015). A further consequence is that grape flavor components no longer reach their peak levels during the growing season in phase with optimum sugar and acid contents. This has significant implications for eventual wine flavor and, thus, value of the grapes and price of the wine.

Climate change has therefore been obliging the winemaking sector into developing adaptation and mitigation measures for about two decades (Fraga et al. 2012; Alonso Ugaglia and Peres 2017). Besides varietal changes, these include a possible relocation of vineyards into cooler climates at higher altitudes or latitudes. For example, southern Australian vineyards are moving into Tasmania. Oregon and Washington may gain new vineyards at the expense of California. Likewise in Europe, wine production is already gradually shifting northward.

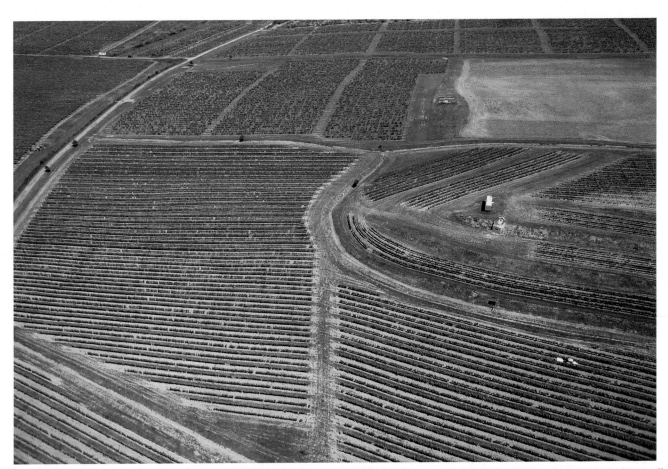

Fig. 17-1 The Tokaj region is famous for a special white wine based on the Furmint grape variety. Most of region is in Hungary with a small portion in the southeastern corner of Slovakia (shown here). Furmint buds early in the season and ripens late, and may produce some of the most complex and longest lived wines in the world (Kavanagh and Gray 2018a). Kite photo with a compact digital camera by SWA and JSA with J. Janočko and M. Prekopová.

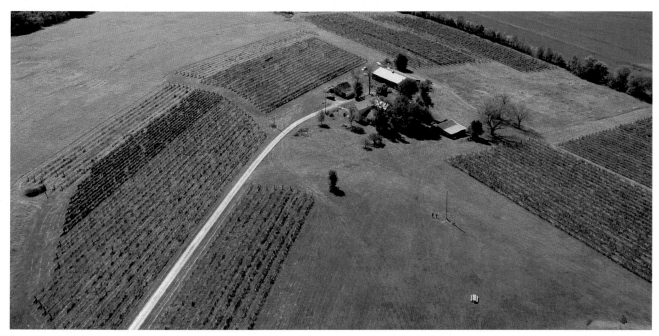

Fig. 17-2 Röbller Vineyard located on a hill top with 18 acres (~7 ha) of grapes in the Missouri wine district. Several French-hybrid varieties are grown as well as the Norton, an American grape that was first found in Missouri in the early 19th century (Kavanagh and Gray 2018b). This vineyard was established in 1988 and has attained a reputation for fine wines. Kite photo with a compact digital camera.

Colder regions cultivating typical varieties such as Riesling are in danger of rising temperatures beyond the cultivation limit in the medium term. Winegrowers are already experimenting with varieties more adapted to warmer temperatures such as the Burgundy grapes. However, these changes are not likely to happen quickly, as developing a vineyard and producing high-quality wine may take many decades to perfect the grape varieties and production techniques (Fig. 17-2).

Growing methods vary between pole cultivation and single vines without growth support, which is particularly common in the Mediterranean region. In southern Spain, Malaga grapes need to be covered by their foliage to prevent grapes from withering during midsummer. Otherwise, the grapes dry up to raisins, which are also coveted. In central Europe, there are different methods of cultivating by means of poles and trellis wires to achieve the optimal exposure of grapes to the sunlight. For this purpose, covering foliage is cut off or bent back. There are numerous regional practices such as cultivation along house walls and as sun protection covering courtyards or squares, which helped create the myth about South Tyrol (Italy) as a place which is particularly merry on wine.

Small-format aerial photography provides appropriate scale, resolution, and vantage to evaluate new vineyards or gauge the impact of changing climate on established vineyards. A variety of manned or unmanned platforms could be employed, particularly with color-infrared cameras, as an aid to precision viticulture

throughout the growing season. SFAP could be used to assess the manner of trellising, pruning, spraying, and irrigation, as well as type of ground cover, weeds, mildew, pests, or diseases. Cover crops on the vineyard floor, for instance, may help to control weeds, soil erosion, and nitrate leaching (Skinkis 2015). Other benefits include better water retention and a stable surface for workers and equipment (Fig. 17-3).

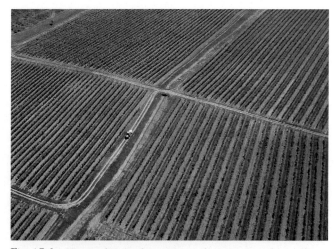

Fig. 17-3 Vineyard ground cover in an alternate-row scheme. Every other row is bare soil for tractors, and intervening rows have clover and grass for walking. Rows are spaced ~2 m apart, just wide enough for a small tractor and sprayer to pass through. Tokaj region, Slovakia. Kite photo with a compact digital camera by SWA and JSA with J. Janočko and M. Prekopová.

17-3 SOIL EROSION IN VINEYARDS OF THE MOSELLE, SAAR AND RUWER VALLEYS, GERMANY

The most extreme forms of steep-slope vineyards may be found in the Moselle Valley and its side valleys of the Saar and Ruwer rivers, which have been used continuously for viticulture since Roman times. While pole cultivation has always been common here, mechanized processing today requires a greater row spacing. As the small tractors are pulled by cable winches, a downslope wire-frame cultivation is indispensable (Fig. 17-4). From such large-scale images, the plant stock structure may be derived and 3D models can be calculated (De Castro et al. 2018). This allows for a more focused herbicide and pesticide management by means of small helicopters. It is also possible to survey the entire canopy down to the level of individual plants (Mathews and Jensen 2013; Mathews 2014; Poblete-Echeverría et al. 2017). Effects of soil management strategies may be elaborated and evaluated (Retzlaff et al. 2015). This is an important prerequisite for monitoring the grape development and for a smart management, enabling efficient and ecologically more-sustainable tillage, fertilization, irrigation, and pest control.

In areas without terracing, where rows of vines are installed downslope, greening of the interrows is abso-lutely preferable. However, bark, straw, or schist-stone mulching are also used, both as weed control and—a specific custom in the Moselle region—as nocturnal heat reservoirs. Nevertheless, these vineyards are highly susceptible to rill erosion and gully formation.

In central Europe, introduction of organic viticulture is currently demanded and promoted. In addition to the absence of pesticides and herbicides, an erosion-reducing and soil-improving grass/herb or mulch cover in between the rows constitutes the most significant difference to conventional cultivation. Fig. 17-5 clearly shows the differences in coverage in a steep slope viticulture area in the lower Saar Valley in Rhineland-Palatinate. The first 22 rows from the left are managed organically, from row 23 onward conventional treatment without greening is applied. The recognizable Gerlach troughs revealed highly significant differences in surface runoff and soil erosion over the observation period from October 2014 until March 2015: 30 L and 80 g on the ecologically treated areas are in contrast to 76 L and 403 g on the conventionally processed ones. From this, soil conservation by means of vegetation cover may be deduced explicitly as the best practice.

Fig. 17-6 shows a vineyard newly established two years ago in the upper Ruwer Valley in Rhineland-Palatinate.

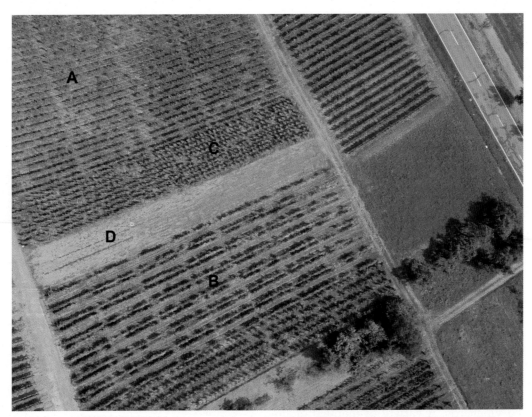

Fig. 17-4 Vertical image of 26°-steep vineyards near Wawern, lower Saar Valley (Rhineland-Palatinate, Germany). Different cultivation practices show differences in the vegetation density. (A) single-wire trellis cultivation, (B) double-wire trellis cultivation, (C) single-pole cultivation, (D) recently cleared vineyard with planted herbs. Taken with an MILC from quadcopter UAV by M. Seeger and JBR.

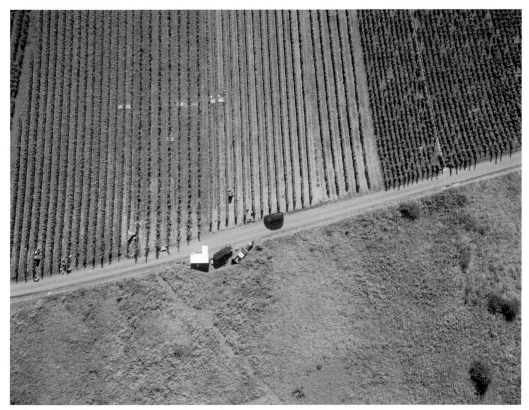

Fig. 17-5 Steep-slope viticulture area in the lower Saar Valley in Rhineland-Palatinate (Germany) with organic cultivation (left) and conventional cultivation without greening (center part). The lower part of the image shows abandoned vineyards with spontaneous vegetation cover. Taken with MILC from a fixed-wing UAV by M. Seeger and Y. Hausener with JBR.

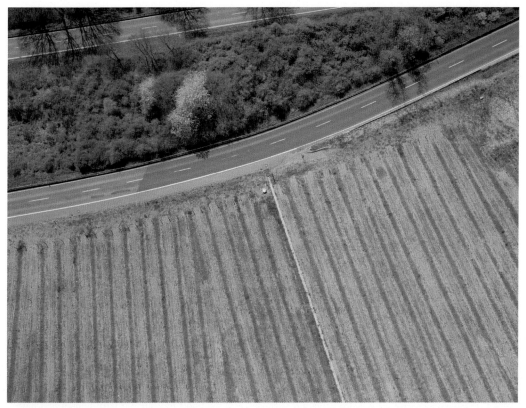

Fig. 17-6 New vineyard in the upper Ruwer Valley. Hardly any cover and a high content of fine soil material are prerequisites for high soil-erosion values. Taken with MILC from a fixed-wing UAV by M. Seeger and C. Brings with JBR.

Completely bare soil surface including treatment lanes may be observed. In our experience, these young vineyards are particularly affected by soil erosion. The traditional deep plowing brings a lot of fine material to the surface that is easily eroded. No protective stone cover has yet been formed as a result of selective removal of different grain sizes. After a few years, drainage and erosion are greatly reduced, as a residual stone deposit builds up and is more stable to rain splash and runoff, and there is more infiltration and hardly any siltation. Normally, the recultivation (*Umtrieb*) takes place every 25–60 years. Thus, wine from so-called old grapes also has ecological advantages. A compilation of all data from the longest series of measurements (25 years) under steep-slope viticulture is provided by Stehling and Schmidt (2017).

17-4 SOIL EROSION IN VINEYARDS OF THE AXARQUÍA, SPAIN

Particularly in the Mediterranean, vineyard design and tillage are more important than cultivation practices. Soil-erosion values on vineyards in this region are among the highest of all land uses (Rodrigo-Comino et al. 2016). Steep to very steep slopes are often stabilized by terraces, traditionally by means of dry stone walls. Many of these terraces have existed for centuries and—unless maintained regularly—are threatened by decay. This happens particularly in areas of extensive sheep and goat grazing. If there is no wall or it is destroyed, a rapid loss of fine material occurs along with the destruction of the often humic terrace horizons.

A particular problem is the relief-changing cultivation, especially in steep-slope viticulture. Fig. 17-7 displays a

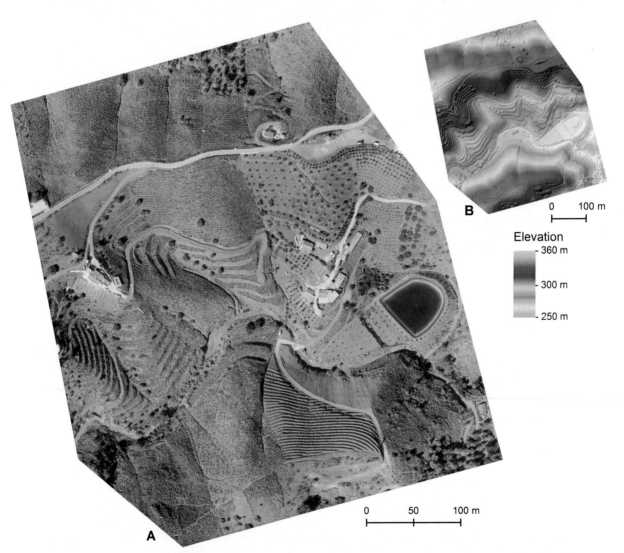

Fig. 17-7 Orthophoto mosaic (A) and DEM (B) of vineyards in the Axarquía near Almáchar (Andalusia, Spain). In this steep-slope viticulture area the main road is located on the crest, the dry torrential river bed of the Almáchar river runs 70 m below. Different forms of cultivation—sloping vineyards, vine terraces, olive and mango plantations, and newly established mango terraces—reflect the latest transformations in land use near the Costa del Sol. The large water reservoir is for irrigation purposes, and the pools indicate old farm houses that have been converted to holiday cottages for rural tourism. Based on aerial imagery taken with on-board camera of quadcopter UAV; photogrammetric processing by IM.

section in the central wine-growing area of the Montes de Malaga in Andalusia, home of the well-known Spanish dessert wine. One can recognize traditional single-plant cultivation on the stretched to convex, up-to-42°-steep slopes, on which the vineyards are manually tilled by hoe (upper third of Fig. 17-7A). These areas generate extremely high surface runoff rates of up to $650 \, L m^{-1}$ and erosion rates of up to $5.5 \, kg m^{-1}$, measured over the period from November 2014 to March 2016 (Rodrigo-Comino et al. 2016, 2017).

Adjacent and below are freshly terraced areas on which machine use is possible, too. Here, however, terrace edges show instability and considerable rill erosion. Recently conducted rainfall experiments with small rainfall simulators resulted in runoff coefficients of 30% on terraced versus 9% on non-terraced (sloping) vineyards and soil losses of $42 \, g m^{-2}$ versus $9.4 \, g m^{-2}$, respectively. This leads to the conclusion that wrong terracing or badly managed terraces do not protect the soil, at least not in the short term, but might trigger erosive processes (Rodrigo-Comino et al. 2019).

Remarkable in this region is the ubiquity of newly created terraces (see lower part of Fig. 17-7A). They represent a widespread trend on Spain's coastal areas. Currently, older and often already abandoned vineyards with matorral association are being removed and substituted by mango (*Mangifera indica*) and avocado (*Persea americana*) orchards to increase productivity and income. Often, also poorly managed terraces and irrigation systems are employed. Excess soil and rock material that accrues during the terracing process has been poured downhill from the newly created track at the lower end of the terrace into the bed of the currently dry Río Almáchar. On this steep slope, the debris material is now easily available for rill and interrill erosion and will be transferred directly to the receiving water (see Fig. 10-39).

Part of this terracing project is the impressive water reservoir on the picture's right edge. This is supplied with groundwater that is presumably pumped from the riverbed gravel deposits of the Rio Almáchar. It remains to be seen with continuous aerial surveys how small and steep terraces and the talus develop in the coming years. The question of whether the young mango trees develop well or fall victim to winter cold-air masses may also be tackled with large-scale SFAP.

17-5 SPECIFIC PROBLEMS OF STEEP-SLOPE VITICULTURE SFAP

Taking SFAP of steep-slope vineyards comes with specific problems, namely:

Extreme slopes—In contrast to many other agricultural areas and permanent crops, steep-slope vineyards feature slopes ranging from 20° to 45° (Fig. 17-8). This results in technical and methodological difficulties such as maintaining the platform height over ground during the flight or coping with angular effects in

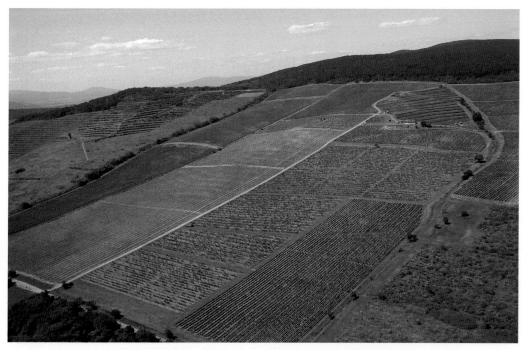

Fig. 17-8 Vineyards on a steep, south-facing slope in the Tokaj region of Slovakia. In some fields, rows run down the slope, and other fields have rows across the slope. Kite photo with a compact digital camera by SWA and JSA with J. Janočko and M. Prekopová.

digital image analysis for deriving quantitative statements, for example, about biomass.

Shadow patterns—Particularly for vines trained on trellis wires, shadowing between the rows may lead to misinterpretations during automatic evaluation. Even in the case of optimal sunshine, shadow effects are always present between rows and within the canopy. Although the shadow proportion may seem regular, it could actually differ strongly throughout the image with varying steepness and exposition of the slopes.

Lack of suitable take-off and landing areas—Well-developed roads and maintenance tracks are often found in vineyards. They are, however, usually narrow and larger parking spaces or open spaces are missing due to land competition. Space for launching and landing of remote-controlled fixed-wing UAVs is therefore scarce. A minor navigation error might inevitably lead to a crash or even total loss in the trellis-wire construction. This makes other SFAP platforms capable of vertical take-off and landing such as multicopters or hybrid VTOL UAVs (Chap. 8-6) and kites (Chap. 7-4) more appropriate.

Limited operation periods—Operation periods in vineyards are generally limited corresponding to the closing of the area to visitors during late summer and autumn months before and during the harvest season in central Europe. In extreme cases, this means that from the beginning of September to the end of the year the area cannot be entered, for example, when ice vine is to be harvested.

17-6 SUMMARY

Winegrowing regions are a special challenge for SFAP. In addition to specific problems of photographing and image analysis, different growing systems and types of cultivation must be considered. Nevertheless, the increasing importance of viticulture with rapidly changing land-use management due to climate change and land-use change is an important reason for long-term monitoring this permanent and widespread viticulture with the help of SFAP. There is hardly any other permanent cultural system where the challenges of a more eco-oriented economy are greater. This applies in particular to the vast amounts of surface runoff and soil erosion associated with wine cultivation, which are among the highest found in the world. But there is also hardly another crop that has a similarly high potential for implementation of more sustainable and organic cultivation methods—wine will always be a beverage that is a delight not only to the palate but also to the heart.

CHAPTER

18

Architecture and Archaeology

18-1 INTRODUCTION

Architecture refers to the design and construction of individual buildings, bridges, monuments, towers, and similar edifices as well as integrated building complexes. Regarding modern architecture, small-format aerial photography (SFAP) has applications for all phases of construction and property management from initial site selection to restoration of historic monuments. Holz et al. (1997) emphasized the need for large-scale, high-resolution aerial imagery for proper interpretation of such human structures. High spatial resolution and the ability to collect imagery from unconventional vantages are important attributes of SFAP. Aerial views depict the architectural structure or building site in relation to its surroundings and may provide highly detailed site surveys or construction measurements (Fig. 18-1).

The fact that many architectural features are in urban settings introduces an added challenge to the small-format aerial photographer. Adjacent buildings, power lines, light poles, radio towers, and other obstacles may be numerous, along with many people, vehicles, and low-flying aircraft. In an age of increased security, SFAP may be restricted around major public buildings, such as sports arenas, museums, government offices, and the like (see Chap. 12). Thus, access to the airspace in proximity to the target site may be difficult or impossible. Finally, it should be noted that cities give rise to increased turbulence in near-surface wind compared with the surrounding countryside, which could affect SFAP platform operation.

Another useful application of SFAP is to document before-and-after architectural conditions, for example during restoration or expansion of an existing building or monument. Consider the Liberty Memorial in Kansas City, Missouri, which is home to the US National WWI Museum and Memorial (Fig. 18-2). It was constructed in the 1920s, but by the 1990s it had fallen into such disrepair that it had to be closed to the public. Following extensive structural renovations and expansion, the memorial was rededicated in 2003, and a new underground museum was opened in 2006.

Fig. 18-1 View across dam construction site at Horse Thief Canyon, Kansas, United States. The partially completed dam extends across the scene and blocks Buckner Creek (right background). The outlet tower and channel are near the center of view, as heavy equipment moves across the dam structure. Kite photograph with a compact digital camera, May 2009.

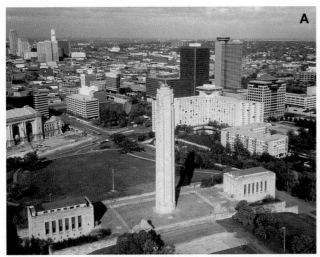 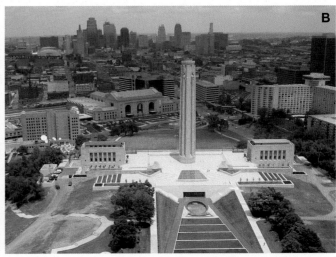

Fig. 18-2 Liberty Memorial, a national monument to World War I in Kansas City, Missouri, United States. (A) Original Liberty Memorial as constructed in the 1920s and closed for repairs when this picture was taken in 1998. The center tower stands 217 ft (66 m) tall. View toward northeast; kite photograph with a compact analog camera by JSA with J.T. Aber. (B) Renovated Liberty Memorial just after its rededication in 2003. Overview northward with Kansas City skyline under clouds in the background. Helium-blimp photograph with a compact digital camera.

Fig. 18-3 Low-oblique view of a former railroad roundhouse that was used to service and repair steam locomotives. It was built in 1926–28, spanned 200°, and had 30 stalls accessed by a turntable at the center of the circle. The structure was torn down in 1983, but the foundation remains and is defined by storage of spare parts and building materials. Piles of scrap metal in the foreground mark the original entrance. BNSF Railway, Emporia, Kansas, United States; kite photograph with a compact digital camera by JSA with D. Leiker.

Archaeology, in contrast, deals with the physical evidence of past human activities as preserved in architectural ruins, artifacts, and other traces that may be clearly visible at the surface, concealed, buried, or under water. This includes archaeologic remains of historical nature (Fig. 18-3) as well as long-lost sites for which no oral or written records exist (see Fig. 10-34). Archaeologists using kites and balloons, indeed, were among the first to contribute to the revival of SFAP in the 1970s and 1980s (Busemeyer 1987;

Heckes 1987). Since then, SFAP has proven extremely valuable for reconnaissance and detailed analysis of archaeological sites by visual interpretation or digital multispectral analysis of crop, soil, and other visibility marks (e.g. Eriksen and Olesen 2002; Verhoeven 2008, 2012).

For documentation and geodetic survey of archaeological remains, the photogrammetric potential of SFAP has been an important aspect even in the predigital age (Fig. 18-4). Spurred by recent developments in UAS and

Fig. 18-4 Documentation of archaeological excavations at Tell Chuera settlement mound, northeastern Syria. The analog SLR camera was fitted with additional fiducial marks to enable photogrammetric analysis of the imagery. Kite photography by IM with J. Wunderlich.

image-processing technology, the creation of digital 3D models and orthophotomosaics has now become an integral part of many archaeological surveys (e.g. Chiabrando et al. 2011; Fernández-Hernández et al. 2015).

Cemeteries combine architectural and archaeological components with remains of human bodies. Cemeteries are often associated with other features, particularly churches and chapels, and gravestones are an important source of information for genealogy. Cemeteries are, furthermore, places of religious faith and remembrance. Military cemeteries, in particular, recall the horrors of past wars and many thousands of deaths. Bieck (2016) has emphasized that special care must be taken when conducting SFAP in such places of memory and emotion.

The examples below elaborate the expansion of a major art museum in Missouri, United States; the Santa Fe Trail across the Great Plains of the United States; and selected cemeteries from Denmark and the United States.

18-2 NELSON-ATKINS MUSEUM OF ART, KANSAS CITY, MISSOURI

Origins of the Nelson-Atkins Museum of Art date from the late 1800s with William Rockhill Nelson (1841–1915), a newspaper publisher and philanthropist, and Mary McAfee Atkins (1836–1911), a widowed teacher. Both left well-endowed trusts. In 1927, by mutual consent of their trustees, the Nelson and Atkins funds were combined to create the financial basis for building a single world-class art museum (Ward and Fidler 1993; Nelson-Atkins Museum of Art 2018). Construction of the original Nelson-Atkins building began in 1930 and was completed in 1933.

Kansas City architects Wight and Wight designed a neoclassical beaux-arts structure built of Indiana limestone featuring massive Ionic columns with interior marble and bronze finishes. The museum was situated on Nelson's baronial estate covering 22 acres (~9 ha). The building sits on a hill top facing south toward the valley of Brush Creek, and the surrounding grounds were developed into a public park. By the mid-20th century, it already had achieved a renowned reputation and was particularly noteworthy for its Asian collections of Chinese, Indian, and Japanese art as well as European and American paintings. It was, in addition, an iconic architectural symbol of Kansas City, Missouri (Fig. 18-5).

During the 1990s, planning for a major addition began. This was the first fundamental change to the museum in more than six decades, and it was intended to be a significant contribution to architecture as well as art display. The expansion dealt with every aspect of museum function (Wood and Slegman 2007). Original ideas for the expansion focused mainly on the northern side of the existing building, which was the main public entrance so that the magnificent southerly view of the existing building and park would not be disturbed.

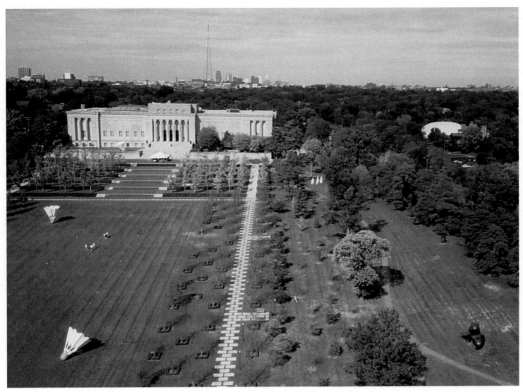

Fig. 18-5 View across the southern lawn of the Nelson-Atkins Museum of Art looking north toward the southern façade of the original building with the downtown Kansas City skyline in the background. The shuttlecock sculptures suggest a giant badminton court in which the building represents the net. Right side of scene is site of the future Bloch building. Kite photograph with a compact analog camera by JSA with J.T. Aber (1998).

Six internationally famous architects were invited to submit design concepts in 1999. Most envisioned plans to develop the northern side of the existing building. The winning proposal from Steven Holl was radically different, however. His design featured a long, narrow, low building that extends southward from the eastern end of the existing Nelson-Atkins building. In Holl's description, the original building is stone, heavy and inward, whereas the new building is feather, light, and outward (Wood and Slegman 2007). Together they complement each other—stone and feather. This concept utilized the park atmosphere and sculpture garden of the museum campus without compromising the grand northern and southern façades of the original building.

Considered daring and innovative, Holl's design immediately generated substantial controversy because of its ultra-modern style that contrasts sharply with the traditional neoclassical appearance of the Nelson-Atkins building. As with other noteworthy museum architectural disputes, such as the *Pyramide du Louvre* in the 1980s, the new building design sparked heated debate within the local community. Construction of the new building, named for Henry W. and Marion Bloch, moved forward in 2001, in spite of local controversy. Indeed debate intensified during construction, as it was quite difficult to appreciate on the ground how the new building would look when finished (Fig. 18-6).

The Bloch building was completed and opened to the public in 2007 (Fig. 18-7). The new building is 840 ft (256 m) long, and much of it lies below ground. Rising above ground are five so-called lenses clad in frosted-glass panels (Fig. 18-8). The primary purpose of these lenses is to channel diffuse natural light into the interior display spaces via vaulted ceilings; at night, the lenses glow with interior lighting. The Bloch building is set next to the outdoor sculpture garden, which overlaps onto the grassy roof of the building between lenses.

In addition to the Bloch building, the expansion project included a new underground parking garage on the northern side of the Nelson-Atkins building. The roof of the parking garage supports a large, shallow, water-filled reflecting pool designed by Walter de Maria called *One Sun/34 Moons* (Fig. 18-9). The pool contains a gold-covered, bronze-and-steel slab that represents the sun and 34 circular lenses that pass daylight through water into the garage underneath. At night, light from below illuminates the reflecting pool and roof plaza.

During the process of museum expansion, small-format aerial photography provided a means to document the unfolding architectural drama from a low-height vantage that would be difficult to achieve by other methods. Tethered kites and a small helium blimp were utilized as lifting platforms depending on wind conditions. In this urban setting, manned aircraft

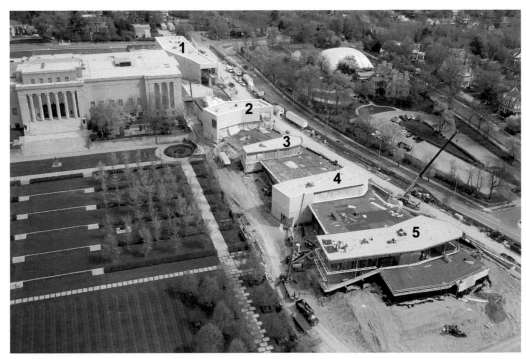

Fig. 18-6 New Bloch building under construction on the eastern side of the Nelson-Atkins Museum of Art campus in 2005. Five raised "lenses" are identified simply by number (1–5); these portions extend above ground in the completed structure. Helium-blimp photograph with a compact digital camera.

are not allowed to fly less than 1000 ft (300 m) above the ground, whereas all the photographs presented here were acquired from heights of less than 500 ft (150 m). Current FAA regulations would prohibit UAS operation over such a public space without a certificate of waiver (FAA 2016a).

Much of the initial controversy about the museum expansion has diminished now, but lingering uncertainty continues. The art as well as the architecture is viewed by each person subjectively, of course, but in the long run the Nelson-Atkins Museum of Art undoubtedly will maintain its world-class stature for both. Architecture is

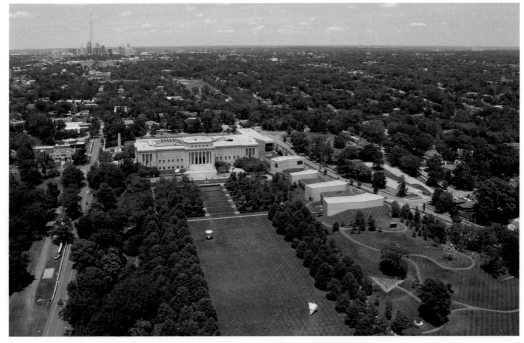

Fig. 18-7 Overview of the Nelson-Atkins Museum of Art. The original classical building to left and the finished Bloch building on the right side with the south lawn and sculpture garden in the foreground. Kite photograph with a compact digital camera by JSA with T. Nagasako (2017).

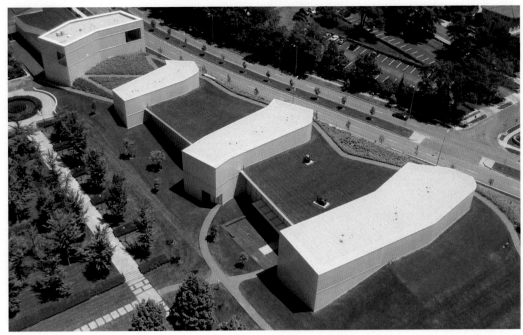

Fig. 18-8 Close-up view of the Bloch building, lenses 2–5 (see Fig. 18-6). Note sculptures on grassed roof top. Kite photograph with a compact digital camera (2008).

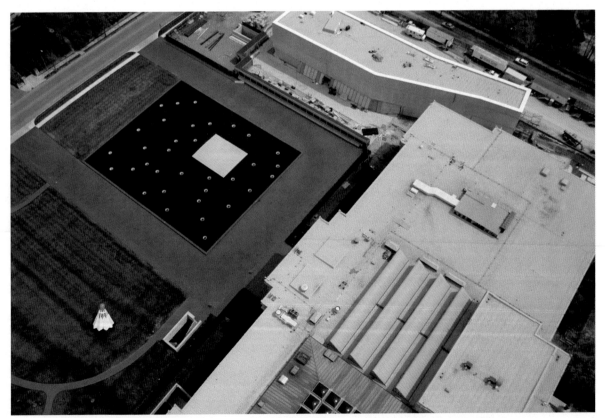

Fig. 18-9 Northern side of the museum complex in 2005. *One Sun/34 Moons* by Walter de Maria is the black square reflecting pool above the parking garage, upper left portion of view. Lens 1 of the Bloch building is under construction in right background. Roof of the Nelson-Atkins building is lower right, and a shuttlecock rests on the lawn in lower left corner of scene. Helium-blimp photograph with a compact digital camera.

considered one of the fine arts, and architectural photography is essential for demonstrating buildings, structures, and monuments (Dubois 2007). Kite and blimp aerial imagery uniquely illustrates and elaborates Holl's stone-and-feather concept for the Nelson-Atkins Museum of Art.

18-3 SANTA FE TRAIL, GREAT PLAINS, UNITED STATES

The Santa Fe Trail is among the most famous preindustrial trails in the historical development of the United States (Peters and Grubb 2000). It involved animal and human power to move goods and people across the Great Plains region. From its easternmost point of departure on the Missouri River, it stretched nearly 1000 miles (~1600 km) to the city of Santa Fe in what was then Spanish America, later Mexico, and finally the United States. The trail was utilized primarily for trading and commerce. During its existence from 1821 until 1880, territorial, state, and national status changed many times; uprisings and massacres took place, military forts and civilian trading posts came and went, tens of thousands of people made the journey, and the Mexican-American War and Civil War were fought.

The trail is designated as the Santa Fe National Historic Trail. The main routes along with its shortcuts, branches, side roads, connecting trails, and related features are well marked by signage along modern highways and mapped in considerable detail (Franzwa 1989; US National Park Service 2017). In spite of this rich history, most relicts of the Santa Fe Trail have been erased by the passage of time and subsequent human activities along much of its former course. As a consequence, few original traces of the Santa Fe Trail remain nowadays, although some portions and surviving structures are well preserved (see Fig. 7-2).

As the Santa Fe Trail bicentennial approaches, we have undertaken SFAP of modern landscapes and current human land uses along the former trail route (Aber and Aber 2013). In some places, the original prairie character has changed only slightly during the past two centuries. In other portions, agriculture, industry, and urban growth have radically altered the landscape. The following SFAP examples were acquired with kite and helium-blimp platforms and are presented below from east to west.

Kansas City, Missouri—The junction of the Missouri River and Kansas River was a key geographic focal point in the exploration and settlement of the United States and is now the location of the Kansas City metropolitan area. Since prehistoric times, this vicinity has served Native Americans, colonial Europeans, and finally the United States as a transportation and development center (Hoffhaus 1984). From the Westport Landing on the Missouri River, the trail followed what is now Main Street southward and up the slope onto the prominent hill, where the Liberty Memorial now resides (Fig. 18-10). No physical traces of the original trail remain in this heavily urban setting.

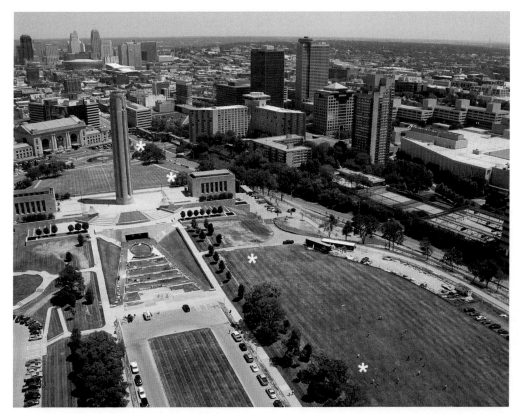

Fig. 18-10 Looking northward from the Liberty Memorial toward the downtown skyline, Kansas City, Missouri. Approximate position of the Santa Fe Trail marked by asterisks (*) according to Franzwa (1989, map 11). Helium-blimp photograph with a compact digital camera.

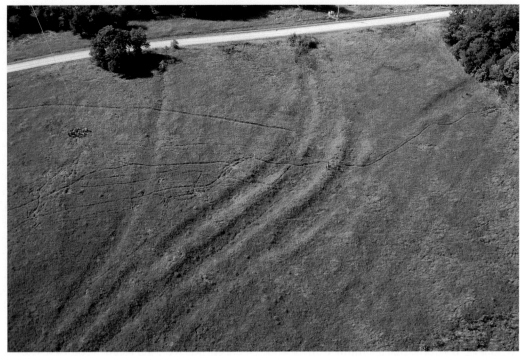

Fig. 18-11 Santa Fe Trail ruts at Ivan Boyd Prairie Preserve, northeastern Kansas are among the best ruts still existing along the entire route. Ruts are emphasized by afternoon shadows and autumn vegetation. Narrow foot paths cross the ruts; kite flyers to upper left. Taken with a compact digital camera.

Northeastern, Kansas—Distinct, multiple trail ruts are visible in the Ivan Boyd Prairie Preserve about three miles (~4 km) east of Baldwin City in Douglas County. When in use, these tracks became muddy at times and eroded into deep ruts that represent the passage of hundreds of wagons and thousands of animals. As a particular track became too deep or impassable, wagons switched to adjacent paths, and the process was repeated. At this location the trail descends across a sloping hillside underlain by easily eroded shale and sandstone. At least seven deep ruts are present along with several shallow ruts (Fig. 18-11). This was the site of a Border War skirmish in 1856, known as the Battle of Black Jack, which was a precursor to the Civil War.

Southwestern, Kansas—Fort Dodge was established in southwestern Kansas in 1865 at the close of the Civil War. Its primary function was to protect the Santa Fe Trail from Indian attacks, which had closed postal service and greatly reduced traffic by 1864 (Fort Dodge 2014). In this vicinity, travelers had to choose between the Cimarron (dry) Route and the Mountain (wet) Route. The former was shorter and more direct to Santa Fe, but often suffered water shortages across the semiarid High Plains. The latter followed the Arkansas River valley upstream, then crossed the mountains at Raton Pass, a longer and more arduous path, but with better water supplies.

The military need to protect the Santa Fe Trail lasted less than two decades, and Fort Dodge was closed in 1882. It now serves as the Kansas Soldier's Home, a veteran's retirement and nursing facility (Fig. 18-12). The Cimarron Route continued upstream along the Cimarron River valley toward the southwest. Then, as now, the river channel often dried up, and wagon trains had to depend on widely spaced springs (Fig. 18-13).

Bent's New Fort, Colorado—The fort is situated on a sandstone bluff next to the Arkansas River along the Santa Fe Trail Mountain Route about eight miles (~13 km) west of Lamar, Colorado. The fort was built in 1853 by William W. Bent as an Indian trading post. It was then sold to the US government in 1859. The following year additional buildings were erected one mile to the west, and named Fort Wise, and then renamed Fort Lyon in 1861. The latter was relocated still farther west in 1867. Thus, Bent's New Fort was active for little more than a decade. Fort walls were constructed of sandstone and adobe, which have collapsed into low ridges and mounds (Fig. 18-14), but little else remains of the fort today.

18-4 CEMETERIES—UNITED STATES AND DENMARK

Nearly every inhabited place has some type of burial ground, cemetery, or sacred site for placing human bodies or cremated remains. Such places range from the monumental Egyptian pyramids to simple holes in the ground with wooden markers. SFAP may be utilized for site surveys and detailed mapping of above-ground

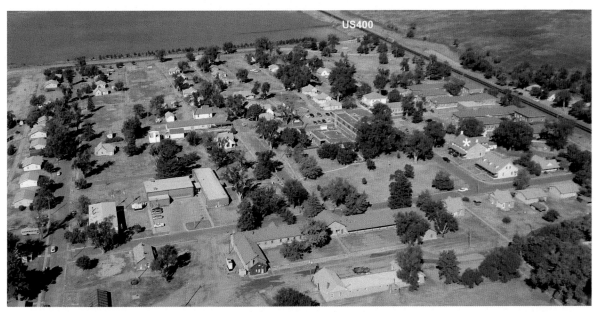

Fig. 18-12 Overview of Fort Dodge, Kansas. The parade ground is the open space just right of scene center, and many original stone buildings are preserved including Custer House (*). The Santa Fe Trail followed the modern highway (US400) next to the fort (right side). Helium-blimp photograph with a compact digital camera.

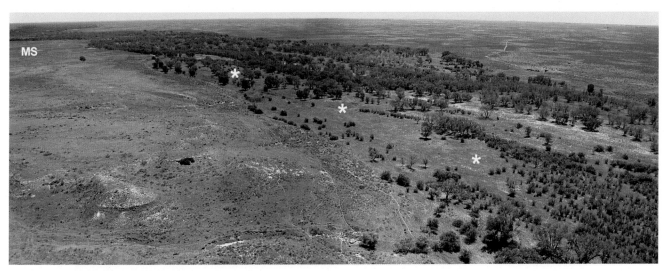

Fig. 18-13 Panoramic view above Point of Rocks, Morton County, southwestern corner of Kansas. Looking northeast toward Middle Spring (MS) in the left distance. Dry valley of the Cimarron River supports a corridor of trees nowadays. Approximate position of the Santa Fe Trail marked by asterisks (*) according to Franzwa (1989, map 58). Kite photograph with a compact digital camera by SWA with P. and J. Johnston.

structures. Furthermore SFAP may reveal subtle variations in soil, vegetation, and microtopography that could indicate unmarked graves or other long-lost archaeologic traces.

In general, non-powered and tethered platforms, such as kites, balloons, and blimps, are preferred to maintain quiet SFAP operation over cemeteries. Conversely UAS and other powered aircraft generate noise and movement that could be quite distracting for visitors. In regard to military cemeteries, Bieck (2016) stated, *kite aerial photography is silent and therefore a suitable method to document these places while preserving the dignity of the surroundings* (p. 26).

Traditional Christian graves in American cemeteries are oriented approximately east-west with the feet to the east, head to the west, and grave marker at the western end (Fig. 18-15). Where this is not possible, the north-south position is acceptable with the head laid to the north and turned eastward (Smoot 2002). American military cemeteries often deviate from this scheme, however, with alignments in different directions, curved rows, or circular plans. According to current design specifications,

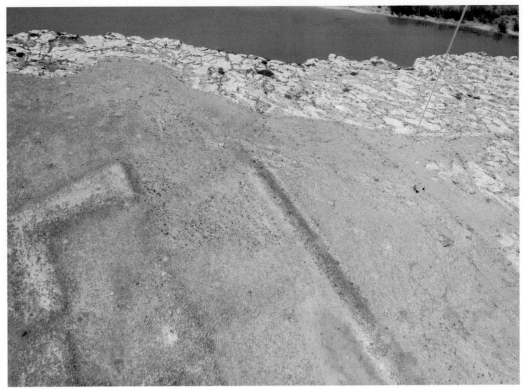

Fig. 18-14 Remains of Bent's New Fort near Lamar, Colorado. Walls and building foundations are clearly visible at scene center and to left. Sandstone bluff and Arkansas River appear across the top of view, and kite flyers are standing to right side. Taken with a compact digital camera.

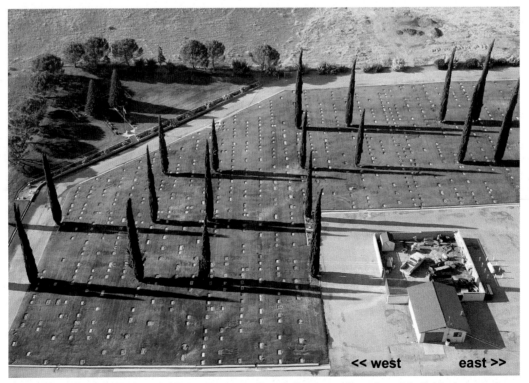

Fig. 18-15 Portion of cemetery at Tehachapi, California. Rows are aligned directly north-south, and individual graves face east. Headstones are placed at the western ends flush with the ground to allow easy mowing. Green vegetation is maintained by irrigation in this semiarid climate. Kite photograph with a compact digital camera.

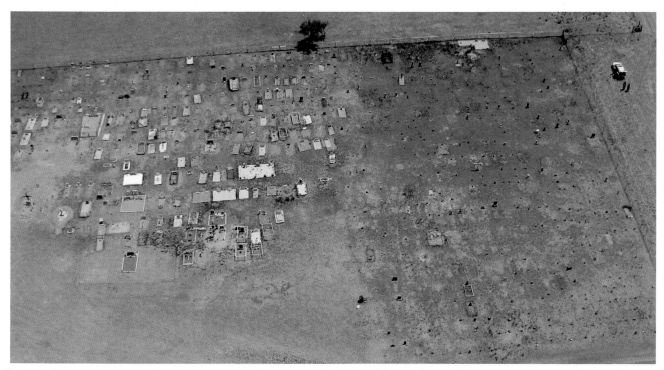

Fig. 18-16 Looking southward over Carnero Creek Cemetery at La Garita, Colorado. Vegetation is sparse in the arid climate of the San Luis Valley at about 7800 ft (~2375 m) altitude. The potter's field is the nearly barren rectangle on the west (right). Some graves possess carved stones or crosses, but many graves are marked simply by a natural stone or not marked at all. Light tan patches indicate grave positions where the soil has been disturbed. Kite flyers in upper right corner; taken with a compact digital camera.

topography of the cemetery site is *the primary factor in determining the direction graves face within a burial section* of a US National Cemetery (Siegel and Holbrook 1999, p. 19).

Many cemeteries include a so-called potter's field, which is used to bury strangers, paupers, and unidentified or unclaimed bodies. Interments in potter's fields are often poorly marked, if at all. A good example of this is the cemetery at La Garita, Saguache County, Colorado. La Garita was established by Spanish settlers in 1858; the Catholic San Juan Baptiste Church (La Capilla de San Juan Bautista) and the adjacent Carnero Creek Cemetery are located just west of the present village of La Garita. The cemetery displays a clear division between the potter's field on the western side and more-affluent and more-elaborate graves on the east (Fig. 18-16). Burial plots in the Carnero Creek Cemetery are arranged in rows that trend east-west, and individual graves are aligned north-south with headstones at the southern ends.

18-4.1 Kansas Cemeteries

Many Kansas cities have public cemeteries of substantial size. A trend in recent years is to privatize these cemeteries, and for the private owners to sell off excess land for development purposes. This is relatively straightforward for those portions of the cemetery with well-marked graves. However, some older portions of

the cemetery may be poorly marked and have few or no records of early burials from the 19th century. Original wooden markers are long gone to rot or prairie fires. Such was the case for one mid-sized town in eastern Kansas at the beginning of the 21st century.

Kite aerial photography was undertaken along with several geophysical methods to identify unmarked graves (Wilson-Agin 2003). The shallow subsurface geophysical methods were generally ambiguous for finding unmarked graves in clay-rich soil. SFAP, on the other hand, clearly showed unmarked graves on the basis of vegetation differences (Fig. 18-17). Early spring, when cool-season grass begins to green up, was most effective for revealing these subtle differences.

One portion of the cemetery was designated to sell for a housing development. This portion had a few marked graves, but suspected unmarked graves also were visible (Fig. 18-18). In spite of the potential for unmarked graves, the sale went forward. Prior to construction, the marked graves were removed, but nothing was done about presumed unmarked graves. During initial excavation and dirt work for the housing complex, fragments of possible human bone were discovered; nonetheless, construction continued and was completed (Fig. 18-19).

A cemetery was opened next to Fort Dodge soon after it was established in 1865 (see above). Both civilians and post personnel are buried in this cemetery. Its most

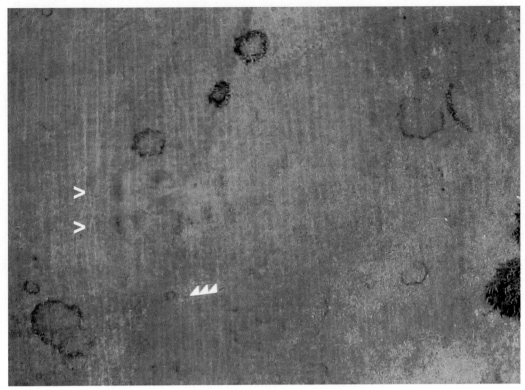

Fig. 18-17 Near-vertical view over a former potter's field. Two rows of unmarked graves are clearly visible (>) on account of slightly greener grass in this early spring image. Individual graves are approximately 1 by 2 m with the long axis oriented east-west. North arrow is 4 m long; dark green circles are fairy rings in the grass. Kite photograph with a compact digital camera by JSA and SWA with E. Wilson-Agin.

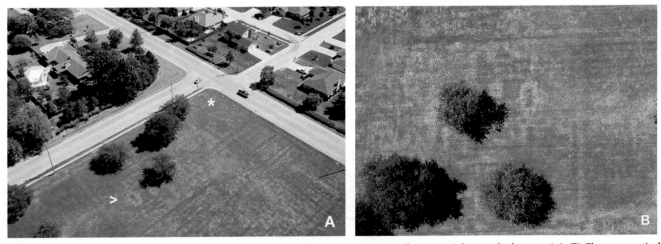

Fig. 18-18 (A) Cemetery in foreground had a few marked graves in the corner (*) as well as potential unmarked graves (>). (B) Close-up vertical shot with suspected unmarked graves near scene center. Kite photographs with a compact digital camera.

famous resident is Edward Masterson, older brother of Bat Masterson (Fort Dodge 2014). Bat was the county sheriff and Edward the city marshal in 1878, when Edward was shot and killed by a drunken gunfighter. Over the decades, the original cemetery filled up, and a new Kansas Veterans Cemetery was opened 2002 (Fig. 18-20). The veterans cemetery at Fort Dodge is one of four in the state (KCVAO 2016).

The older and newer portions of the cemetery display marked differences in plot layout and grave styles. In the older portion, graves are arranged in rows running north-south, individual graves extend east-west, and headstones are at the western ends in typical Christian fashion (Fig. 18-21). Furthermore headstones vary in size, shape, and type of stone, and some graves may not be marked. Turf has considerable variation and patchiness.

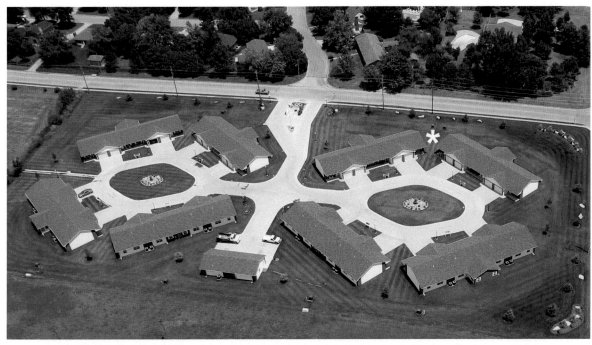

Fig. 18-19 Completed housing project in one portion of the former cemetery. Location of probable unmarked graves (*) that were not removed prior to construction. Kite photograph with a compact digital camera.

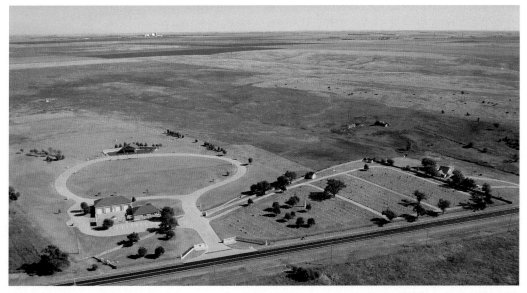

Fig. 18-20 Overview of Kansas Veterans Cemetery next to Fort Dodge; older portion to right, newer part to left. Helium-blimp photograph with a compact digital camera.

The newer portion, in contrast, displays a high degree of uniformity (Fig. 18-22). Gravestones are precisely spaced along straight rows that follow level contours across the sloping site. All stones are light-gray granite, identical in size and shape, and positioned at the southern ends of grave sites. The turf is likewise more consistent in surface coverage.

An extensive colony of prairie dogs, known as a town, occupies the area immediately north of the Kansas Veterans Cemetery (Fig. 18-23). Black-tailed prairie dogs (*Cynomys ludovicianus*) may establish large towns that cover 100s to 1000s of km^2 (EOL Prairie Dog 2017). Preliminary SFAP survey indicated that prairie dogs had expanded the coverage of their town, and their burrows were encroaching on the cemetery ground, which would require continued monitoring and control to prevent further spread of the prairie dog town (Fig. 18-24).

Fig. 18-21 Vertical shot over the older portion of the Kansas Veterans Cemetery. Rows run N-S, and individual graves are oriented E-W. Note variety of headstones. Kite photograph with a compact digital camera.

Fig. 18-22 Newer portion of the Kansas Veterans Cemetery looking westward. In the central portion, rows trend ~120°–300° (SE-NW); rows on the far western side run due east-west. Administrative and maintenance buildings upper left. Kite photograph with a compact digital camera.

18-4.2 Danish Village Cemeteries

Christianity came to Denmark in 826 CE, and the Lutheran Reformation was introduced with little conflict in 1536 (Thodberg 1974). The first churches were wood, but none have survived. Most Danish village churches were constructed in stone in the 12th century beginning with the nave, choir, and apse. Other architectural elements were added later, sometimes in stone or brick, including a Gothic tower and entry ways. The long axis of

Fig. 18-23 View northward from the Kansas Veterans Cemetery showing a large prairie-dog town. Each light-tan patch represents a burrow opening (½ to 1 m in diameter). Kite photograph with a compact digital camera.

Fig. 18-24 Light-tan patches in lower portion of view indicate prairie dog burrows in the field adjacent to the new section of the Kansas Veterans Cemetery. Kite photograph with a compact digital camera.

the church is always oriented east-west, with the choir and apse to the east, nave in the center, and tower to the west.

Gammelsogn Kirke (old parish church) is a good example of this arrangement. The church dates from the 1170s, when the Roman nave and choir were built of dressed field stones. The interior of the church displays frescos from that time. The Gothic tower and entry house were added later in brick. The church stands beside a tiny beach on Ringkøbing Fjord, a large lagoon in western Jutland near the North Sea coast (Fig. 18-25). The beach was used for landing small boats by local residents until 1869, when a new church was built nearby.

Danish Lutheran cemeteries or churchyards (kirkegård) are not restricted by religion, although special sections may be established for non-Christian burials (e.g. Jewish or Muslim). However, space is limited, and the practice of reusing graves has developed (Family Search 2016). Generally bodies are buried for two decades and cremated remains (urns) for one decade. While the family remains actively involved, plots are maintained in meticulously pristine conditions. After the allotted time, the remains and gravestones are removed and the plots used for other burials, unless the family has made special arrangements to keep up the plots. Gravestones are typically stored nearby for remembrance and genealogy purposes (Fig. 18-26).

Mårup Kirke was a small and unremarkable rural church on the Danish North Sea verge (Fig. 18-27). Built in the first half of the 1200s, Mårup Kirke was a simple brick structure that spanned the transition from late Roman to early Gothic styles. In 1808 an English ship, the *Crescent*, wrecked nearby, and the ship's anchor was later brought to the church. North Sea coastal cliffs stand 10s of meters high and are composed of unconsolidated sediments left by the last glaciation of the region. The historic rate of cliff retreat is on the order of 1 meter per year (Aber et al. 2012).

Coastal erosion during the centuries had brought the cliff perilously close to the church, and it was closed in 1926. For many decades, the church remained a historical monument. By 2005, coastal erosion already had begun to carve into the surrounding cemetery (Fig. 18-27) and at other sites along the Danish coast. When an endeavor for coastal protection failed, the church was gradually dismantled by the authorities between 2008 and 2015

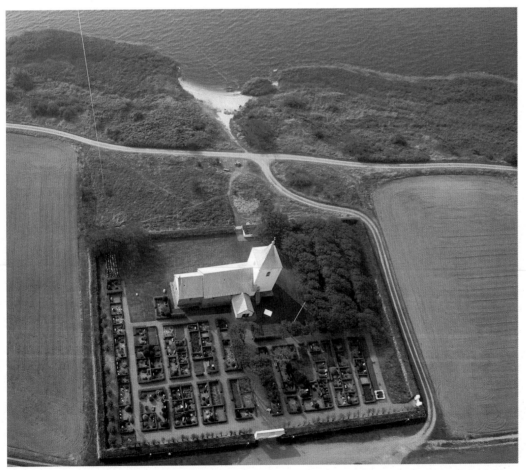

Fig. 18-25 Gammelsogn Kirke (old parish church) looking south toward Ringkøbing Fjord, western Denmark. Church building is oriented east-west; choir to east (left) and tower to west (right) with adjacent cemetery. Kite flyers in upper left portion; taken with a compact digital camera.

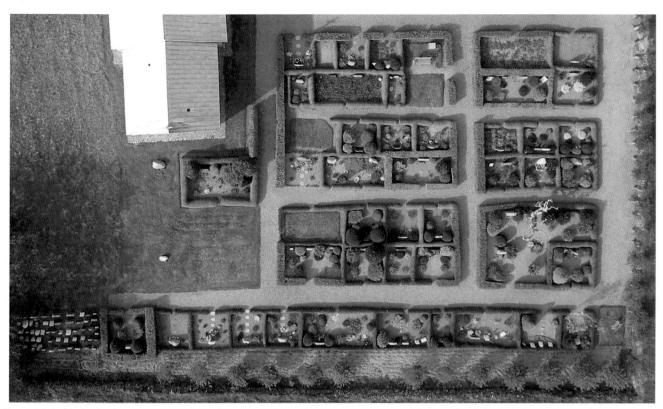

Fig. 18-26 Close-up vertical shot of cemetery at Gammelsogn Kirke. Family plots are enclosed by small hedges and carefully landscaped. Note older, removed headstones stored in lower left corner. Kite photograph with a compact digital camera.

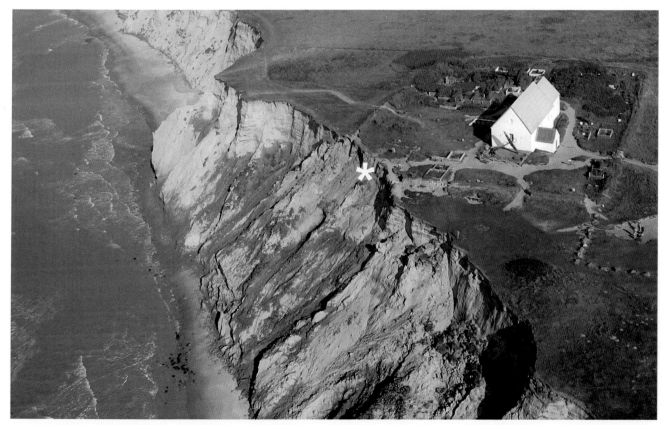

Fig. 18-27 Close-up low-oblique view of Mårup Kirke and the North Sea coast, northwestern Denmark. Note the anchor in front of the church. Rapid cliff erosion is cutting into the site and already had removed a corner of the cemetery (*) at the time this kite photograph was taken in 2005 with a compact digital camera. By 2016, more than half of the cemetery and the original site of the now-dismantled church had been lost to the sea.

Fig. 18-28 Coastal cliff erosion has exposed a grave and pair of human leg bones. Approximate cross section of grave outlined in black. Near Lønstrup, northwestern Denmark.

and its parts put into storage for possible later reconstruction elsewhere. However, in most other places, the debate about what to do has been settled in Denmark that nature should run its course, and human remains are returning to the sea (Fig. 18-28).

18-5 SUMMARY

Small-format aerial photography has worthwhile applications for many aspects of architecture, archaeology, and cemeteries. Primary advantages include low-height, large-scale images that depict structural features, soil conditions, and vegetation cover in great detail. Oblique shots provide unusual viewing angles and portray sites in relation to their surroundings. Vertical views may be acquired for accurate survey, mapping, and 3D reconstruction purposes, for which high spatial resolution is necessary. SFAP could be the only feasible means to position a camera close to a high monument or tall building for aerial inspection.

The ability to rephotograph sites periodically during construction, renovation, or excavation adds an important temporal dimension often lacking from conventional aerial photography. For buried features, seasonal vegetation growth and shadows from low-sun angle may reveal subtle surface expression. Unmanned tethered platforms—kite, balloon or blimp—are recommended for cemeteries as the most respectful means to conduct SFAP in somber circumstances.

19

Recreational Property

19-1 OVERVIEW

Outdoor recreational activities and sports take up an increasing amount of time and human effort, particularly in more affluent countries as well as countries that cater to tourism. From a day at the beach to skydiving, recreation involves various types of land use including private property and public spaces. These sites range from more-or-less natural environments to highly altered landscapes. Some places may be open to the public to conduct a wide variety of activities, such as Bureau of Land Management sites in the western United States. Other places may be highly restricted and require permission, entrance fees, special training, limited seasons, etc. In nearly all cases, some type of management system is in place to control the types of activities that are allowed and to provide for maintenance of the sites.

Among the more popular outdoor sports are golf and water-based activities, such as swimming, sailing, and fishing. Two examples of golf—traditional and disc— are presented below as well as property management at a recreational lake. Small-format aerial photography provides for detailed site assessment as well as general overviews of site layout and property conditions.

19-2 TRADITIONAL GOLF COURSES

Traditional (ball) golf course management is a sizable recreational industry worldwide. Demand depends upon demographics and population growth tempered by economic conditions that influence disposable income and leisure time. In many developing countries, building golf courses is done to increase tourism and enhance local economies, which is the case in central and eastern Europe (Fig. 19-1).

Golf courses represent a type of landscape architecture in which the topography, soils, drainage, and vegetation are altered, sometimes greatly, from natural conditions. In many situations, the maintenance of turf requires substantial use of fertilizers, herbicides, and pesticides, as well as frequent irrigation, mowing, and soil treatments. These practices may have deleterious side effects, and many golf courses are attempting to minimize their environmental impacts nowadays.

SFAP is a tool for managers to visualize and evaluate the conditions of the golf course and consequences of management practices. For example, managers could use these photographs to monitor fairway species encroachment, measure the degree of shading from trees, evaluate irrigation systems, visualize golf-cart traffic patterns, or track changes to green dimensions caused by mowing patterns. The following example demonstrates the potential of SFAP for analysis of turf and irrigation conditions in the semiarid climate of southwestern Kansas, United States.

The Southwind Country Club is located about 3 km (2 miles) south of Garden City, Kansas. Renamed the The Golf Club at Southwind in 2009, the course has 18 holes, is 6920 yards (~6330 m) long at par 71, and hosts championship tournaments at all levels (Southwind 2017). The supply of irrigation water is limited by water-rights appropriation. The country club includes suburban housing around the golf course (Fig. 19-2). The housing division and golf course each have a high-capacity water well, tapping the High Plains aquifer. In an attempt to evaluate the effectiveness of irrigation on the golf course, color-infrared kite aerial photography was conducted to show cool-season turf at its peak growth stage in the spring (Aber et al. 2003).

The golf course is constructed on rolling sand hills terrain, and the native vegetation is sand-sage prairie. The irrigated bentgrass (*Agrostis palustris*) fairways and bluegrass (*Poa pratensis)* roughs contrast sharply with dry sand-sage prairie in color-infrared photographs (Fig. 19-3). The irrigation plan consists of overlapping water circles along the fairways. Color-infrared images demonstrated clearly that water circles extend beyond the fairways into the adjacent sand-sage prairie in many places. A test plot (30 by 30 m) was established to examine the effectiveness of different soil treatments to deal with winterkill of fairway grass.

A vertical color-infrared photograph of the test plot early in the growing season revealed the degree

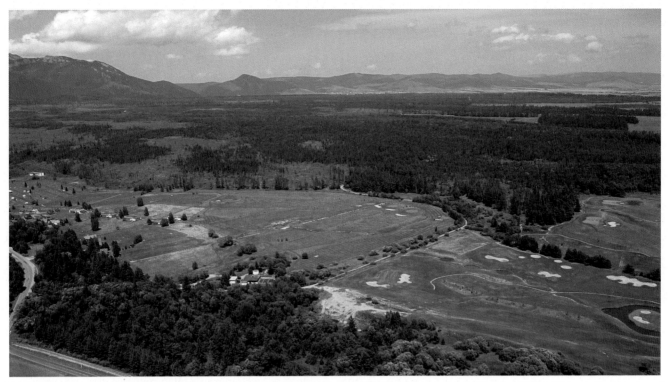

Fig. 19-1 Golf course near the Tatry Mountains in Slovakia at Stará Lesná. Part of a touristic complex of hotels, ski lifts, hiking trails, bicycle and roller-blade trails, sport camps, and other recreational activities based on the scenic beauty and clean environment of the Tatry Mountains. Kite photo taken with a compact digital camera by JSA and SWA with J. Janočko and B. Fricovsky.

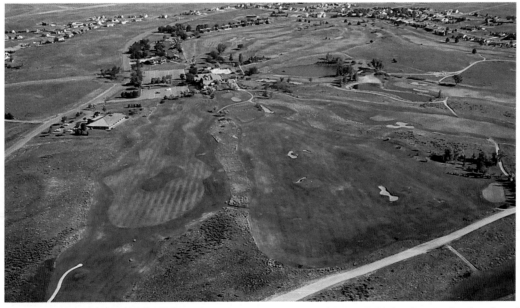

Fig. 19-2 Overview of The Golf Club at Southwind, near Garden City, Kansas, United States. Suburban housing borders the golf course, upper left and right. Kite photo taken with a compact digital camera.

of winterkill that occurred during the prior winter (Fig. 19-4). It also showed darker-colored turf that is related to encroachment of mixed bluegrass and rye-grass (*Lolium perenne*) species. Various combinations of these grasses were overseeded in previous years to provide quick cover following winterkill. Analysis of the study plot image showed that 86% was bentgrass, 11% was a blue/ryegrass combination, and 3% was winterkilled (Fig. 19-5).

The Golf Club at Southwind appears to be facing financial difficulties amid staff layoffs, temporary closing, and changes in management (Marshall 2017). This is

Fig. 19-3 Color-infrared image of the 15th and 17th fairways at The Golf Club at Southwind. Bright pink and red indicate photosynthetically active, irrigated vegetation of the golf course. Some irrigation water has enhanced growth of the sand-sage prairie adjacent to the fairways (A). Blue patches in the fairways (B) indicate zones with weak grass. Kite flyers are standing left of scene center. Image acquired with an analog SLR camera and a yellow filter (Aber et al. 2003, Fig. 4).

Fig. 19-4 Vertical, color-infrared image of test plot on fairway 14 at The Golf Club at Southwind. Large aerial targets are 5 by 5 feet (1½ by 1½ m) square. Small dots indicate grid cells. Pink turf is healthy bentgrass; darker red is encroaching blue/ryegrass mixture (bottom center); gray-white indicates weak or dead turf. Person standing to left. Kite photo acquired with an analog SLR camera and a yellow filter (Aber et al. 2003, Fig. 5).

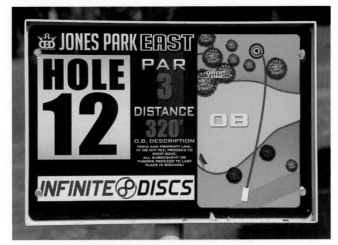

Fig. 19-6 Sign giving information for hole 12 on the Jones Park East disc golf course in Emporia, Kansas, United States. OB = out of bounds.

Fig. 19-5 Reclassified image of the vertical color-infrared airphoto showing the 30×30 m test plot, in which bentgrass (gray), blue/rye-grass (black) encroachment, and winterkilled turf (white) are delineated and quantified. Compare with previous figure. *From Aber et al. (2003, Fig. 6).*

symptomatic of traditional golf across the United States, which currently has less than 15,000 courses (WAG 2018). More than 800 courses have closed during the past decade, however, and many of these abandoned courses have been converted into housing developments (Jacobs 2018). Meanwhile, disc golf is rapidly gaining in popularity in the United States and elsewhere around the world.

19-3 DISC GOLF COURSES

Disc golf, also known as *Frisbee* golf, is similar to traditional (ball) golf. Courses typically have nine or 18 holes, and the disc is thrown from a tee pad toward a basket that represents the hole (Fig. 19-6). Ed Headrick is considered the Father of Disc Golf (PDGA 2016). In 1966, he invented the *Frisbee*, which evolved into modern discs; he patented the *Disc Golf Pole Hole* in 1975, and he founded the Professional Disc Golf Association (PDGA) in 1976. From then, disc golf grew rapidly and spread across the United States and Canada and eventually to many other countries.

As of 2017, PDGA had more than 40,000 active members and sanctioned more than 3500 tournaments around the world that year (PDGA Demographics 2018). Most disc golf courses are in the United States (>5800). Finland is second with more than 460 courses and a population of just 5.5 million (Central Intelligence Agency 2018), giving it the highest per-capita number of disc golf courses. Altogether,

some 8–12 million people have played disc golf, and about two million play on a regular basis.

Disc Golf Pro Tour (2016) predicted that disc golf courses would surpass traditional courses during the coming decade. The growing popularity of disc golf is based on several factors; less land, and less course maintenance are required. Existing public parks, school grounds, and traditional golf courses are often sites for developing disc golf courses. In addition, disc golf is easier to learn, less expensive, quicker to play, and it appeals to a younger demographic than does traditional golf.

Small UAS have been used to collect low-level video of disc golf games in progress and follow discs in flight, as demonstrated on YouTube (e.g. Nelson 2015; Jomez 2016). UAS video also provides aerial tours of disc golf courses (e.g. Cooper 2013a,b). These tours typically are flown at the disc level in order to follow paths through trees, over ponds, and around other obstacles with annotation about hole number, length, and par. Such visual information is especially valuable for those playing a course for the first time. Note: under current US FAA rules, such drone flights could be conducted only with permission.

The cities of Emporia and Olpe in Lyon County, Kansas have emerged as a disc golf destination and have hosted several major tournaments in recent years including the 2016 PDGA World Championships. In April 2018, the Glass Blown Open was the largest disc golf tournament in history with more than 1600 players (Hill 2018). Lyon County has nine disc golf courses with a county population of just ~33,500 (US Census 2016). This dense concentration of courses is explained in part by Eric McCabe, local resident, who designed several of the courses and was the 2010 PDGA World Champion. He was joined by Paige Bjerkaas, another Emporia resident, who won the 2018 PDGA Women's World Championship (Sherwood 2018). Still another factor is the local founding of *Dynamic Discs* in 2005, which has grown rapidly

to become a major supplier of disc golf equipment and sponsor of tournaments (Dynamic Discs 2018).

Disc golf courses are rated on a scale 0–5 with 5 = best of the best (DGCourseReview 2018). Following are brief reviews and SFAP imagery of four 18-hole disc golf courses with high ratings from the Emporia-Olpe vicinity. Such imagery taken from 50 to 150 m above the ground is useful for golfers to preview course layout and playing conditions.

Peter Pan Park, Emporia—The Peter Pan Park–Optimist DGC is located in a public park on the flood-plain adjacent to the Cottonwood River. It is 6006 feet (~1830 m) long, par 57, and rated 3.8 (very good). It is described as *short and technical* (DGCourseReview 2018). Landscape is relatively flat, but numerous trees present obstacles. Water is a factor for up to eight holes; many discs are lost while playing around the pond, and one hole is a peninsula shot (Fig. 19-7).

Jones Park, Emporia—Jones Park is another public site situated on hilly upland terrain. It hosts two disc golf courses—west and east (Fig. 19-8). The Jones Park East course is 6665 to 8044 feet (~2030–2450 m)

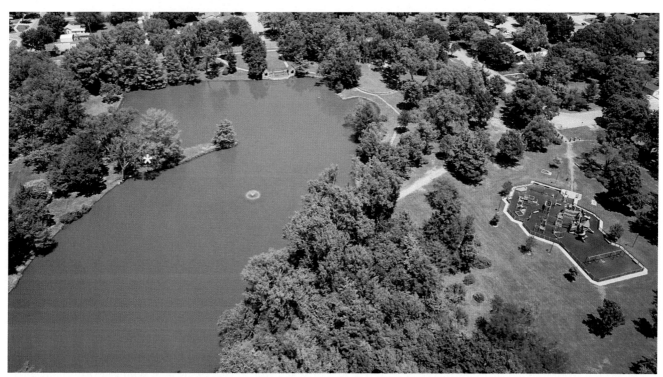

Fig. 19-7 Portion of the Peter Pan Park–Optimist DGC including a playground and sizable pond. One hole is located on the peninsula surrounded by trees (*). Kite photo taken with an MILC by JSA with T. Nagasako.

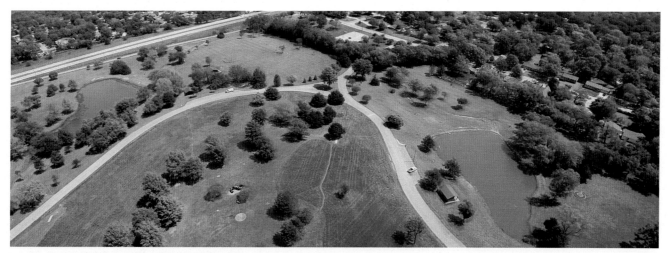

Fig. 19-8 Panoramic overview of Jones Park East disc golf course. Ponds, roads, and tall grass are OB (out of bounds) areas. Hole 12 on right side (see next figure). Assembled from two wide-angle kite photos taken with a compact digital camera by JSA with T. Nagasako.

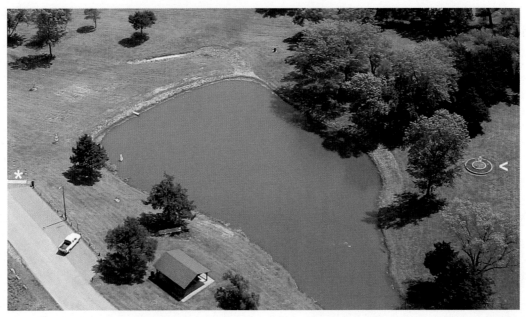

Fig. 19-9 Close-up shot of Jones Park East hole 12. Tee pad on left (*), pond in center, and raised hole designed by Eric McCabe on right (<). See Fig. 19-6 for signage. Kite photo taken with a compact digital camera by JSA with T. Nagasako.

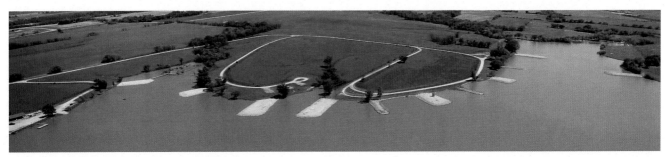

Fig. 19-10 Panoramic overview of the southern portion of the Eagle Disc Golf Course, Olpe, Kansas, United States. Many holes are located on fishing piers that form peninsulas around the lake margin. Note the open aspect of the surrounding prairie landscape. Assembled from two wide-angle kite photos taken with a compact digital camera by JSA with T. Nagasako.

long, par 62, and rated 4.0 (excellent). The east course is especially known for long fairways (DGCourseReview 2018). The Jones Park West course is 5354 to 6637 feet (~1630–2020 m) long, par 55, and rated 4.2 (excellent). Both courses have scattered trees and holes that involve shots over small ponds (Fig. 19-9).

Eagle Disc Golf Course, Olpe—This course surrounds a rural lake in an upland prairie setting. There are few trees, and the site may be quite windy. The course is 8130 to 8395 feet (~2480–2560 m) long, par 62–63, and rated = 4.3 (excellent). The Eagle DGC is described as a *championship caliber course … long and challenging, especially when it's windy* (DGCourseReview 2018). Many shots are over water, and many holes are located on islands or peninsulas (Fig. 19-10).

19-4 LAKE KAHOLA, KANSAS

Lake Kahola is a relatively small, man-made reservoir located in the Flint Hills of east-central Kansas (Fig. 19-11).

It was built in the 1930s as a water-supply lake for the nearby city of Emporia, and the lake surroundings were developed as a park with recreational cabins and homes. The building lots were leased from the city under a long-term arrangement with the Kahola Park Cabin Owners Association. Early in the 21st century, however, the city began the complex legal process of selling the lake and land to the cabin owners association. This sale was completed in 2007, when the renamed Kahola Homeowners Association (KHA) took ownership of the lake and surrounding property.

Over the years, development of cabin sites at Lake Kahola had proceeded in a somewhat piecemeal manner, which was aggravated by the lack of original survey markers. The existing plat of lease lots was a schematic blueprint chart of unknown age, which was not a legally valid survey (Fig. 19-12). This problem was exacerbated over the years by the construction of increasingly large recreational homes and numerous garages, boathouses, docks, and other structures. Two issues were of primary concern: (1) wise management for future development, and (2) arbitration of disputes between adjacent

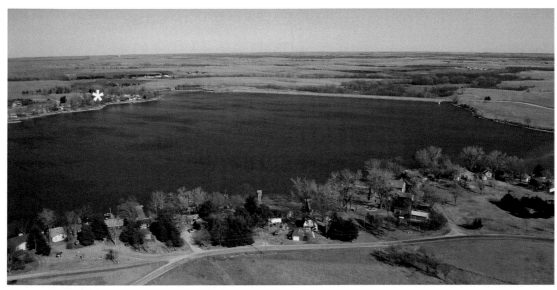

Fig. 19-11 Overview of the eastern portion of Lake Kahola with the dam and spillway on the far side. Deciduous trees are bare and grass is dormant in this winter scene. Numerous cabins and houses are visible around the perimeter of the lake. The area depicted in the next figure is marked (*). Kite photo taken with a compact digital camera.

Fig. 19-12 Portion of existing property chart for northeastern part of Lake Kahola, Kansas. Size and shape of building lots are idealized and do not correspond to actual lot dimensions. *Based on a blueprint of unknown age (Aber and Aber 2003, Fig. 2).*

lot owners. In such densely developed situations, a few inches (cm) are sometimes critical for accurate planning and construction purposes.

Recognizing these issues, the cabin owners association began an effort to place permanent survey markers at the corners of all building lots in the park. To supplement the ground-based survey markers and lot measurements, large-scale airphotos were selected as the tool for documenting lake-shore development and lot boundaries. Vertical kite aerial photography was conducted during the winter, leaf-off period in order to obtain views with minimal obstruction from trees (Aber and Aber 2003). This approach proved to be the most cost-effective means to acquire imagery with sufficiently high spatial resolution for property management applications at Lake Kahola.

Conducting vertical photography around an irregular shoreline proved challenging, especially in regard to numerous power lines, roads, fences, and trees in vicinity of the buildings. Furthermore, images had to be acquired without snow cover so that survey markers could be located. These requirements limited the number of suitable days in which field work could be conducted.

Lot boundary markers were identified with additional ground survey, and these markers were annotated on the images as well (Fig. 19-13). Relating ground survey markers to the airphotos was straightforward in most cases, except where long winter shadows fell across features in the images. Individual images were arranged in sequence to provide complete coverage of all buildings and lot boundaries around the lake, and sets of overlapping images were mosaicked together. The images were assembled in webpage format on a compact disk (CD) so that users may easily select images for visual display or paper printout.

The KHA is able to access the images quickly to evaluate architectural plans, building permits, and property changes. The images in this database could be updated periodically to add new annotation as needed, for example locations of water wells, propane tanks, sanitary holding tanks, etc. In the years since the airphotos were acquired, many changes have appeared in connection with construction of new houses, retaining walls, parking areas, sheds, garages, decks, etc. The caretaker has referenced these aerial images countless times for property management issues.

19-5 SUMMARY

Traditional golf is popular around the world, and golf courses represent substantial human alterations of the natural environment. SFAP is especially useful for golf-course managers to visualize and evaluate the

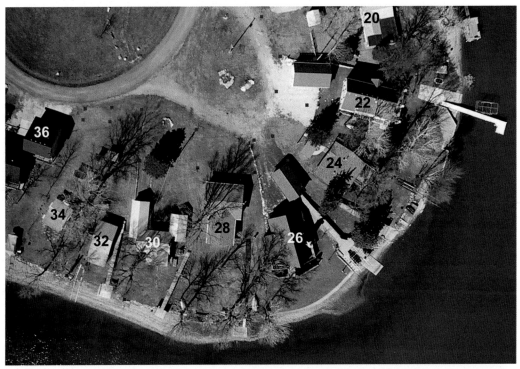

Fig. 19-13 Vertical kite aerial photograph showing a portion of northeastern Lake Kahola. The image is annotated with lot numbers and survey markers (red). Features as small as 15 cm, the size of survey markers, may be identified in the original image. Note long tree shadows. North toward top; compare with right side of chart in previous figure. Kite photo taken with a compact digital camera. *Based on Aber and Aber (2003, Fig. 3).*

effectiveness and impacts of their practices. Low-height, large-scale images, particularly color-infrared photographs, depict vegetation conditions related to irrigation, mowing, and applications of fertilizer, herbicides, pesticides, and other treatments. This type of detailed information is valuable for managers to improve their methods in order to maintain viable golf courses and to achieve minimal environmental impacts.

Disc golf is gaining in popularity rapidly as courses require less land and maintenance; it is easier to learn, less expensive, quicker to play, and it appeals to a younger demographic than does traditional golf. Small UAS video has been utilized to display disc golf players in action. UAS also provides fly-through video of disc golf courses, although under current FAA rules, such drone flights could be conducted only with permission. SFAP from a higher vantage (50–150 m above the ground) is useful for golfers to preview course layout and playing conditions.

Highly detailed ground survey information may be necessary for management of some recreational properties, such as individual lots around Lake Kahola, Kansas. High-resolution vertical SFAP was the basis for creating an aerial survey of cabins, houses, and other structures around the lake. Lot numbers and survey markers were annotated on the images, which have proven quite useful for the lake caretaker to deal with property management issues.

20

Wind Energy

20-1 INTRODUCTION AND ISSUES

The generation of electricity from wind energy has grown phenomenally during the past two decades. In 2000, the global wind-power capacity was just 2000 MW (megawatts); capacity already exceeded 100 GW (gigawatts) by 2008 and represented 1% of total electricity worldwide (Musgrove 2010). As of the end of 2017, total global installed generating capacity had reached nearly 540 GW (World Wind Energy Association 2018). Most development of wind energy has taken place in Asia, Europe, and North America; the top five countries for installed capacity include China, the United States, Germany, India, and Spain, which together accounted for >70% of the total.

Wind energy represents a relatively safe and environmentally friendly means to generate electricity that is not dependent on foreign sources or volatile fuel costs and that does not emit greenhouse gases. Thus, wind farms have proliferated with dozens to hundreds of large turbines both on land and on the shallow sea floor. In spite of this rapid development, wind farms have some negative consequences primarily for wildlife as well as human health (noise) and aesthetic issues (visibility). This brings up the concept of the windscape, which is *the combination of local climate and geography, environmental and ecological conditions, mix of public policies, and human land use and infrastructure associated with harnessing wind power* (Aber et al. 2015, p. viii).

Evaluation of potential sites and analysis of existing wind farms take place at all scales, resolutions, and heights. In this context, small-format aerial photography fills a key niche linking the ground-based view with conventional aerial and space-based imagery (Chorier 2018b). SFAP provides a means to portray windscape conditions from a vantage, scale, and resolution that are readily perceived and understood by most people and, thus, could be used to inform the public as well as depict technical issues connected with wind-energy development.

General SFAP conditions include the ability to operate within wind farms, between and close to working wind turbines, at hub height (80–100 m), amid swirling air flow. Ultralights or other manned platforms would be especially risky in these circumstances, as would small UAS (drones). Tethered platforms allow better control and safety, and we have utilized kite aerial photography in particular to cope with often turbulent conditions in wind farms. The following examples demonstrate kite aerial photography in Denmark, Poland, and Kansas, United States (based on Aber et al. 2015).

20-2 DANISH WIND POWER

Modern wind energy emerged in Denmark during an extremely innovative phase of technical and social development in the 1970s (Maegaard 2009). Since then, Danish wind energy has developed steadily for both domestic electricity production and manufacturing wind turbines that are installed around the world. Denmark has more than 1500 wind farms with a total generating capacity of almost 5.5 GW (The Wind Power 2018a); >40% of the country's electricity came from the wind in 2017. In a small country where every hectare of land is carefully managed, turbines have been integrated into the windscape in two ways. During the late twentieth century, most wind farms were small (1–10 turbines) and developed by local cooperatives and individual landowners, who sold excess electricity to the national grid system.

A shift took place at the turn of the century toward larger wind farms both on land and offshore. On land, the government offered incentives to replace older, smaller turbines with modern, larger, and more efficient turbines. The Ramme wind farm near the North Sea coast is a good example of this process. Furthermore the Ramme wind farm is compatible with nearby archaeologic remains spanning several millennia of prehistory (Fig. 20-1).

The Udbyneder wind farm exemplifies newer wind farms. It is located next to the Kattegat Sea just a few meters above sea level and completely open to wind

343

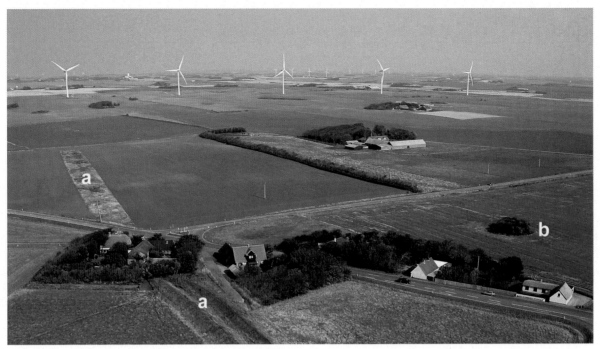

Fig. 20-1 Ramme wind farm in the rural landscape of western Denmark. The current Ramme wind farm has *Vestas* V42 and V80 turbines, which replaced smaller *Vestas* V27 and *Bonus* models (Aber et al. 2015). Ramme Dige is a well-known archaeological site (Eriksen and Olesen 2002) that includes remains of an Iron Age wall (a) as well as Neolithic and Bronze Age burial mounds (b). Kite photograph with a compact digital camera.

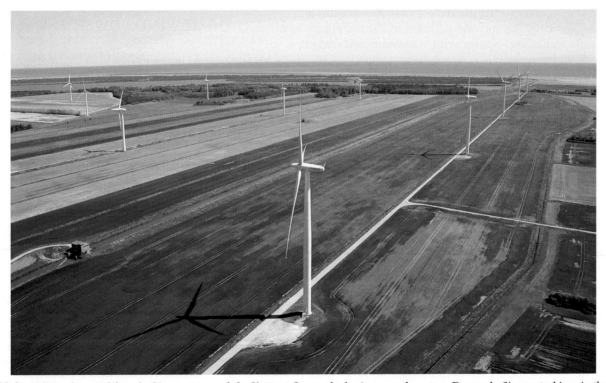

Fig. 20-2 Udbyneder wind farm looking east toward the Kattegat Sea on the horizon, northwestern Denmark. *Siemens* turbines in the foreground and to right; *NEG Micon* turbines in the background. Kite photograph with a compact digital camera.

blowing inland from the sea (Fig. 20-2). From other directions, wind passes over low-lying land that is devoted mostly to pasture and crop agriculture. On this basis, the land-based Udbyneder wind farm closely approaches offshore wind potential. Construction began in 2002 and continued in multiple phases with *NEG-Micon* and *Siemens* turbines.

Turbines are deployed in a grid pattern and serviced by narrow gravel paths along field boundaries, which results in minimal loss of agricultural production and does

not interfere with the drainage system. Udbyneder is far from major highways, touristic attractions, or sensitive environmental sites; thus, the wind farm contributes to Danish energy resources without curtailing local agricultural production and without any adverse aesthetic or environmental impacts.

20-3 POLISH WIND ENERGY

At the beginning of the century, Poland had a trivial 5 MW of installed wind-generating capacity, which had grown to >6.5 GW capacity by the end of 2017 (The Wind Power 2018b). As of 2017, 275 wind farms were located mainly in the north-central, west-central, northwestern and southeastern portions of the country, as well as offshore in the Baltic Sea.

The Radwanki-Margonin wind farm is emblematic of this rapid development. The wind farm occupies high ground on the drainage divide south of the Noteć River valley near Chodziez in northwestern Poland. This site is known for favorable wind conditions as demonstrated by several older turbines in the vicinity. The wind farm was commissioned in 2009 with 60 *Gamesa* turbines that are scattered in agricultural fields surrounding the villages of Radwanki and Kowalewo (Fig. 20-3). Beyond the villages, few trees or human structures are present in proximity to the turbines; adjacent forest is sufficiently far away so as not to impede near-surface wind (Fig. 20-4).

Agriculture is an important part of the Polish economy; food and live animals are exported primarily to Germany and other European countries. The Radwanki-Margonin wind farm demonstrates development and operation compatible with maintaining agricultural production. Poland is a country with abundant energy resources in the form of coal; however, oil and natural gas must be imported mainly from Russia. Burning coal releases significant air pollution and carbon dioxide, which Poland must reduce in the future as well as lessen its dependence on other imported fossil fuels. Wind energy represents a viable option for domestic, non-polluting, and risk-free generation of electricity without adverse impact on agriculture.

20-4 WIND ENERGY IN KANSAS

Kansas has emerged as a major wind-energy producing state within the United States. The first large wind farm was constructed in 2001 on the High Plains in southwestern Kansas (see Fig. 10-23). Rapid development has taken place since then. Transportation, storage, and construction of wind turbines have become a significant industry in the state (see Fig. 5-25). Kansas ranked fifth among states for installed capacity (5.1 GW) at the end of 2017, and wind generated 36% of electricity used in the state, second highest in the nation (American Wind Energy Association 2018). Most wind farms are situated on the High Plains and Blue Hills in western and central parts of the state

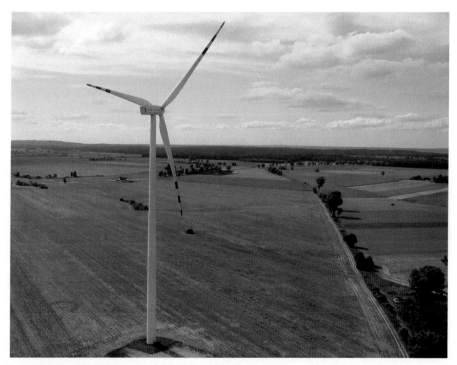

Fig. 20-3 Close-up view of *Gamesa* G90/2000 turbine at hub height (80m). Note the open aspect of the windscape west of Radwanki, Poland with the forest margin in the distant background. Kite and camera flew in the downwind turbulence zone. Taken with a compact digital camera.

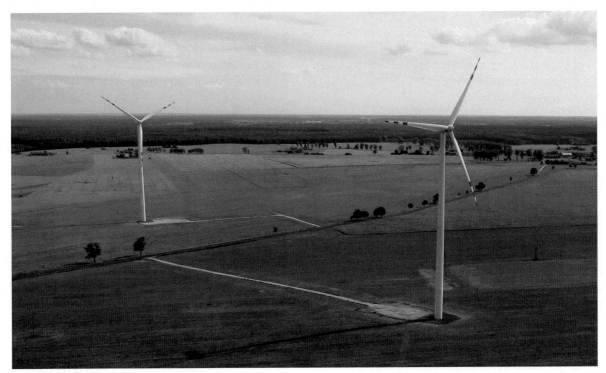

Fig. 20-4 *Gamesa* turbines amid agricultural fields in the Radwanki-Margonin wind farm. Turbines are surrounded by crops, and minimal land is lost from agricultural production, although farm machinery must maneuver around turbine pads and service paths. Kite photo taken with a compact digital camera.

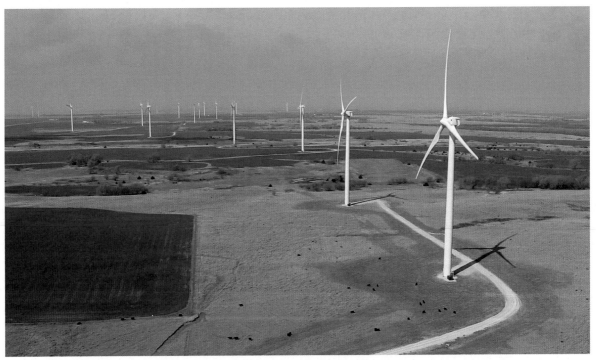

Fig. 20-5 Flat Ridge Wind Farm on the edge of the High Plains in south-central Kansas. *Clipper* 2.5 MW turbines have a hub height of 80 m and rotor diameter of 96 m. Construction began in 2008, and the farm became operational in 2009. Green fields are winter wheat, and cattle graze in the foreground. Kite photo taken with a compact digital camera.

(Fig. 20-5). In eastern Kansas, wind farms are located in the southern Flint Hills and Osage Cuestas (Aber and Aber 2016), and a few new wind farms are located in other parts of the state.

Environmental issues and aesthetic concerns generally are minimal across most of the state. In fact, the Nature Conservancy found that wind farms could be developed with appropriate mitigation for wildlife on more than 10

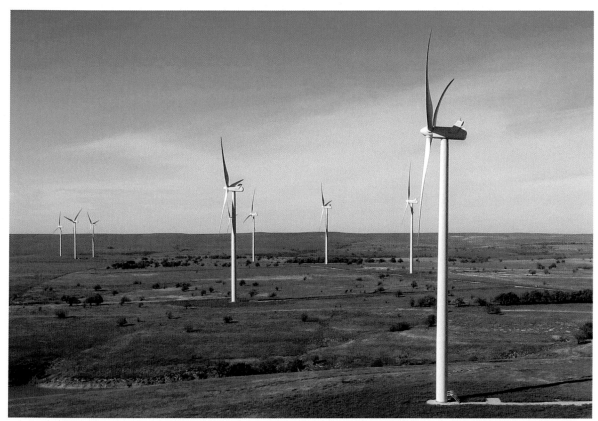

Fig. 20-6 Caney River Wind Farm is situated on a prominent escarpment in the southern Flint Hills. *Vestas* V90 turbines; the towers are 80 m tall, and the blades are 44 m long. Kite and camera flew near hub height under turbulent high-wind conditions. Photo by JSA and J. Schubert.

million hectares (nearly half the state) totaling 478 GW capacity (Obermeyer et al. 2011). The Flint Hills region is a major exception, however. The Flint Hills includes the largest contiguous tract of tallgrass prairie in North America, and as such the region has become a destination for ecotourism and focal point for ecological research.

The Heart of the Flint Hills Area exclusion zone was first proposed by Governor Sebelius in 2004. This wind-energy moratorium area covered that portion of the Flint Hills that preserved the most intact tallgrass prairie habitat, was least altered by human activities, and had the greatest scenic beauty. Governor Brownback more than doubled the extent of the exclusion zone in 2011 (Aber and Aber 2016). Existing wind farms were allowed to continue (Fig. 20-6), and construction of new transmission lines across the Flint Hills is also allowed. In the meantime, the US Fish and Wildlife Service moved toward preserving more than one million acres (>400,000 ha) within the Flint Hills for wildlife habitat (USFWS 2010).

20-5 SUMMARY

Wind energy has grown rapidly during the early 21st century; it is a renewable, relatively safe, and clean method to generate electricity. Most development has taken place in Europe, Asia, and North America as a means to reduce carbon emissions. Wind farms have proliferated both on land and on offshore. Nonetheless, environmental issues and aesthetic concerns continue to be problematic in some cases.

Small-format aerial photography is a way to bridge the gap between ground observations and conventional aerial and space-based imagery. SFAP is able to operate within wind farms in proximity to working turbines, particularly kite aerial photography, which is able to handle often turbulent conditions. The vantage, large scale, and high resolution of SFAP imagery inform the public and depict issues connected with wind-energy development, as demonstrated by examples from Denmark, Poland, and Kansas.

21

Emergence of SFAP

Natural scientists have a *preference for visual over verbal descriptions of real-world phenomena.* Wainer and Friendly (2019, p. 210)

21-1 OVERVIEW

Small-format aerial photography (SFAP) first appeared in the late 19th century with balloons and kites and continued to develop throughout the 20th century with all manner of aircraft (see Chap. 1). By the 1990s, SFAP was recognized as a specialization within the greater realm of remote sensing (Warner et al. 1996; Bauer et al. 1997). Nonetheless, SFAP remained a tiny niche practiced by just a handful of hobbyists and even fewer professionals.

At the turn of this century, for example, there were probably no more than a couple hundred people doing kite aerial photography worldwide, civilian unmanned aerial systems (UAS) hardly existed, and nearly all SFAP was accomplished via custom-built equipment or by simply pointing a camera out the window of an airplane or helicopter. Within the span of just two decades, SFAP has moved from niche status to mainstream activity involving many thousands of people with sizable commercial markets for ready-to-use hardware and software, and diverse technical, scientific, and artistic applications.

21-2 SFAP TECHNOLOGIES

The rapid rise of SFAP parallels development of digital cameras. At the beginning of this century, a typical compact digital camera had a sensor of just 2 megapixels (1600 by 1200 pixels), relatively slow response time, and limited functions and memory. An equivalent modern digital camera is likely to have a 24-megapixel sensor (6000 by 4000 pixels), much improved response time, many functions including WiFi, and a huge memory capacity. Mirrorless interchangeable-lens cameras (MILC) have become quite effective for SFAP, and small digital cameras for color-infrared and multispectral imagery are also readily available now.

The high quality of modern digital cameras is, perhaps, the single most-important factor for emergence of SFAP in the early 21st century. Several other technologies and societal developments have contributed to SFAP, namely GNSS, batteries, airborne platforms, 3D photogrammetry, Internet and mobile phones, and legal frameworks.

Global navigation satellite system (GNSS), such as the US Global Positioning System (GPS), European Galileo, and Chinese BeiDou, is another technology that has moved into the mainstream. Prior to 2000, the United States GPS signals were intentionally degraded for security reasons. Known as selective availability, this procedure was discontinued in 2000 at the direction of President Clinton (GPS.gov 2018). The end of selective availability led to a revolution in GPS applications for civilian use.

Every conceivable GPS device is now available to the public for automobiles, boats, bicycles, and personal wear, and GPS is built into many digital cameras. GPS-guided aircraft enable high-precision survey options for both manned and unmanned small-format aerial photography. Real-time kinematic (RTK) and post-processing kinematic (PPK) GNSS have achieved cm-dm positional accuracy for professional-grade UAS imagery. With Europe's own GNSS, Galileo, at the brink of full operational capability, availability and accuracy of satellite positioning will further increase.

Rechargeable batteries power nearly all devices necessary for SFAP both in cameras and unmanned platforms. In the late 1990s, the usual choices were alkaline batteries based on nickel-cadmium (NiCd) or nickel-metal-hydrate (NiMH). NiCd batteries have excellent performance under a variety of conditions, but they are highly toxic. NiMH batteries are less toxic and have higher specific energy; they have replaced most NiCd batteries (Battery University 2017).

349

Lithium-ion-polymer (LiPo) batteries have proliferated in the early 21st century for all types of devices employed for SFAP. Several varieties incorporate cobalt, manganese, or molybdenum (Schumm 2018), and a protection circuit is necessary for safely charging LiPo cells (Battery University 2017). Initial cost is high, but LiPo batteries may be recharged many more times than nickel-based batteries. Improved battery performance has made SFAP more reliable than in the past, although limitations still exist, and battery issues are among the most common operational and logistical problems.

Unmanned SFAP platforms have evolved swiftly in the early 21st century, especially for free-flying UAS. Multicopters with 4 (quad), 6 (hexa), or 8 (octo) rotors have emerged as stable designs along with flying wings and other more-conventional fixed-wing types of model aircraft. Photographs may be taken by manual radio control, autonomous camera operation, or following pre-programmed routines guided by GNSS. UAS are autopiloted by an inertial measurement unit (IMU) and inertial navigation system (INS) along with additional sensors for measuring altitude and obstacle detection. Electronic, 3-axis gimbals stabilize and allow control of camera position, and First Person View (FPV) live-video downlinking allows the pilot to take the camera's view in real time.

The advantages of fixed-wing and multirotor UAS are combined in hybrid aircraft that have the abilities of vertical takeoff and landing (VTOL), hovering, and high-speed flight like a conventional model airplane. These platforms are currently much in the focus of UAS developers. At the leading edge of UAS design are robotic birds, known as ornithopters, such as the 2-m-wingspan *SmartBird* (Borrell 2018).

Manned platforms, in contrast, have not changed much in recent years as far as SFAP is concerned. Small airplanes, helicopters, autogyros, and various kinds of ultra-light aircraft may be utilized with hand-held cameras or mounted cameras that are remotely controlled by the pilot or copilot-photographer.

Photogrammetry techniques have likewise moved forward rapidly. In truth, the Structure from Motion–Multi-View Stereo (SfM-MVS) approach, originally developed for computer vision, has revolutionized the potential for highly detailed 3D modeling and analysis of earth-surface phenomena by combining vertical and low-oblique SFAP imagery in highly redundant image networks. This capability has been utilized already for many geoscientific applications (e.g. Cook 2017; Feurer et al. 2018).

The growth of Internet communication has been phenomenal since it was privatized in 1995. As of 2000, less than 20,000 websites existed worldwide. The milestone of one billion websites was achieved in 2014, and current websites total ~1.9 billion, although many of these are inactive (InternetLiveStats.com 2018). Online sharing of techniques and experiences has greatly benefitted small-format aerial photographers. Early adopters inspired many others to follow in their footsteps.

Similar explosive growth took place for mobile (cellular) phones. The number of mobile-phone subscriptions worldwide was approximately 740,000 in 2000. By 2015, global subscriptions exceeded 7 billion (Statista.com 2018), approximately the world's human population. This expansion was driven by increasingly sophisticated phones as well as enhanced network capacity and functionality (Table 21-1). Smartphone apps have been adapted for control of airborne platforms and camera functions.

Legal aspects have moved forward along with SFAP technology. Laws and regulations vary considerably from country to country, but some common trends are noted during the past decade. Regarding manned aircraft and more-traditional unmanned tethered platforms, rules and regulations have been relatively stable for SFAP. Small UAS, on the other hand, have prompted many countries to revise and tighten regulations and restrictions for pilot qualifications and UAS operations.

In the United States, for instance, the FAA is funding research and development that may lead to new rules

Table 21-1 Summary of mobile (cellular) phone network capacity and functionality. Based on SmartIPX (2015) and Johansen (2016).

Network	1G	2G	3G	4G	5G
Period	1980s	1990s	2000s	2010s	2020s
Speed	2.4 kbps	64 kbps	2000 kbps	100 Mbps	1 Gbps
Functions	Basic voice Analog protocols	Designed for voice First digital standard	Voice with some data Mobile broadband	Designed for data IP-based protocols	[Still under development]

Note: pilot 5G networks are already available in Estonia to the public in limited areas (Hankewitz 2018).

that would support more complex, low-altitude UAS operations (FAA 2018), and the same may be expected in other countries as well. This provides a legal framework within which SFAP may be conducted safely and properly. Furthermore, ethical and privacy considerations have grown for appropriate use of SFAP platforms in different situations.

21-3 UNMANNED AIRCRAFT FOR SFAP

The emphasis throughout this book has been for unmanned platforms employed at relatively low height for small-format aerial photography. From early kites to the newest experimental ornithopters, many unmanned aircraft have been designed, tested, and further refined as potential platforms for SFAP. Some have fallen by the wayside for various reasons of cost, logistics, flight operation, and legal restrictions. Other types of unmanned aircraft have emerged as viable platforms for SFAP. Aber et al. (2018b) compared the strengths and shortcomings of four types of unmanned SFAP aircraft, namely fixed-wing UAS, multirotor UAS, kite, and helium blimp. They concluded that no single platform is ideal for SFAP in all circumstances.

Cost of aircraft, logistical and local site issues, availability of fuel or electric power, and legal restrictions all may come into play for SFAP in different parts of the world. For example, tethered aircraft could be the only platforms legally allowed to fly in some situations. The requirement to lift heavier or multiple cameras or sensors adds further restrictions on feasible platforms. Helium for balloons or blimps is readily available in the United States, but is costly or simply not an option in many places. Transporting larger LiPo batteries is restricted in some countries. In light of these many issues, seven unmanned platforms for SFAP are summarized in Table 21-2.

On this basis, it should be clear that no single type of unmanned aircraft is ideal for SFAP in all situations. Indeed, each mission and location presents certain requirements and special conditions that favor one type of platform over another. For maximum flexibility, both a free-flying UAS and a tethered platform should be available to the small-format aerial photographer in order to cope with different circumstances.

TABLE 21-2 Comparison of four free-flying UAS and three tethered unmanned platforms for SFAP. Relative qualitative ratings for typical equipment and missions are based on many sources and the authors' experiences. Based on Aber et al. (2018a & 2018b).

SFAP comparison	Fixed-wing UAS	Multirotor UAS (quadcopter)	Multirotor UAS (hexacopter)	Hybrid VTOL UAS	Kite (tethered)	Helium blimp (tethered)	Hot-air blimp (tethered)
Platform cost	High	Moderate	High	High	Low to moderate	Moderate to high	High
Operating energy	Rechargeable battery	Rechargeable battery	Rechargeable battery	Rechargeable battery	Wind	Helium	Propane, heating gas
Operating cost	Low	Low	Low	Low	Low	High	Low
Wind and temperature	Calm to moderate Above freezing	Calm to light Above freezing	Calm to light Above freezing	Calm to light Above freezing	Light to strong Any temperature	Calm to light Any temperature	Calm to light Any temperature
Portability	Moderate	Easy	Moderate	Moderate	Easy	Difficult	Difficult
Personnel	1 to 2	1	1 to 2	1 to 2	1 to 2	2 to 3	4 to 6
Flight time	One hour	15–25 min	15–25 min	One hour	Several hours	Several hours	45 min
Flying height[*]	400 feet	400 feet	400 feet	400 feet	500 feet	500 feet	500 feet
Stationary position	Not possible	Excellent	Excellent	Excellent	Good	Excellent	Excellent
Payload	½ to 6 kg	½ to 1 kg	1 to 6 kg	1 to 6 kg	½ to 3 kg	5 to 10 kg	5 to 25 kg
Technical level	High	Moderate	High	High	Low	Low	Moderate
Vertical areal coverage	Large	Small	Moderate	Large	Small	Moderate	Moderate
Legal status[*]	Many restrictions	Many restrictions	Many restrictions	Many restrictions	Few restrictions	Few restrictions	Few restrictions

[*]Flying height and legal status are given for the United States; regulations vary considerably in other countries from outright prohibition to few restrictions. Logistical factors and costs likewise vary greatly around the world.

21-4 SFAP CONVERGENCE

Small-format aerial photography, thus, represents a convergence of multiple technologies, many of which had no common origin or initial relationships, along with societal recognition and development of legal frameworks. The emergence of SFAP is not due to any single person or institution. Rather, it represents the results of many inventors and self-builders using diverse materials, components, airborne platforms, and cameras. Many of the people involved freely shared their techniques and methods from many parts of the world. This convergence of innovation, manufacturing, and public policy is an example of *bricolage*, a French term that refers to resourcefulness in the creation of a new technology from diverse sources and available resources (Nielsen 2009).

Given the quick pace of recent technological and societal developments, the authors anticipate continued rapid improvements and growth of small-format aerial photography and UAS imagery in the near future. SFAP may be applied for subjects not yet imagined using cameras and airborne platforms that are yet to be designed and built. We look forward to the next decade of innovations for small-format aerial photography particularly for geoscience applications.

References

AAAS/NSF 2005, 'Science and engineering visualization challenge: autumn color, Estonian bog, first place in the photography category', *Science*, vol. 309, p. 1991, viewed 5 November 2018, <https://www.nsf.gov/news/mmg/mmg_disp.jsp?med_id=59614&from=>.

Aaviksoo, K 1988, 'Interpretation of Estonian mire sites from aerial photos', *Acta et Commentationes Universitatis Tartuensis*, vol. 812, pp. 193–208 (in Russian).

Aaviksoo, K & Muru, K 2008, 'A methodology of the satellite mapping and monitoring of protected landscapes in Estonia', *Estonian Journal of Ecology*, vol. 57, no. 3, pp. 159–184, https://doi.org/10.3176/eco.2008.3.01

Aaviksoo, K, Kadarik, H & Masing, V 1997, *Kaug- ja lähivõtteid 30 Eesti soost: esimene raamat telmatograafiast, aerial views and close-up pictures of 30 Estonian mires: the first book on telmatography*, Tallinn, Estonia, EEIC, Eesti Vabariigi Keskkonnaministeerium, Ministry of the Environment.

Aber, JS 2004, 'Lighter-than-air platforms for small-format aerial photography', *Transactions of the Kansas Academy of Science*, vol. 107, no. 1–2, pp. 39–44, https://doi.org/10.1660/0022-8443(2004)107[0039:LPFSAP]2.0.CO;2

Aber, JS 2006, 'Small-format aerial photography for archaeologic applications: Knife River Indian Villages NHS', in LA Manz (ed.), *Quaternary geology of the Missouri River valley and adjacent areas in northwest-central North Dakota*, Geologic Investigations 24, North Dakota Geological Survey, Bismarck, North Dakota, United States, pp. 41–46.

Aber, JS & Aber, SW 2001, 'Potential of kite aerial photography for peatland investigations with examples from Estonia', *Suo*, vol. 52, no. 2, p. 45–56, viewed 10 November 2018, <http://www.suo.fi/pdf/article9812.pdf>.

Aber, JS & Aber, SW 2003, 'Applications of kite aerial photography: property survey', *Transactions of the Kansas Academy of Science*, vol. 106, no. 3–4, pp. 107–110, https://doi.org/10.1660/0022-8443(2003)106[0107:AOKAPP]2.0.CO;2

Aber, JS & Aber, SW 2009, *Kansas physiographic regions: bird's-eye views*, Kansas Geological Survey, Education Series 17, University of Kansas, Lawrence, Kansas, United States.

Aber, JS & Aber, SW 2013, 'Low-level aerial photography of the Santa Fe Trail', *Santa Fe Trail Association Quarterly: Wagon Tracks*, vol. 28, no. 1, pp. 16–22, viewed 21 November 2018, <https://www.santafetrail.org/publications/wagon-tracks/pdf/WT_Nov2013.pdf>.

Aber, JS & Aber, SW 2014, *Beach, tidal lagoons, and shallow sea at Hurup, Aalborg Bay, Kattegat, Denmark*, cover image, *Boreas*, vol. 43, no. 1–4, viewed 21 November 2018, <https://onlinelibrary.wiley.com/loi/15023885/year/2014>.

Aber, JS & Aber, SW 2016, 'Kansas windscape—2016 update', *Transactions of the Kansas Academy of Science*, vol. 119, no. 3–4, pp. 395–405, https://doi.org/10.1660/062.119.0403

Aber, JS & Ber, A 2007, *Glaciotectonism*, Developments in Quaternary Science 6, Elsevier, Amsterdam, Netherlands.

Aber, JS, Sobieski, R, Distler, DA & Nowak, MC 1999, 'Kite aerial photography for environmental site investigations in Kansas', *Transactions of the Kansas Academy of Science*, vol. 102, no. 1–2, pp. 57–67, viewed 23 November 2018, <https://www.jstor.org/stable/3628217>, https://doi.org/10.2307/3628217

Aber, JS, Aber, SW & Leffler, B 2001a, 'Challenge of infrared kite aerial photography', *Transactions of the Kansas Academy of Science*, vol. 104, no. 1–2, pp. 18–27, https://doi.org/10.1660/0022-8443(2001)104[0018:COIKAP]2.0.CO;2

Aber, JS, Kalm, V & Lewicki, M 2001b, 'Geomorphic interpretation of Landsat imagery for western Estonia', *Slovak Geological Magazine*, vol. 7, no. 3, pp. 237–242, viewed 20 November 2018, <https://da.geology.sk/navigator/download.jsp?magazineId=A1001001A18D12B25434C51175>.

Aber, JS, Aaviksoo, K, Karofeld, E & Aber, SW 2002, 'Patterns in Estonian bogs depicted in color kite aerial photographs', *Suo*, vol. 53, no. 1, pp. 1–15, viewed 30 August 2018, <http://www.suo.fi/pdf/article9818.pdf>.

Aber, JS, Zupancic, J & Aber, SW 2003, 'Applications of kite aerial photography: golf course management', *Transactions of the Kansas Academy of Science*, vol. 106, no. 3–4, pp. 211–214, https://doi.org/10.1660/0022-8443(2003)106[0211:AOKAPG]2.0.CO;2

Aber, JS, Eberts, D & Aber, SW 2005, 'Applications of kite aerial photography: biocontrol of salt cedar (*Tamarix*) in the western United States', *Transactions of the Kansas Academy of Science*, vol. 108, no. 1–2, pp. 63–66, https://doi.org/10.1660/0022-8443(2005)108[0063:AOKAPB]2.0.CO;2

Aber, JS, Aber, SW, Pavri, F, Volkova, E & Penner II, RL 2006, 'Small-format aerial photography for assessing change in wetland vegetation, Cheyenne Bottoms, Kansas', *Transactions of the Kansas Academy of Science*, vol. 109, no. 1–2, pp. 47–57, https://doi.org/10.1660/0022-8443(2006)109[47:SAPFAC]2.0.CO;2

Aber, JS, Aber, SW, Janočko, J, Zabielski, R & Górska-Zabielska, M 2008, 'High-altitude kite aerial photography', *Transactions of the Kansas Academy of Science*, vol. 111, no. 1, pp. 49–60, viewed 10 November 2018, <https://www.jstor.org/stable/20476342>.

Aber, JS, Aber, SW, Buster, L, Jensen, WE & Sleezer, RL 2009, 'Challenge of infrared kite aerial photography: a digital update', *Transactions of the Kansas Academy of Science*, vol. 112, no. 1–2, pp. 31–39, viewed 1 January 2019, <https://www.jstor.org/stable/40588218>.

Aber, JS, Marzolff, I & Ries, JB 2010a, *Small-format aerial photography: principles, techniques and geoscience applications*, Elsevier, Amsterdam, Netherlands.

Aber, JS, Owens, LC, Aber, SW, Eddy, T, Schulenberg, JH, Sundberg, M & Penner II, RL 2010b, 'Recent *Azolla* bloom at Cheyenne Bottoms, Kansas', *Transactions of the Kansas Academy of Science*, vol. 113, pp. 56–63, no. 1–2, https://doi.org/10.1660/062.113.0204

Aber, JS, Pavri, F & Aber, SW 2012, *Wetland environments: a global perspective*, Wiley-Blackwell, Chichester, United Kingdom.

Aber, JS, Aber, SW & Pavri, F 2015, *Windscapes: a global perspective on wind power*. Multi-Science Publishing Co. Ltd., Brentwood, Essex, United Kingdom.

Aber, JS, Aber, SW & Penner II, RL 2016, 'Rapid environmental changes in the Nature Conservancy wetland at Cheyenne Bottoms, Kansas: a review 2002-2015', *Transactions of the Kansas Academy of Science*, vol. 119, no. 1, pp. 33–48, https://doi.org/10.1660/062.119.0107

Aber, JS, Aber, SW & Nagasako, T 2018a, 'Color-infrared kite aerial photography with a mirrorless digital SLR camera', *Transactions of the Kansas Academy of Science*, vol. 121, no. 3–4, pp. 319–329, https://doi.org/10.1660/062.121.0401

Aber, JW, Babb, TA, Campbell, DE & Corns, KM 2018b, 'A comparison of the strengths and weaknesses of small-format aerial photography platforms', *International Journal of Aviation, Aeronautics, and Aerospace*, vol. 5, no. 3, viewed 1 December 2018, <https://commons.erau.edu/ijaaa/vol5/iss3/4>.

AgEagle 2018, *Drones: AgEagle RX60*, viewed 23 December 2018, <https://www.ageagle.com/drones>.

Ahmadabadian, AH, Robson, S, Boehm, J, Shortis, M, Wenzel, K & Fritsch, D 2013, 'A comparison of dense matching algorithms for scaled surface reconstruction using stereo camera rigs', *ISPRS Journal of Photogrammetry and Remote Sensing*, vol. 78, pp. 157–167, https://doi.org/10.1016/j.isprsjprs.2013.01.015

Aircraft Owners and Pilots Association 2016, *Frequently asked questions about sport pilot*, viewed 23 November 2018, <https://www.aopa.org/advocacy/advocacy-briefs/frequently-asked-questions-about-sport-pilot>.

Albert, K-D 2002, *Die Altdünenlandschaft im Sahel NE Burkina Fasos: Geomorphogenese und Geomorphodynamik einer semiariden Kulturlandschaft*, PhD thesis, Frankfurt University, Frankfurt am Main, Germany, viewed 24 November 2018, <https://d-nb.info/969057601/34>.

Albertz, J 2007, *Einführung in die Fernerkundung: Grundlagen der Interpretation von Luft- und Satellitenbildern*, 3rd edn, Wissenschaftliche Buchgesellschaft, Darmstadt, Germany.

Alexander, C, Korstjens, AH, Hankinson, E, Usher, G, Harrison, N, Nowak, MG, Abdullah, A, Wich, SA & Hill, RA 2018, 'Locating emergent trees in a tropical rainforest using data from an Unmanned Aerial Vehicle (UAV)', *International Journal of Applied Earth Observation and Geoinformation*, vol. 72, pp. 86–90, https://doi.org/10.1016/j.jag.2018.05.024

All Quotes 2016, *Leonardo da Vinci quotes—25 the best ones*, viewed 4 October 2018, <https://web.archive.org/web/20170625121255/http://www.allquotes.info:80/leonardo-da-vinci-quotes-25-the-best-ones/>.

Allikvee, H & Masing, V 1988, 'Põhja-Eesti kõrgustiku suurte mosaiiksoode valdkond, the area of the great mosaic of the northern Estonian Upland', in U. Valk (ed.), *Eesti sood, Estonian peatlands*, Valgus, Tallinn, Estonia, pp. 264–270.

Allison, AJ & Pettit, CM 2019, 'Aerial investigations of the 19th century Fruitland schoolhouse ruins using unmanned aerial systems (UAS), Ross Natural History Reservation, Lyon County, Kansas', *Transactions of the Kansas Academy of Science*, vol. 121, no. 1–2, pp. 192–193, https://doi.org/10.1660/062.121.0226

Allred, A & Baxter, BK 2016, *Microbial life in hypersaline environments*, Microbial Life Educational Resources, viewed 5 October 2018, <https://serc.carleton.edu/microbelife/extreme/hypersaline/index.html>.

Alonso Ugaglia, A & Peres, S 2017, 'Knowledge dynamics and climate change issues in the wine industry: a literature review', *Journal of Innovation Economics & Management*, vol. 24, no. 3, pp. 105–125, https://doi.org/10.3917/jie.pr1.0016

Altan, MO, Celikoyan, TM, Kemper, G & Toz, G 2004, 'Balloon photogrammetry for cultural heritage', *ISPRS International Archives of Photogrammetry, Remote Sensing and Spatial Information Sciences*, vol. 35, part 5, pp. 964–968.

Amache Preservation Society 2017, 'Timeline: Amache & Japanese American timeline', Amache.org, viewed 24 November 2018, <http://amache.org/timeline/>.

American Wind Energy Association 2018, *State wind energy facts | AWEA*, viewed 9 December 2018, <https://www.awea.org/resources/fact-sheets/state-facts-sheets>.

Amsbury, DL, Evans, C, Ackleson, S, Brumbaugh, FR, Helms, DR, Lulla, KP, Wilkinson, MJ, Brandenstein, DC, Chilton, KP, Hieb, RJ, Melnick, BE, Thuot, PJ, Thornton, KC & Akers, TD 1994, 'Earth observations during space shuttle flight STS-49: Endeavor's mission to planet Earth (May 7-16, 1992)', *Geocarto International*, vol. 9, iss. 2, pp. 67–80, https://doi.org/10.1080/10106049409354452

Andres, W 1972, 'Beobachtungen zur jungquartären Formungsdynamik am Südrand des Anti-Atlas (Marokko)', in J Büdel & C Rathjens (eds), *Neue Wege der Geomorphologie: Zur Differenzierung der Abtragungsprozesse in verschiedenen Klimaten*. Zeitschrift für Geomorphologie N.F., Suppl. 14, pp. 66–80.

Aristotle & Ross, WD 1924, *Aristotle's metaphysics: a revised text with introduction and commentary*, Clarendon Press, Oxford, United Kingdom.

Armenakis, C (ed.) 2015, *Proceedings of the international conference on unmanned aerial vehicles in geomatics (UAV-g2015)*, Toronto, Canada, 30 August–2 September 2015, International Archives of Photogrammetry, Remote Sensing and Spatial Information Sciences, vol. XL-1/W4, viewed 21 December 2018, <https://www.int-arch-photogramm-remote-sens-spatial-inf-sci.net/XL-1-W4/>.

Arthus-Bertrand, Y 2017. *Earth from above, revised and expanded edition*, Abrams, New York, United States.

Asner, GP, Braswell, BH, Schimel, DS & Wessman, CA 1998, 'Ecological research needs from multiangle remote sensing data', *Remote Sensing Environment*, vol. 63, no. 2, pp. 155–165, https://doi.org/10.1016/S0034-4257(97)00139-9

Avni, Y 2005, 'Gully incision as a key factor in desertification in an arid environment, the Negev highlands, Israel', *Catena*, vol. 63, iss. 2–3, pp. 185–220, https://doi.org/10.1016/j.catena.2005.06.004

Baars, DL 2000, *The Colorado Plateau: a geologic history*, University of New Mexico Press, Albuquerque, New Mexico, United States.

BAF 2017, 'Publikationen', *Bundesaufsichtsamt für Flugsicherung*, viewed 27 November 2018, <https://www.baf.bund.de/SiteGlobals/Forms/Suche/Publikationssuche_Formular.html?nn=1575560>.

Bähr, H-P (ed.) 2005, *Digitale Bildverarbeitung. Anwendungen in Photogrammetrie, Fernerkundung und GIS*, Wichmann, Heidelberg, Germany.

Baker, S 1989, 'San Francisco in ruins: the 1906 aerial photographs of George R. Lawrence', *Landscape*, vol. 30, no. 2, pp. 9–14.

Baker, S 1997, 'Controversy: was it kites or a balloon?', *KiteLines*, vol. 12, no. 3, pp. 46–51.

Baker, VR 1986, 'Introduction: regional landforms analysis', in NM Short & RW Blair Jr (eds), *Geomorphology from space: a global overview of regional landforms*, NASA Special Publication 486, U.S. Government Printing Office, Washington, D.C., United States, pp. 1–26.

Baker, AKM, Fitzpatrick, RW & Koehne, SR 2004, 'High resolution low altitude aerial photography for recording temporal changes in dynamic surficial environments', in IC Roach (ed.), *Regolith*, Cooperative Research Centre for Landscape Environments and Mineral Exploration (CRC LEME), Kensington, Australia, pp. 21–25, viewed 23 November 2018, <http://crcleme.org.au/Pubs/Monographs/regolith2004/Baker_et_al.pdf>.

Banerjee, I & McDonald, BC 1975, 'Nature of esker sedimentation', in AV Jopling & BC McDonald (eds), *Glaciofluvial and glaciolacustrine sedimentation*, Society for Sedimentary Geology, Tulsa, Oklahoma, United States, vol. 23, pp. 132–154, https://doi.org/10.2110/pec.75.23

Barrette, J, August, P & Golet, F 2000, 'Accuracy assessment of wetland boundary delineation using aerial photography and digital orthophotography', *Photogrammetric Engineering & Remote Sensing*, vol. 66, no. 4, pp. 409–416.

Bárta, V & Barta, V 2007, *Nad Slovenskom: over Slovakia*, AB Art Press, Slovenská L'upèa, Slovakia.

Battery University 2017, *BU-107: comparison table of secondary batteries*, viewed 9 December 2018, <http://batteryuniversity.com/learn/article/secondary_batteries>.

Batut, A 1890, *La photographie aérienne par cerf-volant*, Gauthier-Villars et fils, Paris, France.

Bauer, M, Befort, W, Coppin, PR & Huberty, B 1997, *Proceedings of the first North American symposium on small format aerial photography*, American Society of Photogrammetry and Remote Sensing, Bethesda, Maryland, United States.

Bauer, PW 2011, *The Rio Grande: a river guide to the geology and landscapes of northern New Mexico*, New Mexico Bureau of Geology and Mineral Resources, Socorro, New Mexico, United States.

Bazzoffi, P 2015, 'Measurement of rill erosion through a new UAV-GIS methodology', *Italian Journal of Agronomy*, vol. 10, no. 1s, pp. 1–18, https://doi.org/10.4081/ija.2015.708

BBC News 2019, *Gatwick drones: military stood down after airport chaos*, viewed 3 January 2019, <https://www.bbc.com/news/uk-england-sussex-46741687>.

Beauffort, G, de & Dusariez, M 1995, *Aerial photographs taken from a kite: yesterday and today*, KAPWA-Foundation Pub. Brussels, Belgium.

Bennett, SJ & Wells, RR 2018, 'Gully erosion processes, disciplinary fragmentation, and technological innovation', *Earth Surface Processes and Landforms*, vol. 43, F1, pp. 1–202.

Benton, CC 2010, *Notes on kite aerial photography*, viewed 23 November 2018, <http://kap.ced.berkeley.edu/kaptoc.html>.

Berlin, GL & Avery TE 2004, *Fundamentals of remote sensing and airphoto interpretation*, 6th edn, Upper Saddle River, Prentice Hall, New Jersey, United States.

Bernard, É, Friedt, JM, Tolle, F, Marlin, C & Griselin, M 2017, 'Using a small COTS UAV to quantify moraine dynamics induced by climate shift in Arctic environments', *International Journal of Remote Sensing*, vol. 38, no. 8–10, pp. 2480–2494, https://doi.org/10.1080/01431161.2016.1249310

Berni, JAJ, Zarco-Tejada, PJ, Suárez, L & Fereres, E 2009, 'Thermal and narrowband multispectral remote sensing for vegetation monitoring from an unmanned aerial vehicle', *IEEE Transactions on Geoscience and Remote Sensing*, vol. 47, no. 3, pp. 722–738, https://doi.org/10.1109/TGRS.2008.2010457

Bethmann, F & Luhmann, T 2017, 'Object-based semi-global multi-image matching', PFG, *Journal of Photogrammetry, Remote Sensing and Geoinformation Science*, vol. 85, no. 6, pp. 349–364, https://doi.org/10.1007/s41064-017-0034-z

Beutnagel, R 2006, *Kite aerial photography*, viewed 12 June 2019, <http://dopero.homepage.t-online.de/Eingang/Kite_Aerial_Photography/kite_aerial_photography.html>.

Beutnagel, R, Bieck, W & Böhnke, O 1995, 'Picavet—past and present', *Aerial Eye*, vol. 1, no. 4, pp. 6–7, 18–19, viewed 23 November 2018, <https://members.kite.org/resources/Documents/aerialeye1.4.pdf>.

Bieck, W 2016, 'In silent remembrance', *Kiting*, vol. 38, no. 3, pp. 24–27.

Bigras, C 1997, 'Kite aerial photography of the Axel Heiberg Island fossil forest', in M Bauer, W Befort, PR Coppin & B Huberty (eds), *Proceedings of the first North American symposium on small format aerial photography*, American Society of Photogrammetry and Remote Sensing, Bethesda, Maryland, United States, pp. 147–153.

Bill, R 2016, *Grundlagen der Geo-Informationssysteme*, Wichmann, Berlin, Germany.

Bitelli, G, Unguendoli, M & Vittuari, L 2001, 'Photographic and photogrammetric archaeological surveying by a kite system', in J Alpuente et al. (ed.), *Proceedings of the 3rd international congress on science and technology for the safeguard of cultural heritage in the Mediterranean Basin*, Alcala de Henares, Spain, 9-14 July 2001, Publication Services Universidad de Alcalá, Madrid, Spain, pp. 538–543.

Bitelli, G, Girelli, VA, Tini, MA & Vittuari, L 2004, 'Low-height aerial imagery and digital photogrammetrical processing for archaeological mapping', *ISPRS International Archives of Photogrammetry, Remote Sensing and Spatial Information Sciences*, vol. 35, part 5, pp. 498–503.

Blaschke, T 2010, 'Object based image analysis for remote sensing', *ISPRS Journal of Photogrammetry and Remote Sensing*, vol. 65, no. 1, pp. 2–16, https://doi.org/10.1016/j.isprsjprs.2009.06.004

Blaschke, T, Hay, GJ, Kelly, M, Lang, S, Hofmann, P, Addink, E, Queiroz Feitosa, R, van der Meer, F, van der Werff, H, van Coillie, F & Tiede, D 2014, 'Geographic object-based image analysis—towards a new paradigm', *ISPRS Journal of Photogrammetry and Remote Sensing*, vol. 87, no. 100, pp. 180–191, https://doi.org/10.1016/j.isprsjprs.2013.09.014

Boike, J & Yoshikawa, K 2003, 'Mapping of periglacial geomorphology using kite/balloon aerial photography', *Permafrost and Periglacial Processes*, vol. 14, no. 1, pp. 81–85, https://doi.org/10.1002/ppp.437

Borrell, B 2018, 'Bots on the wing', *National Geographic*, vol. 233, no. 1, p. 144.

Braasch, O & Planck, D 2005, 'Vom heiteren Himmel: Luftbildarchäologie', *Gesellschaft für Archäologie in Württemberg und Hohenzollern e.V.*, Esslingen am Neckar, Germany.

Brookins, DG 1970, 'The kimberlites of Riley County, Kansas', *Kansas Geological Survey*, Bulletin 200, University of Kansas, Lawrence, Kansas, United States, viewed 20 November 2018, <http://www.kgs.ku.edu/Publications/Bulletins/200/index.html>.

Bruegge, CJ, Schaepman, M, Strub, G, Beisl, U, Demircan, A, Geiger, B, Painter, TH, Paden, BE & Dozier, J 2004, 'Field measurements of bi-directional reflectance', in M von Schönermark, B Geiger & HP Röser (eds), *Reflection properties of vegetation and soil—with a BRDF data base*, Wissenschaft und Technik Verlag, Berlin, pp. 195–224.

Brunier, G, Fleury, J, Anthony, EJ, Gardel, A & Dussouillez, P 2016, 'Close-range airborne structure-from-motion photogrammetry for high-resolution beach morphometric surveys: examples from an embayed rotating beach', *Geomorphology*, vol. 261, pp. 76–88, https://doi.org/10.1016/j.geomorph.2016.02.025

Buchanan, R 1999, 'Survey discovers three new volcanic features in northeast Kansas', *Kansas Geological Survey*, News Release, viewed 20 November 2018, <http://www.kgs.ku.edu/General/News/99_releases/kimberlites.html>.

Budworth, G 1999, *The complete book of knots*, Barnes and Noble, New York, New York, United States, United States.

Buerkert, A, Mahler, F & Marschner, H 1996, 'Soil productivity management and plant growth in the Sahel: potential of an aerial monitoring technique', *Plant and Soil*, vol. 180, no. 1, pp. 29–38, https://doi.org/10.1007/BF00015408

Burge, D 2007, '100 years from now…', in MR Peres (ed.), *Focal encyclopedia of photography: digital imaging, theory and applications, history, and science*, 4th edn, Elsevier, Amsterdam, pp. 456–459.

Burkard, MB & Kostaschuk, RA 1997, 'Patterns and controls of gully growth along the shoreline of Lake Huron', *Earth Surface Processes and Landforms*, vol. 22, no. 10, pp. 901–911, https://doi.org/10.1002/(SICI)1096-9837(199710)22:10<901::AID-ESP743>3.0.CO;2-O

Burkart, A, Aasen, H, Alonso, L, Menz, G, Bareth, G & Rascher, U 2015, 'Angular dependency of hyperspectral measurements over wheat characterized by a novel UAV based goniometer', *Remote Sensing*, vol. 7, no. 1, pp. 725–746, https://doi.org/10.3390/rs70100725

Burkhart, PA, Alley, RB, Thompson, LG, Balog, JD, Baldauf, PE & Baker, GS 2017, 'Savor the cryosphere', *Geological Society of America GSA Today*, vol. 27, no. 8, pp. 4–10, viewed 11 November 2018, <http://www.geosociety.org/gsatoday/science/G293A/article.htm>, https://doi.org/10.1130/GSATG293A.1

Busemeyer, KL 1987, 'Zur Konzeption eines ferngelenkten, gefesselten Heißluftkammersystems', in International Society for Photogrammetry and Remote Sensing (ISPRS) and Deutsches Bergbau-Museum (DBM) (eds), *Luftaufnahmen aus geringer Flughöhe, Veröffentlichungen aus dem Deutschen Bergbaumuseum*, vol. 41, pp. 49–56.

Busemeyer, KL 1994, 'Luftschiffeinsatz in Pakistan', *Modell*, vol. 1994, no. 1, pp. 4–7.

BusinessTech 2018, *The world's biggest wine producers in 2018 including South Africa*, 30 April 2018, viewed 16 December 2018, <https://businesstech.co.za/news/business/240307/the-worlds-biggest-wine-producers-in-2018-including-south-africa/>.

BVDD 2018, 'Die neue Drohnen-Verordnung', *Bundesministerium für Verkehr und digitale Datenverarbeitung*, viewed 28 November 2018, <https://www.bmvi.de/SharedDocs/DE/Publikationen/LF/flyer-die-neue-drohnen-verordnung.pdf?>.

Candiago, S, Remondino, F, De Giglio, M, Dubbini, M & Gattelli, M 2015, 'Evaluating multispectral images and vegetation indices for precision farming applications from UAV images', *Remote Sensing*, vol. 7, no. 4, pp. 4026–4047, https://doi.org/10.3390/rs70404026

Carbonneau, PE & Dietrich, JT 2017, 'Cost-effective non-metric photogrammetry from consumer-grade sUAS: implications for direct georeferencing of structure from motion photogrammetry', *Earth Surface Processes and Landforms*, vol. 42, no. 3, pp. 473–486, https://doi.org/10.1002/esp.4012

Carrivick, JL, Smith, MW & Quincey, DJ 2016, Structure from motion in the geosciences, Wiley Blackwell, Chichester, United Kingdom.

Castillo, C & Gómez, JA 2016, 'A century of gully erosion research: urgency, complexity and study approaches', *Earth-Science Reviews*, vol. 160, pp. 300–319.

Castillo, C, Taguas, EV, Zarco-Tejada, PJ, James, MR & Gómez, JA 2014, 'The normalized topographic method: an automated procedure for gully mapping using GIS', *Earth Surface Processes and Landforms*, vol. 39, no. 15, pp. 2002–2015, https://doi.org/10.1002/esp.3595

Caulfield, P 1987, *Capturing the landscape with your camera: techniques for photographing vistas and closeups in nature*, Amphoto, New York, United States.

Central Intelligence Agency 2018, *The world factbook: Europe: Finland*, viewed 4 October 2018, <https://www.cia.gov/library/publications/the-world-factbook/geos/fi.html>.

Cetinsoy, E, Dikyar, S, Hancer, C, Oner, KT, Sirimoglu, E, Unel, M & Aksit, MF 2012, 'Design and construction of a novel quad tilt-wing UAV', *Mechatronics*, vol. 22, no. 6, pp. 723–745, https://doi.org/10.1016/j.mechatronics.2012.03.003

Chabot, D, Dillon, C, Shemrock, A, Weissflog, N & Sager, E 2018, 'An object-based image analysis workflow for monitoring shallow-water aquatic vegetation in multispectral drone imagery', *ISPRS International Journal of Geo-Information*, vol. 7, iss. 8, pp. 294–309, https://doi.org/10.3390/ijgi7080294

Chandler, JH 1999, 'Effective application of automated digital photogrammetry for geomorphological research', *Earth Surface Processes and Landforms*, vol. 24, pp. 51–63, https://doi.org/10.1002/(SICI)1096-9837(199901)24:1<51::AID-ESP948>3.0.CO;2-H

Chandler, JH, Fryer, JG & Jack, A 2005, 'Metric capabilities of low-cost digital cameras for close range surface measurement', *Photogrammetric Record*, vol. 20, no. 109, pp. 12–26, https://doi.org/10.1111/j.1477-9730.2005.00302.x

Chapman, A 2013, 'What's the difference between latitude and dynamic range?', *XDCAM-USER.COM*, viewed 4 October 2018, <http://www.xdcam-user.com/2013/11/whats-the-difference-between-latitude-and-dynamic-range/>.

Charman, D 2002, *Peatlands and environmental change*, John Wiley & Sons, Chichester, England, United Kingdom.

Cheng, E 2016, *Aerial photography and videography using drones*, Peachpit Press, San Francisco, California, United States.

Chiabrando, F, Nex, F, Piatti, D & Rinaudo, F 2011 'UAV and RPV systems for photogrammetric surveys in archaelogical areas: two tests in the Piedmont region (Italy)', *Journal of Archaeological Science*, vol. 38, no. 3, pp. 697–710, https://doi.org/10.1016/j.jas.2010.10.022

Chorier, N 2016, *Kite's eye view: India between earth and sky*. Lustre Press, Roli Books, New Dehli, India.

Chorier, N 2018a, *Nicolas Chorier, photographe aérien par cerf-volant depuis 1996*, viewed 2 December 2018, <http://nicopix.zenfolio.com/presentation>.

Chorier, N 2018b, 'Eoliennes au Gujarat, et en France', viewed 12 December 2018, <http://nicopix.zenfolio.com/wind>.

Christlein, R & Braasch, O 1998, *Das unterirdische Bayern: 7000 Jahre Geschichte und Archäologie im Luftbild*, 3rd edn, Konrad Theiss, Stuttgart, Germany.

Cignoni, P, Rocchini, C & Scopigno R 1988, 'Metro: measuring error on simplified surfaces', *Computer Graphics Forum*, vol. 17, no. 2, pp. 167–174, https://doi.org/10.1111/1467-8659.00236

Clapuyt, F, Vanacker, V & Van Oost, K 2016, 'Reproducibility of UAV-based earth topography reconstructions based on structure-from-motion algorithms', *Geomorphology*, vol. 260, pp. 4–15, https://doi.org/10.1016/j.geomorph.2015.05.011

Clark RN 2016a, 'Digital Camera Sensor Performance Summary', *ClarkVision*, viewed 20 November 2018, <http://www.clarkvision.com/imagedetail/digital.sensor.performance.summary/>.

Clark RN 2016b, 'Digital Cameras: Does Pixel Size Matter? Factors in Choosing a Digital Camera', *ClarkVision*, viewed 20 November 2018, <http://www.clarkvision.com/imagedetail/does.pixel.size.matter/>.

Cohen, JL 2006, *Above Paris: the aerial survey of Roger Henrard*, Princeton Architectural Press, New York, United States.

Colby, JD 1991, 'Topographic normalization in rugged terrain', *Photogrammetric Engineering & Remote Sensing*, vol. 57, no. 5, pp. 531–537.

Colomina, I & Molina, P 2014, 'Unmanned aerial systems for photogrammetry and remote sensing: a review', *ISPRS Journal of Photogrammetry and Remote Sensing*, vol. 92, pp. 79–97, https://doi.org/10.1016/j.isprsjprs.2014.02.013

Colwell, JE 1974, 'Vegetation canopy reflectance', *Remote Sensing of Environment*, vol. 3, no. 3, pp. 175–183, https://doi.org/10.1016/0034-4257(74)90003-0

Colwell, RN 1997, 'History and place of photographic interpretation', in WR Philipson (ed.), *Manual of photographic interpretation*, 2nd edn, American Society for Photogrammetry and Remote Sensing, Bethesda, Maryland, United States, pp. 3–47.

Combrink, HJ, Delgado-Cartay, MD, Higgins, SI, February, E & Müller, M 2009, 'Spatial and seasonal patterns of NDVI along a rainfall gradient in an African savanna: preliminary results', 7th Annual Savanna Science Network Meeting, Skukuza, Mpumalanga, South Africa, viewed 5 November 2018, <http://www.sanparks.org/parks/kruger/conservation/scientific/noticeboard/science_network_meeting_2009/Presentations/combrink.pdf>.

Comer, RP, Kinn, G, Light, D & Mondello, C 1998, 'Talking digital', *Photogrammetric Engineering & Remote Sensing*, vol. 64, pp. 1139–1142, viewed 5 November 2018, <https://www.asprs.org/wp-content/uploads/pers/1998journal/dec/12-98-digital.pdf>.

Congress.gov 2018, 'S.3132—Securing airspace for emergency responders act of 2018', viewed 16 December 2018, <https://www.congress.gov/bill/115th-congress/senate-bill/3132?r=1>.

Cook, KL 2017, 'An evaluation of the effectiveness of low-cost UAVs and structure from motion for geomorphic change detection', *Geomorphology*, vol. 278, pp. 195–208, https://doi.org/10.1016/j.geomorph.2016.11.009

Cooper, M 2013a, *Flying tour—Lake Olmstead Disc Golf Course*, video, viewed 4 October 2018, <https://www.youtube.com/watch?v=8KV5o89oFgM>.

Cooper, M 2013b, *Flying tour—Riverview Park Disc Golf Course*, video, viewed 4 October 2018, <https://www.youtube.com/watch?v=hb7-XdFaezw>.

Cowardin, LM, Carter, V, Golet, FC & La Roe, ET 1979, 'Classification of wetlands and deepwater habitats in the United States', *U.S. Dept. Interior, Fish & Wildlife Service*, FWS/OBS-79/31, viewed 5 November 2018, <https://www.fws.gov/wetlands/Documents/Classification-of-Wetlands-and-Deepwater-Habitats-of-the-United-States.pdf>.

Cummings, A, McKee, A, Kulkarni, K & Markandey, N 2017, 'The rise of UAVs', *Photogrammetric Engineering & Remote Sensing*, vol. 83, no. 4, pp. 317–325, https://doi.org/10.14358/PERS.83.4.317

Cunliffe, AM, Brazier, RE & Anderson, K 2016, 'Ultra-fine grain landscape-scale quantification of dryland vegetation structure with drone-acquired structure-from-motion photogrammetry', *Remote Sensing of Environment*, vol. 183, pp. 129–143, https://doi.org/10.1016/j.rse.2016.05.019

Dalamagkidis, K 2015, 'Definitions and terminology', in *Handbook of Unmanned Aerial Vehicles*, KP Valavanis & GJ Vachtsevanos (eds), Springer, Dordrecht, Netherlands pp. 43–55.

De Castro, AI, Jiménez-Brenes, FM, Torres-Sánchez, J, Peña, JM, Borra-Serrano, I & López-Granados, F 2018, '3-D characterization of vineyards using a novel UAV imagery-based OBIA procedure for precision viticulture applications', *Remote Sensing*, vol. 10, no. 4, pp. 1–16, https://doi.org/10.3390/rs10040584

Defibaugh, D 2007, 'Landscape photograph', in MR Peres (ed.), *Focal encyclopedia of photography: digital imaging, theory and applications, history, and science*, 4th edn, Elsevier, Amsterdam, p. 333.

DeLoach, CJ & Gould, J 1998, *Biological control of exotic, invading saltcedar (Tamarix spp.) by the introduction of Tamarix-specific control insects from Eurasia, Proposal to U.S. Fish and Wildlife Service*, USDA Agricultural Research Service, Temple, TX and USDA Animal and Plant Health Inspection Service, Plant Protection and Quarantine, Phoenix, AZ.

DeLoach, CJ, Knutson, AE, Moran, PJ, Michels, GJ, Thompson, DC, Carruthers, RI, Nibling, F & Fain, TG 2007, 'Biological control of saltcedar (Cedro salado) (*Tamarix* spp.) in the United States, with implications for Mexico', in RH Lira-Saldivar (ed.), *Bioplaguicidas y Control Biologico*, International Symposium of Sustainable Agriculture, 24-26 October 2007, Saltillo, Coahula, Mexico, pp. 126–155, viewed 5 October 2018, <https://www.scribd.com/doc/104712074/Bioplaguicidas-Y-Control-Biologico>.

Dempsey, T 2016, *Sensor size comparisons for digital cameras, digital image*, PhotoSeek.com, viewed 20 November 2018, <http://photoseek.com/wp-content/uploads/Sensor-sizes_PhotoSeek.jpg>.

Deutsches Jugendinstitut 2016, *Above the world, Earth through a drone's eye*, TeNeues Publishing Group, Kempen, Germany.

Dewey, J 2004, 'Thinking laterally', in D Russell (ed.), *GSA GeoTales*, vol. 1, Geological Society of America, Boulder, Colorado, United States, pp. 94–95, viewed 10 November 2018, <http://www.gsafweb.org/wp-content/uploads/2014/11/GSA-GeoTales1.pdf>.

DGCourseReview 2018, *View and review over 8000 disc golf courses!*, viewed 4 October 2018, <https://www.dgcoursereview.com/>.

Diaz-Varela, RA, Zarco-Tejada, PJ, Angileri, V & Loudjani, P 2014, 'Automatic identification of agricultural terraces through object-oriented analysis of very high resolution DSMs and multispectral imagery obtained from an unmanned aerial vehicle', *Journal of Environmental Management*, vol. 134, pp. 117–126, https://doi.org/10.1016/j.jenvman.2014.01.006

Dickinson, WR 2009, 'Pacific atoll living: how long already and until when?', *Geological Society of America GSA Today*, vol. 19, no. 3, cover and pp. 4–10, viewed 20 November 2018, <https://www.geosociety.org/gsatoday/archive/19/3/pdf/i1052-5173-19-3-4.pdf>, https://doi.org/10.1130/GSATG35A.1

Dippie, BW, Heyman, TT, Mulvey, C & Troccoli, JC 2002, 'George Catlin and his Indian gallery', in G Gurney & TT Heyman (eds), *Smithsonian American Museum of Art*, W.W. Norton & Co., New York, United States, p. 294.

Disc Golf Pro Tour 2016, *Disc golf bigger than ball golf in five or ten years?*, viewed 25 September 2018, <https://www.dgpt.com/news/disc-golf-bigger-than-ball-golf-in-five-or-ten-years>.

DJI 2018, *Phantom 4 RTK user manual*, viewed 21 December 2018, <http://dl.djicdn.com/downloads/phantom_4_rtk/20181015/Phantom_4_RTK_User_Manual_v1.4_EN_.pdf>.

d'Oleire-Oltmanns, S, Marzolff, I, Peter, KD & Ries, JB 2012, 'Unmanned Aerial Vehicle (UAV) for monitoring soil erosion in Morocco', *Remote Sensing*, vol. 4, no. 11, pp. 3390–3416, https://doi.org/10.3390/rs4113390

Dougherty, K 2016, 'Gaia GPS & China's GPS restrictions', *Gaia GPS*, viewed 24 November 2018, <http://blog.gaiagps.com/gaia-gps-chinas-gps-restrictions/>.

Douxchamps, D 2017, *A small list of IMU/INS/INU*, viewed 21 December 2018, <https://damien.douxchamps.net/research/imu/>.

Drone Industry Insights 2018, *The European drone industry: drone industry barometer 2018*, viewed 21 December 2018, <https://www.droneii.com/wp-content/uploads/2018/06/The-European-Drone-Industry-v1.1.pdf>.

Drury, SA 2001, *Image interpretation in geology*, 3rd edn, Blackwell Science, Malden, Massachusetts, United States.

Dubois, WW 2007, 'Architectural photography', in MR Peres (ed.), *Focal encyclopedia of photography*, 4th edn, Elsevier, Amsterdam, Netherlands, pp. 325–326.

Duffy, JP & Anderson, K 2016, 'A 21st-century renaissance of kites as platforms for proximal sensing', *Progress in Physical Geography*, vol. 40, no. 2, pp. 352–361, https://doi.org/10.1177/0309133316641810

Dunakin, R.R. III 2008, 'Rocketry', *Ray Dunakin's World*, viewed 24 November 2018, <http://www.raydunakin.com/Site/Rocketry.html>.

Dunford, R, Michel, K, Gagnage, M, Piégay, H & Trémolo, M-L 2009, 'Potential and constraints of unmanned aerial vehicle technology for the characterization of Mediterranean riparian forest', *International Journal of Remote Sensing*, vol. 30, no. 19, pp. 4915–4935, https://doi.org/10.1080/01431160903023025

Dynamic Discs 2018, *About us*, viewed 4 October 2018, <https://www.dynamicdiscs.com/aboutus.asp>.

Ebeid, E, Skriver, M, Terkildsen, KH, Jensen, K & Schultz, UP 2018, 'A survey of Open-Source UAV flight controllers and flight simulators', *Microprocessors and Microsystems*, vol. 61, pp. 11–20, https://doi.org/10.1016/j.micpro.2018.05.002

Eberts, D, White, L, Broderick, S, White, S, Nelson, SM & Wydoski, R 2003, *Biological control of saltcedar at Pueblo, Colorado: summary of research and insect, vegetation and wildlife monitoring—1997–2002*, Technical Memorandum No. 8220-03-06, Denver, Colorado, U.S. Bureau of Reclamation, Technical Service Center.

Eltner, A & Schneider, D 2015, 'Analysis of different methods for 3D reconstruction of natural surfaces from parallel-axes UAV images', *The Photogrammetric Record*, vol. 30, no. 151, pp. 279–299.

Eltner, A, Baumgart, P, Maas, HG & Faust, D 2015. 'Multi-temporal UAV data for automatic measurement of rill and interrill erosion on loess soil'. *Earth Surface Processes and Landforms*, vol. 40, no. 6, pp. 741–755, https://doi.org/10.1002/esp.3673

Eltner, A, Kaiser, A, Castillo, C, Rock, G, Neugirg, F & Abellán, A 2016, 'Image-based surface reconstruction in geomorphometry—merits, limits and developments'. *Earth Surface Dynamics*, vol. 4, no. 2, pp. 359–389, https://doi.org/10.5194/esurf-4-359-2016

Eltner, A, Maas, H-G & Faust, D 2018, 'Soil micro-topography change detection at hillslopes in fragile Mediterranean landscapes', *Geoderma*, vol. 313, pp. 217–232, https://doi.org/10.1016/j.geoderma.2017.10.034

Elwell H & Stocking, MA 1974, 'Rainfall parameters and a cover model to predict runoff and soil loss from grazing trials in the Rhodesian sandveld', *Proceedings of the annual congresses of the grassland society of southern Africa*, vol. 9, no. 1, pp. 157–164, https://doi.org/10.1080/00725560.1974.9648736

Emery, WJ & Schmalzel, J 2018, 'Editorial for "remote sensing from unmanned aerial vehicles"', *Remote Sensing*, vol. 10, no. 12, p. 1877, https://doi.org/10.3390/rs10121877

Engineering ToolBox 2003, *U.S. standard atmosphere*, viewed 30 October 2018, <https://www.engineeringtoolbox.com/standard-atmosphere-d_604.html>.

EOL (Encyclopedia of Life) Prairie Dog 2017, *Cynomys ludovicianus: black-tailed prairie dog*, viewed 5 October 2018, <http://eol.org/pages/311548/details>.

Eriksen, P & Olesen, LH 2002, *Fortiden set fra himlen: luftfotoarkæologi i Vestjylland*. Holstebro Museum, Holstebro, Denmark.

Espinar, V & Wiese, D 2006, 'Guided to gather: toy plane upgraded with telemetry', *GPS World*, vol. 17, no. 2, pp. 32–38.

European Aviation Safety Agency 2009, *Airworthiness certification of unmanned aircraft systems (UAS)*, Policy Statement E.Y013-01, viewed

9 September 2019, https://www.easa.europa.eu/sites/default/files/dfu/E.Y013-01_%20UAS_%20Policy.pdf.

Evans, T & Worster, D 1998, *The inhabited prairie*, University of Kansas Press, Lawrence, Kansas, United States.

Everaerts, J 2008, 'The use of unmanned aerial vehicles (UAVs) for remote sensing and mapping', *International Archives of Photogrammetry, Remote Sensing and Spatial Information Sciences*, vol. 37, no. B1, pp. 1187–1191.

Everitt, JH, Yang, C, Alaniz, MA & Davis, MR 2006, 'Remote mapping of saltcedar in the Rio Grande System of Texas', *Texas Journal of Science*, vol. 58, no. 1, pp. 13–22.

Experimental Aircraft Association 2017, *FAA sport pilot rule*, viewed 23 November 2018, <https://www.eaa.org/eaa/aviation-interests/light-sport-aircraft/getting-started-in-lsa/become-a-sport-pilot-and-fly-light-sport-aircraft/faa-sport-pilot-rule>.

Eyton, JR 1990, 'Color stereoscopic effect cartography', *Cartographica: The International Journal for Geographic Information and Geovisualization*, vol. 27, no. 1, pp. 20–29, https://doi.org/10.3138/K213-2288-7672-U72T

FAA 2007. *Balloon flying handbook*. Skyhorse Publishing, New York, United States, viewed 24 November 2018, <https://www.faa.gov/regulations_policies/handbooks_manuals/aircraft/media/FAA-H-8083-11.pdf>.

FAA 2014, 'Interpretation of the Special Rule for Model Aircraft', *14 CFR Part 91*, U.S. Federal Aviation Administration, viewed 9 September 2019, https://www.faa.gov/uas/educational_users/media/model_aircraft_spec_rule.pdf.

FAA, 2016a, 'Summary of small unmanned aircraft rule, part 107', *News*, U.S. Federal Aviation Administration, Washington, D.C., United States, viewed 23 November 2018, <https://www.faa.gov/uas/media/Part_107_Summary.pdf>.

FAA 2016b, 'Getting started', *Unmanned Aircraft Systems*, U.S. Federal Aviation Administration, viewed 23 November 2018, <https://www.faa.gov/uas/getting_started/>.

FAA 2016c, 'Educational use of unmanned aircraft systems (UAS)', *Memorandum*, U.S. Federal Aviation Administration, Washington, D.C., United States, viewed 9 September 2019, https://www.faa.gov/uas/resources/policy_library/media/Interpretation-Educational-Use-of-UAS.pdf.

FAA 2018, 'Program overview', *UAS Integration Pilot Program*, U.S. Federal Aviation Administration, Washington, D.C., United States, viewed 12 January 2019, <https://www.faa.gov/uas/programs_partnerships/integration_pilot_program/>.

FAI 2018, *Frequencies*, FAI Aeromodelling Commission (CIAM), viewed 21 December 2018, <https://www.fai.org/page/frequencies>.

Fairbridge, RW 1968, 'Preface', in RW Fairbridge (ed.), *The encyclopedia of geomorphology*, Dowden, Hutchinson & Ross, Stroudsburg, Pennsylvania, United States, pp. v–xi.

Family Search 2016, *Denmark cemeteries*, viewed 5 October 2018, <https://familysearch.org/wiki/en/Denmark_Cemeteries>.

Farid, H 2017, 'How to detect faked photos', *American Scientist*, vol. 105, no. 2, pp. 77–81, viewed 5 November 2018, <https://www.americanscientist.org/article/how-to-detect-faked-photos>, https://doi.org/10.1511/2017.105.2.77

Fazeli, H, Samadzadegan, F & Dadrasjavan, F 2016, 'Evaluating the potential of RT-UAV for automatic point cloud generation in 3D rapid mapping', *International Archives of Photogrammetry, Remote Sensing and Spatial Information Sciences*, vol. XLI-B6, pp. 221–226, https://doi.org/10.5194/isprs-archives-XLI-B6-221-2016

Feil, C, Zepp, A & Rose, E 2005, *The Finger Lakes region of New York, United States: a view from above*. VFA Publishing LLC, Scarborough, Maine, United States.

Fengler, A 2007, *Flächen- und standortbezogene geomorphologische und bodenkundliche Untersuchungen zur Bodentypenverteilung in einem Lössgebiet der Wetterau im Umfeld eines neolithischen Siedlungsplatzes*, Habelt, Bonn, Germany.

Fernández-Hernández, J, González-Aguilera, D, Rodríguez-Gonzálvez, P & Mancera-Taboada, J 2015, 'Image-based modelling from unmanned aerial vehicle (UAV) photogrammetry: an effective, low-cost tool for archaeological applications, *Archaeometry*, vol. 57, no. 1, pp. 128–145, https://doi.org/10.1111/arcm.12078

Feurer, D, Planchon, O, El Maaoui, MA, Ben Slimane, A, Boussema, MR, Pierrot-Deseilligny, M & Raclot, D 2018, 'Using kites for 3-D mapping of gullies at decimetre-resolution over several square kilometres: a case study on the Kamech catchment, Tunisia', *Natural Hazards and Earth System Sciences*, vol. 18, no. 6, pp. 1567–1582, https://doi.org/10.5194/nhess-18-1567-2018

Figueroa, D IV 2018, 'Tampa mom, daughter caught making prison delivery by drone, deputies say', *Tampa Bay Times*, viewed 23 December 2018, <https://www.tampabay.com/news/publicsafety/tampa-mom-daughter-caught-with-drone-delivering-phones-tobacco-to-prison-deputies-say-20181219/>.

Finney, A 2007, 'Infrared photography', in MR Peres (ed.), *Focal encyclopedia of photography: digital imaging, theory and applications, history, and science*, 4th edn, Elsevier, Amsterdam, pp. 556–561.

Fischer, G 2016, 'Mit Drohne auf dem Mount Everest', *Süddeutsche Zeitung*, viewed 30 October 2018, <https://www.sueddeutsche.de/muenchen/film-mit-drohne-auf-dem-mount-everest-1.3186414>.

Fonstad, MA, Dietrich, JT, Courville, BC, Jensen, JL & Carbonneau, PE 2013, 'Topographic structure from motion: a new development in photogrammetric measurement', *Earth Surface Processes and Landforms*, vol. 38, no. 4, pp. 421–430, https://doi.org/10.1002/esp.3366

Förstner, W & Wrobel, BP 2016, *Photogrammetric computer vision: statistics, geometry, orientation and reconstruction*, Springer International Publishing AG, Cham, Switzerland.

Fort Dodge 2014, *Fort Dodge, Kansas, Santa Fe Trail, Ford County, Kansas*, viewed 5 October 2018, <http://www.santafetrailresearch.com/research/fort-dodge.html>.

Fouché, PS & Booysen, NW 1994, 'Assessment of crop stress conditions using low altitude aerial color-infrared photography and computer image processing', *Geocarto International*, vol. 9, no. 2, pp. 25–31, https://doi.org/10.1080/10106049409354447

Fraga, H, Malheiro, AC, Moutinho-Pereira, J & Santos, JA 2012, 'An overview of climate change impacts on European viticulture', *Food and Energy Security*, vol. 1, no. 2, pp. 94–110, https://doi.org/10.1002/fes3.14

Frankl, A, Poesen, J, Deckers, J, Haile, M & Nyssen, J 2012, 'Gully head retreat rates in the semi-arid highlands of Northern Ethiopia', *Geomorphology*, vol. 173–174, pp. 185–195, https://doi.org/10.1016/j.geomorph.2012.06.011

Frankl, A, Stal, C, Abraha, A, Nyssen, J, Rieke-Zapp, D, De Wulf, A & Poesen, J 2015, 'Detailed recording of gully morphology in 3D through image-based modelling', *Catena*, vol. 127, pp. 92–101, https://doi.org/10.1016/j.catena.2014.12.016

Franzwa, GM 1989, *Maps of the Santa Fe Trail*, St. Louis, Missouri, United States, Patrice Press.

Fraser, CS 1997, 'Digital camera self-calibration', *ISPRS Journal of Photogrammetry and Remote Sensing*, vol. 52, no. 4, pp. 149–159, https://doi.org/10.1016/S0924-2716(97)00005-1

Fryer, JG, Mitchell, HL & Chandler, JH (eds) 2007, *Applications of 3D measurement from images*, Whittles, Dunbeath, Scotland, United Kingdom.

Furukawa, Y & Ponce, J 2010, 'Accurate, dense, and robust multiview stereopsis', *IEEE Transactions on Pattern Analysis and Machine Intelligence*, vol. 32, no. 8, pp. 1362–1376, https://doi.org/10.1109/TPAMI.2009.161

Furukawa, Y, Curless, B, Seitz, SM & Szeliski, R 2010, 'Towards internet-scale multi-view stereo', in *Proceedings of the IEEE Computer Society Conference on Computer Vision and Pattern Recognition (CVPR)*, Piscataway, New Jersey, United States, 13-18 June 2010, pp. 1434–1441, https://doi.org/10.1109/CVPR.2010.5539802

Gábris, G, Kertész, Á & Zámbó, L 2003, 'Land use change and gully formation over the last 200 years in a hilly catchment', *Catena*, vol. 50, no. 2–4, pp. 151–164, https://doi.org/10.1016/S0341-8162(02)00141-8

Gambino, M 2008, 'Danger zones', *Smithsonian*, vol. 38, no. 10, pp. 52–57, viewed 5 November 2018, <https://www.smithsonianmag.com/arts-culture/danger-zones-7730645/>.

García-Ruiz, JM, Lasanta, T, Ruiz-Flano, P, Ortigosa, L, White, S, González, C & Martí, C 1996, 'Land-use changes and sustainable development in mountain areas: a case study in the Spanish Pyrenees', *Landscape Ecology*, vol. 11, no. 5, pp. 267–277.

García-Ruiz, JM, Arnáez, J, Beguería, S, Seeger, M, Martí-Bono, C, Regüés, D, Lana-Renault, N & White, S 2005, 'Runoff generation in an intensively disturbed, abandoned farmland catchment, Central Spanish Pyrenees', *Catena*, vol. 59, no. 1, pp. 79–92, https://doi.org/10.1016/j.catena.2004.05.006

Gear, ES 2016, *12 drone photographers changing the way we see the world*, Feature Shoot, viewed 22 December 2018, <https://www.featureshoot.com/2016/11/12-drone-photographers-changing-the-way-we-see-the-world/>.

Gérard, B, Buerkert, A, Hiernaux, P & Marschner, H 1997, 'Non-destructive measurement of plant growth and nitrogen status of pearl millet with low-altitude aerial photography', in T Ando, K Fujita, T Mae, H Matsumoto, S Mori & J Sekiya (eds), *Plant nutrition for sustainable food production and environment: developments in plant and soil sciences*, vol. 78, Kluwer Academic Publishing, Dordrecht, Netherlands, pp. 373–378, https://doi.org/10.1007/978-94-009-0047-9_113

Gerster, G 2004, *Weltbilder: 70 Flugbilder aus sechs Kontinenten*, Schirmer/Mosel, München, Germany.

Giménez, R, Marzolff, I, Campo, MA, Seeger, M, Ries, JB, Casalí, J & Álvarez-Mozos, J 2009, 'Accuracy of high-resolution photogrammetric measurements of gullies with contrasting morphology', *Earth Surface Processes and Landforms*, vol. 34, no. 14, pp. 1915–1926, https://doi.org/10.1002/esp.1868

Gindraux, S, Boesch R & Farinotti, D 2017, 'Accuracy assessment of digital surface models from unmanned aerial vehicles' imagery on glaciers', *Remote Sensing*, vol. 9, no. 2, iss.186, pp. 1–15, https://doi.org/10.3390/rs9020186

GISCafé 2011, *Z/I imaging releases high-end large format digital camera system DMC II 250*, viewed 4 October 2018, <http://www10.giscafe.com/nbc/articles/1/978476/z-imaging-releases-high-end-large-format-digital-camera-system-dmc-ii-250>.

Gómez-Lahoz, J & Gonzáles-Aguilera, D 2009, 'Recovering traditions in the digital era: the use of blimps for modelling the archaeological cultural heritage', *Journal of Archaeological Science*, vol. 36, no. 1, pp. 100–109, https://doi.org/10.1016/j.jas.2008.07.013

Gonçalves, JA & Henriques, R 2015, 'UAV photogrammetry for topographic monitoring of coastal areas', *ISPRS Journal of Photogrammetry and Remote Sensing*, vol. 104, pp. 101–111, https://doi.org/10.1016/j.isprsjprs.2015.02.009

Gonzalez-Aguilera, D & Rodriguez-Gonzalvez, P 2017, 'Drones—an open access journal', *Drones*, vol. 1, no. 1, p. 1, https://doi.org/10.3390/drones1010001

GPO 2012, 'Part 101—Moored balloons, kites, amateur rockets and unmanned balloons', *CFR-2012-title4-vol12-101*, U.S. Federal Aviation Administration, U.S. Government Printing Office, Washington, D.C., pp. 881–886, viewed 24 November 2018, https://www.gpo.gov/fdsys/pkg/CFR-2012-title14-vol2/pdf/CFR-2012-title14-vol2-part101.pdf.

GPS.gov 2018, *Selective availability*, U.S. National Coordination Office for Space-Based Positioning, Navigation, and Timing, viewed 9 December 2018, <https://www.gps.gov/systems/gps/modernization/sa/>.

Granshaw, SI 2018, 'RPV, UAV, UAS, RPAS … or just drone?', *The Photogrammetric Record*, vol. 33, no. 162, pp. 160–170, https://doi.org/10.1111/phor.12244

Gravenor, CP, Green, R & Godfrey, JD 1960, *Air photographs of Alberta*, Research Council of Alberta, Bulletin 5, viewed 20 November 2018, <https://ags.aer.ca/document/BUL/BUL_005.pdf>.

Grenzdörffer, G & Bill, R (eds) 2013, *Proceedings of the international conference on unmanned aerial vehicles in geomatics (UAV-g2013)*, Rostock, Germany, 4–6 September 2013, *International Archives of Photogrammetry, Remote Sensing and Spatial Information Sciences*, vol. XL-1/W2, viewed 21 December 2018, <https://www.int-arch-photogramm-remote-sens-spatial-inf-sci.net/XL-1-W2/>.

Grigonis, H 2018, 'Panasonic has an industry-first global-shutter organic sensor that shoots 8K', *Digital Trends*, viewed 24 November 2018, <https://www.digitaltrends.com/photography/panasonic-global-shutter-organic-sensor-is-an-industry-first/>.

Grün, A 2012, 'Development and status of image matching in photogrammetry', *The Photogrammetric Record*, vol. 27, no. 137, pp. 36–57, https://doi.org/10.1111/j.1477-9730.2011.00671.x

Gudino-Elizondo, N, Biggs, TW, Castillo, C, Bingner, RL, Langendoen, EJ, Taniguchi, KT, Kretzschmar, T, Yuan, Y & Liden, D 2018, 'Measuring ephemeral gully erosion rates and topographical thresholds in an urban watershed using unmanned aerial systems and structure from motion photogrammetric techniques', *Land Degradation & Development*, vol. 29, no. 6, pp. 1896–1905, https://doi.org/10.1002/ldr.2976

Hake, G, Grünreich, D & Meng, L 2002, *Kartographie. Visualisierung raum-zeitlicher Informationen*, De Gruyter, Berlin, Germany.

Hall, RC 1997, 'Post war strategic reconnaissance and the genesis of project Corona', in RA McDonald (ed.), *Corona: between the Sun & the Earth, the first NRO reconnaissance eye in space*, American Society of Photogrammetry and Remote Sensing, Bethesda, Maryland, United States, pp. 25–58.

Ham, WE & Curtis, NM 1960, *Common minerals, rocks, and fossils of Oklahoma*, Oklahoma Geological Survey, Guide Book X.

Hamblin, WK 2004, *Beyond the visible landscape: aerial panoramas of Utah's Geology*, BYU Geology, Provo, Utah, United States.

Hankewitz, S 2018, 'The world's first 5G phone call made in Tallinn', *Estonian World*, viewed 9 December 2018, <http://estonianworld.com/technology/the-worlds-first-5g-phone-call-made-in-tallinn/>.

Hapke, B, DiMucci, D, Nelson, R & Smythe, W 1996, 'The cause of the hot spot in vegetation canopies and soils: shadow-hiding versus coherent backscatter', *Remote Sensing of Environment*, vol. 58, no. 1, pp. 63–68, https://doi.org/10.1016/0034-4257(95)00257-X

Hapke, C & Richmond, B 2000, 'Monitoring beach morphology changes using small-format aerial photography and digital softcopy photogrammetry', *Environmental Geosciences*, vol. 7, no. 1, pp. 32–37, https://doi.org/10.1046/j.1526-0984.2000.71001.x

Hardin, PJ & Jackson, MW 2005, 'An unmanned aerial vehicle for rangeland photography', *Rangeland Ecology & Management*, vol. 58, no. 4, pp. 439–442, https://doi.org/10.2111/1551-5028(2005)058[0439:AUAVFR]2.0.CO;2

Hardin, PJ & Jensen, RR 2011, 'Introduction—Small-scale unmanned aerial systems for environmental remote sensing', *GIScience & Remote Sensing*, vol. 48, no. 1, pp. 1–3, https://doi.org/10.2747/1548-1603.48.1.1

Hardin, PJ, Lulla, V, Jensen, RR & Jensen, JR 2018, 'Small Unmanned Aerial Systems (sUAS) for environmental remote sensing: challenges and opportunities revisited', *GIScience & Remote Sensing*, vol. 37, no. 4, pp. 1–14, https://doi.org/10.1080/15481603.2018.1510088

Hart, C 1982, *Kites: an historical survey*, 2nd edn, P. P. Appel, Mt. Vernon, New York, United States.

Hart, JK, Clayton, AI, Martinez, K & Robson, BA 2018, 'Erosional and depositional subglacial streamlining processes at Skálafellsjökull, Iceland: an analogue for a new bedform continuum model', *GFF, Journal of the Geological Society of Sweden*, vol. 140, no. 2, pp. 153–169, https://doi.org/10.1080/11035897.2018.1477830

Hartmann, W, Havlena, M & Schindler, K 2016, 'Recent developments in large-scale tie-point matching', *ISPRS Journal of Photogrammetry and Remote Sensing*, vol. 115, pp. 47–62, https://doi.org/10.1016/j.isprsjprs.2015.09.005

Harwin, S, Lucieer, A & Osborn, J 2015, 'The impact of the calibration method on the accuracy of point clouds derived using unmanned aerial vehicle multi-view stereopsis', *Remote Sensing*, vol. 7, no. 9, pp. 11933–11953, https://doi.org/10.3390/rs70911933

Heckes J 1987, 'Überblick über Kammerträger für Luftaufnahmen im Nahbereich', in International Society for Photogrammetry and Remote Sensing (ISPRS) & Deutsches Bergbau-Museum (DBM) (eds), *Luftaufnahmen aus geringer Flughöhe. Veröffentlichungen aus dem Deutschen Bergbaumuseum*, vol. 41, Bochum, Germany, pp. 25–32.

Heisey, A 2007, 'Archaeology of the skies', *American Archaeology*, vol. 11, no. 4, pp. 20–27.

Heisey, A & Kawano, K 2001, *In the fifth world: portrait of the Navajo Nation*, Rio Nuevo Publishers, Tucson, Arizona, United States.

Henry, J-B, Malet, J-P, Maquaire, O & Grussenmeyer, P 2002, 'The use of small-format and low-altitude aerial photos for the realization of high-resolution DEMs in mountainous areas: application to the Super-Sauze earthflow (Alpes-de-Haute-Provence, France)', *Earth Surface Processes and Landforms*, vol. 27, no. 12, pp. 1339–1350, https://doi.org/10.1002/esp.411

Hernández-Clemente, R, Navarro-Cerrillo, RM, Romero Ramírez, FJ, Hornero, A & Zarco-Tejada, PJ 2014, 'A novel methodology to estimate single-tree biophysical parameters from 3D digital imagery compared to aerial laser scanner data', *Remote Sensing*, vol. 6, no. 11, pp. 11627–11648, https://doi.org/10.3390/rs61111627

Hervouet, A, Dunford, R, Piégay, H, Belletti, B & Trémélo, M-L 2011, 'Analysis of post-flood recruitment patterns in braided-channel rivers at multiple scales based on an image series collected by unmanned aerial vehicles, ultra-light aerial vehicles, and satellites', *GIScience & Remote Sensing*, vol. 48, no. 1, pp. 50–73, https://doi.org/10.2747/1548-1603.48.1.50

Higgins, SI, Delgado-Cartay, MD, February, EC & Combrink, HJ 2011, 'Is there a temporal niche separation in the leaf phenology of savanna trees and grasses?', *Journal of Biogeography*, vol. 38, no. 11, pp. 2165–2175, https://doi.org/10.1111/j.1365-2699.2011.02549.x

Hill, S 2018, 'Glass Blown Open shatters attendance records', *Professional Disc Golf Association*, viewed 4 October 2018, <https://www.pdga.com/glass-blown-open-shatters-attendance-records>.

Hirschmüller, H 2008, 'Stereo processing by semiglobal matching and mutual information', *IEEE Transactions on Pattern Analysis and Machine Intelligence*, vol. 30, no. 2, pp. 328–341, https://doi.org/10.1109/TPAMI.2007.1166

Hoffhaus, CE 1984, *Chez les Canses: three centuries at Kawsmouth, the French foundations of metropolitan Kansas City*, Lowell Press, Kansas City, Missouri, United States.

Hoffmann, H, Jensen, R, Thomsen, A, Nieto, H, Rasmussen, J & Friborg, T 2016, 'Crop water stress maps for an entire growing season from visible and thermal UAV imagery', *Biogeosciences*, vol. 13, no. 24, pp. 6545–6563, viewed 20 November 2018, <https://www.biogeosciences.net/13/6545/2016/bg-13-6545-2016.pdf>, https://doi.org/10.5194/bg-13-6545-2016

Holz, RK, Baker, RD, Baker, S, Haack, BN, Lindgren, DT & Stow, DA 1997, 'Structures and cultural features', in WR Philipson (ed.), *Manual of photographic interpretation*, 2nd edn, American Society for Photogrammetry and Remote Sensing, Bethesda, Maryland, United States, pp. 269–308.

Hornschuch, A & Lechtenbörger C 2004, 'Fernerkundungsdaten und topographische Karten zur Dokumentation des sabäischen Kulturerbes in der Republik Jemen', *Kartographische Nachrichten*, vol. 2004, no. 3, pp. 112–117.

Hou, J, Wang, H, Fuc, B, Zhu, L, Wang, Y & Li, Z 2016, 'Effects of plant diversity on soil erosion for different vegetation patterns', *Catena*, vol. 147, pp. 632–637, https://doi.org/10.1016/j.catena.2016.08.019

Hugenholtz, CH, Whitehead, K, Brown, OW, Barchyn, TE, Moorman, BJ, LeClair, A, Riddell, K & Hamilton, T 2013, 'Geomorphological mapping with a small unmanned aircraft system (sUAS): feature detection and accuracy assessment of a photogrammetrically-derived digital terrain model', *Geomorphology*, vol. 194, pp. 16–24, https://doi.org/10.1016/j.geomorph.2013.03.023

Hughes, TJ, Denton, GH, Andersen, BG, Schilling, DH, Fastook, JL & Lingle, CS 1981, 'The last great ice sheets: a global view', in GH Denton & TJ Hughes (eds), *The last great ice sheets*, J. Wiley & Sons, New York, United States, pp. 263–317.

Hunt Jr, ER, Everitt, JH, Ritchie, JC, Moran, MS, Booth, DT, Anderson, GL, Clark, PE & Seyfried, MS 2003, Applications and research using remote sensing for rangeland management. *Photogrammetric Engineering & Remote Sensing*, vol. 69, no. 6, pp. 675–693, https://doi.org/10.14358/pers.69.6.675

Hunt Jr, ER, Cavigelli, M, Daughtry, CST, McMurtrey, JE III & Walthall, CL 2005, 'Evaluation of digital photography from model aircraft for remote sensing of crop biomass and nitrogen status', *Precision Agriculture*, vol. 6, no. 4, pp. 359–378, https://doi.org/10.1007/s11119-005-2324-5

Hunt Jr, ER, Hively, WD, McCarty, GW, Daughtry, CST, Forrestal, PJ, Kratochvil, RJ, Carr, JL, Allen, NF, Fox-Rabinovitz, JR & Miller, CD 2011, 'NIR-green-blue high-resolution digital images for assessment of winter cover crop biomass', *GIScience & Remote Sensing*, vol. 48, no. 1, pp. 86–98, https://doi.org/10.2747/1548-1603.48.1.86

Husson, E, Reese, H & Ecke, F 2017, 'Combining spectral data and a DSM from UAS-images for improved classification of non-submerged aquatic vegetation', *Remote Sensing*, vol. 9, no. 3, p. 247, https://doi.org/10.3390/rs9030247

ICAO (International Civil Aviation Organization) 2015, *Manual on remotely piloted aircraft systems (RPAS)*. ICAO Document 10019-AN/507, Montréal, Quebec, Canada, viewed 1 January 2019, <http://www.aviationchief.com/uploads/9/2/0/9/92098238/icao_doc_10019_-_rpas_1.pdf>.

Ilomets, M 1982, 'The productivity of *Sphagnum* communities and the rate of peat accumulation in Estonian bogs', in V Masing (ed.), *Peatland ecosystems: researches into the plant cover of Estonian bogs and their productivity*, Valgus, Tallinn, pp. 102–116.

Immerzeel, WW, Kraaijenbrink, PDA, Shea, JM, Shrestha, AB, Pellicciotti, F, Bierkens, MFP & de Jong, SM 2014, 'High-resolution monitoring of Himalayan glacier dynamics using unmanned aerial vehicles', *Remote Sensing of Environment*, vol. 150, pp. 93–103, https://doi.org/10.1016/j.rse.2014.04.025

InciWeb 2018, '*Spring Creek Fire*', Incident Information System, viewed 1 July 2018, <https://inciweb.nwcg.gov/incident/5875>.

Inoue, Y, Morinaga, S & Tomita, A 2000, 'A blimp-based remote sensing system for low-altitude monitoring of plant variables: a preliminary experiment for agricultural and ecological applications', *International Journal of Remote Sensing*, vol. 21, no. 2, pp. 379–385, https://doi.org/10.1080/014311600210894

InternetLiveStats.com 2018, *Total number of websites—Internet Live Stats*, viewed 9 December 2018, <http://www.internetlivestats.com/total-number-of-websites/>.

Jacobs, S 2018. 'These eerie photos of deserted golf courses reveal a new normal in America', *Business Insider*, viewed 25 September 2018, <https://www.businessinsider.com/inside-two-abandoned-golf-courses-2017-6>.

Jacobson, C 2008, *Knots for the outdoors*, Falcon Guides, Guilford, Connecticut, United States.

James, MR & Robson, S 2012, 'Straightforward reconstruction of 3D surfaces and topography with a camera: accuracy and geoscience application', *Journal of Geophysical Research: Earth Surface*, vol. 117, iss. F3, pp. 1–17, https://doi.org/10.1029/2011JF002289

James, MR & Robson, S 2014, 'Mitigating systematic error in topographic models derived from UAV and ground-based image networks', *Earth Surface Processes and Landforms*, vol. 39, no. 10, pp. 1413–1420, https://doi.org/10.1002/esp.3609

James, MR, Robson, S, d'Oleire-Oltmanns, S & Niethammer, U 2017a, 'Optimising UAV topographic surveys processed with structure-from-motion: ground control quality, quantity and bundle adjustment', *Geomorphology*, vol. 280, pp. 51–66, https://doi.org/10.1016/j.geomorph.2016.11.021

James, MR, Robson, S & Smith, MW 2017b, '3-D uncertainty-based topographic change detection with structure-from-motion photogrammetry: precision maps for ground control and directly georeferenced surveys', *Earth Surface Processes and Landforms*, vol. 42, no. 12, pp. 1769–1788, https://doi.org/10.1002/esp.4125

Janočko, J, Pereszlényi, M, Vass, D, Bezák, V, Kohút, M, Poiák, M, Mello, J, Jacko Jr, S & Jacko, S 2006, 'Geology and hydrocarbon resources of the Inner Western Carpathians, Slovakia, and Poland', in J Golonka & FJ Picha (eds.), *The Carpathian and their foreland: geology and hydrocarbon resources*, American Association of Petroleum Geologists, Memoir vol. 84, Tulsa, Oklahoma, United States, pp. 569–603, https://doi.org/10.1306/985620M843078

Jaud, M, Grasso, F, Le Dantec, N, Verney, R, Delacourt, C, Ammann, J, Deloffre, J & Grandjean, P 2016, 'Potential of UAVs for monitoring mudflat morphodynamics (application to the Seine estuary, France)', *ISPRS International Journal of Geo-Information*, vol. 5, no. 4, p. 50, https://doi.org/10.3390/ijgi5040050

Javernick, L, Brasington, J & Caruso, B 2014, 'Modeling the topography of shallow braided rivers using structure-from-motion photogrammetry', *Geomorphology*, vol. 213, pp. 166–182, https://doi.org/10.1016/j.geomorph.2014.01.006

Jensen, JR 2007, *Remote sensing of the environment: an Earth resource perspective*, 2nd edn, Geographic Information Science, Prentice Hall, Upper Saddle River, New Jersey, United States.

Jensen, JR 2015, *Introductory digital image processing: a remote sensing perspective*, 4th edn, Pearson Education, Inc., Glenview, Illinois, United States.

Jensen, JR, Narumalani, S, Weatherbee, O, Morris, KS & Mackey Jr, HE 1993, 'Predictive modeling of cattail and waterlily distribution in a South Carolina reservoir using GIS', *Photogrammetric Engineering & Remote Sensing*, vol. 58, no. 11, pp. 1561–1568.

Jensen, T, Apan, A, Young, F & Zeller, L 2007, 'Detecting the attributes of a wheat crop using digital imagery acquired from a low-altitude platform', *Computers and Electronics in Agriculture*, vol. 59, no. 1–2, pp. 66–77, https://doi.org/10.1016/j.compag.2007.05.004

Jia, L, Buerkert, A, Chen, X, Roemheld, V & Zhang, F 2004, 'Low-altitude aerial photography for optimum N fertilization of winter wheat on the North China Plain', *Field Crops Research*, vol. 89, no. 2–3, pp. 389–395, https://doi.org/10.1016/j.fcr.2004.02.014

Johansen, S 2016, *1G, 2G, 3G, 4G, 5G*, Wikie for ITS, viewed 9 December 2018, <https://its-wiki.no/images/c/c8/From_1G_to_5G_Simon.pdf>.

John, S & Klein, A 2004, 'Hydrogeomorphic effects of beaver dams on floodplain morphology: avulsion processes and sediment fluxes in upland valley floors (Spessart, Germany)', *Quaternaire*, vol. 15, no. 1–2, pp. 219–231.

Jomez Productions Disc Golf 2016, Drone disc golf ace run, video, viewed 4 October 2018, <https://www.youtube.com/watch?v=kzs5Sh2DmBU>.

Jones IV, GP, Pearlstine, LG & Percival, HF 2006, 'An assessment of small unmanned aerial vehicles for wildlife research', *Wildlife Society Bulletin*, vol. 34, no. 3, pp. 750–758, https://doi.org/10.2193/0091-7648(2006)34[750:AAOSUA]2.0.CO;2

Juvonen, TP, Ojanen, M, Tanttu, JT & Rosnell, J 1997, 'Kaukokartoituksen ympäristösovellukset: suotyyppien erottaminen pintalämpötilojen perusteella, Environmental applications of remote sensing methods: discriminating mire site types by surface temperatures', *Suo*, vol. 48, no. 1, pp. 9-19, viewed 5 November 2018, <http://www.suoseura.fi/Alkuperainen/suo/abstracts48.html>.

Kalacska, M, Chmura, GL, Lucanus, O, Bérubé, D & Arroyo-Mora, JP 2017, 'Structure from motion will revolutionize analyses of tidal wetland landscapes', *Remote Sensing of Environment*, vol. 199, pp. 14–24, https://doi.org/10.1016/j.rse.2017.06.023

Kalisch, A 2009, *Ableitung und Analyse von Erosionsrinnen-Netzwerken aus digitalen Geländemodellen mittels großmaßstäbiger Photogrammetrie und GIS—Südwest-Marokko*, M.Sc. thesis, Frankfurt University, Frankfurt kam Main, Germany, viewed 24 November 2018, <https://www.uni-frankfurt.de/45217488/Kalisch_Photogrammetrische-Ableitung-Erosionsrinnen-Netzwerke_Diplomarbeit2009.pdf>.

Kansas Commission on Veterans' Affairs Office (KCVAO) 2016, *No one is ever buried alone, all are buried with honor*, viewed 5 October 2018, <https://kcva.ks.gov/veteran-cemeteries>.

Karofeld, E 1998, 'The dynamics of the formation and development of hollows in raised bogs in Estonia', *The Holocene*, vol. 8, no. 6, pp. 697–704, https://doi.org/10.1191/095968398677584475

Kavanagh, D & Gray, WB (eds) 2018a, *Furmint wine information*, Wine-Searcher, viewed 10 December 2018, <http://www.wine-searcher.com/grape-178-furmint>.

Kavanagh, D & Gray, WB (eds) 2018b, *Norton wine information*, Wine-Searcher, viewed 10 December 2018, <http://www.wine-searcher.com/grape-901-norton>.

Kempton, PD, Rogers, K & Brueseke, ME 2019, 'Windows into the Cretaceous mantle of the North American midcontinent—kimberlites of Riley County, Kansas', in MK Schulmeister & JS Aber (eds), *Exploring extreme and inusual geology in the stable midcontinent*, Geological Society of America, Field Guide, vol. 52, pp. 37–48.

Keränen, R 1980, 'Vetypallon ja radio-ohjattavan kameran avulla tapahtuvasta ilmakuvauksesta' (On the aerial photography using captive balloon and the radio-controlled camera), *Terra*, vol. 92, no. 1, pp. 34–37.

Kessler, T 2007, 'Photographic optics', in MR Peres (ed.), *Focal encyclopedia of photography: digital imaging, theory and applications, history, and science*, 4th edn, Elsevier, Amsterdam, Netherlands, pp. 711–724.

Kirchhoff, M, Peter, KD, Aït Hssaine, A & Ries, JB 2019, 'Land use in the Souss region, South Morocco, and its influence on wadi dynamics', Zeitschrift für Geomorphologie Supplementary Issues, vol. 62, no. 1, pp.137–160, https://doi.org/10.1127/zfg_suppl/2019/0525

Knetemann, W. 2016, 'KAP safety', *KAPwiki*, viewed 24 November 2018, <https://sites.google.com/site/kapwikipage/safety>.

Koci, J, Jarihani, B, Leon, JX, Sidle, R, Wilkinson, S & Bartley, R 2017, 'Assessment of UAV and ground-based structure from motion with multi-view stereo photogrammetry in a gullied savanna catchment', *ISPRS International Journal of Geo-Information*, vol. 6, no. 11, p. 328–351, https://doi.org/10.3390/ijgi6110328

Koff, T 1997, 'Der Einfluss der Entwicklung eines Hochmoores auf die Ausbildung der Pollenspektren am Beispiel des Nigula-Hochmoores (SW Estland)', *Telma*, vol. 27, pp. 75–90.

Komárek, J, Klouček, T & Prošek, J 2018, 'The potential of unmanned aerial systems: a tool towards precision classification of hard-to-distinguish vegetation types?', *International Journal of Applied Earth Observation and Geoinformation*, vol. 71, pp. 9–19, https://doi.org/10.1016/j.jag.2018.05.003

Konecny, G 2014, *Geoinformation: remote sensing, photogrammetry, and geographic information systems*, 2nd edn, CRC Press, Boca Raton, Florida, United States.

Kraaijenbrink, PDA, Shea, JM, Pellicciotti, F, de Jong, SM & Immerzeel, WW 2016, 'Object-based analysis of unmanned aerial vehicle imagery to map and characterise surface features on a debris-covered glacier', *Remote Sensing of Environment*, vol. 186, pp. 581–595, https://doi.org/10.1016/j.rse.2016.09.013

Krages, BP 2012, *Legal handbook for photographers: the rights and liabilities of making images*, 3rd edn, Amherst Media, Buffalo, New York, United States.

Kraus, K 2012, *Photogrammetrie: Geometrische Informationen aus Photographien und Laserscanneraufnahmen*, 7. vollst. bearb. und erw. Auflage, De Gruyter, Tübingen, Germany.

Kraus, K, Harley, IA & Kyle, S 2007, *Photogrammetry: geometry from images and laser scans*, 2nd edn, De Gruyter, Berlin, Germany.

Kriss, M 2007, 'Solid state imaging sensors', in MR Peres (ed.), *Focal encyclopedia of photography: digital imaging, theory and applications, history, and science*, 4th edn, Elsevier, Amsterdam, Netherlands, pp. 370–371.

Kriyasa, IM 2016, 'Indonesia: legal provisions in operating drones In Indonesia', Hanafiah Ponggawa & Partners, viewed 29 November 2018, <http://www.mondaq.com/x/464802/Aviation/Legal+Provisions+in+Operating+Drones+in+Indonesia>.

Kronberg, P 1995, *Tektonische Strukturen in Luftbildern und Satellitenaufnahmen: ein Bildatlas*, F. Emke, Stuttgart, Germany.

Krueger, DM 2018, *Frequency check: is your UAS FCC compliant?*, Benesch, viewed 21 December 2018, <https://m.beneschlaw.com/frequency-check-is-your-uas-fcc-compliant/>.

Laliberte, AS & Rango, A 2011, 'Image processing and classification procedures for analysis of sub-decimeter imagery acquired with an unmanned aircraft over arid rangelands', *GIScience & Remote Sensing*, vol. 48, no. 1, pp. 4–23, https://doi.org/10.2747/1548-1603.48.1.4

Laliberte, AS, Rango, A, Herrick, JE, Fredrickson, EL & Burkett, L 2007, 'An object-based image analysis approach for determining fractional cover of senescent and green vegetation with digital plot photography', *Journal of Arid Environments*, vol. 69, no. 1, pp. 1–14, https://doi.org/10.1016/j.jaridenv.2006.08.016

Laliberte, AS, Herrick, JE, Rango, A & Winters, C 2010, 'Acquisition, orthorectification, and object-based classification of unmanned aerial vehicle (UAV) imagery for rangeland monitoring', *Photogrammetric Engineering & Remote Sensing*, vol. 76, no. 6, pp. 661–672.

Laliberte, AS, Goforth, MA, Steele, CM & Rango, A 2011, 'Multispectral remote sensing from unmanned aircraft: image processing workflows and applications for rangeland environments', *Remote Sensing*, vol. 3, no. 11, pp. 2529–2551, https://doi.org/10.3390/rs3112529

Landis, B & Aber, JS 2007, 'Low-cost field goniometer for multiangular reflectance measurements', *Emporia State Research Studies*, vol. 44, no. 1, pp. 1–6, viewed 4 October 2018, <http://academic.emporia.edu/esrs/vol44/landis.pdf>.

Lane, SN 2000, 'The measurement of river channel morphology using digital photogrammetry', *The Photogrammetric Record*, vol. 16, no. 96, pp. 937–961, https://doi.org/10.1111/0031-868X.00159

Lane, SN, Chandler, JH & Richards, KS 1998, 'Landform monitoring, modelling and analysis: land form in geomorphological research', in SN Lane, KS Richards & JH Chandler (eds), *Landform monitoring, modelling and analysis*, Wiley, Chichester, United Kingdom, pp. 1–17.

Lane, SN, James, TD & Crowell, MD 2000, 'Application of digital photogrammetry to complex topography for geomorphological research', *The Photogrammetric Record*, vol. 16, no. 95, pp. 793–822, https://doi.org/10.1111/0031-868X.00152

Lane, SN, Westaway, RM & Hicks, DM 2003, 'Estimation of erosion and deposition volumes in a large, gravel-bed, braided river using synoptic remote sensing', *Earth Surface Processes and Landforms*, vol. 28, no. 3, pp. 249–271, https://doi.org/10.1002/esp.483

Langford, M & Bilissi, E 2011, *Langford's advanced photography*, 8th edn, Focal Press, Oxford, United Kingdom.

LBA 2014a, *Nachrichten*, Luftfahrt-Bundesamt, viewed 27 November 2018, <https://www.lba.de/DE/Home/home_node.html>.

LBA 2014b, *Liste der vom LBA nach § 21d Luftverkehrs-Ordnung anerkannten Stellen*, Luftfahrt-Bundesamt, viewed 27 November 2018, <http://www.lba.de/DE/Luftfahrtpersonal/Unbemannte_Fluggeraete/Liste_anerkannte_Stellen.html>.

Le Roy Ladurie, E 1971, *Times of feast, times of famine: a history of climate since the year 1000*. Doubleday, Garden City, New York, United States.

Le Roy Ladurie, E 2004, *Histoire humaine et comparée du climat: caniculers et glaciers XIIIe-XVIIIe siècles*. Librairie Arthème Fayard, Paris, France.

Leachtenauer, JC, Daniel, K & Vogl, TP 1997, 'Digitizing Corona imagery: quality vs. cost', in RA McDonald (ed.), *Corona: between the Sun & the Earth: the first NRO reconnaissance eye in space*', American Society Photogrammetry and Remote Sensing, Bethesda, Maryland, United States, pp. 189–203.

Lee, WT 1922, *The face of the earth as seen from the air: a study in the application of airplane photography to geography*, American Geographical Society, New York, United States.

Leroy, M & Bréon, F-M 1996, 'Angular signatures of surface reflectances from airborne POLDER data', *Remote Sensing of Environment*, vol. 57, no. 2, pp. 97–107, https://doi.org/10.1016/0034-4257(95)00229-4

Lesschen, JP, Cammeraat, LH, Kooijman, AM & van Wesemael, B 2008, 'Development of spatial heterogeneity in vegetation and soil properties after land abandonment in a semi-arid ecosystem', *Journal of Arid Environments*, vol. 72, no. 11, pp. 2082–2092, https://doi.org/10.1016/j.jaridenv.2008.06.006

Li, J, Li, Y, Chapman, MA & Rüther, H 2005, 'Small format digital imaging for informal settlement mapping', *Photogrammetric Engineering & Remote Sensing*, vol. 71, no. 4, pp. 435–442.

Lillesand, TM & Kiefer, RW & Chipman, JW 2015, *Remote sensing and image interpretation*, 7th edn, John Wiley & Sons, Inc., Hoboken, New Jersey, United States.

Lisein, J, Pierrot-Deseilligny, M, Bonnet, S & Lejeune, P 2013, 'A photogrammetric workflow for the creation of a forest canopy height model from small unmanned aerial system imagery', *Forests*, vol. 4, no. 4, pp. 922–944, https://doi.org/10.3390/f4040922

Liu, JG & Mason, PJ 2016, *Essential image processing and GIS for remote sensing*, 2nd edn, Wiley-Blackwell, Chichester, United Kingdom.

Longley, PA, Goodchild, MF, Maguire, DJ & Rhind, D 2015, *Geographic information science & systems*, 4th edn, John Wiley & Sons, Hoboken, New Jersey, United States.

Loopmann, A, Pirrus, R & Ilomets, M 1988, 'Nigula Riiklik Looduskaitseala', in U. Valk (ed.), *Eesti sood*, Valgus, Tallinn, Estonia, pp. 227–233.

Lowe, DG 2004, 'Distinctive image features from scale-invariant keypoints', *International Journal of Computer Vision*, vol. 60, no. 2, pp. 91–110, https://doi.org/10.1023/B:VISI.0000029664.99615.94

Lowman Jr, PD 1999, 'Landsat and Apollo: the forgotten legacy', *Photogrammetric Engineering & Remote Sensing*, vol. 65, pp. 1143–1147, viewed 20 November 2018, <https://www.asprs.org/wp-content/uploads/pers/1999journal/oct/1999_oct_1143-1147.pdf>.

Lu, Y, Xue, Z, Xia, G-S & Zhang, L 2018, 'A survey on vision-based UAV navigation', *Geo-spatial Information Science*, vol. 21, no. 1, pp. 21–32, https://doi.org/10.1080/10095020.2017.1420509

Lucht, W 2004, 'Viewing the Earth from multiple angles: global change and the science of multiangular reflectance', in M von Schönermark, B Geiger & H-P Röser (eds), *Reflection properties of vegetation and soil—with a BDRF data base*, Wissenschaft und Technik Verlag, Berlin, Germany, pp. 9–29.

Lucieer, A, de Jong, SM & Turner, D 2014a, 'Mapping landslide displacements using structure from motion (SfM) and image correlation of multi-temporal UAV photography', *Progress in Physical Geography*, vol. 38, no. 1, pp. 97–116.

Lucieer, A, Turner, D, King, DH & Robinson, SA 2014b, 'Using an unmanned aerial vehicle (UAV) to capture micro-topography of Antarctic moss beds', *International Journal of Applied Earth Observation and Geoinformation*, vol. 27, pp. 53–62, https://doi.org/10.1016/j.jag.2013.05.011

Lucieer, A, Zarco-Tejada, PJ, Rascher, U & Bareth, G (eds) 2014c, 'Special Issue "UAV-Based Remote Sensing Methods for Modeling, Mapping, and Monitoring Vegetation and Agricultural Crops"', *Remote Sensing*, viewed 21 December 2018, <https://www.mdpi.com/si/3047>.

Lueder, DR 1959, *Aerial photographic interpretation-principles and applications*, McGraw-Hill, New York, United States.

Luhmann, T 2018, *Nahbereichsphotogrammetrie: Grundlagen, Methoden, Beispiele*, 4. neu bearbeitete und erweiterte Auflage, Wichmann Verlag, Berlin, Offenbach, Germany.

Luhmann, T, Robson, S, Kyle, S & Boehm, J 2013, *Close-range photogrammetry and 3D imaging*, 2nd edn, De Gruyter, Berlin, Germany.

Lymburner L, Beggs PJ & Jacobson CR 2000, 'Estimation of canopy-average surface-specific leaf area using Landsat TM data', *Photogrammetric Engineering & Remote Sensing*, vol. 66, pp. 183–191.

Lynch, DK & Livingston, W 2004, *Color and light in nature*, 2nd edn, Cambridge University Press, Cambridge, United Kingdom.

Mack, J 2007, *The art of small things*, Harvard University Press, Cambridge, Massachusetts, United States.

Madden, M, Jordan, T, Bernardes, S, Cotten, DL, O'Hare, N & Pasqua, A 2015, 'Unmanned aerial systems and structure from motion revolutionize wetlands mapping', in RW Tiner, MW Lang, VV Klemas (eds), *Remote sensing of wetlands: applications and advances*. CRC Press, Boca Raton, Florida, United States, pp. 195–219.

Maegaard, P 2009, 'The new wind power pioneers and the emergence of the modern wind industry', in B Christensen (ed.), *Wind power the Danish way: from Poul la Cour to modern wind turbines*, The Poul la Cour Foundation, Askov, Denmark, pp. 46–51.

Malin, D & Light, DI 2007, 'Aerial photography', in MR Peres (ed.), *Focal encyclopedia of photography: digital imaging, theory and applications, history, and science*, 4th edn, Elsevier, Amsterdam, Netherlands, pp. 501–504.

Mancini, F, Dubbini, M, Gattelli, M, Stecchi, F, Fabbri, S & Gabbianelli, G 2013, 'Using unmanned aerial vehicles (UAV) for high-resolution reconstruction of topography: the structure from motion approach on coastal environments', *Remote Sensing*, vol. 5, no. 12, pp. 6880–6898, https://doi.org/10.3390/rs5126880

Manfreda, S, McCabe, MF, Miller, PE, Lucas, R, Pajuelo Madrigal, V, Mallinis, G, Ben Dor, E, Helman, D, Estes, L, Ciraolo, G, Müllerová, J, Tauro, F, de Lima, MI, de Lima, JLMP, Maltese, A, Frances, F, Caylor, K, Kohv, M, Perks, M, Ruiz-Pérez, G, Su, Z, Vico, G & Toth, B 2018, 'On the use of unmanned aerial systems for environmental monitoring', *Remote Sensing*, vol. 10, no. 4, p. 641, https://doi.org/10.3390/rs10040641

Marani, M, Belluco, E, Ferrari, S, Silvestri, S, D'Alpaos, A, Lanzoni, S, Feola, A & Rinaldo, A 2006, 'Analysis, synthesis and modelling of high-resolution observations of salt-marsh eco-geomorphological patterns in the Venice lagoon', *Estuarine, Coastal and Shelf Science*, vol. 69, no. 3–4, pp. 414–426, https://doi.org/10.1016/j.ecss.2006.05.021

Marinello, F, Bariani, P, Savio, E, Horsewell, A & De Chiffre, L 2008, 'Critical factors in SEM 3D stereo microscopy', *Measurement Science and Technology*, vol. 19, no. 6, p. 65705, https://doi.org/10.1088/0957-0233/19/6/065705

Markowski, S & Markowski, A 2001, *Nad zamkami Polski: above Poland's Castles*, Twoje Strony, Kraków, Poland.

Marom, E 2016, 'The good, the bad and the ugly of aerial photography—part 2: aircraft', *Digital Photography Review, viewed 23 November 2018*, <https://www.dpreview.com/techniques/4544191304/the-good-the-bad-and-the-ugly-of-aerial-photography-part-2-aircraft>.

Marshall, B 2017, 'Troon to assume management of Southwind', *The Garden City Telegram*, viewed 4 October 2018, <http://www.gctelegram.com/news/20171128/troon-to-assume-management-of-southwind>.

Marteau, B, Vericat, D, Gibbins, C., Batalla, RJ & Green, DR 2017, 'Application of structure-from-motion photogrammetry to river restoration', *Earth Surface Processes and Landforms*, vol. 42, no. 3, pp. 503–515, https://doi.org/10.1002/esp.4086

Martin, G 2018, 'A picture is worth a thousand words—the meaning and origin of this phrase', *The Phrase Finder*, viewed 24 November 2018, <https://www.phrases.org.uk/meanings/a-picture-is-worth-a-thousand-words.html>.

Martínez-Carricondo, P, Agüera-Vega, F, Carvajal-Ramírez, F, Mesas-Carrascosa, F-J, García-Ferrer, A & Pérez-Porras, F-J 2018, 'Assessment of UAV-photogrammetric mapping accuracy based on variation of ground control points', *International Journal of Applied Earth Observation and Geoinformation*, vol. 72, pp. 1–10, https://doi.org/10.1016/j.jag.2018.05.015

Martínez-Casasnovas, JA, Ramos, MC & Poesen, J 2004, 'Assessment of sidewall erosion in large gullies using multi-temporal DEMs and logistic regression analysis', *Geomorphology*, vol. 58, no. 1–4, pp. 305–321, https://doi.org/10.1016/j.geomorph.2003.08.005

Marzolff, I 1999, *Großmaßstäbige Fernerkundung mit einem unbemannten Heißluftzeppelin für GIS-gestütztes Monitoring von Vegetationsentwicklung und Geomorphodynamik in Aragón (Spanien)*, PhD thesis, Albert-Ludwigs University, Freiburg, Germany.

Marzolff, I, 2003, 'Aplicación de la fotografía aérea de alta resolución tomada a partir de un zepelín aerostático teledirigido al seguimiento de la dinámica vegetal y geomorfológica en campos abandonados en Aragón (España).—Hochauflösendes Luftbild-Monitoring von Vegetationsentwicklung und Geomorphodynamik in Aragón (Spanien) mittels ferngesteuerter Heißluftzeppeline', in I Marzolff, JB Ries, J de la Riva & M Seeger (eds), *Landnutzungswandel und Landdegradation in Spanien—El cambio en el uso del suelo y la degradación del territorio en España. Ergebnisse des Workshops vom 18.-21.10.2001 in Frankfurt am Main*. Frankfurt am Main/Zaragoza (Sonderband Frankfurter Geowissenschaftliche Arbeiten/Monografías de la Universidad de Zaragoza), pp. 143–162, viewed 23 November 2018, <https://www.uni-frankfurt.de/45217481/marzolff_2003.pdf>.

Marzolff, I 2014, 'The sky is the limit? 20 years of small-format aerial photography taken from UAS for monitoring geomorphological processes', *Geophysical Research Abstracts*, vol. 16, p. 7005, viewed 24 November 2018, <https://meetingorganizer.copernicus.org/EGU2014/EGU2014-7005.pdf>.

Marzolff, I, Albert, K-D & Ries, JB 2002, 'Fernerkundung vom Fesseldrachen. Luftbild-Monitoring gibt Aufschluss über Schluchterosion in der Sahelzone', *Forschung Frankfurt*, vol. 2002, no. 3, pp. 16–22, viewed 23 November 2018, <http://www.forschung-frankfurt.uni-frankfurt.de/36050175/Luftbild-Monitoring_16-23.pdf>.

Marzolff, I & Pani P 2018, 'Dynamics and patterns of land levelling for agricultural reclamation of erosional badlands in Chambal Valley (Madhya Pradesh, India)', *Earth Surface Processes and Landforms*, vol. 43, no. 2, pp. 524–542, https://doi.org/10.1002/esp.4266

Marzolff, I & Poesen, J 2009, 'The potential of 3D gully monitoring with GIS using high-resolution aerial photography and a digital photogrammetry system', *Geomorphology*, vol. 111, no. 1–2, pp. 48–60, https://doi.org/10.1016/j.geomorph.2008.05.047

Marzolff, I & Ries JB 1997, '35-mm photography taken from a hot-air blimp', in M Bauer, W Befort, PR Coppin & B Huberty (eds), *Proceedings of the first North American symposium on small format aerial photography*, American Society of Photogrammetry and Remote Sensing, pp. 91–101.

Marzolff, I & Ries, JB 2007, 'Gully monitoring in semi-arid landscapes', *Zeitschrift für Geomorphologie N. F.*, vol. 51, no. 4, pp. 405–425, https://doi.org/10.1127/0372-8854/2007/0051-0405

Marzolff, I & Ries, JB 2011, 'Piping as a process of gully erosion in small-format aerial photography: a short note', *Cuadernos de Investigación Geográfica*, vol. 37, no. 1, pp. 115–120.

Marzolff, I, Ries, JB & Albert, K-D 2003, 'Kite aerial photography for gully monitoring in sahelian landscapes', in *Proceedings of the second workshop of the EARSeL special interest group on remote sensing for developing countries*, Bonn, Germany, 18–20 September 2002, pp. 1–9, viewed 4 November 2018, <http://www.uni-frankfurt.de/45217486/marzolff-et-al_earsel2003.pdf>.

Marzolff I, Ries, JB & Poesen, J 2011, 'Short-term versus medium-term monitoring for detecting gully-erosion variability in a Mediterranean environment', *Earth Surface Processes and Landforms*, vol. 36, no. 12, pp. 1604–1623, https://doi.org/10.1002/esp.2172

Masing, V 1997, 'Ancient mires as nature monuments', *Monumenta Estonica*, Estonian Encyclopaedia Publishers, Tallinn, Estonia.

Masing, V 1998, 'Multilevel approach in mire mapping, research, and classification', *International Mire Conservation Group, Classification Workshop*, Greifswald, Germany, 25-29 March 1998, viewed 24 November 2018, <https://web.archive.org/web/20020823135933/http://www.imcg.net/docum/greifswa/masing.htm>.

Maskeri, A 2016, *Mumbai by a thread: meet the India's only professional kite photographer*, Mid-Day Infomedia, viewed 17 December 2018, <http://www.mid-day.com/articles/india-professional-kite-photographer-dinesh-mehta-drones-mumbai/17602187>.

Matese, A, Di Gennaro, SF & Berton, A 2017, 'Assessment of a canopy height model (CHM) in a vineyard using UAV-based multispectral imaging', *International Journal of Remote Sensing*, vol. 38, no. 8–10, pp. 2150–2160, https://doi.org/10.1080/01431161.2016.1226002

Mather, PM & Koch, M 2010, *Computer processing of remotely-sensed images: an introduction*, 4th edn, John Wiley, Chichester, United Kingdom.

Mathews, AJ 2014, 'Object-based spatiotemporal analysis of vine canopy vigor using an inexpensive unmanned aerial vehicle remote sensing system', *Journal of Applied Remote Sensing*, vol. 8, no. 1, pp. 1–18, https://doi.org/10.1117/1.JRS.8.085199

Mathews, AJ & Jensen, JLR 2013, 'Visualizing and quantifying vineyard canopy LAI using an unmanned aerial vehicle (UAV) collected high density structure from motion point cloud', *Remote Sensing*, vol. 5, no. 5, pp. 2164–2183, https://doi.org/10.3390/rs5052164

McGlone, JC & Lee, GYG (eds) 2013, *Manual of photogrammetry*, ASPRS American Society for Photogrammetry and Remote Sensing, Bethesda, Maryland, United States.

McHugh, S 2018, 'Dynamic range in digital photography', *Cambridge in Color*, viewed 4 October 2018, <http://www.cambridgeincolour.com/tutorials/dynamic-range.htm>.

Meehan, L 2003, *Digital photography basics*, Collins and Brown, London, United Kingdom.

Menzies, J & Rose, J 1987, 'Drumlins—trends and perspectives', *Episodes*, vol. 10, no. 1, pp. 29–31, viewed 20 November 2018, <http://52.172.159.94/index.php/epi/article/viewFile/63578/49644>.

Mid-European Clay Conference (MECC) 2008a, 'Post-meeting field trip 3', in I Felisiak, J Magiera, M Drewnik & I Jerzykowska (eds), *The Tatras-rocks, landforms, weathering and soils*, Zakopane, Poland, 27 September, 4th Mid-European Clay Conference MECC'08, viewed 21 November 2018, <http://www.mecc08.agh.edu.pl/?id=22>.

Mid-European Clay Conference (MECC) 2008b, 'Post-meeting field trip 1', in M Krobicki (ed.), *Lower Jurassic black shales-the old flysch deposits of the Carpathians and their relation to geology of the Pieniny Klippen Belt*, Sromowce & Jaworki, Poland, 26 September, 4th Mid-European Clay Conference MECC'08, viewed 21 November 2018, <http://www.mecc08.agh.edu.pl/?id=20>.

Mills, JP, Newton, I & Graham, RW 1996, 'Aerial photography for survey purposes with a high resolution, small format, digital camera', *Photogrammetric Record*, vol. 15, no. 88, pp. 575–587, https://doi.org/10.1111/0031-868X.00065

Mitchell, K 2018, 'Updated for 2018: 20 largest wildfires in Colorado history by acreage burned', *The Denver Post*, viewed 14 December 2018, <https://www.denverpost.com/2018/07/04/20-largest-wildfires-in-colorado-history-in-acreage-burned/>.

Mitsch, WJ & Gosselink, JG 2007, *Wetlands*, 4th edn, J. Wiley & Sons, Hoboken, New Jersey, United States.

Miyamoto, M, Yoshino, K, Nagano, T, Ishida, T & Sata, Y 2004, 'Use of balloon aerial photography for classification of Kushiro wetland vegetation, northeastern Japan', *Wetlands*, vol. 24, no. 3, pp. 701–710, https://doi.org/10.1672/0277-5212(2004)024[0701:UOBAPF]2.0.CO;2

Molinillo, M, Lasanta, T & García-Ruiz, JM 1997, 'Managing mountainous degraded landscapes after farmland abandonment in the Central Spanish Pyrenees', *Environmental Management*, vol. 21, no. 4, pp. 587–598.

Morton, MC 2017, *Aerial geology: a high-altitude tour of North America's spectacular volcanoes, canyons, glaciers, lakes, craters, and peaks*, Timber Press, Portland, Oregon.

Mosbrucker, AR, Major, JJ, Spicer, KR & Pitlick, J 2017, 'Camera system considerations for geomorphic applications of SfM photogrammetry', *Earth Surface Processes and Landforms*, vol. 42, no. 6, pp. 969–986, https://doi.org/10.1002/esp.4066

Mount, R 2005, 'Acquisition of through-water aerial survey images: surface effects and the prediction of sun glitter and subsurface illumination', *Photogrammetric Engineering and Remote Sensing*, vol. 71, no. 12, pp. 1407–1415, https://doi.org/10.14358/PERS.71.12.1407

Mullins, HT & Hinchey, EJ 1989, 'Erosion and infill of New York, New York, United States Finger Lakes: implications for Laurentide ice sheet deglaciation', *Geology*, vol. 17, iss. 7, pp. 622–625, https://doi.org/10.1130/0091-7613(1989)017<0622:EAIONY>2.3.CO;2

Murphy, JB, Oppliger, GL, Brimhall Jr, GH & Hynes, A 1999, 'Mantle plumes and mountains: the progress of southwestern North America across a plume may demonstrate a previously overlooked form of mountain building', *American Scientist*, vol. 87, no. 2, pp. 146–153.

Murtha, PA, Deering, DW, Olson Jr, CE & Bracher, GA 1997, 'Vegetation', in WR Philipson (ed.), *Manual of photographic interpretation*, 2nd edn, American Society for Photogrammetry and Remote Sensing, Bethesda, Maryland, United States, pp. 225–255.

Musgrove, P 2010, *Wind power*, Cambridge University Press, Cambridge, United Kingdom.

Nachtergaele, J & Poesen, J 1999, 'Assessment of soil losses by ephemeral gully erosion using high-altitude (stereo) aerial photographs', *Earth Surface Processes and Landforms*, vol. 24, no. 8, pp. 693–706, https://doi.org/10.1002/(SICI)1096-9837(199908)24:8<693::AID-ESP992>3.0.CO;2-7

Nagler, PL, Pearlstein, S, Glenn, EP, Brown, TB, Bateman, HL, Bean, DW & Hultine, KR 2014, 'Rapid dispersal of saltcedar (*Tamarix* spp.) biocontrol beetles (*Diorhabda carinulata*) on a desert river detected by phenocams, MODIS imagery and ground observations', *Remote Sensing of Environment*, vol. 140, pp. 206–219, https://doi.org/10.1016/j.rse.2013.08.017

National Research Council, 2000, *The impact of selling the Federal Helium Reserve*, The National Academies Press, Washington, D.C., United States, viewed 23 November 2018, <https://www.nap.edu/catalog/9860/the-impact-of-selling-the-federal-helium-reserve>, https://doi.org/10.17226/9860

Nearing, MA, Xie Y, Liu B & Ye, Y 2017, 'Natural and anthropogenic rates of soil erosion', *International soil and water conservation research*, vol. 5, no. 2, pp. 77–84, https://doi.org/10.1016/j.iswcr.2017.04.001

Nelson, T 2015, *Drone disc golf*, video, viewed 4 October 2018, <https://www.youtube.com/watch?v=21leBQEvso8>.

Nelson-Atkins Museum of Art 2018, *About The Nelson-Atkins*, viewed 5 October 2018, <http://www.nelson-atkins.org/about/>.

Nicholas, KA 2015, 'Will we still enjoy Pinot Noir?', *Scientific American*, vol. 312, no. 1, pp. 60–67, https://doi.org/10.1038/scientificamerican0115-60

Niederheiser, R, Mokroš, M, Lange, J, Petschko, H, Prasicek, G & Elberink, SO 2016, 'Deriving 3D point clouds from terrestrial photographs—comparison of different sensors and software', *ISPRS International Archives of Photogrammetry, Remote Sensing and Spatial Information Sciences*, vol. XLI-B5, pp. 685–692, viewed 20 November 2018, <https://www.int-arch-photogramm-remote-sens-spatial-inf-sci.net/XLI-B5/685/2016/isprs-archives-XLI-B5-685-2016.pdf>, https://doi.org/10.5194/isprsarchives-XLI-B5-685-2016

Niedzielski, T, Witek, M & Spallek, W 2016, 'Observing river stages using unmanned aerial vehicles', *Hydrology and Earth System Sciences*, vol. 20, no. 8, pp. 3193–3205, https://doi.org/10.5194/hess-20-3193-2016

Nielsen, KH 2009, 'International perspectives on the history of Danish wind power', in B Christensen (ed.), *Wind power the Danish way: from*

Poul la Cour to modern wind turbines, The Poul la Cour Foundation, Askov, Denmark, pp. 60–65.

Niethammer, U, James, MR, Rothmund, S, Travelletti, J & Joswig, M 2012, 'UAV-based remote sensing of the Super-Sauze landslide: evaluation and results', *Engineering Geology*, vol. 128, pp. 2–11, https://doi.org/10.1016/j.enggeo.2011.03.012

Nilson, T & Kuusk, A 1989, 'A reflectance model for the homogeneous plant canopy and its inversion', *Remote Sensing Environment*, vol. 27, no. 2, pp. 157–167, https://doi.org/10.1016/0034-4257(89)90015-1

Nouwakpo, SK, Weltz, MA, Green, CHM & Arslan, A 2018, 'Combining 3D data and traditional soil erosion assessment techniques to study the effect of a vegetation cover gradient on hillslope runoff and soil erosion in a semi-arid catchment', *Catena*, vol. 170, pp. 129–140, https://doi.org/10.1016/j.catena.2018.06.009

NPS 2004, 'National Historic Landmark nomination: Granada Relocation Center', *National Park Service*, viewed 30 November 2018, <https://npgallery.nps.gov/pdfhost/docs/NHLS/Text/94000425.pdf>.

Nufarm 2018, *Aqua Neat® rises to the top in aquatic weed control*, viewed 5 October 2018, <https://www.nufarm.com/USTO/Aquaneat>.

Obermeyer B, Manes, R, Kiesecker, J, Fargione, J & Sochi, K 2011, 'Development by design: mitigating wind development's impacts on wildlife in Kansas', *PLoS ONE*, vol. 6, no. 10, viewed 9 December 2018, <http://www.plosone.org/article/info:doi/10.1371/journal.pone.0026698>.

Ogleby, C 2007, 'Photogrammetry', in MR Peres (ed.), *Focal encyclopedia of photography: digital imaging, theory and applications, history, and science*, 4th edn, Elsevier, Amsterdam, Netherlands, p. 583.

Oostwoud Wijdenes, DJ & Bryan, RB 2001, 'Gully-Head erosion processes on a semi-arid valley floor in Kenya', *Earth Surface Processes and Landforms*, vol. 26, no. 9, pp. 911–933, https://doi.org/10.1002/esp.225

Open Photographic Society 2017, *Hang-gliding photography*, viewed 23 November 2018, <http://www.openphotographicsociety.org/photography/genres-n-z/specialist/extreme/318-hang-gliding-photography>.

Organisation Internationale de la Vigne et du Vin 2018, *Global state of conditions report: developments and trends*, viewed 9 December 2018, <http://www.oiv.int/public/medias/5948/en-oiv-press-release-24-april-2018.pdf>.

Orru, M, Širokova, M & Veldre, M 1993, *Eesti soo: Estonian mires*, map scale 1:400,000, Geological Survey of Estonia, Tallinn, Estonia.

Oser, B 2014, *Photo manipulation ethics*, PowerPoint presentation, viewed 23 November 2018, <https://www.slideshare.net/DanielleOser/photo-manipulation-ethics>.

Osterman, M 2007, 'Selected photographs from the 19th century', in MR Peres (ed.), *Focal encyclopedia of photography: digital imaging, theory and applications, history, and science*, 4th edn, Elsevier, Amsterdam, Netherlands, pp. 135–156.

Otero, V, Van De Kerchove, R, Satyanarayana, B, Martínez-Espinosa, C, Fisol, MAB, Ibrahim, MRB, Sulong, I, Mohd-Lokman, H, Lucas, R & Dahdouh-Guebas, F 2018, 'Managing mangrove forests from the sky: forest inventory using field data and unmanned aerial vehicle (UAV) imagery in the Matang Mangrove Forest Reserve, peninsular Malaysia', *Forest Ecology and Management*, vol. 411, pp. 35–45, https://doi.org/10.1016/j.foreco.2017.12.049

Ouédraogo, MM, Degré, A, Debouche, C & Lisein, J 2014, 'The evaluation of unmanned aerial system-based photogrammetry and terrestrial laser scanning to generate DEMs of agricultural watersheds', *Geomorphology*, vol. 214, pp. 339–355, https://doi.org/10.1016/j.geomorph.2014.02.016

Pajares, G 2015, 'Overview and current status of remote sensing applications based on unmanned aerial vehicles (UAVs)', *Photogrammetric Engineering & Remote Sensing*, vol. 81, no. 4, pp. 281–329, https://doi.org/10.14358/PERS.81.4.281

Pajares Martinsanz, G (ed.) 2012, Special Issue "Unmanned Aerial Vehicles (UAVs) based Remote Sensing", *Remote Sensing*, viewed 21 December 2018, <https://www.mdpi.com/si/1437>.

Panagiotidis, D, Abdollahnejad, A, Surový, P & Chiteculo, V 2017, 'Determining tree height and crown diameter from high-resolution UAV imagery', *International Journal of Remote Sensing*, vol. 38, no. 8–10, pp. 2392–2410, https://doi.org/10.1080/01431161.2016.1264028

Pande-Chhetri, R, Abd-Elrahman, A, Liu, T, Morton, J & Wilhelm, VL 2017, 'Object-based classification of wetland vegetation using very high-resolution unmanned air system imagery', *European Journal of Remote Sensing*, vol. 50, no. 1, pp. 564–576, https://doi.org/10.1080/22797254.2017.1373602

Pariente, S 2009, 'Pedo-hydrological patchiness in the Northern Negev, Israel, as affected by grazing', *Ecology and Noospherology*, vol. 20, no. 3–4, pp. 164–165.

Passalacqua, P, Belmont, P, Staley, DM, Simley, JD, Arrowsmith, JR, Bode, CA, Crosby, C, DeLong, SB, Glenn, NF, Kelly, SA, Lague, D, Sangireddy, H, Schaffrath, K, Tarboton, DG, Wasklewicz, T & Wheaton, JM 2015, 'Analyzing high resolution topography for advancing the understanding of mass and energy transfer through landscapes: a review', *Earth-Science Reviews*, vol. 148, pp. 174–193, https://doi.org/10.1016/j.earscirev.2015.05.012

Pawson, D 2004, *The handbook of knots: expanded version*, DK Publishing, New York, New York, United States.

Pedersen, SAS 1996, 'Progressive glaciotectonic deformation in Weichselian and Palaeogene deposits at Feggeklit, northern Denmark', *Bulletin of the Geological Society Denmark*, vol. 42, pp. 153–174.

Pedersen, SAS 2014, 'Architecture of glaciotectonic complexes', *Geosciences*, vol. 4, no. 4, pp. 269–296, viewed 11 November 2018, https://doi.org/10.3390/geosciences4040269

Peña, JM, Torres-Sánchez, J, de Castro, AI, Kelly, M & López-Granados, F 2013, 'Weed mapping in early-season maize fields using object-based analysis of unmanned aerial vehicle (UAV) images', *PLoS ONE*, vol. 8, no. 10, pp. 1–11, https://doi.org/10.1371/journal.pone.0077151

Penner II, RL 2009, *The birds of Cheyenne Bottoms*, Kansas Department of Wildlife and Parks, Topeka, Kansas, United States.

Perko, R, Fürnstahl, P, Bauer, J & Klaus, A 2005, 'Geometrical accuracy of Bayer pattern images', in V Skala (ed.), *Proceedings of the 13th international conference in Central Europe on computer graphics, visualization and computer vision WSCG 2005—short papers*, University of West Bohemia, Plzeň, Czech Republic, 31 January-4 February, pp. 117–120, viewed 21 November 2018, <http://wscg.zcu.cz/WSCG2005/Papers_2005/Short/!WSCG2005_Short_Proceedings_Final.pdf>.

Persoz, F, Larsen, E & Singer, KAJ 1972, 'Helium in the thermal springs of Unartoq, South Greenland', *Grønlands Geologiske Undersøgelser Nr. 44*, no. GGU-R-44.

Peter, KD, d'Oleire-Oltmanns, S, Ries, JB, Marzolff, I & Aït Hssaine, A 2014, 'Soil erosion in gully catchments affected by land-levelling measures in the Souss Basin, Morocco, analysed by rainfall simulation and UAV remote sensing data', *Catena*, vol. 113, pp. 24–40, https://doi.org/10.1016/j.catena.2013.09.004

Peters, AK & Grubb, N 2000, *Seven trails west*, Abbeyville Press, New York, New York, United States.

Peterson, U & Aunap, R 1998, 'Changes in agricultural land use in Estonia in the 1990s detected with multitemporal Landsat MSS imagery', *Landscape and Urban Planning*, vol. 41, no. 3–4, pp. 193–201, https://doi.org/10.1016/S0169-2046(98)00058-9

Petrovich, D 2012, 'The surprisingly old art of photo fakery', *Boston Globe*, 14 October, viewed 4 November 2018, <https://www.bostonglobe.com/ideas/2012/10/13/the-surprisingly-old-art-photo-fakery/1s6A05EM9Xt1DJYqPjlpNP/story.html>.

Péwé, TL 1975, 'Quaternary geology of Alaska', Professional Paper 835, *U.S. Geological Survey*, U.S. Government Printing Office, Washington, D.C., https://doi.org/10.3133/pp835

Pfister, C 1981, 'An analysis of the Little Ice Age climate in Switzerland and its consequences for agricultural production', in TML Wigley, MJ Ingram & G Farmer (eds), *Climate and history: studies in past climates and their impacts on man*, Cambridge University Press, Cambridge, United Kingdom, pp. 214–248.

Philipson, WR (ed) 1997, *Manual of photographic interpretation*, 2nd edn, American Society for Photogrammetry and Remote Sensing, Bethesda, Maryland, United States.

Phys.org 2013, *US Congress acts to avert helium shortage*, viewed 23 November 2018, <https://phys.org/news/2013-09-congress-avert-helium-shortage.html>.

Pineux, N, Lisein, J, Swerts, G, Bielders, CL, Lejeune, P, Colinet, G & Degré A 2017, 'Can DEM time series produced by UAV be used to quantify diffuse erosion in an agricultural watershed?', *Geomorphology*, vol. 280, pp. 122–136, https://doi.org/10.1016/j.geomorph.2016.12.003

Pircher, M, Geipel, J, Kusnierek, K & Korsaeth, A 2017, 'Development of a hybrid UAV sensor platform suitable for farm-scale applications in precision agriculture', *ISPRS International Archives of Photogrammetry, Remote Sensing and Spatial Information Sciences*, vol. XLII-2/W6, pp. 297–302, https://doi.org/10.5194/isprs-archives-XLII-2-W6-297-2017, 2017

Pitt, DG & Glover, GR 1993, Large-scale 35-mm aerial photographs for assessment of vegetation-management research plots in eastern Canada', *Canadian Journal of Forest Research*, vol. 23, no. 10, pp. 2159–2169, https://doi.org/10.1139/x93-269

Poblete-Echeverría, C, Federico Olmedo, G, Ingram, B & Bardeen, M 2017, 'Detection and segmentation of vine canopy in ultra-high spatial resolution RGB imagery obtained from unmanned aerial vehicle (UAV): a case study in a commercial vineyard', *Remote Sensing*, vol. 9, no. 3, pp. 1–14, https://doi.org/10.3390/rs9030268

Poesen, J, Vandekerckhove, L, Nachtergaele, J, Oostwoud Wijdenes, DJ, Verstraeten, G & van Wesemael, B 2002, 'Gully erosion in dryland environments', in LJ Bull & MJ Kirkby (eds), *Dryland rivers: hydrology and geomorphology of semi-arid channels*, Wiley, Chichester, United Kingdom, pp. 229–262.

Poesen, J, Nachtergaele, J, Verstraeten, G & Valentin, C 2003, 'Gully erosion and environmental change: importance and research needs', *Catena*, vol. 50, no. 2–4, pp. 91–133, https://doi.org/10.1016/S0341-8162(02)00143-1

Pogue, D 2014, 'The curse of the cloud', *Scientific American*, vol. 310, no. 2, p. 28, https://doi.org/10.1038/scientificamerican0214-28

Pol'noseervis 2018, *Rapeseed oil*, viewed 24 November 2018, <https://www.polnoservis.sk/en/products/rapeseed-oil>.

Potgieter, AB, George-Jaeggli, B, Chapman, SC, Laws, K, Suárez Cadavid, LA, Wixted, J, Watson, J, Eldridge, M, Jordan, DR & Hammer, GL 2017, 'Multi-spectral imaging from an unmanned aerial vehicle enables the assessment of seasonal leaf area dynamics of sorghum breeding lines', *Frontiers in Plant Science*, vol. 8, viewed 21 November 2018, <https://www.frontiersin.org/articles/10.3389/fpls.2017.01532/full>, https://doi.org/10.3389/fpls.2017.01532

Prest, VK 1983, *Canada's heritage of glacial features*, Geological Survey Canada, Miscellaneous Report 28, Energy, Mines and Resources Canada, Ottawa, Ontario, Canada.

Preu, C, Naschold, G & Weerakkody, U 1987, 'Der Einsatz einer Ballon-Fotoeinrichtung für küstenmorphologische Fragestellungen', in B Hofmeister & F Voss (eds), *Beiträge zur Geographie der Küsten und Meere, Arbeitskreis Meere & Küsten, Sylt 1986 und Berlin 1987*, TU Berlin, Berlin, Germany, pp. 377–388.

Professional Disc Golf Association 2016, *Brief history of disc golf and the PDGA*, viewed 4 October 2018, <http://www.pdga.com/history>.

Professional Disc Golf Association 2018, *2017 PDGA year end demographics*, viewed 21 November 2018, <https://www.pdga.com/pdga-documents/demographics-current/2017-pdga-year-end-demographics>.

Prosilica 2009, 'Prosilica cameras go airborne', *Prosilica Camera News*, vol. 11, May 2009, pp. 2–4, viewed 23 November 2018, <https://www.alliedvision.com/en/news/detail/news/prosilica-cameras-go-airborne.html>.

Pu, R, Gong, P, Tians, Y, Miao, X, Carruthers, RI & Anderson, GL 2008, 'Using classification and NDVI differencing methods for monitoring sparse vegetation coverage: a case study of saltcedar in Nevada, USA', *International Journal of Remote Sensing*, vol. 29, no. 14, pp. 3987–4011, https://doi.org/10.1080/01431160801908095

Quilter, MC & Anderson, VJ 2000, 'Low altitude/large scale aerial photographs: a tool for range and resource managers', *Rangelands*, vol. 22, no. 2, pp. 13–17, https://doi.org/10.2458/azu_rangelands_v22i2_Quilter

Rango, A, Laliberte, AS, Steele, C, Herrick, JE, Bestelmeyer, B, Schmugge, T, Roanhorse, A & Jenkins, V 2006. 'Using unmanned aerial vehicles for rangelands: current applications and future potentials', *Environmental Practice*, vol. 8, no. 3, pp. 159–168, https://doi.org/10.1017/S1466046606060224

Rankin, B 2016, 'How high are the humans? humans by altitude: population distribution by altitude', *Radical Cartography*, viewed 30 October 2018, <http://www.radicalcartography.net/index.html?howhigh>.

Ranson, KJ, Irons, JR & Williams, DL 1994, 'Multispectral bidirectional reflectance of northern forest canopies with the advanced solid-state array spectroradiometer (ASAS)', *Remote Sensing of Environment*, vol. 47, no. 2, pp. 276–289, https://doi.org/10.1016/0034-4257(94)90161-9

Rasmussen, J, Ntakos, G, Nielsen, J, Svensgaard, J, Poulsen, RN & Christensen, S 2016, 'Are vegetation indices derived from consumer-grade cameras mounted on UAVs sufficiently reliable for assessing experimental plots?', *European Journal of Agronomy*, vol. 74, pp. 75–92, https://doi.org/10.1016/j.eja.2015.11.026

Rattas, M & Kalm, V 2004, 'Glaciotectonic deformation patterns in Estonia', *Geological Quarterly*, vol. 48, no. 1, pp. 15–22, viewed 21 November 2018, <https://gq.pgi.gov.pl/article/view/7329/5979>.

Ray, SF 2002, *Applied photographic optics: lenses and optical systems for photography, film, video and digital imaging*, 3rd edn, Focal Press, Oxford, United Kingdom.

Red, C 2009, 'The outlook for unmanned aircraft', *CompositesWorld*, viewed 22 December 2018, <https://www.compositesworld.com/articles/the-outlook-for-unmanned-aircraft>.

Retallack, GJ & Burns, SF 2016, 'The effects of soil on the taste of wine', *GSA Today*, vol. 26, no. 5, pp. 4–9, viewed 9 December 2018, <http://www.geosociety.org/gsatoday/archive/26/5/article/i1052-5173-26-5-4.htm>.

Retzlaff, R, Molitor, D, Behr, M, Bossung, C, Rock, G, Hoffmann, L, Evers, D & Udelhoven, T 2015, 'UAS-based multi-angular remote sensing of the effects of soil management strategies on grapevine', *Journal International des Sciences de la Vigne et du Vin*, vol. 49, no. 2, pp. 85–102, viewed 9 December 2018, https://doi.org/10.20870/oeno-one.2015.49.2.91

Rhee, DS, Kim, YD, Kang, B & Kim, D 2018, 'Applications of unmanned aerial vehicles in fluvial remote sensing: an overview of recent achievements', *KSCE Journal of Civil Engineering*, vol. 22, no. 2, pp. 588–602, https://doi.org/10.1007/s12205-017-1862-5

Ribeiro, A, 2013, 'Leica Geosystems announces new Leica ADS100 airborne digital sensor with unique focal plate design', *PRWeb*, viewed 23 November 2018, <http://www.prweb.com/releases/2013/3/prweb10569719.htm>.

Richards, JA 2013, *Remote sensing digital image analysis, an introduction*, 5th edn, Springer, Berlin, Germany.

Rieke-Zapp, DH, Tecklenburg, W, Peipe, J, Hastedt, H & Haig, C 2009, 'Evaluation of the geometric stability and the accuracy potential of digital cameras—comparing mechanical stabilisation versus parameterisation', ISPRS *Journal of Photogrammetry & Remote Sensing*, vol. 64, no. 3, pp. 248–258, https://doi.org/10.1016/j.isprsjprs.2008.09.010

Ries, JB 2000, *Geomorphodynamik und Landdegradation auf Brachflächen zwischen Ebrobecken und Pyrenäen. Großmaßstäbiges Monitoring zur Erfassung und Prognose des Prozessgeschehens im Landnutzungswandel als Beitrag zur Methodenentwicklung*, Habilitation thesis, Faculty of Geosciences/Geography, Frankfurt University, Frankfurt am Main, Germany.

Ries JB 2002, 'Geomorphodynamics on fallow land and abandoned fields in the Ebro Basin and the Pyrenees—monitoring of processes and development', in K-H Schmidt & T Vetter (eds), *Late Quaternary Geomorphodynamics, Zeitschrift für Geomorphologie N.F.*, Suppl. 127, Borntraeger, Berlin, pp. 21–45.

Ries, JB 2003, *Landnutzungswandel und Landdegradation in Spanien— eine Einführung. Cambios de uso del suelo y degradación de territorio en España—una breve introducción*, in I Marzolff, JB Ries, J de La Riva & M Seeger (eds), *Landnutzungswandel und Landdegradation in Spanien—El cambio en el uso del suelo y la degradación del territorio en España. Ergebnisse des Workshops vom 18.-21.10.2001 in Frankfurt am Main*. Frankfurt am Main/Zaragoza (Sonderband Frankfurter Geowissenschaftliche Arbeiten/Monografías de la Universidad de Zaragoza), pp. 11–29.

Ries, JB & Hirt, U 2008, 'Permanence of soil surface crusts on abandoned farmland in the Central Ebro Basin/Spain', *Catena*, vol. 72, no. 2, pp. 282–296, https://doi.org/10.1016/j.catena.2007.06.001

Ries, JB & Marzolff, I 2003, 'Monitoring of gully erosion in the central Ebro Basin by large-scale aerial photography from a remotely controlled blimp', *Catena*, vol. 50, no. 2–4, pp. 309–328, https://doi.org/10.1016/S0341-8162(02)00133-9

Ries, JB & Marzolff, I 2007, *Großmaßstäbiges Gully-Monitoring in semi-ariden Landschaften (MoGul–DFG-Projekt RI 835/2-1 bzw. MA 2549/1-1). Final project report*, 19 p., viewed 9 December 2018 <http://www.uni-frankfurt.de/45217482/Abschlussbericht_MoGul-Projekt_2007.pdf>.

Ries, JB & Marzolff, I 2017, 'Erosionsprozesse in degradierten Arganbeständen in Südmarokko', *DFG Project Summary*, no. 388485989, viewed 30 October 2018, <http://gepris.dfg.de/gepris/projekt/388485989>.

Ries, JB, Seeger, M & Marzolff, I 1998, 'El proyecto EPRODESERT. Cambios de uso del suelo y morfodinámica en el Nordeste de España', *Geograficalia*, vol. 35, pp. 205–225.

Ries, JB, Marzolff, I & Seeger, M 2000, 'Der Beweidungseinfluß auf Vegetationsbedeckung und Bodenerosion in der Flysch-Zone der spanischen Pyrenäen', in G Zollinger (ed.), *Aktuelle Beiträge zur angewandten physischen Geographie der Tropen, Subtropen und der Regio Trirhenia*, Festschrift zum 60. Geburtstag von Prof. Dr. Rüdiger Mäckel, Freiburg, Germany, pp. 167–194.

Ries, JB, Marzolff I & Seeger, M 2003, 'Einfluss der Beweidung auf Vegetationsbedeckung und Geomorphodynamik zwischen Ebrobecken und Pyrenäen', *Geographische Rundschau*, vol. 55, no. 5, pp. 52–59.

Ries, JB, Seeger, M & Marzolff, I 2004, 'Influencia del pastoreo en la cubierta vegetal y la geomorfodinámica en el transecto Depresión del Ebro-Pirineos', *Geograficalia*, vol. 45, pp. 5–19.

Ries JB, Iserloh, T, Seeger, M & Gabriels, D 2013, 'Rainfall simulations— constraints, needs and challenges for a future use in soil erosion research', *Zeitschrift für Geomorphologie, Supplementary Issues*, vol. 57, pp. 1–10, https://doi.org/10.1127/0372-8854/2013/S-00130

Ries, JB, Andres, K, Wirtz, S, Tumbrink, J, Wilms, T, Peter, KD, Burczyk, M, Butzen, V & Seeger, M 2014, 'Sheep and goat erosion—experimental geomorphology as an approach for the quantification of underestimated processes', *Zeitschrift für Geomorphologie*, vol. 58, no. 3, pp. 23–45, https://doi.org/10.1127/0372-8854/2014/S-00158

Ries, JB, Marzolff, I & Aït Hssaïne, A 2016, *AGASouss—Gully-Erosion in agro-industriell genutzten Landschaften zwischen Hohem und Anti-Atlas (Marokko) (DFG-Projekt RI 835/5-1 bzw. MA 2549/3-1). Final project report*, viewed 9 December 2018, <http://www.uni-frankfurt.de/62093968/MA2549-RI835-AGASouss_Abschlussbericht.pdf>.

Rizzo, M 2014, 'Before drone cameras: kite cameras!', *National Public Radio, Daily Picture Show*, viewed 4 October 2018, <http://www.npr.org/sections/pictureshow/2014/01/15/260152557/before-drone-cameras-kite-cameras>.

Robinson, M 2003a, 'The genius of Rogallo's Wing', *Kiting*, vol. 25, no. 2, pp. 27, 32.

Robinson, M 2003b, 'The flying cowboy', *Kiting*, vol. 25, no. 3, pp. 27, 34–35.

Rock-Color Chart Committee 1991, 'Rock-color chart', *The Geological Society of America*, 8th printing, 1995, Boulder, Colorado, United States.

Rodrigo-Comino, J, Ruiz-Sinoga, JD, Senciales González, JM, Guerra-Merchán, A, Seeger, M & Ries, JB 2016, 'High variability of soil erosion and hydrological processes in Mediterranean hillslope vineyards (Montes de Málaga, Spain)', *Catena*, vol. 145, pp. 274–284, https://doi.org/10.1016/j.catena.2016.06.012

Rodrigo-Comino, J, Senciales, JM, Ramos, MC, Martínez-Casasnovas, JA, Lasanta, T, Brevik, EC, Ries, JB & Ruiz-Sinoga, JD 2017, 'Understanding soil erosion processes in Mediterranean sloping vineyards (Montes de Málaga, Spain)', *Geoderma*, vol. 296, pp. 47–59, https://doi.org/10.1016/j.geoderma.2017.02.021

Rodrigo-Comino, J, Neumann, M, Remke, A & Ries JB 2018, 'Assessing environmental changes in abandoned German vineyards: understanding key issues for restoration management plans', *Hungarian Geographical Bulletin*, vol. 67, no. 4, pp. 319–332, https://doi.org/10.15201/hungeobull.67.4.2

Rodrigo-Comino, J, Seeger, M, Senciales, JM, Ruiz-Sinoga & Ries, JB 2019, 'Rainfall-simulated quantification of initial soil erosion processes in sloping and poorly maintained terraced vineyards—key issues for sustainable management systems', *Science of the Total Environment*, vol. 660, pp. 1047–1057, https://doi.org/10.1016/j.scitotenv.2018.12.451

Romer, GB 2007, 'Introduction to the biographies of selected innovators of photographic technology', in MR Peres (ed.), *Focal encyclopedia of photography: digital imaging, theory and applications, history, and science*, 4th edn, Elsevier, Amsterdam, Netherlands, pp. 123–134.

Roosjen, PPJ, Suomalainen, JM, Bartholomeus, HM, Kooistra, L & Clevers, JGPW 2017, 'Mapping reflectance anisotropy of a potato canopy using aerial images acquired with an unmanned aerial vehicle', *Remote Sensing*, vol. 9, no. 5, p. 417, https://doi.org/10.3390/rs9050417

Rosenthaler, L 2007, 'Digital archiving', in MR Peres (ed.), *Focal encyclopedia of photography: digital imaging, theory and applications, history, and science*, 4th edn, Elsevier, Amsterdam, pp. 359–363.

Roy, EJ 1954, 'Kite takes aerial photos', *Mechanix Illustrated*, vol. 50, no. 10, pp. 174–176, 199, viewed 4 October 2018, <http://blog.modernmechanix.com/kite-takes-aerial-photos/>.

Ruleman, CA, Machette, MN, Thompson, RA, Miggines, DP, Goehring, BM & Paces, JB 2016, 'Geomorphic evolution of the San Luis Basin and Rio Grande in southern Colorado and northern New Mexico', Geological Society of America, Field Guide, vol. 44, pp. 291–333.

Ružić, I, Marović, I, Benac, Č & Ilić, S 2014, 'Coastal cliff geometry derived from structure-from-motion photogrammetry at Stara Baška, Krk Island, Croatia', *Geo-Marine Letters*, vol. 34, no. 6, pp. 555–565, https://doi.org/10.1007/s00367-014-0380-4

Ryerson, RA, Curran, PJ & Stephans, PR 1997, 'Agriculture', in WR Philipson (ed.), *Manual of photographic interpretation*, 2nd edn, American Society for Photogrammetry and Remote Sensing, Bethesda, Maryland, United States, pp. 365–397.

Saeed, AS, Younes, AB, Cai, C & Cai, G 2018, 'A survey of hybrid unmanned aerial vehicles', *Progress in Aerospace Sciences*, vol. 98, pp. 91–105, https://doi.org/10.1016/j.paerosci.2018.03.007

Salomon, JG, Schaaf, CB, Stahler, AH, Geo, F & Jin, Y 2006, 'Validation of the MODIS bidirectional reflectance distribution function and albedo retrievals using combined observations from the Aqua and Terra platforms', *IEEE Transaction on Geoscience and Remote Sensing*, vol. 44, no. 6, pp. 1555–1565, https://doi.org/10.1109/TGRS.2006.871564

Sandercock, P, Hooke, J, De Baets, S, Poesen J, Meerkerk, A, van Wesemael, B & Cammeraat, LH, 2017, 'Effectiveness of plants and vegetation in erosion control and restoration', in J Hooke & P Sandercock, (eds), *Combating desertification and land degradation: spatial strategies using vegetation*, Springer, Basel, pp. 79–104.

Sandmeier, S 2004, 'Spectral variability of BRDF-data', in M von Schönermark, B Geiger & HP Röser (eds), *Reflection properties of vegetation and soil—with a BRDF data base*, Wissenschaft und Technik Verlag, Berlin, pp. 131–146.

Sankaran, S, Khot, LR & Carter, AH 2015a, 'Field-based crop phenotyping: multispectral aerial imaging for evaluation of winter wheat emergence and spring stand', *Computers and Electronics in Agriculture*, vol. 118, pp. 372–379, https://doi.org/10.1016/j.compag.2015.09.001

Sankaran, S, Khot, LR, Espinoza, CZ, Jarolmasjed, S, Sathuvalli, VR, Vandemark, GJ, Miklas, PN, Carter, AH, Pumphrey, MO, Knowles, NR & Pavek, MJ 2015b, 'Low-altitude, high-resolution aerial imaging systems for row and field crop phenotyping: a review', *European Journal of Agronomy*, vol. 70, pp. 112–123, https://doi.org/10.1016/j.eja.2015.07.004

Satellite Imaging 2017, *Satellite sensors*, viewed 3 September 2018, <http://www.satimagingcorp.com/satellite-sensors/>.

Schaaf, CB & Strahler, AH 1994, 'Validation of bidirectional and hemispherical reflectances from a geometric-optical model using ASAS imagery and pyranometer measurements of a spruce forest', *Remote Sensing Environment*, vol. 49, no. 2, pp. 138–144, https://doi.org/10.1016/0034-4257(94)90050-7

Scheritz, M, Dietrich, R, Scheller, S, Schneider, W & Boike, J 2008, 'Digital elevation model of polygonal patterned ground on Samoylov Island, Siberia, using small-format photography', in DL Kane & KM Hinkel (eds), *Proceedings of the 9th international conference on permafrost*, University of Alaska, Fairbanks, USA, 29 June–3 July 2008, pp. 1589–1594.

Schneider, S 1974, *Luftbild und Luftbildinterpretation*, De Gruyter, Berlin, Germany.

Schomacker, A, Johnson, MD & Möller, P 2018, 'Drumlin formation: a mystery or not?', *GFF, Journal of the Geological Society of Sweden*, vol. 140, no. 2, pp. 91–92, https://doi.org/10.1080/11035897.2018.1485326

Schot, PP 1999, 'Wetlands', in B Nath, L Hens, P Compton & D Devuyst (eds), *Environmental management in practice: managing the ecosystem*, vol. 3. Routledge, London, United Kingdom, pp. 62–85.

Schumm, B 2018, *Battery*, Encyclopædia Britannica, viewed 9 December 2018, <https://www.britannica.com/technology/battery-electronics>.

Seang, TP & Mund, J-P 2006, 'Balloon-based geo-referenced digital photo technique—a low cost high-resolution option for developing countries', *Proceedings of the XXIII International Federation of Surveyors (FIG) Congress, Shaping the Change*, Munich, Germany, 8-13 October 2006, pp. 1–12, viewed 23 November 2018, <https://www.fig.net/resources/proceedings/fig_proceedings/fig2006/papers/ts73/ts73_02_mund_peng_0425.pdf>.

Seang, TP, Mund, JP & Symann, R 2008, *Practitioner's guide: low cost amateur aerial pictures with balloon and digital camera*, MethodFinder, Centre for International Migration and Development, Usingen, Germany, viewed 2 December 2018, <http://www.methodfinder.net/download_all.html>.

Sébrier, M, Siame, L, Zouine, M, Winter, T, Missenard, Y & Leturmy, P 2006, 'Active tectonics in the Moroccan high atlas', *Comptes Rendus Geoscience*, vol. 338, pp. 65–79, https://doi.org/10.1016/j.crte.2005.12.001

Šechtl and Voseček Museum of Photography 2006, '*Sergei Mikhailovich Prokudin-Gorsky: a selection from the collection the splendors of Russia in natural color—color photographs from the years 1905–1916*', viewed 4 October 2018, <https://sechtl-vosecek.ucw.cz/en/expozice5.html#p-g>.

Seeger, M, Marzolff, I & Ries, JB 2009, 'Identification of gully-development processes in semi-arid NE-Spain', *Zeitschrift für Geomorphologie N. F.*, vol. 53, no. 4, pp. 417–431, https://doi.org/10.1127/0372-8854/2009/0053-0417

Shachtman, N 2011, Look: giant spy blimp dwarfs an 18-wheeler, *Wired*, viewed 23 November 2018, <https://www.wired.com/2011/10/giant-blimp-dwarfs-truck/>.

Shackelford, AK 2004, *Development of urban area geospatial information products from high resolution satellite imagery using advanced image analysis techniques*, PhD thesis, University of Missouri-Columbia, Missouri, United States.

Shan, J, Fu, C-S, Li, B, Bethel, J, Kretsch, J & Mikhail, E 2006, 'Principles and evaluation of autostereoscopic photogrammetric measurement', *Photogrammetric Engineering & Remote Sensing*, vol. 72, no. 4, pp. 365–372.

Shaw, J 1995, *John Shaw's Landscape photography: professional techniques for shooting spectacular scenes*, Amphoto, New York, United States.

Sherwood, D 2018, 'Emporian wins world disc golf title', *The Emporia Gazette*, 10 September, viewed 4 October 2018, <http://www.emporiagazette.com/area_news/article_a713d675-5e15-5025-a589-d05ab522dd21.html>.

Short, NM 1982, *The Landsat tutorial workbook: basics of satellite remote sensing*, NASA Reference Publication 1078, U.S. Government Printing Office, Washington DC, viewed 21 November 2018, <https://catalog.hathitrust.org/Record/011409073>.

Shortis, MR, Seager, JW, Harvey, ES & Robson, S 2005, 'The influence of Bayer filters on the quality of photogrammetric measurement', in JA Beraldin, SF El-Hakim, A Gruen & JS Walton (eds), Proceedings vol. 5665, *Videometrics VIII*, San José, California, USA, 16–20 January 2005, SPIE Proceedings, Bellingham, Washington, pp. 164–171, viewed 21 November 2018, https://doi.org/10.1117/12.588217

Shortis, MR, Bellman, CJ, Robson, S, Johnston, GJ & Johnson, GW 2006, 'Stability of zoom and fixed lenses used with digital SLR cameras', *International Archives of Photogrammetry & Remote Sensing*, vol. 36, no. 5, pp. 285–290, viewed 21 November 2018, <http://www.isprs.org/proceedings/XXXVI/part5/paper/SHOR_617.pdf>.

Sieberth, T, Wackrow, R & Chandler, JH 2016, 'Automatic detection of blurred images in UAV image sets', *ISPRS Journal of Photogrammetry and Remote Sensing*, vol. 122, pp. 1–16, https://doi.org/10.1016/j.isprsjprs.2016.09.010

Siegel, LH & Holbrook, RB 1999, *National Cemetery Administration (NCA) facilities design guide*, U.S. Department of Veterans Affairs, viewed 6 October 2018, <https://www.nist.gov/document-12314>.

Sillasoo, Ü, Mauquoy, D, Blundell, A, Charman, D, Blaauw, M, Daniell, JRG, Toms, P, Newberry, J, Chambers, FM & Karofeld, E 2007, 'Peat multi-proxy data from Männikjärve bog as indicators of late Holocene climate changes in Estonia', *Boreas*, vol. 36, no. 1, p. 20–37, https://doi.org/10.1111/j.1502-3885.2007.tb01177.x

Simic Milas, A, Romanko, M, Reil, P, Abeysinghe, T & Marambe, A 2018a, 'The importance of leaf area index in mapping chlorophyll content of corn under different agricultural treatments using UAV images', *International Journal of Remote Sensing*, vol. 39, no. 15-16, pp. 5415–5431, https://doi.org/10.1080/01431161.2018.1455244

Simic Milas, A, Sousa, JJ, Warner, TA, Teodoro, AC, Peres, E, Gonçalves, JA, Delgado Garcia, J, Bento, R, Phinn, S & Woodget, A 2018b, 'Unmanned Aerial Systems (UAS) for environmental applications special issue preface', *International Journal of Remote Sensing*, vol. 39, no. 15–16, pp. 4845–4851, https://doi.org/10.1080/01431161.2018.1491518

Skinkis, P 2015, *Overview of vineyard floor management-eXtension'*, U.S. Cooperative Extension System, viewed 9 December 2018, <http://articles.extension.org/pages/31597/overview-of-vineyard-floor-management>.

SmartIPX 2015, *A (not so) brief history of mobile telephony*, viewed 9 December 2018, <http://smartipx.com/brief-history-mobile-telephony/>.

Smith, MW & Vericat, D 2015, 'From experimental plots to experimental landscapes: topography, erosion and deposition in sub-humid badlands from structure-from-motion photogrammetry', *Earth Surface Processes and Landforms*, vol. 40, no. 12, pp. 1656–1671, https://doi.org/10.1002/esp.3747

Smith, MJ, Chandler, JH & Rose, J 2009, 'High spatial resolution data acquisition for the geosciences: kite aerial photography', *Earth Surface Processes and Landforms*, vol. 34, no. 1, pp. 155–161, https://doi.org/10.1002/esp.1702

Smith, MW, Carrivick, JL & Quincey, DJ 2016. 'Structure from motion photogrammetry in physical geography', *Progress in Physical Geography*, vol. 40, no. 2, pp. 247–275, https://doi.org/10.1177/0309133315615805

Smoot, F 2002, *Sickness and death in the Old South: facing east, the traditional burial position*, viewed 23 November 2018, <http://tngenweb.org/darkside/facing-east.html>.

Snavely, N, Seitz, SM & Szeliski, R, 2008, 'Modeling the world from internet photo collections', *International Journal of Computer Vision*, vol. 80, no. 2, pp. 189–210, https://doi.org/10.1007/s11263-007-0107-3

Southwind 2017, *The Golf Club at Southwind*, viewed 4 October 2018, <https://web.archive.org/web/20170709095606/http://tgcsouthwind.com:80/>.

Stachniss, C, Förstner, W & Schneider, J (eds) 2017, *Proceedings of the international conference on unmanned aerial vehicles in geomatics (UAV-g2017)*, Bonn, Germany, 4–7 September 2017, International Archives of Photogrammetry, Remote Sensing and Spatial Information Sciences, vol. XLII-2/W6, viewed 22 December 2018 <https://www.int-arch-photogramm-remote-sens-spatial-inf-sci.net/XLII-2-W6/>.

Statista.com 2018, *Number of mobile (cellular) subscriptions worldwide from 1993 to 2017 (in millions)*, Statista: The Statistics Portal, viewed 1 December 2018, <https://www.statista.com/statistics/262950/global-mobile-subscriptions-since-1993/>.

Staver, A 2018, 'Colorado lawmakers want to make it a felony to fly a drone over a wildfire', *The Denver Post*, June 28, viewed 18 December 2018, <https://www.denverpost.com/2018/06/27/colorado-lawmakers-drone-wildfire/>.

Stavi, I, Ungar, ED, Lavee, H & Pariente, S 2008, 'Grazing-induced spatial variability of soil bulk density and content of moisture, organic carbon and calcium carbonate in a semi-arid rangeland', *Catena*, vol. 75, no. 3, pp. 288–296, https://doi.org/10.1016/j.catena.2008.07.007

Stavi, I, Lavee, H, Ungar, ED & Pariente, S 2009a, 'Eco-geomorphic feedbacks in semi-arid rangelands: a review', *Pedosphere*, vol. 19, no. 2, pp. 217–229, https://doi.org/10.1016/S1002-0160(09)60111-9

Stavi, I, Ungar, ED, Lavee, H & Pariente, S 2009b, 'Livestock modify ground surface microtopography and penetration resistance in a semi-arid shrubland', *Arid Land Research and Management*, vol. 23, no. 3, pp. 237–247, https://doi.org/10.1080/15324980903028371

Steenblock, G 2006, 'Hauptsache gut versichert', *RC-Network Magazin*, viewed 14 December 2018, <http://www.rc-network.de/magazin/artikel_06/art_06-021/art_021-01.html>.

Stehling, E & Schmidt, R-G 2017, 'Das Datenarchiv der Forschungsstelle Bodenerosion in Mertesdorf (Ruwertal). Eine Dokumentation über 25 Messjahre (1975-1999); Informationszusammenstellung zum Gebrauch der Daten-CD', in JB Ries & R-G Schmidt (eds), *Forschungsstelle Bodenerosion*, vol. 16, Universität Trier, Trier, pp. 95.

Steinbeck, J, Steinbeck, EA (ed.) & Wallsten, R (ed.) 1975, *Steinbeck: a life in letters*, Viking Press, New York, United States.

Steiner, F 2015, *Hydrologic validation of a structure-from-motion DEM derived from low-altitude UAV imagery*, Master's thesis, Frankfurt University, Frankfurt, Germany, viewed 3 September 2018, <http://www.uni-frankfurt.de/73359757/Steiner_Hydrologic-validation-of-a-structure-from-motion-DEM_MScThesis2015.pdf>.

Steinmetz, G 2018, 'Drones are changing how we see the world', *Time*, vol. 191, no. 22, viewed 22 December, 2018, <http://time.com/longform/drones-career/>.

Stöcker, C, Eltner, A & Karrasch, P 2015, 'Measuring gullies by synergetic application of UAV and close range photogrammetry—a case study from Andalusia, Spain', *Catena*, vol. 132, pp. 1–11, https://doi.org/10.1016/j.catena.2015.04.004

Stöcker, C, Bennett, R, Nex, F, Gerke, M & Zevenbergen, J 2017, 'Review of the current state of UAV regulations', *Remote Sensing*, vol. 9, no. 5, pp. 1–26, https://doi.org/10.3390/rs9050459

Stroebel, L 2007, 'Perspective', in MR Peres (ed.), *Focal encyclopedia of photography: digital imaging, theory and applications, history, and science*, 4th edn, Elsevier, Amsterdam, Netherland, pp. 728–732.

Sutton, K 1999, 'From chute to kite: how the classic flow form came to be', *Kitelines*, vol. 13, no. 1, pp. 39–41.

Tamminga, AD, Eaton, BC & Hugenholtz, CH 2015, 'UAS-based remote sensing of fluvial change following an extreme flood event', *Earth Surface Processes and Landforms*, vol. 40, no. 11, pp. 1464–1476, https://doi.org/10.1002/esp.3728

Tarolli, P 2014, 'High-resolution topography for understanding Earth surface processes: opportunities and challenges', *Geomorphology*, vol. 216, pp. 295–312, https://doi.org/10.1016/j.geomorph.2014.03.008

Taylor, D 2014, *Understanding composition: the expanded guide-techniques'*, Ammonite Press, Lewes, East Sussex, United Kingdom.

Teng, WL, Loew, ER, Ross, DI, Zsilinszky, VG, Lo, CP, Philipson, WR, Philpot, WD & Morain, SA 1997, 'Fundamentals of photographic interpretation', in WR Philipson (ed.), *Manual of photographic interpretation*, 2nd edn, American Society for Photogrammetry and Remote Sensing, Bethesda, Maryland, United States pp. 49–113.

Tepper, R 2013, 'George Steinmetz, National Geographic photographer, arrested taking photos of Kansas feedlot [update]', Huffington *Post*, 6 December 2017, viewed 13 December 2018, <http://www.huffingtonpost.com/2013/07/11/george-steinmetz-arrested-feedlot_n_3575593.html>.

Thamm, H-P & Judex, M 2006, 'The "low cost drone"—an interesting tool for process monitoring in a high spatial and temporal resolution', *International Archives of Photogrammetry, Remote Sensing and Spatial Information Sciences*, vol. 36, no. 7, pp. 140–144.

Thamm, F-P, Brieger, N, Neitzke, K-P, Meyer, M, Jansen, R & Mönninghof, M 2015, 'SONGBIRD—an innovative UAS combining the advantages of fixed wing and multi rotor UAS', *ISPRS International Archives of the Photogrammetry, Remote Sensing and Spatial Information Sciences*, vol. XL-1/W4, pp. 345–349, https://doi.org/10.5194/isprsarchives-XL-1-W4-345-2015

The Wind Power 2018a, *Denmark: production capacities*, viewed 9 December 2018, <http://www.thewindpower.net/country_en_6_denmark.php>.

The Wind Power 2018b, *Poland: production capacities*, viewed 9 December 2018, <http://www.thewindpower.net/country_en_27_poland.php>.

Thodberg, C 1974, 'Religion', in B Rying & M Rode (eds), *Denmark: an official handbook*, Press and Cultural Relations Department, Ministry of Foreign Affairs, Christiansborg, Denmark, pp. 236–247.

Thoeni, K, Giacomini, A, Murtagh, R & Kniest, E 2014, 'A comparison of multi-view 3D reconstruction of a rock wall using several cameras and a laser scanner', *ISPRS International Archives of Photogrammetry, Remote Sensing and Spatial Information Sciences*, vol. XL-5, pp. 573–580.

Thornes, JB 1990, *Vegetation and erosion: processes and environments*, Wiley, Chichester, United Kingdom.

Thornes, J 2009, 'Vegetation and erosion', *European Geosciences Union General Assembly 2009*, Vienna, Austria, 19-24 April, viewed 22 December 2018, <http://meetingorganizer.copernicus.org/EGU2009/session/878>.

Tielkes, E 2003, *L'oeil du cerf-volant: evaluation et suivi des états de surface par photographie aérienne sous cerf-volant*, Margraf Publishers, Weikersheim, Germany.

Time 2018, 'Time special report: the drone age', *Time*, vol. 191, no. 22, viewed 22 December 2018, <http://time.com/collection/drones/>.

Tiner, RW 1997, 'Wetlands', in WR Philipson (ed.), *Manual of photographic interpretation*, 2nd edn, American Society for Photogrammetry and Remote Sensing, Bethesda, Maryland, United States, pp. 475–494.

Toro, FG & Tsourdos, A (eds) 2018, *UAV or drones for remote sensing applications*, vol. 1–2, MDPI, Basel, Switzerland.

Torres, J, Ten, M, Zarzoso, J, Salom, L, Gaitán, R & Lluch, J 2013, 'Comparative study of stereoscopic techniques applied to a virtual globe', *The Cartographic Journal*, vol. 50, no. 4, pp. 369–375, https://doi.org/10.1179/1743277413Y.0000000034

Torresan, C, Berton, A, Carotenuto, F, Di Gennaro, SF, Gioli, B, Matese, A, Miglietta, F, Vagnoli, C, Zaldei, A & Wallace, L 2017, 'Forestry applications of UAVs in Europe: a review', *International Journal of Remote Sensing*, vol. 38, 8–10, pp. 2427–2447, https://doi.org/10.1080/01431161.2016.1252477

Torres-Sánchez, J, López-Granados, F, Serrano, N, Arquero, O, Peña, JM & Hassan, QK 2015, 'High-throughput 3-D monitoring of agricultural-tree plantations with unmanned aerial vehicle (UAV) technology', *PLoS ONE*, vol. 10, no. 6, pp. 1–20, https://doi.org/10.1371/journal.pone.0130479

Trade Data & Analysis 2017, *World wine production by country 2015*, Statistics—The Wine Institute, viewed 9 December 2018, <https://www.wineinstitute.org/files/World_Wine_Production_by_Country_2015.pdf>.

Trémeau, A, Tominaga, S & Plataniotis, KN 2008, 'Color in image and video processing: most recent trends and future research directions', *EURASIP Journal on Image and Video Processing*, vol. 2008, no. 1, pp. 1–26, https://doi.org/10.1155/2008/581371

Trimble, S 2001, *Great Sand Dunes: the shape of the wind*, Southwest Parks and Monuments Association, Tucson, Arizona, United States.

Troll, C 1939, 'Luftbildplan und ökologische Bodenforschung: Ihr zweckmäßiger Einsatz für die wissenschaftliche Erforschung und praktische Erschließung wenig bekannter Länder', *Zeitschrift der Gesellschaft für Erdkunde zu Berlin*, vol. 7, no. 8, pp. 241-298.

Tschudi, MA, Maslanik, JA & Perovich, DK 2008, 'Derivation of melt pond coverage on Arctic sea ice using MODIS observations', *Remote Sensing of Environment*, vol. 112, no. 5, pp. 2605–2614, https://doi.org/10.1016/j.rse.2007.12.009

Tucker, A 2009, Winging it, *Smithsonian*, vol. 39, no. 10, pp. 46–53, viewed 24 November 2018, <https://www.smithsonianmag.com/travel/africa-on-the-fly-131756071/>.

Tucker, CJ 1979, 'Red and photographic infrared linear combinations for monitoring vegetation', *Remote Sensing Environment*, vol. 8, no. 2, pp. 127–150, https://doi.org/10.1016/0034-4257(79)90013-0

Tumbrink, J 2012, *Experimental studies on sheep erosion: distribution patterns and impact*, Examination thesis, Trier University, Faculty VI, Geography and Geosciences, Physical Geography.

Turner, D, Lucieer, A & Wallace, L 2014, 'Direct georeferencing of ultrahigh-resolution UAV imagery', *IEEE Transactions on Geoscience and Remote Sensing*, vol. 52, no. 5, pp. 2738–2745, https://doi.org/10.1109/TGRS.2013.2265295

Turner, IL, Harley, MD & Drummond, CD 2016, 'UAVs for coastal surveying', *Coastal Engineering*, vol. 114, pp. 19–24, https://doi.org/10.1016/j.coastaleng.2016.03.011

UAV Slovakia 2018, 'Slovakia drone laws', *UAV Systems*, viewed 13 December 2018, <https://www.uavsystemsinternational.com/drone-laws-by-country/slovakia-drone-laws/>.

Ullman, S 1979, 'The interpretation of structure from motion', *Proceedings of the Royal Society of London, Series B, Biological Sciences*, vol. 203, pp. 405–426, https://doi.org/10.1098/rspb.1979.0006

Ullmann, H 1971, 'Hochmoor-Luftbilder mit Hilfe eines Kunststoff-ballons', *Österreichische Botanische Zeitschrift*, vol. 119, no. 4–5, pp. 549–556, https://doi.org/10.1007/BF01377506

U.S. Census 2016, 'Total population: Lyon County, Kansas', *American Fact Finder*, viewed 25 September 2018, <https://factfinder.census.gov/>.

U.S. National Park Service 2017, 'Santa Fe National Historic Trail maps', *National Park Service*, viewed 6 October 2018, <https://www.nps.gov/safe/planyourvisit/maps.htm>.

USFWS 2010, 'Conserving treasured landscapes in America's great outdoors', *U.S. Fish & Wildlife Service, Mountain-Prairie Region, Factsheet*, viewed 30 November 2018, <http://www.fws.gov/mountain-prairie/planning/lpp/ks/flh/documents/flh_lpp_factsheet.pdf>.

Valavanis, KP (ed.) 2018, *Handbook of Unmanned Aerial Vehicles*, 2nd edn, Springer, Dordrecht, Netherlands.

Van Blyenburgh, P 2015, 'Foreword: civil RPAS in European Union airspace—the road to integration', in KP Valavanis & GJ Vachtsevanos (eds), *Handbook of unmanned aerial vehicles*, Springer, Dordrecht, Netherlands, pp. vii–xvii.

Van Blyenburgh, P (ed.) 2018, *RPAS remotely piloted aerial vehicles: the global perspective*, 15th edn, Blyenburgh & Co, Paris, France, viewed 22 December 2018, <https://rps-info.com/publications/rpas-yearbook-2018/>.

Van Iersel, W, Straatsma, M, Middelkoop, H & Addink, E 2018, 'Multitemporal classification of river floodplain vegetation using time series of UAV images', *Remote Sensing*, vol. 10, no. 7, p. 1144, https://doi.org/10.3390/rs10071144

Vandaele, K, Poesen, J, Marques de Silva, JR, Govers, G & Desmet, PJ 1997, 'Assessment of factors controlling ephemeral gully erosion in southern Portugal and central Belgium using aerial photographs', *Zeitschrift für Geomorphologie*, vol. 41, no. 3, pp. 273–287.

Vandekerckhove, L, Poesen, J, Oostwoud Wijdenes, D & Gyssels, G 2001, 'Short-term gully retreat rates in Mediterranean environments', *Catena*, vol. 44, no. 2, pp. 133–161, https://doi.org/10.1016/S0341-8162(00)00152-1

Vandekerckhove, L, Poesen, J & Govers, G 2003, 'Medium-term gully headcut retreat rates in southeast Spain determined from aerial photographs and ground measurements', *Catena*, vol. 50, no. 2-4, pp. 329–352, https://doi.org/10.1016/S0341-8162(02)00132-7

Vanmaercke, M, Poesen, J, Van Mele, B, Demuzere, M, Bruynseels, A, Golosov, V, Bezerra, JFR, Bolysov, S, Dvinskih, A, Frankl, A, Fuseina, Y, Guerra, AJT, Haregeweyn, N, Ionita, I, Makanzu Imwangana, F, Moeyersons, J, Moshe, I, Nazari Samani, A, Niacsu, L, Nyssen, J, Otsuki, Y, Radoane, M, Rysin, I, Ryzhov, YV & Yermolaev, O 2016, 'How fast do gully headcuts retreat?', *Earth Science Reviews*, vol. 154, pp. 336–355, https://doi.org/10.1016/j.earscirev.2016.01.009

Verger, A, Vigneau, N, Chéron, C, Gilliot, J-M, Comar, A & Baret, F 2014, 'Green area index from an unmanned aerial system over wheat and rapeseed crops', *Remote Sensing of Environment*, vol. 152, pp. 654–664, https://doi.org/10.1016/j.rse.2014.06.006

Verhoeven, GJ 2008, 'Imaging the invisible using modified digital still cameras for straightforward and low-cost archaeological near-infrared photography', *Journal of Archaeological Science*, vol. 35, no. 12, pp. 3087–3100, https://doi.org/10.1016/j.jas.2008.06.012

Verhoeven, GJ 2010, 'It's all about the format—unleashing the power of RAW aerial photography', *International Journal of Remote Sensing*, vol. 31, no. 8, pp. 2009–2042, https://doi.org/10.1080/01431160902929271

Verhoeven, GJ 2012, 'Near-infrared aerial crop mark archaeology: from its historical use to current digital implementations', *Journal of Archaeological Method and Theory*, vol. 19, no. 1, pp. 132–160, https://doi.org/10.1007/s10816-011-9104-5

Verhoeven, GJ 2016, 'BRDF and its impact on aerial archaeological photography', *Archaeological Prospection*, vol. 24, no. 2, pp. 133–140, https://doi.org/10.1002/arp.1559

Verhoeven, GJ, Loenders, J, Vermeulen, F & Docter, R 2009, 'Helikite aerial photography or HAP—a versatile means of unmanned, radio controlled, low-altitude aerial archaeology', *Archaeological Prospection*, vol. 16, no. 2, pp. 125–138, https://doi.org/10.1002/arp.353

Vericat, D, Brasington, J, Wheaton, J & Cowie, M 2009, 'Accuracy assessment of aerial photographs acquired using lighter-than-air blimps: low-cost tools for mapping river corridors', *River Research and Applications,* vol. 25, no. 8, pp. 985–1000, https://doi.org/10.1002/rra.1198

Vierling, LA, Fersdahl, M, Chen, X, Li, Z & Zimmerman, P 2006, 'The Short Wave Aerostat-Mounted Imager (SWAMI): a novel platform for acquiring remotely sensed data from a tethered balloon', *Remote Sensing of Environment,* vol. 103, no. 3, pp. 255–264, https://doi.org/10.1016/j.rse.2005.01.021

Visser, F, Buis, K, Verschoren, V & Meire, P 2015, 'Depth estimation of submerged aquatic vegetation in clear water streams using low-altitude optical remote sensing', *Sensors,* vol. 15, no. 10, pp. 25287–25312, https://doi.org/10.3390/s151025287

Vopata, J, Aber, JS & Kalm, V 2006, 'Patterned ground in the Culebra Range, southern Colorado', *Emporia State Research Studies,* vol. 43, pp. 8–21, viewed 10 November 2018, <http://academic.emporia.edu/esrs/vol43/vopata.pdf>.

Vrignaud, J-P 2014, 'Winners of first drone aerial photo contest announced', *National Geographic Society Newsroom,* blog, 11 July, viewed 13 December 2018, <https://blog.nationalgeographic.org/2014/07/11/winners-of-first-drone-aerial-photo-contest-announced/>.

Wackrow, R 2008, *Spatial measurement with consumer grade digital cameras,* PhD thesis, Faculty of Engineering, Loughborough University, Loughborough, United Kingdom.

Wackrow, R & Chandler, JH 2008, 'A convergent image configuration for DEM extraction that minimises the systematic effects caused by an inaccurate lens model', *The Photogrammetric Record,* vol. 23, no. 121, pp. 6–18, https://doi.org/10.1111/j.1477-9730.2008.00467.x

WAG 2018, 'The National Golf Foundation issues 2018 Golf Industry Report', *We Are Golf,* viewed 9 September 2019, http://wearegolf.org/industry-news/the-national-golf-foundation-issues-2018-golf-industry-report/.

Wainer, H & Friendly, M 2019, 'Visual answers to scientific questions', *American Scientist,* vol. 107, pp. 210–213. https://doi.org/10.1511/2019.107.4.210

Wang, R, Zhang, S, Pu, L, Yang, J, Yang, C, Chen, J, Guan, C, Wang, Q, Chen, D, Fu, B & Sang, X 2016, 'Gully erosion mapping and monitoring at multiple scales based on multi-source remote sensing data of the Sancha River Catchment, Northeast China', *ISPRS International Journal of Geo-Information,* vol. 5, no. 11, p. 1–17, https://doi.org/10.3390/ijgi5110200

Wanzke, H 1984, 'The employment of a hot-air ship for the stereophotogrammetric documentation of antique ruins', *International Archives of Photogrammetry and Remote Sensing,* vol. 25, no. A5, pp. 746-756, viewed 13 December 2018, <http://www.isprs.org/proceedings/XXV/congress/part5/746_XXV-part5.pdf>.

Ward, R & Fidler, PJ 1993, *The Nelson-Atkins Museum of Art: a handbook of the collection,* Hudson Hills Press, New York, New York, United States.

Wark, J 2004, *America: flying high,* White Star Publishers, Vercelli, Italy.

Warner, WS, Graham, RW & Read, RE 1996, *Small format aerial photography,* American Society for Photogrammetry and Remote Sensing, Bethesda, Maryland, United States.

Weems, J 2015, *Barnstorming the prairies: how aerial vision shaped the Midwest,* University of Minnesota Press, Minneapolis, Minnesota, United States.

Weise, BR & White, WA 1980, *Padre Island National Seashore: a guide to the geology, natural environments, and history of a Texas barrier island,* Bureau of Economic Geology, University of Texas, Guidebook 17, Austin, Texas, United States, viewed 21 November 2018, <https://www.nps.gov/parkhistory/online_books/pais/1980-17/index.htm>.

Wells, RR, Momm, HG & Castillo, C 2017, 'Quantifying uncertainty in high-resolution remotely sensed topographic surveys for ephemeral gully channel monitoring', *Earth Surface Dynamics,* vol. 5, no. 3, pp. 347–367, https://doi.org/10.5194/esurf-5-347-2017

Westoby, MJ, Glasser, NF, Hambrey, MJ, Brasington, J & Reynolds, JM 2012, 'Structure-from-motion photogrammetry: a low-cost, effective tool for geoscience applications', *Geomorphology,* vol. 179, pp. 300–314, https://doi.org/10.1016/j.geomorph.2012.08.021

Wheaton, JM, Brasington, J, Darby, SE & Sear D 2010, 'Accounting for uncertainty in DEMs from repeat topographic surveys: improved sediment budgets', *Earth Surface Processes and Landforms,* vol. 35, no. 2, pp. 136–156, https://doi.org/10.1002/esp.1886

Wigmore, O & Mark, B 2018, 'High altitude kite mapping: evaluation of kite aerial photography (KAP) and structure from motion digital elevation models in the Peruvian Andes', *International Journal of Remote Sensing,* vol. 39, no. 15–16, pp. 4995–5015, https://doi.org/10.1080/01431161.2017.1387312

Wildi, E 2006, *Master composition guide for digital photographers,* Amherst Media, Buffalo, New York, United States.

Williams Jr, RS 1986, 'Glaciers and glacial landforms', in NM Short & RW Blair Jr (eds), *Geomorphology from space: a global overview of regional landforms,* NASA Special Publication 486, U.S. Government Printing Office, Washington, D, C., United States, pp. 521–596.

Wilmarth, VR 1977, 'Summary', *Skylab explores the Earth,* NASA Special Publication 380, Washington, D.C., pp. 1–3.

Wilson, CM 2006, *Hanging by a thread: a kite's view of Wisconsin,* Itchy Cat Press, Blue Mounds, Wisconsin, United States.

Wilson, JP & Gallant, JC 2000, 'Chapter 1: digital terrain analysis', in JP Wilson & JC Gallant (eds), *Terrain analysis: principles and applications,* John Wiley & Sons, New York, New York, United States, pp. 1–27.

Wilson-Agin, ER 2003, *The use of geophysical and remote-sensing technology to locate and delineate unmarked graves in clay-rich soils of Kansas,* MS thesis, Emporia State University, Emporia, Kansas, United States.

Wingtra 2018, *WingtraOne technical specification sheet,* viewed 22 December 2018, <https://wingtra.com/wp-content/uploads/2018/05/WingtraOne-Tech-Specs-detailed-metric-and-imperial-units.pdf>.

Wolf, P, Dewitt, B & Wilkinson, B 2014, *Elements of photogrammetry with application in GIS,* 4th edn, McGraw-Hill Education, Maidenhead, United Kingdom.

Wood, T & Slegman, A 2007, *Bold expansion: The Nelson-Atkins Museum of Art Bloch Building,* Scala Arts Publishers, Inc., London, United Kingdom.

Woodget, AS, Carbonneau, PE, Visser, F, Maddock, IP 2015, 'Quantifying submerged fluvial topography using hyperspatial resolution UAS imagery and structure from motion photogrammetry', *Earth Surface Processes and Landforms,* vol. 40, no. 1, pp. 47–64, https://doi.org/10.1002/esp.3613

World Standards 2018a. *Plug, socket & voltage by country,* viewed 10 November 2018, <http://www.worldstandards.eu/electricity/plug-voltage-by-country/>.

World Standards 2018b. *Plug & socket types,* viewed 10 November 2018, <http://www.worldstandards.eu/electricity/plugs-and-sockets/>.

World Wind Energy Association 2018, *Wind power capacity reaches 539 GW, 52,6 GW added in 2017,* viewed 9 December 2018, <https://wwindea.org/blog/2018/02/12/2017-statistics/>.

Wu, Y, Zheng, Q, Zhang, Y, Liu, B, Cheng, H & Wang, Y 2008, 'Development of gullies and sediment production in the black soil region of northeastern China', *Geomorphology,* vol. 101, no. 4, pp. 683–691, https://doi.org/10.1016/j.geomorph.2008.03.008

Yang, G, Liu, J, Zhao, C, Li, Z, Huang, Y, Yu, H, Xu, B, Yang, X, Zhu, D, Zhang, X, Zhang, R, Feng, H, Zhao, X, Li, Z, Li, H & Yang, H 2017, 'Unmanned aerial vehicle remote sensing for field-based crop phenotyping: Current status and perspectives', *Frontiers in Plant Science,* vol. 8, pp. 1111–1137, https://doi.org/10.3389/fpls.2017.01111

Zahorcak, M 2007, 'Evolution of the photographic lens in the 19th century', in MR Peres (ed.), *Focal encyclopedia of photography: digital imaging, theory and applications, history, and science,* 4th edn, Elsevier, Amsterdam, Netherlands, pp. 157–176.

Zaman-Allah, M, Vergara, O, Araus, JL, Tarekegne, A, Magorokosho, C, Zarco-Tejada, PJ, Hornero, A, Albà, AH, Das, B, Craufurd, P, Olsen, M, Prasanna, BM & Cairns, J 2015, 'Unmanned aerial platform-based multi-spectral imaging for field phenotyping of

maize', *Plant Methods*, vol. 11, p. 35, https://doi.org/10.1186/s13007-015-0078-2

Zarco-Tejada, PJ, Diaz-Varela, R, Angileri, V & Loudjani, P 2014, 'Tree height quantification using very high resolution imagery acquired from an unmanned aerial vehicle (UAV) and automatic 3D photo-reconstruction methods', *European Journal of Agronomy*, vol. 55, pp. 89–99, https://doi.org/10.1016/j.eja.2014.01.004

Zavaleta, E 2000, 'The economic value of controlling an invasive shrub', *Ambio*, vol. 29, no. 8, pp. 462–467, https://doi.org/10.1579/0044-7447-29.8.462

Zhan, Q, Shi, W & Xiao, Y 2005, 'Quantitative analysis of shadow effects in high-resolution images of urban areas', *ISPRS International Archives of the Photogrammetry, Remote Sensing and Spatial Information Sciences*, vol. XXXVI, Part 8/W27, viewed 4 November 2018, <http://www.isprs.org/proceedings/XXXVI/8-W27/zhan.pdf>.

Zhang, C & Kovacs, JM 2012, 'The application of small unmanned aerial systems for precision agriculture: a review', *Precision Agriculture*, vol. 13, no. 6, pp. 693–712, https://doi.org/10.1007/s11119-012-9274-5

Zimmerman, JL 1995, *Cheyenne Bottoms: Wetland in jeopardy*, University Press of Kansas, Lawrence, Kansas, United States.

Zuckerman, J 1996, *Techniques of natural light photography*, Writer's Digest Books, Cincinnati, Ohio, United States.

Zweig, CL, Burgess, MA, Percival, HF & Kitchens, WM 2015, 'Use of unmanned aircraft systems to delineate fine-scale wetland vegetation communities', *Wetlands*, vol. 35, no. 2, pp. 303–309, https://doi.org/10.1007/s13157-014-0612-4

Index

Note: Page numbers followed by *f* indicate figures and *t* indicate tables.